MYTHOLOGY AND MISOGYNY

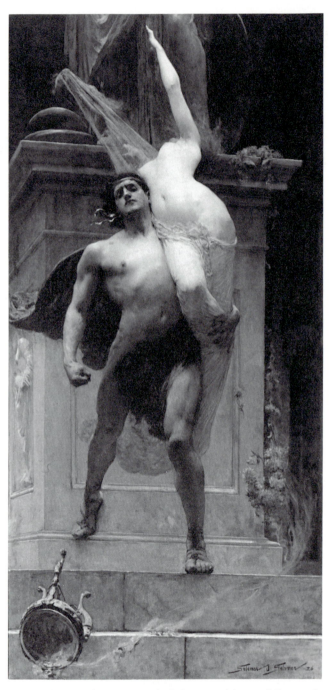

Frontispiece. Solomon Joseph Solomon: *Ajax and Cassandra*, 1886; 132 × 60; Ballaarat Fine Art Gallery, Victoria.

MYTHOLOGY
AND
MISOGYNY

The Social Discourse of Nineteenth-Century British Classical-Subject Painting

Joseph A. Kestner

THE UNIVERSITY OF WISCONSIN PRESS

The University of Wisconsin Press
114 North Murray Street
Madison, Wisconsin 53715

The University of Wisconsin Press, Ltd.
1 Gower Street
London WC1E 6HA, England

Library of Congress Cataloging-in-Publication Data
Kestner, Joseph A.
Mythology and misogyny.
Bibliography: pp. 369–398.
Includes index.
1. Painting, British. 2. Painting, Modern—19th
century—Great Britain. 3. Mythology, Classical, in
art. 4. Women in art. 5. Women—Great Britain—
Sociological aspects. I. Title.
ND1460.W65K47 1988 758'.930542'0941 87-40365
ISBN 0-299-11530-5

For Carl R. Woodring

The male is by nature superior, and the female inferior; and the one rules, and the other is ruled; this principle, of necessity, extends to all mankind.

—ARISTOTLE, *The Politics*

It is very kind of you to give me so interesting and so reassuring an account of the damaged picture. My hope is that no Maenad will whack the beautiful bust. It is philosophical of you to be unaffected by the crimes of these people. . . . But I cannot be so Olympian. . . . I find it difficult to think of these women with composure.

—EDMUND GOSSE to Hamo Thorny-
croft on the attack by a suffragette
on Velásquez's *Venus with a Mir-
ror* ["Rokeby Venus"] 6 May 1914

Contents

Plates

Acknowledgments

THIS book could not have been written without the cooperation of many individuals, libraries, dealers, and institutions and the access provided to their collections of paintings and documents. The author wishes to express his gratitude for the invaluable assistance rendered by these individuals and institutions.

The author is particularly grateful to Lance Thirkell for allowing access to the papers of his great-grandfather Sir Edward Burne-Jones. His warm hospitality extended during the course of this research is equally appreciated.

The author is indebted to Stephen Jones, Curator of Leighton House, and Helen Valentine of the Royal Academy of Arts for their unfailing assistance during the writing of this book. Vern G. Swanson provided access to his materials concerning Sir Lawrence Alma-Tadema, for which the author is grateful.

In Great Britain the author wishes to express his gratitude to the following: Alex Robertson, City Art Gallery, Leeds; Julian Treuherz, Manchester City Art Gallery; Alex Kidson, Walker Art Gallery, Liverpool; Helena Moore, Ferens Art Gallery, Hull; Richard Green, York City Art Gallery; Joan Hervey, Courtauld Institute of Art; Peter Cormack, William Morris Gallery, Walthamstow; Colin Franklin; Jennifer Melville, Aberdeen Art Gallery; Tessa Sidey and Stephen Wildman, Birmingham Museum and Art Gallery; Lucy Wood, Lady Lever Art Gallery, Port Sunlight; Wilfrid Blunt and Richard Jefferies, Watts Gallery, Compton; Alice Munro-Faure, Sotheby's Belgravia; Julian Rex-Parkes, Christie's; Guy Redmond, Peter Nahum Gallery; Paul Lawson, Bradford Museum and Art Gallery; Christine Bayliss, Fulham Public Library; Anthony Hobson; David Scrase, Fitzwilliam Museum, Cambridge University; Davis Naylor, Ashmolean Museum, Oxford University; Wolverhampton Art Gallery; The Fine Art Society, London; Laing Art Gallery, Newcastle upon Tyne; Rochdale Art Gallery; Sudley House, Liverpool; The National Trust,

Buscot Park; The DeMorgan Foundation; Glasgow Art Gallery; National Gallery of Scotland; Bradford Art Galleries; Blackburn Museum and Art Gallery; Guildhall Art Gallery; Leicester Museum and Art Gallery; Dundee Art Galleries and Museums; Leger Galleries Ltd.; Marlborough Fine Art; Whitford and Hughes Gallery; Oldham Art Gallery; Harris Museum and Art Gallery, Preston; Southampton Art Museum; Russell-Cotes Museum, Bournemouth; Forbes Collection, Old Battersea House; Linley Sambourne House, London; the Tate Gallery; Victoria and Albert Museum; and the British Library. Julian Hartnoll and Christopher Wood permitted access to their personal files of materials and catalogues. John Christian kindly provided offprints of his excellent Burne-Jones scholarship; Richard Ormond supplied valuable information concerning Frederic Leighton.

In Australia, the author would like to thank the following institutions: Art Gallery of South Australia, Adelaide; National Gallery of Victoria, Melbourne; Art Gallery of New South Wales, Sydney; and the Ballaarat Fine Art Gallery, Victoria. In Canada, the author is grateful to the Montreal Museum of Fine Arts.

In the United States the author would like to thank the following individuals and institutions for their assistance: Mary Holahan, Delaware Art Museum; David Daniels; Robert Kashey of Shepherd Gallery Associates, New York; The Metropolitan Museum of Art; Mary Sarnacki, the New York State Library, Albany; Tom Young, Philbrook Art Center, Tulsa; the Los Angeles County Museum; Getty Museum, Malibu; Clark Art Institute; Humanities Research Center, University of Texas at Austin; Helene E. Roberts, Fogg Art Museum, Harvard University; Susan P. Casteras, Yale Center for British Art; René Taylor, Museo de Arte de Ponce, Puerto Rico; Edmund J. and Suzanne McCormick; Fearn Thurlow, Newark Museum; Chicago Art Institute; Museum of Fine Arts, Boston; Walters Art Gallery, Baltimore; Philadelphia Museum of Art; Richard Hilligass; James R. Kincaid; Coral Lansbury. Alberta Frost and David Flaxbart of the McFarlin Library of the University of Tulsa gave invaluable assistance.

Kurt Löcher provided crucial insights regarding Burne-Jones's *Perseus* series. The Staatsgalerie Stuttgart provided a copy of Kurt Löcher's essential monograph on the series as well as great assistance in examining the series in Stuttgart.

A portion of this book appeared in *Biography* (1984). Sections were read at the Tate Gallery, 1984; the Northeast Victorian Studies Association, 1984; and the Victorians Institute Conference, Georgetown University, Washington,

D.C., 1985. Richard Humphries of the Tate Gallery was especially helpful during the Pre-Raphaelite retrospective exhibition in London in 1984. An additional section of this work appeared in the *Victorians Institute Journal* in 1987.

The author is grateful to the University of Tulsa for the academic leave which permitted the consolidation of this research.

To Allen N. Fitchen, Director, the University of Wisconsin Press, the author wishes to express his gratitude for the encouragement he received during the production of this book.

The author is indebted to John Halperin and Joseph Wiesenfarth for their friendship, and their probing recommendations, during the writing of this work.

Anna Norberg has been a strong and loving source of support during the writing of this book.

In the galleries, the legend for each plate includes artist, title, date, medium (if other than oil on canvas or panel or board), dimensions in inches, height before width (if known), and provenance (if known). Where the provenance is unknown or private, the source of the plate is identified; the abbreviation *RAP* indicates the Cassell series *Royal Academy Pictures*.

In the text, classical gods and goddesses are referred to by their Greek designations except where titles or context require the Roman identification.

MYTHOLOGY AND MISOGYNY

Introduction:
Classicism as Social Discourse

THE sixth of July 1885 is an important date in the history of Victorian social legislation. On that Monday, William Thomas Stead published in the *Pall Mall Gazette* the first installment of his investigation into the white slave trade in England. The series, *The Maiden Tribute of Modern Babylon,* continued on the seventh, eighth, and tenth of July. By the ninth of July, public reaction was already being printed in the paper. Stead's series of investigations into the brothels of England and the Continent led to the passage of the Criminal Law Amendment Act, by which the age of consent for girls was raised from thirteen to sixteen. Stead's essay had effectively made its case through an intriguing strategy. Throughout the *Maiden Tribute,* Stead invoked classical mythology, specifically the story of Theseus, to advocate social policy and reform. Stead's essay indicates the manner in which classical mythology became part of social discourse about the situation of women in the nineteenth century. Such prose was not the only form of expression in which classical legend informed social discourse. The focus of this book is the manner in which classical-subject painting, the use of classical motifs and legends by artists, was part of this social discourse. Such painting was a powerful expression of male attitudes about women and their condition. In a period of political and legal transition for women, classical-subject painting was a conservative, frequently reactionary, force in the process of women's gradual change of status.

In the *Maiden Tribute,* several legends are operative. In the first installment, Stead observes: "In ancient times, if we may believe the myths of Hellas, Athens, after a disastrous campaign, was compelled by her conqueror to send once every nine years a tribute to Crete of seven youths and seven maidens. . . . The vessel that bore them to Crete unfurled black sails as the symbol

3

of despair, and on arrival her passengers were flung into the famous labyrinth of Daedalus, there to wander about blindly until such time as they were devoured by the Minotaur" (1). Theseus became the hero who volunteered to terminate this tribute. Stead quotes Ovid to reinforce his contention. Then he turns to contemporary London: "The fact that the Athenians should have taken so bitterly to heart the paltry maiden tribute that once in nine years they had to pay to the Minotaur seems incredible, almost inconceivable. This very night in London, and every night, year in and year out, not seven maidens only, but many times seven, selected almost as much by chance as those who in the Athenian market-place drew lots as to which would be flung into the Cretan labyrinth, will be offered up as the Maiden Tribute of Modern Babylon . . . within the portals of the maze of London brotheldom. . . . The maw of the London Minotaur is insatiable" (2). Throughout Stead's essay, the image of the suffering woman is invoked to call male legislators to imitate ancient heroism and save these women. Further classical allusions reinforce Stead's case. "You wander in a Circe's isle, where the victims of the foul enchantress's wand meet you at every turn" (3), he comments. Most of the girls were confined to these brothels with little opportunity to escape. All these references are mythological. Theseus, Circe, the preying Minotaur, and the confined Andromeda are the bases of Stead's arguments.

The myth controlling the entire series is that of Danaë, imprisoned in a tower and impregnated by Zeus in a shower of gold. This transformation of semen into gold becomes the archetypal image of prostitution. In his third installment Stead focuses on a legislator who patronizes these brothels as "this English Tiberius, whose Capreae is in London" (5), and concludes: "The blindest unbelief must admit that in this 'English gentleman' we have a far more hideous Minotaur than that which Ovid fabled and Theseus slew." Stead's selection of the Theseus/Ariadne legend was conditioned by the archaeological discoveries of Minos Kalokairinos, who uncovered the remains of walls, supposedly of the Labyrinth, at Knossos in 1880. For several months Stead was imprisoned in Holloway Prison for gathering the evidence he presented in his exposé. This intersection of classical archaeology, legislation involving women, and the mythic interpretations of women's situation played a significant role in the formation of nineteenth-century ideograms of female nature. Stead was conceived of as a hero in the classical model. Millicent Fawcett said he was "the hero saint who in every age of the world's history has been picked out for misrepresentation" (Pearsall, *Worm* 374). His death on the *Titanic* only enhanced the legend.

I

Stead's *Maiden Tribute* is only one example of the manner in which classical mythology permeated Victorian social discourse. Numerous other instances indicate that classical-subject painters were deploying a common strategy of using mythological allusion to discuss contemporary culture. In 1843, William Bevan published a study of prostitution in Liverpool, noting the danger a young tradesman might encounter: "He lounges in lassitude about the neighborhood. He is allured by a syren voice that charms but to destroy. . . . He yields and is undone." A similar myth is evoked in 1861 about prostitutes: "On they come in countless myriads, to swell that tide of corruption which is sweeping away into one common, nameless grave the noblest and most promising of England's sons. The 'helpmeet' is transformed into the guilty tempter; the 'woman' of Eden loses her identity in the syren of the streets; the minister of heaven gives place to the accomplice of hell. Alas, how fallen!" (Nead, "Woman as Temptress" 11). It is estimated that there were 8,000 known prostitutes in London around 1850, with more than 50,000 in the United Kingdom. By 1858 it is estimated that one-sixth of unmarried women between fifteen and fifty were prostitutes, that is, around 83,000. In 1856 three hospitals in London treated some 30,000 cases of venereal disease, and half the outpatients at another fell into this category (Chesney, *Victorian Underworld* 355). Many physicians believed that only women could transmit venereal disease.

Mythological allusion was used either to reinforce or to condemn a certain norm of behavior. Negatively, the language of nineteenth-century social discourse invoked classical precedents like the Siren or Aphrodite or Circe to indicate that women's nature had been eternally prone to deviant behavior. Writing of "redundant women" in 1862, William R. Greg noted that these numbers of superfluous women constituted the "besetting problem which, like the sphinx's, society must solve or die" ("Why Are Women Redundant?" 277). Positively, in an essay published in 1890, "Modern Mannish Maidens," S. P. White introduced mythological examples to indicate the proper nature of women. Andromache was considered the "undying type of sweetest womanhood" in contrast to "Amazonian regiments" of mannish females. "For, *pace* the shade of the swift-footed Atalanta, running, we submit, is not the strong point of woman" (253, 259–260). The *Lancet* commented that in the West End there were many painted women: "The children of Cornelia inquire concerning the 'beautiful lady'" (Basch, *Relative Creatures* 197). Matthew Ar-

nold refers to the goddess Lubricity in his essay "Numbers." Frequently in
My Secret Life, "Walter" denominates his lovers as Venus. Henry James noted
that girls coming in from tennis "might have passed for the attendant nymphs
of Diana flocking in from the chase" (Pearsall, *Worm* 618). The variety of en-
tertainments offered in the tableaux of the *poses plastiques* was announced
in language using classical discourse: "About 'The witching hour of night' com-
mence what may really be termed the orgies of the Cyprian goddess. Girls
of every state, from complete nudity to the half-dressed, go through the most
voluptuous exhibitions—and perform the most spirit-stirring dances," pro-
claimed a guidebook around 1840 (Pearsall, *Worm* 302). Artists such as Ros-
setti and Burne-Jones visited such places, locales where classicism came liter-
ally to life.

Contemporary analyses of nineteenth-century cultural discourse reveal its
use of a classical matrix. For example, Ann Richelieu Lamb, in "Can Woman
Regenerate Society?" in 1844, wrote: "Woman, chained and fettered, is yet
expected to work miracles. . . . Her business is to love! to suffer!! and obey!!!
the three articles of woman's creed. She must on no account reason or suppose
herself wiser than her protector and legislator" (Janet Murray, *Strong* 31). This
reference clearly demonstrates the relevance of the many depictions of An-
dromeda during the century, the locus classicus of the enchained female await-
ing her "protector." When he argued for the Contagious Diseases Acts, Wil-
liam Acton stated: "Prostitution ought to be an object of legislation. . . .
Kings, philosophers, and priests, the learned and the noble, no less than the
ignorant and simple, have drunk without stint in every age and every clime
of Circe's cup" (Janet Murray, *Strong* 427). As with the equation of Siren and
prostitute, Acton employs an insidious mythical predecessor to define wom-
en's nature. The eternality of the relevance of the myth is evident from the
statement "in every age and every clime." Writing in 1869, Frances Power Cobbe
objected to the fact that a woman was considered, among other things, a "God-
dess" (Bauer, *Free and Ennobled* 66), realizing that such a designation was
actually enslaving. Yet classical-subject canvases, which Cobbe must have had
in mind, constantly reinforced this identification.

In 1838, John Mitchell Kemble denounced the Custody of Infants Bill,
in the process denominating women as "she-beasts" (Bauer, *Free and Ennobled*
241). This association evokes the myriad examples of female/animal hybrids,
such as Sirens, Harpies, and mermaids. Eliza Linn Linton denominated femi-
nists in the nineties "Wild Women," associating them with beasts. In her es-
say "The Wild Women as Social Insurgents," Linton observed: "Such women

as Panthea and Alcestis, Cornelia and Lucretia, are as much out of date as the chiton and the peplum." In contrast to the desirable mythical prototypes, the feminist was mercenary, subversive, daring, competitive, "rebellious," and "tyrannous." The womanly ideal was Alcestis, not Xanthippe (596, 604–605). Advocates of rights for women were thus repudiating the eternal ideals of womanhood embodied in these prototypes. Linton suggests, furthermore, that such women were atavisms, closer to savages than to civilized beings. As "Wild Women," they also exhibited aberrancies that suggested potential insanity. The "Wild Woman" was becoming a *"domina"*: "Her ideal of life for herself is absolute personal independence coupled with supreme power over men" (596). Part of this independence in Linton's estimation is the Wild Woman's "absolutely unwomanly indifference to death and suffering. . . . The viragoes of all times have always had this same instinct, this same indifference. For nothing of all this is new in substance. What is new is the translation into the cultured classes of certain qualities and practices hitherto confined to the uncultured and — savages" (598). In "The Partisans of the Wild Women" in 1892, Linton declared that male adherents of women's rights praised a woman "who trails about in tigerskins" (460). It was thus that women were depicted in the many classical-subject canvases of Bacchantes and Maenads, savage atavisms both mad and bestial. As did the classical-subject painters, Linton celebrates a moral system specifically associated with male heroism: "Their [the Wild Women's partisans'] morals are the morals of women, not of men. The grand and heroic virtues of masculine men . . . are nowhere with them" (458–459). The partisans, to Linton, are like Phaëton seizing the chariot of Apollo; in this comparison she records in prose the superiority of the solar hypermasculine Apollo celebrated on canvas by artists such as Leighton and Riviere. The social discourses of prose and picture become ideologically identical, reinforcing patriarchal dominance by the deployment of myth.

That women had small brains indicated their inferiority on the evolutionary scale, many males believed. In "Mental Differences between Men and Women," George J. Romanes noted that "the average brain-weight of women is about five ounces less than that of men," a condition which led to "a marked inferiority of intellectual power" in women (654–655). According to Romanes, "as a general rule the judgment of women is inferior to that of men has been a matter of universal recognition from the earliest times," and he found in ancient civilization a confirmation of his assertion: "Even in monagamous, or quasi-monogamous, communities so highly civilised as ancient Greece and pagan Rome, woman was still, as it were, an intellectual cipher — and this at

a time when the intellect of man had attained an eminence which has never been equalled" (656, 664). For Romanes as for the classical-subject painters, the ancient world and its mythology represented the pinnacle of male-superior culture. Romanes concluded that "it must take many centuries for heredity to produce the missing five ounces of the female brain" (666). Romanes' essay indicates the manner in which classicism and Social Darwinism interpenetrated one another. Citing Charles Darwin and W. H. Lecky, Romanes concluded that women's development had been arrested in the evolutionary process. He echoed the opinion of Herbert Spencer, who by 1873 in *The Study of Sociology* could write that there had been "a somewhat earlier arrest of individual evolution in women than in men" (340). Women were less developed in both their intellectual and emotional capacities. This Social Darwinism led writers like Linton to select mythic prototypes that reinforced the prejudices of such thinkers as Lecky, Darwin, and Spencer. In 1880 Alexander Keiller opposed higher education for women because proprietors of lunatic asylums, nearly always men, did "not hesitate to report against the maddening influence of undue educational efforts" (Pearsall, *Worm* 252), one of many declarations about women's inclination to insanity that was reflected in the mad and debauched Bacchantes that covered the walls of exhibitions. That classicism had become a mode of social indoctrination was equally evident in the essays of Stead, Romanes, and Linton and in the pictorial ideograms of classical-subject art. Walcot argues that many Greek myths "demonstrate the devastating power of the female and the male's inability to resist that power." The "evidence offered by Greek mythology [shows] how compulsively a fear of woman's sexuality did condition Greek attitudes towards women. . . . Myth may both explain attitudes as well as expose deep-seated traumas" ("Greek Attitudes" 39–40). The use of myth by social commentators and by artists in nineteenth-century England parallels this particular function of myth in ancient Greece. It was common for writers to resort to heroic analogies to describe their subjects. For example, Alice Corkran, in her 1904 study of Leighton, praised Leighton's self-portrait, noting "the head with its Jovian curls" (*Frederic Leighton* 107). Reviewing Swinburne's *Poems and Ballads* in 1866, John Morley accused the poet of detailing the habits of Pasiphae to the extent that he was becoming "the libidinous laureate of a pack of satyrs" (Houghton and Stange, *Victorian Poetry* 835). Such references express moral outrage and fear of Swinburne's sensuality.

Medical discourse employed mythology in a similar manner to reinforce the concept of female deception. In a poem from 1878, the lure of opium was

likened to the song of a Siren. A court physician in 1876 observed: "It [temptation] is not the beautiful Goddess of Love but Circe, the wanton one, and the floating forms are Sirens who allure him — the luckless, the headless, within their deadly embrace" (Haller, *Physician and Sexuality* 202). One advertisement in 1848 noted that "The *Preventive Lotion* will enable [a man] to have connexion with the fair but frail Cyprians who perambulate our streets" (Haller 261). A treatise published in 1882 invoked a mythological woman in its title, *Diana: A Psycho-Fyziological Essay on Sexual Relations for Married Men and Women.* In emulation of Roman society, a man was frequently referred to as a *paterfamilias,* an invocation of the powerful authority enjoyed by Roman husbands. In the social discourse of nineteenth-century Britain, classicism and classical allusions constituted a code which was known thoroughly by the men who directed and guided social policy, and which was used to reinforce patriarchal privilege and authority.

The mythology presented in classical-subject pictorial ideograms reflects the cultural predispositions regarding women in the nineteenth century. These predispositions are evident in many documents of the period, such as Ruskin's "Of Queens' Gardens" and Stead's *Maiden Tribute of Modern Babylon.* A different use of mythology in cultural statements is evident in Florence Nightingale's *Cassandra* (1852; privately printed 1860). Its appearance at relatively the same time as William Acton's *The Functions and Disorders of the Reproductive Organs* (1857; subsequent editions 1858, 1862, 1865, 1867, 1875), and at the beginning of the classical-subject period in nineteenth-century art, is intriguing. One invokes a standard of female "heroism," the other supports male superiority.

Nightingale selected a crucial myth about women in choosing the title *Cassandra* for her treatise. Cassandra, given the gift of prophecy by Apollo, was never believed, a punishment for her repudiation of the god's advances. Nightingale is here opposing myths of male superiority as promulgated in Max Müller's solar mythology and as seen in the reverence for Apollo embodied later in classical-subject canvases. Nightingale's thesis is expressed in her question "Why have women passion, intellect, moral activity — these three — and a place in society where no one of the three can be exercised?" (25). These traits characterize the mythical Cassandra and indicate the qualities Nightingale believes are nullified in the social situation of women. Women have no professions, no time, no privacy; their "duties" are domestic and unfulfilling. Nightingale repudiates the role of woman as Angel in the House. "Do we ever *utilize* this heroism?" (36) of either men or women, she asks.

In rejecting the myths of domesticity, Nightingale repudiates the myths of Nausicaa (the nurse), Ariadne (man's assistant), Penelope (the forlorn wife), and Alcestis (the sacrificial spouse), icons repeatedly presented to the Victorian public. She substitutes contemporary heroines for these images, much as did the suffragette who preferred Sylvia Pankhurst to Velásquez's "Rokeby Venus," which she slashed. For Nightingale, Caroline Chisholm, Elizabeth Fry, and Mary Somerville, pioneers in female emigration, female prison reform, and female education, are exemplary heroines. These energetic contemporary women give the lie to traits the culture attached to women, such as passivity and the tendency to madness, which were embodied in the countless pictures of women dozing or somnolent by Leighton, Moore, and other artists. The madness was signaled by every depiction of the Maenad or Bacchante, of which there were hundreds. Nightingale notes that many times a woman "is blamed, and her own sex unites against her" (51), the situation of many mythic women confronted by immortal goddesses, such as Niobe. Nightingale's cry "Awake, ye woman, all ye that sleep, awake!" (52) deplores the icon that would be presented in classical-subject art of the somnolent female.

In his treatise Acton, remarking on prostitutes, used mythology to foster male gynophobia: "Any susceptible boy is easily led to believe, whether he is altogether overcome by the syren or not, that she, and therefore all women, must have at least as strong passions as himself" (163). Acton discusses the absence of female sexual response, and the general lack of interest of women in sex, in a chapter concentrating on a discussion of "false impotence"; therefore, Acton's argument is that women are responsible for male impotence when they do show sexual responsiveness. This condemnation led to the classical-subject emphasis on Sirens, mermaids, nymphs, nixies, and Harpies, all images of predatory, hypersexual, terrifying females.

The diagnosis "nymphomania," frequently used to condemn women who showed sexual responsiveness, indicates that the many pictures of nymphs and other lesser mythological types universalized the intimidating aspects of Aphrodite and other major female deities. In discussing marriage, Acton gave this advice for selecting a wife: "Closely connected with the question of health is that of *education*. . . . As to intellect, accomplishments, and fortune, men need little advice. Literary women are not likely to be much sought after for wives. And great accomplishments so seldom survive the first year of married life, that men of the world are too sensible to allow them to outweigh the sterling qualities of a pleasant manner, a sweet temper, and a cheerful disposition" (127). Acton did not hesitate to declare: "I am ready to maintain that

there are many females who never feel any sexual excitement whatever. . . . Many of the best mothers, wives, and managers of households, know little of or are careless about sexual indulgences. Love of home, of children, and of domestic duties are the only passions they feel" (164). Jeffrey Weeks notes that "it was not until the nineteenth century that sexual ideology attempted to deny female sexuality altogether" (*Coming Out* 5).

Acton's statements about male sexuality were not calculated to allay fears. He devotes his first section to masturbation and its attendant consequences; he discusses castration as a method of dealing with epilepsy. Acton emphasizes the exhaustion that follows coitus; he cautions against the waste of vital energy through coitus or masturbation, recommending intercourse once every seven or ten days; he accuses men of priapism and satyriasis. Classical-subject painters rarely showed Satyrs and never Priapus for fear of being accused of such aberrancy. Acton's mythologies of men and women did not encourage mutual understanding, commitment, or tolerance. Several of Acton's case histories fostered opposition to women's emancipation. One example appears in the discussion of "false impotence": "I was lately in conversation with a lady who maintains woman's rights to such an extent that she denied the husband any voice in the matter, whether or not cohabitation should take place. She maintained, most strenuously, that as the woman bears the consequences . . . a married woman has a perfect right to refuse to cohabit with her husband" (166).

As the author of the treatise *Prostitution,* Acton's authority was considerable. His education and audience need to be recalled when assessing his opinions about female sexuality. He had received his training at the Female Venereal Hospital in Paris, an experience which undoubtedly contributed to his conception of woman as Siren or Circe. He wrote "for an educated, masculine readership" (Chesney, *Victorian Underworld* 318). The compound of anxiety about male sexuality and persistent gynophobia intersected with the misogyny, apprehension, and mistrust evident in classical-subject art. Medical doctrine and classical-subject painting both were directed toward this insidious cultural indoctrination. Classical-subject painting, elevating Nausicaa, Alcestis, or Penelope, argued for the compliant wife, not the self-assertive.

Victorian literature is another manifestation of the use of classical myths to depict women. In her novels, for example, George Eliot frequently employed mythological names and matrices in the presentation of her characters. In *Adam Bede,* the face of Hetty Sorrel is compared to that of Medusa: "the sadder for its beauty, like that wondrous Medusa-face, with the passion-

ate, passionless lips." In such a reference, Eliot is making the same equation as Acton regarding women's sexuality; the seduced woman is like Medusa, that is, the sexual woman is terrifying. In *Scenes of Clerical Life,* Eliot associates one lethal character, Caroline Czerlaski, with the vengeful Artemis; Maynard Gilfil and Caterina Sarti become Orpheus and Eurydice. In "Janet's Repentance," Dempster regards his wife as Medusa: "her hair is all serpents . . . they're black serpents . . . they hiss . . . her arms are serpents . . . she wants to drag me into the cold water . . . it is all serpents." Eliot telescopes the deadly Medusa and the deceiving mermaid. Joseph Wiesenfarth shows that in *Middlemarch* Will Ladislaw is both Dionysus and Theseus, as well as Apollo and Eros, while Dorothea is Ariadne and Psyche, and Casaubon is the devouring Minotaur. The dangerous Rosamond Vincy becomes a mermaid. The mythical complex of Dionysus and Ariadne underlies the principal characters in *Romola,* while the Medea myth is an archetype in *Daniel Deronda.* Becky Sharp in Thackeray's *Vanity Fair* is associated with Clytemnestra. In chapter 64 of his novel, Thackeray aligns his heroine with fatal predecessors: "In describing this syren, singing and smiling, coaxing and cajoling, the author, with modest pride, asks his readers all round, has he once forgotten the laws of politeness, and showed the monster's hideous tail above water? . . . Those who like may peep down under waves that are pretty transparent, and see it writhing and twirling, diabolically hideous and slimy, flapping amongst bones, or curling round corpses." Danaë is a prostitution myth in Dante Gabriel Rossetti's "Jenny." "Walter" in *My Secret Life* fills the vagina of a prostitute with shillings in literal imitation of the myth of Danaë. Arnold devotes his "Bacchanalia" to the Bacchantes. Thomas Hardy associated his men and women with classical prototypes. Bathsheba Everdene is a compound of Artemis, Hera, and Atalanta in *Far from the Madding Crowd.* Phryne and Atalanta appear in *Tess of the d'Urbervilles.* The figure of the pig-woman Circe underlies the presentation of Arabella Donn in *Jude the Obscure.* In the same novel, Sue Bridehead's two statues of Aphrodite and Apollo link her with a complex mythical dualism of sensuality and male hero worship. These and multitudinous other examples illustrate the Victorian disposition to use myth as cultural discourse when presenting women.

One may look at the Edwardian period and recognize examples of the same practice. Suffragettes carried banners of Artemis and of Boadicea to repudiate the image of women as the abandoned Ariadne, the prostituted Danaë, the impulsive Psyche, the wayward Pandora, the forlorn Penelope, the mad Bacchante, the fearful Medusa, the death-bearing Persephone, the murder-

ous Medea, the dehumanizing Circe, the death-bearing Eurydice and Alcestis, the sacrilegious Hero, the disastrous Helen, the sensuous Aphrodite, and the deluding Siren, Lamia, and mermaid. Sylvia Pankhurst used the figure of Nike, goddess of Victory from Greek mythology, as the emblem of her journal *Votes for Women,* countering the selectivity of males who emphasized Aphrodite, Psyche, Pandora, or Persephone. (The queen herself had been named after this goddess, not after the Christian saint.) On 10 March 1914 a suffragette, Mary Richardson, attacked Velásquez's *Venus with a Mirror* (the "Rokeby Venus") to protest the treatment of Sylvia Pankhurst, declaring: "I have tried to destroy the picture of the most beautiful woman in mythological history as a protest against the Government for destroying Mrs. Pankhurst, who is the most beautiful character in modern history" (*Times,* 11 March 1914, p. 9).

In the nineteenth century, when classical studies and icons were conspicuous, myths were crucial to the formation of attitudes about women that created predispositions about female qualities. Classical-subject canvases employed legends that reinforced the practice of the patriarchal society to define women by emphasizing sexual identity over gender identity, men by gender identity as much as by sexual identity. The result of this stress was that woman's biological function was construed as central in determining her nature, while a man's physiological role received less accentuation than his gender role. According to the patriarchy, the fact that a woman was female was a greater definer than that she was feminine, while men emphasized being masculine as well as being male. As a result, a woman could be construed as born with an unvarying nature, while a man exhibited development, progress, and advancement as well as an unchanging heroic predisposition. Thus, for example, menstruation could be interpreted to connote a proclivity to madness, encoded in paintings of the Bacchante or Maenad.

It is the contention of this study that Victorian paintings of classical subjects are part of a cultural discourse concerning women which restricted and delayed the progress of social reform. This attitude is clear in Stead's essay, where no mention is made of Ariadne, who had given the thread to Theseus, enabling him to accomplish the male heroic "rescue" of the sufferers. Stead uses the classical myth to inspire male legislators to emulate classical heroism. He reflects his own culture in neglecting to mention the role of Ariadne. In the nineteenth century, she was conceived of as the archetypal abandoned woman, not the heroic woman. Stead manipulates the classical legend, reading it in male terms, omitting aid by a woman to enforce male cultural "res-

cue" prerogatives. The major classical-subject painters (Edward Poynter, Edward Burne-Jones, Frederic Leighton, John William Waterhouse, Herbert Draper, Lawrence Alma-Tadema, Frederick Sandys, Albert Moore) as well as many artists now less well known (Ernest Normand, William Blake Richmond, John Collier, Philip Hermogenes Calderon, Walter Crane, Frank Dicksee, and others) provided iconological ideograms of mythical types sanctioned by the culture as a true representation of women's permanent nature and men's characteristic behavior. Such ideograms constituted encoded semaphores of the culture which reinforced patriarchal control and phallocentric authority. The widespread knowledge of classical allusion exhibited in familiar letters, the popular press, parliamentary debates, social treatises, and scholarly texts guaranteed that those in authority, and those subject to it, could decipher such codes with acuity, certainty, and precision.

These pictures deployed classical myth to construct a meaning about gender roles and sexual norms. In Victorian classical-subject canvases, women were continually represented in one of two ways: either as irresponsible, outcast, prostituted, vicious, sensuous, demented, bestial, castrating, sinister, delusive, conniving, domineering, and fatal; or as submissive, passive, forlorn, abject, somnolent, dependent, unintelligent, enervated, helpless, nonsexual, ethereal, compliant, abandoned, and indecisive. These polarities defined women's nature for patriarchal society. The subliminal messages of a male-dominated culture were on the walls of Victorian mansions and museums. The purpose of this book is to explore and investigate male attitudes toward women as these were expressed in the range of subjects and the iconographic strategies of nineteenth-century British classical-subject or mythological painting. These paintings used classical legend as social discourse to universalize misogynistic or gynophobic predispositions and ideas. The femme fatale in particular was disturbing because she exhibited beauty independent of morality, a separation that confuted the idea of woman as the Angel in the House, the arbiter and guardian of familial morals.

Heretofore conceived of as primarily decorative, classical-subject canvases in fact constituted ideograms of male psychological and political conceptions about women. For examining this process of cultural indoctrination, mythological pictorial ideograms are the strongest kind of evidence. Genre and portraiture offered images of roles for women, but neither form could achieve the simultaneous specificity, eternality, and universality of classical-subject art. The encoded subjects of these mythological canvases both distilled and universalized invidious attitudes toward women for the purpose of cultural in-

doctrination. "Psychic impulses compel the creation of the myth, but once objectified and projected outward, the myth reinforces, legitimates, and even influences the formation of those impulses by the authoritative power of that projection, especially when it is embedded in a magisterial work of art" (Zeitlin, "Dynamics of Misogyny" 174). These mythologies became part of a legal, medical, educational, religious, and marital system of cultural indoctrination that emphasized male superiority.

Nineteenth-century classical-subject painting and its process of cultural indoctrination operated through a system of association of ideas. Writing of the standards of art reviewers during the period, Helene Roberts observes: "What the reviewer wanted from a painting was some kind of experience. He wished to have his imagination stimulated, his senses aroused, and, above all, his sentiments engaged. He wanted a painting to set off a stream of associations. . . . The work of art, of course, must provide the clues that guide this chain of associations along the desired course. . . . It was the subject content and the viewer's response to it that consumed their main interest" ("Art Reviewing" 13–14). Classical-subject canvases controlled, reinforced, or created definitions of male and female character through "associative patterns" (14) evoked by the legends and situations represented. The knowledge of mythology on the part of a classically-educated public, the recurrence of certain mythic icons, and the eternality and universality inherent in mythic representation convinced the culture that certain sexual qualities were unchanging verities. The hanging committees which selected pictures for exhibition were totally male controlled at such institutions as the Royal Academy, the Grosvenor Gallery, and the New Gallery. In the exhibitions, the encoded canvases reflected the prejudices of male juries of art. Critics occasionally reviewed the work of women artists in separate sections of a review, implying a difference in their command of technique. Many of these classical-subject canvases achieved wide circulation among and thereby influence over the public from popular engravings and photogravures. These ideograms existed to be decoded by a patriarchal society well informed about classical mythology.

The artists who painted classical-subject ideograms of Greco-Roman culture developed their ideas against an intellectual background involving many movements. These movements formed the matrix of the association of ideas that directed the consciousness of the public when examining works of art and when appraising legislation involving women. Two of the most conspicuous are classical archaeology and feminism. Classical-subject depictions of women represent the confluence of these two movements—the progress of

archaeology, with the attendant development of theories of mythology, and the advances in the reformation of the status of women.

The attractions of Greco-Roman culture to the nineteenth century were diverse and not always consonant with one another. Yet the images of women produced by archaeology and mythology shaped the consciousness of the nineteenth century, especially when promulgated by thinkers such as Andrew Lang, John Ruskin, Jane E. Harrison, Matthew Arnold, and Walter Pater. In 1885, the year of Stead's *Maiden Tribute,* a new chair in classical archaeology was instituted at Oxford. Feminism and classicism, parallel developments, intersected. The intersection of anthropology, mythology, and sociology marked a crucial period of formation of attitudes about women's nature. While it is difficult to be comprehensive, one may isolate certain conceptions of the Greco-Roman world that distinguished Victorian thought.

II

Part of the attraction of the ancient world was political. The period of democratic reform in England, commencing in the 1830s and persisting throughout the century to the Edwardian period, found a prototype of its democratizing practices in its conception of Greece and Rome as structured societies that advanced human progress by legislative reform and extension of the prerogatives of citizenship. Ogilvie notes: "Pericles' measure in the 450s to extend the franchise is the counterpart of the Reform Bill of 1832" (*Latin and Greek* 106). Thomas Arnold conceived of Greek and Roman history, however, as also providing a cautionary example of "the danger of premature concessions to democracy" (Jenkyns, *Victorians and Ancient Greece* 62). The fact that Pericles' extension of the franchise did not include women also found a parallel in Victorian legislation.

The expanionist policies of British imperialism were foreshadowed in the Roman Empire, which to the British mind was fulfilling a civilizing mission similar to its own. Christopher Wood comments that Victorian "colonial administrators . . . saw themselves as Roman proconsuls, or even generals" (*Victorian Parnassus* [catalogue] 2). The concept of peacemaker, by which the Greeks inculcated respect for virtue and the Romans for law, was reflected in the Victorian idea of the use of politics to advance ethics. The belief in progress, so crucial to nineteenth-century self-conceptions, found its prototype in Rome's development from an agricultural to an industrial society. At the same time, the tradition of Roman republican virtue, represented by the strong

family under the authority of the *paterfamilias,* reinforced patriarchal authority and the position of men as moral leaders.

This identification is epitomized in John Stuart Mill's belief that "The battle of Marathon, even as an event in English history, is more important than the battle of Hastings" (*Works* 11.273). In *On Liberty* in 1859, Mill linked Britain with Greece and Rome: "The struggle between Liberty and Authority is the most conspicuous feature in the portions of history with which we are earliest familiar, particularly in that of Greece, Rome, and England" (3). One of Mill's strongest defenses of the classics was in the *Edinburgh Review,* in 1840, when he appraised the second volume of Tocqueville's *Democracy in America:*

> We think M. de Tocqueville right in the great importance he attaches to the study of Greek and Roman literature, not as being without faults, but as having the contrary faults to those of our own day. Not only do those literatures furnish examples of high finish and perfection in workmanship, to correct the slovenly habits of modern hasty writing, but they exhibit, in the military and agricultural commonwealths of antiquity, precisely that order of virtues in which a commercial society is apt to be deficient; and they altogether show human nature on a grander scale—with less benevolence but more patriotism, less sentiment but more self-control; if a lower average of virtue, more striking individual examples of it; fewer small goodnesses but more greatness and appreciation of greatness; more which tends to exalt the imagination, and inspire high conceptions of the capabilities of human nature. (*Ethical Writings* 153)

Earlier, in the preface to *Hellas* (1821), Shelley had noted: "We are all Greeks —our laws, our literature, our religion, our arts have their roots in Greece." This statement may be linked with his belief as set forth in *A Defence of Poetry* the same year that "Poets are the unacknowledged legislators of the world," by which he meant that the poet was "maker" or *poietes* whose prototypes were classical. Shelley's contention led to the equation of "Greco-Roman" with legislator. Thomas Arnold declared that "Aristotle, and Plato, and Thucydides, and Cicero . . . are most untruly called ancient writers; they are virtually our own countrymen and contemporaries" (Jenkyns, *Victorians and Ancient Greece* 62).

Greco-Roman culture served other functions in nineteenth-century society. The classical tradition, fostered in school curricula, provided authentication of social status as a gentleman; knowledge of Greek and Latin certified status. While it provided the benefit of social recognition, it also was a civi-

lizing influence on the rising middle classes. Individuals, such as the manu-
facturer Thornton in Elizabeth Gaskell's *North and South* (1855), could study
classical authors or purchase classical-subject paintings to ratify their contract
with the ancient tradition. The classical tradition, as conceived by Thomas
and Matthew Arnold, combated bourgeois philistinism. The attention to duty,
which could veer into self-righteousness, led as Matthew Arnold claimed in
Culture and Anarchy (1869) to an emphasis on the Hebraic (conscience) rather
than the Hellenic (consciousness) in Victorian culture. He stated: "It is a time
to Hellenise, and to praise knowing; for we have Hebraised too much, and
have over-valued doing" (37). The classics also allowed the nineteenth-century
individual an alternative to the industrialism of the period. In Arnold's con-
ception, the classical tradition was not only ethical and admonitory but also
consolatory.

In *Culture and Anarchy* Arnold further argued that the function of cul-
ture, to develop the spirit, "is particularly important in our modern world,
of which the whole civilisation is, to a much greater degree than the civilisa-
tion of Greece and Rome, mechanical and external, and tends constantly to
become more so" (49). To define the perfection which culture brings, Arnold
resorted to the Greek *euphuia*, or "finely tempered nature" (53). For Arnold
one source of this perfection was Greek art: "Greek art . . . Greek beauty, have
their root in the same impulse to see things as they really are, inasmuch as
Greek art and beauty rest on fidelity to nature,—the *best* nature" (147).

The parallels drawn in classical-subject canvases between ancient customs
and contemporary practices universalized individual experiences, providing
continuity amid the disorientation of industrial transition. The Greek world
particularly was considered a culture in which beauty and aesthetic values were
respected and even revered. "There was enough in the resemblance between
the situations of England and Athens to tempt the Victorians into feeling
a spiritual kinship" (Ogilvie, *Latin and Greek* 108). The Victorians liked to
believe that in aesthetic and ethical matters they were Greek, in legal and
political astuteness Roman.

Simultaneously, the Greco-Roman world was an alternative to Evangelical
moralizing and pretentious self-righteousness. Greek and Roman religion was
conceived of as being free of the skepticism that marked nineteenth-century
Christianity, as being immune to the attacks of Higher Criticism and ration-
alism. Classical legend was a means of emancipation from the constraints of
Christianity; agnostic painters such as Frederic Leighton, Lawrence Alma-
Tadema, and G. F. Watts could disassociate themselves from Christian be-

lief by depicting Greco-Roman mythology. Watts noted in 1889: "Probably neither Ictinus nor Phidias believed in the personality of Pallas Athene, but the symbol represented an idea of a spiritual and vital nature, such as humanity can never dispense with without bewilderment . . . commanding, intellectual, perfect in beauty; not emotional or spiritual as Christian art was" ("More Thoughts" 254). In his essay "On the Modern Element in Literature," written in 1857 and published in 1869, Arnold noted: "The literature of ancient Greece is, even for modern times, a mighty agent of intellectual deliverance" (*Selected Prose* 58). Leighton conceived of his life in both Greek and nineteenth-century terms when he wrote J. Comyns Carr in 1873 that while his life was marked by "steady growth and development, there had been no peripateia" (Carr, *Some Eminent Victorians* 97).

Classical education, of course, could be a ready source of misogyny and gynophobia if one read certain texts, such as Plato's *Timaeus,* which stated: "The better of the two [sexes] was that which in future would be called man. . . . Anyone who lived well for his appointed time would return home to his native star and live an appropriately happy life, but anyone who failed to do so would be changed into a woman at his second birth" (57–58). Thus, even if one were agnostic, texts other than Pauline might inculcate negative attitudes toward women. "The *Iliad* . . . became a handbook of ethics, not just in Great Britain, but over a wide swathe of Europe, from the end of the eighteenth century onwards" (Warner 103). Images of Aphrodite or of her victim Helen would reinforce with classical models the negative image of women found in Christianity, whether one were a believer or not.

Classical-subject painters also reacted to several artistic movements. Classical-subject painting was a revolt against the preponderance of genre painting from the 1820s to the 1850s. For later artists it was also a revolt against the pseudo-medievalism and slavish naturalism of the Pre-Raphaelites. Classical-subject artists would concur with Arnold's belief as stated in the preface to *Poems* (1853): "Achilles, Prometheus, Clytemnestra, Dido—what modern poem presents personages as interesting, even to us moderns, as these personages of an 'exhausted past'? . . . Why is this? Simply because . . . the action is greater, the personages nobler, the situations more intense" (*Poetry and Criticism* 206).

As Helene Roberts notes, reviewers and public were concerned with "the idea of clearly delineated intelligible subject matter—one that sets off a stream of associated responses" ("Art Reviewing" 15). Classical-subject painters universalized their reactions to their era through the Greco-Roman mythological canon, providing subliminal messages that conveyed a masculine political,

cultural, and sexual ideology. It is appropriate to denominate these artists as "classical-subject" painters rather than "neoclassical" painters because of this emphasis. Relatively few of these painters practiced the linearity and emphasis on form that distinguished the "classical" style of art. Instead, they concentrated on mythological classical subjects although not working in a classical style.

<div align="center">III</div>

The art of painters like Leighton, Poynter, Burne-Jones, Alma-Tadema, Sandys, and Waterhouse would have been impossible without a long period of advances in classical archaeology and speculation about mythology. In the fields of archaeology and mythological theory, the British occupied positions of prominence going back to the eighteenth century. Although the discovery of the Apollo Belvedere in 1503 and of the Laocoön in 1506, and the explosion of the Parthenon in 1687 during a war between Turkey and Venice, each sparked some interest in classical civilization, serious interest dates from the discovery of Herculaneum in 1711 and of Pompeii in 1748. Pope's translation of the *Iliad* (1717–1720) and Lady Mary Wortley Montagu's travels to Troy in 1718 increased public interest. In 1755 Johann Joachim Winckelmann published his *Reflections on the Painting and Sculpture of the Greeks,* which was translated by Henry Fuseli in 1765. The first part of James Stuart and Nicholas Revett's *The Antiquities of Athens* was published in 1762.

By this time, literary works such as John Dyer's *The Ruins of Rome* (1740) and Mark Akenside's "Hymn to the Naiads" (1758) had appeared. Key treatises on classical art, Winckelmann's *History of Ancient Art* (1764) and Lessing's *Laocoön* (1766), appeared at a time of exciting archaeological discoveries, such as Gavin Hamilton's finding of the Discobolus of Myron in 1771 and the Apollo Sauroctonus about 1780. Toward the end of the eighteenth century, Emma Hart was appearing in classical draperies, bewitching even Goethe when he visited Naples in 1787. Likewise in the 1780s, Richard Payne Knight published a pioneering analysis of the symbolic significance of ancient artifacts, *An Account of the Remains of the Worship of Priapus.* John Flaxman, with his genius for line drawing, illustrated the *Iliad* and the *Odyssey* in 1793 and 1795, respectively.

In classical archaeology, the first two decades of the nineteenth century were distinguished by the removal of the Elgin marbles from Athens to London by Thomas Bruce, earl of Elgin (1766–1841). In 1801, the first consign-

ment of marbles left for England via Alexandria. In 1802 the first marbles arrived in England. Elgin was imprisoned in France from 1803 to 1806, but on his return to Britain the first Parthenon sculptures were displayed at his home in 1807. Byron denounced Elgin in 1809 in *English Bards and Scotch Reviewers,* and later in 1811 in "The Curse of Minerva" and in 1812 in the second canto of *Childe Harold's Pilgrimage.* After protracted negotiation, the Elgin Marbles were purchased for the nation in 1815 and went on public display in 1816.

Schools of art began to use plaster casts of the marbles soon after this display. Keats wrote his sonnet praising the marbles in 1817, the year which saw the publication of illustrated books on the marbles. During these two decades, important discoveries and excavations occurred, keeping classical civilization before the public: the beginning of the systematic excavation of the Forum Romanum in 1803, the finding of the pediment sculptures of Aegina by Byron's friend C. R. Cockerell in 1811, the purchase of the marbles of Aegina in 1812 by Bavaria, the excavation of the Forum of Trajan in 1812, and the purchase in 1814 of the Phigaleian marbles for the British Museum.

During the 1820s and 1830s political, archaeological, and literary events stimulated public awareness of the Greco-Roman world. Shelley's *Prometheus Unbound* (1820) and "Adonais" (1821), Keats's *Lamia* and *Hyperion* (1820), and Byron's *Don Juan* Canto 3 (1821) were published. Shelley and Keats provided icons of male heroism in the figures of Prometheus and Hyperion. Discoveries included the Venus de Milo in 1820, the Lateran Poseidon in 1824, and the Marsyas of Myron in 1825. The Greek war of independence (1821–1828) assumed special significance for the British with the death of Byron at Missolonghi.

The most conspicuous architectural result was the beginning of the building of the British Museum in 1827 in the Ionic style, designed by Robert Smirke (1781–1867), who had visited Athens in 1803 and criticized Elgin's removal of the marbles. Greece became independent in 1833, with Athens established as its capital in 1834, the year that marked the publication of Edward Bulwer-Lytton's *The Last Days of Pompeii.* Excavation at the Acropolis included the uncovering of the Propylaean steps and the Temple of Nike in 1835 and of the Erechtheum in 1837. Painters and travelers visited Greece, bringing to public attention the archaeological discoveries of the region.

The period from the 1840s to the 1860s, during which many of the classical-subject painters were in adolescence or were developing their styles, was a phase of intense discovery. The period was marked by a new scholarly interest in

archaeology and speculation about the significance of classical civilization. In 1844 the British Archaeological Association was founded, and the first volume of the *Archaeological Journal* was published the following year. Charles Fellows retrieved the Nereid Monument for Britain in 1842, and by 1845 F. C. Penrose had published the first accurate measurements of the Parthenon, demonstrating its entasis. The finding of the François Vase in 1844, with its depiction of Theseus with the freed hostages from Crete, provided an image of male heroic rescue that inspired Stead's essay four decades later. In 1858 Charles T. Newton discovered the Demeter of Cnidus, later to be important for the image of women in the art of Burne-Jones. Numerous publications began analyzing classical texts and their ethical and aesthetic significance: Gladstone's *Studies in Homer and the Homeric Age* in 1858, Arnold's preface to his poems in 1853, his lectures *On Translating Homer* during 1860 and 1861, Swinburne's *Atalanta in Calydon* in 1865, Pater's essay on Winckelmann in 1867, and Ruskin's *The Queen of the Air* (on the uses of mythology) in 1869 as well as Arnold's *Culture and Anarchy*.

Later archaeological activity during this period included the finding of the Victory of Samothrace in one hundred fragments in 1863, the excavation of the Temple of Dionysus in 1862, the building of the Acropolis Museum in 1864, and the beginning of the excavations of Heinrich Schliemann in Ithaca in 1868 and of British excavations of the Temple of Athene at Priene and of Ephesus in 1869. This period saw the publication of influential works such as Macaulay's *Lays of Ancient Rome* (1842), George Grote's *History of Greece* (1846) and Thomas Arnold's *History of Rome* (1838–1843). The middle decades of the period saw the emergence of greater scientific and theoretical methodology in classical studies.

This intensity of discussion parallels the rise of classical-subject painting and provided the foundation of associated ideas that was its context. Thus, in the decades from the 1870s to the end of the century, one of the greatest periods of classical-subject painting, archaeology, literature, and art vied in presentations and interpretations of Greco-Roman materials. Many of the activities of the 1870s are associated with Heinrich Schliemann, who began excavations at Troy in 1870 and discovered the "Treasury of Priam" in 1873. Schliemann delivered an address to the Society of Antiquaries in London in 1875. The following year he excavated the acropolis of Tiryns and found the Tomb of Agamemnon at Mycenae.

Archaeology yielded many works, some of which shaped the conception of women's nature, such as the discovery of the Esquiline Venus in 1874 which

influenced Poynter and Alma-Tadema. The finding in 1877 of the metopes of the Temple of Hera at Selinus was important because these metopes depicted Heracles fighting the Amazons and Actaeon attacked by Artemis' hounds, images of male superiority and female intimidation, respectively. In 1877 the discovery of the Hermes of Praxiteles at Olympia by Ernst Curtius set a new standard of male beauty. The female counterpart of Hermes was to be the finding in 1887 of the Ludovisi Throne, showing the birth of Aphrodite, a manipulation of drapery for sexual connotations that coincided with multitudinous representations of female form in classical attire at the Royal Academy.

Pater and Ruskin shaped ideas of classical civilization and mythology with their works. Pater published his "Myth of Demeter and Persephone" and "A Study of Dionysus" in 1876, the essays "The Beginnings of Greek Sculpture" and "The Marbles of Aegina" in 1880, *Marius the Epicurean* in 1885, and "The Age of Athletic Prizemen" in 1894. In his lectures *The Art of England* in 1883, Ruskin codified the uses of myth and illustrated his theories by examining the work of artists like Burne-Jones, Alma-Tadema, and Leighton. The fictional treatment of the ancient world is exemplified by Lew Wallace's *Ben-Hur* (1880) and Henry Sienkiewicz's *Quo Vadis?* (1895).

The discovery of the Bronze Charioteer of Delphi in 1896 confirmed the conjunction of morality and beauty, a coincidental summary of the century's interpretation of classical civilization in ethical and aesthetic terms. The simplicity of its draperies and the implied dignity of its aesthetic design subsumed the Doric virtues of *physis* (breeding), *eusebia* (reverence) and *sophrosyne* (moderation). Both the popular press and the specialized art periodicals such as the *Magazine of Art*, the *Art Journal*, and the *Studio* regularly informed their readers of these artistic and archaeological advances, bringing to the attention of painters and critics the continuing vitality of the classical tradition and deepening their associative capacity.

Myth and Male Attitudes toward Women in Nineteenth-Century Painting

THE discoveries of archaeology generated a new interest in Greco-Roman mythology, not merely in the content of legends but in the explanations of the origin of myth itself. The Greek word *mythos* means word or speech in Homer, its Latin equivalent being *vera narratio* or true story. Myths are not fictions but rather embryonic truths which serve four broadly distinguished objectives, as Joseph Campbell observes: to explain (1) man's origin and the nature of his purpose in the world, focusing on death and religion, the "reconciliation of consciousness with the preconditions of its own existence" (*Myths, Dreams* 138); (2) the processes of the universe; (3) the origin of customs or social rituals in terms of significant group behavior; and (4) the meaning of significant individual behavior. These objectives may be designated as the mystical or metaphysical, the cosmological, the sociological or etiological, and the psychological. If one takes Ovid's *Metamorphoses* as one standard reference, the four uses could be illustrated respectively by the legend of Demeter and Persephone, the Golden Age, the tale of Actaeon, and the story of Narcissus. Myths are both emotional and intellectual, conveying emotional reactions as well as complexes of ideas. As Janet Burstein observes, "Myths were not merely imaginative, but also speculative and contemplative" ("Victorian Mythography" 314). Max Müller's declaration is still valid: "Nothing is excluded from mythological expression; neither morals, nor philosophy, neither history nor religion, have escaped the spell of that ancient sybil" he stated in *Comparative Mythology* (178). For Victorian society, experiencing "the feeling of isolation and fragmentation that accompanied industrial development . . . myth quite naturally appeared to

represent a world and way of thinking that seemed at once attractive — by virtue of its wholeness and vitality," even if it were not scientific. Myths could be conceived of as "the forerunners of modern ways of thinking" (Burstein 324, 312).

The nineteenth century produced a variety of theories and interpretations of myth. One conception, going back to Euhemerus (c. 300 B.C.) contended that myths were historical in origin, recounting the deeds of great men who were subsequently deified. Herbert Spencer, for example, believed that the worship of ancestors in savage societies led to mythology. The Euhemerists or historicists read mythical events as representing martial conquests. The ritualist theory of myth was advanced by J. G. Frazer in *The Golden Bough* and by Bronislaw Malinowski, who derived analogies between savage customs and classical myth.

The greatest controversy surrounding myth in the nineteenth century was between the adherents of the philological "Solar theory" of Max Müller and the anthropological beliefs of Andrew Lang. In his essay "Comparative Mythology" in 1856, Müller contended that all myths expressed the function of the sun but that in the degeneration of languages from an ur-Aryan language this significance had become obscured. The basic conflict was between the Sun and Night. Müller based his work on philological, particularly phonemic, analyses. Lang destroyed Müller's etymological method by declaring that myth was the product of "an animistic stage of culture, which personalized the elements" (Sebeok, *Myth* 35). The names which Müller analyzed, Lang contended, were later accretions to the legends, not degenerations by virtue of diseased language. Lang noted in *Custom and Myth* that "the tale may occur where the names have never been heard" (70). For Lang a myth such as Eros and Psyche originates in a nuptial taboo. Of the story of Jason and Medea, Lang declared: "The central part of the Jason myth is incapable of being explained, either as a nature-myth, or as a myth founded on a disease of language" (101). The question of interpreting myths and their stages of development was part of the concern of the 1860s and 1870s, the decades which saw the rise of classical-subject painting. Two of the individuals who explained levels of interpretation of myth to Victorian culture were Walter Pater and John Ruskin.

I

Pater's concern with the influence of the classical tradition appears in his essay on Winckelmann (1867): "The Hellenic element alone has not been so

absorbed, or content with this underground life; from time to time it has started to the surface; culture has been drawn back to its sources to be clarified and corrected. Hellenism is not merely an element in our intellectual life; it is a conscious tradition in it" (*Renaissance* 135). To Pater Greek religion "is at once a magnificent ritualistic system, and a cycle of poetical conceptions" (*Renaissance* 136). Pater concluded that "breadth, centrality, with blitheness and repose, are the marks of Hellenic culture" (153) which might be pursued in the nineteenth century.

In 1876, Pater evolved a tripartite model for interpreting myth. In his essay "The Myth of Demeter and Persephone," Pater distinguished three levels of meaning in a myth, the natural, the literary, and the ethical: "In the story of Demeter . . . we may trace the action of three different influences . . . in three successive phases of its development. There is first its half-conscious, instinctive, or mystical phase, . . . primitive impressions of the phenomena of the natural world. We may trace it next in its conscious, poetical or literary phase. . . . Thirdly, the myth passes into the ethical phase, in which the persons and incidents of the . . . narrative are realised as abstract symbols, because intensely characteristic examples, of moral and spiritual conditions" (*Greek Studies* 91). The story of Demeter and the abduction of her daughter Persephone by Hades could be interpreted in the first sense, the natural, as a myth of the recurrence of the seasons, as spring returns on Persephone's release from the Underworld. In the second sense, the literary, the myth represents the importance of maternal devotion. In this sense, a canvas such as Leighton's *The Return of Persephone* reinforces the maternal role for women emphasized by Victorian culture. In the third sense, the ethical, the myth embodies ideas of resurrection and optimism. In the course of the essay, Pater notes the discovery of the Demeter of Cnidus. This essay is a particularly fine illustration of the intersection of archaeological discovery, social stereotype, and popular dissemination.

Ruskin's statements about myth recur throughout his works, but for purposes of classical-subject painting, his lectures on Athene that constituted *The Queen of the Air* in 1869 provide a summary of his conceptions. Speaking of Athene Chalinitis, Ruskin declares first of all: "You must forgive me, therefore, for not always distinctively calling the creeds of the past 'superstition,' and the creeds of the present day 'religion'" (*Works* 19.295). Ruskin believed that "in nearly every myth of importance . . . you have to discern these three structural parts—the root and the two branches:—the root, in physical existence, sun, or sky, or cloud, or sea: then the personal incarnation of that; . . .

and, lastly, the moral significance of the image, which is in all the great myths eternally and beneficently true" (300). The Homeric poems had an "ethical nature; for they are not conceived didactically, but are didactic in their essence as all good art is" (307). Ruskin argued in discussing the myth of Athene that the development of a race exposes greater depths of truth in a basic myth but does not invalidate it.

Ruskin proceeded to take up myths involving women, such as the Harpies, which he defined in this manner: "They are devouring and desolating, merciless, making all things disappear that come in their grasp: and so, spiritually, they are the gusts of vexatious, fretful, lawless passion, vain and overshadowing, discontented and lamenting, meagre and insane" (314). This comment leads to a canvas like Waterhouse's *Ulysses and the Sirens* and the myriad depictions of Sirens. Of particular note are the adjectives Ruskin applies to Harpies, many of which coincide with the cultural definition of women; for example, "insane" coincides with women's perceived tendency to madness. The fact that Ruskin's lecture was delivered in 1869, during the period of the third Contagious Diseases Act, makes the comment "lawless passion" particularly forceful. Ruskin later discusses Perseus in gynophobic terms: "Then there is the entire tradition of the Danaïdes, and of the tower of Danaë and the golden shower; the birth of Perseus connecting this legend with that of the Gorgons and Graiae, who are the true clouds of thunderous and ruinous tempest. I must, in passing, mark for you that the form of the sword or sickle of Perseus, with which he kills Medusa, is another image of the whirling harpy vortex, and belongs especially to the sword of destruction or annihilation" (327). Ruskin gave vatic stature to his utterances: "my power is owing to what of right there is in me" (396).

Ruskin's interpretations of myth had a strongly antifeminist force, as Ruskin was wont to allegorize corruption as a female proclivity. A note of Ruskin's on corruption, republished on 9 July 1885 between installments of *The Maiden Tribute of Modern Babylon,* had shown the gynophobic attitude behind a work like *The Stones of Venice.* The reprinted letter ran in part: "Hence if from any place on earth I ought to be able to send you some words of warning to English youths, for the ruin of this mighty city was all in one word— fornication," he wrote from Venice in 1877 (Ruskin, "Letter" 4). Referring to Dante's *Inferno,* Ruskin notes in *Munera Pulveris:* "The great enemy is obeyed knowingly and willingly; but the spirit—feminine—and called a Siren—is the '*Deceitfulness* of riches.'" He studies various meanings of the Sirens: "Bacon's interpretation, 'the Sirens, *or pleasures*' which has become universal since his

time, is opposed alike to Plato's meaning and Homer's. The Sirens are not pleasures, but *Desires*" (*Works* 17.211–212). "The deadly Sirens . . . promise pleasure, but never give it. They nourish in no wise; but slay by slow death" (213–214). Ruskin's language partakes of the earlier rhetoric of William Bevan, the minister in Liverpool.

Ruskin distinguishes the Sirens' power from the "power of Circe . . . her power is that of frank, and full vital pleasure, which, if governed and watched, nourishes men; but, unwatched, and having no 'moly,' or bitterness or delay, mixed with it, turns men into beasts, but does not slay them. . . . She is herself indeed an Enchantress;—pure Animal life" (*Works* 17.213). Ruskin's interpretations of such myths as the Sirens and Circe derive not only from his own predispositions but also from the culture: women are bestial, death bearing, sensuous, deluding. Even in his dreams, women assumed such forms: "Got restless—taste in mouth—and had the most horrible serpent dream I ever had yet in my life. The deadliest came out into the room under a door. It rose up like a Cobra—with horrible round eyes and had woman's, or at least Medusa's, breasts" (Pearsall, *Worm* 542). Pearsall notes that serpents frequently appeared in Ruskin's dreams, where "the sexual symbolism of the serpent is self-evident" (537).

The prominence of Ruskin as interpreter of myth was linked to his dictating the qualities that comprise women. "Of Queens' Gardens," from *Sesame and Lilies* (1865), illustrates the conjunction of mythological interpretation and Ruskinian gynophobia and his strategy of selecting myths to illustrate female inferiority or ferocity. Ruskin was a sage not only of mythological interpretation but of male/female relations. In "Of Queens' Gardens," Ruskin expressed the doctrine of "separate spheres" for men and women: "The man's power is active, progressive, defensive. He is eminently the doer, the creator, the discoverer, the defender. . . . But the woman's power is for rule, not for battle,—her intellect is not for invention or creation, but for sweet ordering, arrangement, and decision. . . . Her great function is Praise; she enters into no contest, but infallibly adjudges the crown of contest" (*Works* 18.121–122). Home is "the woman's true place and power . . . infallibly wise—wise, not for self-development, but for self-renunciation: wise, not that she may set herself above her husband, but that she may never fail from his side . . . with the passionate gentleness of an infinitely variable, because infinitely applicable, modesty of service—the true changefulness of woman" (123). Ruskin's reading of myth could not be disassociated from social statements such as this one. He promulgated a doctrine of male heroism and female inferiority,

inferiority by virtue of a female's presumed devious nature, sensuous inclination, and intellectual insufficiency. Mythology became part of contemporary sociology and psychology through Ruskin. As Pearsall notes, "men read and listened to Ruskin because this was what they wanted to have confirmed" (*Worm* 109).

II

The nineteenth century saw not only the rise of mythography but the birth of anthropology. Among the most distinguished of these early anthropologists were Henry Maine, Johann J. Bachofen, John McLennan, John Lubbock, and Herbert Spencer. Many of their theories supported the idea of a male-dominant culture. For example, Henry Maine, in his *Ancient Law* (1861), claimed that patriarchy had been the mode of rule in early cultures: "The effect of the evidence of comparative jurisprudence is to establish the view of the primeval condition of the human race which is known as the Patriarchal Theory" (Fee, "Sexual Politics" 25). Bachofen published his *Mother Right* in 1861, which supported the idea that males were the higher, more spiritual element in human cultural development, women the more materialistic, that is, the more "natural." "Mother right [is] the law of material-corporeal, not of higher spiritual life, and shows the matriarchal world as a whole to be a product of the maternal-tellurian, not of the paternal-uranian attitude toward human existence" (Bachofen 78). "The realm of the idea belongs to the man, the realm of material life to the woman" (150). Thus, femaleness is associated with an earlier and lower stage of human development. A woman was an atavism. To Bachofen, cultural progress occurred in three stages: hetaerism, matriarchy, and patriarchy. He believed: "The mythical tradition may be taken as a faithful reflection of the life of those times in which historical antiquity is rooted. It is a manifestation of primordial thinking, an immediate historical revelation, and consequently a highly reliable historical source" (73).

Hellenism is equated by Bachofen with patriarchal development. Demeter supplants Aphrodite, and Demeter is subsequently supplanted by patriarchy. Amazons are forms of the old matriarchy, that is, an early stage of human development. Women conceived of as Amazons, Gorgons (Medusa), Bacchantes, or Aphrodite were perforce construed to be more primitive in nature than spiritual man. To Bachofen, Greek heroes like Theseus, Zeus, Heracles, Achilles, Dionysus, Perseus, and Apollo indicate the triumph of patriarchal authority over the more primitive female authority. The sun be-

comes the exemplification of male power, "the diurnal luminary [which] ushers in the triumph of the patriarchate" (114). Bachofen's theories, albeit questionable, established for the nineteenth century several crucial ideas about myth: that it was historically accurate and that its narrative was the gradual triumph of patriarchal order. Artists painting mythological subjects were working in a central cultural discourse essentially androcentric, phallocentric, and hypermasculine. To Bachofen, in fact, Heracles was "the indefatigable battler of Amazons, the misogynist" (176).

Early anthropologists contributed to this discourse. John McLennan, author of *Primitive Marriage* (1865) and *Studies in Ancient History* (1876), believed that "women were less useful to society than were men" (Fee, "Sexual Politics" 30). John Lubbock, in *Primitive Times* (1865), held that it was woman's vulnerability that was attractive to man and caused him to love her. As Fee notes, "for Lubbock and doubtless many of his contemporaries, the essence and beauty of the male-female relationship resided in inequality" (32). To Herbert Spencer, the greatest benefit of monogamy was that it controlled sensuality and strictly defined sex roles. Evolution indicated that "feminism appeared distinctly reactionary" (37). The result of these theories was that "patriarchalism was . . . inextricably linked with the progress of civilization" (38). Women were often conceived of as children or childlike. Carl Vogt wrote in 1864 that "woman is a constantly growing child, and in the brain, as in so many other parts of her body, she conforms to her childish type" (Haller, *Physician and Sexuality* 54). Vogt concluded that as females had smaller skulls than males, they were inferior to men. The fact that Charles Darwin accepted some of Vogt's theories lent them additional force in nineteenth-century culture.

Woman was characterized by traits such as dependence that were infantile and paralleled those of "the more primitive races" (Haller, *Physician and Sexuality* 73). Such discourse parallels Ruskin's praise in "Of Queens' Gardens" of the "majestic childishness" of the mature woman. Male dominance became equated with sexual control, rationality, and spirituality. The selective use of myth by classical-subject painters reinforced these ideas, becoming part of the social discourse about male and female roles. Images of women as Aphrodite or Medusa constituted a gynophobic matrix about female nature and helped to establish the idea of female control as reactionary and reversionary. The fact that men were conceived of as spiritual, women as natural, had important cultural consequences, as Pierrot observes: "Antinaturalism leads quite naturally to antifeminism, since woman symbolizes nature" (*Decadent Imagina-*

tion 124). The femme fatale expressed the patriarchy's antifeminine belief that female nature was dangerous, animalistic, and atavistic.

The history of classical-subject painting as it relates to women is a product of the rise of mythology and the fervor for the Greco-Roman world intersecting with the history of women's political development in the nineteenth century. In 1885, when Stead published his *Maiden Tribute,* Edward Poynter exhibited his nude young bather, *Diadumenè,* a canvas which created a furor. The publication of the essay and the appearance of the canvas signal a cultural conjunction, according to the anthropological theory of Redundancy in Culture, by which aspects of a culture reflect each other in certain ways. The myths depicted in classical-subject painting represent the selection by the male-dominated culture of a relatively small quantity of icons to demarcate the nature of women. Jeffrey Weeks notes of the nineteenth century: "Sexual behaviour [had] . . . become a symbol of much wider social features" (*Sex, Politics, and Society* 93). Classical-subject painting developed a system of mythological reference that reflected cultural disposition and simultaneously enforced it by initiating associative responses. The definition of men and women in these canvases became a symbolic language, a system of ideograms with strong associative valences.

The myths reflected male reaction to the evolving political situation of women during the period. This reaction took the form of misogyny, gynophobia, and obstruction of or denial of civil rights. As women's legal, familial, educational, and marital status altered, male reaction by a significant part of the public was conservative, unsupportive, or constrictive. The images of women presented in classical-subject canvases reflected the historical situation and reinforced negative male conceptions of female nature. The power of mythological pictorial ideograms of women as mad, abandoned, deceiving, sensuous, and intimidating derived force from the seemingly unchanging nature and continuous relevance of myth. Mythic eternality was a basis for resisting the progress of women.

Six factors are involved in the presentation of mythical conceptions of women: (1) the myth chosen (e.g., Ariadne); (2) the particular episode of the myth depicted (e.g., the abandonment of Ariadne by Theseus); (3) the elements implied by the representation (e.g., women abandoned become mad or despairing); (4) the use of typological detail (e.g., the unbound hair); (5) the repetition of a certain myth (e.g., Ariadne as the archetypal abandoned woman); and (6) the omission of narrative elements (e.g., Ariadne depicted as abandoned by rather than as assisting Theseus). Proto-feminist elements

and details of myths (e.g., Ariadne aiding Theseus or the goddesses in the judgment of Paris being giftgivers rather than competitors) were suppressed, diluted, ignored, or camouflaged by male artists and mythographers in order to form cultural ideograms consonant with the prevailing patriarchal norms and power. It was primarily men who decided in the nineteenth century that the "martial Athena [of the *Iliad*] . . . prevailed . . . over the protean goddess of the *Odyssey*" (Warner, *Monuments and Maidens* 103). These six factors, which may be exemplified in other myths, were conditioned by the historical situation of women during the period.

<div align="center">III</div>

The origins of the social condition of women encountered by classical-subject artists in the 1860s can be located in the earlier part of the century. The 1820s and 1830s saw a conflict in the definition of women's nature. For instance, the sexual nature of women was discussed in connection with the introduction of the contraceptive sponge to England by Francis Place in 1823. If the sexual status of women was one focus of attention, the legal status was queried in 1825 when William Thompson and Anna Wheeler published *An Appeal of One Half the Human Race,* which advocated the abolition of private property and questioned the prerogatives of patriarchal authority. In 1836 Mrs. John Sandford argued for better education for women and more respect for unmarried women in *Female Improvement.* Caroline Norton in 1837 dared the courts in *The Natural Claims of a Mother to the Custody of Her Children.* In 1839, small changes occurred with the Custody of Infants Act, which granted the woman visitation privileges and allowed her to solicit custody of children under seven.

The situation of a single woman or *feme sole* in the period was in the legal sense enviable, since she retained many of the rights over property and person enjoyed by men married or single. However the situation of the *feme covert* or married woman was distressing. The woman became, as Barbara Leigh Smith noted in an 1854 pamphlet, "legally an infant." After a woman was engaged, she could not dispose of "her property without the consent of her fiancé. Her personal property, her real property, passed into her husband's possession. Without his permission she could not make a will concerning even her personal property. . . . The legal custody of the children was the father's. . . . A husband had the right over his wife's person. . . . A married woman could not sue or be sued for contracts, or enter into them. She could not be

a witness against her husband nor he against her. . . . Before the law . . . a married woman was a chattel, an infant, made helpless by a system designed for primitive society" (Neff, *Victorian Working Women* 209–210).

During the 1840s, when the classical-subject artists were young, advances in education and other areas began slowly to alter women's situation. Societies like the Governesses' Benevolent Institution (1843), the Society for Prevention of Cruelty to Children (1844), the Family Colonization Loan Society under Caroline Chisholm (1848), and the British Ladies Female Emigrant Society (1849) represent early responses to women's difficulties in employment and family life. Chloroform, discovered in 1847 by James Simpson and used by Queen Victoria during childbirth, provided women comfort during parturition. Education was advanced by the founding of Queen's College in 1848 and Bedford College in 1849. The 1841 census revealed that 40 percent of women were unmarried, indicating the need for social accommodation to the situation. The belief by a commissioner of police that there were 3,325 brothels in London alone showed that women were falling into the hazardous fringes of society in greater numbers than suspected. When Anne Knight published the first women's suffrage pamphlet in 1847, she indicated a new direction for reform.

The 1850s elevated the consciousness of the public about the plight of women. In 1850 William Greg wrote about prostitution in the *Westminster Review*, denouncing the double standard in a year when it was revealed there were 8,000 known prostitutes in London. The revelation in 1851 that 42,000 illegitimate children were born in London indicated the relevance of Greg's plea. In 1851 Harriet Taylor published an article in the *Westminster Review* on the enfranchisement of women. The first petition of women for the franchise was submitted to the House of Lords the same year. Various pieces of legislation altered the situation of some women. Barbara Leigh Smith [Bodichon's] *A Brief Summary in Plain Language of the Most Important Laws concerning Women* and Caroline Norton's *English Laws for Women in the Nineteenth Century,* both published in 1854, revealed the anomalies of legal treatment of women. In 1857 the Matrimonial Causes Act established civil courts to grant separation and divorce. By its provisions, women who were divorced, separated, or abandoned could obtain some property rights. Publications for women provided forums for discussion: the *Englishwoman's Domestic Magazine* (1852); the *Englishwoman's Review* (1857), edited by Bessie Parkes and Bodichon; and the *Englishwoman's Journal,* founded by Parkes, Bodichon, Jessie Boucherett, and Adelaide Procter. Many of these women

formed the 1859 Society for Promoting the Employment of Women, becoming the "Ladies of Langham Place."

The succeeding decade was particularly controversial. It is not coincidence that classical-subject painting began its rise during this decade, for it provided security to male legislators by showing them eternal images of females quite different from the new heroines of the period. Ruskin issued one manifesto of the male definition of female nature with his lecture "Of Queens' Gardens," a definition brought into question by Elizabeth Garrett Anderson in 1865 when she obtained a medical license. Greg's famous essay "Why Are Women Redundant?" appeared in the *National Review* in 1862, accusing unmarried women of being unnatural and espousing emigration as a solution to their status. Frances Power Cobbe rebutted Greg in "What Shall We Do with Our Old Maids?" in *Fraser's Magazine.* Suffrage committees were formed in Manchester in 1866 and Bristol in 1868, with the National Society for Women's Suffrage formed in 1869, the year John Stuart Mill published a landmark refutation of Ruskin, *The Subjection of Women.* Educational reforms included the opening of Cambridge local examinations to women in 1863 and the founding of Girton College, Cambridge, by Emily Davies in 1869. The passage of the three Contagious Diseases Acts in 1864, 1866, and 1869, which mandated that women suspected of prostitution could be compelled to undergo a pelvic examination, was met by a campaign to repeal the acts, led by Josephine Butler; the cause galvanized women during the 1870s and 1880s.

During the 1870s and 1880s significant legal and educational reforms altered women's condition and therefore their self-conception. The Married Women's Property Act of 1870 decreed women's right to equitable property rights, earnings after marriage, investment monies, life insurance policies, and inherited estates. Its passage marked a significant moment in the legal emancipation of married women. By the provisions of the 1882 Married Women's Property Act, married women were given the same rights as unmarried women. The act established that the common law and equity must be fused. In establishing that women could have independent ownership of property, the act broadened the sphere of influence of women. In 1886, the repeal of the Contagious Diseases Acts, which had been suspended in 1883, marked the end of an extensive campaign that had focused attention not only on the issue of arresting suspected prostitutes but also on the hazardous and distressing situation of destitute women. The result of these legal improvements was that many men perceived women as threatening and unnatural. The myths of

classical-subject canvases reflected this male anxiety in studies of Clytemnes-
tra, Electra, and Medea.

The 1870s and 1880s were a period of sexual transition, as the images of
men's and women's sexuality began to alter. In 1870 Ernest Boulton and
Frederick William Park were arrested for public cross-dressing. Their trial in
1871 revealed the transvestism in society that anticipates androgynous studies
of men and women, as in Leighton's *Electra* or *Clytemnestra.* The public rec-
ognized that giving good-looking boys at Eton and Harrow female names was
not entirely innocent. Henry Maudsley published "Sex and Mind in Educa-
tion" in the *Fortnightly Review* in 1874, alleging that women's physical con-
stitution prevented their undertaking strenuous learning. The following month,
Elizabeth Garrett Anderson, who had obtained her M.D. from the University
of Paris in 1870, repudiated Maudsley's contentions in the same periodical.
It was becoming apparent that birth control was spreading during the 1870s.
The Bradlaugh/Besant trial in 1877, for publishing Charles Knowlton's *The
Fruits of Philosophy,* coupled with Annie Besant's *The Law of Population*
the same year, demonstrated that women were involved in family-planning
decisions.

Meanwhile, male sexuality was given renewed attention with John Ad-
dington Symonds' *A Problem in Greek Ethics* (1883), which discussed homo-
sexual behavior in the context of classical situations. The addition of the La-
bouchere Amendment to the Criminal Law Amendment Act in 1885, by
which homosexual behavior between consenting adults in private was punish-
able by two years in prison, acknowledged the phobias of the culture. In 1889–
1890 the Cleveland Street homosexual brothel scandal brought to public
attention the extent and the activity of the homosexual substratum in Vic-
torian society. Symonds, arguing in *A Problem in Modern Ethics* (1891), de-
manded legal reform for homosexuals. The androgynous persons in the can-
vases of Burne-Jones, Leighton, and many other classical-subject painters reflect
this redefinition of male sexual identity. In his diary, Symonds recorded that
boys at Eton were somebody's "bitches" and had female nicknames. Simeon
Solomon's 1865 drawing *Love amongst the Schoolboys* indicates the actuality
of such attachments.

The year 1884 was significant for women. Elizabeth Blackwell, the first
woman doctor (1849), argued in *The Human Element in Sex* that women de-
rived pleasure from their sexuality. Blackwell was refuting a long-standing be-
lief that women had no sexual feelings whatsoever, the position propounded
by William Acton in 1857. In *The Functions and Disorders of the Reproduc-*

tive Organs, Acton had argued that while men are sexual, women are not: "What men are habitually, women are only exceptionally." Acton claimed that only prostitutes had sexual inclinations, thereby associating female sexuality with criminality: "Married men . . . or married women themselves, would, if appealed to, tell a very different tale, and vindicate female nature from the vile aspersions cast on it by the abandoned conduct and ungoverned lusts of a few of its worst examples. . . . There are many females who never feel any sexual excitement whatever. . . . As a general rule, a modest woman seldom desires any sexual gratification for herself" (162–164). Blackwell argued that such was not the case. A later manual, *The Wife's Handbook* in 1889, gave women information about birth control to free them to have a less tense sexual life. The discovery of the diplococcus of gonorrhea in 1879 and of the bacillus of soft chancre in 1889 brought scientific rather than emotional argument to the discussion of venereal disease.

Discussions of women's sexuality frequently maintained that women were unable to undertake rigorous study. In 1883 Robert Lawson Tait argued in his treatise *Diseases of the Ovaries* that women's physical weakness made education dangerous to them. John Thorburn detailed the supposed interference of education with menstruation in *Female Education from a Physiological Point of View* in 1884. Progress in women's education continued, however, despite such arguments from biology. Oxford local examinations were opened to women in 1870, while at the University of London women were admitted to all degrees when separate examinations were ended in 1878. Newnham College, Cambridge, was established in 1871, the Girls' Public Day School Company in 1872, Somerville and Lady Margaret Hall Colleges at Oxford in 1879. In 1884 an Oxford statute permitted women to take honors examinations in history and mathematics. In the same year Parliament abolished imprisonment as a penalty for denying conjugal rights to spouses. Classical-subject painting was to reflect this turbulent period of the 1870s and 1880s, with its sexual redefinitions. The rescue themes (Perseus and Andromeda, Dionysus and Ariadne) reflected the rescue motivations of reformers like Gladstone with his nocturnal perambulations to reclaim prostitutes or of organizations like the Salvation Army, founded by William Booth in 1878.

The final decade of the nineteenth century and the early decades of the twentieth century were periods of increasingly strong reactions against female sexuality. In 1895 the trial of the Chrimes brothers for performing abortions indicated that unwanted pregnancies were not the concern only of birth-control advocates. Women suffered as a result of disclosures such as that of

1895. It was found that in the British Army in India, of 68,000 soldiers examined, 36,000 had venereal diseases. It was simple to explain that such disease was transmitted by profligate women. Figures of Lamia, Harpies, and Sirens communicated the devouring nature of women's dangerous sexuality. The blood test for syphilis was developed in 1906 and the use of Salvarsan for treatment of syphilis was introduced in 1909, steps that brought medical rather than religious remediation to human sexual behavior. In marches for the franchise, women incorporated historical and mythological prototypes. In 1908 women paraded with pictures of Boadicea; in 1909 they carried banners of Artemis and her hounds during the turmoil involving the Conciliation Bill. The violence against mythological types reached a climax with the slashing of Velásquez's "Rokeby Venus" in 1914. By the beginning of the First World War, a period marking the decline of classical-subject painting, the practice of defining women by biological function had been altered by legal and educational progress in their condition.

Thus, male reactions to women's increasing emancipation ranged from support in the case of Mill or Disraeli to suspicion on the part of many men. Coventry Patmore, in *The Angel in the House* (1854), had enunciated dogmas about women's nature that anticipated the codifications of Ruskin in "Of Queens' Gardens" and the statements of physicians like Acton. The conflicted attitude of men to women's nature is apparent in the manifest solicitation for one kind of woman and the latent fear of another, the one the angelic female, the other the sexually debasing one. The manifest belief was that a woman was and should be passive, loving, serviceable, self-effacing, sacrificing, compassionate, unintellectual, accessible, sweet, compliant, and above all submissive and subordinate. The mythological prototypes of these behaviors were Penelope patiently awaiting the return of Ulysses or Alcestis dying in place of her husband, Admetus. Other exemplars of this type were Oenone, Echo, Syrinx, Daphne, Thisbe, Cassandra, Clytie, Nausicaa, and Andromeda. For many men in the century, Saint Paul in First Corinthians said it best: "I wish you to understand that, while every man has Christ for his head, woman's head is man. . . . For man did not originally spring from woman, but woman was made out of man; and man was not created for woman's sake, but woman for the sake of man." If Saint Paul said it best, Greco-Roman mythology displayed it best. The opposite, latent, belief was that women were fatal and dangerous, embodied in the femme fatale (a term of only twentieth-century coinage).

IV

The qualities that men believed women possessed and that needed to be checked may be summarized in their conceptions of this "latent" woman. The feared archetype was characterized as cruel, perverse, sadistic, powerful, beautiful, aggressive, sexual, terrifying, destructive, vampiric, death bearing, defiant, deviant, sterile, instinctual, degrading, demonic, mysterious, nymphomaniacal, torturing, inaccessible, disdainful, ironic, narcissistic, intoxicating, willful, flagellating, vicious, tormenting, murderous, deceptive, treacherous, unfaithful, cynical, and diseased. This woman was embodied in such figures as Helen of Troy, Clytemnestra, Athene, Electra, Phryne, Persephone, Atalanta, Pandora, Medusa, Circe, Calypso, Astarte, Medea, the Sirens, Artemis, Aphrodite, the Bacchante, mermaids, nymphs, Bellona, Phaedra, Hero, Leda, Procris, Simaetha, Psyche, Danaë, Ariadne, the Danaïdes, Niobe, Lotus, Selene, Undine, and Europa. To these images of women, men opposed figures of innovators, leaders, or rescuers such as Apollo, Prometheus, Odysseus, Perseus, Bellerophon, Ares, Zeus, and Hermes. Icons of such figures as Actaeon, Hippolytus, and Haemon showed men who have suffered at the hands of despotic women. Classical-subject painting presented images of women which counteracted the emerging contemporary "heroinism" of Parkes, Butler, Pankhurst, Davies, and other reformers. If one surveys the range of icons of women in nineteenth-century classical-subject painting, the canvases rarely present women in other than intimidating or passive forms.

These mythological encoded subjects were widely depicted during the nineteenth century. Artists selected the myth and its particular episode to both reflect and enforce the beliefs of the culture concerning female nature, pursuing the example of Ruskin, Greg, and hosts of clergymen and politicians. The focus of several myths is the dangerous woman or her imperiled counterpart, as in the story of Perseus, Medusa, and Andromeda. The artists—painters and sculptors—who depicted one or more of these three characters are numerous: Dicksee (1890), Gale (1851), Frost (1850), Etty (1840), Haley (1924, 1927), Thomas Harrison (1879), De Morgan, Nowell (1899), Pickersgill, Sandys (1867), Simeon Solomon, Speed (1896), Calderon (1885), Calthrop (1869), Fehr (1893, 1894), Burne-Jones (1876–1892), Fennessy (1873), Forsyth (1866), Poynter (1870, 1872), Hill (1875), Hook (1890), Jeffray (1846), Leifchild (1869), McClure (1903), McCulloch (1890), Lawrence Macdonald (1842), Papworth (1866), Simonds (1878, 1881, 1883), Leighton (1892, 1896), C. N. Kennedy (1890), Stanhope (1872),

Zambaco (1888), Tuke (1890), and Goodall (1887). The story of Perseus, Andromeda, and Medusa presented a triad of rescuer, victim, and persecutor that appealed to the male consciousness. Several artists painted Perseus' mother, Danaë, including Burne-Jones (1888), Batten (1892), Strong (1915), and Harrison (1885). Because Zeus had intercourse with Danaë in the form of a shower of gold, Danaë is the epitome of sexuality in the era of the Industrial Revolution, of the Carlylean "cash nexus" permeating sexual behavior.

The large number of canvases and sculptures from the 1860s and 1870s indicates the strength of the male "rescue" compulsion at this time. Male legislators could be "rescuers" of women by reclaiming prostitutes. The Perseus and Andromeda legend is the typological antecedent of such a mental conception. Medusa, who to Freud symbolized castration anxiety, was a multivalent symbol. Warner observes that since Medusa was in the center of Athene's aegis, and since Athene herself was associated with patriarchy, she could also be considered "an expression of the required subordination of wives and mothers in patrilineage" (*Monuments and Maidens* 111), of the "subordination of women to men over children's lineage" (111, 124). Thus the legend is sexually ambiguous, comprising elements of narcissism, castration, and domination. It reflects both male superiority (rescue) and insecurity (fear of domination). Many classical legends added to this insecurity. The subject of the sorceress and enchantress Medea was prevalent during the period. Some of the artists presenting this image included Bayes (1900), Draper (1904), Howard (1841), Solomon (1878), Prinsep (1888), and Sandys (1869). The myths represented in Victorian classical-subject canvases frequently exhibited this dual nature, both reflecting the idea of male superiority and indicating latent anxiety.

Representations of the god Apollo were especially significant in reinforcing male dominance during the nineteenth century. Apollo, sometimes pursuing Daphne, was presented by such artists as Hacker (1895), Rae (1895), Riviere (1874, 1895), Rooke, Speed (1910), Watts, Bulleid (1889), Fowler (1896), Gale (1880), Hampton (1899), and Storey (1880). Apollo's speech in Aeschylus's *Eumenides,* in which he contends the man is the begetter, the woman only the nurturer, of human seed, lent itself to misogynistic construction. The icon of Apollo, particularly when discussed by the adherents of the solar interpretation of mythology, reinforced male heroism and patriarchal dominance by depicting the sun-god conquering the female death/night. Worship of the male/sun was implicit in depictions of Apollo. Leighton, in his *Perseus and Andromeda,* for example, showed the rescuer in a sunburst, associating Apollo with heroism. The epitome of female self-abasement before this god was Cly-

tie, depicted by such artists as Watts and Leighton. The heroism of Apollo was reinforced, as well, by nineteenth-century Aryanist ideas, since it was assumed that the Aryans migrated westward, following the path of the sun. It was not accidental that the great proponent of solar interpretation, Max Müller, wrote a preface to a new edition of Kingsley's rabid Aryanist lectures, *The Roman and the Teuton,* in 1881. As Léon Poliakov has noted, in the nineteenth century "the true Aryan appeared to be a Westerner of the male sex, belonging to the upper or middle classes, who could be defined equally by reference to coloured men, proletarians or women" (*Aryan Myth* 272). Canvases of Apollo, therefore, became part of the pro-Aryanist position during the century, paralleling the discourses of writers like Robert Knox and E. A. Freeman. Apollo embodied sexual and racial superiority.

Apollo's sister Artemis was frequently depicted, with her vengeful nature sometimes concealed but always implicit. Crane (1881, 1872), Frost (1846, 1855), Grimshaw (1880), Kennington (1898), Long (1881), Wardle (1897), Copping (1890), Gunthorp (1895), Holiday (1877), Hughes (1870), Hamilton Jackson (1876), Ryland (1890), Wetherbee (1901), MacKennal (1908), Maud Earl (1901), Gloag (1911), and Sauber presented this image of fierce virginity. Riviere painted both an *Endymion* (1880) and an *Actaeon* (1884) illustrating the dual nature of the goddess. Demeter and Persephone were illustrated by Chambers (1882), Crane (1878), Hacker (1889), Pickersgill (1850), Sandys (1878), Storey (1904), and Leighton (1891), thus exhibiting the rescue function of Hermes guiding Persephone to the upper world and the reverse of the rescue in the abduction of Persephone by Hades. In one the woman was the rescued; in the other, the appropriated.

The sensuous Aphrodite was a favorite composition throughout the period, in many manifestations. Some artists emphasized her birth, the Aphrodite Anadyomene, from the foam of the severed erection of her father Uranos. Other showed her as vain seductress, in conjunction with Adonis, or in the Judgment of Paris. Stott (1887), Alma-Tadema, Burne-Jones (1877), Draper, Fowler (1898), Fulleylove (1881), Koe (1896), Richmond, Rooke, Riviere, Solomon Solomon (1896, 1891), Stanhope, Storey (1877, 1905), Waterhouse (1900), Watson (1901, 1905), Watts (1905), Wetherbee (1897), Bulleid (1888), Dicksee (1890), Hamilton Jackson (1896), and Lambert (1888), portrayed the sensuous and amoral goddess. The association of her birth with castration accorded with nineteenth-century gynophobia. The wily Pandora was depicted by Appleby, Batten, Normand (1899), Spence (1894), Waterhouse (1896), Williams (1901), and Bates (1891), while the sinister Circe, the atavism attracted to beasts,

appeared frequently: Barker (1900, 1904, 1912), Hacker (1893), Jack (1898), Nettleship, Riviere (1871), Waterhouse (1891, 1892), Storey (1909), Strudwick (1886), Wardle (1908), Wetherbee (1911), Collier (1885), Muschamp (1897), Pickersgill (1849), Harry Dixon (1899), Nott (1898), Spence (1897), Godward, and Paget (1884). Aphrodite, Circe, and Pandora constituted a triad of female deviousness that generated a range of gynophobic associations.

The hapless Psyche, abandoned by Eros and persecuted by Aphrodite, was a favorite theme with artists, as it presented the abandoned woman requiring rescue by the male. Burne-Jones (1871), Derwent Wood (1919), Busk (1878), Harcourt (1894, 1897), Stanhope (1883), Swynnerton, Waterhouse (1903, 1904), Appleby (1897), Mortimer Brown (1903), Speed (1914), Hacker (1914), Corbet (1900), Lawson (1871), Pickersgill (1851), Solomon Solomon (1902), Williams (1897), Watts, and Albano (1888) all painted this legend. The suffering Clytie, abandoned by Apollo, was depicted by such artists as Watts (1868) and De Morgan (1886–1887), reinforcing the power of the male sun-god.

The sacrilegious Hero was a frequent subject. McCulloch (1898), Perugini (1914), Hill (1887), Watts, Leighton (1887), Joseph Durham (1871), Giles (1896), Robert Herdman (1865), McGill (1890, 1892), Poole (1901), Williamson (1867), Spence (1843), Etty (1827, 1829), Armitage (1869), Armstead (1875), and Fry (1888) depicted either the lovers parting or the fate of the disconsolate Hero awaiting her lover or lying dead on the shore. The Hero legend conveyed an image of women destroyed by their wild passions. Psyche and Clytie were the women abandoned; Hero as a priestess of Aphrodite revealed the dangers of female sexuality.

The sad Echo, dependent on Narcissus, the quintessential passive female, appeared in works by Waterhouse (1903), Rae (1906), Stott (1903), Watts, Ethel Wright (1893), and William Bennett (1902), while the self-sacrificing Alcestis, the mythical prototype of the Angel in the House or the Ruskinian Queen, was depicted in works by Leighton (1871), Rickes (1872), and Harper (1886). The forlorn Oenone figured in exhibits by Marshall (1864), Brock (1875), Calderon (1868), Von Glehn (1888), Storey (1890), and Ryland. The murderous Danaïdes appeared in the works of Solomon Solomon (1889), Waterhouse (1906), and Schafer (1881). Forlorn women such as Oenone and Echo were the opposite extreme of dangerous females like the Danaïdes who slew their husbands on their wedding nights.

Among the most negative of the images of women presented were those involving females and Dionysus, especially the Bacchante/Maenad and the abandoned Ariadne. The idea of the mad woman, in the figure of the wor-

shipers of Dionysus, appears in works by Watts (1875), Alma-Tadema (numerous), Café (1884), Calderon (1880), Collier (1886), Corbet (1896), Dixon, Angle (1892), Machell (1889), Bridgman (1897), Merritt (1875), George Edwards (1897), Kinloch (1884), Lawrance (1880), Sax (1877), Van Beurden (1896), Richmond, Hacker (1913), Sawyer (1892), Wardle (1909), and Dicksee (1909). In numerous canvases women were depicted on leopard skins, a Dionysiac detail symbolizing their potential for madness and guaranteed to generate an association of women with mental instability and bestiality. Men particularly feared the Maenad and Bacchante because Dionysus, as the son of Semele (moon, femaleness), represented a worship, as Jane E. Harrison believed, essentially "matriarchal" (*Myths of Greece* 75). The worshipers manifested the violent passion and ungoverned independence which intimidated male legislators and nineteenth-century patriarchs. As the woman abandoned, awaiting "rescue" by Dionysus, Ariadne was a popular theme. It reinforced the image of women dependent on men and destitute of resources. Leighton (1868), Nowell (1895), Watts (1875), Draper (1905), Grimshaw (1877), Calderon (1895), Prinsep (1869), Richmond (1872), Sauber, Graham (1888), Sims (1908), Parker (1908), Bell (1896), Buckland (1899), Buckman (1899), and Leifchild (1882) were among the painters and sculptors who by this mythologem portrayed woman as abandoned.

Two categories of women frequently depicted involved the icons of the Sirens and of the sorceress, representing male fears of female sexuality and female secret power. Both these myths portrayed women as delusive and inscrutable. Strongly contrasting with the passive, abandoned Ariadne, the Sirens were aggressive avengers of Ariadne, demanding atonement from men because Theseus had abandoned Ariadne. The Sirens were fierce atavisms, regressive females close to beasts in some representations, and always predatory, representatives of savage, precivilized existence. The Sirens were a frequent motif at exhibitions, receiving treatment by Armitage (1888), Cockerell, Dow, Von Glehn, Thomas Harrison, Langstaff (1894), Rae (1903), Poynter (1861), Swan (1896), Wetherbee (1915), Wyllie (1912), Boyes (1899), Wardle (1893, 1903), Brewtnall (1900), Jacomb-Hood (1892), and Talbot Hughes (1901). Acton and many clergymen used the word "siren" as a code term for prostitute, with the result that such images associated female sexuality with debasement, criminality, and animality. During the years of the Contagious Diseases Acts, Siren icons were political. While Medea remained the archetypal sorceress, more generalized depictions of sinister sorceresses were finished by Barber (1911), Bundy (1896), Collier (1887, 1891), Dicksee (1894), Dollman (1912),

Fowler (1897), Knowles (1894), Piffard, Poynter, Prinsep (1895), Van Ruith (1902), Wardle (1901), Waterhouse (1914), Havers (1909), Boughton, and Appleyard.

The mermaid imagery intersected with the presentation of Sirens: Piffard, Naish, Olsson, Pickersgill, Poynter, Spooner, Swynnerton, Waterhouse, Watts, Wheelwright, Charles Allen, Swan, Collier, Smithers, Buckland, Grayson, Frost, Etty, Buckman, Burne-Jones, Calvert, Coleman, Clark, Crane, Draper, Fowler, Hacker, Hale, Haley, Hopkins, Jacomb-Hood, Knight, and Margetson completed such depictions. Herbert Draper made them a specialty, presenting them in 1894, 1901, 1902, 1908, and 1910. Mermaids were variants of the Aphrodite Anadyomene inasmuch as they were born of the sea. The castration of Uranos which produced the goddess linked females with castration, as the mermaid's dangerous tail made evident, for example in Burne-Jones's *The Depths of the Sea*. The severed erection of Uranos, appearing as the mermaid's phallic tail, confirms the mermaid as the "woman with a phallus," like Aphrodite herself. As such, the mermaid reflects male fears of losing phallic power to dangerous women. Figures such as the Lorelei and Undine completed this gallery of marine enchantment. These predatory mythological females must be placed in the context of a world in which physicians advised against too frequent intercourse because women robbed men of their sperm during copulation. In their predatory behavior, mermaids and Sirens made this "robbery" a form not only of seduction but of abduction.

Through the period from the 1860s through the early twentieth century, the galleries were exhibiting an endless series of classical-subject pictorial ideograms, either reinforcing male prejudices or supporting male heroic action, by a calculated association of ideas that constituted cultural indoctrination. In 1868, the year in which Swinburne wrote his "Notes," legends involving Clytie, Medusa, Actaea, Medea, Lilith, and Aphrodite were depicted. The image of women as requiring protection from their evil natures could scarcely be more clear than in the classical-subject icons of that year alone. In any year during these decades, not only specific myths but the countless paintings of nymphs, dryads, Sphinxes, Harpies, hamadryads, mermaids, sorceresses, and generalized classical nudes conveyed an image of sexual promiscuity and danger. The fact that writers as diverse as Ruskin and Stead invoked Circe indicates the manner in which mythology informed discussions of public issues.

Archaeology no less than sociology contributed to these reciprocal influences of mythology and social policy by conditioning legislators' minds about the definitions of male and female identity. The finding of the Demeter of

Cnidus, for example, occurred in the same year it was learned that one-sixth of unmarried women between fifteen and fifty were prostitutes; the goddess associated with secret mysteries and death, who was made to laugh in the Homeric Hymn by the sight of a woman's pudendum, reflected the social condition. The finding of the Esquiline Venus occurred the same year as Maudsley published his essay on women's inability to learn because of their sexual natures. After this conjunction, images of Aphrodite, nymphs, and other female sensual figures were visible at exhibitions and in reproductions. These images established in the public consciousness that Maudsley was correct, as proved by the eternal sensuality of the uncovered statue, which inspired canvases by Tadema and Poynter. Artists rarely or never depicted mythical prototypes such as Caenis, a woman turned into a man; Coelia, a heroic female warrior; Bellona, the goddess of war; the Amazons; or the malelike goddess Athene. When depicting Medea, artists invariably portrayed the fierce sorceress of the *Argonautica* of Apollonius Rhodius rather than the outraged mother of the drama by Euripides. In dealing with a heroic figure such as Heracles, artists showed his deeds rather than the transvestite episode of his stay with Omphale. Zeus as ruler of the gods was depicted as the seducer of women such as Danaë, but no artist depicted his seduction of the nymph Callisto, since he had to disguise himself as the goddess Artemis to achieve his purpose. By this process of selection and exclusion, classical-subject ideograms shaped the discourse about sexuality.

V

Although many artists kept informed about the discoveries of classical archaeology, it was easy to read the latest theories about various myths and their origins in the art periodicals themselves. The *Magazine of Art,* for example, had a continuing series on mythology written by Jane Harrison, a distinguished classical scholar whose *Ancient Art and Ritual* (1913) and *Themis* (1912) remain classics of ritual theory. From 1882 to 1894, Harrison published a series of studies analyzing the presentation of mythological subjects in ancient art. These essays contributed to the subject matter that artists painted. For example, Harrison published "Myths of the Dawn on Greek Vase-Paintings" in 1894, and William Blake Richmond produced a canvas on the subject in 1895. These essays assumed that readers, predominantly artists, were familiar with mythological theory. In beginning her discussion of myths of Dawn, for example, Harrison notes: "Modes in mythology are swift to change. What may

be called nature-myths are now out of fashion. Apollo is no longer explicable as the sun-god" (59). The comment assumes that readers have grasped the conflict between Müller and Lang. The fact that male artists continued to glorify Apollo as the sun-god illustrates that male painters retained their own interpretations of myths, even if theoretical evidence to the contrary appeared.

Harrison's first essay, "The Judgment of Paris" in 1882, illustrates the close relationship between theoretical writing and art. She cites Burne-Jones's *Feast of Peleus,* noting that the Greek vase painter's conception of the goddess Eris (Strife) is "not the kind of Demon whom Mr. Burne-Jones has imagined . . . the dread Appearance, with snakes in its hair and pallid hunger in its eyes" (507). As a female scholar, Harrison objects to the image of the goddess as presented by the male painter, indicating that Burne-Jones's conception of the myth is not in accord with ancient practice. Harrison's essays were illustrated with reproductions of Greek vase depictions. These icons, and the accompanying analyses in technical terms of the dress of the figures, provided artists accurate sources of detail, gesture, and costume. In "Helen of Troy" in 1883, Harrison noted, "In these modern days it is impossible . . . that we should so passionately worship this vision of beauty" (55), although she includes the detail that Stesichorus and Homer were both blinded for reviling Helen. Harrison injects moral disquisition in her discussion. She notes of the conception of love in Greek culture: "It is obvious that the artist has expressed an idea very frequent in Greek art:— that love comes to mortals from the gods. Helen loves at the prompting of Aphrodite, Paris at the whisper of Eros. This to our minds perilous doctrine the Greeks held unflinchingly. By its help they excused much that to us seems unpardonable, and were able to admire much that we find unworthy" (50). In discussing the myth of Demeter, Harrison uses such terms as the *anados* or return of Persephone, informing readers of the technical Greek terminology.

Harrison interprets myths in terms that echo the status of women in the nineteenth century. In "Demeter" (1883) she observes: "She is . . . the goddess of hearth and home, of order and custom, she is above all things friend and helper of housewives, of women who rule in the home. She is the goddess of marriage, the patron deity of civilised woman" (149). This explanation of the dread goddess sounds like Ruskin's "Of Queens' Gardens" and explains the icon presented in a canvas like Leighton's *The Return of Persephone* (1891). Harrison contrasts the abstract style of Phidias with the more natural style of Praxiteles, instructing artists/readers on the evolution of styles of sculpture. The final illustration in this essay is the head of the Demeter of Cnidus.

Harrison indicated, in "Death and the Underworld," that Harpies were originally beneficent bearers of the soul to Hades, a reading that male painters repudiated in favor of the more predatory interpretation of female nature. Her discussion of Sleep and Death parallels Waterhouse's canvas of the same name. At the same time that Harrison accepts certain Ruskinian notions, she observes that in mythological presentation of a maid, her dress is "not a mere abortive badge of servitude like the lace and ribbon of the modern serving-maid" (446). Sexual labeling appears in her comment about the postures of Hermes and Orpheus in a grave stele: "The English man stands erect in equal balance, combative, defensive. . . . It is only Mr. Du Maurier's emasculate poets who are allowed the bending, knock-kneed pose of our centre figure. . . . The two male figures before us are nowise effeminate, but their pose is just that which modern society relegates to untaught woman" (467).

Of particular interest is the fact that Harrison's essay on Perseus and Andromeda appeared in 1885, the year of the Criminal Law Amendment Act and Stead's essay *Maiden Tribute,* the epitome of "rescue" ideas in Victorian culture. "Wherever in Greek legend we find this element of chivalrous protection we may be sure that it is the outcome of an advanced civilisation," she notes ("Myth of Perseus" 498). Harrison observes that in some representations of the legend, Andromeda has stones in her hand to help Perseus slay the monster. Male artists invariably selected the image reaffirming their preconceptions about female roles and used the myth accordingly, never showing Andromeda assisting Perseus in the rescue.

In 1884 Harrison had written of Theseus and Ariadne, a story full of abandonment and betrayal, as the abducted Europa is the grandmother of Ariadne. Harrison notes that Catullus' presentation of Ariadne depicts her abandoned but enraged. This was an image no artist depicted. Instead, Ariadne was always depicted abandoned and usually asleep, awaiting the rescuer Dionysus, and never was she angry. When discussing Odysseus and the Sirens, Harrison notes that there were only two creatures in Homer, three in other sources. The classical-subject painters frequently showed a crowd of them. She includes one medieval picture as a form of pagan/Christian celebration of male heroism: "In the third picture comes the triumph of the Christian soldier. His ears are stopped; he is bound to the mast; he may pass secure, and more than secure, for his holy crew drag down the wicked Sirens by the hair, and they perish miserably. The Sirens are the pleasures of the world; the bark is the Church; the mast is the Cross, bound to which the Christian in full armour may safely . . . navigate the world" ("Myth of Odysseus" 134). The Si-

rens represent "fatal attraction" in another representation (135). Harrison notes that Homer does not describe the Sirens at all and that their form as bird-women or mermaids is a later male accretion. Nineteenth-century Social Darwinism confirmed this identification of Siren and bird-woman.

Most fearful of all was the nightingale as depicted in Greek vases, illustrated by a picture of Aedonaia stabbing the youth Itys, a fearful image of female murderousness. Harrison notes that the myth involves "confusion of sex" ("Myth of the Nightingale" 230). The discussion of myths of the Dawn includes mention of a man carried off by a woman in the legend of Eos and Cephalus, a myth never depicted by classical-subject painters. Instead, the tale of Cephalus and Procris is depicted, showing the woman accidentally slain as a result of her foolish jealousy. The prejudice of Victorian mythological painting is clearly indicated in such selectivity. The discussion of Eros and Psyche by Elisabeth Lecky includes several illustrations of Psyche being tortured by burning brands or herself torturing Eros, both ideas that never appear in classical-subject canvases. The emphasis in these is invariably on Psyche's abandoned state and her impulsiveness. In the discussion of Hades and Alcestis by Margaret Stokes, the Demeter of Cnidus is treated in nineteenth-century terms. The sculpture exhibits "the noblest attitude woman can assume in the presence of sorrow—a calm and steadfast trust in the overruling power of good; resignation and awe when face to face with the great mystery of death" ("Hades in Art" 218).

The myths discussed in these essays involve two central types, those of male heroism (Theseus, Perseus) and those of female sacrifice or evil (Sirens, Alcestis, Helen, Ariadne, Andromeda). In these instances, critical essays conditioned the nature of the images associated with each mythic figure. In such essays, the image of men as heroic and of women as unheroic is universalized through mythic types. Myths were modeled to suit the contemporary situation, a process of selection that excluded certain myths, retained others, appropriated only part of a myth, or reiterated certain myths but not others. This process of selection accorded with the patriarchially biased definition of the male and the female natures, of masculine and feminine roles. By this portrayal of classical myths, nineteenth-century British culture was "Hellenized." As Otto Rank observed in *The Trauma of Birth,* "this process of 'Hellenization' rests . . . on the most intense repression of the mother principle" (149), that is, Greek myth is perforce a sign of patriarchal domination. Such Hellenizing constituted a conservative political force.

The myths involving women demonstrate these tendencies. Their details

were chosen to increase men's gynophobia. Arachne, for example, inspires fear because the spider emits poison. The thread associates Arachne with Penelope, weaving while awaiting Odysseus, and with the Fates, whose weaving represents Destiny. The final Fate, Atropos, or "she who cannot be avoided," associates women with death; the woman is "at the end" of the journey, like Penelope. The myth of Arachne associates women with death by this nexus. The nineteenth-century association of women with textile work and with death in childbirth is reflected in the weaving/death association of the myth. The myth of Arachne veers into the myth of Theseus and Ariadne, who supplied the hero with the thread by which to explore the Labyrinth. This myth is an exemplification of sexual exploitation and male domination familiar from the male treatment of prostitutes as revealed by nineteenth-century statistics. The images of women such as Arachne, Ariadne, and the Fates are appropriate to the industrial era which associated spinning with females on a massive scale. In turn, the myths reflect the psychosexual reaction of men to women's condition. The frequency with which the abandoned Ariadne was presented is the male response to this fear of the thread/pudendum/death complex associated with the female. The fact that the final Fate uses shears to cut the thread of life represents a latent castration anxiety in the legend.

Similar attitudes are revealed in the complex of Artemis/Atalanta/Amazon. Classical-subject painters invariably showed Artemis as independent huntress or as the lover of Endymion. They avoided the attributes of the goddess that indicated her vengeful nature or the ruthlessness of her independence, although occasionally someone would present the fate of Actaeon. Artemis, alone of the female Olympian deities, developed no patroness relationship with a male, like that of Athene with Perseus or Hera with Jason. Jane Harrison claimed that the coming of patriarchal order relegated goddesses to lesser status, Artemis alone remaining in her fierce independence. The Homeric Hymn described her as the "arrow-pouring virgin." Artemis became identified with Selene or the moon, which associated her with menstruation. The emphasis on women's cyclical sexual nature was translated into the belief in male progressive development and female cyclical recurrence, i.e., men develop and women do not. While Atalanta beheaded the lovers who could not outrace her, this incident was never depicted. Instead, she was shown by an artist such as Poynter stooping to retrieve one of the golden apples hurled by Melanion. No painter ever pursued the legend to its grim conclusion. Melanion and his lover were destroyed by the fierce goddess Cybele (whose priests castrated themselves) after they made love in her temple. The male culture dealt with the

myth only in terms of male possession of the woman, avoiding the association
of decapitation. The Amazons, who cut off one breast to enhance their spear-
throwing function, were considered in terms of their defeat by Heracles or
Theseus, not in their self-sufficiency. Nicholas Cooke in *Satan in Society* (1870)
declared that a woman engaged in female emancipation would "cease to be
the gentle mother, and become the Amazonian brawler" (86). The message
Cooke conveyed in print was conveyed by the classical-subject artists in their
painted representations of female independence. Men had to be like their
mythical predecessors and defeat the Amazons. Nineteenth-century criticisms
of female redundancy represent the fear of this independent virginity em-
bodied in the Artemis/Atalanta/Amazon structure. The encoded mythologies
of male superiority emphasized the triumph of the hero over this Amazon:
Theseus/Antiope, Achilles/Penthesilea.

Classical-subject painters reacted to political and legal changes by repre-
senting them in icons. It is not satisfactory to claim that these images arose
simply to enable artists to present the female nude. Most artists, and many
in the viewing public, were familiar with the details of these legends. The
subtext in such canvases is gynophobic. The ancient Homeric Hymn to Aphro-
dite expresses this fear of women. After intercourse with the goddess, An-
chises is rendered impotent, as he had suspected would be the case. The god-
dess, when he queried her regarding this hazard, lied in order to satisfy her
lust. Aphrodite's independence, Jane Harrison claims, is in her origin: "She
can never tolerate permanent patriarchal wedlock. Her will is always turned
toward love rather than marriage" (*Myths of Greece* 26). Her will is toward
sex rather than marriage. Canvases of Aphrodite are not merely depictions
of beauty. They represent the goddess's repudiation of the patriarchal author-
ity embodied in marriage legislation during the nineteenth century, with the
concomitant male fear of the goddess's independence. As Roheim observes,
the sexual double standard enforces this fear.

Although frequently considered purely decorative, classical-subject can-
vases in fact exhibit the highly encoded valences of significance of their mythic
contents. Like myths, their meanings are eternally potential and virtually in-
exhaustible. The principle of Redundancy in Culture indicates that these
canvases are not solely beautiful. An exclusively aesthetic appraisal of classical-
subject canvases ignores the narratological content and its detail, obviously
of strong cultural relevance. The culture's belief that women were sexually
passive preserved the myth of male domination and obscured the castration
fear that sustained this belief. Following the myth of the Judgment of Paris,

who gave the apple to Aphrodite, Aphrodite was represented holding an apple. The Judgment of Paris is a later, patriarchal accretion to the earliest, matriarchal depictions of the three goddesses, who were rival gift givers rather than suppliants to a man for his favor. As Edward Lucie-Smith observes, the patriarchal version of the Judgment of Paris "serves as an assertion of male superiority: though Paris is a mere mortal, he has become, thanks to his rights as a male, the judge of three immortals" (*Eroticism* 178).

These mythic details allowed classical-subject artists to allude to latent sexual meanings without offense. Pandora is given great beauty by Aphrodite and ability in weaving by Athene. Pandora, as Warner observes, is "the prototype passive recipient of divine or male energy, and yet at the same time an agent of calamity, a danger to men" (*Monuments and Maidens* xxii). Pandora's representation by Hesiod in the *Theogony* and *Works and Days* is surrounded with misogynistic contexts: Zeus had her created in anger at Prometheus' theft of fire, so she is an instrument of revenge; Epimetheus accepts her as bride against his brother Prometheus' advice; her "box" (actually a storage jar) releases terror on the world; before her creation grain grew without man's labor. Marylin Arthur notes that in Hesiod's *Works and Days* and *Theogony* "we come up against the earliest and most extensive formulation of the misogynistic attitude that was to become a veritable *topos* in Greek life and literature of later periods" (22). The *Theogony,* in particular, "presented the progress of history and civilization in terms of a triumph of the male over the female forces" (48). The power of the female could be beneficent only "when it was regulated by the male principle of order," such as Apollo "taming" the Muses ("Early Greece" 49). Even if one rejects the symbolic association of Pandora's box or jar with the vagina, "Hesiod's message [is] that sexual desire for a woman lies at the root of man's undoing" (Warner 217). Both desirable and dangerous, Pandora indicates "the plural significations of women's bodies" in the femme fatale (xix); she "provided a canonical Greek confirmation of nineteenth-century ambivalence about women" (237).

The sexually accessible nymphs, painted repeatedly by classical-subject artists during the era, are the associates of Aphrodite without her intimidating phallic penumbra, which accounts for their extreme popularity during the later Victorian and particularly Edwardian periods. Nymph canvases could present sexual accessibility without anxiety; the nymphs were not so specifically associated with detailed mythological narrative and could be presented frequently by the same painter. The fact that nymphs were ultimately mortal made them less threatening than Aphrodite.

The myth of Demeter and Persephone is a complex association of abduction, rape, and death. Depictions of the rape of Persephone by Hades, for example in canvases by Crane, Burne-Jones, Stanhope, Etty, and Pickersgill, express male appropriations of women's bodies. Only rarely is Demeter portrayed at all, a sign of patriarchal interpretation of the myth. As goddess of grain, Demeter was dominant in an agricultural society; in an industrial age, she is superseded. Demeter's power is that of a matriarchal system, which the patriarchal organization dominated. Artists represent instead the death-bearing Persephone, whose fate involves the male power of Hades rather than the matriarchal/agricultural association of Demeter. The association of Demeter and Persephone with the Eleusinian mysteries suggests the powerful matriarchy, which painters avoided in favor of the abduction or the return, as in the canvases of Leighton (1891) or Hacker (1889). In the Homeric Hymn Persephone was in a field accompanied by two goddesses, Athene and Artemis, when she was abducted. Athene, never born of woman, and Artemis are the most fiercely independent women of the Olympian pantheon. The fact that Persephone eats the pomegranate, the fruit of Hades, which means she cannot return to earth forever, associates women with death.

Women's latent sexual frenzy is suggested in the depictions of the devotées of Dionysus. The cyclical/lunar menstrual period signified a proclivity to madness and blood shedding. It was easy to equate female sexual desire with hysteria and neurasthenia via the image of the Bacchante or Maenad. Cesare Lombroso in *The Female Offender* argued that prostitutes represented female atavism, regression to more primitive behavior. Bacchantes embodied images of female lust, demonstrating women were potentially mad by virtue of their sexuality. Lombroso specifically claimed that red-haired women were unchaste, a detail frequently occurring in depictions of Maenads or mermaids. During the nineteenth century, classical-subject pictorial ideograms reinforced and reflected this attitude about women's sexuality by depictions of Maenads. A subclass of these depictions is the group of canvases concerning the legend of Orpheus. The dismemberment and decapitation of the poet at the hands of Maenads indicated the artist's fear of being destroyed by women. The subject reflects not only the exaltation of the male artist but also the fear of the destruction of artistic power by women through sexuality. Among the artists and sculptors who depicted the legend were Burne-Jones, Meteyard, Richmond (Diploma Picture, 1900), Wetherbee (1901), Watts (frequently), Solomon Solomon (1892), Poynter, Beacon (1898), March (1901), Ryland (1901), and Ricketts. By showing the episode of Orpheus rescuing Eurydice, artists

reinforced the "rescue" phenomenon of the culture and avoided the sinister decapitation/castration of the later part of the legend.

The association of women with madness, reflected in these encoded ideograms, was extensive in nineteenth-century British culture. By the middle of the century, the majority of patients in lunatic asylums were female. Elaine Showalter notes that madness was "the essential feminine nature unveiling itself before scientific male rationality," that there was an equation between "femininity and insanity" (*Female Malady* 3), an affiliation encouraged by classical-subject Bacchantes and representations of the unfortunate Ophelia. "Female irrationality . . . might also represent an unknowable and untamable sexual force" (10). By 1871, there were 1,182 female lunatics for every 1,000 male lunatics. In 1872, of the 58,640 lunatics in England, over 31,000 were females (52). In asylums, men were the authorities over the females. Social Darwinists regarded insanity as a regression to a lower state of formation; menstruation was taken to indicate the lower stage of female development, a bestial component to women's nature. Specially associated with women were hysteria, neurasthenia, and anorexia nervosa. When women were deemed mad, they were often considered monstrous. Thus the iconography of Bacchantes signaled female madness; Harpies and Sphinxes, half female and half animal, marked women as creatures with a strong bestial component. It was feared during the nineteenth century that distribution of birth control information would lead to bestiality because female sexuality would no longer be linked with maternity.

VI

The male response to frightening mythological figures such as Artemis, Aphrodite, Pandora, and Persephone was to depict legends that confirmed male superiority, such as the group of Apollonian paintings that celebrate male/sun domination. Walters notes that certain mythical figures are supremely phallic: "The whole body may come to represent the phallus; Hercules is the archetypal phallic nude" (*Male Nude* 9). Leighton's *Hercules Wrestling with Death* (1871) is an icon of male phallic supremacy in the context of a "rescue" situation. The bodies of men and women presented in mythological situations became ideograms in classical-subject canvases, associative vortices of sexual typology.

Prominent among legends supporting male superiority were those involving the "rescue" compulsion, by which men rescued women, sometimes later

subjugating them in marriage. Heracles and Alcestis, Perseus and Androm-
eda, Orpheus and Eurydice are three of these relationships indicating the
rescue compulsion, the mythological prototype of the rescue societies and mis-
sions established in the nineteenth century to help the destitute, often en-
visioned solely as females. Rescue missions and societies, frequently with
men as their founders or heads, particularly devoted their attention to deal-
ing with vagrant women (i.e., prostitutes) or redundant women (seamstresses,
governesses). There is no doubt that such rescue societies contained an altru-
istic goal. The men who sponsored and directed them sincerely desired to
remediate the condition of women. It must be recognized, however, that males
were the authorities in many of these schemes, reinforcing male superiority
while simultaneously helping inferior females. The legal victories gained by
women during the nineteenth century allowed men to appear as rescuers/
champions of the sex. The rescue myths of the Greco-Roman pantheon re-
inforced the idea of woman as victim and man as heroic rescuer.

After persisting for several decades, this preoccupation with male heroism
was so entrenched that "the Edwardian age has all the marks of an heroic
or Homeric age. . . . [A man] had to show himself to be strong, brave, and
courageous. . . . The Homeric world of the heroes has other resemblances.
There is the same attitude to wealth, the same regard for other heroes, the
same atmosphere of competitive exclusiveness . . . the same dependence on
the sea" (Ogilvie, *Latin and Greek* 137). Reviewers and critics reinforced the
interpretation of artworks as expressions of male heroism. Writing in 1904,
Alice Corkran noted that Perseus in Leighton's 1891 canvas was a "saviour"
(*Frederic Leighton* 91). Leighton wrote to Mrs. Russell Barrington in 1887:
"I sympathise warmly with the thought of keeping the memory of heroic
deeds alive in our people" (Corkran 157). The heroism preserved was a hyper-
masculine heroism. M. J. D. Roberts notes: "Victorian males of social rank
fairly clearly valued the classics and other forms of art as an informal source
of instruction and entertainment in sexual matters as well as a formal source
of instruction in matters of public morality and character formation" ("Mor-
als, Art" 617). The most important element of this dual source of enlighten-
ment, simultaneously sexual and political, was that it created ideograms that
devalued women and elevated male heroism.

Heracles, Perseus, and Theseus were the mythological heroes elevated in
classical-subject canvases. This is an extension of the hero worship propounded
by Carlyle in his lectures in 1840: "Worship of a Hero is transcendent admira-
tion of a Great Man. . . . Society is founded on Hero-worship" (248–249).

Carlyle believed in a *Hero*archy, and his examples—Odin, Mohammed, Dante, Shakespeare, Luther, Knox, Johnson, Rousseau, Cromwell, Napoleon—are all male. Classical-subject painters were creating their own "Heroarchy" to combat female heroines like Josephine Butler and the Pankhursts, thereby retaining male prerogatives and privileges. Classical-subject painting emphasized the superiority of the male by presenting images of women in a selective manner and by recognizing "heroes" like Perseus, Heracles, and Theseus. The phallocentric significance of such depictions was increased when the hero appeared in armor. Lucie-Smith comments that this armor "is characteristically both rigid and form-fitting, so that it is a kind of substitution (taking the whole body for part of the body) for a permanently erect penis" (*Eroticism* 246). Victorian artists therefore avoided depicting female warriors like Bellona, for in armor they would appear to have appropriated the phallus.

Lord Raglan listed twenty-two characteristics of a "hero," according to which figures like Theseus, Perseus, Jason, Bellerophon, and Dionysus most epitomized the type. In the strict sense a hero is an individual with one divine parent. In the nineteenth-century the individual's status was verified by deeds, as espoused by Carlyle in *Signs of the Times, Characteristics,* and *Past and Present.* In mythology these deeds took the form of slaying monsters: Theseus/Minotaur, Perseus/Medusa, Bellorophon/Chimaera, Heracles/Ladon. A text promulgating the heroic idea to children, Charles Kingsley's *The Heroes* (1855), explored the idea in three figures—Perseus, Jason, and Theseus. Lady Diana Cooper recalled being raised "on a book of Flaxman's drawings for the *Odyssey,* followed by Church's *Homer* and Kingsley's *Heroes*" (Ogilvie, *Latin and Greek* 142). The influence of such a book on the psychological development of men and women during the Victorian and Edwardian periods is incalculable. There can be little question that it formed one of the associative matrices of their development. Boys were encouraged in this identification of heroism with performing great deeds by being given such reading as *Men Who Have Risen* and *Famous Boys and How They Became Great Men.*

Kingsley began by emphasizing in his preface the Victorian belief in the Greco-Roman tradition: "You can hardly find a well-written book which has not in it Greek names, and words, and proverbs; you cannot walk through a great town without passing Greek buildings; you cannot go into a well-furnished room without seeing Greek statues and ornaments, even Greek patterns of furniture and paper. . . . We owe to these old Greeks . . . the beginnings of our geography and astronomy; and of our laws, and freedom, and

politics" (10–11). To Kingsley heroes are "men who were brave and skilful, and dare do more than other men" (17). Kingsley states that boys and girls alike may strive for the heroic, yet his illustrations are exclusively male. Perseus is "brave and truthful, gentle and courteous" (25). The fear engendered in the Perseus legend is soon confronted: "As Perseus looked on it his blood ran cold. It was the face of a beautiful woman; but her cheeks were pale as death. . . . Vipers wreathed about her temples. . . . Day and night Perseus saw before him the face of that dreadful woman, with the vipers writhing around her head" (28–29). The salient fact of the Perseus legend as retold by Kingsley to half the children in England is that woman's beauty is fatal. When Perseus sights Medusa, "for all her beauty, she was as foul and venomous as the rest" (46). Kingsley's distortions of legend include such male-superior readings of the Jason/Medea encounter as the following: "He looked at Medea cunningly, and held her with his glittering eye, till she blushed and trembled" (117), a nineteenth-century construction imposed on classical myth. The plight of Jason is that he "had taken a wicked wife. . . . Jason could not love her, after all her cruel deeds. So he was ungrateful to her, and wronged her; and she re-venged herself on him" (159).

By implying that Jason had a right to be "ungrateful," Kingsley ignores the fact that Medea did many of her "cruel deeds" for Jason. Medea is later called the "dark witch-woman" (189). Kingsley glides over Theseus' abandon-ment of Ariadne. The impression given by Kingsley's *The Heroes* is that men perform deeds befitting their heroic essence. The assistance given by Medea and Ariadne to their respective heroes is muted in his account. Kingsley's statement about the Medusa is the youthful version of Pater's declaration in "Leonardo da Vinci" in the *Fortnightly Review* in 1869: "[Medusa] has been treated in various ways; Leonardo alone cuts to its center; he alone realizes it as the head of a corpse, exercising its powers through all the circumstances of death. What may be called the fascination of corruption penetrates in every touch its exquisitely finished beauty" (*Renaissance* 78). As children, males heard this gynophobic propaganda from Kingsley; as adults, they read it in Pater. The myth of Medusa verified the permanent evil nature of women. Classical-subject pictorial ideograms reinforced these cultural prescriptions by emphasizing male heroism in the form of rescues of helpless women or the destruction of evil ones. This form of cultural indoctrination was persistent, even relentless.

In addition to the selective interpretation of myths by such authors as Kingsley, another form of cultural indoctrination was the emphasis on spe-

cific classical texts that reinforced the privileging of the male. One source particularly favored by artists was Ovid's *Heroides* ("Heroines"), a series of twenty-one letters, eighteen of which are from women to men, mostly male heroes. In many instances, the writer is a woman either abandoned by or awaiting a man, as with Penelope to Odysseus, Phyllis to Demophoön, Dido to Aeneas, Ariadne to Theseus, Medea to Jason, Sappho to Phaeon, or Hero to Leander. Many of these women, such as Dido, Phyllis, Ariadne, or Medea, are desperate, nearly deranged by their shame for having been seduced by faithless men. Oenone tells Paris he is "lighter than leaves" (65); Dido declares, "Undone myself, I fear lest I be the undoing of him who is my undoing" (87); Medea recalls, "Quickly was I ensnared, girl that I was, by your words" (149); Phyllis observes, "I was deceived by your words—I, who loved and was a woman" (25). The iconography of classical-subject canvases was suggested by the details Ovid supplied to emphasize the situation of these women. Ariadne describes herself "with hair loose flying" (125). Fearing Jason might be destroyed by his tasks, Medea spends a sleepless night "with loosened hair and lying prone upon my face, and everywhere my tears" (147). The association of women and madness is evident in many of the letters. Since being abandoned by him, Ariadne tells Theseus: "I have either roamed about, like a Bacchante roused by the Ogygian god, or, looking out upon the sea, I have sat all chilled upon the rock, as much a stone myself as was the stone I sat upon" (125). Ariadne's rage is self-destructive: "Straight then my palms resounded upon my breasts, and I tore my hair, all disarrayed as it was from sleep" (123). In the *Heroides* women are depicted as deranged and self-destructive because of their erotic desires. As "heroines" they are in great contrast with their lovers, heroic adventurers like Jason, Theseus, and Aeneas. The study of such a work by impressionable young men contributed to the formation of insidious cultural paradigms of women.

Such cultural indoctrination, and the use of such ideograms in classical-subject art, reveal much about nineteenth-century sexual thought, and about the psychology of sexuality during the era. John Addington Symonds noted in *Studies of the Greek Poets* in 1873 that "the truth to be looked for in myths is psychological" (2.15). Writing of the nineteenth century, Peter Cominos observes: "Women were classified into polar extremes. They were either sexless ministering angels or sensuously oversexed temptresses of the devil; they were either aids to continence or incontinence; they facilitated or they exacerbated male sexual control. Although apart, these polarities shared an attitude of disguised masculine hostility toward women. It was a fragment of that

antifeminine ideology that represented at the level of consciousness those corresponding relations of domination and dependent submission that characterized family existence" ("Innocent Femina Sensualis" 167).

Misogyny and gynophobia, with the concomitant emphasis on male heroism, were the psychological manifestations embodied in classical-subject painting. Such canvases reflect the misogyny and gynophobia expressed in legal, educational, familial, political, and marital suppression of women during the century. Women were desexualized, as Cominos notes, "to help gentlemen cope with the problem of controlling their own sexuality" (162). Numerous images of women somnolent or narcotized in classical-subject canvases calmed men's anxieties about female sexual responsiveness. Catering to the voyeurism of the male, such canvases, for example by Albert Moore, were erotic but unthreatening. Victorian males could gaze like Actaeon at Artemis without suffering his fate.

Although the great era of classical-subject painting, from 1870 to 1910, occurred prior to the rise of psychoanalysis, there can be little doubt that classical-subject painting is psychodynamic. Cominos observes one source of this psychodynamism: "The perfectly continent, the completely sublimated sensual man, represented the Respectable or normative standard of gentlemanly sexual morality. Perhaps, the ultimate ideal of Respectable sublimation was rescue work among fallen women, the chief instrument of incontinence. For an individual like Gladstone, who was preoccupied with rescuing fallen women, rescue work was an important aspect of that process of sublimation" ("Late-Victorian Sexual Respectability" 31). It is known that Gladstone engaged in self-flagellation after these encounters, indicating the sexual component of the "rescue." Gladstone reclaimed perhaps a dozen women in three years, a record of failure that proved ludicrous to other Victorians. William Etty, the shy celibate, during faithful attendance at the life school of the Royal Academy similarly sublimated his sexual drives by painting voluptuous nudes. Lucie-Smith notes that in several Etty canvases the female is in armor, "a confession of male impotence and sexual confusion" (*Eroticism* 249). Such sublimation provided males an opportunity to rechannel their sexual instincts into other spheres of expression. Victorian culture, as well as being marked by such sublimation, was also a repressed society. Pearsall observes that "wishes of a sexual nature that were not acceptable to the conscious mind were pushed underground" (515), creating a "climate of repression" in the culture (*Worm* 98). "Ruskin's madness was almost certainly due to sexual repression" (301). Lewis Carroll's interest in little girls reveals the same repression of sexual in-

stincts. Symonds' statement that myths are primarily psychological indicates that their function in Victorian culture was partially an expression of this repression. When used in conjunction with other collateral evidence and sources such as diaries, letters, sketchbooks, or iconographic detail, psychological data permit additional insight into mythological material.

Classical-subject art must be studied in this context to appreciate its full significance. Peter Webb notes: "The academic nude painters gave expression to repressed feelings, and this fulfilled a great need felt by millions of English . . . men and women who had learnt to be afraid of sex" (*Erotic Arts* 168). Nudes in classical settings deflected censorship in such a climate. "The inhibitions under which the English artists operated turned in a curious way to their advantage, and straightforward historical and mythological scenes were given a piquancy that strangely forms them into quasi-erotic paintings. . . . The painter had much more freedom and could depict what he felt about legs, breasts, and any other primary or secondary sexual characteristic with a precision that was denied his literary brethren. . . . For the extremely repressed, their work, overtly mythological, was a sex substitute" (143). An element of voyeurism unquestionably entered into the use of myth, and one should recall that brothels were equipped with peepholes to permit observation of copulating couples. Despite attempts to prevent the study of the nude in art schools or to conceal the genitals of male statues at the Great Exhibition, "the nude in high art was something that slipped through the clutches of middle-class morality" (149).

Painters who depicted naked women were deploying myth for both ideological and sexual reasons, to express both a cultural attitude of distrust and fear of women and a personal as well as cultural sexual anxiety; the manifest mythological content allowed a latent psychodynamic connotation. Classical associations were conspicuous in other aspects of Victorian sexual culture: girls dressed *à la Grecque* in the Archery Rooms; women appeared in pornographic photographs as classical deities or as statues of Aphrodite Pudica; Greek friendship was invoked in homosexual liaisons (following Plato's *Phaedrus*); "mythological divinities" were represented in the *poses plastiques* or *tableaux vivants* of places like the Hall of Rome.

Classical-subject art and its mythology comprises a cultural semiotic system that may be decoded and deciphered by various means, biographical, anthropological, sociological, mythographical, and psychological. Classical-subject art, so frequently thought of as primarily decorative in intention, becomes a multivalent system of connotations. Only recently have critics be-

gun to recognize the latent sexual significance of these canvases. Writing of Rossetti's *Beata Beatrix* in the 1984 Tate Gallery catalogue, Alastair Grieve remarked: "Strangely, nobody has remarked on the phallic pointer of the sundial projecting toward the frozen ecstasy of Beatrice's face" (*Pre-Raphaelites* 209). Anthony Hobson notes in his introduction to an exhibition of John William Waterhouse that his canvas *La Belle Dame sans Merci* reflects sexual mores: "The shadowy figure of the knight is without doubt that of the artist himself, the armour of his Victorian propriety resisting the embrace he ardently desires and overtly suggests" (*John William Waterhouse*). Myths themselves contain data so obvious that significances must be clear to thinking people even if one totally excludes Freud: Electra's name means "out of the marriage bed"; Aphrodite means "out of the sea-foam" of her father's severed erection; Oedipus means "swollen foot"; Pentheus "suffering."

The sexual symbolism associated with mythology was not a discovery of modern psychoanalysis. Male impotence is confronted in the early Homeric Hymn to Aphrodite. Richard Payne Knight's *Discourse on the Worship of Priapus* and Thomas Wright's *The Worship of the Generative Powers* appeared in 1786 and 1866 respectively, both known to most artists of the nineteenth century. The language of riddles and bawdy poems was permeated with references to objects as sexual semaphores. The work of anthropologists such as Andrew Lang on such subjects as polyandry recognized the differences of sexual practices. Writing in the catalogue *Victorian Romantics* in 1979, Dan Perrin notes: "The ancient Greek myths and legends were a common source of inspiration. . . . Most Victorians were well acquainted with the myths and needed no explanation to their symbolic iconography. Unconsciously, and in many instances probably consciously, Classical myth served political and sexual expression simultaneously."

The existence of the unconscious during the nineteenth century was well established, as Jean Pierrot had noted: "However original and revolutionary Freud's theories may have seemed at first, . . . the fact is that the foundations for them had already been laid down by a succession of earlier thinkers over a long period. Freud did not invent the hypothesis of the unconscious; he simply brought it to final fruition by making it the basic hypothesis of psychoanalysis" (*Decadent Imagination* 119). Thinkers such as E. V. Hartmann, Edmond Colsenet, W. B. Carpenter, Maine de Biran, and J. D. Morell all enunciated the belief in the unconscious before the publication of Freud's *The Interpretation of Dreams* in 1899. The interest in dreams, as Pearsall demonstrates, is extensive in Victorian culture; Ruskin was not alone in recording

his dreams in considerable, and revealing, detail. Lancelot Whyte summarizes the development of the idea of the unconscious: "In the limited perspective of the mid-twentieth century the history of our idea appears to start moving with a rush as it enters the 1850's. It would be possible to name some ten or twenty thinkers in each decade from 1850 to 1880 as having made minor contributions. Viewed more objectively it may be that in the hundred years from 1850 to 1950 only a very few, perhaps five, basic theoretical advances were made, mainly round 1900" (*Unconscious before Freud* 153). The great rise of the mythological, classical-subject canvas in nineteenth-century England coincides with this development of the unconscious. The evidence of mythography, anthropology, and sociology indicates that this art expresses sexual attitudes and is far from being only decorative. Whyte asserts, in fact, that "it cannot be disputed that by 1870–1880 the general conception of the unconscious mind was a European commonplace, and that many special applications of this general idea had been vigorously discussed for several decades" (169–170). Many classical-subject paintings constitute expressions of cultural subconscious or unconscious attitudes, as well as conscious suspicion of the nature of women.

Mario Praz has noted a marked "virility complex" in nineteenth-century society, a disposition he defines as "an anxious desire to appear masculine" (*Romantic Agony* 238). One manifestation of this desire would be the growth of facial hair to be seen on men during this period. This hypermasculinity is also evident in canvases showing debased women and male heroes. Mythic detail indicates the intention of these narratives. The Sphinx, a man-eater, anticipates Otto Rank's formulation of the birth trauma, which he contended was confronted by slaying a devouring monster. These monsters were frequently female, such as Medusa, the Chimaera, or the Sphinx. The female devourer was a version of a type Pearsall identifies as "predator," "vampirish" (*Worm* 120, 129). The figure of Lamia sheds her skin in symbolic rebirth. Medusa was pregnant when slain by Perseus. Frequently heroes were delivered by cesarean section to avoid the birth trauma, and Pygmalion was created without the agency of a woman, a "Victorian superman," as Janson notes (*From Slave to Siren* [catalogue] 3). Gladstone's attraction to rescuing prostitutes might have illustrated Sigmund Freud's study of object choice in men, where in certain males there exists a compulsion to rescue a distressed female, often a fallen one. The debased female in Victorian culture, and her mythic "rescue," was expressed by such figures as Danaë, Theseus/Ariadne, Perseus/Andromeda, and Jason/Medea. Mythic figures such as Echo and Clytie showed

a female dependency that enhanced the power of narcissists. In Victorian culture, male self-absorption was evident in countless manifestations, such as men's clubs or the doctrine of separate spheres enunciated by writers like Ruskin or Patmore.

Narcissism as expressed in the doctrine of separate spheres is one form of evading sexual anxiety by self-absorption. Another strategy was androgyny, common in the work of male nineteenth-century British artists, as Busst observes: "The asexuality associated with mental erethism may also be seen in the androgynous faces drawn by . . . Burne-Jones and Simeon Solomon, in whose works . . . it is often impossible to distinguish a man from a woman" ("Image of the Androgyne" 47). The asexuality of the androgyne reinforces self-sufficiency in a narcissistic manner. Pierrot believes that this function is also served by the hermaphrodite, which he contends underlies "certain male figures by English artists such as Burne-Jones" (*Decadent Imagination* 132).

Androgynous depictions of men and women represent an attempt to deny difference to reinforce narcissism, as well as an expression of fear of loss of sexual identity. Leighton's powerful androgynes, Clytemnestra and Electra, for example, indicate the latter property. In 1898 Joseph Comyns Carr recorded a certain kind of reaction to Burne-Jones's paintings which illustrates the virility complex very well: "For it must not be forgotten that when ridicule had done its work, Burne-Jones was very seriously taken to task by 'the apostles of the robust.' There are men so constituted that all delicate beauty seems to move them to resentment; . . . men who go about the world constantly reassuring themselves of their own virility by denouncing what they conceive to be the effeminate weakness of others. To this class the art of Burne-Jones came in the nature of a personal offence. They raged against it" (New Gallery Exhibition 1898–1899, 27). Carr adds, "the very vehemence of such opposition was in its own way a tribute to his power" (28). Men feared suggestions of an identity of the sexes, for it might eventually lead to gynocracy if women eventually surpassed men. Perceptive Victorians themselves knew that, as Kerényi observed, "myths . . . have a vital meaning. Not merely do they represent, they *are* the psychic life" (Kerényi and Jung, *Essays* 73). Pierrot concludes: "The discovery . . . had been made, in those pre-Freudian days, of a whole area of the life of the 'soul'" (*Decadent Imagination* 143).

Nineteenth-century classical-subject painting depicted women in mythological situations to universalize masculine attitudes prevalent in the culture. Misogyny and gynophobia, manifesting themselves in the legal, educational, medical, and familial structures of Victorian culture, were universalized by

mythological presentations of women as sensuous, death bearing, deceiving, or dependent. Classical-subject pictorial ideograms gave both eternality and universality to repressive icons of women, delaying if not preventing the improvement in conditions of women. The use of mythology, as in Stead's essay, reinforced the idea of inherent male superiority and inherent female inferiority. Classical-subject iconography represented the confluence of sublimation and classical education, archaeology, and mythology. If the male's genuine beliefs about women could not be expressed in contemporary terms, in classical representations these attitudes found expression despite sublimation in personal life. Lingering doubts about one's personal beliefs about sexuality and women were removed in classical-subject canvases by virtue of the universality and eternality of male and female myths, the former supporting male heroism, the latter confirming female inferiority or degeneracy. This art became a means of expressing the passion sublimated in private life. That classical-subject ideograms assumed prominence in the late sixties and early seventies is not a historical accident. Cominos observes: "The relatively *laissez-faire* attitude of the fifties and sixties in respect to London's flourishing night life contrasted remarkably with its termination early in the seventies when several famous salons, night houses, casinos, and pleasure gardens were closed down" ("Late-Victorian Sexual Respectability" 46). At the same time, in the early seventies, the demimonde reached its apex in London life, represented in the allure of Circes, Calypsos, and Sirens who were also Harpies and Medusas.

The misogyny and gynophobia engendered by this sublimation that was a component of the political system were expressed, disseminated, reviewed, reproduced, and universalized by the selective use of Greco-Roman mythology in encoded classical-subject art. Classical-subject paintings constituted cultural, psychological, and political ideograms that through association of ideas reinforced societal male superiority. Pearsall observes that "nineteenth-century society was oriented to make dominance" (*Worm* 114). Nineteenth-century British mythological painting was part of a system of cultural indoctrination that represented women as terrifying or submissive and men as the heroic stabilizing factor in the social structure.

❧ TWO ❦

Edward Burne-Jones and the
Early Classical-Subject Tradition

THE art of Edward Coley Burne-Jones (1833–1898), the first major painter of classical-subject art, followed a period of artistic experimentation with classical themes. Burne-Jones's early association with the Pre-Raphaelite Brotherhood and his acquaintance with Little Holland House and G. F. Watts make him an inheritor, but not an imitator, of certain themes and myths associated with the painters of the 1840s and 1850s. The themes of rescue and of male domination appearing in classical-subject paintings are an amalgamation of two forms of painting that preceded the classical-subject works of Burne-Jones, Leighton, Poynter, Alma-Tadema, and others during the last four decades of the nineteenth century. These two groups are the Pre-Raphaelites (Dante Gabriel Rossetti, John Everett Millais, William Holman Hunt) and the two painters of the pseudoclassical nude, William Etty and William Edward Frost. The classical-subject artists drew on some of the themes or subjects (but not the technique) of the former and the interest in the nude expressed by Etty and Frost.

Their work has certain continuities with both movements. Pre-Raphaelite art has a strong element of male-dominant "rescue" conceptions, usually in medieval or contemporary form. The classical-subject artist universalized these paradigms by returning to legendary material of Greco-Roman origin. Frost and Etty too drew on certain legendary material. The painter G. F. Watts, who knew the Pre-Raphaelites as well as the classical-subject artists, bridges the stages of nineteenth-century British art, presenting women in his social-realist canvases as a persecuted group needing rescue while evolving an allegorical style of classicizing art. Depictions of women as abandoned or persecuted appear prominently in several of the canvases of the Pre-Raphaelite and the Etty/Frost groups.

I

The work of John Everett Millais (1829–1896) contains a number of draw-
ings and canvases that reflect both an ambiguous attitude to women and the
force of the rescue compulsion. Millais's canvases frequently depict rescue sit-
uations, which reinforce male superiority. *The Order of Release 1746* (1853),
The Rescue (1858), and *The Knight Errant* (1870) represent variations of the
rescue compulsion. In the first, a soldier from Culloden has been let out of
prison by the English after his wife has obtained an order of release. The em-
phasis is not on the woman's rescue but on her consolatory function. Helene
Roberts notes that in presenting a scene where the woman appears to be the
rescuer, "Millais makes the woman of the lower class and sets the scene in
another country and century" (Vicinus, *Suffer* 48). In *The Rescue,* a fireman
carries children from a burning building as the frantic mother reaches to em-
brace them, while in *The Knight Errant* a knight saves a woman who has al-
ready been violated. In *The Escape of a Heretic* (1857) a young man rescues
his mistress from the Inquisition. In *The Ransom* (1862), a man rescues his
children from kidnapers. The classical-subject painters would universalize the
rescue compulsion by resorting to myths of rescue, such as Perseus and An-
dromeda or Dionysus and Ariadne.

In the case of Millais, the rescue compulsion was associated with the cir-
cumstances of his marriage to Effie Ruskin. Millais married her in 1855 after
the annulment of her marriage to Ruskin. His own reactions are revealing.
He wrote to Charles Collins on his wedding day:

> How strange it is. I am only hopeful it may be the right course I have taken which
> can only be known from experience. . . . I know I have all your prayers which is not
> a little comfort to me. This is a trial without doubt as it either proves a blessing or
> a curse to two poor bodies only anxious to do their best. . . . There are some startling
> accompaniments, my boy, like the glimpse of the dentists instruments — My poor brain
> and soul is fatigued with dwelling on unpleasant probabilities so I am aroused for
> the fight. (Lutyens, *Millais* 261)

This letter is an intriguing document about male attitudes, exhibiting acute
anxiety about sexual duties. The "fight" invokes male heroism, as in the Per-
seus/Andromeda story. Millais, probably a virgin when he married, feared im-
potence and resorted to this heroic icon to reinforce his belief in himself. Mil-
lais's canvases and drawings indicate conceptions about the nature of women
that would reappear in the classical-subject works from the 1870s to the end
of the century.

Another of the original founders of the Pre-Raphaelite Brotherhood was William Holman Hunt (1827–1910), whose long life embraced the rise and decline of classical-subject painting in England. Hunt's earliest canvases conveyed an interest in sexual situations of unusual tension. The 1848 *Flight of Madeline and Porphyro* is not a chaste picture, for in Keats's *Eve of St. Agnes,* upon which it is based, Porphyro has seduced Madeline prior to their escape into the winter night. Hunt indicates this by the phallic belt the hero wears as they depart the hall, a detail that is more graphic in a preliminary drawing for this canvas. He has "rescued" Madeline, in that she feared she would be abandoned. In *Claudio and Isabella* (1850), Hunt focused on a difficult episode in *Measure for Measure,* as Claudio must decide if he will sacrifice his sister's chastity to save his life, a sordid permutation of the rescue situation. In 1851 Hunt finished *Valentine Rescuing Sylvia from Proteus,* based on *The Two Gentlemen of Verona.* Valentine rescues Sylvia from being raped by Proteus, his best friend. *The Awakening Conscience* of 1853 depicts a kept woman having a sudden revelation of her state and vowing to alter her life. Hunt was attracted to "rescue" in his personal life when he tried to transform model Annie Miller into a suitable spouse, a project he abandoned in 1859.

The art of Dante Gabriel Rossetti (1826–1882) is replete with women of dubious intentions. Some of Rossetti's earliest work involved classical legends of poets and their mistresses, such as *The Return of Tibullus to Delia* (1851) (Plate 2-1) and *Boatmen and Siren* (1853) (Plate 2-2). In the former Tibullus is shown bursting into Delia's room, while an old woman with a lyre sings to her. Derived from Tibullus' third elegy, the work is strongly erotic. As Grieve notes, "such strong eroticism would only have been acceptable in a Classical subject" (*Watercolours and Drawings* 56). The erotic potential of the picture is strong: Delia holds her distaff suggestively on her lap, while an Eros is figured on the wall. In *Boatmen and Siren,* a man restrains his friend from pursuing a Siren, who passes by their skiff with hair flying.

Rossetti's greatest rescue canvas is *Found,* begun around 1853 and unfinished at his death. The canvas shows a farmer from the country who has come at dawn to market and discovered his former beloved is a prostitute. She huddles against a wall, turning from him as he attempts to lift her. The model for the woman was Fanny Cornforth, a Cockney girl who became Rossetti's mistress around 1858. With Holman Hunt's *The Awakening Conscience,* the canvas is the best-known depiction of the fallen woman in contemporary dress. Later, Burne-Jones worked on details in an attempt to finish the canvas. The classical-subject painters would take this theme, as they did other Pre-Raphaelite

motifs, and universalize it in a legend such as that of Ariadne. The phallic bollard indicates the sexual nature of the encounter. It is impossible to decide whether the farmer will rescue the woman, take her to a house of reclamation, or abandon her.

Rossetti painted a number of classical-subject canvases during his career that parallel and anticipate those of the Victorian High Renaissance painters. In the drawing *Cassandra* (1861), the prophetess is shown with streaming hair warning Hector against entering the combat with Achilles. Andromache stands to the right of Hector cradling the infant Astyanax, while Helen is assisting an androgynous Paris with his armor. The plight of the misunderstood woman, condemned by Apollo, is vividly conveyed in this crowded design. The stance of Hector is duplicated in the final canvas of Burne-Jones's *Perseus* series, *The Baleful Head.* Rossetti did a bust-length portrait of Annie Miller, *Helen of Troy,* in 1863. In 1868, Rossetti exhibited *Aspecta Medusa,* a work admired by Swinburne and an inspiration for the final canvas, *The Baleful Head,* in Burne-Jones's *Perseus* series.

Rossetti's uses of mythological material are particularly evident in *Pandora* (1869) (Plate 2-3), *Astarte Syriaca* (1877), and *Proserpine* (1877). In a sonnet Rossetti wondered about Pandora: "Was it . . . that all men might see / In Venus' eyes the gaze of Proserpine?" Rossetti aligns the story of Pandora with that of the phallic woman Aphrodite and the death-bearing Persephone. In Rossetti's treatment, Jane Morris is posed holding a small casket as its soporific fumes rise. This associates Pandora not only with evil but also with the somnolence of the narcotized woman embodied in the icons of Ariadne or the many sleeping women depicted by Leighton, Waterhouse, and other classical-subject artists. Pandora's vaginal/uterine casket/box with its evils reveals anxiety about female sexuality. The chalk study of 1869 shows a Pandora with massive shoulders holding a casket, a threatening androgynous figure.

The *Astarte Syriaca* depicts the most fearsome androgynous icon of the nineteenth century in the person of Jane Morris. The goddess, whose devotees castrated themselves, is shown in heavy green robe, her genital area embraced by a daunting chain girdle, which partially encircles her breasts. The face is decidedly masculine in appearance. In *Proserpine* (Plate 2-4), the daughter of Demeter is shown in her palace in Hades, holding the fateful pomegranate that linked her forever to death. Rossetti painted eight versions of the subject, a fearsome image of women and their death-bearing propensities. Rossetti derived inspiration for the canvas from the circumstances of his own relation-

ship with Jane Morris, who was allowed brief periods of freedom from her husband, William Morris. Rossetti has universalized a personal situation by this ingenious presentation of the myth. Peter Webb has noted the vulva-like depiction of the pomegranate, a linkage of female sexuality and death (*Erotic Arts* 177). In the 1877 *A Sea-Spell*, Rossetti depicted an entranced Siren playing bewitching music, while the 1875 pencil drawing *The Question* (Plate 2-5) showed men of three different ages ascending a hill to a fatal interview with the impassive Sphinx. Rossetti derives the pose of the dying youth from the third century B.C. statue Menelaus with the Body of Patroclus. In his sonnet sequence *The House of Life,* Rossetti invokes dangerous females in such sonnets as number 87 with its Helen and Sirens and number 88 with its alluring Hero. Rossetti's reaction to women follows a trajectory from the adulation of the Dante-inspired *Beatrice* (1864) to the degradation of *Found* to the outright fear of *Pandora, Astarte Syriaca,* and *Proserpine.*

Rossetti, Millais, and Hunt established images of women in contemporary, classical, and medieval dress that anticipated or paralleled some of the images of women in the classical-subject canvases: the abandoned woman, the fallen woman, the victim, the rescuer. Classical-subject painters universalized these ideas by their exploitation of mythological subjects. In this use of mythology, artists such as Leighton, Burne-Jones, Waterhouse, Alma-Tadema, Poynter, and others had predecessors in two painters earlier in the century, William Etty (1787–1849) and William Edward Frost (1810–1877). William Etty was a native of York who studied anatomy, attended the Royal Academy life class throughout his life, and traveled in Italy in 1816 and in Europe generally. Etty's motive in painting was to depict "some great moral on the heart" (Farr, *William Etty* 47), and frequently his figures were intended to represent abstract ideas: Mars was strength, Judith patriotism. Etty employed mythological figures and detail but not for the sake of the legends themselves. In this he differs from the classical-subject painters who exploited the particular narrative potential of a myth.

Etty has remained famous for his voluptuous nudes and his startling contrasts of color. His knowledge of women in his own life was restricted at the outset by a physical appearance distinctly unprepossessing: "a large head, with unruly sandy hair, a face strongly marked by small-pox scars, and a stocky figure with rather large hands and feet. . . . His physical appearance . . . made him a somewhat shy lover, and doomed to failure all his many matrimonial projects" (Farr 4). He was also pathologically lonely. Several of Etty's earliest canvases involved women like Aphrodite and Cleopatra. In *The Coral Finder*

(1820), Etty depicts Aphrodite arriving at Paphos, the "goddess" sitting in a boat guided by mermaids with Eros flying above dropping flowers. The excessive number of figures in the canvas prevents any exploration of the significance of the goddess. Etty's inability to avoid transcribing the literal model diffuses his mythological material and prevents it from becoming universalizing. This literalness may arise from his lack of sexual knowledge of women. Brian Bailey observes: "Etty's art became a substitute for sex. . . . He was fascinated by women, but afraid of them" (*William Etty's Nudes* 24–25). Etty's work foreshadows the gynophobia that is latent in much classical-subject painting. Working with a single model in his studio may have further intimidated Etty, for such a situation lacked the anonymity of the life class. Peter Webb believes that Etty's endless study of female nudes at the Royal Academy life school "met a real need for the outwardly gentle and retiring Etty" (*Erotic Arts* 188). Etty's inability to focus on the legend is exemplified in *Pandora Crowned by the Seasons* (1824) (Plate 2-6), in which the woman stands amid clouds, while Aphrodite and other deities see her off to earth. Etty ignores the casket or any of the signs in Hesiod of Pandora's deviousness, weakening the depiction by not adhering to signifying iconography.

Two of Etty's most successful mythological canvases are *The Parting of Hero and Leander* (1827) and *Hero and the Drowned Leander* (1829). In the first, Leander embraces Hero on his departure, with the waves and crescent moon in the background. The modeling of the flesh exploits the contrasts of skin textures of the man and the woman, a practice favored later by Leighton. *Hero and the Drowned Leander* (Plate 2-7) is dramatic from the foreshortened position of the bodies, Hero cast over the dead Leander. She is robed in a black cape, he in a green loincloth, with the sun beginning to rise in the background. The dynamism of the canvas, the crucifixion pose of Leander, the disarrayed hair of Hero convey the tragedy successfully. Etty's *Andromeda* (Plate 2-8), showing a woman with chains below her mammoth breasts, fails in its intention by focusing on the mammary anatomy. It is impossible to notice much else. An 1840s *Andromeda and Perseus* shows her more effectively than in the *Andromeda*. A red cloak outlines Andromeda's nude body, while the tail of the dragon insinuates itself beneath her cloak. Perseus holds a Medusa head that looks male, suggesting the hardening, erectile, masculine properties of her power.

In *The Sirens and Ulysses* (1837) (Plate 2-9), three heavily endowed women signal to Ulysses' ship. The modeling of Ulysses' body is impossibly detailed for the distance suggested. Despite its mythological subject, the canvas aroused

disgust in some reviewers. The *Observer* wrote: "The subject cannot fail of producing the most unpleasant feelings. Ulysses is represented at the interview with the Sirens, who are completely in a state of nudity; the ground is covered with dead bodies and skeletons. . . . It is to be hoped there are few who would nauseate their friends by placing it in their galleries." The *Spectator* considered it "a disgusting combination of voluptuousness and loathsome putridity—glowing in colour and wonderful in execution, but conceived in the worst possible taste" (Nead, "Woman as Temptress" 9). Etty's nudes appeared too much like the women who participated in the *poses plastiques* and *tableaux vivants.* The 1846 *Circe and the Sirens Three* shows the enchantress surrounded by Sirens and Naiads, all voluptuous nudes showing Rubensesque posteriors to the viewer. When working with more limited numbers of figures Etty can be successful, as a tondo *Circe,* a study of head and shoulders, indicates. Freed of the mass of bodies and accessories, the study conveys some of the elusive nature of the goddess.

Etty's most successful works, with the exception of the *Hero and Leander* canvases, are his portraits and his exceptional single-figure nude drawings of models, whom he depicted in suggestive postures. In his drawings of the male nude, unlike his successors like Burne-Jones, Etty depicts men with fully developed genitals, as in his study for *The Bowman.* Etty frequently draws men spread in crucifixion postures, almost as if tortured. His reclining male nudes appear muscular like Michelangelo's figures and strangely tormented. The *Prometheus* (1825–1830) (Plate 2-10) shows the man inverted, spread-eagled, and crucified, with an arrow piercing his side, a picture of sadistic violence but also of male heroism.

Etty stated about the female nude: "Finding God's most glorious work to be Woman, that all human beauty had been concentrated in her, I resolved to dedicate myself to painting—not the Draper's or Milliner's work,—but God's most glorious work more finely than ever had been done" (Bailey, *William Etty's Nudes* 16). Nevertheless, his female nudes are not so idealized as Etty's avowal would indicate. Such a portrayal of the nude runs counter to the mythological thrust of the canvases. Brian Bailey notes that Etty was "psychologically—in his art at least—a realist, forced by the dictates of his time into a sham idealism" (43). This falsity detracts from the effectiveness of his work. His inability to free himself from the model denies his mythological canvases the universal potential of the works of the classical-subject artists. The *Times* was correct in its assessment in 1847 that "the attempts and conceptions of Mr. Etty are very great, but he does not quite abandon the preparatory as-

pect" (2 May 1847). In suggesting the drama if not the potential of Greco-Roman myths, however, Etty anticipated the work of the classical-subject artists.

William Edward Frost was introduced to Etty at the age of fifteen and followed him, without imitating him, in painting the female nude. Frost's anatomy is more accurate and more refined than Etty's. Frost supplies the idealization as well as the accuracy which made his nudes acceptable, in the manner of the work of John Flaxman and Antonio Canova. Frost frequently depicted imperiled women; he painted an _Andromeda_ in both 1846 and 1850. In a pen-and-ink drawing of 1850, Frost depicts Andromeda chained to a rock surrounded by a number of marine deities (nymphs and a Triton). The difference between Frost and the later classical-subject artists is apparent in the ancillary figures Frost includes in his drawing. No later representations included any but the essential figures of Andromeda and/or Perseus and the monster. Andromeda, with a wisp of drapery covering her pubis, has one hand raised and shackled over her head. _Diana and Her Nymphs Surprised by Actaeon_ (1846) exhibits Frost's perhaps too marmoreal modeling of the female nude. The painting suffers by the stilted sculpturesque nature of Diana's gesture and her pantomimic posture. Neither Etty nor Frost mastered the use of drapery for signifying effect, as did the classical-subject painters. The _Mermaid_ of 1855 shows a figure combing her hair in much greater detail than Etty's small tondo _Circe_. The artificial lighting of the two breasts is a legacy of Etty with which Frost ought to have dispensed. The significant is separated from the sensuous, rather than perceived through the sensuous as in the classical-subject artists.

The Sirens (Plate 2-11), one of Frost's more successful canvases, exhibited in 1849, shows three naked women on a seashore. The lighting, the contrast in skin tones and facial expression, and the stare of the crouching third Siren strike a balance between the nude figures and the narrative. Frost's work maintained greater finish, idealization of body, and elegance of line than Etty's and prevented the adverse reactions aroused by Etty's models. Writing of _Panope_ (1862), the _Art Journal_ noted that "whereas Etty's manipulation was rapid and broad, Mr. Frost's practice is minute and most careful" (130). The achieved balance of _The Sirens_, however, is lost in another version, _Ulysses and the Sirens_, with the three contorted nudes in the foreground signaling to the ship sketched in the distance. The mannered contrapposto attitudes have become the subject.

Frost and Etty maintained the classicizing if not classical nude before the public. It was for the classical-subject painters of the later decades to endow

this subject with historical and psychological significance by using the dynamism of Etty and the draftsmanship of Frost to go beyond mere technical virtuosity. Etty's and Frost's "mythological" canvases diluted the potential of the narratives by omitting significant detail, by preventing engagement of the viewer, and by obtruding excessive nude bodies.

II

The work of George Frederic Watts (1817–1904) exhibited the compound of influences that made him the major precursor of the classical-subject artists. Early in his career he was influenced simultaneously by Etty's work and by the model of the Elgin Marbles. The drapery of the Parthenon pediment sculptures influenced everything Watts was to paint in the classical style. Poses, such as in *Ariadne on Naxos* (1875) and *Endymion* (1873), were taken from specific pediment sculptures. Ford Madox Brown remarked that Watts's *Ariadne* was "as fine as a fine Etty" (*George Frederic Watts* [catalogue], no. 62). Throughout his life, Watts maintained his allegiance to Greek art: "I learned in one school only: that of Phidias," he stated (Blunt, *"England's Michelangelo"* 7). Watts declared his objective in art: "I have since pursued my studies ever with the ardent and disinterested view of raising art to the level it attained in the great days of Greece" (46). Watts believed that his art served intellectual purposes by presenting allegories of ideas which provoked improving reactions: "My language appeals to the mind through the medium of the eye. . . . I wished to stimulate the mind and awaken large thoughts" (62). This allegorical use of classical-subject design is indicative of Watts's own personal qualities. Watts's intellectual abstraction represents an avoidance of human passion: severe sexual repression characterized him throughout his life.

Watts was chronically unhealthy, subject to "migraines, vertigos and vomiting that were . . . the bane of his whole life" (Blunt 2). He confided to a friend, "I often think very seriously of Prussic acid," and he was desperately lonely. In 1858 he observed: "The misery and despondency that often fall upon me make my life a burden. I am constantly so nervous that I am afraid almost of mounting the stairs and really quite alarmed at the idea of getting on my horse. Then it is I feel the horror of being alone, yet the dread of seeing anyone" (101). The consolations of religion were denied Watts, who was a confirmed agnostic. Blunt concedes that Watts's sex life "must always remain a mystery" (25). Blunt contends that in his early thirties Watts was "emotionally unstable, sexually frustrated, and probably sexually ignorant" (57) and

suffered from "sexual repression" (154). Watts's life with the Prinseps at Little
Holland House, observed George du Maurier, was so protected during his stay
of several decades that "his manliness hath almost departed" (Blunt 80).

Watts's conception of men and women was conditioned by this tempera-
ment. What this conception was is indicated by the unusual first marriage
with Ellen Terry, who was barely seventeen to Watts's forty-seven when they
were married in 1864. Watts's motivation reflects the Victorian "rescue" com-
pulsion. He wrote in 1862 to a friend that he was "determined to remove the
youngest [of the Terrys] from the temptation and abominations of the stage,
give her an education and if she continues to have the affection she now feels
for me, marry her." He added: "To make the poor child what I wish her to
be will take a long time and most likely cost a great deal of trouble" (Blunt
105).

Like Rossetti's relationship with Elizabeth Siddal, William Holman Hunt's
with Annie Miller, and Frederic Leighton's with Dorothy Dene, Watts's rela-
tionship with Ellen Terry is that of Perseus/Andromeda combined with Pyg-
malion/Galatea. The pair separated less than a year later. During the divorce
proceedings, not officially undertaken until 1877, Watts deposed "that although
considerably older than his intended wife he admired her very much and hoped
to influence, guide and cultivate a very artistic and peculiar nature and to
remove an impulsive girl from the dangers and temptations of the stage" (Blunt
118). The marriage probably was never consummated; some critics have con-
tended Watts was impotent. This sexual timidity and inexperience are re-
flected in the unusual models who posed for Watts in some instances. For
the bust of *Clytie,* first executed in marble in 1868, the musculature was taken
from a favorite Italian male model in London, Angelo Colorosi, a practice
which lent Watts's work a peculiarly androgynous cast.

Watts's first allegorical canvas, *Time and Oblivion* of 1848, was described
by Watts in 1881: "Time, as the type of stalwart manhood gifted with imper-
ishable youth, holds in his right hand the emblematic scythe, while Oblivion,
with bent head and downcast eyes, spreads her ample cloak and speeds swiftly
towards the tomb" (Blunt 62). The male is the hero, the woman the death
bearer and the forgotton. Watts's classical subjects focused on women in depen-
dent or threatening positions. In 1868 the bronze *Clytie* (Plate 2-12) was ex-
hibited. The bust showed the abandoned woman yearning over her shoulder
for Apollo. The shoulders and the affixed breasts make the work unconvinc-
ing. The theme was depicted with more insight by Leighton in the 1890s. Rep-
resentations of Clytie support Victorian male worship of Apollo the sun-god.

Watts depicted other myths that presented women in such conditions. In the *Ariadne on Naxos* (1875) (Plate 2-13), Watts imitates one of the Fate figures from the Parthenon pediment. Ariadne sits weakened and half dead staring at the ocean. An attendant approaches to alert her to the coming presence of the rescuer/god, whose leopards appear in the lower part of the canvas. The popularity of the theme of the abandoned woman caused the Ariadne legend to be deployed numerous times. Never portrayed was Ariadne giving Theseus the thread by which he became a hero. Watts painted male heroes like Prometheus, a sculpturesque Titan, or Hyperion, connected with Victorian Apollonian sun worship. Women were the abducted Europa or the helpless Psyche.

Watts depicted the legend of Orpheus and Eurydice several times, exhibiting the first completed conception in 1869, a year after the *Pygmalion* and *Clytie.* Leighton had exhibited an *Orpheus* in 1864, showing a disdainful Orpheus pushing aside an ardent Eurydice. In Watts, Orpheus has sensuously turned to Eurydice, putting his hand to her naked breast as she tries to avoid his gaze. As one of Watts's most sensual canvases, *Orpheus and Eurydice* reveals his repressed sexuality. The theme of the artist who has lost his wife parallels the misalliance of Watts and Ellen Terry. Watts's other passionate classical-subject canvas was *Endymion* (1873), which shows Artemis/Selene bending over the sleeping shepherd. Endymion is patterned after the Theseus of the Parthenon. Unlike Etty and Frost, who never learned to use drapery for emotional effect, Watts resembles the classical-subject artists in his entwining arcs. The canvas embodies Watts's ideal of being worshiped by women with no sexual responsibility or response required of the male. Artemis' worship of Endymion is similar to the constant adulation accorded Watts at Little Holland House. In the several heads of Medusa completed by Watts the face is unquestionably androgynous, reflecting Watts's fear of her masculine power to rigidify.

Watts's work draws on the influence of Rossetti and Etty, the Elgin Marbles and Michelangelo, in a synthesis that marked a transition from the earlier part of the nineteenth century to the era of the classical-subject artists of the last four decades. His work presents many of the mythological subjects employed by these artists—Ariadne, the Bacchante, Clytie, Eurydice, the Judgment of Paris—subjects that reinforce male superiority. His work was admired by Leighton, Burne-Jones, and other artists. Burne-Jones, however, disliked Watts's emphasis on allegory. In 1897 Watts had written, in a catalogue for an exhibition of his pictures at the New Gallery, that his canvases should be

regarded "rather as heiroglyphs than anything else . . . frankly didactic." Burne-Jones commented: "Watts has written a most amazing preface to his catalogue. . . . It's so astonishingly bung-eyed. I don't suppose he means it, but it sounds almost as though he apologised for his pictures, and when an artist takes to doing that, I do think he'd better not paint them." Burne-Jones felt that Watts "did men better than women. The shoulders and all the torso he does splendidly" (Burne-Jones and Rooke, "Conversations" 219, 224). Burne-Jones especially admired his *Endymion*.

The female themes of the Pre-Raphaelites, the classicizing nudes of Etty and Frost, and Watts's absorption of the Elgin Marbles coalesced in the work of the classical-subject painters. The two themes of the threatening woman and the female victim in need of rescue inform many of these works and anticipated two central themes of the classical-subject painters. Although each had his loyalties to other influences as well (Burne-Jones to Botticelli, Poynter to Michelangelo), the artists of the Victorian High Renaissance exhibit continuities with their predecessors that argue for viewing nineteenth-century British painting as more continuous than heretofore represented.

III

Edward Burne-Jones was an enigma to his era. F. G. Stephens wrote in 1885: "[He] in effect protests against the tendencies of an overwhelmingly 'practical' and demonstrative age" ("Edward Burne-Jones" 220). On the opening of the Grosvenor Gallery, 1 May 1877, Henry James recorded that while Burne-Jones was "quite the lion of the exhibition," "Mr. Burne-Jones's Lionship is owing partly to his 'queerness' and partly to a certain air of mystery which had long surrounded him. He had not exhibited in public for many years, and people had an impression that in private prosperity his genius was growing 'queerer' than ever." "The fullness of their mystical meaning I do not profess to have fathomed," James confessed about Burne-Jones's *The Days of Creation* (*Painter's Eye* 144, 145). Later in the century Paul Leprieur spoke of a Burne-Jones canvas as a "strange and mysterious painting which intrigues and surprises, like an incomprehensible enigma" ("Légende" 462).

The "mystical meaning" and "incomprehensible enigma" of Burne-Jones are not so elusive or remote as James and Leprieur may have supposed. James notes an aspect of the enigma in speaking of *The Days of Creation:* "I call them young women, but even this is talking a grosser prose than is proper in speaking of creatures so mysteriously poetic. Perhaps they are young men;

they look indeed like beautiful, rather sickly boys. Or rather, they are sublimely sexless, and ready to assume whatever charm of manhood or maidenhood the imagination desires" (*Painter's Eye* 146–147). James was not alone in noting the ambivalent sexuality of Burne-Jones's figures. Justin McCarthy commented on a painting obviously by Burne-Jones: "Her lover is always singularly like herself. . . . The hero and heroine are very much the same sort of thing. The hero has the high cheekbones, the gaunt face, the red hair; he is almost invariably beardless, and only for the dress I doubt whether you would know one from the other" ("Pre-Raphaelites" 727).

James and McCarthy astutely detect certain distinguishing marks of a Burne-Jones canvas, such as exquisite coloration, shallow relief, and sinuous linearity. A final mark is the ambiguous sexuality of the figures. Graham Hough's belief that such figures represent "personifications of forces . . . deep in the human psyche" (*Last Romantics* 191) suggests a valuable direction of inquiry for studying Burne-Jones and his use of classical-subject elements. Two "forces" drove Burne-Jones to depict such figures: the painter's attitude toward women, as expressed in his sexual life; and the early influences that shaped his artistic choice of subject. Burne-Jones's conception of women derives from three sources: his relationship with Rossetti as pupil and friend; his marriage to Georgiana Macdonald and his subsequent affair with Maria Zambaco; and his reaction to this affair in his work after 1870, particularly in the *Perseus* cycle. The gynophobia that formed one dimension of the Victorian consciousness underlies the enigmatic figures of Burne-Jones.

Burne-Jones's relationship with Dante Gabriel Rossetti was decisive in forming his two conceptions of women, as epipsyche and as Siren. "There I first saw the name of Rossetti," Burne-Jones recalled, remembering the day William Morris showed him the edition of Ruskin's *Edinburgh Lectures* in 1854 (Georgiana Burne-Jones, *Memorials* 1.99). The following year Burne-Jones saw Rossetti's *The Maids of Elfen-Mere*, published in William Allingham's *Day and Night Songs*. This illustration Burne-Jones praised in the *Oxford and Cambridge Magazine* in 1856: "It is I think the most beautiful drawing for an illustration I have ever seen, the weird faces of the maids . . . are such as only a great artist could conceive" ("Essay on *The Newcomes*" 60).

The effect of Rossetti's work was crucial. Burne-Jones made a resolution: "And I am to be, Heaven knows what, painter I hope, if that is possible —: if not, why anything so it be not a parson. Save me from that, for I have looked behind the veil" (Georgiana Burne-Jones, *Memorials* 1.121). The echo of Shelley is significant. Burne-Jones went to London and introduced himself

to Rossetti in January 1856. Soon he was his pupil and companion. By the time Burne-Jones met Rossetti, he had already experienced woman as Siren. In 1854 he had written to Archibald Maclaren: "One thing that prevented me writing was the heart-aches and love-troubles I have been getting into," and to Cormel Price he confided: "You wrote at a time when I was suffering greater mental troubles than I ever remember" (1.102). Rossetti influenced Burne-Jones's conception of women by his use of Burne-Jones as a model and through his story "Hand and Soul," published in January 1850 in the *Germ*. Rossetti also took Burne-Jones to the *poses plastiques,* where the neophyte could view women as living embodiments of classicism.

Rossetti first used Burne-Jones as a model in 1856, when he drew him in *Launcelot and the Lady of Shalott* (Plate 2-14) for Edward Moxon's edition of Tennyson's *Poems.* Burne-Jones is shown bending over the Lady, poignant regret expressed on his face. The following year, Rossetti, Burne-Jones, and other associates became involved in decorating the walls of the Oxford Union. Rossetti's picture was *Launcelot's Dream of the San Graal,* while Burne-Jones's was *Nimuë Luring Merlin.* In Rossetti's drawing, Burne-Jones as Launcelot is asleep before a shrine of angels, with the interposing figure of Guinevere modeled by Jane Burden, later Mrs. William Morris. Another drawing of the same year shows Burne-Jones and Jane Burden in *Sir Launcelot in the Queen's Chamber.* Burne-Jones was thus modeling for Launcelot while drawing Nimuë, the destructive woman. In 1858, Burne-Jones changed his role, posing for the face of Christ in Rossetti's *Mary Magdalene at the Door of Simon the Pharisee.* This picture and *Launcelot in the Queen's Chamber,* as Nicoll notes, depict "sexual crisis," with Burne-Jones the adulterous lover and the redeeming Christ (*Rossetti* 119), a rescue role that had great appeal to him. Burne-Jones recalled that Rossetti "used to chaff me very much for having sat for the Christ . . . as though it had been my doing and not his" (Burne-Jones and Rooke, "Conversations" 308). For Burne-Jones, woman, as experienced through Rossetti, was Nimuë, Guinevere, and Magdalene. The student who had joined the Order of Sir Galahad gradually changed under these influences.

The counterimage, of woman as epipsyche, Burne-Jones found reinforced in Rossetti's "Hand and Soul," a story praised by Burne-Jones in the *Oxford and Cambridge Magazine.* In this tale of the artist Chiaro, woman appears in two spiritual guises. First, she is "the mystical lady . . . even she, his own gracious and holy Italian art." Later, she is the apparition of the artist's own soul: "I am an image, Chiaro, of thine own soul within thee" (John Weeks, *Dream Weavers* 26, 30). This was an alternative to the Siren/Stunner, but its

substratum was narcissistic, since the woman was a projection of the self. In his "Essay on *The Newcomes*," Burne-Jones wondered: "Why is the author of the *Blessed Damozel*, and the story of Chiaro, so seldom on the lips of men?" (60). The narcissistic epipsyche is evident in the two stories Burne-Jones wrote for the *Oxford and Cambridge Magazine* in 1856, "The Cousins" and "A Story of the North," both concerning cousins who love one another.

In the former, published in January 1856, the narrator loves his cousin Gertrude Aymas, to whom he has given a watercolor of Dante and his vision of Hell. Rejected by her, he goes to Paris and attempts suicide, only to be rescued by another cousin, Onore, whom he eventually marries. Gertrude and Onore are two halves of the culture's perception of women, the coldhearted seducer and the nurturing mother. He recalls of Onore: "I spoke also of my love for her, deep, intense, enduring; and whether she sorrowed for my sorrow, and pitied me for my griefs, so many and so cruel; or whether she really loved the thing she had saved I know not" (131). "A Story of the North" concerns Engeltram and Lady Irminhilda, lovers who "seemed divided halves of one same life" (137). They discover they are cousins and achieve a transcendental union after death. Like "Hand and Soul," both stories treat the woman as Shelleyan epipsyche, with the attendant narcissistic impulse. The consanguinity of the lovers indicates that the beloved is more identical than different.

Other contributions to the *Oxford and Cambridge Magazine* extend the background of Burne-Jones's ideas about the epipsyche and the Siren. The short tale "The Sacrifice," possibly by Georgiana Macdonald, Burne-Jones's future wife, concerns the painter Henry Radcliffe and the cruel woman he loves, Helen Musgrave: "She could not help seeing how he felt towards her; and she did see it, shamefully triumphing therein. For it pleased her selfish vanity that another should love her. . . . Turning, he left her standing, looking after him, like a beautiful enchantress at a victim" (271, 273). In August, William Fulford's essay "Woman, Her Duties, Education, and Position," provided the alternative image. Fulford believed that "worship" of women was innate in men: "In the heart of man himself is a most powerful ally, that which has been called the woman-worshipping instinct, implanted at least in the Teutonic races" (473), an argument that anticipates Ruskin's "Of Queens' Gardens." When the latter was published in *Sesame and Lilies* in 1865, Burne-Jones designed a picture for the title page, which was not used. It indicates, however, his familiarity with Ruskin's argument of separate spheres for men and women. Burne-Jones told Rooke, "It's a pity to educate women, only spoils them, takes away all their charm, to make them into tenth-rate men" ("Con-

versations" 19). On another occasion he declared: "I must confess that my interest in a woman is because she is a woman and is of such a nice shape and so different to mine" (54).

IV

Burne-Jones became engaged to Georgiana Macdonald on 9 June 1856 and married her on the same date in 1860, commemorating the death of Dante's Beatrice. Burne-Jones, however, had secured not his Beatrice but his Gemma Donati. When Burne-Jones wrote his "Essay on *The Newcomes*" for the *Oxford and Cambridge Magazine,* he explained the main tenor of Thackeray's novel as follows: "And first of the central purpose of the book for which I imagine it was mainly written, reaching to the very heart and core of social disease, unhappy wedded life—the marriages that are not made in heaven, but if anywhere out of this world, why least of all in Heaven. Of all marvels in this same universe that pass our poor philosophy I doubt not this of marriage is the very strangest" (55). It is difficult to find Burne-Jones being so direct about his own marriage. He commented later: "I hold it a point of honour with every gentleman to conceal himself, and make a fair show before people, to ease life for everyone" (Georgiana Burne-Jones, *Memorials* 1.102). Georgiana Macdonald, sister of Agnes Macdonald (later the wife of Edward Poynter), was neither Beatrice nor Nimuë, neither the saving soul nor the bewitching enchantress. Shelley's ideal of the "soul out of the soul" in *Epipsychidion* was the object of Burne-Jones's quest during his lifetime, as his interest in the legend of Eros and Psyche was to demonstrate.

In Burne-Jones's portrait of her begun in 1883, Georgiana stares out from the canvas, while a panel to the right and rear shows their two children, Margaret and Phil, before an easel. Her prototype was classical, for hers is the face of the Demeter of Cnidus, found by Sir Charles Newton in 1858. Burne-Jones's classical-subject pictures begin in the 1860s, and there can be little doubt that such discoveries affected him. Charles Newton had led an expedition in 1856 to Asia Minor with several of Burne-Jones's friends, including Watts and John Roddam Spencer Stanhope. Burne-Jones kept a plaster cast of the head of the Demeter of Cnidus in his studio throughout his life. The Beggar Maid in *King Cophetua and the Beggar Maid* was modeled after Georgiana, but the pose and head are those of Demeter, the fierce mother. That was how Georgiana, so still and quiet on the surface, came to seem to the artist, for her iron will, endurance, and fervent love.

When Burne-Jones met Georgiana Macdonald, unusual attitudes about women already characterized the artist. Georgiana recorded that in 1852 her brother "once applied in my hearing the dreadful-sounding name 'Misogynist'" to Burne-Jones (*Memorials* 1.66). Perceiving that the Order of Sir Galahad contained elements not of woman worship but of gynophobia, she detected "half-jesting references to celibacy and misogyny" in letters that Burne-Jones wrote in 1853 (1.87). These misogynistic and gynophobic attitudes were frequently expressed in conversations about marriage. He said in 1899: "It is possible, and not seldom happens, that people's lives are quite destroyed by what they began in the hope of helping them" (2.193). Georgiana, when asked by her husband if marriage were a lottery, responded in the affirmative. Burne-Jones replied: "Then as lotteries are illegal, don't you think it ought to be suppressed by law?" (2.193). Burne-Jones admitted to Helen Gaskell in 1894: "I seldom dream of anyone I love . . . sometimes of Georgie who is always unkind in dreams" ("Letters to Mrs. Gaskell").

Burne-Jones felt that artists should not marry: "A painter ought not to be married; children and pictures are each too important to be both produced by one man. . . . No, the great painters were not married—Michael Angelo not married, Raphael not married . . . Del Sarto married! but we know what happened to *him*" (Burne-Jones and Rooke, "Conversations" 5). Burne-Jones, possibly thinking of his one great love affair, told Rooke: "There will have to be a separation of things that a man does because of a woman from other faults he may have" (303). He wrote to Helen Gaskell in May 1893: "And for me I hate marriage and think it a wicked mechanical device of lawyers for the sake of property & other beastliness," adding: "I lie in the dust in your presence." Burne-Jones admitted on the brink of his wedding: "I shouldn't be surprised if I bolt off the day before and am never heard of again" (Marsh, *Pre-Raphaelite Sisterhood* 176). In 1894–1895 he recalled a man "who . . . was always thinking about women. . . . The next day he committed suicide" ("Conversations" 7).

Burne-Jones noted in 1884, before painting *The Depths of the Sea* (showing a mermaid dragging a sailor into the deep): "A woman at her best, self-denying and devoted, is pathetic and lovely beyond words; but once she gets the upper hand and flaunts, she's the devil—there's no other word for it, she's the devil . . . as soon as you've taken pity on her she's no longer to be pitied. You're the one to be pitied then" (Burne-Jones and Rooke, "Conversations" 90). Burne-Jones opposed the extension of the franchise to women, believing that they were decorative parts of the landscape but nothing politically, an

attitude opposed by his wife. In 1897, toward the end of his life, he told his studio assistant Rooke: "Women ought to be locked up. In some place where we could have access to them but that they couldn't get out from" (239). This comment is a gloss on a canvas Burne-Jones completed in 1888, *Danaë and the Brazen Tower*, where the woman is "locked up." From the mid-1870s Burne-Jones worked on one consuming legend, that of Danaë's son Perseus, a myth encompassing rescue, castration, narcissism, prostitution, and sexual debasement. The Perseus legend, in its various significances, reflected the nineteenth-century culture, and Burne-Jones was deeply involved in a personal rendering of this cultural tradition.

In 1866 the Burne-Joneses came into contact with a new group of acquaintances in London, as Georgiana Burne-Jones recorded: "Another and very noticeable introduction of these days was to a part of what may be called the Greek colony in London. Before this we had had the pleasure of meeting the beautiful Miss Spartali and her sister, daughters of the Greek consul, but now, I forget in what way, we became acquainted with one or two other families of her nation" (*Memorials* 1.303). This notice is evasive. The Greek colony meant the Ionides family, by the 1860s established as cotton importers in Manchester and in London.

The woman who became Burne-Jones's Beatrice and Nimuë was Maria Teresa Cassavetti, granddaughter of the man who founded the mercantile family. Born in 1843, Maria had married a Parisian physician, Demetrius Zambaco, in 1861, bearing him two children in 1864 and 1865. In 1866 Maria left her husband to return to London and her mother, Euphrosyne, who took Maria and Marie Spartali to Burne-Jones's studio to commission a picture for Maria. Left to choose a subject, Burne-Jones selected that of Cupid finding Psyche, from which at least seven pictures resulted. For Burne-Jones, the epipsyche about which he had read in "Hand and Soul" and written in "The Cousins" and "A Story of the North" had appeared. The final page of the first volume of Georgiana's *Memorials* notes: "Two things had tremendous power over him — beauty and misfortune — and far would he go to serve either; indeed his impulse to comfort those in trouble was so strong that while the trouble lasted the sufferer took precedence of every one else" (1.309). It is significant that the *Memorials* breaks with a mere five pages devoted to 1867, to resume in volume two with 1868, eliding a most important year in the marriage of Georgiana and Edward Burne-Jones.

Burne-Jones's affair with Maria Zambaco progressed rapidly, nearing a crisis in 1868. On 24 April 1895 Burne-Jones wrote to Helen Gaskell: "I wish

I was thirty-five—do you know I once was—isn't it strange & incredible?—but it's quite true—and stranger still I was once three and twenty!" Those two ages were turning points in his life, 1856 when he decided to become an artist, and 1868, when his affair with Maria entered a crisis. In 1869 there was some kind of rupture, about which Rossetti wrote to Ford Madox Brown:

Poor Ned's affairs have come to smash altogether, and he and Topsy [William Morris], after the most dreadful to-do, started for Rome suddenly, leaving the Greek damsel beating up the quarters of all his friends for him and howling like Cassandra. Georgie has stayed behind. I hear today however that Top and Ned got no further than Dover. Ned being now so dreadfully ill that they will probably have to return to London. Of course the dodge will be not to let a single hint of their movements become known to anybody, or the Greek (whom I believe he is really bent on cutting) will catch him again. She provided herself with laudanum for two at least, and insisted on their winding up matters in Lord Holland's Lane. Ned didn't see it, when she tried to drown herself in the water in front of Browning's house &c.—bobbies collaring Ned who was rolling with her on the stones to prevent it, and God knows what else. (Doughty, *Letters* 2.684–685)

David Cecil records rumors that Burne-Jones went to live with Maria Zambaco about this time and that the two had a suicide pact to drown themselves in the Serpentine. He cites another story that Charles Howell brought Maria Zambaco to see Georgiana and that Burne-Jones, walking in, collapsed, thereby revealing the affair to his wife (81).

Possibly the story of Howell's treachery is true. Georgiana's only reference to Howell in the *Memorials* records in 1865: "And on this day of union and reunion of friends there was one who had come amongst us in friend's clothing, but inwardly he was a stranger to all that our life meant. This was Mr. Howell" (1.294). Howell wrote Rossetti in 1875 that Burne-Jones had tried to ruin him, and Burne-Jones remarked: "That fellow Howell that Rookie knows of preyed upon us all" (Burne-Jones and Rooke, "Conversations" 342). About Maria Zambaco, Rossetti was distressed. "Do let me know any news of Ned and his affairs. . . . P.S. How is poor Mary Z?" he asked Howell. In March 1870 Rossetti wrote Jane Morris: "I think I have made a good portrait of Mary Zambaco, and Ned [Burne-Jones] is greatly delighted with it. . . . I like her very much and am sure that her love is all in all to her. I never had an opportunity of understanding her before. . . . She is really extremely beautiful herself when one gets to study her face. I think she has got much more so within the last year with all her love and trouble" (*Burne-Jones* [catalogue, 1971], no. 51).

The year 1869 is completely ignored in the *Memorials*. However, as the epigraph to her recollections for the 1868–1871 period, Georgiana Burne-Jones selected "Heart, thou and I are here sad and alone."

If it was possible for Georgiana Burne-Jones to efface the memory of Maria Zambaco after several decades, it was impossible for Burne-Jones himself, already cast by Rossetti as the adulterous Launcelot. In 1874 Burne-Jones wrote to Charles Fairfax Murray: "I havent said a word to you about that miserable affair Mr. Morris told you of—because I want to help myself to forget it & because there are no words for it really in any known tongue—nor should I write this only as you are going to Pisa for a bit you are sure to come across the person [Maria Zambaco], party or individual & I should like you for my sake not to exchange a word of any kind—or if you like not even recognize— but I hope you wont meet" ("Letters" [Austin]). Reflecting his psychological state, but also that of his age, Burne-Jones was to paint Maria Zambaco in roles that included Nimuë, Beatrice, Phyllis, the Hesperides, Night, and Summer. While working on some of his most successful canvases, Burne-Jones was transforming Maria Zambaco into various female guises, first beneficent, later sinister.

Throughout his life Burne-Jones suffered from recurrent depression, insomnia, hypochondria, and acute loneliness. To one correspondent in particular, Helen Mary Gaskell, Burne-Jones confessed the attitudes and anxieties of a lifetime. Married to a military captain, Mrs. Gaskell was introduced to Burne-Jones in 1892; although she was twenty-five years younger than he, they became close friends. His statements to her reveal an individual whose reactions to women influenced his reactions to existence itself. For several years his letters to her chronicled his situation. Many of these involve images of or attitudes about women. On 11 January 1893 he confessed to her about temptation: "If I have given in I have given in with all my will, & meant to do it," a comment about his affair with Maria Zambaco. In the same month he wrote her about two models he had known:

Antonia Caiva of the City of Basilicata stood for it—she was like Eve & Semiramis and people at the beginning of time—and if she had a mind, which I always doubted, it had never had one idea put into it—not so much as one—and she never spoke, but looked like a creature coming from Olympus—I never drew from any one who came near her for splendour & solemnity and her glory lasted near ten years. Then I couldn't draw any more from her for she was growing like the witch of Endor. At the same time I had another Italian called Allessandro di Marco who was like Adam—ah! it was a fine time when I had those two and . . . if I had them now in

their glory I could better use them — they came a little too early for me . . . I should have to put Antonia Caiva and Miriam Salome Ariadne Vaughan amongst my spiritual teachers.

This part of a long letter suggests many elements of Burne-Jones's attitudes to women, the linking of Eve and Semiramis, and the fact that Salome and Ariadne, the seductive and the abandoned woman, were his teachers, the latter of course Greek. Burne-Jones continued, eventually commenting about Maria Zambaco:

How easy it is to talk to you — to write to you — how you radiate life — & like a vampire I drink it in. I would talk to you for ever & never tire . . . Yet you did say it was a nasty woman the head of Nimue in the picture called "the enchanting of Merlin" was painted from that poor traitor, & was very like — all the action is like — the name of her was Mary — now isn't that very funny. & She was born at the foot of Olympus and looked and was primeval but that's the head & the way of standing and turning . . . and I was being turned into a hawthorn tree in the forest of Broceliande the spell is on him for ever — Arthur will come back out of his restful sleep but Merlin's face can never be undone . . . the head of the Phyllis in the Demophoon picture is from the same — and would have been very arch for a portrait. It was a wonderful head — neither profile was like the other quite — & the full face was different again — don't hate them — some things are beyond scolding — hurricanes & tempests & forked lightning — & billows of the sea — it's no use blaming them . . . a hurricane is beautiful no, dont hate . . . it was a very glorious head — & belonged to a remote past — only it didn't do in English suburban surroundings — we are soaked in puritanishness and it will never be out of us — & I hate it — it makes us the most canting & hypocritical race on earth . . . & shall I dedicate the Perseus pictures to you? I will. Yes, I do hope the technique is growing. That is, that I can say my say more to the intelligence of people. . . . Perseus was designed 20 years ago, you know.

In March of 1893 Burne-Jones was in despair: "I have worked so badly this morning that I even took the model into my confidence, & said I wished I had never been born — indeed, what a salvation of trouble that idea suggests — and who would have been the worse off? Georgie? Well, it would have been much better for her — she could have married a good clergyman . . . the art of the country? Well there is no art of the country — I have only bewildered it — the Public? — OH D——N THE PUBLIC and the public be d——d."

Burne-Jones regarded the terror of love as existential, as he wrote in July: "[God] showed [man] the face of Love, poor devil, so he could never forget it, nor ever attain it. I think some reparation is due." Burne-Jones likened himself, as well as Maria Zambaco and his models, to classical prototypes:

"I wish the past would bury its past—that was the sin of Orpheus, to look
behind him even though Eurydice called. . . . Yes, my life has been too hard
& bitter to remember & not be fevered," he wrote in August 1893. He asked
Helen Gaskell: "Shall you really grow to be a good woman with all my love
& care? What is a good woman? St. Theresa, St. Elizabeth of Hungary? Chau-
cer says Cleopatra was one, & Medea, & I believe all he says—he never said
a thing yet I didn't like. . . . And highly educated women are in great peril
—I tremble for them—they are fast scurrying towards the HORRIBLE—warn
them, will you.—warn Miss Arnold, who is a nice thing—too good for sta-
tistics—the very word ought to make a delicate woman blush."

In March 1895, Burne-Jones reviewed his past life and realized that his
happiest years were those before the rupture with Maria Zambaco: "I am so
tired suddenly of all the past years—of the long years between twenty years
ago and two years ago [when he began writing Gaskell]—tired of them as
if they had worn me out—which is silly, for they are past—but I dont want
to think of one hour of them—nor of one hour of the seven years before that
[1869–1875]—I have but my work to show for those years—of life I had none—
not any hour happy to remember & think upon.—but there were eleven years
that were bonny years [1857–1868] & of those I love to think—years of the
beginning of art in me & Gabriel every day, & Ruskin in his splendid days
& Morris every day & Swinburne every day, & a thousand visions in me always,
more real than the outer world—& eleven years is a great number of years
to have been happy in." Thus his early years with Rossetti and the flourishing
years with Maria Zambaco, before the 1869 rupture, were the happiest of his
existence. The three great classical subjects of his maturity—the *Psyche, Pyg-
malion,* and *Perseus* series—all reflect dimensions of his experience of woman
as epipsyche and as Siren, originating in the years with Rossetti.

V

Burne-Jones's earliest artistic expressions are of interest in a consideration
of the classical-subject canvases. In 1854 Burne-Jones began a series of illus-
trations for Archibald Maclaren's *The Fairy Family: A Series of Ballads and
Metrical Tales Illustrating the Fairy Mythology of Europe.* This book eventu-
ally was published in 1857, with only three of the many illustrations anony-
mously included. The surviving illustrations divide into two groups, those
done between 1854 and 1855 and those finished after 1855 when Burne-Jones
had encountered the art of Rossetti. Maclaren's text and Burne-Jones's illustra-

tions are important because they demonstrate the nature of mythology and the presentation of ambiguous female types. In his introduction, Maclaren enumerates several methods of interpreting mythology, including the historical, the allegorical ("impersonations of certain virtues") and the natural ("the embodied ideas of certain elemental phenomena") (8). He cites critics who note the transformation of classical into fairy deities, such as Nereids into mermaids, the Lares into brownies.

The stories have some bearing on Burne-Jones's childhood. In "The Elf-Folk," a child is orphaned when its mother dies, like Burne-Jones. "The Korrigan" presents a femme fatale of the forest of Brézeliande, where a knight is tested and resists temptation; Burne-Jones was to show Merlin beguiled by Nimuë/Maria Zambaco much later in the same locale. "The Vila" involves a decapitation, as does the Medusa element of the *Perseus* series. In all the fairy stories, an element of magic exists, which anticipates one of the final canvases of Burne-Jones, *The Wizard.* Dangerous women appear in such tales as "The Fata Morgana" with elements suggesting the lure of Sirens; "The Rusalki" with a sea maiden rescuing a child and restoring it to its mother, as Burne-Jones had wished to be restored to his deceased mother; "The Still-Man," which includes reference to the "cloud cap" that makes the wearer invisible, anticipating the motif in the *Perseus* series; and "The Merman" with its sailor St. Clair who goes beneath the sea, a tale accompanied by a picture anticipating *The Depths of the Sea* with its treacherous mermaid. The merman is said to be always beneficent, the mermaid more ambivalent in her powers. In "The Neck" the woman Nina is an abandoned woman. At the conclusion, references appear to King Arthur, the subject of Burne-Jones's largest unfinished canvas at his death, and to Morgan le Fay, the enchantress. One illustration for "La Dame Abonde" shows Joan of Arc bound to a stake, a woman "locked up" in the manner of Andromeda and Danaë.

A second early product of Burne-Jones's imagination is *The Little Holland House Album,* a compilation of poetry and illustrations made in 1859 for Sophia Pattle Dalrymple. Burne-Jones had been introduced into the Pattle circle at Little Holland House in 1857 by Rossetti. Of the poems illustrated, three were by Rossetti, one each by Tennyson, Poe, Dante, Keats ("La Belle Dame sans Merci"), and one was a Scottish ballad. Several of these poems reflect interesting attitudes about women. In the selection from Browning, "Rudel to the Lady of Tripoli" (1842), a knight chooses for his device a sunflower, image of constancy and idealism. Later in the nineteenth century the sunflower was associated with a woman, Clytie, the beloved of Apollo. (The preva-

lence of the sunflower in Aesthetic design from 1870 to 1890 was a constant reminder of female dependence because of its association with Clytie.) After the knight abandoned her, she yearned for him by leaning to the light. The implication contained in this sun worship is worship of male supremacy. Burne-Jones had met Browning in 1856 through Rossetti. The interest in Keats reflects the prominent position of romantic medievalism in the Pre-Raphaelite circle as well as a premonition of the interest in the femme fatale later in the century. Rossetti's poem "The Card-Dealer" (1852) forms the basis of another design. The woman is seen as a femme fatale/Fate figure dealing the cards: "What be her cards, you ask? Even these: / The heart that does but crave / More, having fed; the diamond, / Skilled to make base seem brave; / The club for smiting in the dark; / The spade to dig a grave." *The Fairy Family* and *The Little Holland House Album* both anticipate Burne-Jones's later depictions of women. Between 1854 and 1859 he was experimenting with ideas about women that paralleled some of the *Oxford and Cambridge Magazine* material as well as some of his personal beliefs, as recorded by his wife in the *Memorials*.

Burne-Jones's early paintings and other work during the 1860s generally involved "medieval" themes, often with a sinister depiction of women. In the early *Sidonia von Bork* (1860), Burne-Jones depicted a sorceress from Wilhelm Meinhold's *Sidonia the Sorceress* (1847), a woman whose beauty concealed a life of crime. This figure was a prototype of the femme fatale, and so strong was the interest in Meinhold's text that it was reprinted by the Kelmscott Press in 1893. Sidonia von Bork was drawn from Rossetti's mistress Fanny Cornforth; the companion picture *Clara von Bork,* showing one of Sidonia's virtuous victims, was inspired by Georgiana Macdonald, Burne-Jones's future wife. These two paintings already reveal the dichotomous conception of women that would resonate throughout the artist's career. Women "locked up" appear in the several treatments of Fair Rosamund and Queen Eleanor (1861–1863), showing the young mistress of Henry II in her retreat being discovered by Henry's wife. In 1861 Burne-Jones completed *The Enchantments of Nimuë,* showing the sorceress trapping Merlin. The model for the sorceress was Fanny Cornforth.

At the same time, an emerging interest in classical subject matter began to appear, as in two designs for tiles in 1862, *Theseus in the Labyrinth* and *Paris and Helen.* In the former, a humorous treatment, Theseus holding the twine from Ariadne is seen approaching a Minotaur, who spies him from behind a corner. In the *Paris and Helen,* Helen is seen worshiping at a statue

of Aphrodite as Paris prepares to lead her to his waiting ship. A more serious endeavor at a classical theme was the *Theseus and Ariadne* of 1861–1862. This gouache shows Ariadne in classical dress giving Theseus (in medieval dress) a spear and a ball of thread. The work illustrates the transition from medieval to classical subject matter in the different costumes of the two figures. This picture is also of considerable interest for being one of the few treatments of Ariadne to show her helping a male. Usually in nineteenth-century British painting she is depicted abandoned by Theseus on Naxos, awaiting the arrival of Dionysus. The idea of being "locked up" appears in the *Ariadne* stories as well as the *Fair Rosamund,* linking the medieval and classical subjects of Burne-Jones's early canvases. In 1863, Burne-Jones was also attracted to the story of Danaë, which was to figure so prominently in his later work. Burne-Jones completed a *Danaë* in that year, but it was subsequently destroyed in a fire. A black chalk study for *Danaë* indicates Burne-Jones's study of the draperies of the pediment sculptures of the Parthenon. The mythologem of Danaë, impregnated by Zeus in a shower of gold, is the quintessential myth of prostitution, gold coin representing semen. Also in 1863, Burne-Jones did a watercolor *Love Leading Alcestis.* Ruskin was to praise Alcestis as "the Greek womanly type of faithfulness" in his lecture "On the Present State of Modern Art" in 1867. Such icons as Alcestis, the woman dying for her husband, and Ariadne, the woman abandoned by her lover, shaped the century's consciousness about the nature of women.

From 1863 to 1869 Burne-Jones worked on a gouache entitled *The Wine of Circe,* showing the enchantress in burnished gold classical drapery poisoning the wine to be drunk by the crew of Odysseus' ship, seen in the distance. The early designs for this painting were more medieval, in Burne-Jones's style of the late fifties and early sixties. Burne-Jones replaced the pigs in the early drawings with panthers. The figure of Circe has affiliations with several events occurring in England at this time. Ruskin denounced the corruption of materialistic England in mythological terms in the treatise *Munera Pulveris.* Ruskin asked Burne-Jones to illustrate the text: "I want you to do me a set of simple line illustrations of mythology and figurative creatures, to be engraved and to make a lovely book of my four Political Economy papers in Fraser. . . . I want to print it beautifully and make it a book everybody *must* have. And I want a Ceres for it, and a Proserpine, and a Plutus, and a Pluto, and a Circe, and an Helen . . . and a Charybdis and a Scylla" (Georgiana Burne-Jones, *Memorials* 1.271–272). Ruskin equated the Sirens with avarice, but to him Circe represented "pure Animal life," sinister only because men abuse

her gifts, a strange interpretation of the myth. The idea of the enchantress who turns men into swine suited the cultural attitude expressed by the Contagious Diseases Acts of 1864, 1866, and 1869, which present women as seductresses who turn men into beasts. Marsh suggests that the face of Circe resembles that of Maria Zambaco (*Pre-Raphaelite Sisterhood* 272).

The same year that Burne-Jones met Maria Zambaco he finished *The Lament*, a composition of two figures in classical garb. The figures evoke Burne-Jones's study of the Parthenon pediment sculptures. Such canvases as *The Lament, Theseus and Ariadne, Love Leading Alcestis,* and *Circe* indicate Burne-Jones's turning to classical subject matter, much as Frederic Leighton and Edward Poynter were doing at the same period. These images of women as abandoned, seductive, and sacrificing reflect the culture that shaped the predilections of artists like Leighton and Burne-Jones. Through this development from medieval to classical material, Burne-Jones began to universalize his thematic material, giving it the authority of mythological tradition.

VI

Among the earliest evidence of this classical direction are some treatments of the legend of Eros and Psyche. In 1864 William Morris and Edward Burne-Jones decided to produce an illustrated version of Morris' *The Earthly Paradise*, the first poem of which was "The Story of Cupid and Psyche," a development of the legend made famous in the second century A.D. by Apuleius in *The Golden Ass.* Burne-Jones completed about seventy designs for the project, forty-seven of which involved the legend of Psyche. Burne-Jones was commissioned by George Howard, earl of Carlisle, to paint a mural decoration for his home at Palace Green, a project completed by both Burne-Jones and Walter Crane between 1872 and 1881. The *Cupid and Psyche* frieze was particularly important in Burne-Jones's career because it marks a transition in his style. Waters observes: "Burne-Jones was in the throes of a change in style, abandoning the medieval style inspired by Rossetti and moving into a more classical one inspired by his study of the Elgin Marbles. . . . The murals display a conscious classicism" ("Painter and Patron" 340). Burne-Jones also completed a number of separate gouaches and oils concerning the legend, including *Zephyrus and Psyche* (1865), *Cupid Finding Psyche* (1865–1867), *Pan and Psyche* (1869), and *Cupid Delivering Psyche* (1867 and c. 1871). Involving as it does a sequence of love, betrayal, and rescue, the legend is a powerful compound of men's attitudes to women's faithlessness and helplessness.

The youngest of three daughters of a king, Psyche is so lovely that people worship her rather than the goddess Aphrodite. Incensed, Aphrodite sends Eros to compel Psyche to fall in love with a wretch; instead, Eros falls in love with her. He persuades Apollo to have her father abandon her on a mountain, from which she is spirited away by Zephyrus to Eros' palace. He visits her at night, until her evil sisters arouse her curiosity to see him. She approaches him with a lamp and a knife, at first intending to kill him. However, she falls in love with him at seeing his beauty. He awakens when a drop of oil falls on him; angry at her, he departs. Attempting to regain him, she goes to Aphrodite, who sets her four impossible tasks: to sort barley, at which she is aided by ants; to get wool from golden rams, which she does with the aid of the reed; to fill a vessel with water from Styx and Cocytus, at which she is aided by Zeus's eagle; and to obtain a casket containing beauty ointments from Persephone, where her curiosity overcomes her and she fails at the last moment. The casket contains a powerful soporific instead of cosmetics. Eros finally rescues her and takes her to Olympus, where she is apotheosized. In the twelve sections of the story selected for Palace Green, Burne-Jones depicts only one of the tasks, Psyche's obtaining the casket from Persephone, which is the one task in which she fails. The element of male "rescue" is heightened by this selectivity. Otherwise, the emphasis in the murals is on Psyche finding Eros asleep, Eros flying away, Psyche with Charon, and Eros rescuing Psyche, episodes which emphasize her dependence rather than her resourcefulness.

As the name Psyche means "soul," the legend has been allegorized into the Platonic desire of the soul for love, a sign of ideal aspiration. One may construe the legend as a conflict between two forms of womanhood, the fierce fertility force represented by Aphrodite and the loving power represented by Psyche. The old fierce matriarchate principle of fertility is replaced by the more equal male/female conception of love. The legend of Eros and Psyche signifies the passing from the matriarchal culture to one essentially male-dominant, with the male love rescuing the soul. The attraction of the legend for the nineteenth century is clear in this enforcement of patriarchal power over the prerogatives of an older matriarchal order. In the case of Burne-Jones, the legend underwent "secondary personalization," according to which "the originally archetypal elements are reduced to a personal level" (Fromm, *Art of Loving* 67). Burne-Jones painted a *Cupid Finding Psyche* for Maria Zambaco, an appropriate selection, indicating as it does Cupid rescuing the distraught Psyche before taking her to Olympus.

The sequence of events illustrated in gouaches and oils invariably empha-

sizes the male role in the situation of Psyche. In *Zephyrus and Psyche,* the
West Wind is shown carrying Psyche away to Eros' palace. This conjunction
is particularly interesting because the West Wind was homosexual, having loved
Hyacinth, who left him for Apollo. Homosexual lovers were associated with
opposition to the dominance of the female. The presence of Zephyrus sig-
nifies the beginning of male dominance. There are several versions of *Cupid
Finding Psyche,* some showing her naked torso, with Cupid bending over her,
struck by her beauty. *Pan and Psyche* shows the woman emerging naked from
a stream into which she had thrown herself in despair after the departure of
her lover. The god bends over her, caressing her head. Psyche's tasks are the
female variant of the labors of Heracles, but they are carried out with the
help of male heroes. In *Cupid Delivering Psyche* (1867) (Plate 2-15), a great
Victorian "rescue" canvas, Cupid takes Psyche into his arms, preparing to ele-
vate her to Olympus. In the background is the river Styx and Charon in his
boat. Psyche's descent into hell has resulted in her rebirth. The legend cele-
brates the substitution of love for fertility, but it also marks the passing of
the matriarchy, enforcing an attitude of male superiority.

Although he treated the tasks of Psyche in the designs for *The Earthly
Paradise,* in the oils and gouaches Burne-Jones emphasized the male-dominant
aspects of the legend when he was not obliged to illustrate Morris' text. The
story of Eros and Psyche represents domination by male cultural prerogatives
in two ways: in the depiction of female "heroinism" as less independent than
male "heroism"; and in the superseding of the matriarchal culture by the patri-
archal. The transition from matriarchy to patriarchy is demonstrated in Psyche's
approach to the sleeping Eros, whom her sisters urged her to decapitate —
that is, castrate — to preserve the female prerogative. Her decision to love rather
than destroy him signifies a cultural transition.

While Burne-Jones was developing his idea of Eros and Psyche, another
legend preoccupied him during the period 1868–1880, that of Pygmalion.
Burne-Jones made two sets of four panels each based on the legend, a small
set in 1868–1870 and a larger series from 1869 to 1879 (Plates 2-16, 2-17, 2-18,
2-19). The original designs were completed in 1867 as illustration to "Pygma-
lion and the Image" in *The Earthly Paradise.* The four panels were called *The
Heart Desires, The Hand Refrains, The Godhead Fires,* and *The Soul Attains.*
Pygmalion pursues the conception of male supremacy embodied in Burne-
Jones's version of the Eros and Psyche legend. Ovid's account states that
Pygmalion turned away from the women of the island of Cyprus because they
were whorish. To compensate, he finished an ivory image of his idealized

woman, dressing it and even taking it to bed. During a celebration on the island, he prayed to Aphrodite, who endowed the sculpture with life; sources give the name Galatea to this woman. It is important that Galatea was made from ivory, an animal-generated substance, rather than from marble; thus the legend associates the female with the tellurian and material rather than with the transcendental and spiritual. An unusual aspect of Pygmalion is that he was a sculptor as well as a king, which makes his attitude more universal in its connotation. The myth deals with male fantasies of women and the corrupt nature of women in men's conceptions.

There are several latent significances to the legend. The repudiation of actual women is a gynophobic defense mechanism expressing fear of female sexuality. The woman is spurned as depraved to prevent the male from experiencing sexual anxiety. Acton's treatise indicates that some men were impotent from fear of female sexuality as manifested by prostitutes. A further connotation is that only a woman who accords with male fantasies can be loved, that is, men create narcissistic idealities to love, fearing to deal with a genuine Other; this is a variant of the self-projection of the epipsyche theory. The beloved is then an extension of the self and does not threaten the self. Warner states that Pygmalion loves Galatea because "Galatea is his mirror image of himself as an idealized ethereal force" (238). The legend also represents Burne-Jones's conception of the woman as epipsyche, the other half of the soul, an idealized projection. The early series was painted for Maria Zambaco's mother, Euphrosyne Cassavetti. The Pygmalion legend documents male sexual self-protection and is inextricably involved with Maria Zambaco. Davidoff notes that "the power to create or transform another human being and in so doing to reaffirm upper-middle-class masculine identity" ("Class and Gender" 46) was a component of the rescue phenomenon. The myth of Pygmalion is the prototype of rescue.

The New Gallery catalogue indicated that *The Heart Desires* expresses Pygmalion's longing for "greater beauty than is to be found in his previous work, or in actual life" (*Edward Burne-Jones* 69). Both versions express the narcissism of the legend and its significance for the nineteenth century. They show the artist standing in contemplation, with two women passing in the street outside. Inside the studio, female nudes, four in the early version and three in the later, represent the inadequate nature of his conceptions and of actual models. In the initial studies for this panel, the figures were three nude men and a draped woman. This fact indicates the narcissism of the entire series, as Pygmalion first intended to embody his ideal in a male youth. In

the second part of the series, *The Hand Refrains,* Pygmalion contemplates his finished statue. The rupture of Burne-Jones's relationship with Maria Zambaco becomes significant. In the early series, the statue represents a woman yielding, vulnerable, and somnolent, the image of the controlled woman. In the later series, the statue is much more sexually forceful, with eyes open. In both series the male is shown hesitant before female sexuality, but the woman in the second is more intimidating. Again, the initial studies indicated a more aggressive Pygmalion, showing him with a phallic mallet and chisel. The chisel is pointed at one of the statue's breasts as he prepares to strike. In the finished canvases, the statue is complete and the aggression of the process has been eliminated. In the final canvases Pygmalion holds the chisel and mallet, the "hand" unquestionably "refraining" from sexual contact.

In *The Godhead Fires* Aphrodite accompanied by her doves endows the figure with life. In the earlier series, Pygmalion is shown in the background bowing before a statue of the goddess in the courtyard; this detail is eliminated in the later representation. A study of the head of Aphrodite in the Pygmalion series appears to be derived from Maria Zambaco, suggesting that she was the desired Galatea. Another design for Galatea might also have been drawn from Maria Zambaco. In *The Soul Attains* Pygmalion is kneeling before Galatea. Pygmalion in the second series subtly expresses anxiety as well as aspiration. A study for this episode, however, shows Pygmalion helping Galatea off the pedestal, his arms embracing her, a far more sexual conception than the final treatment, which expresses apprehension. In all three episodes in which Pygmalion appears, he shows the hesitancy and fear that characterized nineteenth-century male attitudes about female sexuality. As a result of the rupture with Maria Zambaco, the second series contains less worship than fear with its more frank statue and elimination of Pygmalion worshiping before Aphrodite in its third panel.

VII

It will be recalled that the artist's letter to Helen Mary Gaskell wondering if he should dedicate the *Perseus* series to her contains a long discussion of Maria Zambaco. Even in the 1890s she was indelibly associated with the *Perseus* sequence. In Burne-Jones's canvases of the early 1870s Maria Zambaco appears, first in beneficent images and later in icons increasingly terrifying and threatening. Of the studies of Maria Zambaco herself, several pencil sketches and one gouache portrait exist. In the pencil sketches, dating from 1870 and 1871,

the wistful eyes, flowing hair, and melancholy gaze depict both an enchantress and an epipsyche. The details in the gouache portrait (1870) are of particular interest. Maria holds a book open to a reproduction of an early version of Burne-Jones's *Le Chant d'Amour* (1865), the artist's name appears on the arrow, and Eros draws the curtain. The ambiguous sexuality of the later *Le Chant d'Amour* of 1878, noted by Henry James and Justin McCarthy, suggests the narcissism underlying the *Oxford and Cambridge Magazine* stories of the epipsyche and the cousins/lovers. The roles for which Maria Zambaco became the model form an index of the artist's conception of women.

Two of the most indicative appeared in 1870, the gouaches *Phyllis and Demophoön* and *Beatrice*. Inspired by Ovid's *Heroides* and Chaucer's *Legend of Good Women*, *Phyllis and Demophoön* (Plate 2-20) concerns the story of Phyllis, the queen of Thrace, who falls in love with Theseus' son Demophoön, who abandons her. When he returns to the country, he learns she has been transformed into an almond tree. In Burne-Jones's canvas, Maria Zambaco is shown leaning from the tree, embracing a reluctant Demophoön; she is draped and he is nude. On its exhibition in 1870 at the Old Water-Colour Society the picture caused an outcry because of the nudity of the male figure. Burne-Jones withdrew the canvas and resigned from the society. A study for the canvas shows a much more aggressive Phyllis embracing a diminutive Demophoön, more accurately expressing Burne-Jones's fears of domination. Another preliminary drawing shows Demophoön's face with more suspicion and fear than in the final canvas. Burne-Jones did a later version of this legend, *The Tree of Forgiveness* (Plate 2-21) in 1882, showing Phyllis totally nude leaning out of the tree, embracing a Demophoön inspired by Michelangelo. The face of Maria Zambaco from the earlier version has been slightly altered, but the anxiety of the male is apparent in both versions. In 1871 Maria appeared naked in a gouache *Venus Epithalamia,* standing nude beside a statue of Eros as a procession passes in the distance. The painting was completed as a wedding gift for Marie Spartali Stillman, a friend of both Burne-Jones and Maria Zambaco. The pose of Venus anticipates the similar position of Danaë in a panel completed in 1872, indicating the linkage of Maria Zambaco to the Perseus legend.

In the late 1860s and early 1870s Burne-Jones did a number of allegorical paintings, several involving Maria Zambaco and his wife, Georgiana Macdonald. *Summer* (Plate 2-22) finished in 1870 shows Maria Zambaco in a transparent white garment, standing before a pool of water and forget-me-nots, her eyes poignant and melancholy. As with Leighton's *Bath of Psyche* twenty

years later, the pose of Maria in *Summer* is inspired by the Venus Kalipigge
at Naples; Maria thus embodies a classical sculpturesque erotic ideal. Maria
appears in the figure of *Night* completed the same year, standing in a dark
blue gown and holding an inverted torch in her left hand, recalling the un-
lucky torch from the Orpheus legend. In contrast to these depictions of Ma-
ria, Georgiana appears as the chilly nun of *Winter* (Plate 2-23), garbed in
white drapery and black cloak. In her right hand she holds what appears to
be a missal; her left is extended over a fire of burning sticks. The contrast
between the erotic depiction of Maria Zambaco and the frigidity of Georgi-
ana could not be more emphatic. Georgiana also appears in a figure entitled
Charity, dated 1867 but worked on in 1870, dressed in blue and crimson drap-
ery and holding two children in her arms while four others stand at her feet.
Georgiana is the archetypal Victorian maternal image, associated with an-
other stereotypical activity for women, charitable duty.

 One of Burne-Jones's most wrenching depictions of his deteriorated rela-
tionship with Maria Zambaco is the canvas *Souls on the Bank of the River
Styx,* completed during 1871–1872 but never exhibited during Burne-Jones's
lifetime (Plate 2-24). Burne-Jones's source is Vergil's account of Aeneas' ex-
cursion to the Underworld in the sixth book of the *Aeneid.* William Morris
was working on a translation of the *Aeneid* during the early 1870s, published
in 1875, and Burne-Jones undoubtedly discussed it with him. The painting
shows the souls waiting for Charon to ferry them to the kingdom of Hades,
the tower of whose realm is dimly perceived in the distance. In this episode
of the *Aeneid,* Burne-Jones found a record of terrifying separation, abandon-
ment, and alienation that paralleled his own response to Maria Zambaco dur-
ing this period. In this book of the *Aeneid,* Aeneas encounters the shade of
Dido, his lover whom he had to abandon to found the city of Rome, choosing
duty over personal inclination. Burne-Jones records an equally catastrophic
separation: he and Maria may be the couples depicted in the canvas, cling-
ing to one another though dead, or he may be the solitary figure huddling
at the left. *Souls on the Bank of the River Styx* reveals the extent of the suffer-
ing suggested in canvases like *Summer* or *Night.*

 In *The Garden of the Hesperides* (1870–1873), Maria appears as one of
the figures beneath the tree with the golden apples. Connected with the story
of Jason and the Argonauts, the tale connotes betrayal. A drawing of Maria
in 1870 shows her as the doomed Cassandra. Classical subject matter becomes
the most personal of discourses in this instance. In another drawing, of 1871,
Maria was Ariadne, a clear anticipation of her abandonment. There can be

little doubt that Maria Zambaco embodied Hellenism for Burne-Jones. He was to see her as late as Easter 1873 when he traveled with William Morris to Italy.

In the 1870s and 1880s the images of Maria and of Georgiana were extended in threatening or maternal directions. Burne-Jones did a gouache study (Plate 2-25) of Maria's head in 1873 as Nimuë the enchantress for *The Beguiling of Merlin*. The magnificent hair has become entwined with snakes, a Medusa image. When shown in 1877 at the first Grosvenor exhibition, *The Beguiling of Merlin* (Plate 2-26) included a full-length figure of Maria in classical drapery, hair full of serpents, holding the book of magic she has taken from Merlin, who is reposing in a hawthorn tree in the forest of Broceliande. It has already been seen that Burne-Jones identified with Merlin in this canvas. Merlin awakens to find himself "locked up." Instead of the woman "locked up" in the tree, as in *Phyllis and Demophoön,* the male is now the prisoner. The images of Phyllis and Beatrice have yielded to more sinister depictions. Georgiana, meanwhile, was transformed in 1884 in *King Cophetua and the Beggar Maid,* drawn from Elizabethan balladry. Georgiana sits enthroned, as Burne-Jones in the figure of the king sits beneath her, holding his crown in his lap. *King Cophetua* depicts the male worshiping the chill divinity of the spouse, whose aspect recalls Demeter, the mother of the bride of Hades. In 1884 Burne-Jones could both fear women in the figure of Maria Zambaco and worship them in the figure of his wife. *King Cophetua* embodies the Victorian worship of virginal, majestic womanhood, as expressed in Fulford's essay in the *Oxford and Cambridge Magazine.*

The most sexually frightening depiction of the 1880s after the *Perseus* sequences is *The Depths of the Sea* of 1886, repeated as a gouache in 1887 (Plate 2-27), showing a mermaid dragging a doomed sailor into the ocean. A result of the artist's visits to Italy in 1871 and 1873, the Leonardo smile of the mermaid is one of the artist's enigmas. It is the face of the Mona Lisa described by Pater in the essay on Leonardo da Vinci in 1869. The face of the mermaid resembles that of Laura Tennant, whom Burne-Jones called "The Siren" (Georgiana Burne-Jones *Memorials* 2.148). Burne-Jones had painted a canvas *The Sirens* in the 1870s, and was to declare in 1891: "I am making a plan for a picture. . . . It is a sort of Siren-Land—I don't know when or where—not Greek Sirens, but any Sirens, anywhere, that lure on men to destruction" (2.222). In 1897 Burne-Jones told Rooke: "There are two kinds of women I like; the very good, the goldenhaired, and the exceedingly mischievous, the sirens with oat-coloured hair" ("Conversations" 257). *The Depths of the Sea* was inter-

preted by the *Athenaeum* as follows: "She, with wicked triumph gleaming in her eyes, smiles over her victory. . . . Delight in evil gleams in her witch-like face. . . . Her delighted clutch will not relax its hold of the human toy that perishes" (561). The face is one of "wicked witchery" (590). The *Art Journal* commented: "The elfish expression of the . . . woman's face is excellent, and we can quite believe her capable . . . when she realises her disappointment, of giving the useless body a flick with her tail and sending it up again" (222). The *Athenaeum* reviewer reads into the canvas his cultural attitude; few could find the eyes expressing "wicked triumph" or "delight in evil." By a perverse coincidence, when *The Depths of the Sea* was shown in 1886 at the Academy, Maria Zambaco was exhibiting a sculpture. Two years later she exhibited a bronze entitled *Medusa's Horror.* Her transformation was complete. The drowning exhibited in *The Depths of the Sea* indicates the self-destructive nature of male narcissism. The mermaid's tail and the arm over the sailor's genitals reflect the castration fear stimulated by attitudes such as Acton's concerning female sexuality. Burne-Jones's depictions of Maria Zambaco and Georgiana Burne-Jones, in both subject and allegorical canvases, reveal the disturbed nature of his reactions to female sexuality.

These attitudes culminate in the greatest series of classical-subject canvases in his career, the *Perseus* series. The *Perseus* cycle, like the series *Cupid and Psyche* and *Pygmalion*, is an encoded sequential narrative. Burne-Jones noted in 1884, the time of *King Cophetua* and *The Tree of Forgiveness*: "Apart from portraiture . . . you only want types, symbols, suggestions" (Georgiana Burne-Jones, *Memorials* 2.140). He praised Michelangelo because he knew "how to symbolize mystery" (2.263). The *Perseus* sequence is "symbolized mystery." Commissioned in 1875 by Arthur Balfour, it was unfinished at Burne-Jones's death, with only four of the eight final selected episodes completed: *The Baleful Head* (Grosvenor 1887), *The Rock of Doom* and *The Doom Fulfilled* (New Gallery 1888), and *Perseus and the Graiae* (1892; Salon du Champ de Mars 1893). *The Calling of Perseus, The Nymphs Arming Perseus, The Finding of Medusa,* and *The Death of Medusa* remained unfinished. Of the two central aspects of the legend, the slaying of Medusa and the rescue of Andromeda, only the Andromeda story was complete. The cycle was inspired by Morris' "The Doom of King Acrisius" from *The Earthly Paradise*. As early as 1865 Burne-Jones had drawn up a list of twenty-eight episodes for possible wood engravings. A series of ten gouache studies includes not only these eight episodes but also *The Birth of Chrysaor* and *Atlas Turned to Stone.* When *The Rock of Doom* and *The Doom Fulfilled* were exhibited at the New Gallery,

the reviewer of the *Times* noted their symbolic intention: "The action itself is conveyed in a strangely individual way; it is, if one may so express it, not so much action as the spirit of action" (9 May 1888, p. 10).

The Medusa legend, as Mario Praz has observed, is significant in nineteenth-century cultural history, revealing "the discovery of Horror as a source of delight and beauty" and "the inseparability of pleasure and pain" (*Romantic Agony* 27–28). Burne-Jones's failure to complete the Medusa canvases would be less striking were it not that, according to Georgiana Burne-Jones, "the Medusa part of the legend, which attracted him most, he studied deeply; the Andromeda scenes, though they came later in the story, were finished first" (*Memorials* 2.60).

The legend caused the artist direct physical pain. In August 1876 Burne-Jones had to cease work on the *Perseus* series, having been depressed for five weeks. Reviewers recognized this despair, which was not concealed in the finished canvases. The *Athenaeum* noted in 1878: "Every face painted by Mr. Burne-Jones is stamped with despair" (579). The association of Perseus with pain reveals that the pictures are symptoms in Richard Sennett's sense: "A symptom is a pain which does not explain itself. It requires an act of decoding. Symptoms are the language of repression" ("Narcissism" 76). Repression in the *Perseus* is indicated by Burne-Jones's determination to avoid as well as to confront the implications of the legend.

One reason for the repression exhibited in the *Perseus* canvases is indicated by the canvas *Danaë and the Brazen Tower* (Plate 2-28), exhibited in 1888 along with *The Rock of Doom* and *The Doom Fulfilled. Danaë,* although not part of the *Perseus* series, is an integral part of the legend, since it deals with the life of Perseus' mother. Danaë had long interested Burne-Jones. As early as 1863, he had completed a canvas and a number of sketches of the figure. In 1872 and in 1888 Burne-Jones painted canvases of Danaë watching the brazen tower being built, in which her father, King Acrisius, would imprison her. Acrisius had heard from an oracle that Danaë's son would slay him. In the 1872 canvas Danaë is shown watching the erection of the tower. To the right of the canvas is a fountain, anticipating the fountain in the climactic canvas of the *Perseus* series, *The Baleful Head.* Behind her is a cypress tree, connoting the death of Acrisius as well as the living death to which her father condemns Danaë. In the 1888 canvas Danaë stands in the same red cloak, but Burne-Jones has made the canvas more vertical and eliminated the fountain. The pose of Danaë in both treatments parallels that of Maria Zambaco in the *Venus Epithalamia* of 1871, who becomes closely associated with

the Danaë figure. Zeus penetrated the tower, impregnating Danaë in a shower of gold. This linkage of semen with coin is the archetypal image of prostitution. Unlike many artists before him, Burne-Jones refused to portray this incident. Although he may have been searching for an original treatment, it is also a reaction against explicit sexuality.

In 1898 Burne-Jones revealed his feelings about Aubrey Beardsley's *The Fat Woman,* indicating one of his sexual attitudes: "The drawings were as stupid as they could be. Empty of any great quality and detestable. I was looking at some the other day, and they were more lustful than any I've seen. . . . She looked like a mere lustful animal. Lust does frighten me, I must say. It looks like such despair—despair of any happiness and search for it in new degradation. . . . I don't know why I've such a dread of lust. Whether it is the fear of what might happen to me if I were to lose all fortitude and sanity and strength of mind—let myself rush down hill without any self-restraint" (Burne-Jones and Rooke, "Conversations" 412). In 1888, when *The Rock of Doom* and *The Doom Fulfilled* were exhibited, Burne-Jones's daughter was married. So great was his fear of women that all references to procreation in the service were eliminated to avoid irritating him.

The linkage of Danaë, who was cast out to sea and was thus in need of rescue, and Maria Zambaco suggests a particular dimension of male sexuality as expressed in Freud's "A Special Type of Choice of Object Made by Men." Freud describes a pathology, the conditions of which were that: (1) the woman be attached so there can be an injured third party; (2) the woman be sexually experienced; (3) the attachment be compulsive; and (4) the woman be in need of rescue. Both Danaë and Maria Zambaco fulfill these conditions. Rescuing the female is actually a means of enforcing domination of her. The sexual experience of Danaë in mythical prostitution degrades the object so that the male may feel more exalted in rescuing her. The activities of rescue societies in the nineteenth century, reclamation missions for prostitutes, and the peregrinations of Gladstone are paralleled in the details of the Danaë/Andromeda debasement and "rescue."

Fear of sexuality is expressed in the *Perseus* series through various details of the canvases and studies. One of the most apparent is the shading of the eyes. While the Medusa story inherently prevents the meeting of the eyes (for fear the viewer would be turned to stone), Löcher notes that this avoidance occurs frequently. Perseus shades his eyes at his calling by Athene; he merely glances at Andromeda on sighting her. This detail may symbolize a concern with losing the testicles, a fear that corresponds to the castration fears aroused

by the decapitation of Medusa. Two dimensions of the series require emphasis: the androgyny and the avoidance of the birth of Chrysaor. Its androgynous emphasis intersects with the fear of castration, if the androgyne is seen as a female who appropriates male characteristics. One of Burne-Jones's earliest recollections of school was the following: "I was stabbed at school. . . . The boy who did it was simply furious with me. It may have been my fault for anything I can remember—we hated each other I know. . . . It was in the groin, which was in a dangerous place. It didn't hurt much, but I felt something warm from my leg and putting my hand there, I found it was blood" (Burne-Jones and Rooke, "Conversations" 160). The protection of the testicles/eyes is one consequence of this gesture. In some nude studies of Perseus and Chrysaor the genitals are either obscured or eliminated. In one study (Plate 2-29), Perseus is shading his eyes and has very small genitals. In a study for Chrysaor (Plate 2-30), there are no genitals at all. Chrysaor is in the same position as the sailor in *The Depths of the Sea,* whose genitals are cut by the embrace of the mermaid with the fierce tail. Acton noted: "One of the first characteristics of the perfect athlete of classic times was unusually small though well-shaped genital organs" (*Functions and Disorders* 208). These small genitals indicate the elevated class of the hero. Joined with the shading of the eyes, they also reflect fear of castration. As Zeitlin observes, the castration component "can be deduced from the parallel between the myth of Medusa and that of Uranos. Aphrodite is born from Uranos' severed phallos and Pegasus (and Chrysaor) from Medusa's severed head" ("Cultic Models" 154). The corresponding overcompensation is evident in several nude studies for *The Doom Fulfilled,* which show the monster cutting through the groin of Perseus to rise like a phallus. In one drawing (Plate 2-31) Perseus grasps the decapitated monster, which looks like a phallus. The sea monster in Burne-Jones's canvas is of indeterminate sex, but the legend specified that it was female: the hero thus regains the phallus seized by the female.

This fear of female sexuality had even greater significance for Burne-Jones because of the circumstances of his birth. For several reasons Burne-Jones could not finish *The Birth of Chrysaor.* The most significant is that his mother died six days after his birth. The death of a mother in childbirth may be variously interpreted by the child, who may feel rejected or believe that he or she killed the mother. Burne-Jones avoided finishing *The Death of Medusa* (working on Andromeda's rescue instead) because it represented his killing of his mother. It also signifies her rejection of him, symbolically represented in the castrated Chrysaor/Burne-Jones emerging from the dead woman, mother/Medusa.

Burne-Jones perhaps interpreted the fact that his father could not bear to hold him until he was four years old as rejection for slaying his mother.

Burne-Jones suffered terribly from the death of his mother, as he confessed to Helen Mary Gaskell in September 1893: "Isn't it strange to have no least idea about his mammy—neither of her height, nor colour, nor form, nor of one word she ever said—nor her handwriting, nor anything that was hers—I can't help thinking it a very sad death & it used to afflict me sorely when I was old enough to know how she came to die." Burne-Jones came to realize how pitiful his father was. He continued; "No—my little father wasn't like that at all—he was a very poetical little fellow—very tender-hearted & touching—quite unfit for the world into which he was pitched." Burne-Jones recalled the ritual kept to commemorate this mother: "Sunday was Sep 3rd. I always keep it with what piety I can.—That was the day my mammy died. The sixth day after my birth day. It used to be the saddest of days at home—while my father remembered things—a day of tears & the show of tears—and I used to hate it when I was tiny but when I knew why it was I tried to keep it too."

Every year on the anniversary, Burne-Jones's father took him to the grave and the son had to watch the father weep in the cemetery. Guilt, hatred, overcompensation, and fear originated in such rituals. The slaying of Medusa, which resulted in the birth of a son from her dead body, was extremely close to Burne-Jones's psychological history. The mature artist could not bring himself to finish the canvases dealing with Medusa. Focusing on the rescue of Andromeda, which reinforced male power, he avoided the consequences of the legend of the slaying of Medusa. Burne-Jones admitted to Rooke: "People abused me when I was young, but I daresay it was very good for me" ("Conversations" 45). The series of gouaches, oils, and their related preliminary drawings give evidence of sexual anxiety, overcompensation, fear of castration, and repression. Throughout the development of the *Perseus* series, the most prominent sign is the suppression of emotion in the transformation from initial conception to final realization.

The first episode of the series, *The Calling of Perseus* (Plate 2-32), depicts Athene summoning Perseus to his mission, giving him a sword and a mirror, by which to slay Medusa without having to see her. Burne-Jones's alterations from conception to execution of this episode are revealing. In a sketchbook in the Fitzwilliam Museum, Athene gives him a mirror, but the sword, extremely large, he already holds; she instead holds her spear. In the gouache and in the oil two changes are noticeable. She endows him with phallicism

in the shape of the sword, and she looms much larger. In the sketchbook, he is nearly her height even though he is seated. The muscular torso and small genitals derive from Michelangelo; in Burne-Jones's case, however, the painting of the genitals would reflect castration fear. When there is no reason to do so, Perseus nevertheless shades his eyes.

In the second canvas, *Perseus and the Graiae* (Plate 2-33), Perseus finds the Gorgons' sisters and steals their one eye from them, illustrating male desire to deprive women of power. In a sketchbook the figures of both Perseus and the Graiae are more vigorous than in either the gouache or the oil. The gouache contains an inscription over the depiction which is eliminated in the oil. The final line of this inscription—"en virgo horrendam in speculo mirata Medusam"—exploits the possibilities of Latin syntax to conjoin *virgo* (a reference to Andromeda) and *horrendam* (describing Medusa), indicating the relationship of the two and their equally fearsome sexual natures. The third canvas, *The Nymphs Arming Perseus* (Plate 2-34), depicts Perseus receiving the helmet of invisibility, the winged sandals, and the sack for Medusa's head from the nymphs. In the Fitzwilliam Sketchbook (no. 1085), Perseus is shown vigorously pulling on the sandals. In the gouache and the unfinished oil, he is doing so much more languidly. As Löcher points out, Perseus' pose is that of the *ignudi* from the Sistine ceiling, although more effete in body.

The next two oils and the next three gouaches deal with the Medusa aspect of the legend. The two oils, *The Finding of Medusa* (Plate 2-35) and *The Death of Medusa*, are unfinished. The three gouaches are *The Finding of Medusa*, *The Birth of Chrysaor*, and *The Death of Medusa*. The *Birth of Chrysaor* was eliminated in the oils for reasons already discussed. For *The Finding of Medusa*, several sketches of her head depict her as much more fierce than in the oil or gouache, where she is beautiful and vulnerable. Medusa is garbed like Parthenon pediment figures. In the oil there are no snakes in her hair. Burne-Jones attempts to remove the terror of her phallic snake hair.

The gouache *The Birth of Chrysaor* (Plate 2-36) shows Chrysaor with barely discernible genitals and the winged horse Pegasus rising out of the slain body of Medusa, as Perseus stands holding her head at his side. The decapitation of the head, coupled with the man born without genitals, suggests a fear of castration. For Burne-Jones the episode paralleled the situation of his birth. Burne-Jones avoided the death of Medusa because it represented his killing of his mother. It also signified her rejection of him, symbolically represented in the castrated Chrysaor, powerless against the rejecting father. Gynophobia is the result of such feelings of sexual inadequacy. In *The Death of Medusa*

(Plate 2-37), Perseus is depicted putting Medusa's head in the wallet. In the gouache she has snake hair; in the unfinished oil, no snakes appear. Her two sisters, the immortal Gorgons, fly up in reaction to her death. None of the Medusa episodes was ever finished, demonstrating Burne-Jones's extreme reluctance to confront an episode that involved memories of his birth and his sexual anxieties. A gouache *Atlas Turned to Stone,* not executed in oil, shows the paralyzed Atlas holding up the world as Perseus flies past him. This is the first moment to suggest the undying power of the slain Medusa: she has the male power to harden, but it is directed in this series against men, a mockery of the erection stimulus. In appropriating this male prerogative, she deprives men of their potency.

The final three canvases of the series, *The Rock of Doom, The Doom Fulfilled,* and *The Baleful Head,* were executed both as gouaches and as completed oils. In *The Rock of Doom* (Plate 2-38), Perseus removes his cap of Hades to reveal his face to Andromeda. In both the gouache and the oil, he glances hesitantly toward her. In the gouache her chains are much more finished than her naked body. The expression of Perseus' face, which is more stern in the Medusa depictions, has here become cautious, especially in *The Rock of Doom.* His sword is a large substitute phallus by its positioning. In early sketchbook drawings, Andromeda is shown reaching her arms toward her rescuer. In the final treatments she is depicted bound, indicating Burne-Jones's reluctance to have the woman show any assertive action.

In *The Doom Fulfilled* (Plate 2-39), Perseus slays the monster as Andromeda watches. In the gouache he has the sack with Medusa's head, showing the hair but no snakes, hanging by his side; in the oil, any reference to Medusa has been eliminated. Perseus' facial expression has been muted from its fierceness in the sketches. Even in the "rescue," Burne-Jones cannot confront the decapitation of a monster, although in sketches the creature is shown beheaded. It has already been noted that the monster cuts through Perseus' groin. In the sketches Andromeda is much more active, yearning, and involved than in the final still attitude. The "rescue" accomplished, Perseus returns to claim Andromeda's hand from her father King Cepheus.

In *The Baleful Head* (Plate 2-40), Perseus is showing Andromeda Medusa's head reflected in a fountain pool. The design of the canvas underwent many alterations from its initial conception. In drawings Perseus and Andromeda are standing side by side, with Andromeda grasping his waist or putting her arm around his neck. In the gouache and in the oil, however, the two stand clasping hands on opposite sides of the fountain, as Perseus holds the Medusa

head above both their heads. Andromeda gazes into the reflection as Perseus stares at her, very sullenly in the gouache. His pose indicates he wishes to have her glance quickly at the reflection; her gaze, however, is intent. Looking into the well, Andromeda sees herself as Medusa. Perseus can now look directly at Andromeda since "rescue" is in fact the slaying of Andromeda's separate identity to accord with the narcissist's refusal to recognize the Other. The sexual anxiety of the Medusa legend is the immediate cause of the sexual result in the Andromeda myth. Perseus has slain Woman/Medusa (and thereby the reflected Andromeda) so he may possess not Andromeda but an epipsyche that is, as the androgyny indicates, narcissistically himself. Philip Burne-Jones recorded that his father "made a special point of finishing the last of the series . . . lest, as was unfortunately the case, he should never finish all the others, and in order that, whatever happened, the series should be intelligible as a whole and end with its proper conclusion" ("Notes" 162). Through the *Perseus* cycle Burne-Jones has slain the feared Medusa/Maria by transforming her into the androgynous, narcissistic epipsyche Andromeda/Maria. This androgyny is not a convention of the artist but reflects a cultural anxiety.

Even in 1868, during the affair with Maria Zambaco, Burne-Jones was subject to self-debasement: "About every fifth day I fall into despair as usual. Yesterday it culminated and I walked about like an exposed imposter. . . . At present I have evil nights and am most often awake at three, with some four hours of blank time to lie on my back and think over all my days—many and evil they seem" (Georgiana Burne-Jones, *Memorials* 2.2–3). During 1886, finishing *The Depths of the Sea,* he described himself as "nigh unto despair" (2.168). That painting, with its drowning mariner, conjoins the feared female and the dead Narcissus. In 1883 Burne-Jones wrote a letter to Katie Lewis with five illustrations of himself before a canvas. In the first he sits despairingly before the canvas; in the second, he throws his hands over his head; in the third, he stares at the canvas; in the fourth he puts his foot through it; and in the final drawing he sits on the other side of the ripped canvas, more forlorn and disconsolate than ever. The relationship of art and despair is manifest in these drawings. In another letter to Katie Lewis he is shown standing by a wall watching his daughter dance, shoulders hunched over, hands in pocket, totally abject. In a letter in the Ashley Collection of the British Library, dated June 1896, he is sitting on a box, haggard and forlorn. Although these are caricatures, the latent significance is one of loneliness, persecution by his own art, and self-destruction.

The narcissistic androgyny of the figures in the *Perseus* represents both

an attempt to slay the Medusa and its futility. Burne-Jones never finished the
Medusa sequence because she could not be slain. The power of the Medusa
is psychological, not physical. Medusa's survival is the resurgence of mother-
right, female-right, at a time when women were indeed agitating for greater
sexual, educational, and social freedom. The feared woman, whose phallic
power (the *penetrating* gaze that hardens) transcended death, could not be
destroyed by transformation into an epipsyche of woman worship. In *The Bale-
ful Head,* Andromeda has become Medusa. Richard and Leonée Ormond com-
ment: "Any analysis of nineteenth-century classical subjects would certainly
suggest that woman is a devourer, rather than a source of happiness. . . .
Nineteenth-century sexual fantasies have clearly affected this painter's inter-
pretation of his subject" ("Victorian Painting" 34). In the *Perseus* cycle, Burne-
Jones reflects his culture in his depiction of male sexual fear and gynophobia.

Burne-Jones completed several other canvases that reflect this preoccupa-
tion with the psycho-sexual anxieties of the *Perseus* series. To Helen Mary Gaskell
he confided: "My Fortune's Wheel is a true image and we take our turn at
it, and are broken upon it." Between 1871 and 1885, Burne-Jones completed
at least six depictions in various media of The Wheel of Fortune, showing
a monumental heroic female figure in classically inspired robes turning a wheel.
Bound to the wheel are three male figures, a slave, a king, and a poet. The
model for Fortune was Lily Langtry; the males are modeled after Michelan-
gelo's *Dying Slave* (of which Burne-Jones possessed a plaster version) in the
Louvre and the *Captives* in Florence. The males' powerful torsos belie their
subjugated situation, which shows woman triumphing over man in a permu-
tation of the Ixion myth. Burne-Jones's son attested that *The Wheel of For-
tune* (Plate 2-41) was the artist's "favourite finished oil painting" ("Notes"
167). The inclusion of a slave and a king reflects the narcissist's simultane-
ous megalomania and self-denigration. In the early 1870s Burne-Jones began
work on *Laus Veneris,* completed in 1878. In this canvas, Venus is shown in
an orange robe sitting and listening to four attendants chant a song, while
knights, soon to be seduced, ride past the window. This canvas telescopes the
Aphrodite of sexual satiety and the Sirens. The conception derives from Swin-
burne's treatment in his poem of the same name, where Venus is the prin-
ciple of eroticism. The figure of Aphrodite Anadyomene at the top left of
the canvas reiterates the erotic nature of the goddess. Classical-subject can-
vases allowed Burne-Jones to universalize his conceptions, as Ruskin indicated
by selecting Burne-Jones and Watts to denote "Mythic Schools of Painting"
in 1883: "The modern painter of mythology [can] realize for us, with a truth

then impossible, the visions described by the wisest of men as embodying their most pious thoughts and their most exalted doctrines." "The mythic school seeks to teach you the spiritual truth of myths" (*Works* 14.278, 276).

One of Burne-Jones's canvases remaining unfinished at his death was a portrait of himself in *The Wizard,* begun around 1896. In contrast to *Circe,* where the woman is the sorcerer, here the artist himself is the magician, a further sign of narcissism. This depiction accords with Freud's lecture on narcissism. There, in reference to the aggrandized self-image of narcissists, Freud mentions as a trait "a technique for dealing with the external world—'magic'— which appears to be a logical application of these grandiose premises" ("On Narcissism" 32). Philip Burne-Jones described the subject of *The Wizard:* "In it a magician is depicted disclosing the vision of a shipwreck in a magic mirror to a girl who stands beside him" ("Notes" 161). This canvas is the reverse of *The Depths of the Sea,* in which the artist is the wrecked sailor.

In *The Wizard,* Burne-Jones attempts to reappropriate the book of magic stolen by Nimuë/Maria Zambaco in *The Beguiling of Merlin,* reasserting his prerogatives against the power of the deathless Medusa. According to Philip Burne-Jones the idea of *The Wizard* "dates from quite early years" (161), indicating the continuity of the artist's thinking throughout his career. The gynophobia and anxiety remained as well, however. Burne-Jones told Rooke: "Tiresome the modern woman is. I like women when they're good and kind and pretty—agreeable objects in the landscape of existence—give life to it— and pleasant to look at and think about. What do they want with votes?" ("Conversations" 316). Burne-Jones said of women: "They [never will] understand that when [a man's] caught he's lost" (55). His reactions to art reflect the cultural moment. Their nature, from the evidence of individual canvases as well as the *Cupid and Psyche, Pygmalion,* and *Perseus* series, is best summarized by Simeon Solomon's comment on the back of a pencil drawing he did of the artist in 1859: "Ed Be Js. THE SAVAGE MINDED."

VIII

The "savagery" of Burne-Jones's attitudes to women became diluted in the work of his followers, such as John Roddam Spencer Stanhope (1829–1908), John Melhuish Strudwick (1849–1937), Evelyn De Morgan (1855–1919), and Sidney Harold Meteyard (1868–1947). Rather than concentrate on mythological series such as *Cupid and Psyche, Pygmalion, Orpheus,* and *Perseus,* these artists tended to deal with classical-subject materials separately and dis-

continuously. Walter Crane recalled Spencer Stanhope, a pupil of G. F. Watts, when he met him in 1873: "Our acquaintance with the Poynters led to again meeting the Burne-Jones's, who were not so far away at the Grange. I think it was there that I first met Mr. Spencer Stanhope, for whose work I had long entertained a great admiration. It was kindred in sentiment and treatment to the early work of Burne-Jones, but quite distinct and individual. . . . Mr. Stanhope may be said to have drawn his inspiration from much the same sources as Burne-Jones, and, like him, showed in his early works the influence of D. G. Rossetti" (*Artist's Reminiscences* 154–155). The challenge faced by Burne-Jones's successors was to find an individual method of adapting his androgynous figures to their specific purposes.

Like Burne-Jones, Stanhope became part of the Little Holland House circle aroung 1850, when he first met G. F. Watts. Watts encouraged Stanhope to study the antique only in the Elgin Marbles; otherwise, as Stanhope wrote, "*nothing* ought to be studied . . . but nature" (Stirling, *Painter of Dreams* 302). Stanhope went with Watts to Italy in 1853. Stanhope even proposed painting the Elgin Marbles on the walls of his parents' townhouse. At this time the drawings of Flaxman, with their linearity, intrigued Stanhope, whose work retained this trait. His mother recorded in 1852: "I found Roddy at his High Art this morning before breakfast. He is crazy about Flaxman" (307). To Stanhope Greek art remained the ultimate standard. When studying the works of Tintoretto, he noted: "I am satisfied that he must be the greatest artist, Phidias always excepted, in the world" (322).

Stanhope was one of the group, led by Rossetti and including Burne-Jones and Morris, commissioned to decorate the walls of the Oxford Union Debating Society in 1857. As early as 1853 Stanhope believed: "Jones, I am confident, is a very great artist, and one who ought to rank quite in the first flight amongst . . . the 'old masters'" (325). Stanhope remained a friend of Burne-Jones during his lifetime, and Burne-Jones painted such details as the landscape for *The Merciful Knight* (1863) while staying with Stanhope in Surrey. The importance of archaeology to the classical-subject artist is indicated by the excursion Stanhope, Watts, and Val Prinsep made to Budrum in Asia Minor to record the recovery of the Mausoleum of Halicarnassus in autumn 1856.

Stanhope's first major picture was *Thoughts of the Past* (1858–1859), a study of a prostitute at Blackfriars reviewing her past life. The picture was painted when Stanhope occupied a studio at Chatham Place, Blackfriars, with Rossetti one floor above him. In 1864, Stanhope exhibited a *Penelope* at the Royal

Academy, a painting that marks his interest in classical themes. Stanhope exhibited *Cephalus and Procris* at the Academy in 1872. This picture, derived from Ovid, presents one of the archetypes of female jealousy from classical antiquity. Believing a rumor, Procris thought her husband, Cephalus, was having an affair with Aura when he went hunting. In reality, he was merely calling on the "aura" or breeze to cool his body. When she hid in a bush to watch him, he thought he heard a noise and killed her with a spear. Cephalus is depicted cradling Procris on his knees, his visage less identical to his wife's than might have been the case in Burne-Jones. Stanhope uses draperies to emphasize the contorted death struggle of Procris. *Cephalus and Procris* presents a stereotype of female nature, woman's jealousy, in a universalizing context.

Stanhope became a regular exhibitor at the Grosvenor Gallery on its opening in 1877. This circumstance challenged him to define his art against the hero of the gallery, Burne-Jones. In 1883 Stanhope showed *Charon and Psyche* (Plate 2-42), at the Grosvenor. Undoubtedly inspired by Burne-Jones's *Cupid and Psyche* series, the episode shows Psyche offering the coin to an aged Charon. As the *Athenaeum* remarked, the length of Charon's arm is beyond correct anatomy, but the picture effectively conveys Psyche's daring and apprehension. Charon is unmoved by her, an effective handling of the legend. Stanhope's individualizing of Burne-Jones's style rests on his manipulation of design and treatment of color. His tendency to paint allegorical subjects distinguishes him from Burne-Jones, who focused on series of myths. Stirling notes that "Stanhope must be regarded primarily as a unit of a great whole, a supporter of a movement which was epoch-making in the latter-day history of Art. . . . It is true that a similar ideal appealed to both Burne-Jones and Stanhope, but the work of the former is essentially Greek in character, that of the latter is Florentine" (*Painter of Dreams* 340–342). Stanhope's strength rested in his coloring rather than in his technique, but he evolved through long residence in Italy an amalgamation of the classical and the Florentine that remains individual.

John Melhuish Strudwick was a studio assistant for both Stanhope and Burne-Jones, during which time he developed his practice of using classical motifs for mythological and allegorical figures. In 1891 George Bernard Shaw emphasized the importance of Strudwick's *Passing Days* of 1878, a frieze/processional canvas. A youth is seated on a throne viewing the procession of the days of his life, represented by women in classical draperies. Time, interposing his scythe, prevents the man from reaching the bygone days of his

youth, while Love hovers watching the scene in despair. The future days, finally including the figure of Death, prepare to pass before him. Behind the procession is a sculptured classical frieze of the various incidents of the man's life. Shaw noted, "As a pictorial poem, this subject could hardly be surpassed" ("J. M. Strudwick" 101).

In *Passing Days,* the women are associated with the fleeting beauty of life that leads to death. Only in a work like the 1880 *Marsyas and Apollo,* showing an anguished, defeated, androgynous Marsyas, does Strudwick depict men in any conflict, and here their competition is specifically artistic. Strudwick is more successful with the 1886 *Circe and Scylla.* The canvas shows Circe squeezing poison into a stream as the luckless Scylla comes to bathe. Circe appears a malevolent deity, while Scylla is the chaste innocent going to her doom. Strudwick's enchantress is not the devouring femme fatale but the mature woman indifferent to the consequences of her magic. In *Circe and Scylla,* however, Strudwick does unite the two polarities of pictorial representation of women in the nineteenth century, the chaste innocent and the sensuous woman gifted with magical but fatal power.

The decline of the tradition of Burne-Jones appears in the works of such painters as Evelyn De Morgan and Sidney Meteyard. Evelyn De Morgan was the pupil of her uncle Spencer Stanhope and thus inherited the Burne-Jones tradition. Her work takes the form of allegories or occasionally mythological figures. The allegories exhibit attention to drapery and design (often too architectonic) and melodramatic posing, as in *Hope in the Prison of Despair,* showing an androgynous figure bringing light to the crouching female. De Morgan's single figures generally avoid the excess of the allegorical canvases. *Ariadne in Naxos* (1877) (Plate 2-43) exhibits the influence of Leighton rather than of Burne-Jones, as the figure of the abandoned woman fills the canvas. The simplicity of the drapery and the silhouette of the face convey the tragedy with restraint. *Luna* (1885) (Plate 2-44) is one of the century's most convincing representations of woman as Artemis/Selene. The female is conceived as a goddess, not swooning over Endymion but aloft on the crescent over the world, the supreme deity of the universe, not dependent on the masculine sun.

In *Clytie* (1886–1887) the woman is being metamorphosed into a sunflower, her hands clasped to her head. The figure has none of the splendor of Leighton's depictions nor the power of Watts's sculpture, but its treatment domesticates the suffering of the unloved woman. In *Deianira* (1878) De Morgan depicts the wife of Heracles, presumably after the death she caused by

sending him the shirt poisoned with the blood of Nessus. The wife's jealousy is a theme presented by Spencer Stanhope in *Cephalus and Procris*. It is repeated effectively by De Morgan by silhouetting the woman against the sky, the drapery waving above her head. De Morgan did a *Medusa* pastel in 1885, showing Medusa as beautiful rather than seductive, an alternative reading to the depiction of Burne-Jones. In the same year De Morgan completed a gouache, *Hero Awaiting the Return of Leander*. Swathed in green drapery, the priestess is shown holding a torch on a rocky ocean projection, searching for Leander. The awkwardness of the drawing of the right arm detracts from the composition. De Morgan chooses a tense dramatic moment, which the body's modeling indicates, but the face lacks the anguish of Leighton's depiction two years later.

Sidney Meteyard used the Burne-Jones tradition to present effete young men. In the *Orpheus,* the poet sits in a glade, with long naked legs and thin chest, staring to his left. *Eros* (c. 1902) (Plate 2-45) is a canvas of a languid ephebe staring seductively at the viewer while lounging on a couch. Meteyard's effeminate characters suggest the waning of masculine muscular Christianity in favor of aesthetic weakness. The *Venus and Mars* shows Ares in convoluted draperies eyeing the overdecked Aphrodite beside him. The canvas has a static quality which destroys the vitality of narrative impulse. With Meteyard and De Morgan, the Burne-Jones tradition survived into the twentieth century, in the process losing its significance. These canvases signal the decline of the classical Burne-Jones conceptions into manneristic productions.

The art of Edward Burne-Jones in its origins embraces the tradition of the Pre-Raphaelites and G. F. Watts. No other classical-subject artist so incorporated earlier nineteenth-century movements and in turn produced a legacy so extensive. Burne-Jones's friendships with Rossetti, Crane, and Stanhope indicated the comprehensive nature of his contacts with predecessors and successors in the tradition. Rossetti's fallen woman in *Found* is metamorphosed to the lethal Medusa of the *Perseus* series, who in turn finds a pale successor in Strudwick's *Circe and Scylla*. Strudwick synthesizes the styles of the two men for whom he worked, Burne-Jones and Stanhope. This debased form of Burne-Jones's classical-subject art inspired the early work of Aubrey Beardsley and the later tradition of Art Deco. The Elgin Marbles revered by Watts passed through the conceptions of Burne-Jones, Stanhope, and Strudwick to find ultimate extension in the engulfing draperies of a later movement in the twentieth century. In the interval, another form of classical-subject art arose—that

of the greatest president of the Royal Academy after Reynolds, Frederic Leighton. With his grasp of both painting and sculpture, Leighton gave the classical-subject tradition prominence and force during the last three decades of the nineteenth century. The scale of his selective mythic ideograms increased the message of the fearsome nature of women.

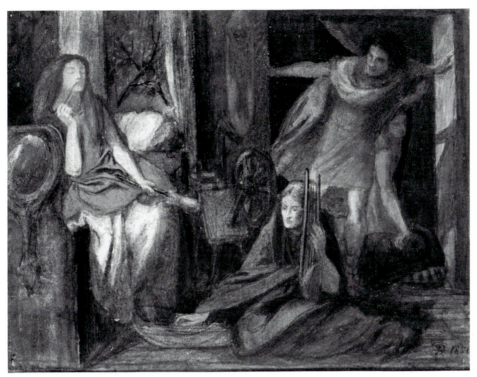

2-1. Dante Gabriel Rossetti: *The Return of Tibullus to Delia,* 1851; watercolor; 9 × 11½; photo: Sotheby's Belgravia.

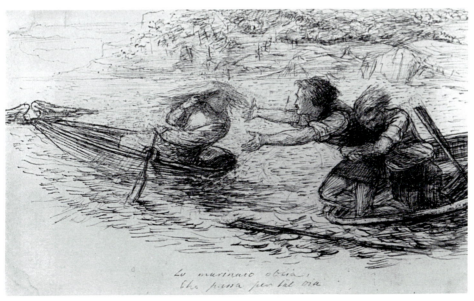

2-2. Dante Gabriel Rossetti: *Boatmen and Siren,* 1853; ink on paper; 4 × 7¼; Manchester City Art Gallery.

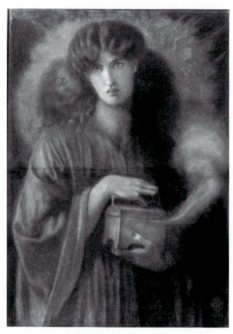

2-3. Dante Gabriel Rossetti: *Pandora*,
1869; chalk on paper; 39⅝ × 28⅝; The
National Trust, Buscot Park.

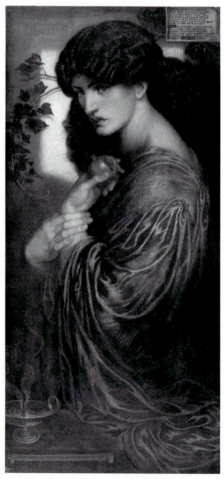

2-4. Dante Gabriel Rossetti:
Proserpine, 1877; 46 × 22; Manchester
City Art Gallery.

114

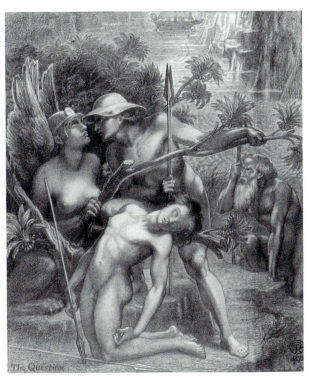

2-5. Dante Gabriel Rossetti: *The Question,* 1875; pencil; 18¾ × 16; Birmingham City Art Gallery.

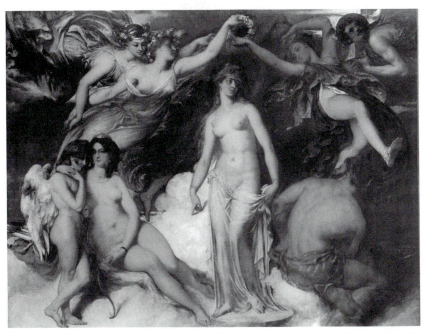

2-6. William Etty: *Pandora Crowned by the Seasons,* 1824; 34¾ × 44⅛; City Art Gallery, Leeds.

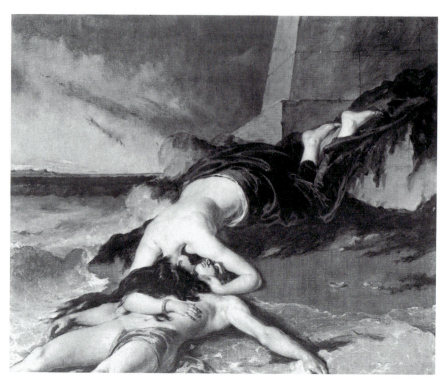

2-7. William Etty: *Hero and the Drowned Leander,* 1829; 30½ × 37¼; Private Collection, on loan to York City Art Gallery.

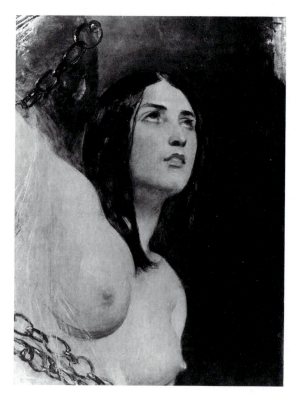

2-8. William Etty: *Andromeda,* c. 1840; 26⅜ × 20; National Museums and Galleries on Merseyside (Lady Lever Art Gallery, Port Sunlight).

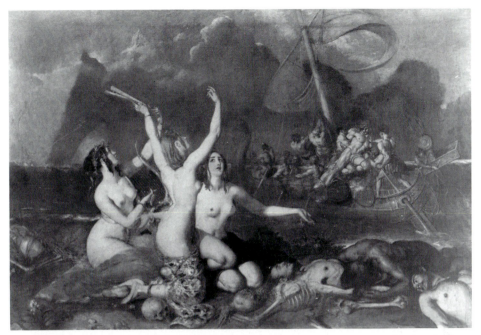

2-9. William Etty: *The Sirens and Ulysses,* 1837; 117 × 174; Manchester City Art Gallery.

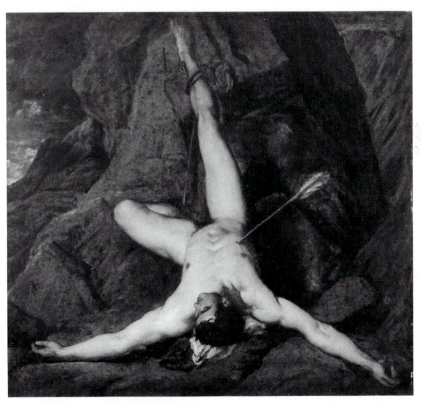

2-10. William Etty: *Prometheus,* 1825–30; 27¾ × 30½; National Museums and Galleries on Merseyside (Lady Lever Art Gallery, Port Sunlight).

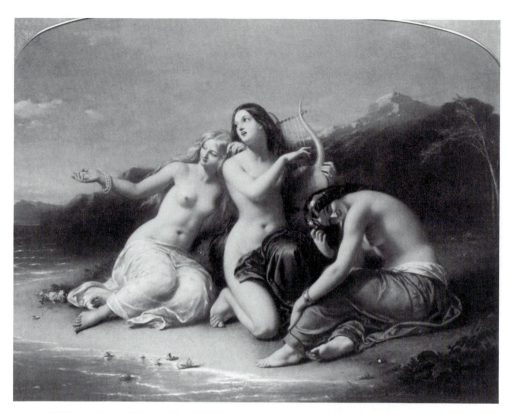

2-11. William Edward Frost: *The Sirens*, 1849; 26 × 34; photo: Sotheby's Belgravia.

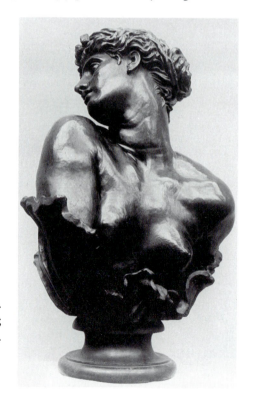

2-12. George Frederic Watts: *Clytie,* c. 1868; bronze; 28 × 23½ × 16½; Leighton House, London.

118

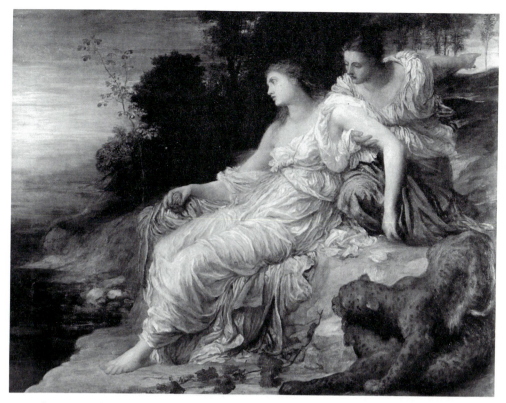

2-13. George Frederic Watts: *Ariadne on Naxos,* 1875; 29½ × 37; Guildhall Art Gallery, London.

2-14. Dante Gabriel Rossetti: *Launcelot and the Lady of Shalott,* 1856; ink on paper; 4¹⁄₁₆ × 3½; Samuel and Mary R. Bancroft Memorial Collection, Delaware Art Museum, Wilmington.

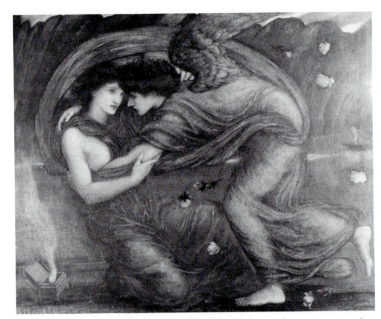

2-15. Edward Burne-Jones: *Cupid Delivering Psyche*, 1867; gouache on canvas; 31½ × 36; Cecil French Bequest, London Borough of Hammersmith and Fulham.

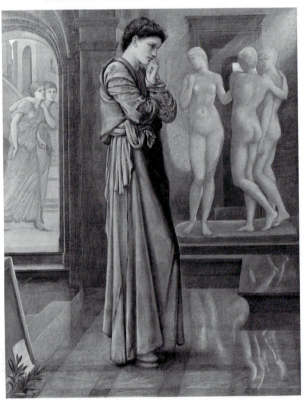

2-16. Edward Burne-Jones: *Pygmalion and the Image I: The Heart Desires*, 1879; 38 × 29½; Birmingham City Art Gallery.

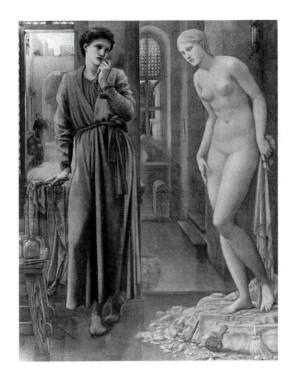

2-17. Edward Burne-Jones:
*Pygmalion and the Image II:
The Hand Refrains,* 1879;
38 × 29½; Birmingham City
Art Gallery.

2-18. Edward Burne-Jones:
*Pygmalion and the Image III:
The Godhead Fires,* 1879;
38 × 29½; Birmingham City
Art Gallery.

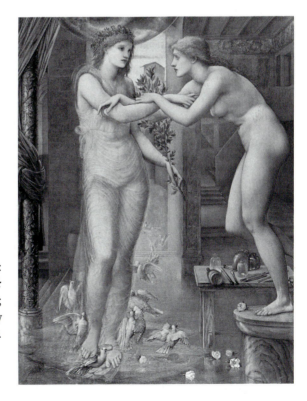

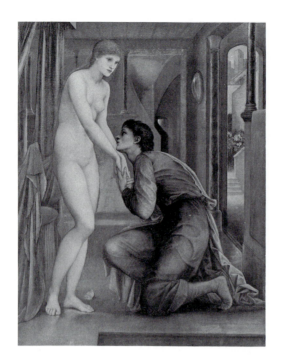

2-19. Edward Burne-Jones:
*Pygmalion and the Image IV:
The Soul Attains,* 1879;
38 × 29½; Birmingham City
Art Gallery.

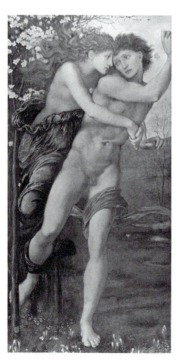

2-20. Edward Burne-Jones: *Phyllis
and Demophoön,* 1870; gouache on
paper; 36 × 18; Birmingham City
Art Gallery.

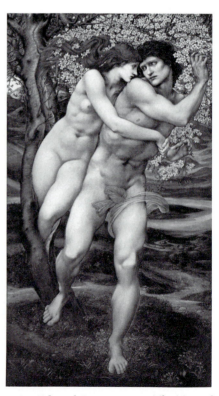

2-21. Edward Burne-Jones: *The Tree of
Forgiveness,* 1882; 75 × 42; National
Museums and Galleries on Merseyside
(Lady Lever Art Gallery, Port Sunlight).

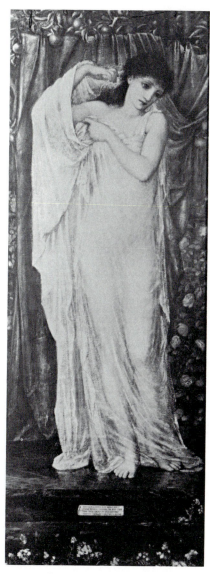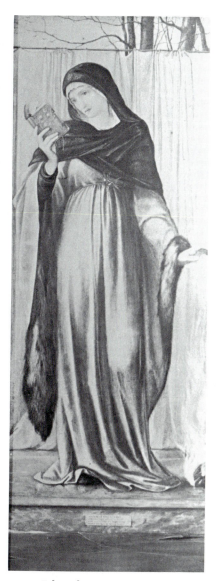

2-22. Edward Burne-Jones: *Summer,*
1870; gouache on paper; 47½ × 17½;
Piccadilly Gallery, London.

2-23. Edward Burne-Jones: *Winter,*
1870; gouache on paper; 47½ × 17½;
Piccadilly Gallery, London.

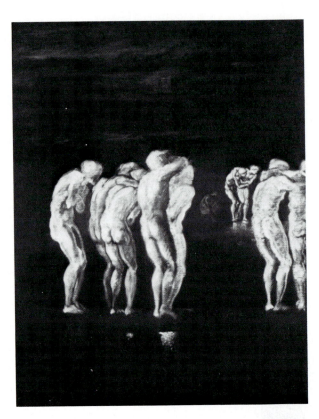

2-24. Edward Burne-Jones:
*Souls on the Bank of the River
Styx,* 1871–72; 35 × 27½;
Peter Nahum, London.

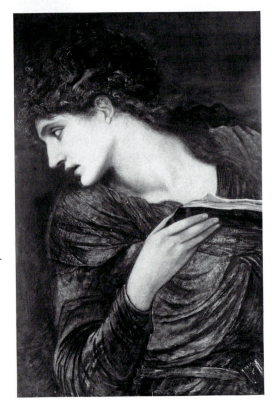

2-25. Edward Burne-Jones: *Head of
Nimuë,* c. 1873; gouache on paper;
30 × 20; Samuel and Mary R.
Bancroft Memorial Collection,
Delaware Art Museum,
Wilmington.

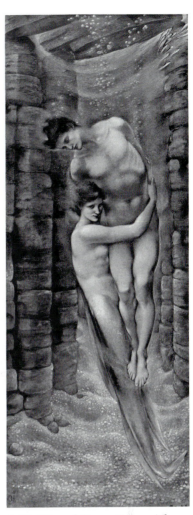

2-27. Edward Burne-Jones: *The Depths of the Sea*, 1887; gouache on panel; 77 × 30; Fogg Art Museum, Harvard, Grenville L. Winthrop Bequest.

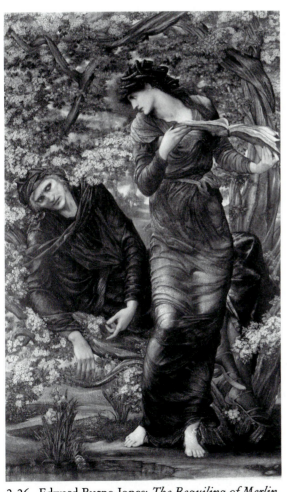

2-26. Edward Burne-Jones: *The Beguiling of Merlin*, 1877; 73 × 43 ¾; National Museums and Galleries on Merseyside (Lady Lever Art Gallery, Port Sunlight).

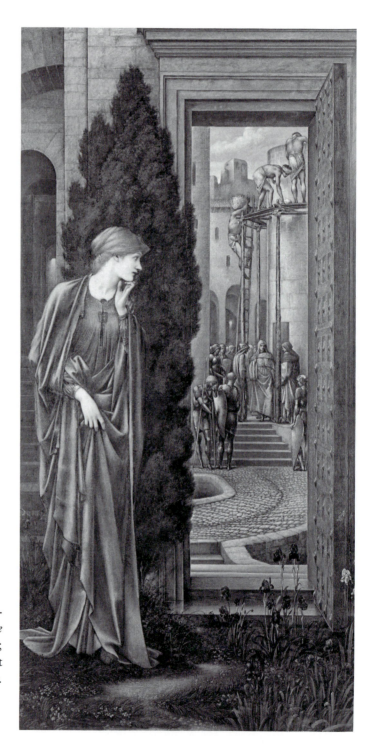

2-28. Edward Burne-Jones: *Danaë and the Brazen Tower*, 1888; 91 × 44½; Glasgow Art Gallery.

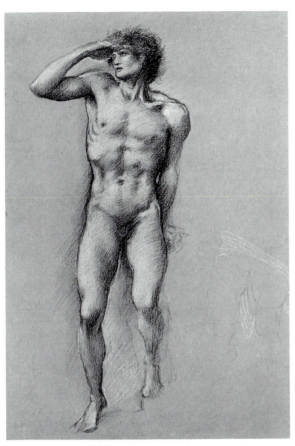

2-29. Edward Burne-Jones: Study for *The Calling of Perseus*, c. 1876; chalk on paper; 19½ × 13; S. Baloga, New York.

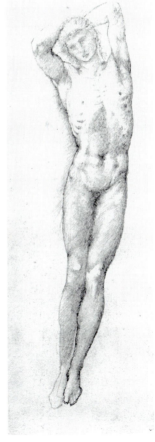

2-30. Edward Burne-Jones: Study of Chrysaor for *The Birth of Chrysaor*, c. 1876; pencil; 10⁵⁄₁₆ × 5¾; Sketchbook E. 1613–1926, fol. 4v, Victoria and Albert Museum, London.

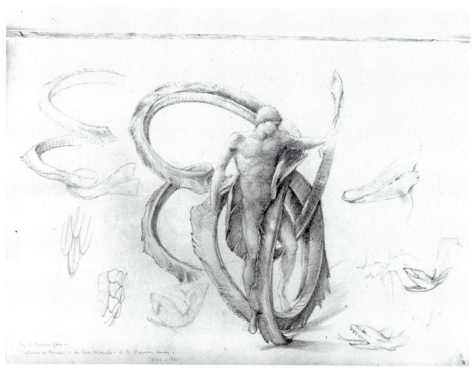

2-31. Edward Burne-Jones: Study of Perseus for *The Doom Fulfilled,* 1880s; pencil; 10 × 14⁷⁄₁₆; Sketchbook 962, fol. 14r, Fitzwilliam Museum, Cambridge.

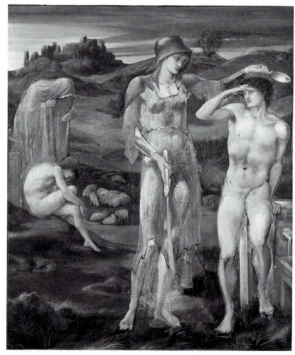

2-32. Edward Burne-Jones: *The Calling of Perseus,* unfinished; 60½ × 50¼; Staatsgalerie Stuttgart.

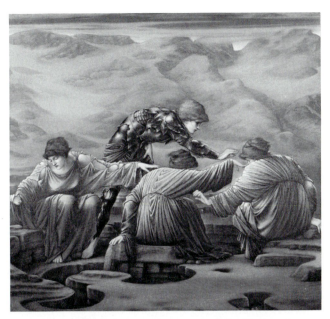

2-33. Edward Burne-Jones: *Perseus and the Graiae*, 1892; 60½ × 67; Staatsgalerie Stuttgart.

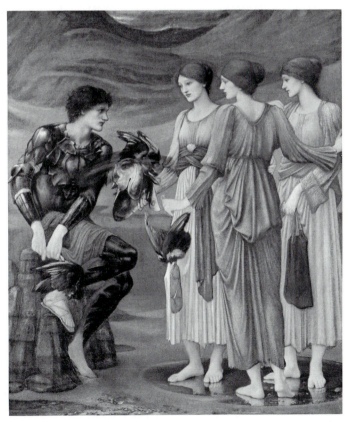

2-34. Edward Burne-Jones: *The Nymphs Arming Perseus*, unfinished; 60 × 54; Staatsgalerie Stuttgart.

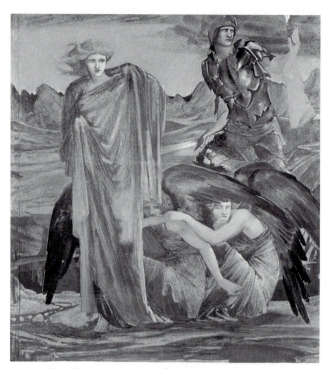

2-35. Edward Burne-Jones: *The Finding of Medusa,*
unfinished; chalk and gouache on paper; 60 × 54⅛;
Staatsgalerie Stuttgart.

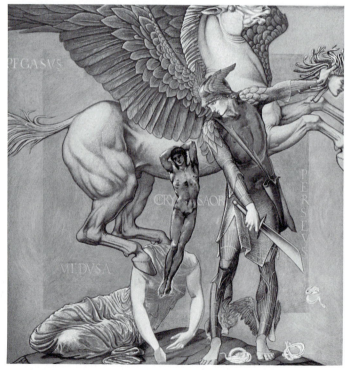

2-36. Edward Burne-Jones: *The Birth of Chrysaor,* 1877;
gouache on paper; 48½ × 46; Southampton City Art Gallery.

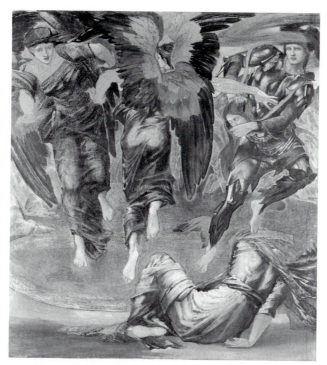

2-37. Edward Burne-Jones: *The Death of Medusa*, unfinished; chalk and gouache on paper; 60 × 54⅛; Staatsgalerie Stuttgart.

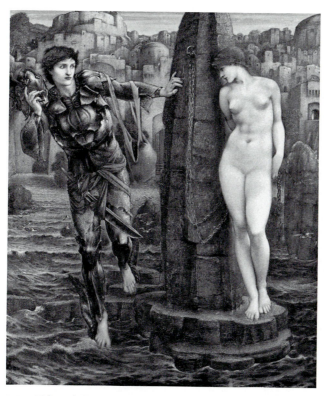

2-38. Edward Burne-Jones: *The Rock of Doom*, 1888; 60 × 51¼; Staatsgalerie Stuttgart.

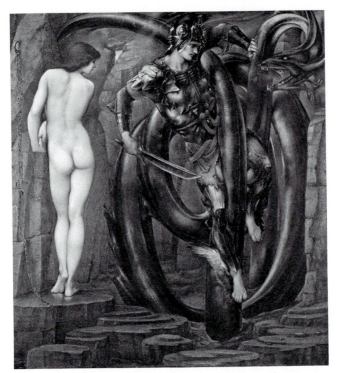

2-39. Edward Burne-Jones: *The Doom Fulfilled*, 1888; 61 × 55¼; Staatsgalerie Stuttgart.

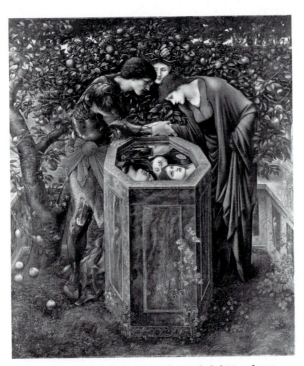

2-40. Edward Burne-Jones: *The Baleful Head*, 1887; 61 × 51¼; Staatsgalerie Stuttgart.

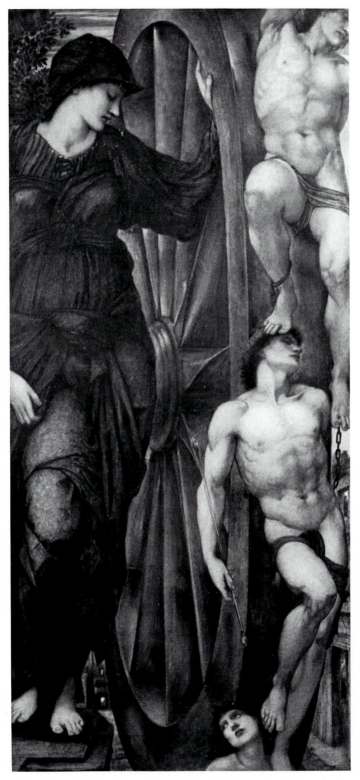

2-41. Edward Burne-Jones: *The Wheel of Fortune*, 1886; gouache on canvas; 45 × 21; Cecil French Bequest, London Borough of Hammersmith and Fulham.

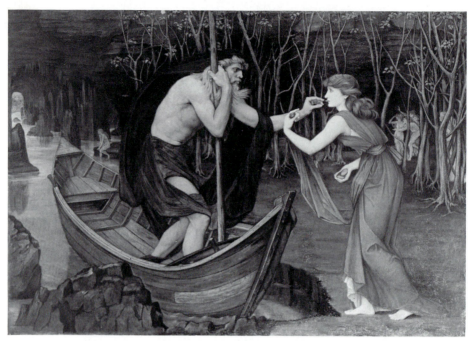

2-42. John Roddam Spencer Stanhope: *Charon and Psyche*, 1883; 37 × 53; photo: Sotheby's Belgravia.

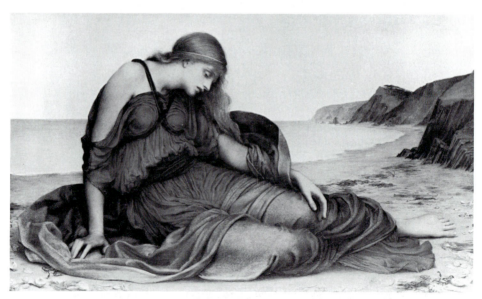

2-43. Evelyn De Morgan: *Ariadne in Naxos*, 1877; 23¾ × 38¼; De Morgan Foundation, London.

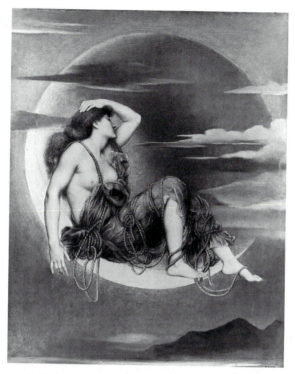

2-44. Evelyn De Morgan: *Luna,* 1885; 28¾ × 22; De Morgan Foundation, London.

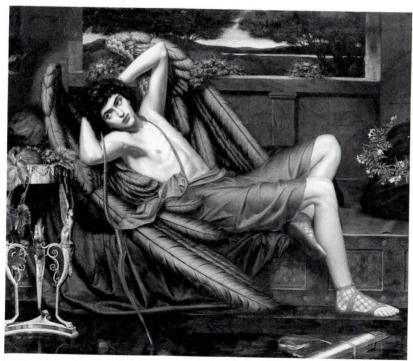

2-45. Sidney Meteyard: *Eros,* c. 1902; 34 × 41½; photo: Piccadilly Gallery, London.

↣ THREE ↤

Frederic Leighton, Albert Moore, and the Emergence of the Victorian High Renaissance

FREDERIC Leighton (1830–1896) was one of the greatest proponents of the classical style in nineteenth-century British painting. This was true not only because of the qualities of his art but also because of the prestige conferred by his continental education and by the position he occupied as president of the Royal Academy from 1878 until his death. Leighton's work is doubly classical, not only in using Greco-Roman material but also in depicting it in the style of painting one designates as classical, marked by sensitivity to line and clarity of execution. Although many artists in the classical-subject tradition used mythical material, few were classical in their manner of execution. Burne-Jones was influenced by Botticelli, other artists by *pleinairisme.* With Leighton, however, the classical tradition appeared in both subject and technique.

As president of the Royal Academy, Leighton delivered a series of addresses that, along with the *Lectures* of Edward Poynter, express the theoretical position of the practitioners of classical-subject painting during the era. Because of Leighton's prominence and his conspicuous gifts, his portrayals of women are serious elements in the discussion about the nature and role of women during the period. Leighton's paintings, so brilliant in their effects of form and color, cannot be evaluated solely as decorative art. Leighton presented his iconography of women on a frequently grand scale, in canvases imitating classical friezes. In his studio there ran a reproduction of the Parthenon frieze. Many of his images of victimized women, heroic men, or intimidating females were large in scale, increasing their correspondence to the eternality and universality of the myth itself. The focus on certain myths, the concen-

137

tration on a particular dimension of that myth, the similarity in the mythic situations selected for depiction, all compel serious attention. Leighton's life, his personal qualities and affiliations, intersect with the cultural predisposition regarding women. Throughout his career, Leighton used the classical subject as a social commentary. The source in his life of this generally suspicious or even hostile attitude to women may be construed from his discourses, letters, and personal qualities.

I

Leighton's allegiance to Greco-Roman culture rose from the circumstances of his upbringing. F. G. Stephens, who knew the painter well, observed Leighton's "unwavering love for his ideal, which is essentially Greek of a pure type and strain. . . . In every one [of Leighton's canvases] the Greekish strain and chastity are manifest, nay, in the very style, type, and casting of the drapery studies . . . that art-strain which is Greek runs through them. [His] drapery studies . . . irresistibly remind students of the robes of the so-called Fates, carved by Phidias for the Parthenon" (Rhys, *Sir Frederic Leighton* xviii–xix). Leighton's sources of inspiration for his canvases reflect this inclination to ancient art: the Erechtheum Caryatid for *Clytemnestra;* the Borghese Warrior for *Hercules Wrestling with Death;* the Laocoön of Leochares (with the head of Michelangelo's *David*) for the bronze *Athlete Struggling with a Python;* the Hermes of Praxiteles for the *Boy with a Shield Holding a Vase;* the Apollo Belvedere for *Daedalus and Icarus;* the Fates for the women in *An Idyll* or *The Garden of the Hesperides;* the Venus Anadyomene for *Phryne at Eleusis;* the Venus Kalipigge for *The Bath of Psyche;* the raised foot of Polykleitos' Diadumenos for *Jonathan's Token to David.*

Leighton declared in his first Academy address in 1879: "In Sculpture the most memorable evolution is that which the fifth century saw in Greece" (*Addresses* 7). For him Athenian art was "the serenest and most spontaneous men have ever seen" (4). The classical world was a world of certainty and symmetry: "The questioning spirit is now abroad, it asserts itself on all sides, and is paramount; it leaves nothing unassailed, takes nothing for granted, calls every belief to account, casts everything into the balance. . . . We are the children of our time, we breathe perforce the intellectual atmosphere in which we move" (5). The Greek spirit was distinctly "Aryan" to Leighton. In Periclean Athens, there was "a new ideal of balanced form wholly Aryan, and of which the only parallel I know is sometimes found in the women of another Aryan race—

your own" (89). Leighton's art is a part of the great classical revival that touched figures like Walter Pater and Matthew Arnold during the century.

Through the training of his father, Leighton was decidedly proficient in Latin language and literature and knew Greek. Leighton's father was "well read in the classics," and Leighton as a student was "especially fond of the stories of classic literature" (Williamson, *Frederic, Lord Leighton* 1-2). Leighton's library at his death indicates the extraordinary range of his classical scholarship. Classical authors included Apuleius, Horace, Plato, Longus, Vergil, and Sappho. Leighton's grasp of ancient architecture is attested by volumes such as Lloyd's *Age of Pericles*, Stahr's *Torso*, Middleton's *Ancient Rome*, Murray's *Handbook of Greek Archaeology* and *History of Greek Sculpture*, Perrot and Chipiez's *Histoire d'architecture*, J. T. Wood's *Discoveries at Ephesus*, and C. R. Cockerell's *Temples of Jupiter Panhellenius at Aegina and of Apollo Epicurus at Bassae*. Other works included Flaxman's *Lectures on Sculpture*, Gibbon's *History of the Roman Empire*, Grote's *History of Greece*, Landor's *Pericles and Aspasia*, Symonds' *Studies of the Greek Poets*, and Smith's *Dictionary of Greek and Roman Antiquities*. Leighton's knowledge of Greek and Latin literature was linked with a specific knowledge of certain types of ancient art, such as vases, and specific excavations, such as those at Ephesus or Aegina. This interest in contemporary theory about the ancient world was reflected in several of his addresses on aesthetic subjects in the later part of his life.

Greek art, whatever the intangible ethics it may contain, was in essence the paradigm of art. Greek art was an intensification of beautiful form: "the intensification of life it was which . . . called Art into existence" (14). In this respect, Leighton's art challenged Ruskin's precepts. In the 1881 discourse he refuses to acquiesce to Ruskin's denunciation of the Dutch painters. "Now the language of Art is not the appointed vehicle of ethic truths; of these . . . the obvious and only fitted vehicle is speech, written or spoken" (55). The "duty" of art is to operate through "association of ideas. . . . You will find . . . that, through this operation of Association, lines and forms and combinations of lines and forms, colours and combinations of colours have acquired a distinct expressional significance, and, so to speak, an *ethos* of their own" (56-57).

Art is characterized by the "intensification of the simple aesthetic sensation through ethic and intellectual suggestiveness" (56-57). "Whilst the inculcation of Moral and Religious truths must be admitted not to be the object of Art, as such, nor moral edification its appointed task, it is not therefore

true, as some would have us believe, that the Artist's work is uninfluenced by his moral tone" (61). Leighton's doctrine of associationism parallels the expectations of reviewers. As a catalyst for this associationism, classical mythology, selectively presented to advance a political and personal ideology, accommodated Leighton's objective with extreme precision. To explore the nature of this "intensification," one of the great catalytic functions of myth, and the "ethic and intellectual suggestiveness" of Leighton's art requires a multivalent cultural investigation. Leighton's disposition to certain mythical materials was conditioned by his complex responses to sexuality.

Leighton was a man who suffered from nervous strain throughout his life. Barrington records: "Then there was the third aspect of Leighton, the Leighton at times half-hidden from himself; the yearning, unsatisfied spirit, which, though subject at times to great elevations of delight, at others was also the victim of profound depressions and a sense of loneliness" (*Life* 1.10). Shortly before his death Leighton exclaimed, "Oh, what a disappointing world it is!" (1.10). From Germany Leighton wrote his father in 1848, complaining "of the intense irritation which bad sitting . . . occasions to my nerves" (1.44). During his stay in Paris in 1855 he was constantly nervous. Richard and Leonée Ormond conclude that his concern for his eyesight was "essentially psychosomatic" (*Lord Leighton* 16). In 1857 at the age of twenty-six, Leighton wrote his sister a letter outlining a schizophrenic realization: "And yet what I have said of my feelings, though literally *true,* does not give you an exactly true notion; for, together with, and as it were behind, so much pleasurable emotion, there is always that other strange second man in me, calm, observant, critical, unmoved, blašé—odious! He is a shadow that walks with me, a sort of nineteenth-century canker of doubt and discretion; it's very, very seldom that I forget his loathsome presence" (Barrington, *Life* 1.viii–ix).

This presence had much to do with his father and with his mother. Leighton's father was domineering and overbearing. Barrington recorded: "It must always remain, to say the least, a questionable advantage to a student of art that his intellectual faculties should be forced forward at the expense of the development of his more emotional and ingenuous instincts" (*Life* 1.18). Leighton's bitterness is apparent in a letter he wrote to his mother in 1853, when his father was restricting his money:

> I can say nothing more myself to Papa, since he has given me to understand that his reason is want of confidence in me. . . . I confess I do not feel much flattered that this feeling should have so penetrated him as to make him fall back from me

on an occasion so momentous as the painting of my first exhibiting picture, a moment critical in my career. . . . Is it this doubt that makes him throw obstacles in my way? . . . Now, if I, like so many other young men, had gone into the army, he would not—for what father does?—have hesitated for a moment to provide me with my complete outfit . . . but now that I am girding myself for a far greater struggle, now that I am about, single-handed, to face the bitter weapons of public criticism, does he withhold the sword with which he might arm me, for fear I should waste my blows on the butterflies that pass me as I march into the field? At two and twenty I am still in his eyes a schoolboy. (1.135–136)

Leighton's references to the sword and single combat are consonant with nineteenth-century male conceptions of masculine heroism. This letter reveals that Leighton felt that his father weakened rather than strengthened him. Leighton recognizes that his father does not regard his profession as masculine, as the concluding remark about butterflies indicates.

The anger is not only that his father would not finance him at a crucial moment. It arises because he perceives that his father does not think him masculine. One result of this sense of inadequacy was a strengthening of Leighton's resolve. A memoir published in the *Times* on 28 January 1896 observed: "His most marked characteristic was his conviction not only that he would succeed, but that he deserved success," a trait evident in 1854 ("Late Lord Leighton"). His close friend Giovanni Costa noted, "He had little of that which is unforeseen in his work" ("Notes on Lord Leighton" 381), which was an additional result of his father's doubts; Leighton would leave nothing to chance. Costa continues: "This absence of life-giving sustenance is not felt in his studies, in which he is directly in touch with nature" (383). Leighton repressed emotional expression before undertaking a final composition design, caution having become equal with creation. Distrust of his father made him calculating throughout his life.

Throughout Leighton's career, nevertheless, critics referred to the femininity of his works. This sexual ambiguity underlies many of his massive female figures, such as those of *Fatidica, Clytemnestra from the Battlements of Argos Watches for the Beacon Fires Which Are to Announce the Return of Agamemnon,* or *Electra at the Tomb of Agamemnon,* who appear "masculine" in build, as critics recognized. The money Leighton received for *Cimabue's Madonna,* bought by the queen in 1855, was deposited in his father's account. As late as 1864, when Leighton intended to purchase property for a home, he had to justify the action to a skeptical father. "As to the possible expense of the house, my dear Papa, you have taken, I assure you, false

alarm" (Barrington, *Life* 2.115). At one point Leighton's father criticizes his use of mythological sources as a sign the artist lacked invention. Leighton was forced to respond: "I do not think honestly that the choice of a mythological subject like Orpheus shows the least poverty of invention, a quality, I take it, much more manifested in the manner of treatment than in the choice of a moment" (1.244). On both personal and professional accounts, Leighton's father was psychologically damaging to his son.

Leighton's mother was equally adept at irritating her son. In 1853 he wrote her: "How could you for one instant suppose that I could suspect you of coldness toward me? I was quite distressed that you should have entertained such an idea" (Barrington, *Life* 1.137). In 1854 Mrs. Leighton complained to him: "I cannot help feeling a little disappointed when you do not answer my inquiries. I do not wish to be unreasonable, my darling, in my demands on your time, but I cannot bear that your letters should be mere unavoidable monthly reports" (1.44). She could give him religious advice, calculated to increase guilt: "I beseech you, do not suffer your disbelief in the dogmas of the Protestant Church to weaken the belief I hope you entertain of the existence of a Supreme Being." This advice was continued by the following: "I can but repeat what I have continually told you—to refine your feelings you must neither utter nor encourage a coarse thought" (1.57–58). In 1859 at the age of twenty-nine, Leighton wrote his mother: "You see, dear Mammy, you need not be so uneasy. I fully appreciate your and Papa's anxiety about my pictures; but it has too great a hold on you when it makes you think that I am entirely reckless and foolish" (2.46). As a result of his upbringing, it is not difficult to perceive the "other man" haunting Leighton as an exacting superego humiliating the ego with its sexual and artistic demands.

When Leighton became part of the circle of Adelaide Sartoris in 1854 at Rome, he encountered some interesting variations among her friends, particularly Charles Hamilton Aïdé. Aïdé, according to one source, had a "precieux manner of speech, more like a woman's than a man's" (Ormond and Ormond, *Lord Leighton* 22). Henry Greville, whom Leighton met in Paris in 1856, adopted "Fay," Mrs. Sartoris' nickname for Leighton, in their correspondence. Leighton himself was given to adopting young men, such as John Hanson Walker, whom he painted in an androgynous fashion in such canvases as *Duett* (1862). In a painting like *Lieder ohne Worte* (1861), Leighton included an androgynous figure as the area of interest. Leighton's association with Mrs. Sartoris led him to write in 1855: "I feel terrified at the idea of how much more exacting she has made me for the future choice of a wife, by show-

ing one what opposite excellencies a woman may unite in herself" (Barrington, *Life* 1.176). Leighton seems to realize Mrs. Sartoris' imperfections, but she still remains an ideal. The terror was to last a lifetime. Leighton wrote his mother: "If I don't marry, the reason has been that I have never seen a girl to whom I felt the least desire to be united for life. I should certainly never marry for the sake of doing so" (2.56). In 1860 he had told his mother: "I would not insult a girl that I did not love by asking her to tie her existence to mine, and I have not yet found one that I felt the slightest wish to marry: it is no doubt ludicrous to place this ideal so high, but it is not my fault—theoretically I should like to be married very well" (2.56). His mother had begun to accept the fact that Leighton would not marry. Her own impossible expectations, coupled with those of his father, caused Leighton to distrust his judgment.

II

Throughout his life, Leighton avoided intimacy. In 1892, Henry James published a story, "The Private Life," in which the two central male characters, Lord Mellifont and Clare Vawdrey, are supposed to imitate Leighton and Robert Browning. James's story describes Mellifont thus: "He *was* first—extraordinarily first. I don't say greatest or wisest or most renowned, but essentially at the top of the list . . . it was not possible for him to be taken—he only took" (221). "He had never in his life needed the prompter—his very embarrassments had been rehearsed. . . . He *was* a style" (226–227). "He was all public and had no corresponding private life" (246). The characters finally realize: "He's there from the moment he knows somebody else is" (254). Richard and Leonée Ormond define Leighton's sexual nature as "homoerotic," similar in this respect to Henry James's (*Lord Leighton* 48), citing the good-looking Italian models like Alessandro di Marco and Angelo Colorosi, plus the young men, such as John Hanson Walker, Leighton supported, as evidence of his suppressed sexual inclinations. The *Studio* published Wilhelm von Gloeden's photographs of nude Sicilian youths as classical ideals in 1893, and Peter Webb believes that these "had a strong appeal for artists such as Leighton" (*Erotic Arts* 189). Pearsall contends that "there is support for . . . the tradition that during the Oscar Wilde trial in 1895 Leighton left the country to avoid being involved," (*Worm* 622–623) although Leighton was an ill man that year. Leighton wrote his sister in May 1895 a letter subject to varying interpretation; "I am grieved that you should have been worried—as well

you might—by that idiotic report that I should not return to society or my profession (I wonder who invented it!), but you were fortunately soon relieved" (Barrington, *Life* 2.322).

The massive scale and masculinity of Leighton's women, as in *Clytemnestra from the Battlements of Argos* and *Electra at the Tomb of Agamemnon,* reflect a latent fear of women. Repulsion is the only term to describe the expression with which Orpheus pushes aside Eurydice in the 1864 canvas. Leighton persistently was unable to color the female nude in a convincing manner. Frequently, as in *Actaea, the Nymph of the Shore,* the draughtsmanship is ugly and the figure distorted. Many reviewers found the flesh of Leighton's women waxy and insubstantial, surprising since he had spent so much time in Florence mastering the drawing of the nude under the guidance of Giuseppe Bezzuoli and Benedetto Servolini at the Accademia delle Belle Arti in 1845. In a canvas like *At the Fountain,* the flesh has a greenish cast distinctly cadaverous.

Spielmann admitted in his essay on Leighton in 1896 that Leighton "never did sufficiently free himself from [the corrupting influence of Florentine flesh-painting], and that his rendering of flesh, which at the end became more imperfect than at any time during his middle career, reproduced in his age the evil training of his youth" (202). It is difficult to believe that Leighton's treatment of women's flesh could not after so long a career have avoided the deathlike hue or sickly pale cast of many of his canvases. The *Spectator* frequently cited the flesh painting as "beautiful waxwork," while the *Times* felt that Leighton's "polishing and smoothing down . . . have given a lifeless look to many of the pictures painted in his last period." Reviewing the retrospective exhibition of Leighton's work in 1897, the *Athenaeum* felt that "the work reminds us less of actual life than of an elaborate Greek bas-relief." One critic felt that Leighton "had surrendered himself to feeling with the organs of a dead Greek" (Corkran, *Frederic Leighton* 182–183, 186). Harry Quilter, art critic of the *Times,* wrote in 1883 that from 1875 on, for Leighton "women and waxwork were to form his ideals" (28). This trait, so universally recognized, of treating female flesh as diseased or dead suggests an aversion that Leighton could not camouflage.

As a result, Leighton's work was felt to be unemotional, lacking in spontaneity and individuality, as Corkran observes. Williamson asserted in 1902: "One is disposed to wish that he had been more passionate" (*Frederic, Lord Leighton* 24). Leighton's suppressed hostility is evident in the very lack of attention to anatomy. In the case of *At the Fountain* the tracings at the Royal

Academy do not exhibit the peculiar anatomy of the final canvas. The fore-shortening of the *Bacchante* is more successful in the tracing than in the canvas of 1892. In the tracing for *Perseus and Andromeda*, Andromeda's face is clear, unlike her visage in the final canvas. In the tracing for *Vestal*, the woman's face is slightly turned to the left and more stern than in the final canvas. The androgynous nature of Leighton's conceptions may be judged from the fact that the first drawings for *Flaming June* were taken from a male model.

There is a phallicism in several of Leighton's tracings that suggests a latently homosexual focus. In the completed *Fisherman and the Syren* (1858), the loincloth is used to emphasize the sailor's genitals. The tracing for *Boy with a Shield Holding a Vase* (1869) again uses the drapery to suggest a large phallus. The most conspicuous form of this phallic emphasis is in the bronze *Athlete Struggling with a Python* (1877) (Plates 3-1, 3-2), the model for which was Angelo Colorosi. Seeing the work at the Academy, Henry James recorded: "It is a noble and beautiful work. . . . Whenever I have been to the Academy I have found a certain relief in looking for a while at this representation of the naked human body, the whole story of which begins and ends with the beautiful play of its muscles and limbs. It is worth noting . . . that this is to the best of my recollection the only study of the beautiful nude on the walls of the Academy" (*Painter's Eye* 149). This was a particularly explicit nude. Although most photographs do not indicate it, in fact the athlete is totally naked, with the python winding between the man's legs. The contrast between the large cylinder of the writhing snake and the comparatively small penis is evident. The fact that the serpent nearly crushes the genitals may represent the guilt Leighton associated with sexuality. The snake itself is the gigantic phallus that is part of some homoerotic fantasies. Leighton could scarcely be innocent of the sexual force of his canvases. He was, for example, a close friend of Richard Burton, the translator of the *Arabian Nights* and the anatomist of Eastern sexual practices. (Burton was known to have circulated photographs of naked European women for the African chieftains with whom he associated.) Leighton painted a famous portrait of Burton in 1876.

The *Athlete* celebrates masculine power in a comprehensive image. Wrestling with the python was the role of Apollo, the sun-god and representative of the masculine principle in mythology. The serpent Python in mythology was sent by the goddess Hera to destroy Leto, Apollo's mother, at the moment of his birth, an attempt foiled by Poseidon. The most striking element of the legend is that the Python was female. When Apollo had slain the creature, he condemned it to "rot," from the Greek verb *pytho*. The location of this

struggle was called Pytho, later Delphi. Leighton's *Athlete* embodies the triumph of the masculine sun/Apollo as well as the anxiety that the female might appropriate the phallus or become the phallus. (In drawings for the later *The Garden of the Hesperides,* the serpent appears to rise like a gigantic phallus from between the legs of the sleeping woman.) The injunction to "rot" or "decay" exhibits the same contempt for the female body as the diseased flesh tones of some of Leighton's women. Reverence for this hypermasculine solar deity is evident in many of Leighton's canvases, including *Daedalus and Icarus, Helios and Rhodos, The Daphnephoria,* and *Clytie.* These paintings contain elements of worshiping the sun/male, whose hair/rays indicate phallic power, the alternative to the snake-haired castrating Medusa. Leighton's worship of Apollo as the sun is a form of Aryan and masculine assertion. An acquaintance in Rome described Leighton as having "the form and features of a Greek god, nor wanting either, the tower of ambrosial curls of the Apollo" (Ormond and Ormond, *Lord Leighton* 25). Hersey notes that Leighton advocated "a recurring Phidian racial type" as the model for his students ("Aryanism" 108), a type Leighton in his *Addresses* identifies as Aryan. Stephen Jones has noted the "racial characteristics" ("Attic Attitudes" 36) of Leighton's theories, which revere Greek art. Worship of the sun and Aryanism are associated because the Aryans were thought to have followed the path of the sun, migrating westward from central Asia. It has been previously observed that, as Léon Poliakov notes, in the nineteenth century "the true Aryan appeared to be a Westerner of the male sex" (*Aryan Myth* 272). Greek art embodied Aryan characteristics, and Apollo embodied the most intense Aryan/masculine linkage. (Benjamin Disraeli satirized Leighton's Aryanism in the figure of Mr. Phoebus in his novel *Lothair* in 1870.) The fact that Leighton's mother was reputed to be Jewish adds another dimension to this celebration of Grecian Apollonian masculinity, for in the Academy *Addresses* Leighton indicates that the Semitic peoples were hostile to artistic development. Apollo's homosexual affairs, for example with Hyacinthus, are a form of hypermasculine phalanx against women, for homosexual bonding in classical legend may be construed as an alliance against female dominance and matriarchal power.

The homosexual element is apparent in several drawings for *Hit!* (1893), Leighton's canvas of a youth teaching a boy to hold a bow. In two drawings, the young man is nuzzling the youth. In one drawing the nude boy stands beside the seated youth; in the other he stands between his legs, with the outline of the bow all but disappeared, making the sketch a seduction scene.

Attempts to say that this is father and son, as in the notice from the *Athe-naeum*, are refuted by the age of the instructor. The fact that the child is vine-crowned in the final canvas but not in the extant drawings increases one's awareness of the shift of intention, from instruction to amorousness. Leighton's drawing *A Contrast,* exhibited at the Hogarth Club in 1859, shows a crippled old man gazing at a statue of a naked youth, for which he was the model as a young man. Without its title and without the explanation, it represents an aging homosexual's admiration for naked Hellenic youth, similar to the admiration accorded the photographs of naked Sicilian boys taken by Wilhelm von Gloeden later in the century. The clay model for Perseus in *Perseus and Andromeda,* with the evidently phallic neck of the horse, joins sexual fantasy to the idea of the winged phallus of classical antiquity. While there is no evidence that Leighton was actively homosexual, a suppressed homosexual inclination is suggested in the drawings and clay models.

Leighton's psychosexual reactions to women conditioned his response to women's emancipation during the nineteenth century. One of Leighton's earliest contacts in Rome was with the American sculptress Harriet Hosmer, an ardent believer in women's rights. Within his own family, such movements were opposed. This situation became evident in 1889 with the publication of "An Appeal against Female Suffrage" in the June 1889 issue of the *Nineteenth Century.* The opening of the "Appeal" declared that the signers appealed "to the common sense and the educated thought of the men and women of England against the proposed extension of the Parliamentary suffrage to women" (781). The signees stated that "disabilities of sex" or "strong formations of custom and habit resting ultimately upon physical difference" (781) prevented women from participating in Parliament or the military. While praising the advances in education, the signees declared that "the emancipating process has now reached the limits fixed by the physical constitution of women" and that women's "natural" qualities of "sympathy and disinterestedness" would be "impaired" if they were given the franchise (782–783). Sexual anxiety is evident in their protest: "If votes be given to unmarried women on the same terms as they are given to men, large numbers of women leading immoral lives will be enfranchised" (784). "We are convinced that the pursuit of a mere outward equality with men is for women not only vain but demoralising" (785). The petition was signed by women such as Beatrix Potter, Mrs. Leslie Stephen, Mrs. Poynter, Mrs. Baldwin, Mrs. Russell Barrington (Leighton's future biographer), Mrs. Alma-Tadema, Mrs. Matthew Arnold, Eliza Lynn Linton and Mrs. Humphry Ward. Also included among the signees was Leigh-

ton's sister Mrs. Sutherland Orr. Millicent Garrett Fawcett and others responded in the July issue. The fact that Leighton's sister signed the original protest against the suffrage, along with his friend and biographer, Mrs. Barrington, indicates that in this group there was hostility to the extension of the franchise to women. It is significant that Georgiana Burne-Jones did not sign the petition, while two of her sisters, Mrs. Baldwin and Mrs. Poynter, did.

Leighton actively supported his sister's involvement in this petition, even to the extent of contacting G. F. Watts on the attitude of his second wife to the question. He wrote on 24 May 1889 to Watts: "Now I want you to ask Mrs. Mary something from me — there is at this moment a movement in contemplation in which many well known women take an active interest — women like Mrs. Lynn Linton, Lady Alwyn Compton, Mrs. Humphry Ward, Miss Beatrice [sic] Potter, and which *opposes* itself to the attempt to obtain the *suffrage* for women — thereby drawing them out of the natural sphere in which they exercise such enormous and beneficial influence; a very temperate article in this sense is about to be published in the 19th century and my sister, amongst others, is endeavoring to obtain signatures to it. *Does the Signora sympathise with this view?* If so my sister would send her a copy of the article so that she might see whether she was inclined to add her name to those already secured — of whom I have named a few." Leighton inquired: "If she *is* in sympathy could she, think you, enlist Lady Tennyson and Mrs. Hallam Tennyson?" ("Letters"). Mrs. Watts did not sign the petition, but the wife of Max Müller, the proponent of the "Solar theory" of mythology, did sign. Canvases of Apollo did convey a message of male superiority that reflected the political situation.

In 1880 there had been a discussion concerning the admission of women as members to the Royal Academy and the further question of whether women could serve on the Council of the Academy, that is, its legislative body. Leighton supported the admission of women as members but felt that custom, later reinforced by royal sanction, prevented their serving on the Council. Participating on the Council "can and must on the same grounds be refused to 'elected' female members after the custom is consecrated by Royal sanction" (Barrington, *Life* 2.250). His friend Henry Wells felt that by original intention, all members could sit on the Council, even though it appeared that by custom the women at the founding of the Academy had not. Leighton's resistance to complete membership rights for women in the Academy in 1880 shows the cautious, and discriminatory, attitude he maintained in official matters. Thus his opinions on personal questions and on national politics were connected.

III

The roles in which Leighton depicted women in his canvases were to reflect these same biases, emphasizing male superiority and female deference. Electra, Alcestis, Hero, Eurydice, Andromeda, Clytie, and Andromache are given identity only as they relate to human males or male divinities. Leighton's sexual nature, his attitude to worship of the sun/Apollo, his suspicion of women's power, and his inability to color female flesh convincingly or to execute the female model with assurance, contribute to the selection of myth and manner of treatment in his classical-subject canvases. For purposes of analyzing Leighton's canvases, his work may be divided into two groups: mythical canvases (including the single-figure allegorical paintings of the later part of his career) and classical genre pictures (including the figures of sleeping women). In both these groups, Leighton's Aryan/Grecian phallicism and sun worship resulted in the presentation of a beautiful but demeaning and insidious image of woman before the visitors to the Royal Academy. Leighton's earliest canvases were Quattrocento in feeling, as in *Cimabue's Madonna* (1855) or *The Death of Brunelleschi* (1852). In the 1860s, however, the classical subject became pronounced.

One of the earliest of these canvases is *The Fisherman and the Syren* (1858) (Plate 3-3), derived from a ballad by Goethe. In this canvas a dark-skinned young man is being drawn into the water by a sinuous mermaid. The immediate impact of the canvas comes from its coloring, with contrast in flesh tones between the mermaid and the man, his orange loincloth, deep purple mantle, and red skullcap contrasting with her blonde hair, woven with pearls and coral clasps. The castrating element of the scene is evident in the mermaid's tail, which coils between the man's legs, not however approaching the genitals as in the *Athlete* sculpture. There is a contrast between the mermaid's phallic tail and the comparatively small male genitals. The fact that the man assumes a cruciform pose while sliding into the waves implies female predatory sexuality. The picture conveys an early form of Leighton's suspicions of women, especially when one recalls that Sirens were prototypes of prostitutes (as in Acton).

In 1864, Leighton completed *Orpheus and Eurydice* (Plate 3-4), which extends this connotation. It appeared at the Academy accompanied by a text from Browning; another source was Gluck's opera, which Leighton had gone to Paris to hear in 1860. Orpheus is depicted pushing Eurydice aside, his expression denoting disgust with her for breaking the condition of her release,

rather than concern for her. As in *Fisherman and the Syren,* the contrast of flesh tones between the male and female bodies is apparent. The Orpheus legend in this configuration indicates Leighton's belief that women destroy the lives of artists (as in his friend Browning's "Andrea del Sarto"). Leighton distorts the legend, in which Orpheus was to blame for gazing back at Eurydice, to shift the blame to her. The Orpheus legend is also peculiarly anti-female in that after Orpheus lost Eurydice he disdained all women, in fact preached homosexual love as opposed to the Bacchic devotions of the Maenads. In several accounts of the legend, Orpheus was a follower of Helios/Apollo. Orpheus' lyre reposed in a temple of Apollo until the god mandated it be placed in the heavens as a constellation. In examining a painting such as *Orpheus and Eurydice,* one must account for the dimensions of the myth Leighton suggests by the action of Orpheus: disgust, possible homosexual repulsion, Apollonian allegiance. In 1864, Ruskin delivered "Of Queens' Gardens," and the first Contagious Diseases Act was passed. Both events find a reflection in the study of a poet rejecting the predatory advances of a female who is leaving her sphere, here that of death.

In the mid-1860s Leighton completed *Helen of Troy* (1865), showing the Grecian princess walking along the city ramparts to watch the single combat of Menelaus and Paris, the *taichoskopeia* (view from the walls) of the *Iliad.* Leighton's portrayal shows a woman with an inscrutable face. Homer's text expresses the belief of the elders of Troy that for such beauty, it is no wonder the war occurred. They observe: "Terrible is the likeness of her face to immortal goddesses," and later Priam refuses to blame her for the catastrophe, so great is her beauty and so helpless is she before the goddess Aphrodite. Helen, however, calls herself a "slut" several lines later. Leighton's viewers could be expected to grasp the specific context of the painting. The Homeric allusions would have been known since the episode is so crucial. *Helen of Troy* cannot be dismissed as simply a canvas of a femme fatale. The episode selected is not a common representation of Helen; it was more usual to show her linked with Paris. Homer's lines, of which this is a specific depiction, introduce a complexity into the evaluation of Helen that confirms the culture's ambivalence to women, indicated by the Contagious Diseases Acts.

In 1866 Leighton exhibited *The Syracusan Bride Leading Wild Beasts in Procession to the Temple of Diana* (Plate 3-5), based on a passage from the Second Idyll of Theocritus: "One day Eubulus' daughter, our own Anaxo, / was taking a basket to Artemis' grove, / and in the procession, marching beside her / were many wild beasts, among them a lioness" (53-54). The painting

recalls the friezelike processional structure of *Cimabue's Madonna,* Leighton's first success. The base of the Artemis of Versailles is visible in the canvas. As in the *Helen of Troy,* Leighton's literary source indicates the necessary complexity of response to this canvas. Theocritus' Idyll is a monologue by the sorceress Simaetha (herself the subject of a painting by Leighton in 1887). Simaetha first saw her faithless lover Delphis when she accompanied the procession. Now she is attempting to concoct a love philter to secure him. Theocritus mentions that the lovers met for sexual indulgence as many as four times a day. The source makes evident that the subject of the canvas is the contrast between the devotion to Artemis/Diana, the goddess of chastity, and the sexual indulgence of the speaker, and thus the two polarities of nineteenth-century conceptions of women: the virgin and the whore.

In Leighton's canvases, the association of women with beasts indicates suspicion about female sexuality. On the right of the canvas, one member of the procession is all but nurturing a cub at her breast; another figure on the right seems to be repelling a sexual advance from a tiger. Women are shown alternately taming the beast (as does the bride in the center) and arousing it. The Artemis of Versailles, partially seen in this canvas, is singularly cold and aloof as she telegraphs her warning by reaching to the quiver on her back. Men in this canvas are relegated to observers: the one on the right is too old for sexuality, the single man on the left appears to be on crutches, and the two men at the far left could be homosexual lovers (as one critic has suggested privately). The canvas mirrors the debate about female sexuality. The huntress and fierce virgin Artemis is shown as the fearsome defender of female sexual prerogatives.

In the 1867 *Venus Disrobing for the Bath,* Leighton presented a full-length nude which, as the *Art Journal* observed, was "a little startling now-a-days," a Venus "not so much 'disrobing' as already undressed" (141). "A figure like this, which braves prevailing prejudices, not to say principles, can only be justified by success. . . . His picture is eminently chaste. . . . In this reading of the character, Mr. Leighton, instead of adopting corrupt Roman notions respecting Venus . . . has wisely reverted to the Greek idea of Aphrodite, a goddess worshipped. . . . It is just in proportion as such supersensuous qualities are attained, that a figure of Venus can be justified in a modern exhibition." The critic has misread Greek literature (for example Euripides' *Hippolytus*) in his citing of the Greek idea as inherently "chaste." The critic was, however, skeptical of the flesh painting: "According to the manner, not to say the mannerism, of the artist, it has a pale silvery hue, not as white as mar-

ble, and not so life-glowing as flesh." The question of the chastity of the canvas may perhaps be answered by comparing it with a statuette of Aphrodite removing a sandal, with Priapus, found at Pompeii in a building presumed to be a brothel. This figure is no less "chaste" than Leighton's canvas. Chastity is in the eye of the beholder writing in a mass-circulation review. Leighton eliminates the Priapus, but the idea of Aphrodite bathing certainly had a potentially lewd context in the ancient world. Another significant prototype would be the relief from the balustrade of the Nike temple on the Acropolis, where the draped figure is fastening a sandal. Leighton's *Venus* is thus both erotic and, as the setting overlooking the sea indicates, victorious like a Nike.

A nude completed in 1868, *Actaea, the Nymph of the Shore* (Plate 3-6), shows a full-length Nereid reclining on a coast, with two dolphins in the background. The anatomy of the figure is awkward and badly conceived, her right side being impossibly extended compared with the left, a defect that would appear as late as *Flaming June* in 1895. This distortion in drawing the female figure is particularly strange because Leighton's training was so thorough in the drawing of the nude. William Blake Richmond commented: "Few men have ever possessed such a complete fundamental knowledge of, and intimate acquaintance with the human figure—not only scientifically and anatomically, but tactfully and analytically" (Edgcumbe Staley, *Lord Leighton* 253). The drawing in the *Actaea* exhibits the same aversion to the female figure as does the flesh color of women in such paintings as *At the Fountain*. Swinburne wrote: "The 'Actaea' has the charm that a well-trained draughtsman can give to a naked fair figure; this charm it has, and no other" ("Notes" 361). He thought the figure of Jonathan in *Jonathan's Token to David* far better: "The majestic figure and noble head of Jonathan are worthy of the warrior whose love was wonderful, passing the love of woman" (368). As in the *Orpheus and Eurydice*, the *Actaea* expresses disgust rather than admiration. A surviving sketch for this canvas exhibits the same peculiar anatomy, with the left arm even more awkwardly drawn. In 1868, another canvas of a woman by a coast, *Ariadne Abandoned by Theseus,* depicts a somnolent, outstretched figure on a promontory. If the *Actaea* depicts a sexually abandoned nymph, Ariadne is the woman abandoned sexually, cast off by her lover Theseus. Leighton depicts the deserted Ariadne, not the resourceful woman who aided the hero, diminishing the woman's role as Kingsley did in his accounts of men's exploits in *The Heroes.*

At the 1869 Academy Leighton exhibited two canvases that in their pairing indicate the diversity of Leighton's reactions to women, *Daedalus and Icarus*

and *Electra at the Tomb of Agamemnon. Daedalus and Icarus* (Plate 3-7) permits Leighton to paint the male nude. He follows the model of the Apollo Belvedere and the raised foot established by Polykleitos, an appropriate prototype for a legend concerning worship of the sun. The contrast between the dark-hued flesh tones of the father and the white skin of the son is carried through by the dark blue robe behind Icarus, the pink sash covering his genitals, and the red handle he grasps on the wing. To the left is a bronze statue, patterned after the Athene Parthenos of Phidias. Rather than counteract the masculine emphasis of the picture, the statue of Athene confirms it, since she was born from Zeus's head, not of woman. A sketch indicates the statue facing front, rather than turned to the rear as in the final canvas. The effete nature of Icarus was noted in the *Times,* which commented that Icarus' torso exhibited "the soft, rounded contour of a feminine breast" (15 May 1869, p. 12).

In the same year, 1869, as the *Daedalus and Icarus,* Leighton exhibited *Electra at the Tomb of Agamemnon* (Plate 3-8), a study of the daughter of Agamemnon leaving offerings at his tomb. Her cropped hair, heavy eyebrows, and massive exposed arm make her decidedly masculine in appearance, the reverse of the feminized Icarus. While the picture expresses the attitude of grief by the olive green and black draperies, the details of the canvas convey unbridled sensuality, a linkage of sex with death. The vase to her right, with a frieze of grazing animals, contains the image of a wolf or jackal. A phallic phial rests at her feet, while on the kylix to her left a satyr is pursuing a Maenad. The satyr extends his hand to the devotee's genitals, exposed by the yellow cloak open at her crotch. The satyr has his right leg up as if dancing before the seated Maenad. The painting presents the reaction of Electra to her father as one of extreme sexual regret.

In 1871, Leighton exhibited his greatest "rescue" painting, derived from Euripides' drama *Alcestis: Hercules Wrestling with Death for the Body of Alcestis.* (Plate 3-9). The canvas is designed as a triptych: mourners on the left, the dead Alcestis in the center, and Hercules and Death wrestling on the right. Pauline Viardot had sung an aria from Gluck's *Alceste* at a party Leighton gave in April 1871. Browning praised the canvas in *Balaustion's Adventure,* published in July 1871, and William Morris had treated the idea in *The Earthly Paradise.* Leighton and Browning had attended a performance of Gluck's *Alceste* in 1871. Leighton's *Hercules* is one of the era's greatest rescue paintings, showing the man triumphing over the Death that has seized the woman. The head of Hercules is bound with a fillet similar to that in the Diadumenos of Polykleitos, with the same raised foot. The situation of

women is so extreme that they need to be rescued as if "dead." The canvas has vigor because of the action on the right; Hercules has the force of the lion whose skin he wears. Since Hercules had strangled serpents in his cradle, the canvas celebrates male rather than female heroism. The legend has an Apollonian cast. Apollo once fell in love with Admetus, Alcestis' cowardly husband, and served him as a shepherd. Apollo bargained with the Fates that someone could die in Admetus' place. Apollo's homosexual attraction is therefore the indirect catalyst of the sacrifice of Alcestis. Significantly, the figure of Admetus is eliminated from the painting.

In contrast to the male heroism of the *Hercules,* in 1874 Leighton exhibited the fearsome *Clytemnestra from the Battlements of Argos* (Plate 3-10), with the figure of the queen patterned after a Caryatid. She was called Titanic by critics of the period, so fearsome is her presence. With her massive arms and broad shoulders, the queen has a masculine force as she stands in the moonlight of Mycenae. The *Art Journal* used the occasion to distinguish between art termed "masculine," derived directly from nature, and that termed "feminine," art "which seeks nature through intermediate examples of art" (198), in this case presumably the Caryatid. The *Journal* concluded that Leighton's genius was of the "feminine" type. This particular critique is strange considering the masculine appearance of the figure, indicating the extent to which critics refused to recognize so dominant a woman as Clytemnestra. Uncertainty about masculine roles is behind this reaction to Leighton's *Clytemnestra.* The queen has usurped the place of the Watchman in the opening of Aeschylus' *Agamemnon,* assuming a male role.

In 1876 Leighton exhibited *The Daphnephoria* (Plate 3-11), representing the procession held every nine years in May at Thebes to honor Apollo. This event was recorded in the *Christomath,* supposedly by the Neoplatonic philosopher Proclus; an edition of 1832 was included in Leighton's library. A similar event was held in Tempe to commemorate Apollo's slaying of the Python. *The Daphnephoria* is the third of Leighton's great processional pictures, after *Cimabue's Madonna* and *The Syracusan Bride.* The canvas contains eight groups in its processional frieze: a youth carrying a standard, the *kopo,* with representations of the sun, moon, and stars; the *daphnephoros* or laurel bearer, wearing an image of the sun around his head; boys carrying trophies; the *choragos* or chorus leader, holding a seven-stringed lyre and with hand raised to lead his singers; three groups of women singers; and finally a group of youths bearing vessels for the service. The sculptural sources range from the Hermes of Praxiteles for the boys at the rear to the Doryphoros and Diadumenos of

Polykleitos for the *choragos*. The canvas is the quintessential celebration of sun worship and male supremacy, as the laurel bearer and chorus leader govern the procession. The procession in honor of Apollo celebrates the religion of art, praising the god of poetry and the cultivator of the Muses. This religion is unquestionably male. The *choragos,* who wears thin kid shoes associated with racing, holds the center of the canvas by his physical splendor and artistic genius. The *daphnephoros* was male according to ancient ritual. Women are excluded from the practice of art, although they may worship it. The idea that art is male is signified by the solar context of *The Daphnephoria.* With the simultaneous exhibition of Poynter's *Atalanta's Race* with its triumphing Melanion, male supremacy was emphasized in 1876.

The celebration of the Apollonian/masculine sun continues in the bronze *Athlete Struggling with a Python* of 1877. This bronze was the instigating force of the New Sculpture, which emphasized a detailed grasp of anatomical structure. In Leighton's *Athlete,* the meticulous depiction of muscles, tendons, and joints, with the exact rendering of the Athlete's breathing, signifies a new standard for sculpture, advancing beyond the smooth contours of Canova or even of the Apollo Belvedere with its idealized musculature. There was little question that the statue represented masculine heroism. In the *Athlete,* Leighton's great classical predecessor was Polykleitos, particularly the Doryphoros and Diadumenos, themselves statues celebrating male heroism. Leighton had adopted "a vigorous and, to some extent, massive style, which is inclined to realism, because the subject is human in all its elements, and severe because it is serious, and elaborate and searching in the treatment of details, because the motive is heroic, and the antitype Greek," declared F. G. Stephens in the *Athenaeum* (580). The sources of this work include Michelangelo's *David* for the head, Polykleitos for the raised left foot, and the Laocoön, which represented the slaughter of a priest of Apollo, most conspicuously for the left arm and the prominent buttocks. In the depiction of anatomy, the statue recalls the figure of Hercules in Leighton's canvas, especially in the treatment of the feet and of the extended arm. While the serpent represents the fantasized gigantic phallus, its proximity to the penis reminds one that in Goethe's reading of the Laocoön sculpture the serpent was female. The bronze appears to be an overcompensating fantasy of sexual aggrandizement as well as an expression of castration anxiety.

The masculine heroic ideal becomes associated with the sun-god Apollo, an allegiance always masculine in its orientation. Later Otto Rank would observe in *The Trauma of Birth* that "the development of sun worship always

goes hand in hand with a decisive turning from mother culture to father culture . . . the entire repression of woman even from the erotic life" (152–153). In the *Athlete* Leighton expresses this combination of male superiority and exclusion of the female that marked nineteenth-century society. If one follows the argument of Géza Roheim, furthermore, the slaying of the Python represented the killing of the father. The hostility recorded in Leighton's letters to his parents would therefore find release in this statue. G. F. Watts exhibited a portrait of Leighton in 1881 with the legs of the wrestler and the tail of the python visible in the canvas, presumably at Leighton's request.

The year after exhibiting the *Athlete,* Leighton finished a study of Nausicaa, standing pensively by a doorway, presumably watching Odysseus depart on his journey to Ithaca. Instead of showing the woman aiding the stranded mariner, Leighton elects to show her abandonment. Like Poynter's treatment two years later, which again ignores her "rescue" function, Leighton's Nausicaa is not resourceful but ancillary. *Nausicaa* is the archetypal image of female as servant and nurse, demanding nothing and offering all.

Leighton's next significant classical-subject work was the *Phryne at Eleusis* of 1882, with its subject posed as a *diadumenè* against the columns of a temple, and the sea behind her. Phryne is reputed to have been the mistress of the Greek sculptor Praxiteles. This famous courtesan also offered to fund the reconstruction of Thebes after Alexander destroyed it in the fourth century. *Phryne,* like *Psamathe,* is a sensual descendant of the Aphrodite Anadyomene. This is the painting by Apelles that, according to legend, was inspired by a woman who stepped into the sea in worship of Poseidon; it thus represents Aphrodite as a fearless goddess. In the 1904 version of his study of Leighton, Rhys called Phryne "super-womanly," an indication that politics subsumed aesthetic reaction. The similarity of Phryne to the Aphrodite Anadyomene of Cyrene is evident in the tilted breasts. By its scale, the figure of Phryne fills the canvas with its threatening but strange beauty. Henry James observed: "Her loveliness is considerable, for Sir Frederick [*sic*] Leighton has a great deal of elegance, a great sense of beauty; but neither in modelling nor in colour does her elongated person appear to justify this lavish exposure. The head is charming and charmingly placed. . . . But the body strikes one as too monotonously yellow, too flat, too remodelled. . . . More than any English painter he devotes himself to the plastic, but his efforts remain strongly and brilliantly superficial" (*Painter's Eye* 214).

Phryne at Eleusis celebrates fearsome female power while simultaneously degrading the source of that power, female sexuality. In the same year, Leigh-

ton exhibited *Antigone,* an austere treatment of a heroic woman, although in the nineteenth century her image was more ambiguous. Some believed she ought to have accepted the edict of Creon and capitulated to male authority. Leighton had illustrated George Eliot's novel *Romola* in 1863, where the Antigone myth is a prominent thematic element, and it recurred in Eliot's last novel, *Daniel Deronda.* In 1887 W. F. Barry published *The New Antigone: a Romance,* attacking the "new woman" and the feminist objectives the myth supported.

In 1887 Leighton depicted two different types of womanhood with *The Jealousy of Simaetha the Sorceress* and *The Last Watch of Hero,* the former a woman from the Second Idyll of Theocritus possessed of magical power, the latter a priestess of Aphrodite who took Leander as her lover. In the *Simaetha,* the woman has magical power; in *Hero,* she has lost all power with the death of her lover, who lies drowned in the predella below her. Leighton's newly acquired favorite model, Dorothy Dene, posed in these two canvases, which reflect the intensity introduced into his work by Dene's presence. Simaetha sits glaring to her right, a monolithic figure recalling Michelangelo's sybils. Her yellow and white drapery increases the intensity of the personality depicted. The face is not unlike that of Jonathan in *Jonathan's Token to David* (1868). The inspiration for such faces is Michelangelo's *David,* with the result that the women so illustrated have an androgynous quality.

The same gaze appears in *The Last Watch of Hero* (Plate 3-12), as the priestess stares over the sea in search of her lover. Hero is the archetypal woman "waiting." Just as the plight of Alcestis represents the need of women for "rescue," these canvases depict women who have been abandoned by lovers, Simaetha hoping to regain Delphis, Hero having forever lost Leander. Leighton's interest in the legend of Hero and Leander is shown by his having a copy in his library of an edition of 1894 with illustrations by Charles Ricketts and Charles Shannon. *The Last Watch of Hero* has the quality of a *tableau vivant,* some of which Leighton designed. The canvas contains, however, a peculiar tension in its execution. The two arms of Hero are not consonant in design, the right being incommensurate with the left. Beyond this distortion is the discrepancy between the relative massiveness of Hero and the thin outstretched body of Leander presented in the predella, even granting the difference caused by the distant glimpse of Leander. Hero is pathetic in being abandoned but dominant with her larger body. The resonances of the two parts of the canvas reveal anxieties about sexual domination.

The woman abandoned and unrescued received powerful treatment in 1888

with the exhibition of the *Captive Andromache* (Plate 3-13), the last of Leighton's processional canvases. Dorothy Dene posed for the central figure. *Captive Andromache* had been conceived a quarter of a century earlier, which demonstrates the persistence of Leighton's attitudes about women over a long period. Leighton's canvas portrays a passage in the *Iliad* detailing Andromache's fate should Hector die. Homer in fact does not dramatize the episode, which derives also from suggestions in *The Trojan Women* of Euripides. In book 6 of the *Iliad,* Hector realizes prophetically Andromache's fate: "The thought of you, when some bronze-armoured / Achaian leads you off, taking away your day of liberty, / in tears; and in Argos you must work at the loom of another, / and carry water from the spring Messeis or Hypereia, / all unwilling, but strong will be the necessity upon you; / and some day seeing you shedding tears a man will say of you; / 'This is the wife of Hektor, who was ever the bravest fighter / of the Trojans'" (6.454–461). In Leighton's composition, Andromache is isolated in the center, her head in profile between the receding walls. Cumulus clouds mar the summer day, an element of the pathetic fallacy Leighton introduces to emphasize the captive's plight. Andromache is framed by symbols of inevitability and of loss: the old woman with the distaff on the left representing Fate, the young family below her recalling Hector and her son Astyanax. Three men below the platform gaze at her, the one in the center derisively pointing her out to his companion. The fact that Andromache was given to Pyrrhus, the son of Achilles who had slain Hector, increases the tragedy of her destiny.

The vases carried by the women telegraph dimensions of female sexuality: one contains pictures of Maenads, another bears a figure of a Nike/Victory; the one at Andromache's feet derives from a vase showing Menelaus trying to regain Helen, a commentary on the origin of the Trojan War. One vase even contains a fountain-house scene which echoes the motif of the canvas. Leighton emphasizes the universality of her station by the costuming of his figures. Some are in Greek dress of the fifth century, others in costumes of the Archaic period. *Captive Andromache* is one of the greatest Victorian images of the abandoned woman, a commentary on the plight of women whose only resource in life is marriage and family. The general movement from dark to light bitterly glosses the hopeless situation of the central figure. Being neither mother nor wife, Andromache has no identity. In depicting her alienation, Leighton undoubtedly evokes the situation of Euripides' Andromache, who in the play of that title has been the mistress of Pyrrhus, borne him a son, and is persecuted by his wife, Hermione. She is rescued

only by the intervention of Peleus and the slaying of Pyrrhus at the shrine of Apollo at Delphi. The drama is one of the ancient world's most searching discussions of women's nature, with its presentation of the horizontal hostility of Hermione, the purported promiscuity of women in general, and the persecution women wreak on one another for a man's love. Both Burne-Jones with his *Danaë* and Leighton with *Captive Andromache* depicted the image of the imprisoned woman in 1888. The mythology demonstrated that this was their eternal condition.

Leighton's last mythological canvases appeared in the early 1890s, each a component of a diverse attitude to women. In 1890 *The Bath of Psyche* (Plate 3-14) was exhibited, showing the future goddess undressing and partially reflected in a pool at her feet. The conception of the figure was derived from the Venus Kalipigge, as is indicated by the two doves at the top of the steps behind her. The Psyche legend was popular during the period, as shown in *The Earthly Paradise* by Morris and *Marius the Epicurean* by Pater. Leighton's original idea was first depicted in the wall screen decoration for Alma-Tadema's home. The figure is one of Leighton's more successful nudes, carefully modeled but never with Poynter's exactitude. Psyche's beauty is self-involved. She is her own doppelgänger by virtue of her narcissistic beauty. The *Athenaeum* noted that Leighton, "warned . . . by the experience of Mr. Poynter in his painting 'Diadumene,'. . . has presented a whole-length, life-size figure partly draped" (560). Leighton avoided the denunciation of Poynter's *Diadumenè* not only by adding drapery but also by increasing the age of the female depicted. The woman undressing for the bath is the quintessential voyeur's fantasy and object.

In 1891 two entirely different icons of women appeared from Leighton, *Perseus and Andromeda* and *The Return of Persephone*. Leighton's *Perseus and Andromeda* (Plate 3-15) shows the hero, mounted on Pegasus, shooting an arrow at the dragon, who covers the chained Andromeda with one wing. The *Athenaeum* noted that the *Perseus* was "much superior in virility of conception" to *The Return of Persephone*. Leighton's conception is unusual in that Perseus is not traditionally associated with Pegasus. Instead Pegasus was tamed by Bellerophon, who rode him to slay the Chimaera, a female monster. According to legend, the bow and arrow in the painting also properly belong to Bellerophon. Leighton telescopes two rescues (Perseus, Bellerophon) to reinforce the male rescue conception. By appearing in a sunburst at dawn in the sky, Perseus is inevitably associated with Apollo. This triple heroism (Perseus, Apollo, Bellerophon) makes the picture a summation of Victorian

male rescue fantasies. Leighton's Perseus, in keeping with the male heroic Victorian idea behind the canvas, reveals none of the hesitancy of the Perseus of Burne-Jones. He is more active in a manner similar to Poynter's rendering in 1872. In contrast to Poynter's canvas of 1872, Andromeda is not alone. Leighton increases the harrowing need of rescue by having her all but raped by the monster, as her falling white drapery and flowing hair indicate. Leighton's emphasis on the rescue rather than the victim is apparent from the bizarre contortion of the upper body of Andromeda, which is modified from the even more extreme distortion of the clay model, which virtually twists her spine.

The sun worship is further explored in *The Return of Persephone* (Plate 3-16), showing Hermes (as Hermes Psychopompos or "Conductor of Souls") bringing Persephone up from Hades to her mother, Demeter, The theme of Persephone was an enduring one in Victorian literature, with Swinburne's "Hymn to Proserpine" and monologue of Demeter, "At Eleusis"; Pater's essay; and Tennyson's "Demeter and Persephone." Leighton chooses to reinforce the Victorian maternal icon in this canvas by showing Demeter standing with outstretched arms in a womblike opening to receive her daughter. The design of the canvas is extremely thorough. Both mother and daughter have one hand in darkness, one in light; Persephone's robe indicates the yellow of young spring corn, the amber of Demeter's dress the fruition of autumn. The storm cloud behind Demeter suggests that her daughter can remain with her only temporarily. Persephone's skin has a slightly greenish cast to it, but considering her return from death, Leighton's defect does not detract. The presence of Hermes signifies the male as rescuer.

Leighton's final three narrative canvases, all exhibited in 1892, were *The Garden of the Hesperides* (Plate 3-17), *Bacchante,* and *Clytie.* The first canvas uses the myth to present the icon of sleeping or resting women. One plays a lyre, another cradles the dragon Ladon in her lap, a third lies asleep, all beneath the tree containing the golden apples. In the finished canvas the dragon encircles the waist of the woman; in several drawings he rises from her crotch, a position Leighton recognized as too erotic and eliminated. The tondo form reveals a world of self-contained isolation, soon to be ruptured by the theft of the apples and slaying of the dragon by Heracles. This canvas indicates a female community before the irruption of man. Leighton's *Bacchante* shows a vine-crowned dancer holding a tambourine and raising her fingers to a fawn below her. Dressed in leopard skin, she has an androgynous appearance. The foreshortening of her extended arm is one of Leighton's anatomical failures.

The *Clytie* is an astounding work, containing according to Stephens in the *Athenaeum* a sunrise worthy of Turner over most of its surface. Clytie kneels before an altar of the god Apollo in the lower right of the canvas. This amalgamation of worship of the male sun and female abandonment is one of the most revealing indications of Leighton's attitudes about women. The desperation of the woman abandoned by man was never more convincingly expressed than in this canvas.

This same palimpsest of significance appears in Leighton's final two narrative mythological canvases, *Perseus on Pegasus Hastening to the Rescue of Andromeda* (Plate 3-18) and a second *Clytie,* both dated around 1896 and officially unfinished. In this rendering of the Perseus story, Pegasus rides the winged horse, holding in his left hand the head of the dreaded Medusa. Andromeda is absent from the picture, which concentrates solely on the male rescuer. The draperies behind Perseus have become so overdetailed that they are artificial. By showing Perseus as the conqueror of Medusa, Leighton emphasizes the conquest of sexual fears. In the *Clytie,* the woman is shown kneeling before a sunrise and awaiting the sun symbolic of her lover, Apollo. The streaming hair indicates not entrapment but abandonment. Inadvertently, the *Clytie* and the *Perseus* became summations of Leighton's presentation of attitudes about women when he died in 1896. Leighton's conception of women's nature is diverse but consistent, a reflection of nineteenth-century cultural expectations. Woman is maternal in *The Return of Persephone;* in need of rescue in the *Perseus* canvases; abandoned in the *Clytie,* the 1868 *Ariadne Abandoned by Theseus, Nausicaa, Andromache,* and *Hero;* mad in the *Bacchante;* insidious in the *Simaetha;* sexually threatening in the *Phryne.* The message conveyed in these canvases is that women cannot exist without male assistance. If they do, they violate nature and go mad or deteriorate.

IV

In addition to explicitly mythological canvases, Leighton painted a number of figure studies or genre subjects using classical motifs. These frequently reflect the attitudes about women revealed in the more narrative canvases. Both types of canvases were often exhibited together. For example in 1882 *Phryne at Eleusis* was exhibited with *Wedded;* in 1890 *The Bath of Psyche* appeared with *The Tragic Poetess;* in 1878 *Winding the Skein* appeared with *Nausicaa;* in 1867 *Venus Disrobing for the Bath* with *Knuckle-bone Player.* Several of these canvases present the image of the sleeping woman, such as *Idyll, Sum-*

mer Moon, Summer Slumber, and *Flaming June.* In these canvases female sexual power is lulled to quiescence. Leighton was fond of single-figure monolithic women in vaguely allegorical presentations, as in *Solitude, The Tragic Poetess,* and *The Spirit of the Summit.*

Among Leighton's earliest anecdotal subjects was *A Pastoral* (1867), showing a vine-crowned man teaching a draped female to play the double pipes. The picture translates the genre of the idyll to canvas, but even in a slight subject the man is the teacher. The canvas exploits the contrast of flesh tones which characterizes much of Leighton's work. The phallic gourd to the left of the canvas suggests sexual power, as do the pipes and the vine-crowned male, evocative of Pan/Dionysus. It is a reversal of the Syrinx myth, where the woman, instead of being transformed into a reed, chooses to be seduced. Exhibited in the same year was the *Knuckle-bone Player,* a brilliant experiment in drapery study. A pomegranate, associated with death/Persephone, suggests the Fate symbolized in the tossing of the bones. These two pictures appeared at the same Academy as the *Venus Disrobing,* so the contrasting poles of male authority and female sexuality were evident. In 1871 Leighton exhibited *Greek Girls Picking Up Pebbles by the Shore,* a group of four women in orange, red, and white draperies by a seacoast. The triviality of this image can be contrasted with the same year's *Hercules Wrestling with Death.* The women have become figures on which to hang drapery studies. Emilie Barrington remarked: "Sometimes one missed in his work just the touch of the rugged which would have given more grace by comparison, by contrast. His grace of diction, his oratory, his writing, was sometimes over-refined, and missed its mark by over-elaboration. The very speciality of Leighton was completeness" (*Life* 2.5). Barrington's comment refers to many of the elaborate drapery treatments in such canvases, which reflect Leighton's wariness of spontaneity. His art loses tension from this emotional repression.

There is an intricacy of connotation in *Winding the Skein* (Plate 3-19) of 1878, exhibited with *Nausicaa.* In this canvas, a woman and a young girl are winding thread against a background of Rhodes. The contrasting ages of the two figures, one older and poignant, the other young and expectant, indicate that this thread is that of Fate inexorably joining the two. The *Magazine of Art* complained that the heroic stature of one woman was not commensurate with the triviality of the subject, but the Fate motif endows the figures with significant symbolic expression. Although the two figures appear tranquil, the older woman sits on a Dionysiac leopard skin, suggesting the violence of fate itself. Her divinity is emphasized by the similarity of her drap-

ery to that of the deities of the east pediment sculptures of the Parthenon. The 1881 *Idyll* (Plate 3-20) shows two female figures lulled by the piping of a dark-skinned man seated on the left. Lily Langtry modeled for the woman on the right, the entire construction of which derives from the Fates of the Parthenon pediment. The canvas presents a golden-toned evocation of a golden age. The partially exposed breasts of one woman suggest quiescent sexuality, controlled by the powerful artistry of the male. The following year, 1882, Leighton presented *Wedded* along with *Phryne at Eleusis* at the Academy. *Wedded* depicts two lovers, the man with a fillet around his head and in leopard skin, the woman leaning against his shoulder, against the background of an amphitheater at Taormina, Sicily. According to the *Athenaeum* the picture represented "lovers on their wedding morning" (1893, 543). Robert Browning, after seeing this canvas, could declare: "I find a poetry in that man's work that I can find in no other" (Barrington, *Life* 2.29). The painting was popularized through an engraving. The peculiarity of the picture is the strange attitude of the man, who appears to be kissing the woman's head because of her pleading. In drawings for the canvas he appears more ardent, passionate, and solicitous.

Leighton exhibited a number of single-figure studies of women with varying connotations. Frequently these female heads were androgynous, as in the *Elegy* (1889) or the better-known *Corinna of Tanagra* (1893) (Plate 3-21). The *Elegy* was exhibited along with *Invocation,* showing a woman in white veiling her head before an altar. In 1892, the anatomy of the figure in *At the Fountain,* with its greenish hue and peculiar modeling of the shoulders, expresses distaste despite the beauty of the profiled head. Mrs. Barrington noted of Dorothy Dene, Leighton's model: "Her very beautiful face and throat were not seen to advantage, as they were hardly in proportion with her figure, which was short and too stiffly set" (*Life* 2.272). The year 1893 saw the appearance of a complex of unusual icons relating to women. The *Corinna* represents a female gazing at the viewer as she rests her right arm on a lyre. Without the title it would be impossible to call this visage female. It is an extreme form of the androgynous, sexually ambiguous face Leighton admired. In *Farewell!,* a woman has seen her lover off and is standing regretfully gazing at his departure. These pictures appeared with Leighton's most latently homosexual canvas, *Hit!*, showing a youth teaching a boy to shoot an arrow.

An additional group of Leighton's classical-subject pictures involves women sleeping, a narcotizing of their sexual power. In *Summer Moon* (1872), two women are sleeping, one resting beside the other, their hands joined. Mod-

eled from the Parthenon and from Michelangelo, the figures are massive in their fecundity. The nightingale singing on the branch of a pomegranate tree evokes the stillness of death as well as sleep, making both women descendants of Persephone. The moonlight suggests Artemis/Diana and the self-enclosure of chastity. The moon and the pomegranate, Artemis and Persephone, contrast chastity with death: the canvas is thus about absolute sexual stillness. In *Summer Slumber* (1894), a woman is resting on a bench, her hair falling in cascades below her. Statues of Silence on the left and Repose on the right reinforce the stillness of the canvas. The *Athenaeum* noted the woman's "virginal contours" (583), but this is a virgin with a difference, for her sexuality is merely slumbering. Leighton's most famous study of a sleeping woman is the 1895 *Flaming June* (Plate 3-22), a figure recalling Michelangelo's *Night*, in orange-colored dress reclining in a fetal position on a bench. Behind stretches a shimmering sea. The engraving accompanying Mrs. Andrew Lang's study of Leighton indicates that reproductions of the Michelangelo Medici Tombs figures were hanging in the studio window area.

Flaming June was reproduced in the *Graphic* (1895), which had once sponsored a "Gallery of Beauty" series. Leighton's canvas conveys not only beauty but somnolence, suggesting the one was appropriate for the other. A prototype of *Flaming June* is sculpted on the lower right of the basin rim on which the woman in the previous year's *Summer Slumber* reclines. The sleeper's right breast in *Flaming June* indicates her erotic potential. The woman is also dangerous, as the poisonous oleander flower rises above the sleeper. (Tadema had used this same semaphore in his canvas *The Oleander* of 1882.) The *Athenaeum,* having praised the "chromatic scheme" that is the picture's triumph, noted: "It seems defective in one respect alone: the legs of the sleeper are somewhat larger than they should be" (576). This may be a consequence of the androgynous nature of its origin, since the figure was sketched from male as well as female models. Exhibited with *Flaming June* was *Lachrymae* (Plate 3-23), a study of a Greek woman resting on a marble pedestal containing a funeral urn. The mood of the picture is established by the trunks of cypresses and the deep blue of her garment. The canvas contains a kylix with a picture of Hermes, presumably in the role of Hermes Psychopompos. The hydria atop the column depicts the same fountain scene that had appeared in the *Captive Andromache.* Considered in conjunction with the companion picture *Flaming June,* the image in *Lachrymae,* although not sleeping, suggests the proximity of sleep and death. The woman in *Lachrymae* according to the *Athenaeum* represents "a hero's betrothed" visiting "the ashes of her lover slain

in battle" (576), an interpretation reinforcing male heroism and female passivity and abandonment.

Several of Leighton's most monumental representations of women were allegorical figures, usually on thrones, symbolizing abstract ideas, occasionally ideas of art. The prototype of these is the *Sibyl* exhibited in 1889, which depicts a woman staring at the viewer, inspired by Michelangelo's figures for the Sistine Chapel. In 1890 Leighton exhibited both *Solitude* (Plate 3-24) and *The Tragic Poetess*. In the former, a figure in white drapery, sitting on a promontory covered with an orange drape, is lost in thought. Leighton wrote that the landscape, that of the Lynn of Dee in Scotland, inspired him: "The silent mystery of it all absolutely invades and possesses you; that is what I faintly tried to put into my 'Solitude'" (Barrington, *Life* 2.310). The figure recalls Michelangelo's sibyls and also derives from Joshua Reynolds' *Sarah Siddons as the Tragic Muse*. In these canvases, Leighton's women have become superwomen, having gained prophetic insight by their complete removal from sexuality, physicality, and death. The large scale of these canvases increases the impression of indomitable — that is, "masculine" — authority. Their lofty but solitary grandeur reflects the human condition even as they rise above it.

In *The Tragic Poetess*, a woman in dark robes is seated on a marble chair, with scrolls beside her; behind is a melancholy sky. Whether her gloom is generated by the condition depicted in tragic drama or by the futility of tragedy to alleviate it cannot be determined. Her solitude represents the inevitable isolation of the artist whose work is uncomprehended by the public. Baldry contended that "Leighton died a disappointed man. . . . The popular homage was offered to his personality rather than to his art. He was conscious that he had failed to convey to the people among whom he lived that aesthetic message which was to him so vital and so urgent. . . . His artistic purpose was persistently misunderstood and, it may be added, habitually misrepresented" (*Leighton* 63–64, 67). Baldry also observed that Leighton "was absorbed always in the pursuit of beauty, which he had sought and found in many lands, and it was his earnest desire to give to his representations of this beauty a kind of unhuman perfection, passionless, perhaps, and cold, but exquisite always in its studied refinement" (67–68). *The Tragic Poetess* illustrates not only these pictorial traits but also Leighton's feeling of inability to communicate with his public. That he would embody such a conviction in a monumental androgynous female reflects both his belief in beauty and his sexual ambivalence.

Leighton's despair of his artistic mission and feeling of isolation inform an address he delivered at the Art Congress of Liverpool of 1888, a denunciation of British Philistinism that outdoes Arnold and must have caused considerable stir among his listeners. He stated baldly: "Our charge is that with the great majority of Englishmen the appreciation of art, as art, is blunt, is superficial, is desultory, is spasmodic; that our countrymen have no adequate perception of the place of art as an element of national greatness" (Barrington, *Life* 2.343). "The enemy . . . is this indifference in the presence of the ugly, . . . this callous tolerance of the unsightly," he declared. "As a nation," the country had fallen "short of the ideal which we should have before us" (2.351, 350). Drawing on his own experience, he said that art could provide "regenerating elements . . . more and more called for by our jaded nervous systems" (2.358). Condemning the narrative element of art, which was the public's most frequent reason for admiring a canvas, Leighton claimed that aesthetic principles and values had scarcely gained recognition. The canvases of *The Tragic Poetess, Solitude,* and the subsequent *Fatidica* and *The Spirit of the Summit* are classically derived subjects with a nonnarrative emphasis. In the figures of the women in these works, Leighton seems to have defied the culture which refused to comprehend him.

Fatidica (1894) (Plate 3-25) shows a woman in austere white, massive and inscrutable, sitting isolated near a tripod, in front of a silver wall. The sexual reversal has been complete, for in this figure Apollo the prophet has been superseded by the androgynous prophetess. Leighton was known to say, "I'm married to my Art" (Edgcumbe Staley, *Lord Leighton* 201), but in two final canvases he found the feminine in himself and expressed it in androgynous form. The laurel branch at the priestess's feet indicates she was once in the service of Apollo, but her masculine proportions reveal that she has supplanted him. Leighton has abandoned the sun worship of masculine strength for the triumphant female, in capitulation to the feminine principle or in recognition of its greatness. This attitude is embodied in his final monumental female, *The Spirit of the Summit* (1894) in which a draped female sits atop a mountain range. This represents Leighton himself, atop his own Mount Olympus but dressed as a woman, the isolated, misunderstood artist expressing his own androgynous nature. Staley records that Leighton was "endowed with a hot temper" but "was as sensitive as a woman and had quite a feminine sense of yielding," a man whose "instincts were imperial" but who had "overstrung nerves" (186, 189, 194). Leighton had written his father in 1890: "I undergo much humiliation; whilst [ladies] make with comfort and ease de-

lightful ascents to neighbouring peaks, I humbly pant up an antihill or two, resting at every third yard—puffy, helpless, effete" (Barrington, *Life* 2.313). *The Spirit of the Summit* shows Leighton metamorphosing himself into this androgynous power to attain the summit.

In 1870 Lord Redesdale had thought Leighton's "a soft, willowy, rather effeminate manner" (Ormond and Ormond, *Lord Leighton* 111), but in these two canvases Leighton welds Michelangelesque masculine force to feminine beauty, accepting the feminine side of himself but mastering its temperament in an "imperial" manner. In a notebook in the Royal Academy from 1893–1894, he noted of figures carved on a cathedral: "Women . . . East End . . . most powerful, masculine & striking," a statement describing the figures in these allegorical canvases. In *Fatidica* and *The Spirit of the Summit,* femaleness has been transmuted to an androgynous, unphysical, but metaphysical ideality. Leighton admitted to his sister in 1895, "I am not a demonstrative person" (2.329). The physician who attended him on his deathbed noted in his report, "Lord Leighton gave very few close intimacies" (Barton, "Lord Leighton's Death" 13). One of those at the deathbed was S. P. Cockerell, who noted of Leighton that his pictures were "generally impersonal" but "now and again his heart appeared in them, and once at any rate the springs of his innermost life were committed to canvas in a picture which was the type of his general mental attitude, viz., 'The Spirit of the Summit'" ("Lord Leighton's Drawings" 815). In these large allegorical canvases, Leighton revealed the complexity of his artistic and sexual nature.

Leighton's appraisal of his career as recorded by Edgcumbe Staley was: "I am not satisfied . . . I alone know how far I have fallen short of my ideal" (*Lord Leighton* 187). Even during his lifetime critics noted this failure to realize the ideal. In 1885 the *Magazine of Art* observed: "There is about his work that old, same haunting suggesting of the romance of Pygmalion—with the miracle but half-accomplished. . . . His painting is as smooth, as self-satisfied, as P.R.A.-ish as ever: his flesh is, as always, wax that would but cannot altogether live; his craftsmanship, for all its look of perfection, is still not perfect enough" (317). Leighton's treatment of female flesh only half lives, an indication of the anxiety that the feminine produced in him. Writing of Leighton's sketches, Baldry admitted that in treating the model Leighton "imposed upon both the living forms and their coverings the aspect which his personal inclination led him to prefer" ("Lord Leighton's Sketches" 71–72). Leighton's meticulous method of building a picture exhaustively from nude sketches, drapery studies, and color studies arose from "a distrust of his own capacity

to decide offhand what was most suitable for his purpose," which "seems to
have dominated him throughout his life" (70). Baldry argues that Leighton's
work turned from the Italian manner to "the purer and less emotional dignity
of Greece" (37). While this transition altered his style, it did not prevent him
from disclosing his own psychosexual nature. Nor did it prevent him from
revealing the cultural predispositions about women that observers brought
to the Royal Academy exhibitions each May.

In the 1904 version of his book, Rhys quotes Leighton as stating: "I am
not a great painter, but I am always striving to finish my work up to my first
conception" (118). This first conception—an inimical attitude to women and
an emphasis on the heroism of men—was conveyed more thoroughly than
Leighton might have granted by the particular version of Hellenism he dis-
played in his work. This Hellenism celebrated male "rescue" and female "na-
ture" in a variety of ways. When Leighton planned so public a work as the
fresco *The Arts of Industry as Applied to Peace* for the South Kensington
Museum, he used the classical to express the doctrine of "separate spheres"
for men and women advanced by Ruskin in "Of Queens' Gardens." The men
on the left and right are engaged in work, the women in dressing, posing,
and self-admiration. Two children in a corner on the right are painting a tragic
mask of Medusa; thus the only mythological reference in the fresco is to the
ultimate femme fatale castrating female. So bizarre was the status of women
legally that on his deathbed, when making a will, Leighton remarked: "I am
not sure if next of kin includes women, so that my sisters may not have all
I want. They know exactly my wishes, and I want them to have everything"
(Barton, "Lord Leighton's Death" 11).

Leighton observed in one of his notebooks in the Royal Academy (no. 15):
"A great element of our sympathetic appreciation of art is based on what it
reveals of the artist himself." Viewing the Leighton exhibition in 1897, Henry
James believed that the public enthusiasm for Leighton really was reverence
"simply to nothing at all." To James this was proved by the inability of Leigh-
ton's sisters to convince the public to purchase Leighton House or even ini-
tially to have it accepted as a gift provided the maintenance would be public.
James concluded that Leighton's achievement was marked by "the presence
of so much beauty and so little passion, so much seeking, and, on the whole,
so little finding—that the late President of the institution was one of the
happy celebrities who take it out, as the phrase is, in life" (*Painter's Eye* 248–
249). But if Leighton was happy in life, it was only in public life. As he sug-
gests in his notebook entry, the work does reflect the life, the inner life. The

oeuvre gives the impression of idealism combined with insecurity, of belief linked to absolutism. This patriarchal conception of male identity led Leighton to depict the women of the nineteenth century in classical subjects which reinforced this authority.

The decades of the 1870s, 1880s, and 1890s, with their educational reforms, Married Women's Property Acts, Contagious Diseases campaigns, debates about female sexuality, and new professions for women, saw a gradual but persistent improvement in the situation of women. Leighton's canvases did not reinforce this progress. As in his opposition to female members' serving on the Council of the Academy or his support of antisuffrage petitions, Leighton presented a conservative argument against these reforms. In Leighton's classical-subject paintings, women are abandoned (*Ariadne*), mad (*Bacchante*), sacrificial (*Alcestis*), death bearing (*Persephone*), regretful (*Nausicaa*), enslaved (*Andromache*), imperiled (*Andromeda*), desperate (*Clytie*), and somnolent (*Flaming June, Summer Moon*). If not in these situations, they are engaged in trivial activities such as playing ball or picking up pebbles. Burne-Jones stated after Leighton's death: "He always did like a bed of down as much as I did a bed of thorns. But I never could care for his work. . . . It was like bad rhetoric to me" (Burne-Jones and Rooke, "Conversations" 205). If this rhetoric contained the "bad," it also conveyed through its beauty a mythical conception of women's nature that had the appearance of eternality. It was the eternality of many classical-subject icons that gave them their insidious power. The essence of Leighton is embodied in his *Self-Portrait* of 1881 (Plate 3-26), where he sits like Zeus before the Panathenaic Frieze of the Parthenon. In his hero-worshiping of 1902, Wyke Bayliss declared that Leighton had "the face of Jupiter Capitolinus" (43). With its hair enfringing the forehead and its distinctive beard, Leighton's head suggests the more stylized late Archaic bronze Olympian Zeus discovered in 1877 and resembles the face of the Artemision Zeus found in 1928.

V

During the 1860s, when Leighton was beginning to turn to classical subjects, an artist with strong ties to the Pre-Raphaelite movement was often using classical motifs, Frederick Sandys (1829–1904). In 1857, Sandys produced anonymously a drawing, *A Nightmare,* parodying John Everett Millais's *Sir Isumbras at the Ford.* That same year Sandys met Rossetti, and the two became close friends. In 1866 Sandys was residing with Rossetti at Cheyne Walk,

where he began his best-known classical-subject picture, *Medea.* Sandys had an extremely varied career, as illustrator for many distinguished magazines (*Cornhill, Good Words*), as a portraitist, and as a painter. Sandys' studies of women were generally of one type, which Esther Wood noted in 1896: "For the most part, Sandys is stern towards the beauty of women. . . . He has found most of his dramatic inspirations in the more treacherous and vengeful figures of history and romance. With few exceptions, his models have been women of commanding brilliancy and power rather than loveliness or grace. These severer qualities have undoubtedly made for the exclusion of everything trivial and flippant in his subjects; they are unflinchingly serious, and even intense. No modern artist has portrayed so fearlessly the malignant aspects of womanhood. From the great warrior-wives of Greece and Rome to the witch-like enchantresses of medieval lore, he covers the whole gamut of unscrupulous passion, and paints the traitress, the seducer, and the murderess in every phase of jealousy, fury, and desperate revenge. . . . One looks in vain for the more near and familiar realities of womanhood: its best and its worst are shown us, but we miss the 'little human woman' of every day" ("Consideration" 24). Excluding his portraits, Sandys was scarcely interested in ordinary females. He became a specialist in depicting female power and depravity.

Sandys' first interpretation of Cassandra was completed around 1864 and exhibited at the Academy in 1865; it showed a woman letting out a violent cry. Rossetti had written a poem about the woman and also finished a drawing, *Cassandra,* in 1861. In Sandys the prophetess is beautiful and desperate, woman disbelieved because of a male god's curse. The picture symbolizes the plight of women unable to transmit their truths to uncomprehending men. In 1866 Sandys did a pen-and-ink drawing, *Helen and Cassandra,* with the prophetess showing a shrinking Helen the burning of the city. The Siren woman and the misunderstood martyr are brought together. Sandys finished a *Helen of Troy* in 1867, a malevolent woman glaring at the observer, lips turned in a sneer. Sandys' representation deliberately contrasts with the pervasive classicism of its catalyst, Leighton's *Helen of Troy* exhibited two years earlier. Sandys had lived with Rossetti during 1866, and his Helen shows Rossetti's influence in being a bust portrait with long reddish hair. Leighton's canvas had emphasized a specific moment from the *Iliad,* with a full-length figure of Helen. In 1867 Sandys finished a *Danaë in the Brazen Chamber* (Plate 3-27), intended to illustrate a poem by Swinburne for *Once a Week.* The picture was considered too erotic and was withheld from publication. It shows Danaë in a transparent shift, standing before an image of the man who will be her

lover. She has virtually had an orgasm in front of the image, her hair stream-ing behind her.

Toward the end of the 1860s came Sandys' *Medea* (Plate 3-28), which had a strange history at the Academy. The picture was accepted for exhibition in 1868 but then was rejected after press notices had already mentioned it. The outcry was sufficiently great to force the hanging committee to display the painting the following year. The canvas shows Medea mixing a potion before a representation of the ship *Argo.* Swinburne noted of the picture: "This, be-yond all doubt, is as yet his masterpiece. Pale as from poison, with the blood drawn back from her very lips, agonized in face and limbs with the labour and the fierce contention of old love with new, of daughter's love with a bride's, the fatal figure of Medea pauses a little on the funereal verge of the wood of death, in act to pour a blood-like liquid into the soft opal-coloured hollow of a shell. The future is hard upon her, as a cup of bitter poison set close to her mouth" ("Notes" 372). Swinburne concluded, "The picture is grand alike for wealth of symbol and solemnity of beauty." The contrast of the red necklace and the pale skin enhances the exotic nature of *Medea.*

In the 1870s and following, Sandys did various studies, mostly portraits, of mythological females. He turned away from oil to a favored medium, chalk. In the early 1870s Sandys drew *The Tangled Skein,* a woman in classical drape caught in the thread of Fate and herself representing Fate, with draperies in-spired by the Parthenon pediment sculptures. The century's greatest image of the narcotized woman appeared with *Lethe* (c. 1874), a woman in classical drapes standing in a poppy field, eyes shut in a virtual trance. Sandys was to repeat this image as late as 1892 with *Nepenthe,* a bust with exactly the same head as the *Lethe.* Other classical subjects included a *Medusa* (c. 1875), showing an androgynous face similar to those used by Leighton, a figure more disturbed than terrifying. A chalk drawing, *Penelope,* of 1878, is a study of a profile head in classical drape, hair bound with fillet, a moving icon of the abandoned woman, different from the industrious woman painted later by John William Waterhouse; her haunting expression conveys a sense of loss and despair. In 1878 Sandys completed a *Persephone,* showing her as the god-dess of fruition rather than of death. She holds corn grains in her hand, with only her heavy-lidded eyes suggesting she is from the Underworld.

One of Sandys' most powerful classical subjects is the 1896 *Cassandra.* The prophetess is depicted with mouth open and hair streaming, in front of the walls of Troy. Sandys' use of her drapery to parallel the wild flight of her hair lends dynamism to the design. Although Sandys did not concentrate exclu-

sively on classical subjects during his career, the icons he presented of Medea, Fate, or Persephone reflect the culture's suspicion and fear of women. Unlike Leighton, Sandys was a sensual man who appears to have used some classical subjects like Cassandra to express sympathy for the miserable condition of women abandoned in an uncomprehending world. His works provide a tempering contrast to the relentless misogyny found in the work of Leighton. Behind this compassion, nevertheless, is the possibility that Cassandra manifests only the latent madness of women. In the history of classical-subject painting Sandys bridges the Pre-Raphaelite and Olympian worlds, using Rossetti's busts as models to convey his own ideology of pathos and anxiety.

In 1865 William Blake Richmond (1842–1921) visited Rome after the death of his first wife. There he met Frederic Leighton, whom he had known slightly in 1860. This meeting was momentous. In Rome Richmond studied landscape under Leighton's friend Giovanni Costa, but the great influence on his art was to be Leighton. Richmond became one of the most astute evaluators of Leighton's art, and his estimates of Leighton's work are a standard by which to judge his own. In 1896 Richmond perceived the connection between Leighton's personality and his artistry: "Very impulsive, highly strung, nervous and sensitive to the last degree, Leighton was a master of taking trouble about every act of his life. . . . Once seen, that beauty had to be recorded and reported . . . by methods entirely under control and regulated, wherein there was no accident" ("Lord Leighton" 62). To Richmond the "classical temper of mind" was "more analytical than emotional, the emotions being under obedience to reason" (65). Richmond was attracted to the procession/frieze composition exemplified in *Cimabue's Madonna, The Daphnephoria,* and the *Captive Andromache,* the latter two of which he regarded as Leighton's masterpieces. For Emilie Barrington's 1906 study of Leighton, Richmond contributed a short essay, still an informed appraisal of Leighton. Richmond recognized that Leighton "feared the facility in himself" and that erudition and "Aristotelian preciseness" had marred spontaneity in Leighton's canvases (2.1). Richmond believed it was "the reserve of emotions" (5) which touched Leighton in Greek art. Leighton's lack of comprehension by the public Richmond attributed to the fact that "his standard is graphic or plastic, not literary. He appeals by form" ("Leighton, Millais" 117). Like Leighton, Richmond was moved by the Elgin Marbles and classical sculpture. Classical art also influenced Richmond's choice of his second wife, whom a friend described: "Her features were classic, and she did her hair in her young days like a Greek goddess— nor was she unlike one herself, if you can imagine anyone with the form of

a Venus and the mind of a Minerva tempered to mere mortal converse" (Stirling, *Richmond Papers* 245).

Richmond's first classical-subject painting was the *Procession in Honour of Bacchus* (1869), a large canvas that in its movement and processional structure recalled *Cimabue's Madonna*. Richmond was exhibiting this painting — emphasizing the "madness" of female sexual indulgence in Dionysiac orgies — in the year of the third Contagious Diseases Act. Drawing on the prototype of Leighton's *Syracusan Bride,* the canvas shows a procession of women moving to an unseen shrine. While those in the front of the procession carry ritual offerings, those in the rear are already becoming infected with the Dionysiac fury. In a sketch for *Dionysus and the Maenads,* Richmond shows the exhausted naked worshipers fallen on the ground before the god who stands exalted in their midst. Richmond turned from the woman abandoned in sexual frenzy to the woman abandoned by love in the 1872 *Ariadne Lamenting the Desertion of Theseus* (Plate 3-29), based on Catullus' poem on the marriage of Peleus and Thetis. A large single-figure composition, it shows Ariadne in a bronze-green robe stretching one hand to the sky, standing in the waves, while Theseus' ship departs. Stirling correctly views her as a figure of "bitter, impotent protest; . . . the waves which lap her feet are suggestive of imprisonment — of an impassible barrier which has severed her from joy and love" (*Richmond Papers* 256). The figure suggests not only the Parthenon pediment sculptures but also the Victory of Samothrace discovered in 1863. Unlike Leighton, who treated the same episode with Ariadne asleep, Richmond sought the more theatrical dramatic gesture and the turbulent natural background. Lascelles described the picture as one of "bitter, impotent despair" ("Sir William B. Richmond" 16), a close depiction of women's condition.

In the 1885 *An Audience at Athens during the Presentation of the "Agamemnon"* (Plate 3-30) Richmond selected the moment of Clytemnestra's revelation of her murder of Agamemnon at the conclusion of Aeschylus' drama. An entire paragraph is devoted to describing the spectators in the *Athenaeum* notice, and although the audience included both men and women no mention is made of women's reactions. The males are described as being "entranced" and "absorbed" (Blackburn, *Grosvenor Notes* 18). The male world is appalled at the secret passion of woman; no mention is made, either in the notice or in the accompanying quotation, of Clytemnestra's basis for outrage — the murder of Iphigenia by Agamemnon. Woman is conceived of as unpredictable in her "passion." Richmond attempted to introduce into his work an element

of spontaneity of gesture and design that he observed to be lacking in his mentor Leighton.

This sense of drama was particularly evident in Richmond's studies of male heroes, which show a dynamism of conception beyond Leighton. In 1874 Richmond exhibited *Prometheus Bound* at the Academy. *Prometheus Bound* attempted to dramatize male heroism, as the *Art Journal* recorded: "He has striven to do justice to the beauty of human form, and to reach the grand imaginative conclusion secured by the noblest artists of every age." Richmond set Prometheus on a promontory surrounded by a threateningly still sea and an ominous sky, thus "employing the incidents of natural scenery to suggest and emphasise human passion." The figure of Prometheus itself aroused discussion: "There is here a double impression of exaggeration and weakness. The treatment of the head is noble, but the countenance bears an expression too dramatic. The limbs are forced into action" (227). Richmond's undoubted purpose to display male heroism, however, is fulfilled in the canvas. Richmond depicted male heroism in 1877 with his canvas *Sleep and Death Carrying the Body of Sarpedon into Lykia* (Plate 3-31), from Homer's *Iliad*, book sixteen. One of the greatest of the Trojan warriors, Sarpedon is slain by Patroklus, soon himself to die at the hands of Hector. The canvas celebrates male heroism not only in the death of Sarpedon himself, who is compared to an oak tree, a pine, and a bull, but also in the importance given to Apollo, who anoints Sarpedon's body before Sleep and Death remove it to Sarpedon's homeland of Lykia, preventing its defilement by the Greeks. Carried above the sea, Sarpedon is elevated to the ranks of the Apollonian heroes.

In *Hermes* (1886) (Plate 3-32), Richmond shows the god between white temple columns, fastening his sandal as he prepares for flight. The musculature of the dark body combined with the swirl of the rose drapery suggests the youthful force of a young Hermes prepared to take flight over the sea behind him. This is not the solemn deity Hermes Psychopompos guiding Persephone in Leighton's canvas. The *Athenaeum* noted: "From under his cap Hermes, all his beautiful face in shadow and lit up by a cunning smile, looks at us over his shoulder" (592). However, the reviewer continued, "Mr. Richmond's success . . . has not encouraged him to devote that care to drawing the nudity and to modelling its surface with the thoroughness the spontaneity of the design, the energy of the conception . . . deserved, if they did not command." Richmond's studies of Greek gods advance an argument of male heroism during the last two decades of the century, coinciding with Pater's conception in the essay "Athletic Prizemen" from *Greek Studies*. Pater

praised "the fairness of the bodily soul" when engaged in "this mystery of combined motion and rest, of rest in motion" (305–306). The bronze *Greek Runner* (1879) and the canvas *Icarus* (1887) convey this Paterian sense of heroism, elevating male superiority and achievement.

Richmond's main theme throughout most of his oeuvre, with the exception of his portraits, was this male heroic impulse. In his sequence on the story of Phaeton, Richmond followed Leighton in advancing the sun worship associated with male superiority. In *The Rise of Phaeton,* the male is shown lashing his team against the darkness in a transcendent sphere, the ruler of the cosmos. Richmond's dynamism aggrandizes the conception of male heroism. In *The Death of Ulysses* (1888), Richmond shows the hero lying supine in the lap of the faithful Penelope, who takes his hand. Richmond constructs the painting as a classical pietà. The symbols of Ulysses' heroism — his helmet, breastplate, and shield — rest beside him. In these depictions, Richmond uses the iconography to convey the loftiness of male achievement. In the *Ulysses* Penelope is a classical Angel in the House, signifying the enduring nature of this role, and the difficulty of escaping it. Richmond's *Icarus,* exhibited at the Grosvenor in 1887, exalts male daring. Icarus is poised on a dizzying promontory, arms extended as he prepares to take flight against a brilliant sunlit landscape. With his yellow hair and pink wings, Icarus appears ethereal as well as heroic. The association of Icarus with the brilliant sun links him to the hypermasculine world of Apollonian sun worship.

In *The Release of Prometheus by Hercules* (1882) (Plate 3-33), Richmond exhibits two male nudes: Prometheus rising from his rock, back to the viewer, a god being reborn; and the exultant figure of Hercules raising his bow to the sky to shoot the eagle. The dizzying promontory on which they are placed elevates their status. This promontory was matched by the scale of the picture itself, which was more than eleven feet high. In this ideogram Prometheus and Hercules, signifying respectively the contemplative life and the active life, are conjoined in an indelible presentation of male heroism. *Orpheus Returning from the Shades* (1900) (Plate 3-34), Richmond's Diploma Picture, shows a naked male emerging from the darkness, his drapery swirling, his lyre raised triumphantly in his left hand. Not even a suggestion of Eurydice appears in the canvas, which celebrates the supremacy of masculine art. The mood in the *Orpheus* and *The Release of Prometheus* is Pindaric in its exaltation of the male body as spiritually heroic, conquering death and the gods themselves. Richmond noted that it is through art that "we expose our tendency of thought," and Wilfred Praeger comments that in Richmond the word "de-

sign" has a striking connotation; "A theme may be illustrated to which the particularity of the forms and colours give a thorough interpretation. In this way painting became a language" ("W. B. Richmond" 508, 506). For Victorian critics, such canvases as the *Hermes, Orpheus,* or *The Release of Prometheus* were evidently intended as ideograms of patriarchal power and heroism.

In *Perseus and Andromeda* (Plate 3-35), a work distinctly less successful than *The Release of Prometheus* and *Orpheus,* Richmond presents his version of the "rescue." The figure of Perseus appears to be inspired by Caravaggio's *Perseus and Andromeda,* known through engravings during the nineteenth century. Andromeda is shown chained at the right, while Perseus swoops to destroy the dragon below her. The contorted position of Perseus detracts from the tension of the situation, one of Richmond's rare failures when dealing with male heroic ideals. But since the chalk version of the episode shows the same contorted posture, it is possible that the emphasis on the grasp of the shield rather than on the thrust at the monster was meant to bring the two figures of rescuer and rescued into conjunction. The same emphasis on male heroic nudity appears in Richmond's sculpture of 1889, *The Arcadian Shepherd,* showing a nude male balancing a crook behind his shoulders. The figure is powerful, an heroic ideal in an idyllic context. The well-defined genitals must have startled some observers despite the classical association evoked by the title. Unlike the males of Burne-Jones, Richmond's statue exhibits a defiant phallicism. In 1879 Richmond had completed a bronze, *Greek Runner,* deploying the same male heroic nudity. In contrast to *The Arcadian Shepherd,* the *Greek Runner* exemplifies the energetic rather than the contemplative male, but both sculptures emphasize triumphant masculinity.

When Richmond turned to canvases involving goddesses, his style in general became more frozen and sculpturesque. In 1890 Richmond exhibited *Venus and Anchises* (Plate 3-36) at the New Gallery, a large canvas showing the goddess unveiling her beauty before a stunned and intent Anchises on her right. Before her proceed lions, attesting to her invincibility. Richmond devoted great attention to the face of Venus, with its calm assurance that her beauty will triumph, and to the cautious amazement in the gaze of Anchises. As recounted in the Homeric Hymn, the future father of Aeneas recognizes that if he has intercourse with a goddess, he will thereafter be impotent. The canvas depicts not only the guile of Venus but also Anchises' fear of impotence. The force of female sexuality in this legend leaves the man sexually dead.

In *The Bath of Venus* (Plate 3-37), exhibited the following year at the New

Gallery, Venus is shown standing before a pool, her attendants preparing to dress her. The face of the goddess is sly, without the grandeur the deity possesses in the 1890 canvas. In the female nude, Richmond seems less assured than in his male figures. In his study of Richmond in 1901, Baldry commented upon Richmond's portraits, indicating the difference between Richmond's conceptions of male and of female subjects: "Sir William, in his feminine portraits, regards a woman mainly as a decorative object, on whom—with rare exceptions—psychology, profundity of character, and even truth (when it is inconvenient) have little to do. These qualities are apt to interfere with decoration, and the painter has aimed at treating women as the most beautiful ornaments of the universe. . . . He adds a little cosmetic here, a curl there. . . . Does any modern Englishman more completely understand the dignified daintiness of the modern lady?" ("Sir W. B. Richmond" 198, 200). Baldry's reaction illustrates not only the nature of Richmond's treatment of women in the classical-subject canvases but also a contemporary reaction to the female subject itself.

Baldry's comment indicates his own predisposition, based on cultural norms, to stereotype women, denying them the heroism that he feels in Richmond's male subjects like Hermes or Prometheus. Richmond's allegorical representations of women present them as austere, static figures in accord with this attitude. Sexually much more secure than Leighton, Richmond did not draw women in androgynous forms, threateningly masculine like Clytemnestra. His treatment of the male and female figure made it apparent that men were for action, women for display. Richmond declared of his art: "My nature must live back; I must dream; the past has for me a vividness which receives suggestions from the present. Somehow in the woods and mountains of Italy, among the islands of Greece, in Arcadia, in the deserts of Egypt, or in the city of Pompeii, it is not the people treading those grounds who are real to me, but what is uppermost is the world two thousand years ago—that exists. . . . Emotion must never be allowed to run away from intellect, they must keep pace together; it is so easy to start lustily upon a race and to get out of breath before it is finished" (Lascelles, "Sir William B. Richmond" 32). Richmond's artistry did in fact "live back," as he used his mythical icons to reinforce male heroism. His metaphor of the artist as athlete indicates the nature of his aim and achievement.

An artist who spanned the Pre-Raphaelite and classical movements in the nineteenth century with several arresting canvases was Philip Hermogenes Calderon (1833–1898). Calderon's first great success was the Pre-Raphaelite

canvas *Broken Vows* of 1857, showing a dark-haired woman overhearing her lover with a blonde rival on the other side of a fence. The meticulous detail reflected the canons of the Pre-Raphaelites, but the theme itself anticipated Calderon's treatment of women in some of his classical-subject paintings. In 1868, during the same period when Leighton was turning to classical subjects, Calderon exhibited *Oenone,* which was recognized by the *Art Journal* as a new departure for him: "Calderon, in his voluptuous figure, 'Oenone', has played truant to mediaevalism, and given himself over, at least for once, to the opposing school of romantic classicism. The picture is in the main a study from a magnificent model who created quite a sensation when set before the students of the Royal Academy. The figure does not answer to the character of Oenone; the girl is redolent in life, not wasted with love. The picture . . . may, at any rate, be accepted as a noble type of womanhood, handsome to look at" (106).

While Calderon did not suggest the fate of Oenone in this canvas, the theme of the woman betrayed by Paris for Helen relates to the betrayal theme of the earlier *Broken Vows.* In painting something "handsome to look at," Calderon was showing beauty on the brink of abandonment, a shrewd choice of dramatic moment relating to the culture itself: beauty that is proud will have its downfall, yet there is no other value in women. This cultural paradox is insidiously revealed in Calderon's *Oenone.* Calderon exhibited another *Oenone* in 1886; the *Athenaeum* described her as "deserted of Paris and meditating her unhappy fate" (592). In this depiction, Oenone sits naked except for some white drapery emphasizing her bare breasts. The canvas without its title would be extremely ambiguous in intention, as the ripe sexuality of the woman suggests that only Helen could distract Paris. Calderon felt that the theme of the deserted woman was worth more than one depiction.

In 1885, the year of Poynter's *Diadumenè,* Calderon exhibited his *Andromeda,* a nude gazing out to sea, with hair flying in the wind. The *Magazine of Art* noted: "His Andromeda is of the finest kid; . . . the seas that rage at her feet are of the richest and crudest ultramarine, the purest and paintiest flake-white" (350). The *Athenaeum* thought: "The fair, plump princess is not so like a Greek as we could wish her to be. She stands erect in the bright sunlight, chained by both hands to a dark cliff. . . . Her naked form, rather modern than statuesque . . . savours a little (a very little) more of the stage than the studio . . . something less than heroic" (637). If one considers that the *Diadumenè* and this *Andromeda* were on the walls the same year, the public was given strange messages of victimization and nubile nudity simul-

taneously. Calderon's *Aphrodite* of 1884, a golden-haired woman on a blue sea, was accompanied with the statement "Fresh as the foam," a subtle allusion to her spermatic origin. The 1895 *Ariadne* (Plate 3-38) is a strongly poignant composition, showing the dramatic gesture, a device familiar from Richmond's treatments. With her hands uplifted to the sky, Ariadne walks into the water, supposedly in pursuit of Theseus' ship. The canvas makes it appear she is committing suicide. The rocky coast of the bay, opening into the blank sea beyond, emphasizes her loneliness and abandonment. No suggestion is given of her "rescue" by Dionysus. Calderon's occasional classical-subject canvases focus dramatically on the abandoned female. Andromeda, Ariadne, Oenone all exhibit the situation of women bereft of male aid. As such they express the dependency that Ruskin had isolated as part of woman's character.

VI

In 1875, an important classicizing artist exhibited two works at the Royal Academy, prompting this response from John Ruskin: "It is worthwhile to go straight from this picture [Tadema's *Sculpture Gallery*] to the two small studies by Mr. Albert Moore . . . which are consummately artistic and scientific work. . . . And for comparison with the elementary method of Mr. Tadema, look at . . . the general modes of unaffected relief by which the extended left arm in 'Pansies' detaches itself from the background. And you ought afterwards if you have an eye for colour, never more to mistake a tinted drawing for a painting" (Green, "Albert Moore" 26). This notice, contrasting Albert Moore (1841–1893) with Tadema, is unflattering to the latter. It suggests, however, the impact of Albert Moore's version of classical-subject painting on the tradition of Victorian neoclassicism. Christopher Wood contends that Moore's art "is an entirely personal and individual fusion of classical and aesthetic elements. Unlike Tadema . . . he was not remotely concerned with historical or archaeological accuracy. . . . The narrative element is minimal" (*Olympian Dreamers* 156). More specifically, Moore's art, in disregarding "historical reconstruction" and "creating pictorial harmonies independent of narrative subject matter" (Green 5), reveals the significance of the friendship between Moore and Whistler, who had met in 1865. Moore welds his intense study of the Elgin Marbles to the sense of color in Japanese art.

During Moore's lifetime, as is apparent from Cosmo Monkhouse's essay (1885), many claimed that Moore attempted archaeological recreations of Greece and Rome and failed in the attempt. Monkhouse denied that Moore

had any such objective: "He is no Alma-Tadema. . . . [Moore] employs the robes and draperies of Athens only because they are to his eyes far more beautiful than any costume which has been invented since." Still, Moore "is Greek . . . in the spirit of his art. He seeks after beauty in the first place. . . . He is Greek also in his choice of expressing himself greatly if not mainly by form" (195). Moore's artistry, in its very rejection of explicit anecdotal subject matter, makes his canvases very significant in the tradition of nineteenth-century classical-subject painting. While one may concur that the narrative element of Moore's canvases is minimal, amid their rich harmonies of color there remains an icon of women that reflected a cultural predisposition: the idea of the female as aesthetic object, passive, somnolent, or indolent. The faces of Moore's women have the "impassivity of mood" (Allen Staley, "Condition" 85) of Greek sculptured goddesses. Moore seems to have lived a totally ascetic life as a bachelor, channeling his sexuality into the beautiful repression of his canvases.

Whether this asceticism is a result of sexual inhibition or preference is difficult to determine. Aestheticism, however, allowed Moore to confront women from a psychologically safe distance. If Moore is an "aesthetic classicist" (Wood, *Olympian Dreamers* 159), he was not so disengaged from the prevailing icons of women as one may at first suppose. In *Time Was,* Graham Robertson remembered Moore as having a "splendid Christ-like head . . . set upon an odd awkward little body that seemed to have no connection with it" (57). This physical appearance may have prompted Moore to prefer viewing women in postures of repose and somnolence. He also suffered considerable ill health; in 1883 he was attacked simultaneously by blood poisoning, lung congestion, and pleurisy. In 1866 Moore did a black-and-white chalk drawing entitled *Somnus,* which established the strongest of Moore's images of women, the woman asleep, sexually narcotized. In the early stages of his painting Moore occasionally provided significant detail, such as the arrangement of drapery, to convey a subtextual apprehensive attitude about women. Furthermore, the friezelike arrangements of his female figures enhanced their immobility and inaction. Moore's figures, usually placed before planes cutting off pictorial distance, appear imprisoned within the canvas, remote, inaccessible in their aesthetically stunning draperies. Moore sought to give his women "the unconsciousness of Greek art" or "the inexpressive self-sufficing beauty of the Athenian ideal" (Baldry, *Albert Moore* 34, 38) so that he could voyeuristically and safely contemplate them. Moore hesitates to animate them.

These tendencies are evident in Moore's canvases of the 1860s. In *The Mar-*

ble Seat (1865) (Plate 3-39), three women, lounging in a woodland setting, are being served wine by a nude youth, evoking the Dionysiac element. The three figures, patterned after goddesses from the Parthenon pediment, suggest incipient female sensuality. Considerably younger than the three women, the youth represents Moore's own sexual immaturity and inexperience confronting mature female sexuality. Peter Webb believes that *The Marble Seat* has strong erotic connotations: "One would have thought that a painting which showed a nude boy, his genitals precisely depicted, pouring wine for three girls wearing transparent robes, would have caused a . . . sensation, although the Grecian setting presumably gave it respectability" (*Erotic Arts* 189). In *Pomegranates* (c. 1866), Moore developed the idea of three classically draped women appearing in *The Marble Seat. A Musician* (1867) (Plate 3-40) shows a man playing a lyre to two resting females, all derived from the Parthenon pediment, from which Moore has also derived the flat composition. It is obvious that the figures were painted and conceived as nude, with a tracing of drapery thrown about them as the canvas neared completion; Moore's final canvas is less erotic than its original conception. Harry Quilter, writing of the 1873 exhibition, praised "the painting of thin draperies by Mr. Albert Moore. To the best of my belief no painter, past or present, has grasped the beauty and the character of such robes with anything like the success which this artist habitually attains" (*Academy* 19). Female sensuality is lulled by the musician, whose prototype is Orpheus. Moore's first painting of a single female classical figure was *Azaleas* (c. 1868), which drew an admiring tribute from Swinburne: "No one has so keen and clear a sense of this absolute beauty as Mr. Albert Moore. . . . The melody of colour, the symphony of form is complete. . . . Its meaning is beauty" ("Notes" 360–361). Swinburne perceived "the gentle mould of her fine limbs through the thin soft raiment," judging it as more sexual than Leighton's *Actaea* of the same year.

With the decisive intervention of Leighton, Moore in 1869 exhibited *A Venus* (Plate 3-41), modeled after the Venus de Milo. The muscles of the stomach and abdomen are more evident than in the classical original and appear masculine in outline. The lack of sensuality of the figure is increased by the fact that the breasts, as in Watts's *Clytie,* appear tacked on rather than organic. The figure is in fact an Aphrodite Diadumene. When exhibited at the Academy, it was considered a companion piece to Leighton's unusual *Electra at the Tomb of Agamemnon.* The *Art Journal* noted of the *Venus:* "It is too ugly and repulsive to be objectionable except to taste" (*Albert Moore* [catalogue] 17). The Aphrodite image recurs in *Shells* (1874) and *Sea Shells*

(1878) (Plate 3-42). The pose of the draped figure is that of the Venus Pudica, best exemplified in the Aphrodite figure of the Venus de Medici. Just as the Aphrodite Diadumene inspired *A Venus,* the suggestion behind *Shells* and *Sea Shells* is the Aphrodite Anadyomene, the goddess born of the sea foam, from the sperm of Uranos. In both these canvases, the Venus Pudica pose of the model contrasts with the Aphrodite Anadyomene background. Moore's paintings continued to examine the standing woman or the recumbent or somnolent figure. The standing woman, frequently in a *contrapposto* attitude, appears in such canvases as *A Reader* (1877), *Birds of the Air* (1878), *The Painted Wardrobe* (1886), *The End of the Story* (1877), and *Carnations* (1877). In several of these canvases, the figures are posed in shallow spaces before curtains. *The End of the Story* depicts the completion of the reading in *A Reader,* emphasizing the self-absorption of the figures. These single-figure canvases, while seemingly devoid of contemporary relevance, intersect with the view of female sexuality conveyed in the writings of physicians like William Acton, who declared that women have virtually no sexual inclinations. Moore's desexualized figures, by elevating the idea of female as aesthetic object, protect men from female sexuality.

In Moore's sequences involving recumbent and/or sleeping women, the sexual content is more evident. In *Beads* (1875) (Plate 3-43), two women in classical draperies sleep on a sofa. One of the figures has her legs crossed, preventing sexual access. The same configuration appears in *A Sofa* of the same year. In *A Palm Fan* (c. 1875), the erotic content is apparent in the abandoned posture of the sleeping woman. In canvases such as *A Workbasket* (1879) and *Acacias* (1882), Moore depicts sleeping women on couches. In 1882 Moore completed one of the most enduring images of sleeping women during the Victorian period, *Dreamers* (Plate 3-44). As Richard Green notes, the "recumbent figure on a sofa and the figure reading . . . gave Moore the pretext he needed to show figures absolutely motionless" ("Albert Moore" 28). In *Dreamers* two women are asleep, while the third, with one leg raised, stares at the observer; the two asleep appear younger than the waking third woman, perhaps a reference to their unawakened sexuality. The third figure contrasts by her vaguely stirring sensuality, a pose recalling that of *Rose Leaves.* In *The Toilet* (1886), Moore reverts to the pose of a diadumene, emphasizing the intimate nature of the gesture associated with bathing and dressing. In *White Hydrangeas* (1885) Moore had depicted a nude at a door, entering a bath. The sexual significance of such a picture is evident from the fact that when exhibited at the Academy, the canvas was damaged by scratching, presumably

deliberately. Walker noted of the event: "It is not in Glasgow only that 'the nude' agitates Mrs. Grundy and others into evil thoughts and evil deeds" ("Private Picture Collections" 367). Exhibited in the same year as Poynter's *Diadumenè* and during the period of Stead's *Maiden Tribute* series, such a nude with its sexual allusion intersected with politics.

Moore exhibited *Midsummer* (Plate 3-45) in 1887, with its three figures in orange and white draperies. The enthroned central figure is asleep while a woman stands on either side gently fanning her. The configuration is inspired by the classical sculpture of Aphrodite Anadyomene from the Ludovisi Throne. A rite of initiation is suggested in the younger face of the enthroned figure. In 1890 Moore exhibited his finest study of female sexuality, *A Summer Night* (Plate 3-46). In this painting, he synthesized the previous icons. The four women, posed before a brilliant moonlit sea, are in various attitudes of erotic awareness. The figure on the left peers out of the canvas, half undressed; next to her, a nude woman seen from the back stretches, the reverse of the posture of *The Toilet*. A third woman is recumbent and asleep; the fourth is again a diadumene recalling the attitude of *A Venus*. The two urns in the picture, the one small with blossoms, the other larger and empty, contrast the sexual situations of the four women. Peter Webb notes that this picture exhibits "a meticulous photographic technique that goes beyond the merely decorative. . . . The overall effect is certainly erotic, and that must surely have been the artist's intention" (*Erotic Arts* 189). Moore's women are a strange combination of robust health coupled with narcotized stasis, in fact the *poses plastiques* on canvas. Bram Dijkstra suggests that in such canvases Moore is the "master painter of the exhausted, masturbatory woman," the viewers "voyeuristic observers of orgies of solitary feminine sensuality" (*Idols of Perversity* 75).

Toward the end of his life, Moore introduced a narrative element into his canvases. In 1890 Moore developed a tumor in his thigh, a disease which caused his death three years later despite operations in 1890 and 1892. While one must be cautious in interpreting such an event, it is conceivable that a disease near the sexual organs awakened regret at an unfulfilled sexual life. In *An Idyll* (1893) (Plate 3-47), Moore depicts two lovers who have quarreled, the woman imploring the man to reconcile. The work borders on being classical genre in the tradition of Tadema, but its austerity lends it a somber overtone absent in Tadema. The man's legs are crossed; he appears younger than the woman. Moore may suggest his own sexual inexperience in such a figure, evoked at the beginning of his career in *The Marble Seat*. The marble foun-

tain to the left of the canvas suggests the potential life-giving quality of passion, denied to Moore himself. The several ranges of poppies in *An Idyll* may signal the death-in-life nature of Moore's sexuality, that this vital component of existence was moribund in him.

Dating from 1890–1893, Moore's final canvas, *The Loves of the Winds and the Seasons* (Plate 3-48), is his most explicit sexual canvas, couched in an allegory of the four male winds and the female seasons. The South Wind and Autumn, in the foreground right, have reached accord; behind them, the North and East Winds dispute the possession of Winter, with her drapes drawn about her. Summer stands alone while in the back Zephyr, with nude buttocks showing, pursues Spring. To Moore's student Baldry, the picture was "a great allegory of human passion, a piece of symbolism in which dramatic feeling was predominant, and in which every strong natural impulse was revealed" (*Albert Moore* 21). Moore has turned from the somnolent attitudes of his earlier canvases to show his figures in sexual pursuit. Moore worked on the canvas until a week before his death. The fact that Summer remains alone, unpaired with a male wind, suggests the impaired growth he experienced in his own life. His identification with the isolated Summer may indicate the lack of intimacy in his existence. Moore had completed a pastel between 1885 and 1890 of a man in a tree with three women standing below him, which may possibly be a Judgment of Paris. Linked to the isolated figure of Summer in *The Loves of the Winds and the Seasons,* the drawing indicates a fantasy by an individual who did not choose and remained unchosen. Moore's physical appearance at the beginning of his life, and the tumor in his thigh at its conclusion, produced loss and deprivation.

Robert Walker observed that "the women [Moore] imaged for us, have little in common with the hurly-burly of to-day and the human beings we meet upon the streets. It is a land of languorous delights and soft airs, where no jarring note is ever struck, and the shadow of death is quite unknown" ("Private Picture Collections" 362). Moore's interest in the female figure, and his focus on the mythological precedents of the Aphrodite Anadyomene and Aphrodite Diadumene, the posture of the Venus Pudica, and the attitude of the recumbent, somnolent female, illustrate that Moore used his study of the Elgin Marbles to examine Victorian attitudes to sexuality. The dichotomy of presentation is evident in the contrast between the Aphrodite Diadumene and the Venus Pudica. The fact that a Moore nude could be attacked in 1885 indicates that Moore's pictures were not devoid of sexual content. Moore's two

final canvases, which integrate his personal experience into his painting, reveal his regret at an unfulfilled sexuality.

Graham Robertson, who spent three years studying with Moore, recorded in *Time Was* valuable information about the manner in which Moore created his canvases. Of particular interest is that this explanation of Moore's methods comes after a careful consideration of Moore's personality, such that the methodology reflects his temperament. Robertson characterizes Moore as "a sad man" whose "life was in many ways a very lonely one" (60). Noting he was "an untiring worker" who seldom was inclined "to take a holiday or a 'day off,'" Robertson described Moore's method: "He built up his compositions very slowly and laboriously, making elaborate charcoal cartoons of the whole group, then of each single figure, first nude, then draped. Then came chalk studies of the draperies, colour studies of the draperies, rough photographs of the draperies, so that before the great work was actually begun he had already produced many pictures. The colour studies of draped figures, done straight off while the model stood and never retouched, were his most perfect works. The touch was so light, the paint so fresh and exquisite in texture, the drawing and colour so true and sensitive, that they were miracles of artistry. . . . When the studies had all been made, the first step towards the actual picture was the putting in of the whole composition in grey monochrome. Over this, when it was dry, came a thin, fluid painting very delicate in colour through which the grey design clearly showed. Next came heavy impasto, strong and rather hot in colour, over which, when dry, was passed a veil of semi-opaque grey, and on this was wrought the third and final painting, thin and delicate like the first" (61–62). The canvases and the life exhibit a parallel in their similar cautious approaches, while the sadness and loneliness of Moore's life may be gauged by the "grey monochrome" of the underpainting, which could assume vibrancy only in aesthetic creations of women whose distancing reserve, classical in its self-containment, reflected the artist himself.

At Moore's death in 1893, Whistler commented: "Albert Moore—Poor fellow! The greatest artist that, in the century, England might have cared for and called her own—how sad for him to live there—how mad to die in that land of important ignorance" (Baldry, *Albert Moore* 25). Rossetti is recorded as having called Moore "a dull dog," to which Whistler replied, "He thinks slowly, but he's not in the least dull" (Robertson, *Time Was* 60). One cannot avoid the conclusion that this represents an inhibition and repression that marked the artist's character. Moore's canvases, although part of the Aesthetic

Movement and ostensibly "art for art's sake," contain a personal significance that mirrors contemporary attitudes. The regret they express at an unpassionate existence serves as its own commentary on the danger that art for art's sake may not be sufficient for life.

The authority conferred on classical-subject painting by the practice of Frederic Leighton was enhanced by his participation in so public a sphere as arts administration. Leighton was a scrupulous administrator, as precise in his administrative obligations as he was in his preparation of a canvas. Leighton's gynophobic canvases are the artistic presentation of attitudes he maintained in his private life. His work reflects the political situation of women: Leighton's selection of myths (Andromache, Andromeda, Clytemnestra) reveals the partiality that marked many men approaching classical literature in the nineteenth century. An alternative attitude was that of Frederick Sandys, whose repeated studies of Cassandra signify a sympathy with the condition of women. Albert Moore's classically inspired women in their friezelike placement reflect a reticence about sexuality that marks some of Leighton's canvases while lacking Leighton's monumentality. With the work of Richmond and Calderon, compassion for women is replaced by male heroism. Richmond's ideas of the heroic Orpheus, Hermes, Prometheus, and Heracles coincide with the attitude toward male heroism expressed in the work of Pater. The mythological heroes provided an extension of the heroes praised earlier in the century by Thomas Carlyle. By the use of classical legend, the images of men as heroic rescuers and saviors were given universality and eternality. Andromache, Ariadne, and Andromeda presented the female counterpart of the hero, the abandoned woman; Phryne and Clytemnestra, the fearsome femme fatale. The political debates about women's emancipation are reflected in such dichotomies. Leighton and Richmond may not have sat in Parliament, but the political nature of their classical-subject art was unambiguous: their images of women constituted political ideograms that reflected conservative attitudes about women during the nineteenth century.

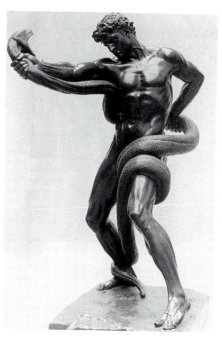

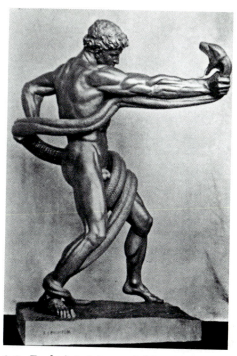

3-1. Frederic Leighton: *Athlete Struggling with a Python,* 1877; bronze; 68¾ × 38¾ × 43¼; Tate Gallery, London, on loan to Leighton House.

3-2. Frederic Leighton: *Athlete Struggling with a Python.*

3-3. Frederic Leighton: *The Fisherman and the Syren,* 1858; 26½ × 18½; Bristol Art Gallery.

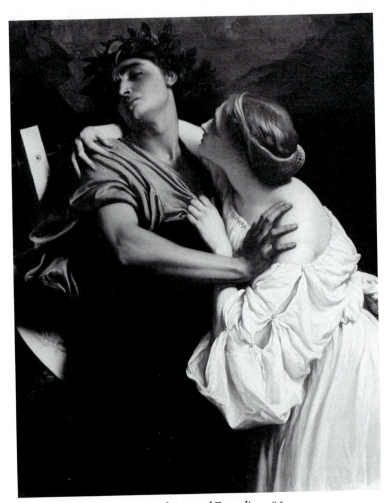

3-4. Frederic Leighton: *Orpheus and Eurydice,* 1864; 49 × 42;
Leighton House, London.

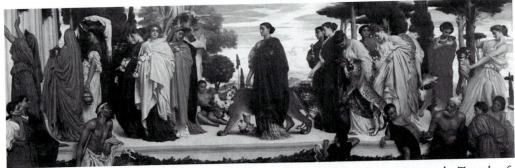

3-5. Frederic Leighton: *The Syracusan Bride Leading Wild Beasts in Procession to the Temple of
Diana,* 1866; 53 × 167; Leighton House, London.

188

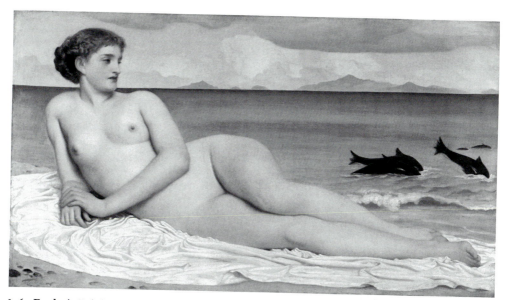

3-6. Frederic Leighton: *Actaea, the Nymph of the Shore,* 1868; 22 × 40; National Gallery of Canada, Ottawa, Gift of R. E. A. Wilson Esq., London 1930.

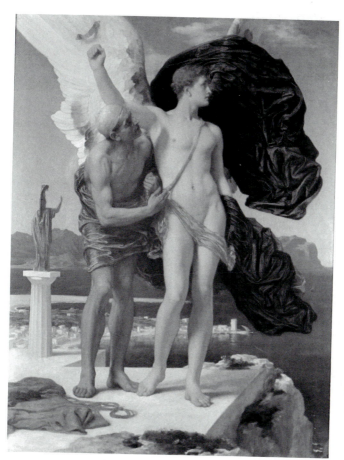

3-7. Frederic Leighton: *Daedalus and Icarus,* 1869; 53½ × 40½; The National Trust, Buscot Park.

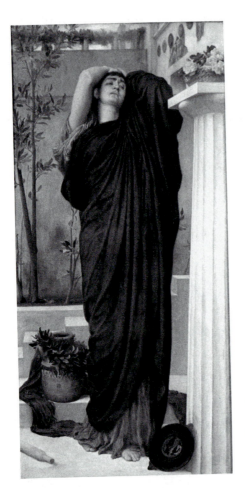

3-8. Frederic Leighton: *Electra at the Tomb of Agamemnon,* 1869; 59½ × 29; Ferens Art Gallery, Hull.

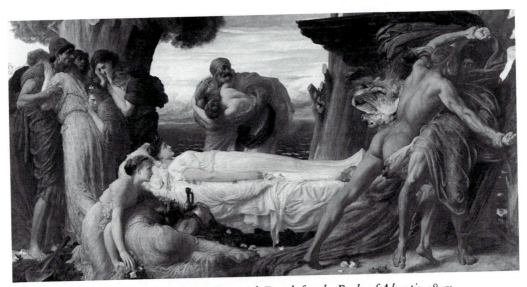

3-9. Frederic Leighton: *Hercules Wrestling with Death for the Body of Alcestis,* 1871; 51½ × 104½; Ella Gallup Sumner and Mary Catlin Sumner Collection, Wadsworth Atheneum, Hartford; photo: Joseph Szaszfai.

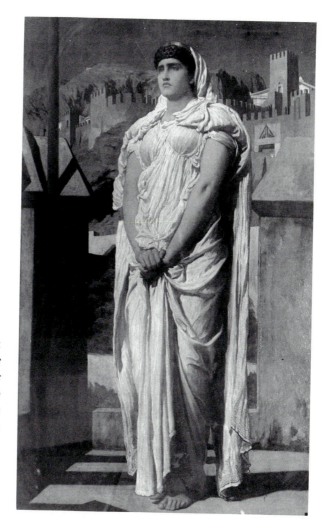

3-10. Frederic Leighton:
*Clytemnestra from the
Battlements of Argos Watches
for the Beacon Fires Which
Are to Announce the Return
of Agamemnon*, 1874;
54 × 34½; Leighton House,
London.

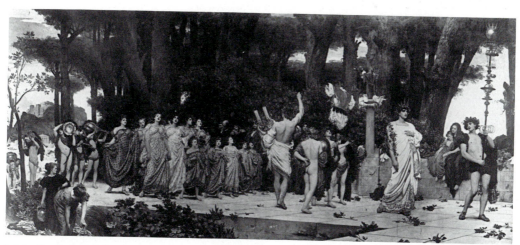

3-11. Frederic Leighton: *The Daphnephoria*, 1876; 89 × 204; National Museums and Galleries on Merseyside (Lady Lever Art Gallery, Port Sunlight).

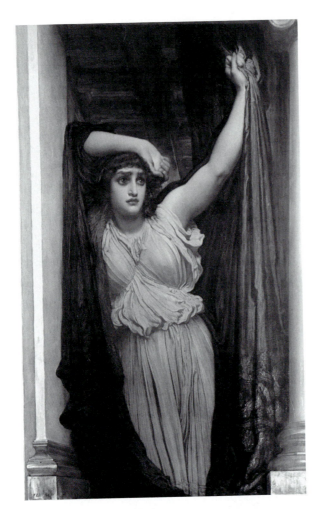

3-12. Frederic Leighton: *The Last Watch of Hero*, 1887; 62½ × 35½; Manchester City Art Gallery.

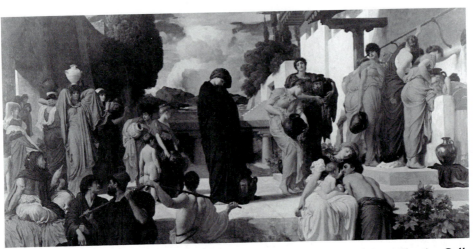

3-13. Frederic Leighton: *Captive Andromache*, 1888; 77 × 160; Manchester City Art Gallery.

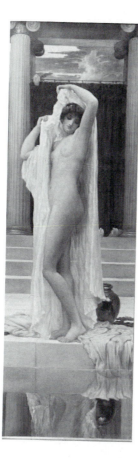

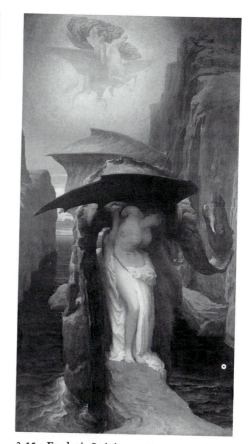

3-14. Frederic
Leighton: *The
Bath of Psyche,*
1890;
75 × 24½;
Tate Gallery,
London.

3-15. Frederic Leighton: *Perseus and
Andromeda,* 1891; 91½ × 50; National
Museums and Galleries on Merseyside
(Walker Art Gallery, Liverpool).

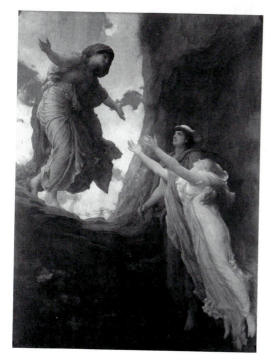

3-16. Frederic Leighton: *The Return of
Persephone,* 1891; 79 × 59½; City Art
Gallery, Leeds.

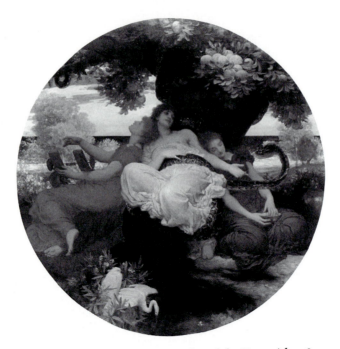

3-17. Frederic Leighton: *The Garden of the Hesperides*, 1892; diameter 66 inches; National Museums and Galleries on Merseyside (Lady Lever Art Gallery, Port Sunlight).

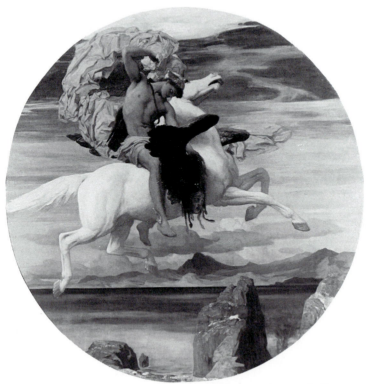

3-18. Frederic Leighton: *Perseus on Pegasus Hastening to the Rescue of Andromeda*, 1896; diameter 72½ inches; Leicester Museum and Art Gallery.

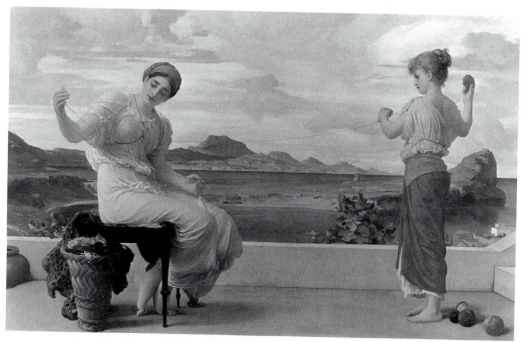

3-19. Frederic Leighton: *Winding the Skein*, 1878; 39½ × 63½; purchased 1973, Art Gallery of New South Wales, Sydney.

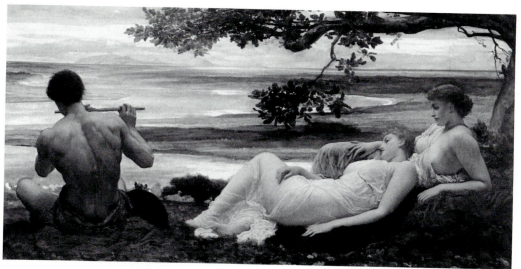

3-20. Frederic Leighton: *Idyll*, 1881; 41½ × 84; photo: Sotheby's Belgravia.

195

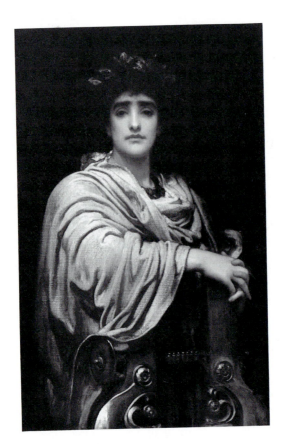

3-21. Frederic Leighton: *Corinna of Tanagra,* 1893; 47½ × 27; Leighton House, London.

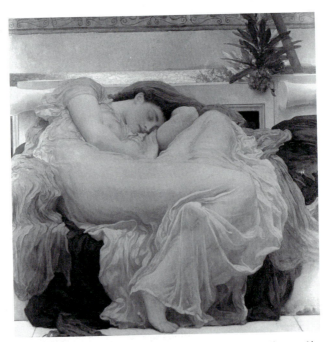

3-22. Frederic Leighton: *Flaming June,* 1895; 47½ × 47½; Museo de Arte de Ponce (Fundación Luis A. Ferré).

196

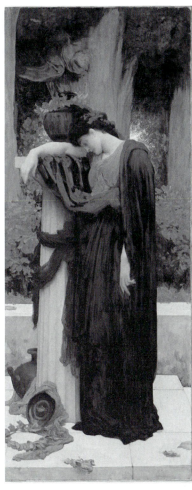

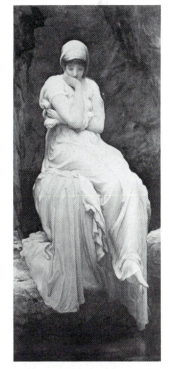

3-24. Frederic Leighton:
Solitude, 1890; 66 × 30;
Maryhill Museum of Art,
Goldendale, Washington.

3-23. Frederic Leighton:
Lachrymae, 1895; 62 × 24¾; The
Metropolitan Museum of Art,
Wolfe Fund, 1896. The Catharine
Lorrilard Wolfe Collection. (96.28).

3-25. Frederic Leighton: *Fatidica,*
1894; 59½ × 43; National Museums
and Galleries on Merseyside (Lady
Lever Art Gallery, Port Sunlight).

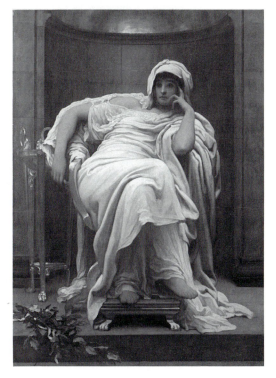

3-26. Frederic
Leighton: *Self-
Portrait*, 1881
(replica);
30⅛ × 25¼;
Leighton House,
London.

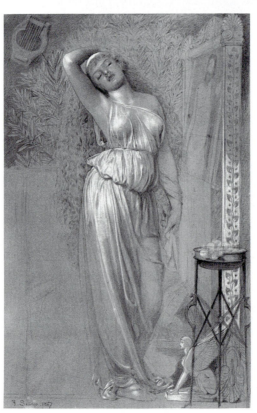

3-27. Frederick Sandys:
*Danaë in the Brazen
Chamber*, 1867; chalk
on paper; 26 × 17;
Bradford Art Galleries
and Museums.

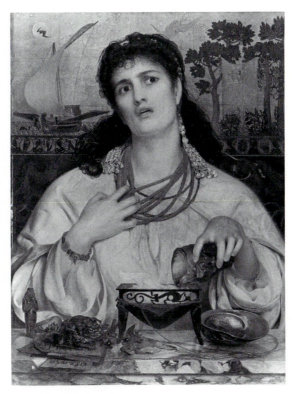

3-28. Frederick Sandys: *Medea*, 1868; 24½ × 18¼; Manchester City Art Gallery.

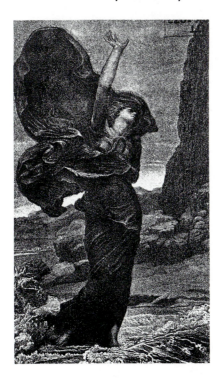

3-29: William Blake Richmond: *Ariadne Lamenting the Desertion of Theseus*, 1872; photo: Kestner from reproduction in The Witt Library, Courtauld Institute of Art, London.

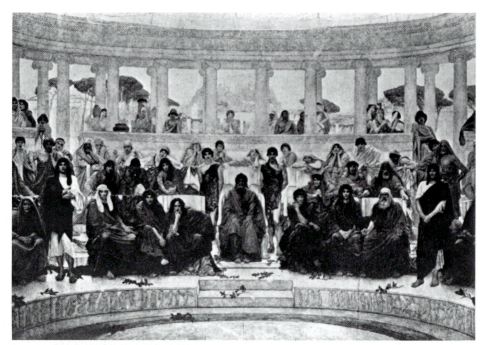

3-30. William Blake Richmond: *An Audience at Athens during the Presentation of the "Agamemnon,"* 1885; 83 × 120; Birmingham City Art Gallery.

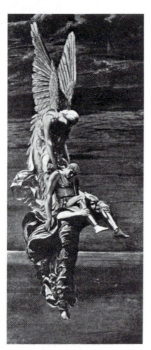

3-31. William Blake Richmond: *Sleep and Death Carrying the Body of Sarpedon into Lykia,* 1877; photo: Stirling, *Richmond Papers* 1926.

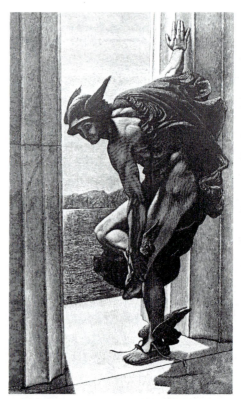

3-32. William Blake Richmond: *Hermes,* 1886; 58 × 36; photo: Kestner from reproduction in The Witt Library, Courtauld Institute of Art, London.

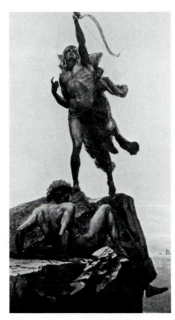

3-33. William Blake
Richmond: *The Release of
Prometheus by Hercules,*
1882; 141 × 72; photo:
Stirling, *Richmond Papers* 1926.

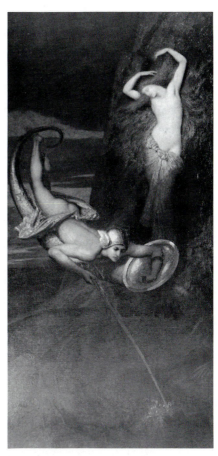

3-35. William Blake Richmond: *Perseus
and Andromeda,* 1890s; 88 × 44; photo:
Sotheby's Belgravia.

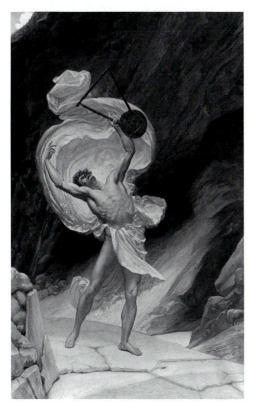

3-34. William Blake Richmond: *Orpheus
Returning from the Shades,* 1900;
73 × 45½; Royal Academy of Arts,
London.

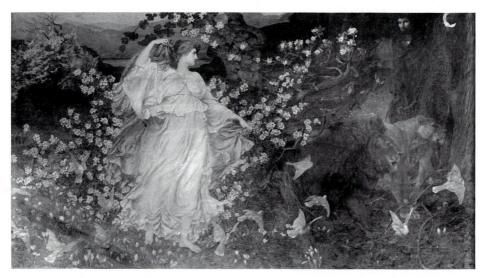

3-36. William Blake Richmond: *Venus and Anchises,* 1890; 58½ × 116½; National Museums and Galleries on Merseyside (Walker Art Gallery, Liverpool).

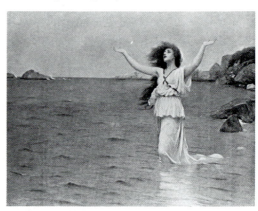

3-38. Philip Hermogenes Calderon: *Ariadne,* 1895; 44 × 56; photo: *RAP* 1895.

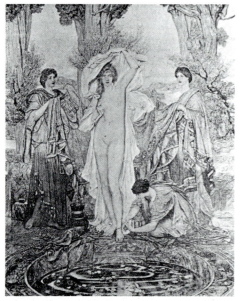

3-37. William Blake Richmond: *The Bath of Venus,* 1891; 80 × 67; Aberdeen Art Gallery.

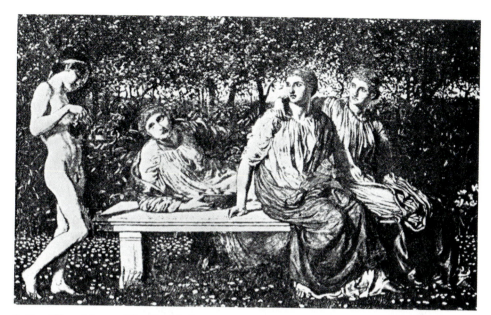

3-39. Albert Moore: *The Marble Seat,* 1865; 18½ × 29; photo: Baldry, *Albert Moore* 1894.

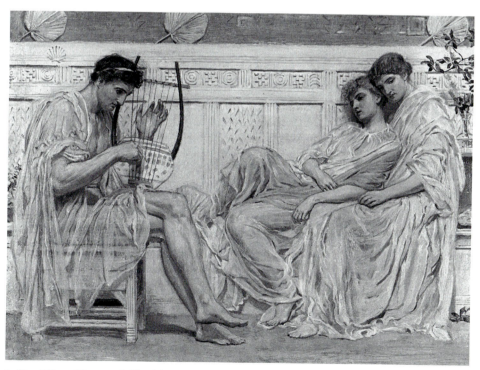

3-40. Albert Moore: *A Musician,* 1867; 11¼ × 15¼; Yale Center for British Art, Paul Mellon Fund.

203

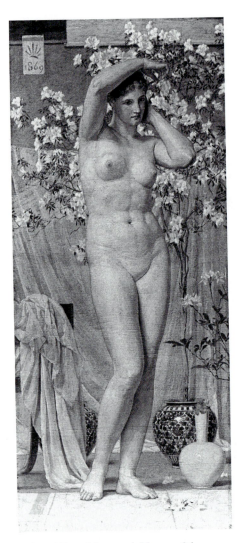

3-41. Albert Moore: *A Venus*, 1869;
63 × 30; York City Art Gallery.

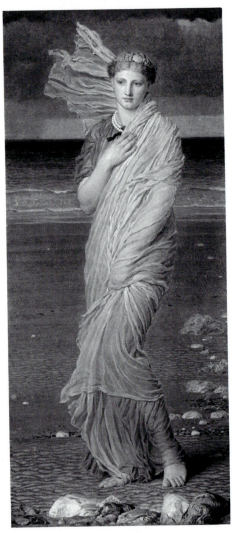

3-42. Albert Moore: *Sea Shells*, 1878;
61 × 27; National Museums and Galleries
on Merseyside (Walker Art Gallery,
Liverpool).

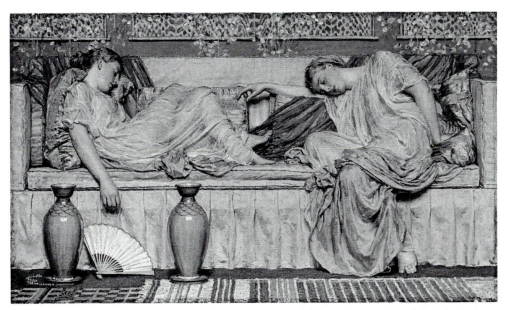

3-43. Albert Moore: *Beads*, 1875; 11¼ × 19¾; National Gallery of Scotland, Edinburgh.

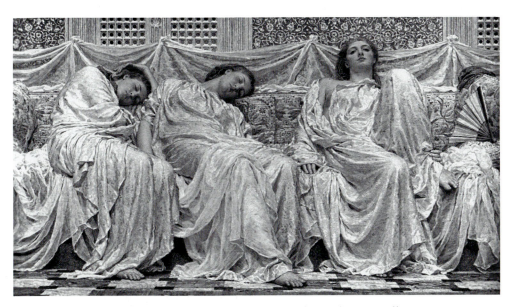

3-44. Albert Moore: *Dreamers*, 1882; 27 × 47; Birmingham City Art Gallery.

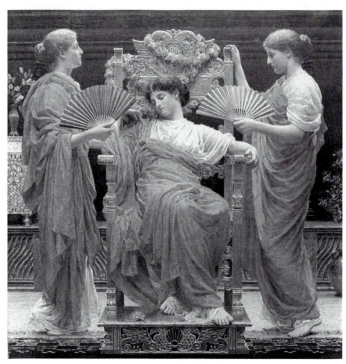

3-45. Albert Moore: *Midsummer,* 1887; 62½ × 60;
Russell-Cotes Art Gallery and Museum, Bournemouth.

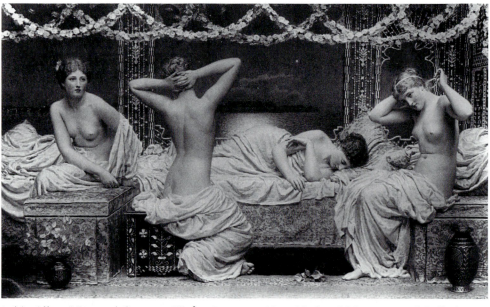

3-46. Albert Moore: *A Summer Night,* 1890; 51 × 88½; National Museums and Galleries
on Merseyside (Walker Art Gallery, Liverpool).

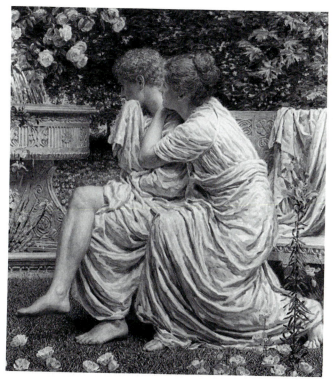

3-47. Albert Moore: *An Idyll,* 1893; 34 × 31; Manchester City Art Gallery.

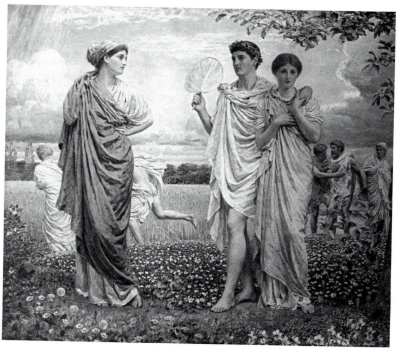

3-48. Albert Moore: *The Loves of the Winds and the Seasons,* 1893; 71 × 84; Blackburn Museum and Art Gallery.

❧ FOUR ❦

Edward John Poynter and the Expansion of the Mythological Tradition

ONE of the most influential classical-subject painters, by virtue of both aesthetic and administrative authority, was Edward John Poynter (1836–1919). He occupied conspicuous positions in various administrative posts during his career, and in the mid-1880s his work generated considerable notoriety. Poynter was born in Paris and by age seventeen had met Leighton in Italy. Although he had studied at various British art schools, his visit to the Paris International Exhibition in 1855 revealed to him that study in France was necessary for his development. He enrolled at the atelier of Charles Gleyre, which he attended from 1856 to 1859. He returned to London in 1860 and exhibited for the first time at the Royal Academy in 1861. Ten years later Poynter became professor at the Slade School of Art; in 1875, he became director of art at the South Kensington Museum.

By 1894 Poynter had become director of the National Gallery, a post he held until 1906. From the death of Millais in 1896 until 1918, he was president of the Royal Academy. Poynter's work in classical-subject painting spans the rise of the form, its period of greatest popularity, and its decline. Poynter was influenced by Leighton, as he admitted in 1896: "My friendship with Leighton has been the accompaniment of my whole artistic career. It was he who, in 1853 . . . encouraged me in my desire to become a painter. . . . He not only allowed me to go constantly to his studio, but let me work from his models, attending to me and counselling me as though I were his accredited pupil" (*Times,* 11 Dec. 1896, p. 10). Poynter's allegiance to sculpture and particularly to the art of Michelangelo encouraged the meticulous detail in the depiction of the human figure that would always distinguish his work from Leighton's.

Poynter's allegiance to Michelangelo prompted him to refute Ruskin's denunciation of the artist.

Poynter's devotion to the art of antiquity was maintained throughout his life, both in the execution of his own canvases and in the philosophy governing his career as a superior teacher of art and director of art institutions. Poynter's canvases retained a sensitivity to linear forms that gave not only his subjects but also his technique a classical direction. In his *Lectures* Poynter frequently noted the classical standard. He regarded "the Greek artists [as] worshippers of the ideal. . . . Witness the most perfect specimen of their decorative art which remains, the most perfect in the world; I mean the frieze of the Parthenon" (49). To Poynter the Greeks had created "sublimely beautiful works which will be the school of art for the whole world as long as the world lasts" (49).

Although Poynter criticized the long apprenticeship in drawing from the antique in art schools in England, and believed in drawing from the life, as indeed the ancients themselves had done, he declared at the Slade: "I am especially glad that I have been able to arrange for some lectures on Classical Archaeology. Independently of its artistic associations, there is no more interesting study in the world than that of ancient history through its antiquities. . . . It is entirely through its art that we are enabled to construct the history of the ancient world" (*Ten Lectures* 132). Poynter later was to finish two mosaics, *Apelles* and *Pheidias,* for the South Kensington Museum, in homage to the greatness of those artists. Poynter's recognition that the art of a country reflects its history remained a strong conviction.

The art of antiquity guided the artist's choice of subject. Poynter declared, "What is it to us that we are told that classical subjects and nude figures have nothing to do with us at the present day? It is not Greeks or Romans we wish specially to paint, it is humanity in the form which gives us the best opportunity of displaying its beauty. One would think, if we listened to prevalent opinions on this subject, that we have no bodies, more or less beautiful, under our clothes. . . . Subjects called classical are capable of a much higher beauty" (196). In his denunciation of Ruskin in 1876, Poynter cited as one of Ruskin's greatest defects his dislike of the nude figure, which prompted him in *Aratra Pentelici* to reject Michelangelo and to praise the Greeks only on ethical, not aesthetic, grounds. The nudes of the Sistine ceiling Poynter defended as expressive of the highest beauty. In male figures like that of Melanion in *Atalanta's Race* or the nude of *The Catapult,* Poynter testified to his belief in the study of anatomy and the magnificence of the

human form. Poynter's challenging of Ruskin's supremacy has not been given the appraisal it deserves.

<div align="center">I</div>

An evaluation of Poynter's art cannot be accomplished without some consideration of his personality. It is in the intersection of his personality with the social issues of the 1870s and 1880s that his art achieves its greatest tension and resonance. A severe, reticent man, Poynter was nevertheless the source of great controversy in 1885 on the exhibition of his nude *Diadumenè* at the Academy. His art, with its perfection of anatomy, was the creation of a cold, unfeeling temperament, a character that nevertheless could passionately support Michelangelo and feel the sensuous beauty of the nude in either classical or Michelangelesque style. The best-known depiction of Poynter is in George du Maurier's *Trilby*, serialized from January to August 1894 in *Harper's Magazine* and published as a book in 1895. After leaving Gleyre's studio, Poynter, du Maurier, Thomas Lamont, and Thomas Armstrong set up a studio in the Rue Notre-Dame des Champs. These experiences became metamorphosed in *Trilby* several decades later.

In the novel, Poynter appears as Lorrimer, the industrious apprentice, as contrasted with Joe Sibley, i.e., James McNeill Whistler, the idle apprentice.

Then there was Lorrimer, the industrious apprentice, who is now also well pinnacled on high; himself a pillar of the Royal Academy—probably, if he lives long enough, its future president. . . .

Tall, thin, red-haired, and well-favored, he was a most eager, earnest, and painstaking young enthusiast, of precocious culture, who read improving books, but spent his evenings at home with Handel, Michael Angelo, and Dante, on the respectable side of the river. Also he went into good society sometimes, with a dress-coat on, and a white tie, and his hair parted in the middle!

But in spite of these blemishes on his otherwise exemplary record as an art student, he was the most delightful companion—the most affectionate, helpful, and sympathetic of friends. May he live long and prosper!

Enthusiast as he was, he could only worship one god at a time. It was either Michael Angelo, Phidias, Paul Veronese, Tintoret, Raphael, or Titian—never a modern—moderns didn't exist! And so thoroughgoing was he in his worship, and so persistent in voicing it, that he made those immortals quite unpopular in the Place St. Anatole des Arts. We grew to dread their very names. Each of them would last him a couple of months or so: then he would give us a month's holiday, and take up another. . . .

Joe Sibley did not think much of Lorrimer in those days, nor Lorrimer of him, for all they were such good friends. . . .

And what is so nice about Lorrimer, now that he is a graybeard, an academician, an accomplished man of the world and society, is that he admires Sibley's genius more than he can say. (121–122)

Du Maurier admitted that Lorrimer/Poynter "is no bohemian." Du Maurier included in *Trilby* a sketch of the two apprentices, the Poynter figure earnest, well dressed, with small beard; the Whistler figure dandified and narcissistic with a monocle. Du Maurier's précis bears considerable resemblance to the man who emerges from other sources. Poynter did become a pillar of the Academy, he revered Michelangelo, and he was no bohemian. Reserve, dedication, perseverance, and earnestness marked Poynter all his life. A letter from du Maurier mentioned that in 1862 Poynter was "more chevalier de la triste figure than ever . . . miserably hard-up . . . overworking himself terribly" (*Macdonald Sisters* 163).

A different and less flattering image of Poynter, however, appears in the pages of Alfred Baldwin's study of the Macdonald sisters. Poynter met Agnes Macdonald in 1865, marrying her in 1866. By this alliance, Edward Burne-Jones and Poynter became brothers-in-law. Baldwin observes that "the male Poynters were not forthcoming in showing praise or affection to their closest relatives" (*Macdonald Sisters* 161). The marriage at first must have brought some happiness, but the tendency toward undemonstrativeness and melancholy was to reassert itself. A conversation is recorded in which Poynter rendered this verdict on his brother-in-law: "Painters such as Burne-Jones, Rossetti, and even Dürer, depend . . . much for their mysticism on imperfect execution"; he denied there could be a "higher mysticism of the intellect" (165). Still, in his lectures he would choose Dürer as an artist with "the most intense dramatic power of forcing the reality of scenes upon the spectator" (238).

Baldwin summarized his appraisal of Poynter: "Within the virtuous artist and high-minded Edward Poynter there dwelt a bleak spirit that could stoop neither to excuse the second-rate nor often to applaud the most deserving. . . . But his very sensitiveness to the beauties of nature and of art seemed to be balanced by an equal insensitiveness to demonstrative human affections. . . . Nature and Art . . . left him with no time to warm even one hand at life's fireside: that faultless draughtsman's hand which lacked the one sufficiency of mortal love that might have made his pictures live for ever"

(166). Poynter's mother was a terror to Agnes Macdonald and to her son. Agnes wrote on one occasion, "I slept better because I was not under her roof" (170). At home, Poynter was so compulsive in his work that "I see little of him and when he is at home he is almost too preoccupied to talk" (174). When her father-in-law died, Agnes recorded: "I do not suppose Mr. Poynter's children remember a tender loving speech" (174). Poynter suffered from recurring malaria, which made him all the more bleak and despondent. With a second child coming fourteen years after the first, Agnes Macdonald hoped for improvement, but it never came.

Poynter as the years passed became increasingly depressed. Graham Reynolds records that Poynter was bitter at his resignation as president of the Royal Academy in 1918, but this acrimony had been a characteristic for years. His wife recalled periods when he "sinks utterly both morally & physically, which is impossible for people of other natures to understand. . . . He groans & travails over his work & does nothing easily. He says there is nothing the matter" (Baldwin, *Macdonald Sisters* 178). When Agnes was dying of cancer, Poynter seems to have realized her value, but their associates thought it was too late to rectify past neglect and coldness. Georgiana Burne-Jones observed that Poynter was "as usual, deeply and darkly reserved" (180).

A letter from Agnes Macdonald is sprinkled with phrases like "I have, in my limited way (or what may be thought so by a man)" or "being, as of course I am aware, only a woman" (180). Such statements may reflect Poynter's attitude toward her. One of her sisters recorded after her death: "He could not tell her, or by manner show dear Aggie his love for her—but he can show his grief now she is gone" (182). It is clear that Poynter was a man emotionally warped by a domineering mother, a situation which made it impossible to express love. Baldwin admitted that Agnes Macdonald's mother-in-law was the "dragon-in-chief" (170). Such inhibition might explain the long hiatus between the two children. Poynter's passions were reserved for the meticulous nudes of his canvases, given far more attention than his wife's needs. Poynter's works convey an impression of latent strong sensuality, perhaps deflected by analytic attention to the human body. It is apparent from the outrageous attack on his nude canvases in 1885 that the public perceived him as a sensual painter.

If one studies the course of Poynter's evolution as an artist, one central theme emerges: that of the heroism of men and the lassitude (occasionally dangerous) of women. Among Poynter's earliest works are two wood engravings for the Dalziel Bible project, *Joseph Introducing Jacob to Pharaoh* (1862)

and *Joseph before Pharaoh* (1863). In the first, Pharaoh lies indolently on a chair, while Joseph leads his father to him. This engraving can be construed as Poynter's expression of the need for paternal love, which he never experienced and which he could not in his turn give. The second study shows Joseph interpreting Pharaoh's dream and indicates the precise attention to anatomy that would distinguish Poynter. In these Egyptian canvases, Poynter develops an ideology of masculine integrity and resourcefulness. One may contrast these images with one of Poynter's early female studies, *The Siren* of 1864, showing a wistful but lethal seated woman playing a large lyre. At her feet lies the mouldering skull of an unlucky mariner. Poynter completed *Orpheus and Eurydice* in 1862, showing the male artist leading the woman from Hades. The pose anticipates the design of Burne-Jones's *Love Leading the Pilgrim.* Orpheus, in red tunic and purple cloak, holds a lyre in his left hand. His right arm is held by Eurydice's two hands. The serpents on the ground recall the cause of her death and suggest the fatal conclusion of this rescue.

The biblical masculine images were prototypes of two canvases of the 1860s dealing with Roman subjects, *Faithful unto Death* (1865) and *The Catapult* (1868). *Faithful unto Death* (Plate 4-1) had been anticipated by one of Poynter's 1864 Academy exhibits, *On Guard, in the Time of the Pharaohs,* which showed an Egyptian sentinel on a watchtower. Inspired by Bulwer-Lytton's *The Last Days of Pompeii,* in *Faithful unto Death* Poynter expands the sentinel motif, showing a soldier in Pompeii maintaining his post during the eruption of Vesuvius in A.D. 79. The painting was accompanied by the following quotation: "In carrying out the excavations near the Herculanean gate of Pompeii, the skeleton of a soldier in full armour was discovered. Forgotten in the terror and confusion that reigned during the destruction of the city, the sentinel had received no order to quit his post, and while all sought their safety in flight, he remained faithful to his duty, notwithstanding the certain doom which awaited him." Caught in the red glare pervading the canvas (inspired by Millais's *The Rescue*), the flesh painting is not so meticulous as in later Poynter canvases. Poynter expresses his own extreme conception of duty. In 1877, James Dafforne observed that the man was "a true hero" who "swerves not from his fidelity to his trust . . . a living death" ("Works" 18). The *Art Journal* noted: "The articulation of the limbs is sure; the eye and the mouth, firm in form, speak calm resolve" (166). *Faithful unto Death* expresses not only Poynter's most characteristic trait of determined resolution but also the culturally defined image of male stoicism. While looters attempt to escape

the flames only to fall in confusion, the sentry, encased in the symbolic armor that protects many men in Victorian classical-subject paintings, is unmoved. The left doorway includes a graffito of a soldier at his post, a relic that will endure to signify the type of male heroism.

In 1868 Poynter exhibited *The Catapult* (Plate 4-2), a canvas that has illustrated countless texts in Latin language and Roman history. M. H. Spielmann wrote of this canvas and Poynter's effort of 1867, *Israel in Egypt,* that they "gave us more of the appearance than the spirit of the age. . . . [Poynter] addresses himself rather to the reason than to the emotions" ("Edward J. Poynter" 116–118). The marvelous technical knowledge exhibited in *The Catapult,* of great appeal to the industrial patrons of artists, can be appreciated for itself. The painting, however, with its all-male contingent of figures, goes beyond mere technical and historical recreation. It may well give only the appearance of the siege of Carthage by the Romans in 146 B.C., down to Cato the Elder's "Delenda est Carthago" incised on the pillar of the catapult. But it reinforces the spirit of another age very well, the nineteenth-century Victorian code of male behavior: in *The Catapult,* men are engaged in civic duty, in warfare, in imperialist expansion, in national defense. Swinburne complained of its "want on the whole of beauty, a want in detail of interest," while believing it was "excellent of its kind" ("Notes" 368).

In fact there is beauty celebrated here, the naked glory of the central engineer, derived from Michelangelo's *ignudi* of the Sistine ceiling. Poynter's nude technocrat is the physical glorification of industry, the anatomy so meticulous that the beauty of the man merges with the nobility of the deed, as in Pindar's athletes. The arm of the catapult appears a fierce phallus, celebrating this genitality, while the flaming tip of its javelin repeats this phallic power. Against the background of the suffrage activity of the mid-1860s, *The Catapult* celebrates a masculine sense of power and duty. The picture is, furthermore, the celebration of heroism after the disillusionment of the Crimean campaign. Ruskin denounced the picture in 1875 as an exercise in anatomy, prompting Poynter to attack him and defend Michelangelo in one of the Slade lectures. In their celebration of male heroism, both *Faithful unto Death* and *The Catapult* are key canvases in Poynter's oeuvre, not divorced from his later works but their prelude.

In 1869 Poynter exhibited at the Academy his very sensitive *The Prodigal's Return* and his first narrative mythological picture, significantly, *Proserpine.* The two paintings are related if placed against the background of 1869 with the Contagious Diseases Acts. There can be little doubt that one of the Prodi-

gal's sins was sexual promiscuity. The daughter of Demeter, in her association with death, links woman with the death of the moral self expressed in the companion painting. This linking of the biblical and the classical demonstrates the manner in which, in Poynter, both operate to express his mental attitude.

The canvases of the 1870s developed the mythological suggestiveness of *Proserpine.* The first of these canvases was the *Andromeda* of 1870 (Plate 4-3), one of the greatest Victorian images of bondage. Her hands bound behind her on a desolate rock, this frontal nude, no drapery covering her pubis, stands assailed by the waters about to bear the sea monster. The *Athenaeum* observed that "Mr. Poynter appears less fully than we hoped with Andromeda" (584), but the *Art Journal* noted that the canvas, exhibited in the most prestigious gallery, No. III, was a composition "choice and out of the common. . . . The forms are lovely; and the expression of the turned head, while quiet, is deeply tragic" (165). It is especially interesting that this canvas was exhibited with Millais's *The Knight Errant,* of a woman rescued by a knight after her rape. While no objection was raised to Poynter's nude, the critic observed of the Millais: "The manner is almost too real for the treatment of the nude, which, in fact, the artist has never before attempted," although the canvas was not "objectionable on the score of morality, the art-treatment being sufficiently high and chaste" (164). The fact that two canvases both depict the rescue motif, however, is indicative of the importance of this mental conception for the period. Men had "rescued" women by the Married Women's Property Act of the same year, but this canvas indicates male dominant status. The rescue compulsion of Victorian males is not better exemplified than in Poynter's *Andromeda.*

To solidify the impression, Poynter exhibited in 1872 a *Perseus and Andromeda* (Plate 4-4), one of four canvases for the earl of Wharncliffe's Wortley Hall near Sheffield. This work received great praise from several of the periodicals. "All will be as nought" when the spectator confronts this canvas, declared the *Art Journal* (182). The nude Andromeda, hands bound to a rock behind her, stands forth, her red robe swirling around her. To the left is a pharos behind which the dawn is breaking, to the right the grim monster and Perseus, thrusting a falchion down the creature's throat; to the rescuer's left the town and citizens are seen awaiting the outcome. In contrast to the small scale of the *Andromeda,* the rescue itself is depicted in a much larger, mural-sized, composition. Poynter uses the scale of a mural to aggrandize the male heroic rescue. Although critics thought the creature was too small rela-

tive to Perseus, the painting is a forceful, dynamic statement of the rescue compulsion of mid-Victorian culture. The model for Perseus appears to be the same as that used for the central figure of *The Catapult*, reiterating the icon of male dynamic duty. Andromeda's hair is outspread, but the lure of the femme fatale has been muted by her enchained posture. Later in the century, the male sword will give way to the entrapping web of hair. The fact that the Medusa head appears nowhere in the canvas removes the femme fatale element and increases the heroism of the male, threatened by nothing. (Poynter in 1873 finished a medieval "rescue" picture, *The Fight between More of More Hall and the Dragon of Wantley*, also intended for the Wharncliffe estate.)

In 1876 Poynter exhibited *Atalanta's Race* (Plate 4-5), showing the woman stooping to pick up the second golden apple as Melanion rushes past her. Poynter's source for this canvas was William Morris' *The Earthly Paradise*. As Monkhouse noted, Poynter's attempt was to portray "arrested action" ("Sir Edward John Poynter" 16). The modeling of the two figures is successful. The drapery around Atalanta suggests her halted movement. The naked Melanion behind her is a celebration of muscular Christianity in pagan guise. Surviving studies for the canvas indicate Poynter's extreme rigor in developing his figures. For the man on the left behind Melanion, Poynter produced sketches of dynamic suggestion, refined into more idealized but less throbbing realization in the final canvas. Poynter worked on one drawing (Malcolm Bell, *Drawings of E. J. Poynter,* Plate 15) to get the expression of the face exactly as he wished. The inclusion of the city fathers at the right of the canvas introduces the civic note observed in *The Catapult* and the *Perseus and Andromeda.* The manner in which Academy guidebooks influenced viewers' perceptions is evident from Henry Blackburn's *Academy Notes* description of this canvas, noting that Atalanta "stooped to *be* conquered" (61), clearly indoctrinating a passive role for women in marriage. He adds that the myth "is made the vehicle for a painting of great interest and instruction." Blackburn emphasizes this submission particularly in reference to Atalanta because prior to her conquest she had been fiercely independent, having participated in the Caledonian boar hunt, "killed two Centaurs," and wrestled with "the hero Peleus" (Lefkowitz 44).

Poynter's study of Atalanta shows her left leg much more extended than in the final canvas. A drapery study for the same figure expresses this same dynamism (Bell, plates 14, 12). But in the final painting both of Atalanta's feet touch the ground; she is earthbound, while Melanion is the heroic run-

ner of Pindar. In a drawing for Melanion, Poynter exaggerated the muscles of the left arm, although he corrected it in the final canvas; thus the force of Melanion was virtually Olympic/Pindaric in its original conception. This strength contrasts with the delicacy with which he holds the third apple, a lightness that in a preparatory drawing was even more emphasized. This combination of grace and strength conveys classical heroism for the nineteenth century.

For the 1879 *Nausicaa and Her Maidens Playing at Ball* (Plate 4-6), Poynter drew on Leighton's single-figure study of 1878 and G. D. Leslie's canvas of 1871. Nausicaa is the prototypical nurse/companion in Victorian iconography. In showing women playing ball and doing laundry, Poynter avoids any suggestion of the princess who dared to confront a naked, outcast Odysseus and give him aid. The rescue compulsion that compelled a woman to rescue a man is ignored in this canvas. Henry James observed that the picture was received with "general disappointment. . . . The picture strikes me as having a good deal of almost inexplicable awkwardness and ugliness. It is a very different affair from the same artist's charming representation of the 'Race of Atalanta' . . . a work with which it challenges comparison by its shape and style" (*Painter's Eye* 178–179). Poynter's unwillingness to depict the meeting of Nausicaa and Odysseus sabotages the legend. Nausicaa is depicted preparing to hit the ball and return it to her companion. A drawing for the figure of Nausicaa shows her right arm raised for greater projectile force than in the final execution. In the sketch of the two women doing the laundry, one is bent over in toil, not decoratively holding the clothing. Her companion is also more engaged in the work than she appears in the final canvas. Poynter added two observers, one a woman with a lyre, in the final canvas. This addition increases the vapidity of the depiction, since in the sketch the emphasis is on the women's activity rather than on their passivity. The alterations from sketch to finished canvas decreased the women's energy and increased their decorative lassitude.

With the increasing obligations of his many offices, Poynter's canvases after the 1870s grew less probing. This turn is marked in 1880 by *A Visit to Aesculapius* (Plate 4-7), inspired by verses of the Elizabethan poet Thomas Watson. Aphrodite, wounded in a hunt with Artemis, goes to the physician to seek his aid. As studies of the nude, Poynter's four figures of the goddess and her attendants (grouped like the three Graces) are a consummate achievement. At the behest of one of the attendants, a servant draws water. Despite the meticulous execution of the work, the canvas diminishes the female; this is

most obvious in the coy pose of the second companion. In 1881 Poynter exhibited *Helen,* a portrait of a Victorian lady in a red and gold robe before the background of the flaming Ilion. Her face, expressing the futility of any action at this point, does not suggest the complexity of Homer's Helen, who resists the terrifying Aphrodite of the *Iliad.* Although it surpasses the depictions of Sandys and Leighton in its meticulous execution, it lacks the force of either in its conception. The painting accords with the conception of Aphrodite in the *Visit to Aesculapius,* a reduction of the significance and complexity of the classical sources at Poynter's disposal.

In the same year Poynter completed *Psyche in the Temple of Love,* showing a figure in orange robe disconsolate in the palace of Eros. This subject appealed to Poynter because of the helplessness of the woman, torn between her satisfaction with her lover and the fatal curiosity to learn his identity. Since Eros had to rescue Psyche in the end, the legend supports male heroism. Unlike his brother-in-law Burne-Jones, Poynter selects only one episode of Psyche's story, one in which she is captive. *The Ides of March* of 1883 (Plate 4-8), showing Caesar and Calpurnia observing the ominous comet in a haunting portico, draws on *Julius Caesar,* act 2. The shadows cast across the floor, and the sentinel statue in the distance, portend disaster. The bust of the Dictator on the left is illuminated by a lamp below, causing the head to loom fearsomely. The *Athenaeum* praised this canvas as "one of the most impressive of Mr. Poynter's creations" (576). Seen in the context of the earlier Roman paintings *Faithful unto Death* and *The Catapult, The Ides of March* presages the end of male heroism.

II

The years 1884 and 1885 marked the most intense period of the campaign against the Contagious Diseases Acts. Stead's exposé *Maiden Tribute* appeared in July 1885. Prior to this revelation, however, there was a great uproar at the Academy's exhibition, with Poynter and other artists at the center of the controversy. On the walls in 1885 were Poynter's *Diadumenè,* Rae's *Ariadne,* and Calderon's *Andromeda,* among other nude figures. The *Art Journal* noted: "Miss Henrietta Rae's Ariadne is a good instance of the attempt at a compromise between classicism and conventionality, and by it an otherwise clever picture is marred. It is perhaps better to be frank and thorough as Mr. Poynter's Diadumene or Mr. Calderon's Andromeda" (257). In 1884 Poynter had already exhibited a *Diadumenè,* the pose inspired by Polykleitos' male ath-

lete binding his hair. The canvas showed a young girl, called a "nymph" by the *Athenaeum* (572), binding her hair with a gold fillet before entering a bath. Behind her are two exotic columns derived from Pompeiian models. Poynter's reworking of this conception in 1885, however, provoked a long discussion about the nude in art, generated by a letter from "A British Matron" to the *Times*.

The 1885 *Diadumenè* (Plate 4-9), now unfortunately clothed, represented a nude girl binding her hair before entering a bath. Spielmann claimed that Poynter's canvas was "a distinct and challenging attempt to proclaim in England the Greek aspect of the nude . . . a championship of neo-classicism in its highest form" ("Edward J. Poynter" 120). In the year of the *Maiden Tribute* essay, this depiction of a *jeune fille* was too close to the nerve. Most significant for Poynter's later *Endymion* canvases is the fact that Poynter takes a traditional male athlete's pose and adapts it to the portrayal of a young woman. Poynter cannot abandon his belief in male heroism, and in the *Diadumenè* he bemoans its passing by showing it debased in a female bathing scene. The *Athenaeum* recognized the figure as "almost virginal" in appearance (570), which was bound to increase the public's antipathy to the canvas.

Poynter's depiction of the nude in the *Diadumenè* canvases was an act of defiance to the established practices of art instruction, in which the study of the antique preceded the study of the nude model. According to Poynter, this sequence "reverses the natural order of things, for until the student knows something of the construction of the human body from the living model, it is impossible he can understand the generalised and idealised forms in Greek sculpture" (*Ten Lectures* 101). "Constant study from the life-model is the only means [students] have of arriving at a comprehension of the beauty in nature" (107). Poynter believed that no study of the antique could train a student in the configuration of the knee or the patterning of veins or the structure of the foot. Poynter promised his students he would try to supply them "with good Italian models to work from," since these had bodies unharmed by boots and other restrictions that made English models less desirable (109). Poynter realized that female students suffered particularly in this respect: "They are debarred from the same complete study of the model that is open to the male students. . . . Nothing but constant practice from the model itself will suffice" (111). Poynter's championship of the nudity of classicism, even in such works as the two *Diadumenè* canvases, aroused intense opposition. He had noted: "There are many prejudices to be overcome" (112), and he was right.

The letter to the *Times* from the British Matron appeared on 20 May 1885.

The writer condemned "the indecent pictures that disgrace our exhibitions" with "nakedness in all perfection of representation." The pictures were "an insult to that modesty which we should desire to foster in both sexes." The writer added that women artists for the moment were exhibiting only female nudes (a reference to Rae), but that when they went on to male nudes, "the degradation of our galleries' walls" would be complete (10). Two days later the artist John Brett responded that the "lady calmly assumes that purity and drapery are inseparable . . . that decency and indecency are dependent on a textile fabric" (6). "Senex," writing the same day, commented that the female nude represented the sad plight of English girls forced to model for such paintings. Frederick Wheeler wrote on 23 May that Greek mythology required such representations, many of which were more moral than the draped figures frequently exhibited. An anonymous writer observed on the twenty-fifth of May that "Poynter's bather is a fine, firm, true, but not a magnificent creature. . . . The Diadumene is not mysterious at all, and yet is not real" (20).

With this judgment one must concur; the anonymous writer has isolated the problem, which was not Poynter's anatomizing of the nude. In suggesting that the figure was neither mysterious nor real, the writer alludes to the reductive nature of Poynter's depiction: it trivializes the subject by focusing on the *jeune fille non fatale*. A drawing now in St. Louis, probably from the 1870s, shows a female in the pose of a diadumene. Here the figure is womanly, not girlish, more forthright than the coy girl of the canvases of 1884 and 1885. Two drawings for the upper torso and hands of the 1884 canvas have a vigor and maturity of physical form that are lacking in the subsequent finished paintings. Poynter's reduction of the age of the subjects in the final canvases is an expression of sexual timidity. In response to the criticism of the nude girl, Poynter painted a drape around her figure, an addition he came to regret. The sex role reversal, from diadumenos to diadumene, exhibits the defiant but artificial adaptation of a classical subject in a canvas simultaneously daring and evasive.

Ruskin's position in this discussion of the nude in 1884 indicates the situation faced by Poynter, Henrietta Rae, and other artists when depicting the nude. Ruskin entered the conflict about *Diadumenè* by noting: "The recent phrenzies of dissection and exposure in science and art are, indeed, merely opposite poles of one and the same rage—substituting, in classic thought, for the noble sorrow . . . the ignoble hope . . . insult alike to the Matron and the Child" (*Works* 14.494). Ruskin supported the position of the British Matron. On 15 October 1885 the *Pall Mall Gazette* published a letter from an

artist who recalled his dilemma when a student: "While my religious convictions seemed to forbid it, I was assured on the other hand that it [studying from the female nude] was a necessity." The correspondent recalled that Ruskin's reply to his query was "Of course you can do without it, and do much better than with it" (*Works* 14.493). Ruskin associated the painting of the female nude with "phrenzy" and "rage," intimating that the female body was a source of madness. In advising a student to avoid the female nude, Ruskin revealed his gynophobia. Poynter's *Diadumenè* symbolically defied this restrictive prescription by Ruskin. Poynter was not afraid to challenge the prophet/critic Ruskin.

Poynter's classical-subject paintings after *Diadumenè* followed two courses: one an increasing focus on classical genre in the tradition but not the manner of Tadema; the other, an emerging depiction of the femme fatale in a variety of pictures of nymphs. *Under the Sea-Wall* (1888), *On the Terrace* (1889), and *A Corner in the Villa* (1889) are examples of the focus on classical genre. One of the most unusual of Poynter's canvases is the gracefully executed *Outward Bound* (1886), showing two little girls watching an acorn boat sail away as they sunbathe, two *jeunes filles*, perhaps not *fatales*. The white slave trade had been exposed the previous year, but the painting appears to spurn such issues when art is concerned. The naked girl binding her hair is defiantly an even younger diadumene than those in the 1884 and 1885 canvases. Nothing is more characteristic of Poynter's temperament than to defy the public by doing a potentially more outrageous canvas after the controversy. In *A Corner in the Villa*, two older women and a girl are watching pigeons eat, one girl resting on a leopard skin. The expressions on the faces are too vacuous for the painting to be convincing, a situation not too common in Poynter, who nearly always managed to avoid the vapidity of Tadema's countenances. With *On the Terrace*, using the same model as in *Diadumenè*, Poynter shows a girl flicking a beetle off a fan at the top of a staircase leading to a coast scene. The modeling of the face is sensitive, but the picture is slight in intention. Unlike Tadema, Poynter never focuses excessively on detail. With Poynter detail contains an implication of latent contexts.

On the Terrace is a reversal of the canvas *Under the Sea-Wall*, which shows a figure on the left seated at the bottom of steps. Her one exposed breast prevents the picture from being quite so innocent as its successor; furthermore, the pomegranates suggest Persephone, thrusting the idea of death into such flourishing life. The *Magazine of Art* recorded in 1890: "It certainly speaks eloquently, and hardly encouragingly, as to the condition of public taste and

its demands upon the artist, that while a painter has striven through a long period of years . . . to justify his position in the highest rank of living designers, his first real popular success should be achieved through a little work of pseudo-classic *genre* — undeniably charming in its colour, pretty in its design, and highly decorative in effect, but manifestly neither very ambitious in conception nor strictly correct in its presentation of archaeology and classicism" (82). This statement indicates the personal distress Poynter must have experienced at the exhibition of *Under the Sea-Wall,* finding himself valued for such an innocuous exhibit.

In competition with Tadema, as Frances Spalding notes, Poynter was at a disadvantage, since he "lacked the Dutchman's flair for the unexpected viewpoint" (*Magnificent Dreams* 68). This lack is evident in *A Roman Boat Race,* exhibited in 1889 at the New Gallery. In this canvas, a young woman in a semidiaphanous white robe watches a race of Roman ships. She holds a basket on her lap to which her fan idly points, giving the canvas a sexual overtone. The *Magazine of Art* had reservations: "Mr. Poynter . . . gets his inspiration from classical literature, and had succeeded entirely as far as design is concerned" (290). The suggestion of triviality is contained in the comment. *On the Temple Steps* of 1890, showing a young girl sitting by a staircase, contains in its frieze a figure dancing with a thyrsus, a suggestion of Dionysiac potential. Such allusive details prevent works like *A Roman Boat Race, On the Temple Steps,* and *Under the Sea-Wall* from being so anecdotal as many of Tadema's canvases might have been with the same theme. In 1889, when Poynter painted an allegorical watercolor, *Music, Heavenly Music,* the reviews were qualified. The *Athenaeum* noted that the work "is a masterpiece of Mr. Poynter's drawing *per se*" (606).

In the 1890s Poynter added dimensions to his genre pictures by evoking classical authors such as Horace. In his two *Chloe* paintings (1892, 1893), Poynter included a reference to Horace *Odes* 3.9: "dulcis docta modos et citharae sciens" ("skilled in the sweet strains and mistress of the lyre"). Poynter's selection of this ode is unusual, as it is the only lyric in Horace in the tradition of the *carmen amoeboeum,* or dialogue between two lovers. The contrast between the two representations is instructive. In the first painting, Chloe with her lyre has none of the spontaneity and wit of the woman in the Horatian source. She stares inscrutably at the viewer. Poynter freezes the woman, contrary to Horace's description. In the second canvas, Poynter has caught her sly nature, as she dangles two cherries in her left hand. The lyre and the leopard skin reflect the passionate and sensual nature of Horace's lively interlocutor.

In 1894, Poynter painted *Idle Fears,* showing a young girl reluctant to enter a bath. With an interior reminiscent of the 1885 *Diadumenè,* the picture is a precise treatment of an inconsequential theme. The voyeurism of these bathing scenes is undeniable, and such canvases are barely rescued from prurience by their classical locales. The querying of woman's nature is evident in *The Dancer* (1896), which shows a flower-clad woman resting with a tambourine, an instrument associated with Dionysiac worship, in her left hand.

At the turn of the century, established as president of the Royal Academy, Poynter created canvases expressing anxiety about female domination, often involving the femme fatale. The sequence of studies and canvases concerning Selene/Diana and Endymion reveal an androgynous conception of the shepherd of Mount Latmos. In an early drawing, the figure which eventually became the beautiful youth is drawn from a female model. She is lying in a *contrapposto* attitude with left hand over her right breast, holding a shepherd's staff. The fact that Poynter's Endymion originated from a female model shows his identification of women with the passive, sleeping role. The story of Endymion—a man put into an eternal sleep—was rarely painted in this period of strong feminist agitation. In another drawing, Poynter shows Endymion with his hand over his right breast, without the shepherd's staff but lying on a leopard skin. Poynter has taken the image of Bacchante-like Dionysiac frenzy and associated it with a male. This subtle transformation reflects a weakening of strong male identity. In the first treatment in oil of the theme, the *Diana and Endymion* of 1901 (Plate 4-10), Poynter shows Endymion in the *contrapposto* attitude, with his left hand now on his hip rather than across his chest. He holds a shepherd's crook in his arm, and Poynter has eliminated the leopard skin. The face is still androgynous, slightly more masculine in appearance than the drawings. The drapery covering his hips outlines his stomach, navel, and genitals, creating a sexual tension between the androgynous face and the male genitals. Diana hovers over him, in a swirl of blue drapery, with a crown on her head. Poppies surround the glade in which Endymion lies, suggesting his deathlike trance.

Poynter's *Endymion* is a homage to the famous canvas *The Sleep of Endymion* by Anne Louis Girodet (1791), which uses the *contrapposto* attitude of the shepherd. Unlike Girodet, who does not show Selene/Artemis in person, Poynter depicts Artemis hovering in worship over the young man, her one amorous departure from the chastity with which she is identified. Despite her solicitation, however, the goddess triumphs over Endymion: the eternal sleep into which she cast him after one sexual encounter has rendered

him sexually nonfunctional forever. In the 1902 *The Vision of Endymion* (Plate 4-11), Poynter has made discreet alterations. As in the drawing, the goddess is no longer crowned. Her facial expression, painted from a different angle, appears more cautious and hesitant. More of Endymion's body is exposed in the 1902 version, including part of the hip. These changes reduce the dominance of the goddess and increase the sexual tension of the androgynous "male" figure. Poynter had observed of Michelangelo's nudes: "The beauty of the heads of these figures is beyond all that ever was done in art. . . . He gives to many of his faces the beautiful refinement of a woman's, he has never sacrificed one atom of the manliness. . . . Not so the Greeks, who made their Apollos so effeminate that it is difficult to tell from the head whether a man or woman is represented" (*Ten Lectures* 57). In his *Endymion* canvases, however, Poynter has not avoided the effeminate. These paintings have taken the classical legend and transformed it into an expression of Edwardian sexually ambiguous tension. Poynter was to return to the subject once more in 1913, showing the persistence of the belief maintained in the canvases of 1901 and 1902.

At the Royal Academy exhibition in 1903 Poynter exhibited *The Cave of the Storm Nymphs* (Plate 4-12). At the same exhibition Henrietta Rae, whose nudes had been censured in 1885, was represented by *The Sirens,* like Poynter's canvas a study with three nude females. Poynter's studies for this canvas indicate he is feminizing the massive features of some of the Sistine Chapel figures, particularly of Michelangelo's sybils, who while feminine have a masculine solidity. Poynter retains their poses but converts them to svelte women. Unfortunately, in the final composition he sacrifices the mysterious vagueness of the drawing of the three figures. In the studies, the bottom nymph and middle figure seem to be older than their counterparts in the final canvas. These three females, derivatives of Sirens, but also the modern variation of the Three Fates, sit amid the loot of the wrecked ships lured to their coast. In returning to the idea of the Siren, Poynter recalls his very earliest work like *The Siren* of 1864. Poynter's painting parallels the *jeunes filles fatales* of the artist John William Waterhouse in many of his late canvases. The *Studio* magazine had felt obliged to defend Poynter's use of the nude in its essay of 1896; the realism of Poynter's treatment "makes it impossible to conceive any demoralising effect being produced" from Poynter's nudes, it had contended (12–13). Seven years later it was still a daring act of the president of the Royal Academy to exhibit such a canvas as *The Storm Nymphs.*

In the same Academy Herbert Draper exhibited *Prospero Summoning*

Nymphs and Deities and Arthur Hacker showed *Leaf Drift,* both containing female nudes, the latter containing three as in Rae's and Poynter's contributions. The exhibition thus revealed the extent of Edwardian titillation. When *The Storm Nymphs* was exhibited in St. Louis, it was accompanied by the ingenuous statement: "The picture is intended to suggest the indifference of nature to destruction, and the worthlessness of the prizes of life." Such an interpretation strains credulity, but it is supported by the accompanying lines: "Fair as their mother-foam, and all as cold, / Untouched alike by pity, love or hate" (*Victorian Paintings and Drawings,* lot 74). In light of Poynter's personal situation at this time, with his wife to die three years later, the evocation of Aphrodite as the cold individual represents an inadvertent identification on his part with this goddess. Women are perceived as cold, when in reality it was he himself who could not express affection.

In the 1904 Academy, Poynter was represented by *Asterie,* showing a single woman, now older, in classical dress by a window. The canvas was accompanied, as had been the *Chloe* studies in the 1890s, by a quotation from Horace: "Prima nocte domum claude neque in vias / sub cantu querulae despice tibiae" ("At nightfall, lock the house, and do not glance into the street as soon as you hear his plangent flute"). The poem dwells on women's and men's potential infidelities. Asterie's lover Gyges is away for the winter, withstanding the temptations of other women. The poet trusts that Asterie will do the same with her neighbor Enipeus. However, the man can perform his duty in public; the woman Asterie is expected to remain locked inside, her own integrity not sufficient proof against temptations. Poynter's canvas depicts Asterie glancing into the street, as she is advised not to do in Horace's lyric. Enipeus, if he sees her in this state of undress, could be in little doubt of his success. The intricate allusion reinforces a conviction critical of women's nature.

The role of literature is evident in the canvas of 1907, *Lesbia and Her Sparrow,* showing a disdainful Lesbia staring at Catullus' loving gift. The Catullan sources indicate that this bird is a substitute for the poet's penis. In the imminent death of the bird, Poynter may suggest his own sexual situation during his wife's final years. The fact that Agnes Macdonald had died the previous year adds to this canvas an element of regret for an unfulfilled passionate life. Several letters to Luke Fildes in 1906 reflect this regret. Poynter wrote on 25 June: "I had hoped much for my dear wife from the change to this bright & cheerful place, but this change came more rapidly & more terribly than I had expected, & she never was able to go into the pretty garden which she would have loved so much." Two weeks later, he revealed: "The blow & the

shattered hopes are terrible, & it is only now on coming back to my unhappy
home that I have fully realized what my future will be" (V&A).

III

It was not only his personal life that caused Poynter distress in his later
years. In 1913 Poynter wrote a correspondent regarding the *Diadumenè* of 1885:
"After the picture came back from the M'chester Exhibition I painted a drap-
ery over the figure, for which I am now very sorry—I still have it, & of course
shd be glad to dispose of it" (V&A). Poynter's attempts to vindicate the nude
had not been entirely successful. Art still carried unexpected moral overtones,
a fact starkly revealed the following year. On 10 March 1914, four years before
his resignation from the presidency of the Academy, Velásquez's *Venus with
a Mirror* (the "Rokeby Venus") was slashed in seven places by Mary Richard-
son, a militant suffragette. The destruction of the "Rokeby Venus" at the Na-
tional Gallery was succeeded in May 1914 by similar attacks. Sargent's portrait
Henry James at the Academy was attacked by Mary Wood on 4 May 1914:
"The attack . . . was made with a meat chopper, the assailant being an el-
derly woman of distinctly peaceable appearance." It is recorded that "several
ladies" assisted in subduing her. Visitors to the gallery "showed their resent-
ment of the outrage so vehemently that the police, who in a brief interval
had taken the suffragist in charge, had to hurry her from the gallery. Mean-
while, a man who attempted to defend her . . . was roughly handled" (*Times*,
5 May 1914, p. 11). A correspondent of Walter M. Lamb, secretary to the Royal
Academy, called the women "hooligan suffragettes" (RA file).

Poynter wrote on 16 May 1914 to Whitehall: "Police & Detectives . . . are
powerless to *prevent* the outrages; their chief use would seem to be to protect
the abominable women who commit them from the anger of the crowd, who
would otherwise give a lesson which would probably make them more careful
in future how they defy the law" (RA). On 26 May Poynter wrote that "arrest
after the offence is committed [is] under present conditions a nugatory pro-
ceeding" (RA). Incidents such as those in 1914 indicated that paintings were
being conceived of as political utterances. Poynter's painting of 1914, *The Cham-
pion Swimmer* (Plate 4-13), must have lost all its effect amid such turmoil.
It showed a little girl having just won a race in a Roman bath. Sensitively
and beautifully modeled, it presents images of naked womanhood calculated
to outrage the suffragette cause. At Wolverhampton Art Gallery, specialists
feel the painting may at one time have been slashed.

At the end of his life, Poynter became reactionary, resisting foreign changes in art, especially those from France. Gaunt believes that, with "the outward semblance of martinet acridity" and "the shell of aloofness," Poynter remained a "shy" man (*Victorian Olympus* 167). It is difficult to believe that a person who could champion Michelangelo against Ruskin and introduce the study from life as a principle of art instruction was a person of retiring disposition. A letter Poynter wrote to Leighton in 1881, when both were successful and had been friends since 1853, indicates his forceful candor:

There has never so far as I am aware been any rule against full length portraits being hung on the line. I certainly remember to have seen many in my time in that position . . . Richmond, Millais & others. If there is any rule therefore it has been made for this occasion & I was not [aware?] of it. My other contribution being small, I reckoned on this picture [portrait of Ld. Wharncliffe], (in which I had taken great pains with the background on which it depends for quality of colour & effect), as my principal work, & it never occurred to me that it would be placed where the best part of the work would be lost. Had I had the least idea it would be treated as it has been I shd not have sent it.

Besides, this rule, if it exists has not been carried out, for Millais who has a number of large works all on the line has his full-length of Lord Wimbourne hung in a conspicuous place in the Lecture Room. Without pretending to compare myself with Millais, I should like to point out that there is a vast difference between a portrait of which the background is a flat wall, & one where it is a carefully painted landscape. If this is really to be a rule in future I think it is a mistake. . . . I am not given to complaining, & I have never before challenged the decision of the hanging committee; but I feel that in this instance a great injustice has been done me. (RA, 21 April 1881)

When one compares this frankness with the oeuvre of the painter, one realizes that Poynter's canvases express the nature of a sexually but not professionally repressed man. When asked to speak at the Royal Academy dinner in 1904, Poynter called the recently deceased Whistler a student, and added derisively: "If he could be called a student, who, to my knowledge, during the two or three years when I was associated with him, devoted hardly as many weeks to study" (Leonée Ormond, *George du Maurier* 62). Poynter's ideal of human relations is embodied in the masculine heroism of *Faithful unto Death* and *The Catapult,* his conception of masculine behavior in the actions of Perseus and Melanion. Poynter's focus on the young girl in the 1880s and later; the strange androgyny of the *Endymion* canvases; and the suspicious attitude toward women in the canvases from Horace and Catullus constitute

dissent from the liberalizing legislation of the 1880s, 1890s, and early 1900s. Poynter's distress at the suffragette outrages is understandable, but it is apparent that mythological art during these decades carried strong societal connotations. The turmoil over *Diadumenè* and the nude in the year of *Maiden Tribute* — 1885 — signifies that the walls of the Royal Academy communicated politicizing messages.

These messages were absorbed by a large contingent of the Victorian and Edwardian public. When Poynter died in 1919, there was not a single unsold picture in his studio. The trajectory from *Faithful unto Death* to *Endymion* reveals the sexual conviction and the sexual tension that characterized Poynter's oeuvre. His emotional reticence at home reflects the stern authoritarianism of the Roman *paterfamilias*. This reticence marked marital relations during the era and had influenced Poynter as a young boy. Poynter's last words were: "I must get up and go to my studio. I have left some work unfinished" (Wood, *Olympian Dreamers* 153). In the decades that saw such improvement in the situation of women, Poynter's art became reactionary, typical of prevailing misconceptions about women. Poynter's defamatory comments about Whistler indicate that his Parisian years were still of deep significance for him. In his attendance at the atelier of Charles Gleyre, he had certainly come into contact with that artist's much-vaunted misogyny, expressed in canvases such as *Hercules and Omphale*. Poynter's oeuvre is that of a man apprehensive about female nature, a man careful to avoid humiliation, reserved to avoid intimacy. His classical-subject painting used a selective mythology about women to present nonprogressive ideograms of male/female relations.

IV

At the time that Edward Poynter was completing many of his classical-subject canvases, Edwin Long (1829–1891) was exhibiting historical, biblical, and classical canvases at the Royal Academy. Influenced by the style of Alma-Tadema, Long is remembered today for his large Egyptian "machine" paintings. *An Egyptian Feast* (1877) is a macabre image of revelers in a hall while the mummified body of the deceased is dragged through the portals. The notorious *Babylonian Marriage Market* (1884) depicts a group of women awaiting exhibition before a crowd of potential suitor-purchasers. Classical/Egyptian genre appeared in such paintings as *An Ancient Custom* (1877), showing two women applying makeup; or *Callista, the Image Maker* (1877), showing a woman painting figurines. The latter canvas derives from John Henry New-

man's series depicting the relations between Christians and heathens in the third century A.D. A woman is painting a small Eros as a child poses opposite her. Along the walls are actor's masks, cupids, and small statuettes of deities. Long's evocation of a craft shop recalls Tadema's pottery canvases, but Long's figures are more whimsical in their facial expressions.

Long completed a number of single-figure studies of women in classical drapery, usually in contexts of disillusionment or melancholy. In *Pensive* (1883), Long showed a woman in classical garb, austere in the manner of David's portraits, leaning on a skin, possibly a leopard skin. She may be a Bacchante come to her senses, or simply a female longing for some undefined person. Derived from Ovid, Long's *Thisbe* (1884) shows a woman, hands chastely crossed over her breasts, leaning to hear through the crack in the wall. The execution of the drapery recalls many sculptural prototypes from the Parthenon and other statues. The interest in the painting comes from the rather smug facial expression accompanying the gesture of the hands. Thisbe appears more clever than innocent, an expression prompting the viewer to wonder at her naïveté, considering the horrific outcome of her love. The trapped female, whose illusion of escape will be momentary, has a calculating look.

Long's major canvases evoking classical subjects are works such as *Diana or Christ?* (1881) and *The Chosen Five* (1885). In *Diana or Christ?* (Plate 4-14), a woman must choose either to offer incense to the statue of the goddess or to suffer martyrdom in the stadium at Ephesus. Long's canvas has a powerful resonance in terms of mythological theory in the nineteenth century. Diana, as the fierce virgin Artemis, represents the independence of the gynocratic order. Christ signifies allegiance to God the Father, the patriarchal system. The woman is being forced to choose not between two creeds but between two systems, one of which, the pagan virginal system, gives her spiritual freedom. To choose Christ is to embrace the patriarchy. The Married Women's Property Act of 1882 gave married women the independence and rights of unmarried women, illustrating the conflict between female emancipation and patriarchal authority presented in *Diana or Christ?*. Closely patterned after Tadema's Coliseum paintings, the picture suffers from the unappealing nature of the physical types presented. Long's exotic tendencies allow him to contrast a sinister figure such as the black man in skins at the right of the canvas with the purity of the woman making her decision: "But one grain and she is free."

The Chosen Five (1885) (Plate 4-15) shows the five models selected to pose for the painter Zeuxis of Crotona for his depiction of Helen in the Temple

of Hera. He then combined their features in his representation. The model for the upper torso stands with arms raised above her head in a pose recalling that of the *Diadumenè* as well as that of the Venus de Milo. The other models, one to the right on a leopard skin, await their turn to be sketched. The diffusion of light on the scene, the tapestry in the rear, the earnest gaze of the artist, and the restrained coloring render the scene a refutation of the letter writers to the *Times* in 1885 who denounced the model's profession. The fact that Long's *Babylonian Marriage Market* achieved the Victorian saleroom record for a living artist attests to the popularity of his images. The subjects of his canvases reinforced the conception of women as captive, sacrificed, waiting, or inconsequential.

One of the inheritors of the tradition of Leighton and Poynter frequently exhibiting on the Academy walls during the 1880s and 1890s was Arthur Hacker (1858–1919), who had like Poynter studied in Paris. Hacker devoted much of his career to portraiture and regularly exhibited such canvases at the Academy along with his classical-subject pictures. Hacker's distinguishing mark is his sensual treatment of the female nude, accompanied by a slyness of expression that suggests and evokes, even if it does not define, the femme fatale. In the 1887 *Pelagia and Philamon,* based on Kingsley's *Hypatia* (1853), the dying Pelagia is watched over by Philamon on the seashore. Some feathers cover her pubis as her hands cover her breasts, but the eroticism is undeniable. The subject is a daring one, as Philamon is a monk and Pelagia his sister, formerly a courtesan in Alexandria. The eroticism of religion and the religion of eroticism, not to mention the incest, sabotage Christian ethics.

The association of women with death is apparent in Hacker's first convincing classical canvas, *The Return of Persephone to the Earth* (Plate 4-16), 1889. As Hades watches on the left, Persephone emerges before her mother Demeter/Ceres, who lies on the earth, her symbolic sickle beside her. The regret of the god, the stunned look on Persephone's face, and the apprehension on the face of Demeter are characteristic of Hacker's work. The most distinct sign of his art, however, is the winged female Love who guides Persephone, introducing an erotic element into the story, the reminder that Persephone was raped by Hades. Considering that both Demeter and Persephone were the focus of the Eleusinian mysteries, and that the daughter was associated with Dionysus in some variations of the cults, the picture gives the spectator the complete legend in miniature by the addition of the Eros. Persephone's dark veil suggests her function as a goddess of death for the period in which she remained in the Underworld.

The 1892 *Syrinx* (4-17) shows a frontal nude standing amid reeds, inspired by a quotation from the Pre-Raphaelite Thomas Woolner's "Silenus." The erotic context—the nymph was transformed into a reed to avoid rape by Pan—is typical of the sexual element Hacker introduces into his canvases through detail and mythological allusiveness. The face of the nymph is less frightened than coy; she has made no attempt to gather her drapery about her. Hacker's *Syrinx* was hung in Gallery Four at the Academy; very astutely, to avoid offending the public, another canvas, the chaste *Annunciation,* was exhibited in Gallery Ten. By the time the visitor exited the Royal Academy, therefore, the icons of whore and virgin were juxtaposed. Elizabeth Barrett Browning inspired Hacker's contribution to the Academy the following year, *The Sleep of the Gods: "Evohe! ah! evohe! ah! Pan is dead"* (Plate 4-18). Hacker depicts the Olympian deities sleeping in a glade, with Aphrodite the female nude stretched in the foreground, a garland of poppies encircling her hair. Eros/ Cupid rests by her side. However, the painting has another significance not necessarily relating to the Olympians, since it could be construed as a band of revelers following an orgy. "Evohe!" is the chant of the Bacchantes, and Hacker's nude figures, especially the female in the foreground, associate the god's devotees with sensuality, bestiality, and earthiness.

To gain a further impression of female beastliness, the visitor to the Academy in 1893 could also examine Hacker's *Circe* (Plate 4-19), a goddess displaying her naked charms to Odysseus as his men, transformed into swine, swarm around. This painting, with its brazen nude and dazed hero, leaves no doubt that Odysseus will spend a year with the goddess, however he escapes in the end. Hacker exploited such rear views to emphasize the sexuality of the female buttocks. In 1895 Hacker painted the frontal nude again in *Daphne* (Plate 4-20), portrait of the nymph who avoided rape by being turned into a laurel. This transformation is only suggested in the canvas, which is basically a woman whose filmy drape has caught in the laurel tree. Hacker's favorite pose of the female breast partly seen in profile is emphasized by the lighting of the canvas. Her expression is more apprehensive than that in the *Syrinx* of 1892. After working in portraits during the late 1890s, Hacker returned to the nude in 1901 with *The Cloud,* a purely erotic picture of a woman stretched full-length in the sky, with an androgynous but presumably male dark-complected torso below her. The accompanying quotation read: "And I all the while bask in Heaven's blue smile, / While he is dissolving in rains." This statement is ironic, for while it attempts to associate women with the transcendental and men with the terrestrial, the painting achieves neither objective. Those who com-

plained of Poynter's *Diadumenè* and Rae's *Bacchante* in 1885 have a case with Hacker in this titillating subject. The aimlessness and sexual abandon of women have rarely been more starkly expressed—unless in the notorious *Leaf Drift* (1903) (Plate 4-21), of naked women lying in the woods, the one in the foreground grasping her right breast. Such a canvas shows the general abandonment of classical-subject material for Edwardian erotic nudity, a deterioration to which Hacker was content to capitulate. The association of women with nature, here decaying nature, adds a new dimension to the "decay" of autumn.

Even after he was elected a full member of the Academy in 1910, possibly on the strength of his portraits and certainly after a delay, Hacker could not abandon the eroticism of his canvases. The erotic emphasis appeared in 1913 with Hacker's *Bacchante* showing a figure holding a thyrsus, with an animal skin flying behind her as she moves in her red dress, accompanied by a panther. One breast is exposed, as frequently in Hacker, to the gaze of the viewer. Hacker's strategy for survival, considering the nature of his canvases, was to focus on portraits and turn out touching genre pictures, as in *The Children's Prayer*, painted about 1895. In this association of religion and children, Hacker could deflect criticism in the same year he exhibited *Daphne* at the Academy. During the Edwardian period—years that saw the introduction of the blood test for syphilis in 1906 and the use of Salvarsan for treatment of the disease in 1909—Hacker's paintings reflect a new explicitness in sexual matters. Hacker capitalized on the prurient aspect of sexual discussions in such canvases as *The Cloud*. Considering that Hacker's anatomical detail is far less acute than Poynter's, it is difficult to believe that Poynter as president of the Royal Academy appreciated an artist like Hacker. Hacker's crudity marked a turning from classical subject to nude exploitation. The deaths of both Poynter and Hacker in 1919 marks the termination of the great flourishing of classical-subject painting. Poynter's conservatism and Hacker's degeneration both indicated the demise of the tradition.

V

Briton Riviere (1840–1920) was the son of William Riviere, who had "managed to get art introduced into the curriculum" of Oxford University (Fenn, "Briton Riviere" 252). At Oxford Briton Riviere had an intense classical education which influenced the nature of his classical-subject canvases but did not restrict the range of materials he would paint during his career. His fa-

ther was a close friend of Josephine Butler's, and he himself was a personal associate of Dinah Mulock Craik, the author of *John Halifax, Gentleman*. He was also a good friend of Frederic Leighton, having designed the mosaic frieze for the Arab Hall of Leighton House. When consulted by Riviere, Leighton advised, significantly, that Riviere "cleave to the Sphinx and the Eagle" (Barrington, *Life* 2.7), a casual statement that indicates Leighton's sexual anxiety and his Olympian ambitions. Riviere remembered that Leighton praised the "quality of [his] light" more than any other trait of his canvases, indicating Leighton's own predisposition to sun worship and also the basis of a canvas such as Riviere's *Phoebus Apollo* (1895) (Plate 4-22). Riviere passed through a Pre-Raphaelite period, being especially impressed by the color of Millais's canvases, before he found his career as the successor to Landseer in the tradition of animal painting. Fenn observes that with *Circe and the Friends of Ulysses* (1871) (Plate 4-23) Riviere "made his first unmistakable score" ("Briton Riviere" 254). Walter Armstrong notes that this canvas, a robed Circe seated and looking at the herd of swine, is even "more decorous" than Smith's *Classical Dictionary*: "His Circe is a modestly robed young woman, counting her pigs. . . . A more Homeric treatment might have been in closer accord with modern fashions, perhaps, but it must be remembered that in 1871 fashions were still old" ("Briton Riviere" 15). The swine are flesh colored to suggest the transformed men. This Circe canvas reinforces prevalent ideas that woman was an atavism, whose evolution had been arrested at a stage closer to bestiality than humanity. In the same year, Riviere completed his oil *Bacchantes*, drawing on the same theme that was being repeated by so many exhibitors.

Riviere in 1874 completed *Apollo with the Herds of Admetus*, accompanying the canvas with a quotation from Euripides' *Alcestis* that noted Apollo's becoming a shepherd as a punishment for slaying the Cyclops. This canvas allowed Riviere to deal with the god in a terrestrial context, domesticating his heroism. Apollo was in service to Admetus, the husband of Alcestis, who agreed to die for her husband and was rescued from Death by Heracles. This subject had been treated by Leighton in 1871. Riviere chooses the opening scene of the play, a long monologue by Apollo. The canvas has a homosexual cast, as Apollo had fallen in love with Admetus. The heroism of Apollo—when Zeus killed Aesculapius, Apollo's son, Apollo defied him—contrasts with the cowardice of Admetus and the valor of Alcestis, the one avoiding death, the other willing to die for love. The *Art Journal* noted that Riviere's canvas raised some problems about the correct subject matter for classical art: "We

think Mr. Riviere does wrong to associate his careful studies of animal-life with any classic names. It is impossible to accept the figure here introduced as in any sense worthy to represent the beauty of the sun-god. . . . The suggestion of an antique theme awakens the recollection of a kind of beauty which is clearly beyond the reach of the artist. . . . Neither here nor in any of Mr. Riviere's pictures, do we find any sufficient signs of a feeling for beauty of form. His power is rather that of expression. . . . We may recall the Circe . . . in witness of the grotesque vision of classic themes the artist possesses. . . . [In *Apollo*] the god is ungodlike and lacks beauty. . . . It is an uncomfortable position in which to set his Apollo, bare-backed against the rugged bark of a tree" (165). Riviere's challenge was to unite realism with classicism, a struggle not always successful.

A decade later, in 1884, Riviere painted *Actaeon and the Hounds*, depicting the revenge of Artemis on the hunter for having seen her bathing. He is shown on Mount Cithaeron trying to fight off his dogs. The story of Actaeon may be read either as illustrating female vengeance or as supporting the inviolability of womanhood. *Adonis's Farewell* (1888) (Plate 4-24) contains this same ambiguity. The hunter is setting out with his dogs on the hunt that would lead to his death at the hands of Artemis, whose lover, Hippolytus, Aphrodite had destroyed. In both canvases female nature is fierce and retributive. Riviere was fond of painting sequences of a myth. In 1887 he had painted *Adonis Wounded* (Plate 4-25). The dogs are baying over the dead corpse, stretched full-length in the foreground. The *contrapposto* pose of the figure is slightly effete, but Riviere's starkness of presentation is notable. Considering that Adonis' worship, linked to vegetation, was particularly associated with women, the androgynous quality of the figure is appropriate. Such a manner expresses the latent fear of female domination, of loss of masculine prerogatives. *The Pale Cynthia* of 1889, showing a shepherd gazing at the pale moon above him, indicates the alternative, where the female principle rules the universe. Riviere conveys this belief by the small scale of the watcher and the immensity of the universe looming above him.

In the 1890s Riviere's classical-subject pictures treated varieties of depictions of males. The *Dead Hector* of 1892 (Plate 4-26) is one of Riviere's most intriguing subjects. Riviere celebrates the extinct heroism of the Trojan prince. On the shore of a blue ocean, resting on gray earth, Hector's body, with no mark on it, draws on the poses of Etty's nude models, bathed in cream-colored light. Riviere exploits a significant detail of the legend, that Apollo kept the sun's rays from the body and Aphrodite preserved it from fierce dogs. He uses

the Apollonian detail to make the presentation of male heroism credible. Riviere's innovation is in depicting the undulations of Hector's body as if they were themselves waves of an ocean, rising to crest at the buttocks. The wolves lurking around the body threaten its still-warm strength, but their stance and glance suggest that they are kept at bay. This stripping of heroism to sheer physical beauty is striking and unusual. In the 1889 *Prometheus* (Plate 4-27) at the Grosvenor Gallery, Riviere shows the hero suspended over an abyss, crucified and enchained in a painful, even sadistic, image, to exemplify the hero's extraordinary endurance. In contrast to the *Hector,* here the man is in physical torment, surviving by strength of will. The *Prometheus* uses the moonlight effect later deployed in the *Dead Hector.* The men destroyed in the *Actaeon* of 1884 and *Adonis* of 1888 have given way to men triumphant in endurance and in death.

One of the most important of the artists of classical-subject pictures during the 1880s and 1890s was Walter Crane (1845–1915), a native of Liverpool with personal ties to Edward Poynter and aesthetic affiliation with Edward Burne-Jones. Crane was early taken with Poynter's drawing for the Dalziel Bible *Moses and Aaron before Pharaoh,* with the changing of rods into serpents. When Crane lived in Shepherd's Bush, the Poynters were neighbors at Beaumont Lodge; Crane recalls Agnes Macdonald Poynter as "an accomplished pianist" (*Artist's Reminiscences* 154), an achievement never mentioned in other references to her. Crane worked in Poynter's studio if he needed additional space. When Poynter became overwhelmed with duties, he suggested Crane to finish the ornamental design of the billiard room at the estate of the earl of Wharncliffe which contained Poynter's *Atalanta* and *Nausicaa.* In 1879 Crane was made an examiner at the South Kensington School through Poynter's advocacy, and in 1888 he was admitted to the Old Water-Colour Society through the same agency. The work of Burne-Jones was a revelation to Crane, as he recalled when seeing *The Merciful Knight* at the Old Water-Colour Society in 1864: "We had a glimpse into a magic world of romance and pictures, poetry . . . a twilight world of dark mysterious woodlands" (Isobel Spencer, *Walter Crane* 65).

As he was in his lifetime, Crane is thought of today as a designer of children's books, a fate he recognized in 1913 as harming any just appraisal of his efforts: "Nothing is dearer to the heart of a commercial age than a label, both for persons and things. . . . I was labelled designer of children's books long ago—although designs for children's books . . . have only formed a comparatively small part of my work" (Anthony Crane, "My Grandfather" 109).

Anthony Crane recalls his grandfather as having endured "troughs of depression in an artistic career of considerable but very variable financial success" (99). Crane's grandson recognized the difference between Crane and an artist like Leighton: "There could be no greater antithesis than his light touch to the Olympian lordliness of a Leighton, or even to the magnificent patriarchal figure of my other grandfather Frederick Sandys" (101).

Crane's classical-subject paintings frequently veered toward allegory. Paul Konody noted that "his figures are devoid of all individual traits and are almost as much symbols as the hieroglyphic figures of the ancient Egyptian wall paintings" (*Art of Walter Crane* 91). The Parthenon frieze influenced Crane in the draperies of his figures, especially of his female figures, and he went to Paris in 1866 partially to worship at "the shrine of the *Venus de Milo*" (Isobel Spencer, *Walter Crane* 67). Crane's readings in mythological theory included Max Müller's *Chips*. An early classical-subject picture such as *Love's Sanctuary* (1870) combines a classical motif and frieze with an altar for mass. The pilgrim kneels before a picture of his beloved, in this canvas the woman who became Crane's wife in 1871. The presence of Aphrodite is signaled by doves. Although the picture is filled with excessive detail and is not well executed, it reveals Crane's interpretation of elements of his own life in a classical form. Crane's wife appears in classical garb, a pale green robe, in *The Herald of Spring* in 1871, where she walks barefoot down a street in Rome. With the single dove flying beside her, and the cupolas of a church behind, the canvas telescopes the pagan and the Christian as in *Love's Sanctuary*.

Crane's best known but not best executed painting is *The Renaissance of Venus* (Plate 4-28), exhibited at the Grosvenor Gallery in 1877. The canvas is an Aphrodite Anadyomene. The goddess stands on a shore, one arm raised above her head, while doves flitter about her. The canvas seems stilted and immature in execution, partly as a result of the circumstances under which it was painted. Anthony Crane observed in 1957: "The fact that he did not use female models is attributable to my grandmother's curiously prudish attitude toward them and to her [his wife's] powerful and dominant personality" ("My Grandfather" 105). Crane's wife was the daughter of Frederick Sandys and strongly objected to her father's philandering. The model for Venus in this canvas was one of Leighton's favorite models, Alessandro di Marco. When Leighton saw the canvas, he remarked: "Why, that's Alessandro" (106). If one examines the figure closely, one sees clearly that the breasts have been "attached" to the torso, in a manner similar to the peculiar anatomy of Watts's sculptured *Clytie*. Graham Robertson noted in *Time Was:* "The fiat of do-

mestic authority had gone forth against female models as being neither necessary nor desirable additions to a young artist's equipment, and thus Walter Crane's goddess showed a blending of the sexes which was mystically correct but anatomically surprising" (39). One should remember that Ruskin conveyed similar information when asked about the necessity of studying the female nude. Robertson recalled that when he first met Crane "The Master looked very young, almost a boy. The Master did not seem very masterful" (37).

This situation—strange when one considers that Poynter was simultaneously championing the more liberal use of male models for women art students—reflects Crane's sexual personality. Anthony Crane noted: "Walter Crane was a small, charming, and unassuming man . . . while my grandmother was a dominant and ambitious woman. . . . I suspect that Walter Crane would have had less interest in seeing himself as a celebrated painter of subject pictures if he had not sought to please his wife" (107). Crane had completed a watercolor in 1872 in Rome, *Diana at the Bath,* that was better executed than the nude in *The Renaissance of Venus.* The pose of *Diana* is the reverse of that of the *Venus.* From this evidence it would seem that Crane's wife jeopardized his ability to do the nude convincingly in the classical-subject canvases. The circumstances of composition of *The Renaissance of Venus* explain a subject finished two years earlier, *Amor Vincit Omnia* (Plate 4-29), which Crane unsuccessfully submitted to the Academy. The painting depicts the surrender of a town of Amazons to the conqueror, presumably Love. This canvas reflects a Victorian "Amazon complex," a fear of "a city, a society, an alternate structure, composed only of women and innately hostile to men, whom they want to dominate, use, and rule" (Zeitlin, "Cultic Models" 146). The battle with the Amazons, or Amazonomachy, as depicted on the Parthenon or on the Temple of Apollo at Bassae, represented the conquest "of the forces which threaten to destroy civilized life," that is, anarchic, unregulated women (Walcot, "Greek Attitudes" 41). The idea of the dominant woman submitting to the male would have accorded with Crane's fantasies. The worshiper of the icon in *Love's Sanctuary* was never allowed the artistic expression that might have made him as well known for his oils as for his illustrations.

In 1878 Crane exhibited *The Fate of Persephone* (Plate 4-30) at the Grosvenor Gallery. This canvas suggests the powerful effects that Crane could achieve by colorful contrasts. Persephone in white dress and yellow tunic has gathered narcissus and is being abducted by a calm Hades, under whose chariot the earth cracks to admit them to the Underworld. Her costume contrasts with the jet black of the god's horses, while three attendants, in gold, cream, and

orange, stand to the left in amazement. The pomegranate tree in the foreground suggests the deathlike fate of Persephone. The three canvases *Love's Sanctuary, The Renaissance of Venus,* and *The Fate of Persephone* each express a dimension of Crane's thought about women: worship, ambiguity, or suppression. The following year Crane exhibited *The Sirens* at the Grosvenor, showing the three figures standing on the coast, inspired by the Parthenon sculptures. The poses in *The Sirens* appear in an earlier panel, *The Seasons* (1874), four women in classical dress in an array of colors, ranging from pink and yellow to green and brown, derived from Greek prototypes. Within a short time Crane had metamorphosed the draped female into a more distressing icon. This additional image of fearsome women affirms Crane's attitude during the first decade of his marriage. Crane's subsequent images of women, particularly during the 1880s, reflect his latent fears of their power. One may regard the *Europa* of 1881 (Plate 4-31) as a fantasy projection of male dominance, but the "hermaphroditic genesis" (Isobel Spencer 123) of Crane's female nudes makes this figure unconvincing as she sits astride the bull.

Crane painted several studies of mythological women in the 1880s, including several of Diana/Artemis. In 1881 he completed a *Diana,* showing the goddess as huntress running through a glade. *Diana and the Shepherd* of 1883 (Plate 4-32) shows the goddess contemplating a sleeping youth, Endymion, although the time is day rather than the night of legend. It is known that as a youth Graham Robertson posed for the figure of Diana, which is particularly clumsy in the execution of the right leg; the figure of Endymion is scarcely better drawn. Crane noted that Harry Quilter remarked of the canvas in the *Spectator* that "it was strange that an artist who had studied so long in Italy could not paint an olive tree. As it happened, the background for this picture had been found on Tunbridge Wells Common, so I was able to turn the tables on him on this point" (*Artist's Reminiscences* 243). This is not the issue, however, for the figures themselves sabotage the canvas. Crane's suspicions of women are verified in the 1885 watercolor *Pandora* (Plate 4-33), showing a woman prostrate over a large chest. Crane said he concentrated on "the mythical lady after the fatal box had been opened—which I had represented as a marriage coffer—she having cast herself upon the lid after the evils had escaped" (276). This is close to saying that marriage contained all the evils of the world. Pandora's hair is draped over the chest, and the ominous figures of Sphinxes are on the platform. Crane's association of Pandora's box with a wedding chest is completely unique, and the connection of marriage with female duplicity could not be more apparent.

Crane sent *The Riddle of the Sphinx* (Plate 4-34) to the Grosvenor in 1887, where it was put behind a pillar; Crane never exhibited there again. The work shows a naked man, presumably Oedipus, kneeling before a monstrous female with dark wings. Crane's sketch for the canvas is even more gynophobic, showing merely the hands of the man in the left corner, the woman grotesque and repellent. There have been few representations of this subject that have revealed so much grim terror on the part of a male artist. The watercolor of 1888, *The Diver,* is the consequence of this fear. One may easily read it as a man committing suicide. Since Burne-Jones had exhibited his *Depths of the Sea* in 1886, there is little doubt of the fate lurking beneath the waves. A panel decoration of a mermaid was completed by Crane expressing this motif, and a mermaid with slimy tail illustrated the *Shakespeare Calendar* of 1897. Despite Crane's attempt to show masculine domination in a canvas such as *Neptune's Horses* (1893), he could not avoid the implications of the studies of the 1880s. In the subsequent medievalizing of works such as *England's Emblem* (1895) and *Lohengrin* (1895), Crane indulges in "rescue" fantasies to counteract the terrors evoked in the classical-subject canvases of *Pandora* and *The Sphinx.* These themes of Sphinx, Pandora, and mermaid all exhibit male sexual anxieties evident in Victorian culture.

Crane's work illustrating *Echoes of Hellas: The Tale of Troy and The Story of Orestes,* in 1887, represents a plethora of threatening women, not merely in the specific illustrations but around the borders of the text, as in the drawings for Odysseus with Circe or the illustration for *Part II: The Odyssey,* showing Odysseus with the enchantress, around which are various Sirens and mermaids. The scene showing Agamemnon entering the citadel presents a large Clytemnestra following behind and an attendant with a shield depicting the Medusa head. The latter detail is a gynophobic addition by Crane himself to the legend.

Crane executed a watercolor drawing, *Medusa,* showing her with frozen stare and snake locks. He also finished a drawing of the warlike Bellona, the ultimate threatening female. The Goddess of War holds a torch above her head symbolizing her destructiveness. Crane's work, whether in oil, watercolor, or book illustration, widely disseminated such views to a mass Victorian audience. Man was perceived as constantly at the mercy of women and their destructive natures. Persephone, Diana, the Sirens, Pandora, and Sphinxes narrate Crane's apprehension of women. In a canvas of about 1895, *The Swan-Women* (Plate 4-35), Crane depicted these females reassuming their true natures after bathing. Since it was Zeus himself in the form of a swan who copu-

lated with Leda, the picture represents women assuming phallic power and authority. The ability of women to transform themselves suggests the instability of their personalities as well as the inclination toward atavistic beastliness. This gynophobia indicates a personal anxiety arising from his own marital situation, which was reflected in the culture of his time. The allegory *The Bridge of Life* (1884), showing the Fates Clotho, Lachesis, and Atropos controling man's fate, was more than mythology for Walter Crane. His inhibitions prevented him from becoming the painter he might have been. Graham Robertson's record remains a fair estimate: "His extraordinary facilities for graceful design beguiled him into over-production and hasty, scamped painting. He never tried to master his material when working in oil or to correct the rapidly growing mannerisms which finally wove a veil between him and the whole face of Nature. . . . He was hardly strong enough to bear the burden of his own great gifts which were, in a way, a misfit and made for a bigger man. His art did not advance, its movement rather was retrograde. He was shy and without self-confidence. . . . He looked weary. . . . He somehow missed his way" (*Time Was* 39, 42). Robertson notes specifically Crane's "boneless, sexless figures" (39) as contributing to his lack of preeminence as an oil painter.

The artist Frank Dicksee (1853–1928) succeeded to the presidency of the Royal Academy in 1924, but several of his canvases have an importance in the tradition of Victorian classical-subject painting. During his lifetime it was difficult to categorize his work, which ranged from medievalizing subjects such as *Harmony* (1877), *The Redemption of Tannhäuser* (1890), and the famous *Chivalry* (1885), to classical themes (*Sylvia*, c. 1891), to genre studies (*Memories*, 1886). Dicksee received his early instruction from his father, Thomas Francis Dicksee (1819–1895), who had himself painted a number of classical figures, such as *A Roman Maiden* in 1879 and *Antigone* in 1884. Dicksee frequently combined the classical and the allegorical nude in such canvases as *The Ideal* (1905) and *Dawn* (1897). Leighton instructed Dicksee at the Royal Academy and influenced him in the treatment of the nude and in the study of drapery. When Dicksee won a medal in 1876 at his first Academy exhibition, the classical influence was strongly represented by Poynter's *Atalanta's Race*, Leighton's *Daphnephoria*, and Tadema's *Audience at Agrippa's*. Dibdin notes that in works such as *The Mountain of the Winds*, *The Ideal*, and *Dawn* Dicksee appears "as an almost unadulterated classicist" (25) by his grace of design. Like his professor Leighton, Dicksee built his pictures by gradual refinement in a series of preliminary drawings and studies.

In 1891 Dicksee exhibited *The Mountain of the Winds* (Plate 4-36), show-
ing three male nudes and a female in classical garb, the first time Dicksee
exhibited undraped figures. The female draped figure in the center, repre-
senting the South Wind, reclines like a goddess from the pediments of the
Parthenon. This canvas has a strongly political cast. The men are energetic
as the other three winds, while the South Wind (representing continental
luxuriousness as opposed to male northern British force) is a reclining female.
The most prominent wind, the East Wind, is a fierce dynamic male. Like
Leighton, Dicksee contrasts the flesh tints of this naked, heroic male with
the female classical figure. The three male winds have the dynamism of the
furious forces evoked by Ruskin in *The Queen of the Air,* undoubtedly the
source of Dicksee's conception of heroic male forces. The impression of fe-
male passivity in *The Mountain of the Winds* was reinforced in Dicksee's
other contribution to the Academy in 1891, *The Crisis,* a contemporary genre
scene showing a male physician studying a sleeping woman lying on her po-
tential deathbed, totally dependent on the man's medical wisdom. When
exhibited, *The Crisis* was in Gallery II, *The Mountain of the Winds* in Gal-
lery VIII, diagonally opposite one another. In both canvases, the woman is
the enervated figure, and this juxtaposition of classical and contemporary
images reinforces the impression that such is woman's unchanging nature.
In 1892 Dicksee completed his Diploma Picture, *Startled,* showing two nude
women, one a girl, the other adolescent, surprised in their bath by the ship
on the river, which may be Roman. The myth behind this is that of Diana
and Actaeon.

It is difficult to grasp why Dicksee submitted this canvas for his Diploma
Picture when he exhibited in the same year the stupendously rendered *Leila,*
a woman in Oriental dress of red and pink, gazing confidently and indolently
at the viewer. Dicksee's use of female beauty in classical drapery is well illus-
trated by *Sylvia,* a panel finished in the early 1890s and engraved by John D.
Miller and published as a mezzotint. Like the *Graphic* figures of beauty, this
canvas with its refined light and classic features established in the popular
mind one standard of female loveliness during the late Victorian era. Dick-
see's restraint in handling the accessories is admirable. Such physical idealiza-
tion of women is carried to an extreme in *The Ideal* of 1905 (Plate 4-37),
showing a naked red-haired youth reaching to a female shape in the clouds,
as her drapery trails behind her. The coloring, with the light falling on the
youth, his skin contrasting with the evanescent vision, is effective in present-
ing the idea of aspiration expressed in the quotation from Browning—"The

passion that left the ground to lose itself in the sky." Contrasted with the idealized female of *The Ideal* is the sinister figure in *The Magic Crystal* (1894), a sorceress sitting enthroned and contemplating a crystal ball. Her gaze is intent and intimidating. The large scale of the woman parallels the monumental prophetesses in Leighton's allegorical canvases. In Dicksee's *Andromeda* (1890) (Plate 4-38), a frontal nude, Andromeda is shown chained to a rock, in an attitude of despair and resignation, neither the monster nor Perseus visible in the canvas. *Andromeda* was painted as a panel for the home of Tadema, to which other classicists such as Leighton and Poynter contributed designs. The woman is shown totally abandoned.

Although Dicksee's work was not predominantly classical, his classical pictures, whether through engravings or discussions in magazines, were sufficiently known to be important in that tradition. Dicksee tended like Crane to paint medieval subjects and classical motifs, alternating from one mode to another. His contradictory representations of women, threatening in *The Magic Crystal* or pathetic in the *Andromeda,* caught a strain of the sensibility of the late Victorian and Edwardian era. The famous *Chivalry* (1885) expresses most sharply Dicksee's preferred male image, that of the heroic rescuer. In his "Discourse" to the students of the Royal Academy in 1925, Dicksee enunciated his aesthetic beliefs: "The Greeks demonstrated for you the perfection of the human form." Dicksee advised students to "get all the help you can from literature" to support an "indwelling spiritual quality [which] if you have it not, then put off your armour, for the battle is not for you" (6, 9). This martial reference indicates that to Dicksee male heroism is not dead. Dicksee goes beyond this doctrine of male superiority: "Our idea of beauty must be the white man's," he declares (13), using the Greek ideal of male beauty to reinforce a doctrine of white male supremacy in art.

Exhibiting at the same time as Dicksee at the Academy was Solomon Joseph Solomon (1860–1927), an inheritor of the classical manner of Leighton and Poynter. Solomon had studied in France in the studio of Alexandre Cabanel. His work drew on the academic nudes made famous by this artist, such as *The Birth of Venus* (1863) which influenced Leighton's *Actaea* (1868). Solomon's earliest classical subject exhibited was the 1885 *Love's First Lesson,* showing Aphrodite teaching Eros the use of the bow, with the arrow tip aimed at her right nipple. The image of female sexuality became violent in Solomon's next canvas. In 1886 Solomon exhibited *Ajax and Cassandra* (Frontispiece), the most famous "rape" or abduction painting in Victorian art. Throwing her hands to the sky, her breasts exposed in uplifted silhouette, Cassandra

is carried down the steps of the temple of Athene by a brutal Ajax, who thus symbolically denies woman the solace of wisdom, as did the culture of the nineteenth century. The fact that Cassandra was cursed by Apollo shows the entrenched force of male authority. Moreover, since Athene was born from Zeus's head, she is identified with male power, as she herself admits in Aeschylus' *Eumenides* when she acquits Orestes. Zeus's appropriation of the faculty of giving birth is clearly misogynistic. Therefore, Athene offers no asylum to Cassandra. Apollo denied her prophecies credibility when she refused his sexual advances; Ajax perpetuated the brutality; Agamemnon took her as his concubine to Mycenae; Clytemnestra slew her. The painting is fierce as Ajax tears her from the goddess's pedestal, his fist clenched. *Ajax and Cassandra* records nineteenth-century sexual anxiety, for as Walcot observes, "rape is yet another violent response on the part of the sexually insecure" ("Greek Attitudes" 42). The canvas asserts the man's right to "capture" the woman, a primitive marriage practice beginning to be discussed by anthropologists of the period.

Solomon's 1888 canvas *Niobe* (Plate 4-39) is a harrowing study of a legend infrequently presented, that of the slaughter of Niobe's children by Apollo and Artemis because Niobe bragged about the number of her offspring. In this canvas she is shown coming down the temple steps holding the body of one child across her lap, her hair streaming behind her. Solomon manages to get bare breasts and buttocks into the canvas, even leaving one of Niobe's breasts exposed to suggest that her sexuality is her doom. The *Ajax* and the *Niobe* demonstrate the complexity of sexual definitions of women. In the former, a woman's refusal of sex leads to doom; in the latter, her exaltation of it leads to destruction. The language of the body lends high dramatic tension to both canvases.

Solomon's misogynistic attitude is exhibited in *The Judgment of Paris* (1891) (Plate 4-40). This canvas depicts the three goddesses but not Paris, allowing the spectator to become the appraiser of female beauty. Aphrodite has just thrown off her veil, revealing a slender but sexual body. To the left, holding a shield on which is embossed a Medusa, is Athene, while Hera still clothed gazes amid blossoms on the right. The fact that Paris chooses beauty over knowledge or power symbolizes the conservative and reactionary attitude to women's emancipation. Such a canvas is one of the clearest manifestations of masculinist definitions of women in 1891. The *Cassandra, Niobe,* and *The Judgment of Paris* are icons of women's oppression.

In the 1890s Solomon exhibited several canvases supporting male power

and superiority in addition to *The Judgment of Paris*. The 1892 *Orpheus* (Plate 4-41) depicts the poet standing before the body of Eurydice, which is entwined by a serpent. In a vision he sees her soul removed to death. Solomon's Orpheus is an ardent young man, crowned with laurel. As he did with Poynter's *Atalanta's Race*, Blackburn in *Academy Notes* prejudices the viewer in his guidebook, claiming that Orpheus is shown "at the moment of his temptation to look back" (19). Although this interpretation is impossible given the iconography of the canvas (Eurydice is still on earth, not in the Underworld), Blackburn's notice, nevertheless, evokes the seductive allure of Eurydice. The *Echo and Narcissus* of 1895 (Plate 4-42) shows Echo gazing desperately into the face of Narcissus, who stares instead into a pool at his own image. Solomon shifts the emphasis of the myth from the destruction of Narcissus (as in Waterhouse) to the desperation of Echo. Baldry noted that Solomon's canvases were "hampered by some idea that a dramatic subject or a well-known incident in classic mythology must necessarily be used as an illustrative basis to his compositions," but that in *Echo and Narcissus* elements of design were becoming more significant ("Work of Solomon J. Solomon" 7). *Echo and Narcissus* is free of the violent gesturing of the *Niobe* and *Cassandra* from the 1880s, but its subject still conveys the same message of female dependency. Echo has thrown off the top part of her dress to attract the self-absorbed Narcissus. In the 1896 *The Birth of Love* (Plate 4-43), an Aphrodite Anadyomene, the goddess is standing on a shell while *putti* encircle her.

Baldry argues that Solomon displayed female flesh for the sake of the color design in his canvases. Nevertheless, the impression given by later works, such as the *Psyche* of 1902, is that Solomon felt an equivalent desire to exhibit the female in abandoned postures. In *Psyche* the neophyte goddess has swooned to the ground, and as late as 1925 Solomon was doing such work as *A Girl on a Leopard-Skin Rug*, which needs no description and defies it. Solomon is one of the most intensely dramatic of the classical-subject painters, with the gestures of the *Niobe* and *Cassandra* remaining memorable. As a result, these works were extremely popular at the Academy. The iconography of women as raped (*Cassandra*), destroyed (*Niobe*), or abandoned (*Echo*) conveyed to the public an ideogram of woman as victim or dependent.

The fact that classical-subject canvases reflected the political situation is evident from the career of Edward Armitage (1817–1896), an artist who had entered the Westminster Hall Competition in 1843. Armitage's work from the 1840s to the 1860s was primarily biblical. During the late 1850s, however, Armitage painted a number of classical-subject canvases. *Retribution* (1858)

(Plate 4-44) shows a warlike female stabbing a tiger who had killed a mother and child. This canvas presents the maternal and the bestial natures of women simultaneously. In *The Return of Ulysses* (1853) (Plate 4-45), Armitage depicts the hero before his nurse. Several other women sit disconsolately since they do not realize that the hero has returned. In *Retribution* women are depicted as fierce or helpless; in *Ulysses,* men are heroic, women are servants. With *Hero Lighting the Beacon* (1869), Armitage showed the priestess of Aphrodite. The sensuality and faithlessness of women could not have been more convincingly depicted than by this dauntless icon. During the early 1880s, however, Armitage was particularly concerned with male heroism. In the 1881 *Samson and the Lion,* Armitage presented a powerful image of maleness conquering atavistic beastliness. *After the Arena* of 1885 showed man triumphing even after death. The body of a young Christian killed in the Coliseum is lowered into the catacombs for burial. His head is kissed by his mother as a sister kneels before the descending corpse. Rays of light shining on the body suggest his heroic martyrdom. The size of the canvas (150 × 115) overwhelms the viewer with the message of victorious male idealism.

In 1888 Armitage exhibited his most important classical subject, *A Siren* (Plate 4-46). This painting shows a slender nude female, raised leg concealing her pubis, sitting on a rock while three ships approach the coast, where another wreck lies scattered. The lyre with which she was supposed to lure the men rests behind her, suggesting that her physical charms are sufficient to lead the men to destruction. The *Athenaeum* noted: "Mr. Armitage's *A Siren* does not represent a dangerous seducer, but a graceful, somewhat cold, and slender damsel seated on a rock overlooking the sea. Her carefully painted flesh is somewhat deficient in rose colour, and, in defiance of the legend, her charms are not exuberant" (668). Armitage injects a strong element of fear of women's power by including only one female in the canvas. One woman can destroy the world.

In 1883 Armitage published his *Lectures on Painting,* all originally delivered at the Royal Academy. In his lecture discussing "The Choice of a Subject," he makes an observation that indicates the intention of *A Siren:* "Jove, Mars, Venus, and Hercules are of interest to us *now,* just as they probably were to the Athenians in the time of Phidias and Praxiteles, namely, as representatives of power, courage, beauty, and strength; and so long as these qualities are valued by the human race, so long will their personifications continue to be interesting" (202). From this statement, it is clear that Armitage's classical subjects represent eternal types of human nature. For Victorian cul-

ture, the icon of woman in *A Siren* propagates the concept of woman as destructive and venal. To Armitage, male mythological deities are prototypes of nineteenth-century masculinist virtues. Correspondingly, females such as Aphrodite and the Siren symbolize traits about women assumed to be universally and eternally true by patriarchal standards. Armitage's prestige as both painter and sage had been indicated by the publication of his *Lectures* five years before *A Siren,* which thus derived increased persuasive force from his status as professor and practitioner of art.

A member of the original "Paris Gang" presented in du Maurier's *Trilby* was Thomas Armstrong (1835–1911), who eventually became director of the South Kensington Museum in 1881. Armstrong painted a few classical-subject canvases in the style of his intimate friend Albert Moore. His canvas *Woman with Calla Lilies* (1876) (Plate 4-47) exhibits the influence of Moore in its single draped figure holding an amphora. The painting has the decorative emphasis one associates with Moore, but the face is more disturbed than the statuesque heads of Moore's women. Moore's fondness for friezelike design is reflected in Armstrong's *Three Female Figures on a Marble Seat with Orange Blossoms and Marigolds* (1878), the title of which indicates its decorative function. Two of the women on either side of a third have raised knees to exhibit the artist's skill in drapery. The marble seat overlooks distant grounds. *A Girl Watching a Tortoise* (1874) (Plate 4-48) shows a draped female observing the slow animal. The woman's face appears irritated and bored, and the gesture with the necklace indicates frustration. The peacock feather signifies her thwarted imperiousness by its connection with Hera. *The Recital—Classical Figures on a Terrace,* in which women and girls listen immobile to the musician in the center of the canvas, reflects Moore's proclivity for the frieze. In contrast to Armitage's intimidating women, Armstrong's are lost in passivity, frozen into static attitudes that prevent their being threatening.

Armstrong's canvases, however, are not enslaved to tradition and convention. Graham Robertson compared Armstrong to Crane, noting that he "had all the knowledge and training that Walter Crane lacked. If Crane painted too much, Armstrong painted too little." The influence of Moore is apparent, as Robertson noted, but there is a difference, a distinction: "His art had much of the calm beauty of Albert Moore's decorations, much of the tone magic of Whistler, yet it was in no wise imitative, but keenly personal. I have seen no such restful schemes of blue and grey with a hint of veiled purple as in many of his works in which shadowy mountains brooded dreamily over grey olive woods in a silver twilight" (*Time Was* 43). The strength of Armstrong's

canvases is clarified by an anecdote Robertson records. Armstrong once dis-
covered a sketch of Robertson's, which Robertson admitted he had done "out
of my head" when Armstrong asked if it were copied. Armstrong replied: "'Mind
you always do a bit of drawing of this kind every day. Of course you'll never
turn out anything decent until you have *learnt* to draw, but this is a trick
that you lose if you don't practise it. Lots of good draughtsmen can't draw
a thing out of their heads to save their lives'" (44). Armstrong could paint
his canvases in the tradition of Moore and Whistler, but the irritated faces
of his women in such works as *Woman with Calla Lilies* or *A Girl Watching
a Tortoise* indicate the individual element implied by creating "out of one's
head." These women are static, but they reflect a frustration in their very sta-
sis. Armstrong refuses to accept the statuesque facial placidity of the classical
sculptural ideal.

The work of Poynter, like that of Leighton, occupies a position of major
importance in the classical-subject art of the century. Poynter's excellent drafts-
manship, his detailed study of the nude, and his refinement of color would
have made him important for technical considerations alone. His theoretical
addresses, in attacking the preeminence of Ruskin, are provocative challenges
to Ruskin's mid-Victorian orthodoxy. The degeneracy of Poynter's art into genre
and then prurient canvases never altered his superb technique, only its motive.
Artists such as Long and Hacker parallel this descent. Poynter's legacy may
be seen in the art of a contemporary such as Arthur Hill (fl. 1858–1893), who
amalgamated Poynter's style to that of Tadema, painting such works as *A
Maenad* (1885) and *A Bacchante* (1886). In *The Signal* of 1887, a naked woman
stands with a torch in her hand, presumably Hero, offering her body to her
approaching lover Leander. Hill's *Andromeda* (1875) (Plate 4-49) follows the
corresponding canvases of Poynter by only a few years and exhibits his careful
anatomy. Contorted in agony, the model has one chained hand raised above
her head. In the eerie light she is the image of Victorian sadism.

As the century progressed, Poynter's reserved character produced a strange
legacy. The sensuality of the canvases by Hacker, the violence of the paintings
by Solomon, and the pathos of studies by Dicksee represent Victorian varia-
tions of male anxiety as the eighties and nineties produced significant changes
in the legislative situation of women. In the pictorial ideograms of all these
artists, one discerns a political conservativism, with mythology reinforcing the
dominance of the male.

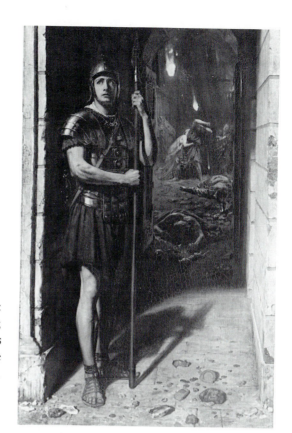

4-1. Edward John Poynter:
Faithful unto Death, 1865;
45¼ × 29¾; National Museums
and Galleries on Merseyside
(Walker Art Gallery, Liverpool).

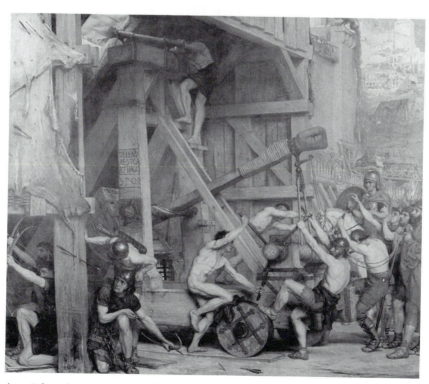

4-2. Edward John Poynter: *The Catapult*, 1868; 61 × 72¼; Laing Art Gallery,
Newcastle.

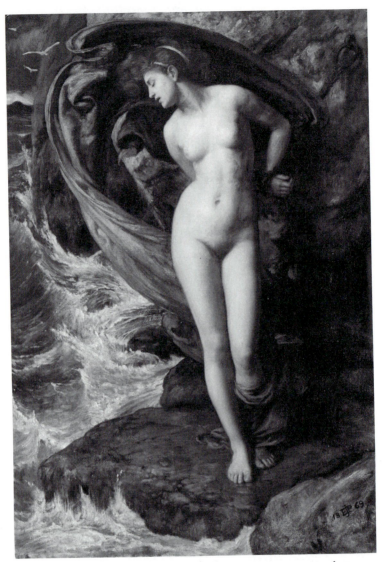

4-3. Edward John Poynter: *Andromeda*, 1870; 19½ × 13½; photo: Rodney Todd-White, London.

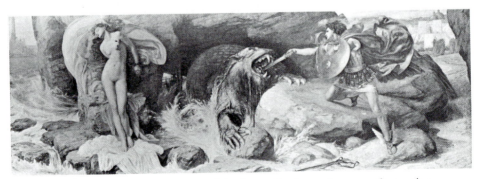

4-4. Edward John Poynter: *Perseus and Andromeda*, 1872; 58 × 174; photo: *Art Annual* 1897.

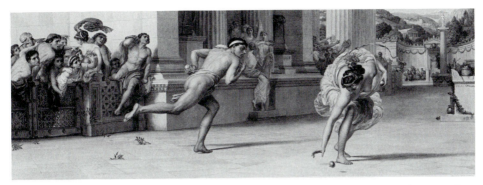

4-5 Edward John Poynter: *Atalanta's Race,* 1876; 58 × 174; photo: Christopher Wood Gallery, London.

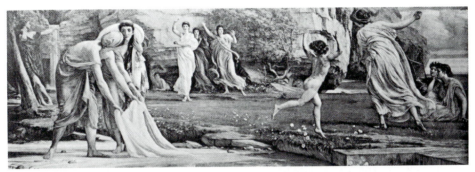

4-6. Edward John Poynter: *Nausicaa and Her Maidens Playing at Ball,* 1879; 58 × 174; photo: *Art Annual* 1897.

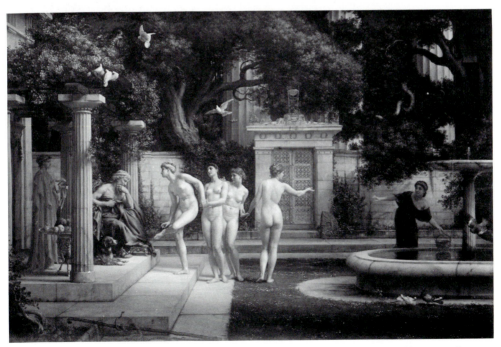

4-7. Edward John Poynter: *A Visit to Aesculapius,* 1880; 59½ × 90; Tate Gallery, London.

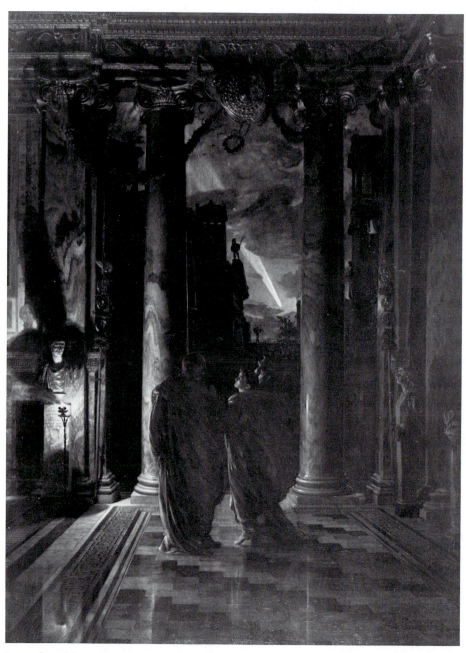

4-8. Edward John Poynter: *The Ides of March*, 1883; 60¼ × 44½; Manchester City
Art Gallery.

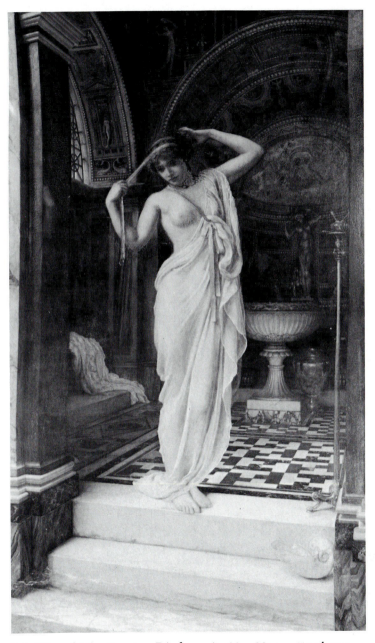

4-9. Edward John Poynter: *Diadumenè*, 1885; 88 × 52½; photo:
Sotheby's Belgravia.

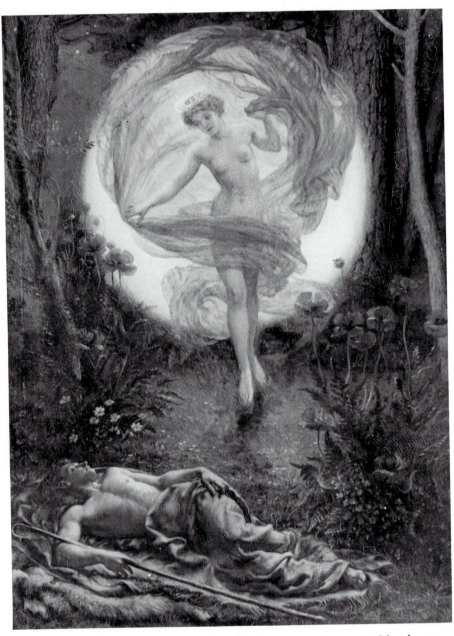

4-10. Edward John Poynter: *Diana and Endymion,* 1901; 30½ × 22½; Manchester City Art Gallery.

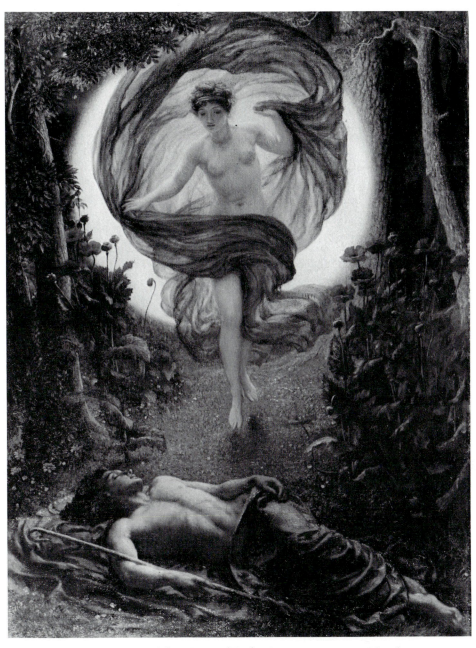

4-11. Edward John Poynter: *The Vision of Endymion*, 1902; 20 × 15; Manchester City Art Gallery.

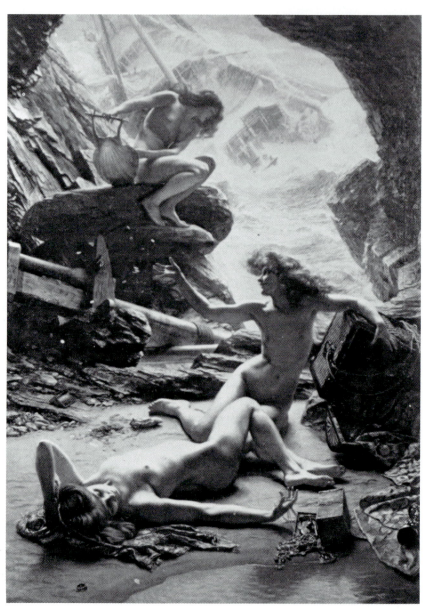

4-12. Edward John Poynter: *The Cave of the Storm Nymphs*, 1903; 57½ × 43½; photo: *RAP* 1903.

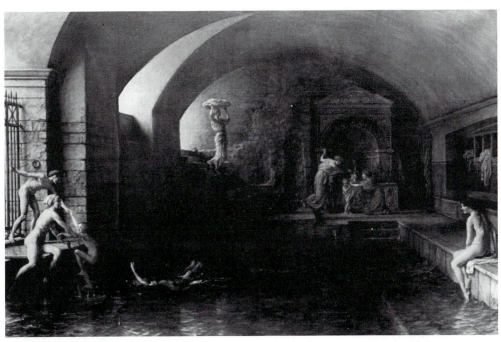

4-13. Edward John Poynter: *The Champion Swimmer*, 1914; 40 × 64; Wolverhampton Art Gallery.

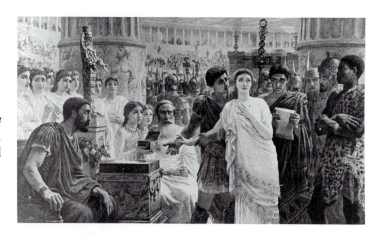

4-14. Edwin Long: *Diana or Christ?*, 1881; 48 × 84; Blackburn Museum and Art Gallery.

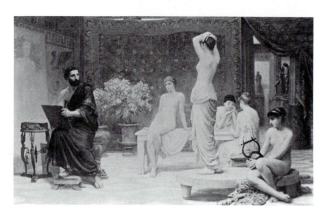

4-15. Edwin Long: *The Chosen Five*, 1885; 59 × 96; Russell-Cotes Art Gallery and Museum, Bournemouth.

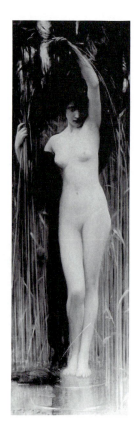

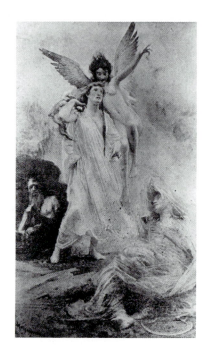

4-16. Arthur Hacker: *The Return of Persephone to the Earth*, 1889; 108 × 66; photo: *Pall Mall Pictures of 1889.*

4-17. Arthur Hacker: *Syrinx*, 1892; 76⅛ × 24³⁄₁₆; Manchester City Art Gallery.

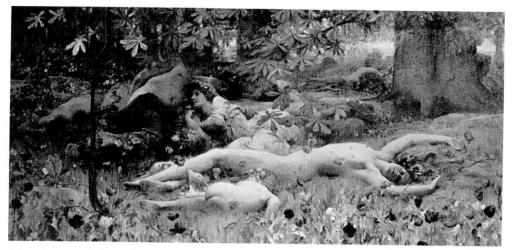

4-18. Arthur Hacker: *The Sleep of the Gods: "Evohe! ah! evohe! ah! Pan is dead"*, 1893; 45 × 94; photo: *RAP* 1893.

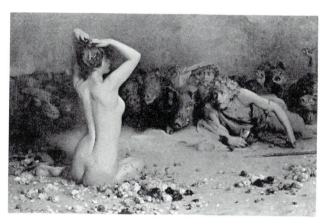

4-19. Arthur Hacker: *Circe*, 1893; 46 × 71; photo: *RAP* 1893.

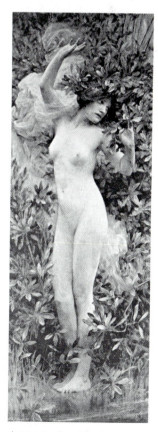

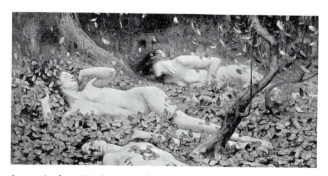

4-21. Arthur Hacker: *Leaf Drift*, 1903; 34 × 68; photo: *RAP* 1903.

4-20. Arthur Hacker: *Daphne*, 1895; 73 × 27; photo: *RAP* 1895.

259

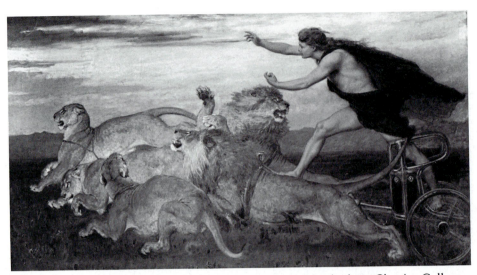

4-22. Briton Riviere: *Phoebus Apollo*, 1895; 53¼ × 96; Birmingham City Art Gallery.

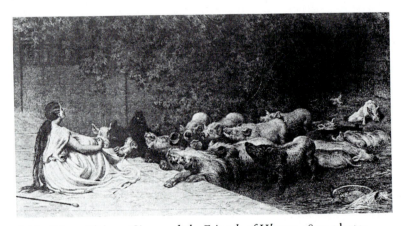

4-23. Briton Riviere: *Circe and the Friends of Ulysses*, 1871; photo: Armstrong "Riviere" 1891.

4-24. Briton Riviere: *Adonis's Farewell*, 1888; 26 × 33; photo: *Pall Mall Pictures of 1888.*

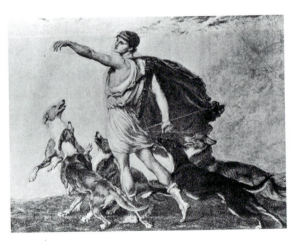

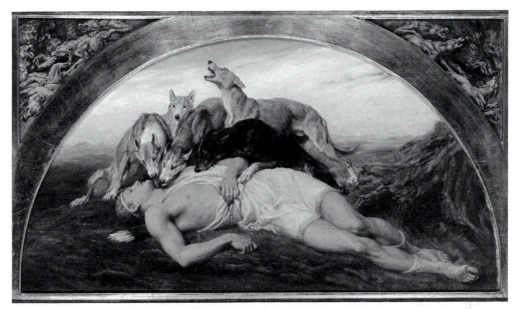

4-25. Briton Riviere: *Adonis Wounded*, 1887; 20 × 38; photo: Sotheby's Belgravia.

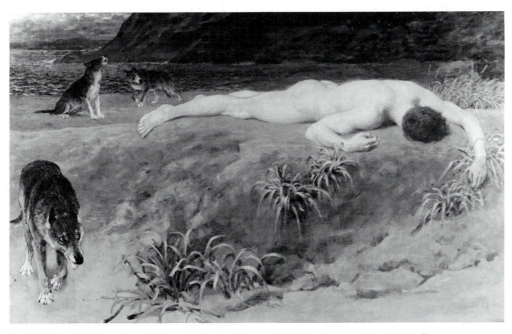

4-26. Briton Riviere: *Dead Hector*, 1892; 30¼ × 48¼; Manchester City Art Gallery.

261

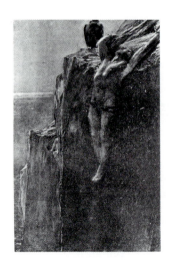

4-27. Briton Riviere: *Prometheus,*
1889; 35 × 23; photo: *Pall Mall*
Pictures of 1889.

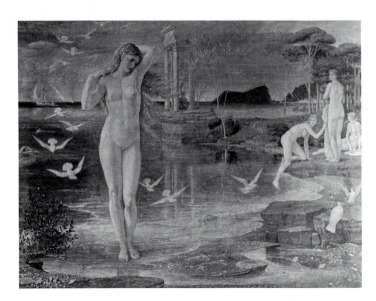

4-28. Walter Crane:
The Renaissance of
Venus, 1877;
54½ × 72½; Tate
Gallery, London.

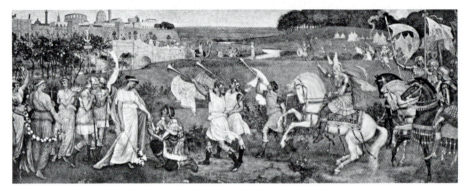

4-29. Walter Crane: *Amor Vincit Omnia,* 1875; photo: Crane, *Artist's Reminiscences*
1907.

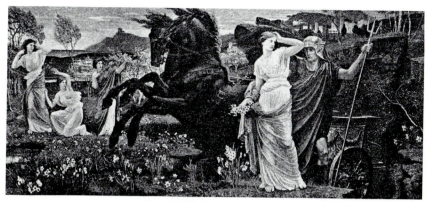

4-30. Walter Crane: *The Fate of Persephone*, 1878; photo: Von Schleinitz, *Walter Crane* 1902.

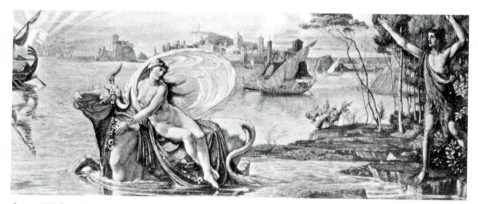

4-31. Walter Crane: *Europa*, 1881; 27 × 65; photo: Crane, *Artist's Reminiscences* 1907.

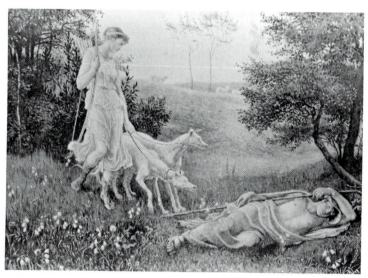

4-32. Walter Crane: *Diana and the Shepherd*, 1883; gouache on paper; 22 × 31; Dundee Art Galleries and Museums.

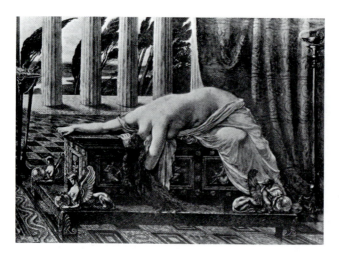

4-33. Walter Crane: *Pandora,*
1885; 21 × 30; watercolor;
photo: Crane, *Artist's
Reminiscences* 1907.

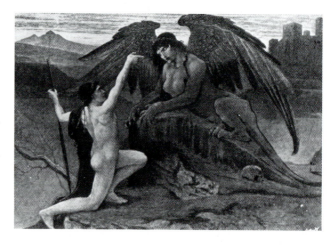

4-34. Walter Crane; *The Riddle
of the Sphinx,* 1887; gouache
sketch; photo: *Pearson's
Magazine* 1906.

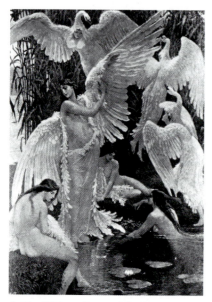

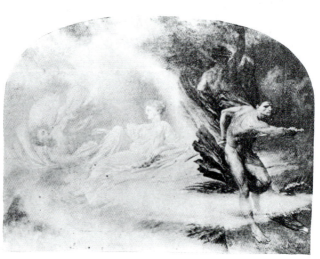

4-35. Walter Crane: *The Swan-
Women,* c. 1895; photo: *Pearson's
Magazine* 1906.

4-36. Frank Dicksee: *The Mountain of the Winds,* 1891;
photo: *Pall Mall Pictures of* 1891.

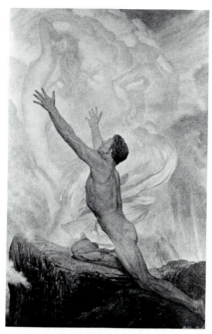

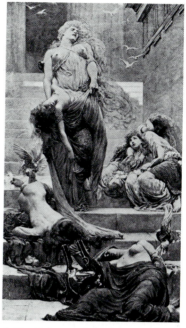

4-37. Frank Dicksee: *The Ideal*, 1905; 90 × 58; photo: *RAP* 1905.

4-39. Solomon Joseph Solomon: *Niobe*, 1888; 126 × 75; photo: *RAP* 1888.

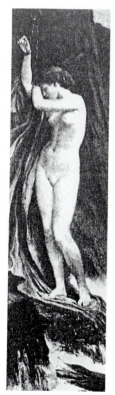

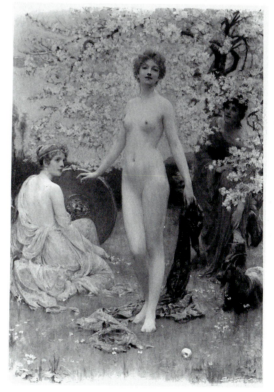

4-38. Frank Dicksee: *Andromeda*, 1890; photo: *Art Annual* 1905.

4-40. Solomon Joseph Solomon: *The Judgment of Paris*, 1891; 96 × 66; National Museums and Galleries on Merseyside (Walker Art Gallery, Liverpool).

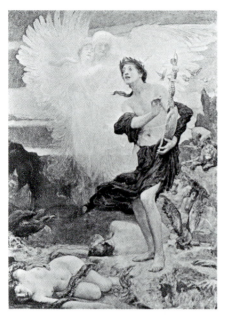

4-41. Solomon Joseph Solomon: *Orpheus*, 1892; 84 × 60; photo: *RAP* 1892.

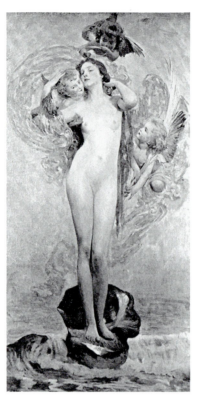

4-43. Solomon Joseph Solomon: *The Birth of Love*, 1896; 100 × 50; photo: *RAP* 1896.

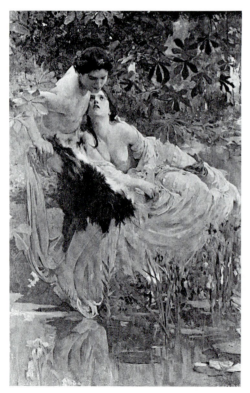

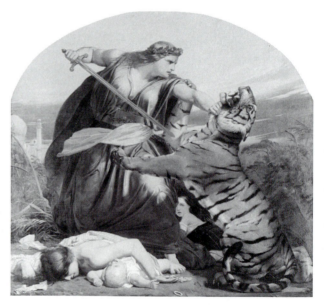

4-42. Solomon Joseph Solomon: *Echo and Narcissus*, 1895; 72 × 48; photo: *RAP* 1895.

4-44. Edward Armitage: *Retribution*, 1858; 114 × 105; City Art Gallery, Leeds.

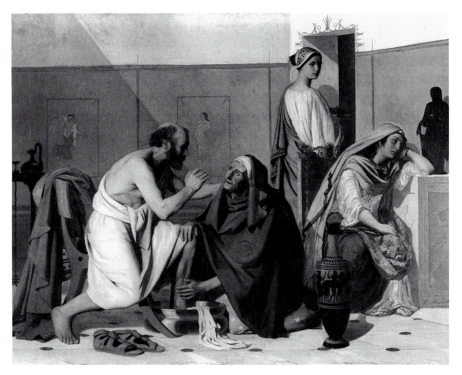

4-45. Edward Armitage: *The Return of Ulysses,* 1853; 44½ × 56; City Art Gallery, Leeds.

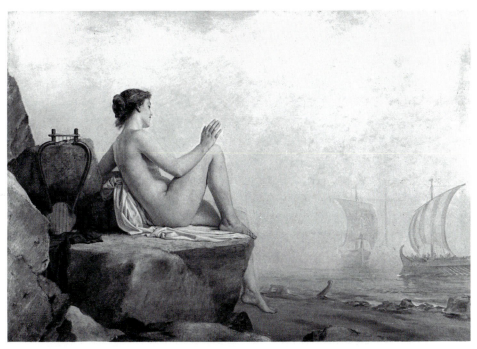

4-46. Edward Armitage: *A Siren,* 1888; 44½ × 63; City Art Gallery, Leeds.

267

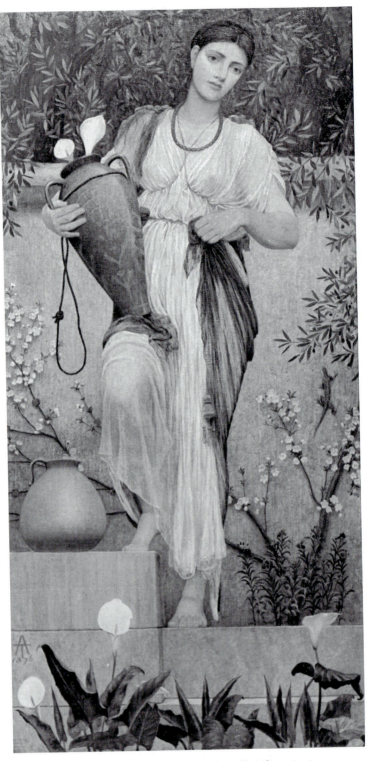

4-47. Thomas Armstrong: *Woman with Calla Lilies*, 1876;
76 × 36; Laing Art Gallery, Newcastle.

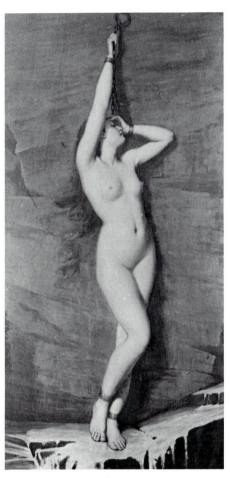

4-49. Arthur Hill: *Andromeda,* 1875;
35½ × 17½; Russell-Cotes Art Gallery
and Museum, Bournemouth.

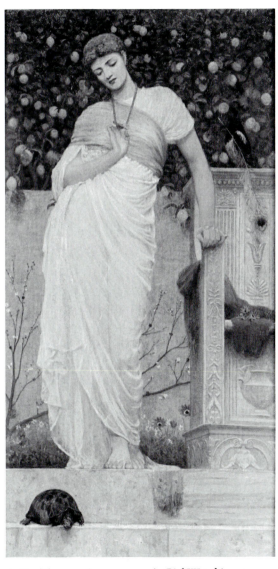

4-48. Thomas Armstrong: *A Girl Watching a
Tortoise,* 1874; 28 × 14½; photo: Sotheby's
Belgravia.

❧ FIVE ❦

Lawrence Alma-Tadema,
John William Waterhouse,
and the Flourishing of the
Classical-Subject Conception

AMONG the painters of the nineteenth century influenced by the archaeological discoveries occurring in Italy was Lawrence Alma-Tadema (1836–1912). By birth a Dutchman, Tadema began his training at the Antwerp Academy under Gustav Wappers and later moved to the studio of Hendryk Leys. Tadema first visited Great Britain in 1862, where he confronted the Elgin Marbles. He was to declare in an essay of 1893 that architecture "reached in a way its highest point in the Parthenon at Athens" ("Art in Its Relation" 10). In 1863 while on his honeymoon he visited Pompeii. Systematic excavations had only begun there in 1861, although the city had been discovered as early as 1748. Tadema recorded in his "Reminiscences": "My first visit to Italy was a revelation to me. It extended my archaeological learning to such a degree that my brain soon became hungry for it. I spent much of my time in Rome and other cities exploring ruined temples, ruined palaces, ruins of amphitheatres, and, in fact, every nook and corner reminiscent of a bygone age." He stated: "I know Pompeii by heart, and have devoted many hours to exploring it, especially during the years 1863 and 1884. In those days the pavements were uncovered, and not, as now, covered up with mud, owing to the misguided methods of preservation adopted by the Italian officials" (290).

Tadema has remained celebrated for the extraordinary quality of the backgrounds of his paintings, virtually an exercise in the art of still life. This archaeological accuracy is one of Tadema's most enduring traits from the Dutch

271

tradition of Vermeer, De Hooch, and other genre painters. Although this attention to detail is notable, it is not always noteworthy. Writing in 1902, Helen Zimmern cited a problem resulting from this technical ingenuity: "Alma-Tadema's pictures may at times seem to proclaim too loudly the equality of all visible things, and this equal attention to each object sometimes prevents the concentration of our attention upon the central point of interest" (*Lawrence Alma-Tadema* 30). "The accessories strike the observer first," she notes (26). To Zimmern this quality was paralleled by an additional characteristic: "About Alma-Tadema's art there is nothing false or strained; he is always healthy, there is in his nature no strain of morbidness. . . . There is never in his work the sickly introspection, the hyper-analysis of modern days. . . . His general inclination leads him to let us see his men and women merely as they present their outward faces. He cares not to look beyond, to apprehend the informing intention, the psychic force of his creations" (27–28).

Zimmern does not link her observations in the way that they must inevitably be joined. Tadema's predilection for archaeological accuracy was not only a result of his Dutch ancestry. It represented a fear of confronting human psychology, an elusion effected by relentless detail. The massive collection of photographs from which Tadema drew his inspiration for classical background (now housed in the University of Birmingham Library) shows the extent of this evasion. Zimmern hints at the truth when she notes that there are objections "that his men and women, but more especially his women, are not in accordance with usually recognized classical standards" (29). Tadema was interested in the beauty of his backgrounds, not the beauty of his figures. While "introspection and analytic research" (28) might have been remote from his character, there remain additional reasons for this evasive attitude. Of one of his pictures, she comments: "It would almost seem at times as though he had painted these accessories with even more care than he bestowed upon his men and women, as if they interested him more. . . . Flowers had impressed his imagination and gained precedence over the human beings with whom they were associated" (50–51).

Several classes of Tadema's pictures illuminate this evasive emphasis on beauty of inanimate objects and ordinariness of human figures. Tadema is especially known for several recurring themes in his pictures: the courting couple, frequently in disagreement; the studio picture; the processional and ritual painting; the bath interior; and the infrequent nude. These pictures, with their predominantly unlovely male and female figures, reveal an aversion to the human figure that becomes disturbing. By the time Tadema han-

dles the nude, he is able to handle the body with voluptuous care; the face is disparagingly ordinary.

I

Tadema frequently painted women in couples, usually in a state of idleness and torpor. *The Favourite Poet* (1888) depicts two women, one reading a papyrus while the other lounges, in a state not of attentiveness but of lassitude. The picture portrays one of the women as anti-intellectual and unreflective, typical character traits applied to women during the agitation for women's higher education. The picture is intriguing since medallions of the Muses are behind the women: the active Muse has become the passive listener. The subtextual message of this canvas is that women are not interested in learning beyond the level of literacy. In *Unconscious Rivals* (1893) two women in a cavernous basilica have realized that they are in competition for a man. The sculpture flanking them telegraphs the same message: the small Eros on the left and the feet of a masculine body on the right show them trapped by the masculine world. *Love's Jewelled Fetter* (1895) shows two women examining a wedding ring. It associates the idea of marriage with captivity, conveying an image of marriage relevant to the end of the century despite legal reforms and repudiated by many reformers. *Love's Votaries* (1891) shows two women in idleness beside a fountain on a terrace overlooking the sea. In this instance the pictorial detail conveys the subtextual message: a frieze of women lying in wild abandon after a revelry suggests dangerous female sexuality and the potential madness of women in Bacchic frenzy.

The Favourite Poet is one of an entire group of literary paintings that transmit the same idea of female lassitude and inattention. An early canvas, *Catullus at Lesbia's* of 1865, shows the Roman poet standing in his mistress' house, holding the dead sparrow in his left hand. In the painting of 1870 *At Lesbia's,* Catullus recites to Lesbia as she reclines listlessly on a couch. Behind her three men, undoubtedly and significantly of three different ages, pause on her threshold. At the extreme right of the painting is a small statuette of the Aphrodite Pudica (the Venus de Medici). In 1866 Tadema painted Lesbia sitting with the dead sparrow on her lap. These three Catullan pictures convey a sexual message relevant to the passage of the Contagious Diseases Acts of 1864, 1866, and 1869. The historical Lesbia—Clodia, the sister of Claudius Pulcher—was identified in Catullus' two sparrow poems with the goddess Venus/Aphrodite, in an explicitly sensual connotation. Any attentive

reader may surmise that the sparrow praised in poem 2 and mourned in poem 3 is the poet's penis. Lesbia delights in holding it in her bosom, giving it her finger to peck when Catullus' "desire" is "shining." He concludes that this sparrow is as much a solace as was the golden apple to Atalanta, which eventually released her virginity. In poem 3 Catullus mourns the death of the sparrow in a nearly mocking tone, suggesting amusement over his temporary impotence. Lesbia the mistress is very much the soiled woman of men's projections at the time of the Contagious Diseases Acts. In the latter poem Lesbia is called Catullus' "domina" or mistress, conveying the fear of female dominant sexuality. The canvas *Catullus at Lesbia's* reinforces this sexual subtext by the waterspout in the form of Silenus, the debauched follower of Dionysus.

Female lassitude appears in the 1885 *A Reading from Homer,* where the men sit listening ardently to a recitation while a female lounges against an exedra. In a depiction of a poetry reading from the seventh century B.C., the *Sappho and Alcaeus* of 1881 (Plate 5-1), Tadema depicts an entire group of women, the Thiasos, a sorority established by Sappho on Lesbos. Unlike the languid woman of *A Reading from Homer,* this community of women listens to the poet Alcaeus, recorded in Aristotle's *Rhetoric* as being the lover of the poetess. According to Johnston, "the head of Sappho conforms to ancient portraits such as the Villa Albani and Oxford busts" (*Nineteenth Century Paintings* 206). The herm, with its phallic connotations, separates Sappho and Alcaeus, suggesting his dominance of the sexual and aesthetic experience. When this painting was first exhibited, viewers thought the reciter was in fact Sappho; this androgyny reflects a fear that women were becoming masculine in accomplishment. The dominance of Alcaeus is enhanced because he plays the kithara sacred to Apollo. Thus, without being directly a portrayal of male sun worship, this canvas has an evident link to the solar paintings of Leighton.

To this group of pictures must be added Tadema's numerous studies of courtship, which show women in attitudes of passivity and expectation, often accompanied by an insidious coyness. In *The Proposal* of 1892, the lounging woman gazes at the viewer, while the androgynous suitor leans seated behind her. Tadema's *Pleading* (1876) was later reworked as *The Question* in 1877 and *The Solicitation* in 1878. The nature of the pleading is suggested by the woman's vaguely distressed reaction to the recumbent lover, whose moustache is an anachronism. The same anachronism appears in *A Difference of Opinion* of 1896, where it graces what might again otherwise be an androgynous suitor. The vapid woman, singularly un-Roman, is an ironic commentary on the title

of the picture, since having any opinion seems beyond her. In *Vain Courtship* (1900) a woman gazes away from her suitor. In both *A Difference of Opinion* and *Vain Courtship,* the suitor is clothed in yellow, a color associated with effeminacy in the Roman consciousness.

Eloquent Silence (1890) is more expressive than these other pictures; the man is glum, the woman displeased. In *The Promise of Spring* (1890) the sensuality of the woman is for once evinced. In *Amo Te, Ama Me* (1881) the pleading lover again is androgynous. *Xanthe and Phaon* (1883) and *A Declaration* (1883) convey this same idea. Only a moustache prevents the latter lover from being an androgynous depiction. The theme of the Waiting Woman is not better expressed than in *A Foregone Conclusion* (1885), as the suitor ascends the stair with the engagement ring to the expectant fiancée and her attendant. Tadema's great study of men and women courting is *A Silent Greeting* (1889) (Plate 5-2). A Roman soldier has quietly laid a bouquet of roses in his beloved's lap. *A Silent Greeting* contains an image that intersects with Victorian ideology about women. The woman's sexuality is asleep. She is associated with the rose that dies in a day, suggesting both the vagina and menstruation, an analogy established by Burns and poetic tradition. The male in armor is protected against any approaches from the woman as he stands over her.

This frightening sensuality is expressed, however, in Tadema's nudes, bathing scenes, or depictions of female rituals. The figure in *A Sculptor's Model* (1877) (Plate 5-3) is drawn after the Venus Esquiline, found in 1874 in Rome, a pose itself suggesting that of the diadumenos. The sculptor examines the exquisite woman posed above him as she grasps an upright palm, one of whose leaves leans directly into her pubis. Although painted as a gift for Tadema's pupil John Collier, the picture aroused a storm of protest. The bishop of Carlisle wrote: "My mind had been considerably exercised this season by the exhibition of Alma-Tadema's nude Venus. . . . [There might] be artistic reasons which justify such public exposure of the female form. . . . In the case of the nude of an old master much allowance has been made . . . for old masters it might be assumed knew no better . . . but for a living artist to exhibit a life-size, life-like, almost photographic representation of a beautiful naked woman strikes my inartistic mind as somewhat if not very mischievous" (Swanson, *Sir Lawrence Alma-Tadema* 22). The bishop objects to the painting's revelation of the Pygmalion myth in reverse: no statue could equal the beauty of the original model. By 1892 artists were tried for painting the nude in a posture the public considered obscene. As is his custom, Tadema's background

frieze, showing the male genitals of a horse, makes explicit the sexual overtone of the canvas.

Tadema's nudes are conspicuously associated with bathing or Bacchic revelry. The most famous of these images is *In the Tepidarium* (1881) (Plate 5-4). Lying on an animal skin, the woman in the "warm room" of a bath holds a strigel in her right hand as she conceals her pubic area with a feathered fan. Peter Webb observes that "the ostrich feather draws attention to the vulva it so carefully hides, and the cleaning instrument has strongly phallic connotations. Whether the artist was consciously aware of the levels of erotic attraction in his painting is open to question, but he must have known that its popularity owed little to a love of Ancient Rome" (*Erotic Arts* 191). The languor and sexuality are heightened by the gleam of the woman's perspiring skin. A later bath scene, *The Apodyterium* (1886), shows women in various stages of undress in the bath, arousing the male mind to contemplate the delights of the tepidarium the women would occupy. A canvas of 1890, *The Frigidarium*, shows a woman being dressed after her plunge into the cold waters. Behind is a voluptuous nude staring at the viewer as she emerges from the bath. Despite the noticeable sexuality of the bodies revealed, the faces are drab. Tadema's attitude could not extend to giving women distinction beyond their sexual function. Their faces remain unemotive, their minds distant and vacant.

A significant number of Tadema nudes are depictions of the rituals of Dionysus, a theme central to his work. In these canvases women's sexuality is associated with the fertility granted by the god and with the madness of the Dionysiac frenzy. In *After the Dance* (1875) Tadema depicts an exhausted Bacchic reveler lying asleep. *A Bacchante* of 1907 shows a figure dressed in a leopard skin, playing cymbals before a statue of the androgynous Dionysus, her eyes half closed in ecstasy, while a confederate plays a pipe behind her. A frieze of nymphs and satyrs behind the two figures conveys the unbridled nature of female sexuality. The face of the god is derived from the Bacchus Richelieu to lend authenticity to the depiction. Directly above the devotee's head one can decipher the words *dulce periculum,* "sweet danger," the very essence of the femme fatale. By such devices, Tadema communicates the insidious madness characteristic of the worshipers of the fertility god, linking female sexuality with insanity. His revelers in their animal skins are atavisms paralleling Eliza Linton's Wild Women in their tiger skins. In *A Dedication to Bacchus* of 1889, priestesses draped in tiger or leopard skins prepare a child for her entry to the Dionysiac dult. F. G. Stephens' monograph on the paint-

ing sold forty thousand copies. The result of such initiation is indicated in
The Women of Amphissa (Plate 5-5) of 1887. Amphissa was a city with a sig-
nificant Dionysiac cult. Tadema found the subject in Plutarch. The exhausted
devotees are awakening after a night of revelry. To protect them from the men
of the city, the local women surrounded them and nourished them, enabling
them to depart unharmed. Tadema leaves the question of the nature of their
nocturnal activity unanswered, but no classicist could remain in doubt about
these rites. Lombroso and Ferrero in fact could state: "Nymphomania trans-
forms the most timid girl into a shameless bacchante" (*Female Offender* 296).
The unbridled sexuality of bestial atavistic women was the message of such
pictorial ideograms.

The atavism described by Lombroso and Ferrero is particularly evident
in *Autumn: A Vintage Festival* of 1873 (Plate 5-6). Crowned with a chaplet
of ivy, and with half-closed drugged eyes, the dancing celebrant appears in
a wine cellar with the accoutrements symbolic of her wild, atavistic nature:
a flaming torch, a leopard skin, and a rhyton. To her left is a bronze statue
of Dionysus. In *"There He Is!"* (1875) (Plate 5-7), a woman decked in vine
leaves and holding a thyrsus leans out a window to spot either her lover or
possibly a statue of the god Dionysus himself. As in many other Tadema can-
vases, the frieze behind the figure conveys the sexual subtext. At the extreme
left, a hand grasps an object explicitly phallic to parallel the phallic nature
of the thyrsus in the Bacchante's hand. Tadema noted in his "Reminiscences"
that "you should paint not only men and women, but some part also of their
accessories or environments" (294), which frequently are keys to the interpre-
tation of his canvases.

The publication of Pater's essay "A Study of Dionysus" in 1876 marked
the beginning of a corrective to the austere view of the Greeks held by
Winckelmann, a writer Tadema quoted publicly in 1906 on receiving the gold
medal from the Royal Institute of British Architects. But the recurrence of
Bacchic subjects in Tadema's work also relates to a personal medical problem.
Vern Swanson speculates that surgery to remove "stony bodies"—urinary
stones—from the bladder may have left Tadema either sterile or impotent,
a situation which would increase his suspicion of female dominance. The per-
sonal history intersects with the social in the canvases of Bacchantes. In *The
Torch Dance* of 1881, a worshiper dances in Dionysiac abandon. In the rela-
tively early *The Vintage Festival* (1870) Tadema produces a favorite form of
Victorian painting, the processional, popularized by Leighton with *The
Daphnephoria*. Here a priestess leads a group of devotees of Bacchus. In a

canvas such as this one, Tadema indicates his awareness of current theories of social behavior, especially those concerning the ritual origin of Greek drama. Tadema's Diploma Picture (1883), *On the Way to the Temple,* shows a priestess before a Greek temple, while Bacchanalian revelers pass in procession behind her. Writing of Tadema in 1883, Ruskin condemned his preoccupation with Dionysiac themes. "It is the last corruption of this Roman state, and its Bacchanalian phrenzy, which M. Alma Tadema seems to hold it his heavenly mission to pourtray" (*Works* 33.322). There was, however, a personal reason for Tadema's selection of this material.

Tadema's first wife, Pauline, had suffered a nervous breakdown in 1865. This collapse was a prelude to the distressing condition of his second daughter, Anna, a talented painter who experienced periods of mental breakdown over a number of years. In January 1887 Tadema noted to George Ebers: "Poor Anna has been very weak the last year & is not yet herself again & consequently is not allowed to spend as much time at her art as she should like" ("Letters" Berlin). This situation can be traced in the letters of Anna's older sister, Laurence. In 1894 she noted of Anna: "She is, I am happy to say, much stronger than she was" ("Letters"). In August 1894, Tadema wrote Ebers that his wife and Anna could not attend a wedding. He mentions his wife's illness and says nothing of the daughter. By December, that condition had deteriorated: "My second daughter Anna is seriously unwell since some three or four weeks. Nerralgia [*sic*] & low system make her life a burden to herself." In September 1897, Laura Alma-Tadema, the artist's second wife, confided to Ebers that she and Anna take holidays in Scotland "since Anna has not been sent to German watering places" ("Letters"). They stayed with a couple in a remote part of the country, avoiding all society.

Anna's distress continued, however, as Tadema wrote George Henschel in August 1900: "My wife & Anna are still in Wells House Ilkley (Yorks) progress in recovery very scanty if I understand well what the wife writes to me." During 1901, the artist recorded the problems Anna was experiencing with her eyesight. The evasion that Tadema practiced in his painting appeared in this terse statement of August 1903 to Henschel: "Anna's still very nervous, bother the thing" (Birmingham). The strain was so great on Laurence that she confided to the Hauptmanns in 1903 that she "for a series of months lost the will to live." In 1904 Tadema wrote that Anna had been in a clinic "and still is not all what she should be. For a whole year is her paintbox staying closed. This afternoon she went to a privat [*sic*] Spital (clinic) of Doctor Harley and do we hope that in 14 days that precious girl will be sent back healthier" (Berlin).

It was Anna's older sister, however, who revealed the extent of her sister's illness: "The Doctor declared my sister for being very neurotic. She began a new treatment isolated, does not see us, gets no news! for 2–3 months it will be as she was dead to us. In such circumstances I do not have the heart to leave my Father. The world does not need my poetry as much as my presence." Laurence could confide to Grete Hauptmann, "My sister is still locked away." Anna returned home in June 1904, to be nursed by Laurence throughout the summer. Anna Alma-Tadema was never cured of her debilitating mental illness. Tadema's last painting reflects this living with madness. *Preparations: In the Coliseum* (1912) shows an attendant in leopard skin standing by a refreshment stand within the structure. Zimmern could write in 1902 that Tadema's "life since his removal to England has been uneventful" (*Lawrence Alma-Tadema* 16). Like many others, critics accepted the manifest situation, not querying the latent significance of these Dionysiac canvases. Zimmern believed that "it is the outward seeming of life and objects that attracts him, their inner deeper meaning matters to him as little as their subject" (41), an opinion which has remained constant about Tadema's artistry. The opposite is the case. Tadema himself had suffered "a physical and mental breakdown" (Swanson, *Sir Lawrence Alma-Tadema* 9) in 1850 when his artistic career was thwarted by his family.

II

It was to counteract this madness in his second daughter that Tadema portrayed women's conventional role of passive lover or satisfied mother. Women in such paintings as *A Coign of Vantage* (1895) or *Expectations* (1885) are shown watching men return, images of Ariadne and Penelope waiting for male support. In *Aphrodite's Cradle* (1908), a group of women stares over the sea, presumably for lovers. These figures in a painting with such a title emphasize the idea of women's expectant, dependent sexuality. The obverse of this idea of waiting is the woman bidding farewell to men going into the world, as in *God-Speed*. A painting like *The Shrine of Venus* (1889) shows women as indolent, narcissistic, self-absorbed. Tadema's belief in women's weak intellect is strongly enforced. Canvases such as *The Parting Kiss* (1882) and *An Earthly Paradise* (1891) depict maternal solicitude. These are homages to his second wife, Laura, for her attention to her stepdaughter. In the former, Laura in fact gazes at the viewer beneath her parasol, while the daughter being kissed bears resemblance to Anna. Women occur in roles reinforcing Victorian stereotypes. Paintings such as *The Convalescent* (1869) and *The Nurse*

(1872) portray women as invalided, a favorite Victorian stereotype. This situation is not surprising considering Laura's constant illnesses and the mental breakdowns of Anna. Laura had been periodically ill since the early 1870s and was to suffer severely from skin disease during the 1890s. She suffered from diabetes during the last five years of her life, until 1909. Tadema depicts women in both threatening and compliant guises in the same canvas. In *A Picture Gallery* of 1874, a woman studies a painting. Behind her is Timomachus' Medea, purchased at one time by Julius Caesar. In *A Roman Art Lover* of 1870, Tadema shows a group of men and women studying a statue, in this case a bronze figure of an Amazon runner. To the left of the canvas is the Venus de Medici, suggestively concealing her pudendum. In *The Picture Gallery* (1867), the woman observing the painting lies upon a sofa, seemingly bored, much in the manner of the listless bourgeois Victorian housewife who had no occupation.

In *The Sculpture Gallery* of 1875 the two kinds of women are juxtaposed, the deferential women accompanying the men to view the sculpture, and those depicted in the works of art themselves. The object being viewed is a basalt mermaid Caryatid, while the reclining female on the right was thought in the nineteenth century to be a sculpture of Nero's mother, Agrippina. The sculptured male figures, in contrast, represent the bust of Pericles from the Vatican and an infant Heracles strangling serpents. The sculpted females are dangerous, the men heroic. An additional signification may rest in the many hanging lamps in the background, patterned after those found at Pompeii. Any aware observer would know that many of these were shaped like winged phalluses. This same elevation of the male appears in *A Sculpture Gallery in Rome at the Time of Augustus* (1867) (Plate 5-8). In this painting, the statue being admired is a representation of the Greek tragic dramatist Sophocles, while the tormented Laocoön is seen in the background, suffering for daring to question the gift of the Trojan horse. On the right appears the statue thought in Tadema's time to be of Agrippina. To her right is the completely contrasting female type, a representation of the prototypical waiting woman, Penelope. The two men, therefore, are visionaries; the women either the self-sacrificing wife or the whorish empress.

Tadema's painting derived from Bulwer-Lytton's *The Last Days of Pompeii, Glaucus and Nydia* of 1867, shows the blind flower girl at the feet of Glaucus after a disagreement. This motif was popular with Tadema, as *On the Steps to the Capitol* (1874) indicates. As ambiguous picture, of a construction similar to *Glaucus and Nydia*, is *Between Hope and Fear* of 1876.

In this canvas a young woman offers a bouquet to an older man; the meaning is by no means clear. Is she offering herself? Critics of the time such as Standing chose to think of this as daughter and father. The *Art Journal* in 1877 noted that the painting was "equivocal in its meaning to the ordinary viewer" (*Lawrence Alma-Tadema* 1913, 16). Tadema's background once again alters one's interpretation, as the mural in the canvas presents women in a funeral procession. The idea of woman as death bearer indicates Victorian anxiety about the dangers of childbirth and possibly the bleeding of menstruation.

Only in a work such as *Phidias and the Parthenon* (1868) does Tadema favorably show a woman, Aspasia, in a position of power and authority. In the same painting, Alcibiades is shown on the left in a definitely androgynous depiction. In *Caracalla and Geta* (1907) (Plate 5-9), Septimius Severus' second wife, Julia Domna, passes notes to an attendant. In contrast to Aspasia, the virtuous mistress of Pericles, Julia is shown sabotaging the state by her sexuality. The history of the Severan emperors was notorious, and Tadema attributes this to the influence of Julia Domna. Upon the death of Severus in 211, Caracalla and Geta should have ruled jointly. However, Caracalla had Geta murdered in 212 and ruled by himself until 217, when he too was murdered. Historians believe he governed following the policies of his mother. Tadema pursued this history of the Severi with *The Roses of Heliogabalus* (1888), depicting the young emperor smothering his guests in a shower of roses. So great were his excesses that he was murdered in 222 along with his mother. At the time of vehement suffrage agitation Tadema in a painting of Julia Domna is making a political statement about the danger of having women in government. Even in a painting seemingly decorative, such as *The Oleander* of 1882 (Plate 5-10), depicting a woman smelling the flower, the danger of women is telegraphed, since the oleander is poisonous.

The appraisal of Tadema as a painter of "classical genre" is valid. In 1883 a critic in *Blackwood's* declared that Tadema recreated history as if "photographers had set up cameras in the Forum. Alma Tadema has fashioned a style in keeping with the realistic taste and tendency of our times" ("Contemporary Art" 402). This classicism contrasted with that of Watts, as the critic observes. Tadema stated in 1901 that to Louis de Taye, professor of archaeology at the Antwerp Academy, he owed "a great deal of the archaeological detail which occurs in my pictures" ("Laurens Alma-Tadema" 204). His manipulation of this detail for subtextual purposes has never been properly acknowledged. It goes beyond historical recreation to symbolic creation. Tadema's pictures did focus on Greeks and Romans as if they were of the upper bourgeoisie.

This focus, however, has a strong element of opposition to feminism. A statement such as that of Burton Fredericksen, that Tadema's pictures are "basically uncomplicated" (*Alma-Tadema's "Spring"* 25) and composed of "trite emotions," must be challenged when his subjects are considered against the background of Victorian feminism. Reviewing the Academy exhibition of 1878, a critic in The *Magazine of Art* cited a female face by Tadema as "an extreme example of the coarse type so prevalent in this artist's pictures" (45). Tadema's use of his wife and his daughters as models was damaging: precision of setting was classical beauty not matched by a corresponding quality in his figures. This is, however, not a product of his Dutch background alone. With the nervous breakdown of his first wife, the recurring illnesses of his second, and the mental collapse of his daughter, it was difficult for Tadema to see classical repose and stability in women.

This period saw the publication of works such as John Thorburn's *Female Education from a Physiological Point of View,* which questioned women's ability to learn because of menstrual problems. The discovery of the diplococcus of gonorrhea in 1879 coupled with the discussion about the Contagious Diseases Acts could not but suggest the fearful side of female sexuality. The critic of the *Art Journal* during the Tadema exhibition in 1883 noted that "in flesh he falls a little below the average of those who have the smallest title to the name of master" (66). Dircks remarks that Tadema is "not a symbolic painter; he has not considered . . . either the mythology of Greece or Rome other than as a Pagan ornament to the life *intime.* . . . In his rejection of the idealisation of human types, we are brought face to face perhaps with a racial characteristic. The painters of the Low Countries have rarely, if ever, been idealists in their interpretation of men and women" ("Later Works" 16). Such was the extent of Tadema's inhibitions that even when he painted portraits, he was more successful with male subjects. One critic notes that a scientist declared "some of his women's arms were positively simian in their length" (Zimmern, "Lawrence Alma-Tadema" 24). Herbert Spencer had suggested in *The Study of Sociology* in 1873 that women's evolution had been arrested at an earlier stage than men's, and other thinkers were not averse to suggesting that this stage was in fact simian. As an agnostic, Tadema found a comforting relativism in opposing ancient religion to Christianity. Wilfrid Meynell declared that Tadema embraced "the doctrine of art for art's sake" by "banishing . . . the emotions from his art" ("Laurens Alma-Tadema" 193, 196). Tadema, however, was more ingenious than that. Pretending to avoid mythological narrative

subjects, he yet used mythical allusion to enforce his subtextual message of female inferiority and madness.

Tadema's praise of Greco-Roman civilization epitomizes a Victorian attitude. Of Greece he declared in his "Address on Sculpture" that "the greatest of all the periods of Art was the Greek period" (50). He recorded in 1907 of antiquity that "its reign has never really ended, for the influence of the Roman civilization lives still, and we are benefited by it more than we are aware of, and the dream of the great rulers has ever since been the reconstruction of the Roman Empire" ("Marbles" 169). Tadema's pride in Victorian imperialism was considerable, and the same masculine imperialism appealed to him in all relations of life. If, as Zimmern contends, "Tadema is always more Roman than Greek" ("Lawrence Alma-Tadema" 2), one explanation is this Roman conception of the *paterfamilias* and patriarchal authority. In a single year—1881—Tadema completed and exhibited *Pandora, In the Tepidarium, A Priestess of Apollo, Amo Te, Ama Me,* and *Sappho and Alcaeus,* all of which convey images of female sensuality. These icons supported the prevailing attitude of patriarchal dominance.

In 1886 Zimmern justly criticized Tadema's figures: "They were too frequently devoid of spiritual life. It was not that we wished to seek Greeks with the morbid self-consciousness of our modern times written on their faces, or Romans with the introspection and self-doubting of this nineteenth century. But these men and women must have had some manner of soul, and very rarely does Tadema show it to us" ("Lawrence Alma-Tadema" 5). Tadema, however, did not avoid dimensions of that soul, especially those involving male and female relations. The precision of his pictorial style should not obscure either the range or the force of his images. In his art classicism served reactionary ends, a result of both his own experience and that of his era. Tadema believed that "art must elevate, not teach," as he told Helen Zimmern in 1886 (28). Tadema did, nevertheless, educate rather than elevate. Although Tadema admitted to Comyns Carr that he was "form-blind" (*Coasting Bohemia* 35), these forms could still be, and were, significant.

Alma-Tadema's reputation declined rapidly after his death. Roger Fry's notice in the *Nation,* "The Case of the Late Sir Lawrence Alma-Tadema," on the occasion of the Tadema exhibition at the Royal Academy in 1913, marks the beginning of a severe and unfavorable reaction to Tadema. Fry accused Tadema of "an extreme of mental and imaginative laziness," of giving his canvas mere "shop-finish" (666, 667). As a proponent of the French school and

champion of Cézanne, Fry found little to admire in Tadema. Yet in portraying women, Tadema did reveal his conception of women's "soul." Tadema's popularity not only among the lower middle classes but with many of their superiors testifies to the persuasive quality of his icons for the time of their creation.

<div align="center">III</div>

An unusual instance of the variability of the classical tradition exists in the work of the best-known husband-and-wife painters of the era, Henrietta Rae (1859–1928) and her husband, Ernest Normand (1857–1923). At the beginning of Arthur Fish's 1905 life of Henrietta Rae is an unusual introductory chapter concerning the situation of women at the Royal Academy during the later Victorian period. Fish noted that "the life of a woman artist is in the natural order of things a circumscribed one." The situation of Henrietta Rae, the outstanding female classical-subject painter of the era, illuminates the entire situation of women artists at the time. Fish declared that even in 1905 "the position of women in art has only quite recently been definitely assigned, and . . . even now in England official honours as artists are denied them because they are women. . . . Many other anomalies in the art-training of women have now been removed . . . [but] full recognition of women artists by the Royal Academy is still withheld." Fish noted that Henrietta Rae had persevered "by a strong, determined fight against the disabilities and discouragements that hinder a woman in the battle of life" (10–13). The Normands lived near Leighton, and throughout her career Henrietta Rae submitted her works to Leighton's judgment. The *Art Journal* noted in 1901 that her art "is associated paramountly with pictures on classical themes" (304). She began by studying the Elgin Marbles and was the first woman admitted to study at Heatherley's School of Art. After her admission to the Academy schools, the teacher of greatest influence was Alma-Tadema.

Henrietta Rae's subjects were selected from a wide range of classical material: *A Bacchante* (1885), *Eurydice Sinking Back to Hades* (1887), *Zephyrus Wooing Flora* (1888), *Psyche before the Throne of Venus* (1894), *Apollo and Daphne* (1895), *Diana and Callisto* (1899), and *The Sirens* (1903). These materials in general portray women as prone to madness, faithless, or victimized. Like many other artists of her time, Rae portrayed women either in dependent postures (which may reflect her situation at the Academy and at the hands of Leighton) or as outcasts (not an unusual situation for a female of

the time). In *A Bacchante* of 1885 (Plate 5-11), the year of *Maiden Tribute* and the year in which Moore's *White Hydrangeas* was vandalized, Rae poses a model with thyrsus grasping a grape cluster, a devotee of Dionysus. Crowned with leaves, the Bacchante stands on a leopard skin in a woodland. Since this canvas was painted after her marriage in 1884, one wonders if it represents the awakened sensuality of her life or her possible fear of it. Exhibited in the same year was *Ariadne Deserted by Theseus*, evoking the image of the abandoned woman. Just as W. T. Stead chose to ignore Ariadne's strong role, Rae focuses on the abandoned victim rather than on the defiant rebel. For painting the nude, Henrietta Rae encountered some of the same opposition confronted by Poynter with *Diadumenè* and Moore with *White Hydrangeas*.

In 1887 Rae exhibited her treatment of the Eurydice theme, *Eurydice Sinking Back to Hades* (Plate 5-12). While the facial expression of Eurydice as she sees Orpheus receding from her seems static, Fish found it "passionately fixed on Orpheus" (44). Rae's innovation is to give Eurydice the major part of the canvas, unlike Leighton in his treatment in 1864. In 1889 Rae exhibited *Cephalus and Procris*, showing the woman wounded by her husband with a spear given him by Artemis. In this painting, as in several other of her canvases, Rae notes some hostility between women. In the 1910 *Hylas and the Water-Nymphs*, the alluring, narcissistic woman of *A Naiad* (1897) has metamorphosed into a dangerous band of women luring an intrigued Hylas into a stream covered with water lilies. In 1894 this idea appears in her large canvas *Psyche before the Throne of Venus* (Plate 5-13), with the subdued Psyche fallen before the aloof enthroned goddess. Christopher Wood cites this as an example of "High Victorian kitsch at its best and quite harmless" (*Olympian Dreamers* 246), but the picture cannot be quite so easily dismissed. Fish notes that "Venus and Psyche were so undoubtedly feminine in character and disposition, the one in her queenly beauty and spiteful pleasantries and the other in her abject love and woe of heartbreak, that their portraiture as women seems a positive necessity for their proper representations" (83). Fish was responding to a criticism by M. H. Spielmann in The *Magazine of Art* that the figures were not Olympian. Fish's defense is that they are genuinely "womanly," revealing that he regards the painting as signifying women's nature. That Rae herself believed this is confirmed by two subsequent canvases, *Venus Enthroned* (1902) and *Roses of Youth* (1907). Both are single-figure works that are almost copies of the figure of Venus in *Psyche before the Throne of Venus*. The 1902 canvas presents the satiated, bored goddess sitting on the throne flanked by Sphinxes, as in the 1894 canvas; the 1907 canvas, a generalized nude, sits on

the identical throne. Rae indicates that, whether a woman be a goddess or a mortal, female nature is beastly and imperious, or beastly because imperious, unnatural because superior.

In *Pandora* (Plate 5-14) of the same year, Rae shows the cunning first woman opening the fatal box. Her stare from her dark-circled eyes suggests the ambiguity of Pandora's nature in Hesiod. This painting was exhibited at the New Gallery while the *Psyche* was at the Academy, so that Rae was presenting conflicting images of women simultaneously, although in each instance the inference is unfavorable. The *Apollo and Daphne* of 1895 (Plate 5-15) shows the woman prior to her metamorphosis into the tree/phallus, but the painting of the figures is unsuccessful. The canvas is striking, however, for Rae's defiance of convention in showing the god actually on his knees pleading with Daphne, who spurns him. In the masculine tradition Apollo was always energetically pursuing a powerless Daphne. Rae repudiates female helplessness by showing Apollo in a suppliant posture, recasting the myth to advocate an assertive role for women in the culture. The seduced nymph of *Diana and Callisto* in 1899 reiterates the message of the *Pandora*. On its exhibition, there was opposition to the nudity of the canvas. Rae's conflict between flouting convention and capitulating to it could not be better illustrated than in the nudity of a canvas depicting female horizontal hostility, initially caused by the machination of Zeus. She received one letter which stated that "from an *ethical* point of view it is also doubtless dangerous to many [in its] appeal to passions that are already of volcanic force in their nature" (Fish 102). The writer objected to women's sitting for such studies, a "trespass upon feminine modesty."

Rae's studies in the early twentieth century concentrate on women in deceptive guises. In *The Sirens* of 1903 (Plate 5-16), three nudes lure sailors. An even stranger painting of the same year is the notorious *Loot* (Plate 5-17), which shows a naked woman standing on a tiger skin, amid other possessions in a ruined palace. The idea of women as sexual prizes is conveyed starkly. By the look of the figure, Rae is undoubtedly criticizing the situation of women who lack any control of their destinies. The captive is the ultimate restricted female. *Echo* of 1906 shows the quintessential image of the woman as shadow of the male.

It is important to realize, however, that even if Henrietta Rae's mythological subjects reflected prevailing masculine conceptions of women's nature, she nevertheless celebrated the naked female body, refusing to capitulate to the censorious attitudes of "the British Matron" regarding portrayals of the

nude. Fish notes that her "love of flesh painting . . . influenced her as much as the classic legends in her choice of subject" (36). The extent of her defiance of public censure is reflected in an anecdote Fish recounts about Henrietta Rae's canvases: "As paintings of the nude, of course, they attracted a certain amount of adverse criticism from that irresponsible section of the public which sees in this class of subject nothing but impropriety or indecency. One of these self-constituted guardians of artists' and the public's morals wrote to Mrs. Normand as a new exhibitor; implored her 'to pause upon the brink' and not pervert her artistic gifts by painting such works. When the letter reached her she was rejoicing in the presence of her infant son, who had been born shortly after the opening of the exhibition. The letter was shown to the doctor who was in attendance, and he made the suggestion that the artist should reply to the letter and state that she had recently given birth to a son 'who came into the world entirely naked,' which fact seemed to suggest to her that there was no impropriety in representing the human form as it was created" (36–37). Rae's reputation grew "as one of the most refined and skilful painters of the nude then exhibiting in England," with the result that "the absurd argument of the purists that such works were degrading and sensual in their conception and influence was confuted and set at naught by these canvases painted by a woman, for such considerations were, under these conditions, futile" (46). Even if other women objected, Rae persevered in depicting female beauty, evoking its classical dignity in defiance of a condemnatory segment of the public.

Rae's classical subjects were painted amid an array of other images of women in distressed situations, such as *Launcelot and Elaine* (1884), *Ophelia* (1890), *Mariana* (1892), and *Abelard and Heloise* (1908). Ernest Normand frequently painted the same icons. In 1886 he exhibited a *Pygmalion and Galatea*, reflecting the female artist's dependent position. In this representation, the King is contemplating the statue being endowed with life, a figure inspired by the Venus de Milo. Archaeological detail, more related to Pompeii than to Cyprus, appears in the objects behind the two figures. Normand explored the legend of Pandora in a triptych of 1899, with three sections, *Evil Sought, Pandora,* and *Evil Wrought.* In the first, Pandora's hair winds like a snake across her body, as she touches the fatal urn set on a Pompeiian tripod; in the second she crouches and tries to prevent the vapor from the urn from circulating. In the final panel, Pandora stands in distress near the urn, her hair covering her pubis. The figure is calculated and insincere, but the intimation that women have caused the anguish of the world is unmistakable. In Normand's

canvas women's sexuality is indicted. The *Art Journal* in 1886 noted of Normand's artistry "that sure, if gradual, progression has been made, not only in technique, but particularly in the direction of simplicity" (141). His depictions, however, reinforce the image of women as playthings, captives, and chattel. No other male artist so frequently depicted women in captivity.

Normand's use of Middle Eastern themes derives from Leighton, Long, and other predecessors. Henrietta Rae concentrated on classical subjects, trying to mute the explicitness that caused her work to be denounced during her career. Rae's oeuvre reveals that it was nearly impossible for a woman classical-subject painter to have a different range of material from that of her male counterparts. She reinforced the stereotypes of her time. Women in her pictures are dangerous and endangering or helpless and abject. The male dominance of the art world, of its schools, galleries, and reviews, allowed no greater independence. Rae's situation correlated with political, legal, and educational practices of the later Victorian period which, despite nascent reforms, constricted women by such preconceptions.

The canvases of Rae and Normand are transitional between the late Victorian and Edwardian periods. An artist with insistent mythological themes who encompasses the same period chronologically is Herbert James Draper (1864–1920). Draper emphasizes a range of female mythological subjects, nearly all of them conveying negative images of women. Draper began to study at the Academy in 1884. The late 1880s were a turbulent period, the period of Stead's essay, Elizabeth Blackwell's defense of women's sexuality, the prosecution of Henry Viztelly in 1888 for publishing Emile Zola's *La Terre,* and the circulation of birth control information in *The Wife's Handbook* of 1889. The activities of the next decade, such as the army report on venereal disease in India of 1895 and the 1898 Vagrancy Act, contributed to the formation of a sexual attitude reflected in Draper's painting. Female seductive and destructive behavior informs the work of this artist.

Draper's pictures of the 1890s reveal a disturbed variation in the depiction of sexuality. *The Sea-Maiden* of 1894 (Plate 5-18) depicts a group of mariners having caught a woman in their nets. The painting drew on Swinburne's *Chastelard,* act 3. This reference is significant and was cited in the third volume of the *Studio.* The lines refer to the capture of the maiden: "*A song of dragnets hauled across thwart seas / And plucked up with rent sides, and caught therein / A strange haired woman with sad singing lips.*" The actual meaning of the canvas appears six lines later, quoted in the *Studio:* The men "having lain with her, / Died soon." The reference can be to nothing else than

venereal infection. The men are described as falling in love with her because of her "little Ahs! of pain / And soft cries sobbing sideways from her mouth." The sadism and masochism of this picture make it an index of nineteenth-century sexuality. Draper's mariners reflect surprise and infatuation at having secured the woman, little knowing the disastrous outcome. Draper has taken the image of Burne-Jones's *Depths of the Sea* (1886) and placed it via Swinburne's poem in an even more insidious context. In this canvas, Draper has given the mermaid/Siren archetype a contemporary relevance.

In the later 1890s Draper turned to classical themes of increasing harshness toward women. In *The Youth of Ulysses* in 1895 (Plate 5-19), Draper poses the young boy on a leopard skin, concealing but not ignoring his genitals. The pose and the dark tone of the skin resemble that of the Sicilian youths who posed for Wilhelm von Gloeden during the period, whose photographs of youths appear in early numbers of the *Studio*. Behind him stands a goddess, presumably the malelike Athene, holding a spear. Draper chooses the Latin name Ulysses rather than the Greek name Odysseus ("the Hater"). The large scale of the goddess suggests the threatening role of women in Homer's text; Odysseus' life becomes for Draper a paradigm of men's surviving the dangers of female predatory sexuality, as embodied in such figures as Circe, Calypso, or the Sirens. Draper was to return to this theme in *Ulysses and the Sirens* (1909) (Plate 5-20), which shows the mature mariner lashed to the post as three females, similar to Waterhouse's *jeunes filles fatales,* board the ship. Draper believes that only men with the survival skills of Homer's hero withstand the lure of predatory female sexuality. The oar piercing the oarlock of the gunwale imitates the sexual penetration of the sea nymphs. The crew, with ears covered, glance either at Ulysses or at the Sirens, one of whom is a mermaid and therefore an atavistic, bestial female. These women are particularly insidious because of their youth and because they do not remain on an island but prowl the sea. These Sirens are no longer the bird-women conceived by Flaxman. Homer had left their appearance undefined in the *Odyssey*. As Linda Nead observes, in the nineteenth century "The siren was a paradigm of prostitution" ("Woman as Temptress" 7). In the 1860s "the syren of the streets" had been cited as the paradigm of the fallen woman. Tied to the mast, Odysseus symbolically protects his phallic/erectile power from the depredations of the women. Such a canvas expresses the destructive nature of female behavior. Some nineteenth-century mythographers believed that the Sirens destroyed men to avenge the abandonment of Ariadne by Theseus. The icon thus amalgamates sensuality and vindictiveness.

In *The Vintage Morn* (1896) Draper shows the "fabled return to earth of the Bacchanal nymphs on the morning of the vintage day" (Baldry, "Mr. Herbert J. Draper" 54). Such abandon also characterizes his two pictures of 1897, *The Foam-Sprite* and *Calypso's Isle.* In the former a *jeune fille fatale* with hair flying in the wind rides a dolphin. Little is left in doubt about the dangerous female sexuality implied. The work evoked the birth of Aphrodite from the severed erection of Uranos. *Calypso's Isle* (Plate 5-21), showing a nude staring over the ocean for the next shipload to ensnare, presents the female from the rear, generalizing her. Seated on a red drape connoting her sexuality and her treachery, she holds a mirror in narcissistic destructiveness.

As in *Ulysses and the Sirens,* only men with the resources of Odysseus can survive encounters with sexually powerful females. The 1897 canvases constitute a fearsome ideogram of insidious femininity. In *The Lament for Icarus* of 1898 (Plate 5-22), the fallen man (in appearance more like a boy) is cradled by nymphs. Icarus' tanned body contrasts both in color and size with the enormous wings embracing the canvas. In the foreground a wreath with a red ribbon floats, symbolizing his fallen aspiration. Although Icarus did not fall from a Siren's song, one nymph holds a lyre, suggesting female complicity, unwarranted by the legend itself. In this instance Draper manipulates the image for his own gynophobic purposes. In his sketches for Icarus, the youth appears castrated. In Draper's *Icarus* the male is destroyed and desexualized.

Draper's work in the twentieth century veered toward allegorical presentations of mythological or classical figures. In 1902, Draper depicted *A Deep Sea Idyll* (Plate 5-23), showing a water nymph holding pearls before the prow of a ship, the *Pygmalion.* The figurehead is that of a man frozen with arms locked behind him. This image shows the dangerous element of the Pygmalion story, in which the woman may be destructive rather than loving. Around the sea maiden are a lyre, pearls, and broken wood, evidence of her piratical and destructive tendencies. *The Golden Fleece* (1904) (Plate 5-24) is one of Draper's most harrowing uses of myth, depicting Medea about to cast her brother Absyrtus into the ocean to delay pursuit by her father. An Apollonian light-bearer, Jason flaunts the Golden Fleece behind her. Unlike artists who ignored the role of Ariadne in assisting Theseus, Draper portrays the woman aiding the lover who will abandon her. The boy grasps her gown, his left hand hovering over her naked breast to suggest her antimaternal tendencies. The faces of the crew are jaded from contact with the sorceress. Draper is not evoking Euripides' Medea, the distraught mother. Instead he regards the murder of Absyrtus as a prelude to the infanticide of the drama. *The*

Golden Fleece demonstrates the violence of female passion. In contrast, since he consulted the Delphic oracle before leading the voyage of the Argonauts, Jason remains the Apollonian hero.

The following year, Draper exhibited *Ariadne Deserted by Theseus* (Plate 5-25), the abandoned woman standing naked with arm stretched to the ocean. There is no suggestion that Dionysus is approaching her; she is entirely outcast. Draper has her posed like the Victory of Samothrace, only with a naked torso, using the pose of triumph to express Ariadne's desertion. Ariadne is rarely depicted in so desolate a circumstance as a rock in a cove. In the 1900 *The Gates of Dawn* (Plate 5-26), Draper depicts a large woman standing at the portals of the universe, in control of the environment, much in contrast to the *Ariadne*. This picture represents the goddess Eos or Aurora, who in mythology abducted young men for her enjoyment; she later was associated with Tithonus, for whom she obtained immortality but not eternal youth. She incarcerated him when he became aged, thus reversing the fate of the imprisoned Danaë. As O'Flaherty notes, this "death of the aging mortal lover" gives the woman supreme power (*Women, Androgynes* 199). As Ariadne is the helpless victim, Eos is the triumphant ruler of the skies, since she controls time itself. The last of Draper's allegories is *Day and the Dawn Star* of 1906 (Plate 5-27), in which a female rapturously embraces the male Dawn. Like Leighton before him, Draper contrasts the dark gold skin of the male with the pale tints of the woman. The painting suggests that Day is rescuing the female Dawn Star, enforcing male dominance by the elevation of the male figure. The canvas recalls Leighton's Apollonian male sun worship. Draper's return in 1909 to the sinister woman in *Lamia* (Plate 5-28) is powerful. The dangerous woman with serpentine face has shed her skin. Little snakes crawl over her arm, as if just born, in a sinister image of maternity. The poppy held in her hand, dropping between her breasts, reveals her death-bearing nature. This painting was exhibited with *Ulysses and the Sirens;* the dual impact appears a commentary on the suffragette marches of the previous year, which used pictures of Joan of Arc and Boadicea in the processions. Draper counters with his own ideograms.

Draper's focus on hostile imagery continued, a virtual campaign to illustrate female destructiveness. In *The Kelpie* (1913) Draper used the sharp facial features of his figure to indicate her delusive nature as she sits amid cascades of garish blue water. The Kelpie appears mad and unpredictable as she bares her body to the light. In 1915 Draper exhibited *Halcyone*, showing the one of the Pleiades to be impregnated by Poseidon. She stands on a rock, with

water nymphs surrounding her, awaiting her lover or recently ravished and still stunned. Draper's attitude to women is summarized in *The Pearls of Aphrodite* (c. 1917), where an arrogant goddess stares at a strand of pearls while attendant water nymphs surround her. The association of women with the sea suggests the Aphrodite Anadyomene, the goddess born of the foam/ sperm/sea. For Draper, the association of women and ocean (Aphrodites, sea sprite, mermaid, Siren, Medea on the ocean) confirmed a bleak analysis of the nature of women. In a period that saw suffragette agitation coupled with wide discussion of sexuality, Draper's paintings constitute a record of fear, suspicion, and disgust. A retrospective exhibition of his work in 1913 was a chronicle of these images in the year that saw the death of the suffragette Emily Davies at the Derby, the institution of the Cat and Mouse Act, and the establishment of the Royal Commission on Venereal Disease. Draper's classical art was a dimension of the politics of the era.

The Alma-Tadema retrospective in 1913 was greeted by the critics with derision, censure, and mockery. Only 17,000 persons filed through the Royal Academy to view the oeuvre of a man who had enjoyed unparalleled popularity during his life, so dramatically had his value sunk within a year of his death in 1912. Among the supporters of Tadema was his former pupil John Collier (1850–1934), who defended him in an essay in March 1913. After giving guarded praise to Impressionism, Collier proceeded to denounce Expressionism, Futurism, and finally Cubism, explaining the critics' dislike of Tadema by their fear of being thought outdated. Collier stated that Tadema "was essentially a realist" (571) who had a dual allegiance to the decorative and to the beautiful. Collier admitted that "throughout his work I am not quite satisfied with the majority of his types. They are good-looking and pleasant and wholesome, but they are sometimes a little uninteresting" (603). He also noted that Tadema's later small canvases with their tricks of light lacked "strength and virility" (606). He praised him, however, for his care in detail and his stupendous effects in reproducing marble. Collier's essay provides a standard by which to judge his own art, which spanned the same period as that of Rae and Draper. Having consulted Millais and studied with Poynter as well as Tadema, Collier inherited the tradition of classical-subject painting established by Leighton and Poynter.

That Collier considered his classical-subject painting a commentary on contemporary mores is clear from his canvas *The Garden of Armida* of 1899, showing a man in evening dress surrounded by alluring late Victorian Sirens offering him drink in the manner of the fatal Circe, preparing to turn him

into a swine. There are two essential icons of women with which Collier experimented, one the terrifying female like *Clytemnestra* (1882, 1914), *A Daughter of Eve* (1881), *Eve* (1911), and *Circe* (1885); the other the sorceress and madwoman, as in *Maenads* (1886), *Sister Helen, An Incantation* (1887), and *A Priestess of Bacchus* (1888). In a canvas such as *In the Venusberg (Tannhäuser)* of 1901, Collier telescopes the medieval and classical, showing a knight kneeling before a vine-crowned goddess of love. Such paintings reflect in a graphic manner the late Victorian and Edwardian preoccupation with female sexuality.

Collier's paintings of women suggest that females have dangerous occult powers or latent destructiveness. In *Circe* the goddess is shown from the rear, glancing over her left shoulder while sitting with a placid tiger in a woodland. This linkage of women with bestiality, conveyed by the skins associated with Dionysiac worship, reinforced the contention that women were to be defined by their sexual nature, a nature unpredictable and insidious. Collier's *Maenads* (Plate 5-29) shows a troop of Dionysiac revelers leading leopards and dressed in leopard skins, waving thyrsi aloft and rattling tambourines. Where Tadema would have included several devotees, Collier includes an entire band. Collier's dancing troupe represents the Wild Women denounced by Eliza Linton in 1891 in her condemnation of feminists whose work consists "in obliterating the finer distinctions of sex" ("Wild Women" 597). Their wandering through a forest suggests the female's atavistic proximity to dangerous natural forces. Likewise, *A Priestess of Bacchus* shows a vine-crowned woman holding a thyrsus, standing assuredly in a forest, the branches of the trees behind her withered and blasted. Her force goes beyond nature to destroy even the physical world. Several of Collier's most alarming images involve sorcery. In *An Incantation* of 1887, a woman lying on a leopard skin pours a potion, her arm encircled by a serpent amulet. In *A Priestess of Delphi* of 1891 (Plate 5-30), Collier shows the priestess seated on a tripod, her eyes closed during the utterance of her prophecies. The ancient face is forbidding, the body youthful. The visage has an androgynous quality marking the woman as attaining male force. Leighton's *Jealousy of Simaetha the Sorceress* (1887) and Draper's *Golden Fleece* (1904) are the predecessor and successor respectively of Collier's conceptions. In these canvases of sorceresses, Collier goes beyond Tadema's Bacchantes, giving the individuals hieratic status. Collier affirms male fears that women, given certain freedoms, would become not only powerful but anarchic.

Collier's two paintings entitled *Clytemnestra* (1882, 1914) applied this belief to ideas already established in British literary tradition. A reviewer in the

Magazine of Art in 1882 recalled Thackeray's association of Becky Sharp with this image in *Vanity Fair.* The writer contended: "[Clytemnestra] is the most awful figure in antique romance; and she is, besides, the heroine of the mightiest tragedy ever written. . . . She is the heroic type of the adulteress— high of heart, bloody of hand, magnificent in iniquity . . . [a] tremendous Murderess" (390). Two elements emerge from this commentary: that there is a tradition of formidable female "heroes" rivaling anything conceived by Carlyle; and that Clytemnestra is perceived not as a woman avenging the death of her daughter Iphigenia but rather as the murderess of her husband, Aga- memnon. The injustice of this reading of the play reveals the nature of male perception during the era. In the 1882 canvas (Plate 5-31), Clytemnestra has drawn aside a curtain to appear before the Elders of Argos with an axe in- verted in her right hand. Her face is inflexible, her decision taken and carried out. An eerie light behind her alerts the observer's mind to the horrors within. In her gold headdress there can be no mistaking the royalty of this woman. The reviewer in the *Magazine of Art* claimed Collier's figure "is not a bit he- roic and not a bit Greek" (390). One might allow the latter objection but not the former. The reviewer refuses to recognize the figure as that of an out- raged mother. In the canvas of 1914, Collier shows Clytemnestra with less stage melodrama and more dauntless grandeur as she stands before the palace, sword in right hand, bare-breasted. The resolution and defiance of the image in- dicate that Collier has recognized, or has compelled his critics to recognize, the alternative reading of Clytemnestra's tragedy. The picture suggests that the drama itself could be named after the wronged queen rather than the arrogant king.

The paintings of John Collier demonstrate the permutation of the ideas of Tadema and Leighton during the late Victorian and Edwardian periods. Collier's images of Clytemnestra and Circe derive from the mythological ex- plorations of Tadema and the isolated females of Leighton but without Ta- dema's intrusive detail and Leighton's disorienting focus on drapery. Collier painted women as the possessors of demonic power and furious passions. This image of women reflects the violence of the suffragette campaign in the early twentieth century. Collier asserts that the suffragettes, who carried banners of Artemis and John of Arc, had additional predecessors such as Clytemnes- tra. Collier's canvases ought not to be dismissed as mythological fantasies. As the author of *The Primer of Art* (1882), *A Manual of Oil Paintings* (1886), and *The Art of Portrait Painting* (1905), his authority and prestige were such that he had a one-man exhibition of his works at the Leicester Galleries in

1915. As his two portrayals of Clytemnestra demonstrate, Collier perceived the multivalent nature of classical subjects and deployed them for political purposes.

<div align="center">IV</div>

One of the most powerful of the classical-subject painters of the late Victorian and Edwardian eras was John William Waterhouse (1849–1917). Born in Rome to the artist William Waterhouse, John William Waterhouse retained throughout his life an abiding love of Italy, which he revisited during the period 1873–1880, when he began exhibiting at the Royal Academy. As a boy Waterhouse obtained a fragment of a wall from Pompeii, and he visited the area in 1877 with Bulwer-Lytton's novel in hand. Waterhouse entered the Academy schools in 1870 as a student of sculpture. When he turned to painting, the influence of Alma-Tadema was significant in his early canvases. A coincidence occurred when both Tadema and Waterhouse exhibited pictures entitled *After the Dance* at the Academy in 1876. The critic of the *Art Journal* noted: "Mr. Alma-Tadema's nude Bacchante [is] lying on her back" while Waterhouse's figures are "gracefully draped . . . and although they doubtless belong to the professional dancing class, there is nothing in their aspect to offend the most sensitive" (Hobson, *Art and Life* 31). Even in this canvas, however, Waterhouse is less concerned with archaeology than was Tadema.

Waterhouse's early exercises were in classical genre after Tadema. In *Sleep and His Half-brother Death* (1874) Waterhouse contrasted two male figures of different ages, possibly alluding to the deaths of his two brothers from tuberculosis. The painting, however, could be read as a homosexual classical scene. A critic commented that the two young men "might almost be two friends who have banquetted with Lucullus, from one of whom the spirit has passed in the night, while life in the other is expressed only by the less easeful poise of the head, drowsed as though by some opiate" (Blaikie, "J. W. Waterhouse" 3). The picture anticipates the eventual weakness of men in many of Waterhouse's canvases of the 1880s and later. *In the Peristyle* of 1874 shows a young girl feeding doves in a classical setting. The treatment of light and the meticulous rendering of the Doric colonnade are gracefully done. The picture already anticipates the great theme of Waterhouse's life, the *jeune fille fatale,* for doves were Aphrodite's birds.

In *Dolce Far Niente* of 1880, a female with peacock fan lounges in a classical interior. As with Tadema, the leopard skin at her feet indicates that her

listlessness is temporary and that Dionysiac potential exists. Subjects such as *A Pompeian Shop* (1880) and *The Household Gods* (1880) reveal the Tadema influence, as do such historical canvases as *The Favourites of the Emperor Honorius* (1883) and *Diogenes* (1882), a mocking image of the philosopher who, having retreated to a womb/barrel, is playfully sought by three women. In *The Remorse of Nero after the Murder of his Mother* (1878) (Plate 5-32), the Emperor is shown stretched on a couch, disturbed at his deed. Unlike Tadema, Waterhouse keeps the background quite stark, focusing instead on the human tragedy. This painting anticipates one of Waterhouse's most frequent subjects, the anxiety about birth. Nero's destruction of Agrippina anticipates the Orestes complex, the male's revulsion at the mother's sexuality and his own origin. In these pictures, the emperors and the philosopher are marked as antiheroic, and demythologized, signaling the end of male political and intellectual pretension. The last canvas showing men as cultural leaders is *A Sick Child Brought into the Temple of Aesculapius* (1877), where the woman awaits the guidance of the priest. The stark but beautifully colored interior distinguishes Waterhouse from Tadema. These early genre and historical canvases anticipate the representations of diminished male power in Waterhouse's depictions for the remainder of his life.

During the 1880s, Waterhouse's themes concerned women in two contexts, either as assuming unusual powers or as suffering, an opposition that eventually led to the triumph of women in the paintings of the 1890s and thereafter. The *Saint Eulalia* (1885) (Plate 5-33), drawn from an account by Prudentius, epitomizes one of these attitudes. The figure of the martyred woman lies in the snow, the cross on which she was crucified rising above her. The pose is similar to that of the woman in Watts's *Found Drowned.* The hair of the martyr lies swirled around her. It is difficult to interpret this painting as a study of Christian sacrifice. Instead, the crucifixion and the spear held by the Roman sentry suggest a sadistic impulse behind the canvas. The same social significance may be found in *Consulting the Oracle* (1884) and *The Magic Circle* (1886). In the former, a group of women is arranged in a semicircle before a mummified head, while a priestess cautions silence as the oracle begins speaking. The semicircle of women indulging in pagan rites, isolated among themselves with no men present, anticipates the encircling women of *Hylas and the Nymphs* later in Waterhouse's career. In *The Magic Circle* a single female sorceress draws a circle around herself before a flaming cauldron. The woman withdraws into self-containment, suggesting the magical powers of her nature. The sickle in her left hand, the dress with dancing fig-

ures possibly holding serpents, and the mouth open in a chant signify female dominance.

In the 1890s, Waterhouse turned to classical-subject painting to express gynophobic attitudes. From this point to the end of his career, his canvases are analyses of the femme fatale, and frequently a special type of this icon, the *jeune fille fatale*. Pierrot notes that "the femme fatale is often at the same time a child-woman, doing evil involuntarily and unconsciously" (*Decadent Imagination* 126). Waterhouse's paintings have disturbing connections with the cult of the little girl in the nineteenth century, where the naturalness of the female child is sexually alluring as well as dangerous. Writing in 1895, Baldry observed that Waterhouse had entered a phase of "picturesque mysticism," noting that with *Ulysses and the Sirens* (1891) (Plate 5-34) Waterhouse "the painter, as we know him now, first began to appear" ("J. W. Waterhouse" 111).

This painting, in which the figures of the Sirens were taken from a Greek amphora in the British Museum, shows them as figures with birds' bodies, true evolutionary atavisms. In his sketchbooks Waterhouse originally did not have Ulysses with his bound hands visible to the viewer. In the final canvas his bound state is explicit. The Sirens encircle him, several staring at him, one directly above his head; one Siren threatens a crew member in the foreground. Whereas Draper's *Ulysses and the Sirens* shows the women as three young females, Waterhouse's canvas depicts female bestiality. Furthermore, these creatures do not remain stationary on an island as in Etty or Frost; rather, they pursue their victims. By representing them as perching and hovering, Waterhouse emphasizes that these women are not only alluring but predatory. The fact that the Siren was so frequently a code word for prostitute during the period indicates that female sensuality was conceived of as beastly but natural for women. Draper's canvas of 1909 shows a Ulysses more strenuously leaning to hear the song, less passive than Waterhouse's mariner.

During the early 1890s Waterhouse was particularly concerned with the figure of Circe, which he painted in successive years, *Circe Offering the Cup to Ulysses* (1891) (Plate 5-35) and *Circe Invidiosa* (1892). In the first canvas, Circe is depicted holding the poisonous cup in her right hand, a magic wand upraised in her left. Ulysses is seen reflected in a mirror behind her as he approaches her throne. On the floor is one of the crew, now a swine, and another hovers behind the throne, which at its base has a Medusa head. Waterhouse's design enforces the sinister quality of the canvas. As reflected in the mirror, Ulysses is seen close to Circe's left breast, almost cradled in her arm.

This maternal image suggests his forthcoming sexual encounter with the goddess, implying the calculating sexuality of Circe. The lionesses on her throne associate her sexuality with beastliness, as does her magical ability to transform men into swine. Since the artist himself appears as Ulysses in this painting, it represents Waterhouse's own fear of the power of sexuality. In Waterhouse's sketchbooks there are figures of Circe showing her as more dynamic and more mature than in the final canvas. Waterhouse increased the terror of the canvas by making the woman younger. It is important to remember that by the time Odysseus encountered Circe on the island of Aeaea she had murdered her husband. In the 1892 *Circe Invidiosa* (Plate 5-36), Waterhouse depicts the goddess pouring a green poison into the sea to destroy Scylla, a rival for the love of Glaucus. By portraying the evident self-possession and determination of the goddess, Waterhouse has used the Homeric and Ovidian sources of the story of Circe in an incisive misogynistic manner.

Waterhouse during the 1890s explored a variety of classical subjects to define contemporary conditions. Several of these involved the presentation of abandoned women from Greco-Roman mythology. In 1892 Waterhouse exhibited his *Danaë* (Plate 5-37) at the Academy. This picture showed Danaë and the infant Perseus arriving on the shore of the island of Seriphos. The exposure of Perseus on the water prefigures the concept of the birth trauma. Hobson claims that this painting and the *Circe Invidiosa* contain nothing "hideous" (*Art and Life* 75), but Waterhouse knew that his viewers had studied the texts and could supply the detail. Danaë, impregnated by Zeus in the form of a shower of gold, is the archetypal image of prostitution. In Waterhouse's canvas, her maternal aspect clashes with the opposite extreme of Victorian conceptions of womanhood, the whore. Danaë is the mother and the whore, the amalgam of the Orestes complex. In 1896, *Pandora* (Plate 5-38) revealed a *jeune fille fatale* opening a box. Waterhouse's variation is in the age of Pandora, no longer the crafty woman but a nubile, curious girl. The *Ariadne* of 1898 shows a woman sleeping as Theseus' ship sails away, while the leopards of Dionysus hover near her, signaling her "rescue." Inspired by the Ariadne of the Vatican, the canvas shows the woman with her sensuality dormant.

In 1897, Waterhouse exhibited one of his most famous canvases, *Hylas and the Nymphs* (Plate 5-39). The association of evil women with water was to be a constant preoccupation of Waterhouse during the remainder of his career. In *Hylas,* the young lover of Heracles is shown being drawn into the circle of nymphs who lure him. Waterhouse's motif of the encircling com-

munity of dangerous women is unique in classical-subject painting, a device he had already tested in *Consulting the Oracle* and *Ulysses and the Sirens*. Critics recognized this *Hylas* as recalling Burne-Jones in its wistful melancholy, but the canvas also recalls the sinister quality of Burne-Jones's 1886 *The Depths of the Sea*. The painting caused discussion, leading the *Studio* to devote an entire essay to it. The essay praised the "valuable reticence" of the painting, which gives the picture an increased tension; the placidity masks the incipient abduction. The essay continued: "Mr. Waterhouse becomes in this work an apostle of the delightful Paganism, by the loss of which so much that is beautiful has been taken out of life" (244, 247). This notice is a typical evasive review. It is difficult to regard this painting as "delightful," as its very repose creates the effect of disaster. Waterhouse has presented the image of a seduced male, after years of seduction scenes where the woman was the victim. The homosexual connection between Heracles and Hylas explains Heracles' allegiance to and search for the youth. Waterhouse, while making Hylas young, has not made him immature. This is not paedophilia. The nymphs assert the matriarchal principle by sabotaging the male homosexual phalanx of the patriarchy, demonstrating their ancient and fearful power.

The 1901 Diploma Picture, *A Mermaid* (Plate 5-40), shows a figure combing her hair on a shore, glancing with open mouth over her left shoulder. Of this painting, the *Art Journal* commented that "the chill of the sea lies ever on her heart; the endless murmur of waters is a poor substitute for the sounds of human voices; never can this beautiful creature, troubled with emotion, experience on the one hand the unawakened repose, on the other the joys of womanhood" (182). Clearly the critic avoids the sinister connotation. Waterhouse's mermaid looks in no way distressed or dissatisfied; she is disturbed at the intrusion, not at her solitude. Art criticism defies the reality of the canvas to suggest that a man can fulfill the creature's existence.

The same year Waterhouse exhibited at the Academy *Nymphs Finding the Head of Orpheus* (Plate 5-41). Dismembered by women in Dionysiac frenzy, Orpheus serves as the ultimate depiction of the pernicious essence of women. His decapitation, a symbolic castration, reveals not only the destructiveness of women but also the dangers of art. The Orpheus legend indicates that women are ruinous to the artist, whose profession itself is perilous. The Maenads of Thrace destroyed Orpheus because after losing Eurydice he despised all women. It was revenge for the poet's misogyny. One sketch of this painting appears on Waterhouse's copy of Shelley's poems. The hair of Orpheus caught in the floating lyre reverses the spread hair of Saint Eulalia; the

woman is now not martyr but executioner. As in the *Hylas,* the very placidity of the nymphs increases the terror of the situation.

This association of women with water in destructive terms appears in *The Siren* of 1900 (Plate 5-42), where a drowning sailor grasps a rock on which sits a *jeune fille fatale* in the form of a mermaid. The last of Waterhouse's paintings involving water and women is the *Echo and Narcissus* of 1903 (Plate 5-43), with Echo seated at the left and separated from Narcissus by a stream, into which he gazes. Narcissus' eyes can be seen only in the reflection, confirming his total self-absorption. Male self-absorption has left Echo isolated, as the insular rock on which Narcissus stretches indicates. Narcissus had been cursed by a homosexual lover to become enamored of himself, so the idea of *Hylas and the Nymphs* is reverted to in this canvas. Here, however, the homosexuality affirms the patriarchy by excluding the female. Pierrot observes: "Narcissus represents the artistic consciousness in its flight from the coarse world of reality, and from the vulgar contact of women, in order to delight in its own subjectivity and its purely internal world" (*Decadent Imagination* 201). In 1906 in *The Danaïdes* (Plate 5-44), however, Waterhouse presented women as death bearers in the representation of the sisters who murdered and then beheaded their bridegrooms. Of the five figures surrounding the cauldron, the eyes of the woman second from the left are especially dazed and staring; the figure over her right shoulder is even more numbed in facial expression. The ascending and descending figures surrounding the cauldron convey the endless futility of their punishment. Unlike the predatory circle of nymphs in *Hylas and the Nymphs,* the encircling creatures of *Ulysses and the Sirens,* or the entranced group in *Consulting the Oracle,* the circle of murderous brides in *The Danaïdes* transforms the threatening women into an image of self-destructiveness. In *Hylas and the Nymphs, Ulysses and the Sirens,* and *Echo and Narcissus,* the association of women with water portended disaster for men. In *The Danaïdes* women are punished by carrying water. The *femmes fatales* of the earlier canvases have annihilated themselves in this painting by their murderous action. By transforming the imagery of the circle and of water from intimidating to self-defeating, Waterhouse in *The Danaïdes* depicts women as punished and condemned for repudiating marriage and assailing men.

The sorceress appears in *Jason and Medea* (1907) (Plate 5-45), with Medea concocting a potion while Jason sits expectantly beside her. As in Draper's *The Golden Fleece,* the woman is shown to be a frightening rescuer, a sign of the dangers of female dominance. Waterhouse's Jason sits almost docilely

while Medea practices her potent craft. The association of woman and fear appears in two exceptional treatments of the Lamia theme. In the first (1905), Lamia has halted a knight, her snakeskin lying around her but not deterring the ensnared man. In the 1909 canvas a crueler Lamia contemplates her face in the water as the molting skin lies across her lap. In both instances, the legend has been probed for modern significance. The shed skin indicates rebirth, a female function, expressive of the birth trauma beginning to be studied in psychology. The classical Lamia was marked by cannibalism, which links her to the Sphinx and may express an additional element of the birth trauma.

One dimension of Waterhouse's images of women during the Edwardian period focused on such figures as Lamia and Medea. However, as if to counteract the impression of female dominance in such icons, he proposed alternative conceptions expressing the Victorian patriarchal definition of femaleness. Having finished *Ulysses and the Sirens* in 1891, exhibiting a man heroically resisting the predatory female-beasts, Waterhouse depicted the hero's wife in *Penelope and the Suitors* (Plate 5-46) in 1912. If the Sirens represent unnatural female aggression, Penelope embodies the reverse, the resourceful, waiting woman who resists the allure of admirers. The weaving Penelope and her two serving women constitute a trinity of Fates: waiting is the role to which women are predestined by nature, dependent on male rescue. Penelope is the preferred image of woman, particularly because throughout the *Odyssey* she is contrasted with the vengeful Clytemnestra, who awaited her husband Agamemnon to destroy, not embrace, him. The patient but self-destructive waiting woman had appeared in Waterhouse's 1907 treatment of *Phyllis and Demophoön* (Plate 5-47). Unlike the Burne-Jones canvas of 1870, Waterhouse's Phyllis does not attempt to ensnare Demophoön, who kneels in worship before his abandoned, self-sacrificing lover. In this canvas, woman is revered once she has destroyed herself. The hapless Daphne escapes a predatory male in Waterhouse's *Apollo and Daphne* of 1908 (Plate 5-48). Although both Daphne and Phyllis metamorphose into trees, Daphne's situation is fearful, as she barely escapes the pursuing lustful Apollo. Like Phyllis, Daphne is forced into self-abnegation by callous male sexuality. As in Leighton's *Perseus and Andromeda, Clytie,* or *The Daphnephoria,* Watts's *Clytie,* Draper's *Day and the Dawn Star,* Schmalz's *Zenobia's Last Look on Palmyra,* or Riviere's *Phoebus Apollo,* the sun imagery of the solar deity Apollo emphasizes male heroic superiority. Appearing as they did during a period of suffragette activity, the images of Penelope, Phyllis, and Daphne counteract the reformers' idea of the independent woman. While *Jason and Medea* and the *Lamia* can-

vases exhibit the dangers of unnatural female willpower, the ideograms of Penelope, Phyllis, and Daphne accord with the patriarchal conception of female dependency on the male.

One of the strangest aspects of the work of John William Waterhouse is the Edwardian interpretations of it. In 1911 Baldry began an appraisal of his work noting, "There has grown up of late years a certain tendency towards materialism in pictorial art, a tendency not altogether wholesome" ("Some Recent Work" 175). He continued, praising Waterhouse in these terms: "It is as one of the most convinced exponents of sentiment—and of sentiment that is singularly pure and dignified—that Mr. J. W. Waterhouse must be ranked among the artists of our times" (176). At the death of Waterhouse in 1917, Baldry stated that the artist's world was "a place apart in which life moved placidly and followed a peaceful course and in which dream people played their appointed parts," his art one of "wholesome and dignified sentiment," "pure, wholesome, and intellectual art" ("Late J. W. Waterhouse" 4, 10, 14). It is difficult to regard Waterhouse's art as pure and wholesome. As one writer noted in 1909 apropos of *Consulting the Oracle,* such ideograms are "more or less effective appeals to the sub-conscious or sub-liminal self" ("*Consulting the Oracle*" 13–15), implying that Waterhouse's canvases have psychodynamic resonances. Throughout his career Waterhouse avoided allegorizing, unlike other artists using classical elements. One does not need to endow these paintings with significances not acknowledged in their time: it is apparent that "sub-liminal" significance was recognized. Writing in 1909, Sketchley perceived that, although "the general mind has lost kinship with the sentiment of mythology" and "its assurance of the ideal in the actual," its "imagery of what is inmost in thought and feeling" ("Art" 1), Waterhouse "communicates an inward sense of the influence of past imaginative systems" (2). Waterhouse was able "to incorporate wholly the inward with the outward" (15) as "ideas [are] symbolised in these forms" of myth (18).

If, as Sketchley contends, Waterhouse's "production of the last twenty years is a single body of expression" (18), what it expresses is not only the ideal form realized in the actual depiction of objects. Sketchley notes that "for the purpose of a study of art the circumstances of personal life have place only as they touch the work" (1). In the case of Waterhouse, the details of his personal life remain obscure. Hobson suggests his childlessness was a mutual decision between him and his wife. If one considers the range of mythological subjects embraced in his oeuvre (Circe, Thisbe [Plate 5-49], Echo and Narcissus, the Sirens, Danaë, Lamia, Penelope, Psyche, mermaids, Ariadne), it

is apparent that Waterhouse's work reflects the severe polarities defining women's identity. His uniqueness is his ability to complicate one's reactions to these icons, as in the contrasting *Lamia* canvases or the *Circe* studies. In one *Lamia,* the figure is pathetic, in the other forbidding, but both are deluding. In one *Circe* her force is directed against men, in the other against a woman. As the inheritor of the tradition of Leighton, Burne-Jones, and Alma-Tadema, Waterhouse amalgamated the beauty of the first, the melancholy of the second, and the intimacy of the third. Nevertheless, as more than one critic recognized, his art is profoundly intellectual and psychological, probing the "subliminal" to present the complex resonance of male and female roles.

Two artists who exhibit the influence of Tadema and Waterhouse are Edward Matthew Hale (1852–1924), best known for his genre scenes of army life, and Charles Edward Perugini (1839–1918). Hale had studied in Paris at the studio of Alexandre Cabanel. In the scenes derived from classical materials, Hale follows the practice of his contemporaries. Hale exhibited *Mermaids' Rock* in 1894 (Plate 5-50), a canvas showing two mermaids watching a ship in the water as it careens toward them. The men on the ship are attempting to avoid a collision with the unseen rock, to no avail. The mermaids are the *jeunes filles fatales* of Waterhouse. *Sea Nymphs* (1899) presents denizens of the deep between waves, an extension of the similar design in *Mermaids' Rock*. Perugini exhibited a number of classical canvases at the Academy, including a *Pandora* in 1893. Perugini was influenced by Leighton, for whom he may have been a studio assistant, and by the coloring of Waterhouse. Perugini was fond of studies of draped women in somnolent or quiescent postures. *Girl Reading* (1878) (Plate 5-51), effective in its handling of light, shows a female in a classically derived dress reading a bound book. The head exhibits the influence of Moore's faces. *Dolce Far Niente* (1882) presents two women standing near a balustrade overlooking a coast. Their size indicates the influence of Leighton, but the distant view is derived from Tadema. Perugini's *Hero* (1914) (Plate 5-52) portrays the priestess of Aphrodite gazing over the sea at dawn, presumably after the departed Leander. The palette shows the influence of Waterhouse, the promontory that of Tadema, and the drapery that of Leighton. Perugini's treatment of light, and the quiet dignity of the figure, produce a sensitive rendering of the deserted woman, ignorant that she is abandoned forever owing to the catastrophe of her lover. In Perugini and Hale, the classical influences of Waterhouse, Tadema, and Leighton converge while still permitting some individuality of style.

One of the painters of the nineteenth century usually not regarded in the

tradition of the classical subject is John Atkinson Grimshaw (1836–1893), an artist much influenced at the beginning of his career by the minute Pre-Raphaelite artistry of John William Inchbold and the precepts of Ruskin. Grimshaw was to abandon the precepts of Pre-Raphaelite art in the late 1860s for the suggestiveness of the subject that became his great theme, landscapes in moonlight. Whistler was forced to acknowledge him as the inventor of the "Nocturne." In the 1870s, however, Grimshaw passed through a classical-subject phase. Already by the early 1870s, paintings entitled *Dido* and *Medea* had been completed. In 1877 Grimshaw finished *Ariadne at Naxos,* a wraithlike figure standing on a coast with one arm extended in the moonlight. Grimshaw's isolation of the figure on a promontory and use of moonlight to suggest the unbearable sadness of the event are powerful. Unlike other artists, such as Waterhouse and Leighton, who depicted Ariadne lying down and even asleep, Grimshaw shows her persistent but futile watch. The drapery recalls the work of Albert Moore.

In 1878 Grimshaw completed a classical genre subject, *Two Thousand Years Ago* (Plate 5-53), which echoes several Tadema canvases, such as *The Question.* The man is lying prone beside a lady who has turned slightly away from him. The peculiarity of the canvas is that the man is much younger than the woman. The painting is tinged with a less glaring light than the sun of the Sicilian scenes of Tadema. In *An Ode to Summer* (Plate 5-54), Grimshaw recalls the paintings of poets reading to their mistresses by Tadema, particularly *At Lesbia's* of 1870. In Tadema's picture the poet stands; in Grimshaw he is seated in a dark blue-green robe. Lesbia, in yellow, sits, not merely bored but annoyed. Grimshaw modified Tadema's scheme by eliminating the trio of male auditors and simplifying the background. On the right Grimshaw reproduces the Hermes Farnese or the Hermes Belvedere instead of the Venus de Medici in Tadema's rendering, an alteration that shifts the focus to Lesbia's erotic dissatisfaction. In 1880 Grimshaw exhibited *Endymion on Mount Latmus* (Plate 5-55) at the Academy, showing the goddess Diana hovering over the naked Endymion. In contrast to Poynter's treatments later, Grimshaw's depiction is hallucinatory. The picture represents the triumph of female sexuality over male, as the man in the legend remained submissive. In contrast to Leighton, where it is the women who sleep, here the man's sexuality is pacified.

The painters of the later Victorian and Edwardian classical subject followed the example of Burne-Jones, Leighton, and Poynter in presenting mythologies which reflect the situation of women and the debate about equality during the period. These artists' work indicates that the transformational po-

tential of the classical-subject tradition is as considerable as that of the myths it employed. From Tadema's precise genre representations, to Draper's erotic statements, Collier's dramatic presentations, and Waterhouse's potent depictions, classical mythology reinforced a conservative political ideology of male superiority. The work of Collier, Waterhouse, and Draper exhibits the misogyny that marked the turn of the century and the period following the death of Victoria. Draper, Waterhouse, and Collier depicted dangerous femmes fatales and *jeunes filles fatales* that retain the fervor of their disturbed era.

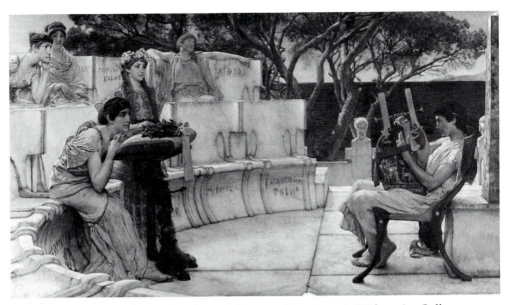

5-1. Lawrence Alma-Tadema: *Sappho and Alcaeus*, 1881; 26 × 48; Walters Art Gallery, Baltimore.

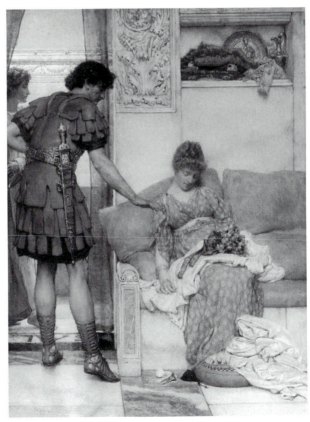

5-2. Lawrence Alma-Tadema: *A Silent Greeting*, 1889;
12 × 9; Tate Gallery, London.

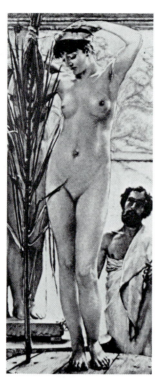

5-3. Lawrence Alma-Tadema: *A Sculptor's Model*, 1877; 77 × 33; photo: Swanson, *Alma-Tadema* 1977.

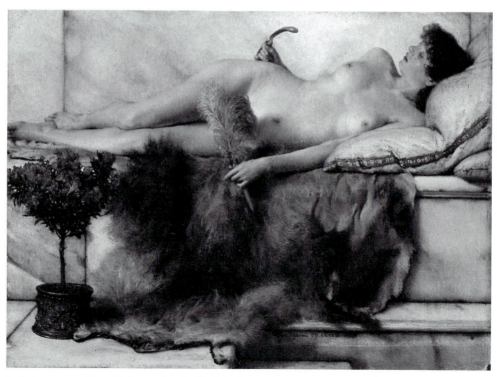

5-4. Lawrence Alma-Tadema: *In the Tepidarium*, 1881; 9½ × 13; National Museums and Galleries on Merseyside (Lady Lever Art Gallery, Port Sunlight).

308

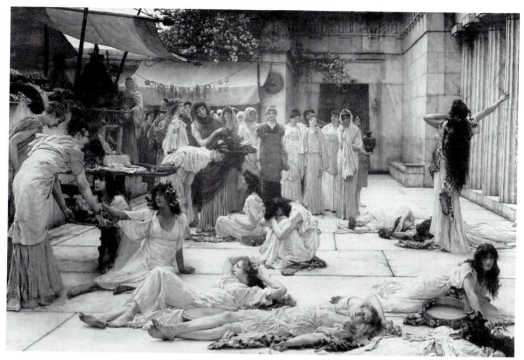

5-5. Lawrence Alma-Tadema: *The Women of Amphissa,* 1887; 48 × 72; Sterling and Francine Clark Art Institute, Williamstown, Massachusetts.

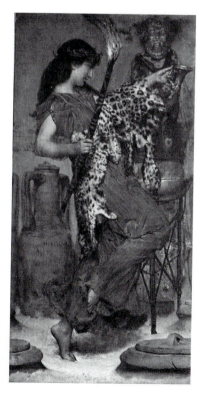

5-6. Lawrence Alma-Tadema: *Autumn: A Vintage Festival,* 1873; 29½ × 15; Birmingham City Art Gallery.

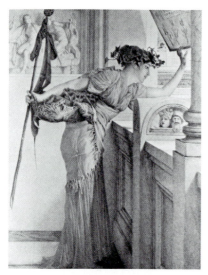

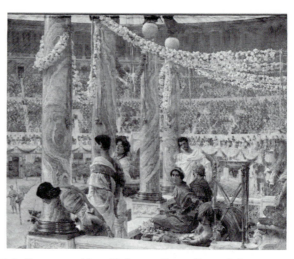

5-7. Lawrence Alma-Tadema: *"There He Is!"*, 1875; 10½ × 7¾; National Museums and Galleries on Merseyside (The Emma Holt Bequest, Sudley House, Liverpool).

5-9. Lawrence Alma-Tadema: *Caracalla and Geta,* 1907; 48½ × 60½; photo: Sotheby's Belgravia.

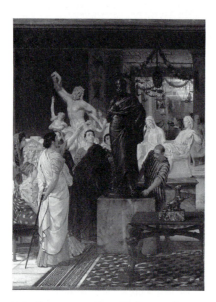

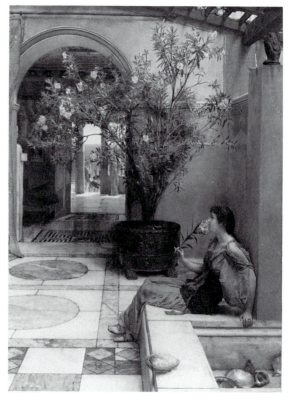

5-8. Lawrence Alma-Tadema: *A Sculpture Gallery in Rome at the Time of Augustus,* 1867; 24½ × 18½; Montreal Museum of Fine Arts, Horsley and Annie Townsend Bequest 1980.2.

5-10. Lawrence Alma-Tadema: *The Oleander,* 1882; 36 × 26; photo: Sotheby's Belgravia.

310

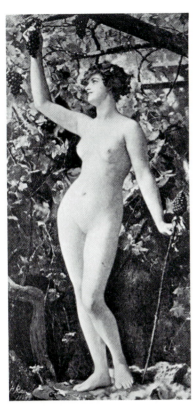

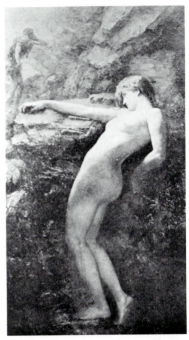

5-11. Henrietta Rae: *A Bacchante,* 1885; 50 × 25; photo: Fish, *Henrietta Rae* 1905.

5-12. Henrietta Rae: *Eurydice Sinking Back to Hades,* 1887; 84 × 48; photo: Fish, *Henrietta Rae* 1905.

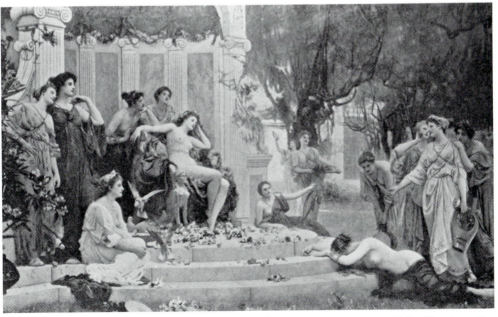

5-13. Henrietta Rae: *Psyche before the Throne of Venus,* 1894; 76 × 120; Fish, *Henrietta Rae* 1905.

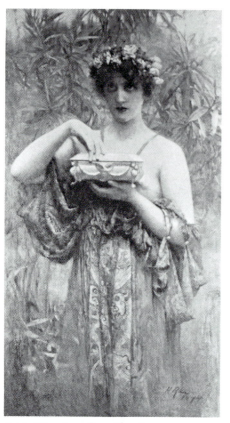

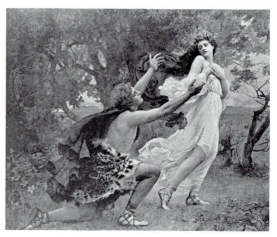

5-15. Henrietta Rae: *Apollo and Daphne*, 1895;
66 × 79; photo: *RAP* 1895.

5-14. Henrietta Rae: *Pandora*, 1894;
photo: Fish, *Henrietta Rae* 1905.

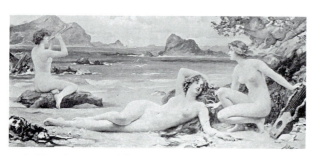

5-16. Henrietta Rae: *The Sirens*, 1903; 46 × 101; photo:
RAP 1903.

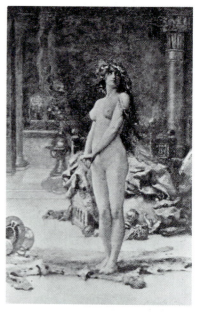

5-17. Henrietta Rae: *Loot*, 1903;
photo: Fish, *Henrietta Rae.*

312

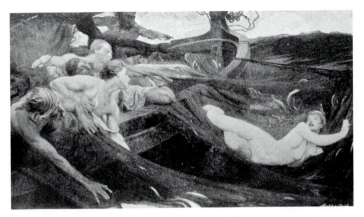

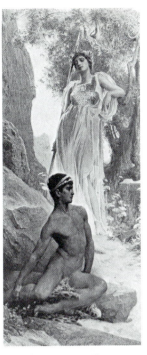

5-18. Herbert James Draper: *The Sea-Maiden*, 1894; 48 × 87; photo: *RAP* 1894.

5-19. Herbert James Draper: *The Youth of Ulysses,* 1895; 78 × 34; photo: *RAP* 1895.

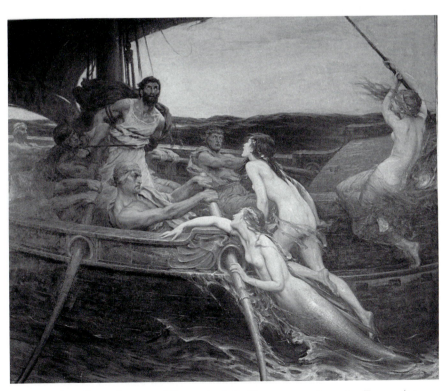

5-20. Herbert James Draper: *Ulysses and the Sirens,* 1909; 64 × 84; Ferens Art Gallery, Hull.

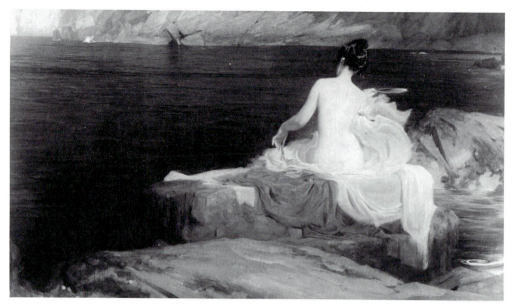

5-21. Herbert James Draper: *Calypso's Isle,* 1897; 33⅛ × 58; Manchester City Art Gallery.

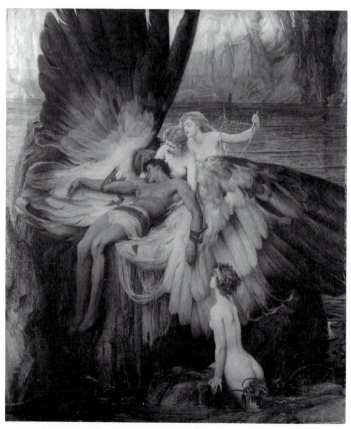

5-22. Herbert James Draper: *The Lament for Icarus,* 1898;
72 × 61¼; Tate Gallery, London.

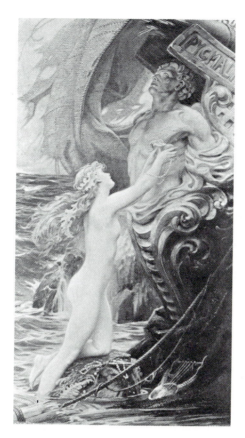

5-23. Herbert James Draper: *A Deep Sea Idyll*, 1902; 53 × 30; photo: *RAP* 1902.

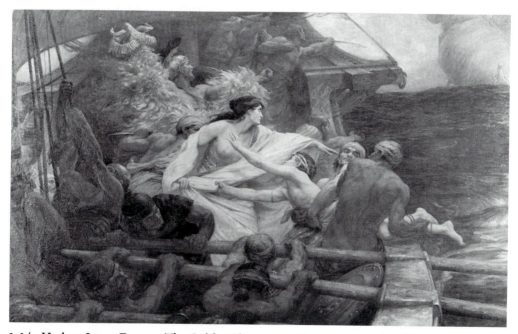

5-24. Herbert James Draper: *The Golden Fleece*, 1904; 61 × 106½; Bradford Art Galleries and Museums.

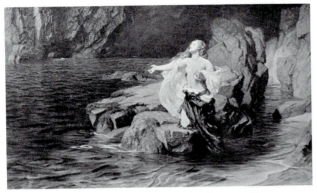

5-25. Herbert James Draper: *Ariadne Deserted by Theseus*, 1905; 45 × 78; photo: *RAP* 1905.

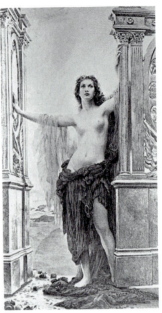

5-26. Herbert James Draper: *The Gates of Dawn*, 1900; 78 × 40; photo: *RAP* 1900.

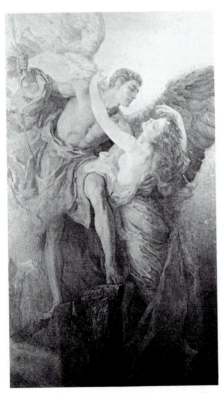

5-27. Herbert James Draper: *Day and the Dawn Star*, 1906; 87 × 52; photo: *RAP* 1906.

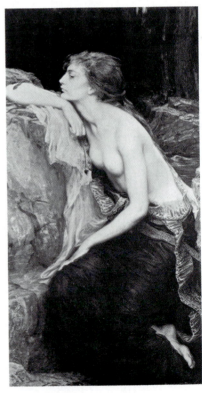

5-28. Herbert James Draper: *Lamia*, 1909; 40 × 27; photo: Whitford and Hughes Gallery, London.

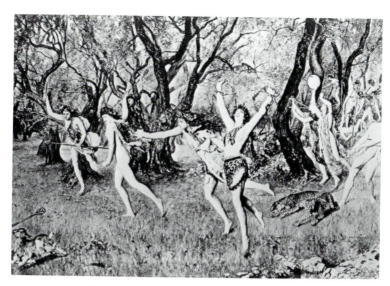

5-29. John Collier: *Maenads,* 1886; 69 × 105; photo: Royal Academy of Arts, *Official Illustrated Catalogue* 1886.

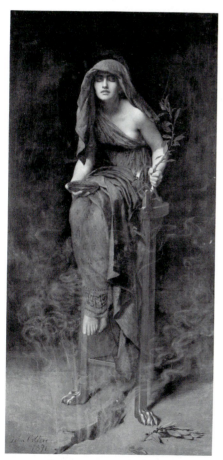

5-30. John Collier: *A Priestess of Delphi,* 1891; 63 × 31½; Art Gallery of South Australia, Adelaide.

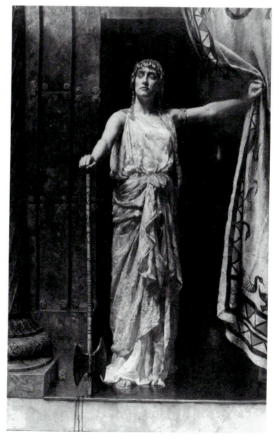

5-31. John Collier: *Clytemnestra,* 1882; 94 × 58; Guildhall Art Gallery, London.

317

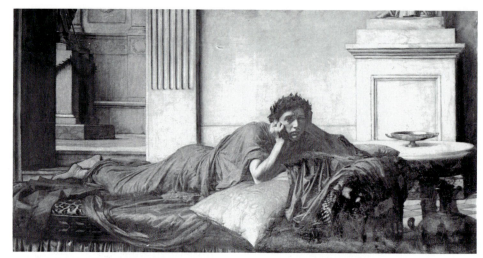

5-32. John William Waterhouse: *The Remorse of Nero after the Murder of His Mother*, 1878; 37 × 66; photo: Sotheby's Belgravia.

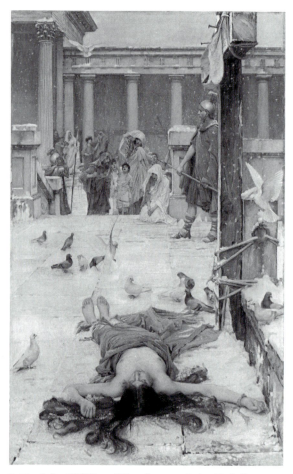

5-33. John William Waterhouse: *Saint Eulalia*, 1885; 74¼ × 46½; Tate Gallery, London.

318

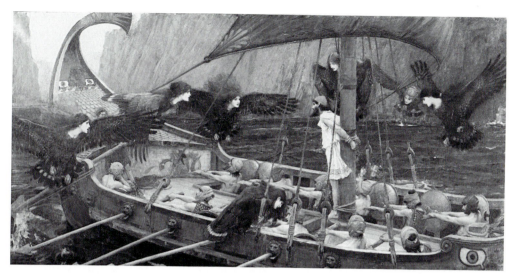

5-34. John William Waterhouse: *Ulysses and the Sirens,* 1891; 79 × 39; National Gallery of Victoria, Melbourne, purchased 1891.

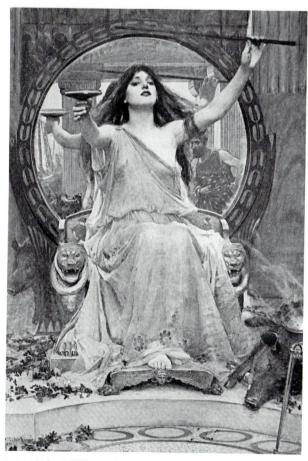

5-35. John William Waterhouse: *Circe Offering the Cup to Ulysses,* 1891; 58½ × 36¼; Oldham Art Gallery.

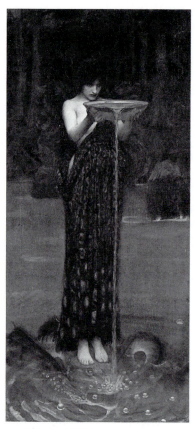

5-36. John William Waterhouse:
Circe Invidiosa, 1892; 70½ × 33½;
Art Gallery of South Australia,
Adelaide.

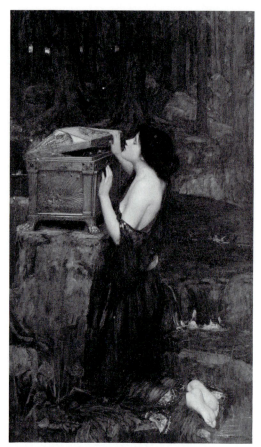

5-38. John William Waterhouse: *Pandora*,
1896; 60 × 36; Private Collection; photo:
Marlborough Fine Art, London.

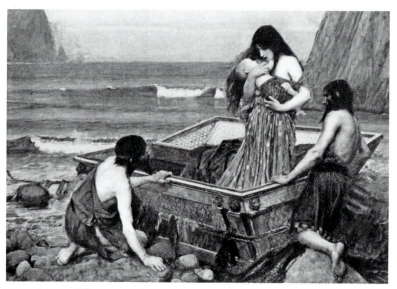

5-37. John William Waterhouse: *Danaë*, 1892; 33 × 51; photo: *Pall Mall
Pictures of 1892.*

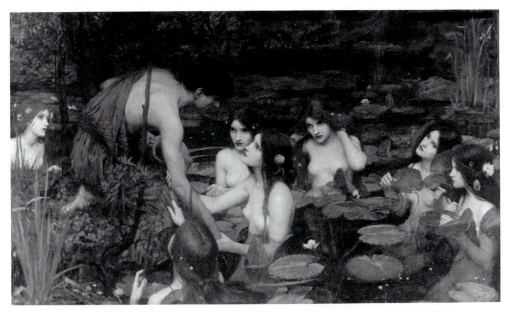

5-39. John William Waterhouse: *Hylas and the Nymphs,* 1897; 38½ × 64; Manchester City Art Gallery.

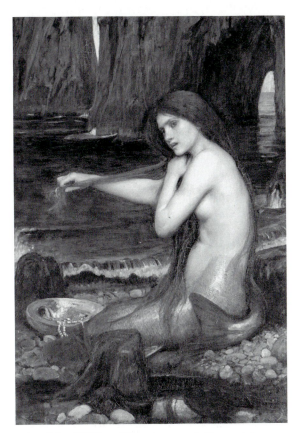

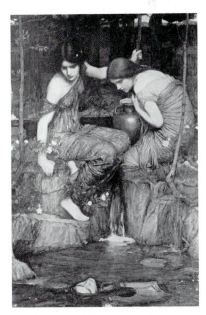

5-41. John William Waterhouse: *Nymphs Finding the Head of Orpheus,* 1901; 58½ × 39; Leger Galleries Ltd., London.

5-40. John William Waterhouse: *A Mermaid,* 1901; 38½ × 36¼; Royal Academy of Arts, London.

321

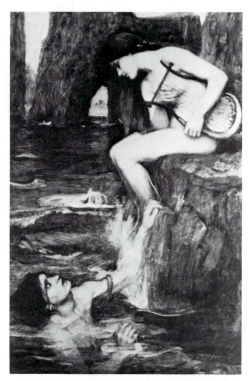

5-42. John William Waterhouse: *The Siren,*
c. 1900; 32 × 21; photo: *Präraffaeliten* 1974.

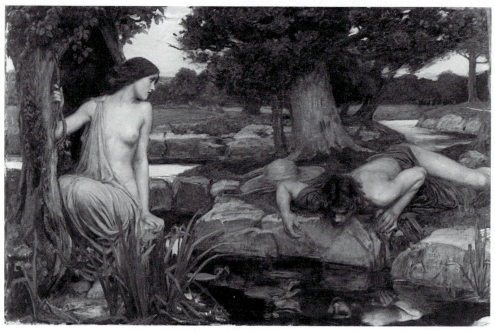

5-43. John William Waterhouse: *Echo and Narcissus,* 1903; 43 × 74½; National Museums
and Galleries on Merseyside (Walker Art Gallery, Liverpool).

322

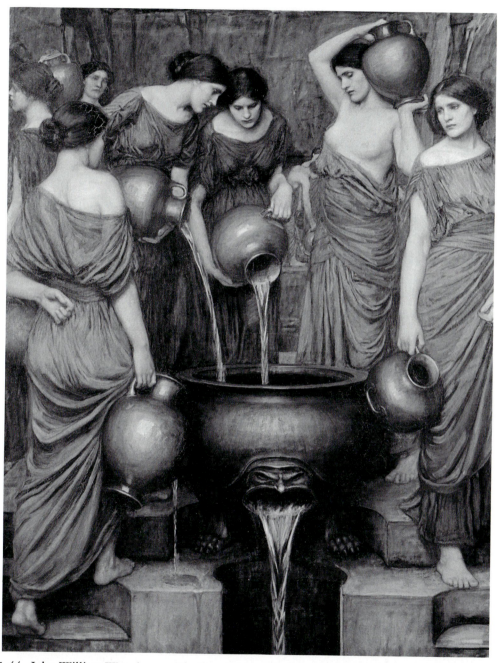

5-44. John William Waterhouse: *The Danaïdes,* 1906; 63½ × 43½; Aberdeen Art Gallery.

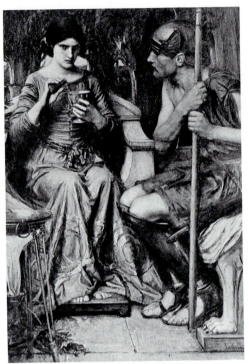

5-45. John William Waterhouse: *Jason and Medea*, 1907; photo: *Art Journal* 1909.

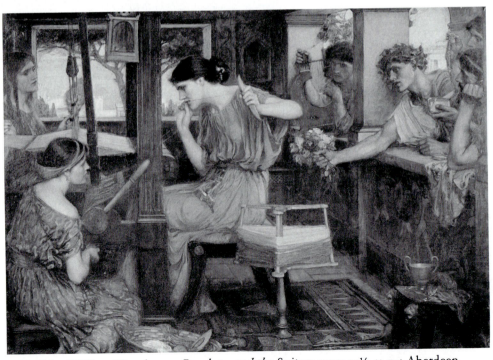

5-46. John William Waterhouse: *Penelope and the Suitors*, 1912; 51½ × 75; Aberdeen Art Gallery.

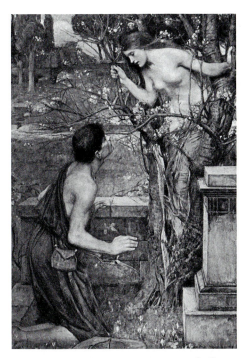

5-47. John William Waterhouse: *Phyllis and Demophoön*, 1907; 53 × 35½; photo: *Art Journal* 1909.

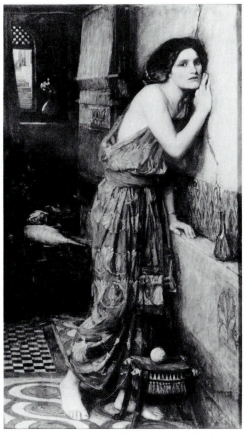

5-49. John William Waterhouse: *Thisbe*, 1909; 38 × 28½; photo: Sotheby's Belgravia.

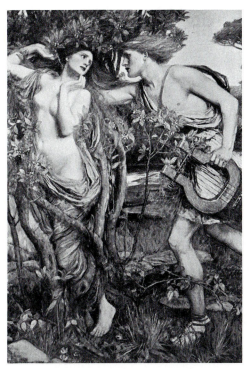

5-48. John William Waterhouse: *Apollo and Daphne*, 1908; 56½ × 43¼; photo: *Art Journal* 1909.

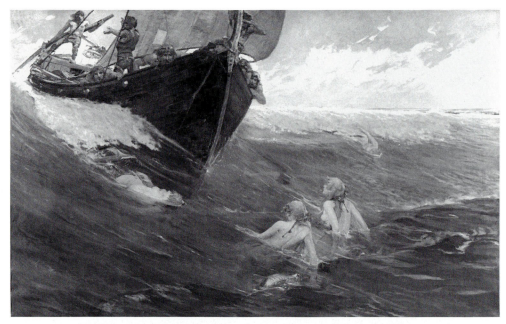

5-50. Edward Matthew Hale: *Mermaids' Rock,* 1894; 48 × 78; City Art Gallery, Leeds.

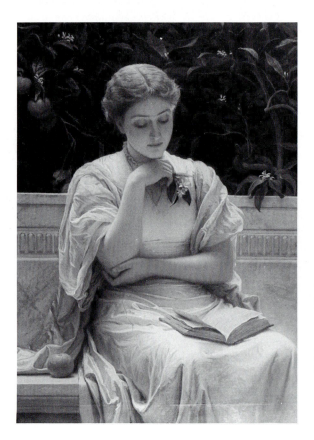

5-51. Charles Edward Perugini: *Girl Reading,* 1878; 38 × 28¾; Manchester City Art Gallery.

326

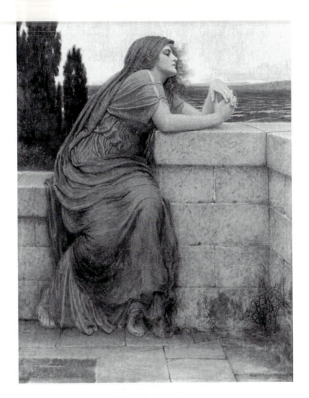

5-52. Charles Edward
Perugini: *Hero*, 1914;
46 × 30; photo: Sotheby's
Belgravia.

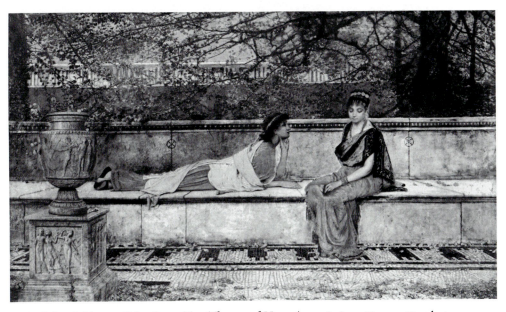

5-53. John Atkinson Grimshaw: *Two Thousand Years Ago*, 1878; 29¾ × 50½; photo:
Sotheby's Belgravia.

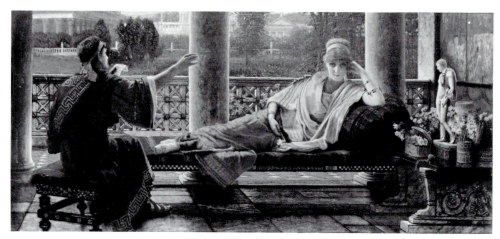

5-54. John Atkinson Grimshaw: *An Ode to Summer*, 1879; 12 × 26; photo: Sotheby's Belgravia.

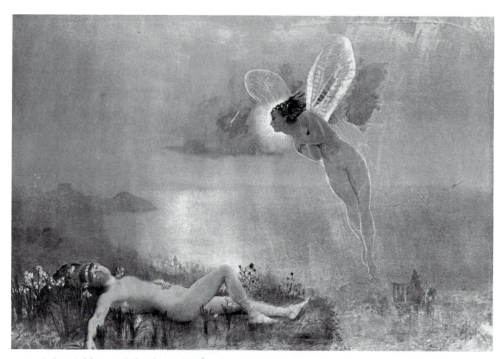

5-55. John Atkinson Grimshaw: *Endymion on Mount Latmus*, 1880; 32 × 47½; photo: Christie's, London.

Conclusion: The Decline of the
Classical-Subject Tradition

THE demise of the classical-subject tradition in the late Victorian period and its disappearance during the Edwardian period are the result of several factors. A principal cause is the change in the status of women achieved by legislation. The classical-subject tradition declined because the images of women presented in its selective use of myth gradually became less relevant. This legal reform coincided with the spread of doctrines of art from France, ranging from Impressionism to Postimpressionism to Cubism. The art of the early twentieth century, with its interest in significant form and abstract design, repudiated the classical-subject tradition. Progress in both the political and the artistic spheres ended the classical-subject era which had begun in the late 1860s with Burne-Jones and Leighton. The last of its greatest exemplars was undoubtedly Waterhouse. Contemporary with him and working after him, a number of lesser artists attempted to maintain the classical-subject tradition, which finally disappeared in the early 1920s.

Peter Cominos notes that in the nineteenth century, "The character of the overall pattern of the respectable relationship between husband and wife was not mature, i.e., a free and equal association, but immature, i.e., an association between unequals characterized by domination and submission. Married love was an immature association of dominance and submissiveness corresponding to the structure of the Respectable family and congruent with the entirety of family associations" ("Late-Victorian Sexual Respectability" 243). As legal, educational, occupational, and political emancipation gradually altered the condition of women, the situation of dominance and submission was replaced by a slowly developing equality. The mythologies of classical-subject painting had emphasized two images, the dependent and the threatening female, which were not consonant with this alteration in the historical

situation. The suffragettes who carried banners of Artemis and Boadicea and slashed the "Rokeby Venus" were expressing a desire to replace these mythologies. The self-effacement, subordination, passivity, and dependence cultivated in the upbringing of women in the nineteenth century began to alter as educational and professional opportunities broadened. The Fourth Reform Bill in 1918, which granted women over thirty the franchise, marks the end of the classical-subject era. The cultural indoctrination which resulted from this pictorial tradition was superseded by more equal definitions of male and female identities.

The passing of Queen Victoria in 1901 and the First World War signaled the end of the exclusively patriarchal system that had sustained the classical-subject mythologies. The selection of myth had always been a question of emphasis, as myth is emphasis. Cultures define and refine the mythologies that accommodate their particular circumstances. Classical-subject artists modeled the myth to suit the contemporary situation. Anthropologists of the nineteenth and early twentieth centuries had had classical training and were concerned with the revelations of Greco-Roman archaeology. As the twentieth century advanced, however, the frames of reference shifted to non-European cultures, undermining the force of Greco-Roman mythological conceptions. Victorian hero worship was a mythologizing of male gender identity, which had used classical-subject painting to advance its prerogatives.

After the First World War, these mythologies were relegated. The changes in women's situation demonstrated that in fact they were able to develop and progress, as men had always been presumed to do. Classical-subject painting had enforced an eternality of men's and women's identities which events had proved untenable. Classical-subject painters employed typologies which were modified and negated by the change in political situations. The advances in feminist causes joined with the realities of the First World War. Prior to the war, "It was a world of heroes. The values and the ambitions were heroic and in Homer the Edwardians found an author who responded to them and who served to canalize and voice their felt but unspoken impulses." However, "the Great War was the fulfilment of the Homeric ideal. It was also its demise" (Ogilvie, *Latin and Greek* 143, 147). After the war and the Fourth Reform Bill, the male heroic code of classical-subject painting was questioned and then replaced.

Part of the reason for this abandonment of the male heroic code was undoubtedly the prevalence of mental disorders among returning servicemen at the conclusion of the war. Showalter notes: "This parade of emotionally

incapacitated men was in itself a shocking contrast to the heroic visions and masculinist fantasies that had preceded it" (*Female Malady* 169). Emotional disturbances among men indicated that madness was not confined to females, and symptoms such as passivity and dependency, associated previously with women, were manifest in emotionally disturbed males. About 114,000 ex-servicemen applied for pensions as a result of shell shock during the decade after the end of the war. Men were no longer rescuers, women victims. A more reciprocally supportive relationship became advocated by society. The mythical ideograms of the classical-subject pictorial tradition gradually receded as the cultural system was altered and transformed.

<div align="center">I</div>

The changes in classical-subject painting may be examined in a range of later Victorian and Edwardian exemplars of the tradition. Wright Barker (fl. 1891–1941) specialized in studies of women in classical interiors. Of the canvases which can be traced, no less than four involve Circe, all finished between 1904 and 1912. In the first, Circe, surrounded by wolves, is shown bidding Odysseus farewell from a marble terrace, an extension of the virtuoso seaside terraces of Poynter. In a second, a very unattractive Circe is looking at a swarm of swine, her face a contemporary Edwardian smiling model. A third canvas shows Circe, more androgynous than the other depictions, reclining in her palace with tamed lions surrounding her, the Poynter-style steps leading from the terrace to the sea. A final depiction (Plate C-1) shows Circe with lions and wolves, looking like an Edwardian lady in costume, on the steps of her palace. Barker, the facile version of Poynter, departed from the classical idea by copying the specific model and trivializing the Circe legend. He lacked the skill that Waterhouse exhibited in his representation of reflecting mirrors.

An artist of greater imaginative grasp of classical legend is George Wether-bee (1851–1920), an American who studied on the Continent and at the Royal Academy schools. *The Pool of Endymion* (1901) depicts a naked woman, presumably Artemis, bathing. Wetherbee's sensitive landscape conveys an idyllic tranquillity combined with isolation. The myth of Endymion per se, so crucial in Poynter or Watts, is here scarcely necessary to understand the landscape. A later single-figure canvas, *Stray'd Hylas* of 1908, shows a slender ephebe dipping his foot into a stream. In contrast to *The Pool of Endymion*, this laurel-crowned young man is prominently displayed against the landscape. The *Orpheus* of 1901 (Plate C-2) is rather different. The poet, an androgynous youth,

is shown playing a lyre while two water nymphs pause to listen at the base of a waterfall. Orpheus has a leopard skin draped around his shoulder, suggesting his eventual death at the hands of the Maenads. Wetherbee's landscape, with its ravine, suggests the descent of Orpheus for Eurydice and his eventual destruction. Wetherbee emphasized the function of light in later mythological canvases, such as the *Circe* of 1911 (Plate C-3), showing the goddess perched on a promontory watching a boat entering her cove. Wetherbee presents the event as a daily occurrence by the naturalistic landscape and brilliant light, a moment seized rather than a climax explained. In *A Summer Sea* (1915), a nude seen from the rear binds her hair on a seacoast. She is not called a Siren, and only the vestige of the legend remains suggested. The canvas suggests but never demarcates a myth. Wetherbee demythologizes the classical-subject canvas, a key sign of the waning of the significance of the myths used by his predecessors. In general, Wetherbee's canvases correlate with the weakening of force of these myths.

However, Wetherbee could evoke elements of male heroism through a modified process of demythologizing. A particularly striking example is *Adventurers* of 1908 (Plate C-4), showing three naked youths entering the ocean at sunrise. This celebration of Aryan Apollo worship is linked with the Aryan ideas of Frederic Leighton in his Academy addresses. The world of emerging manhood is that of new worlds to conquer. Wetherbee's three youths are the phallocentric response to the Three Fates and the Three Graces, a new secularized male trinity. Wetherbee's *Adventurers* was exhibited at the New Gallery, while at the Academy his *Frolic Spring* was shown. In that canvas, three young women were shown skipping along a grass path on a cliff overlooking the sea. The three men in *Adventurers*, in contrast, daringly enter the ocean. They become the iconographic analogue of Ruskin's pronouncement in *The Queen of the Air* about the modern significance of Apollo: "It may be easy to prove that the ascent of Apollo in his chariot signifies nothing but the rising of the sun. But what does the sunrise itself signify to us? If only languid return to frivolous amusement, or fruitless labour, it will, indeed, not be easy for us to conceive the power, over a Greek, of the name of Apollo. But if, for us also, as for the Greek, the sunrise means daily restoration to the sense of passionate gladness, and of perfect life—if it means the thrilling of new strength through every nerve,—the shedding over us of a better peace than the peace of night, in the power of dawn,—the purging of evil vision and fear by the baptism of its dew; if the sun itself is an influence, to us also, of spiritual good,—and becomes thus in reality, not in imagination, to us

also, a spiritual power,—we may then soon over-pass the narrow limit of conception which kept that power impersonal, and rise with the Greek to the thought of an angel who rejoiced as a strong man to run his course, whose voice, calling to life and to labour, rang round the earth, and whose going forth was to the ends of heaven" (*Works* 19.302–303). The women in *Frolic Spring* are engaged in Ruskinian "frivolous amusement." The Apollonian male trinity of *Adventurers* is setting out to "the ends of heaven."

The classical-subject canvases of John Reinhard Weguelin (1849–1927) represent not the demythologizing of the classical subject but its extreme extension. Weguelin began to study art at the Slade School when Edward Poynter was professor of drawing. From him Weguelin learned strict principles of composition which served him throughout his live as a painter in oils, watercolorist, and illustrator. As a boy Weguelin had spent several of his early years in Rome, where he became thoroughly acquainted with ancient monuments. Later, the work of Alma-Tadema influenced him in depictions of classical genre. Weguelin's efforts in the classical subject were often marred by a trivializing recognized by his contemporaries. His first exhibited canvas at the Academy was *The Labour of the Danaïdes* (1878), but the tendency of his work may be gauged by the description of his 1885 offering, *The Swing Feast:* "In expiation of the death of Erigone, who hung herself, and in imitation of her, the maids of Athens on this day swung themselves from trees, while they sang hymns in her honour." The watercolor *The Swing* (1893) recalls rococo art by its subject: a girl in classical drape swinging on a terrace. The face is unidealized, the model's day for sport. A more suggestive subject is Weguelin's *Tribute to the God of Bounty* (1887), showing a young woman draping a herm in worship of Dionysus. The phallic power is alluded to in the title, while a strategic drapery covers the part of the pillar which would have shown the genitals. Weguelin depicted the theme of the herm more than once. In the same year, *The Toilet of Faunus* repeats the motif of the woman dressing a herm. Weguelin's genius for classical titillation is exhibited in *The Roman Acrobat* (1881), showing a female tightrope walker, bare-breasted, walking above the heads of spectators.

In *To Faunus,* two bathers behind a rock call the god, sitting with his back turned, for some sexual sport. The source, Horace's *Odes* 3.18, invokes Faunus as lover of the nymphs, confirming the sexual nature of the depiction. By association with a deity like Faunus, women's character is indisputably defined by sexual nature. In *A Whispered Question* (1892), a woman whispers into the ear of a Sphinx, an alteration of a picture such as Rossetti's *The Question*

of 1875. Here a woman, rather than three men, questions the stone image. As in Henrietta Rae's *Psyche before the Throne of Venus, Venus Enthroned,* and *Roses of Youth,* female nature is atavistic, close to beastliness. Weguelin's most successful canvas, however, reflects his simplifying of Tadema. In *Old Love Renewed* (1891) (Plate C-5), Weguelin depicts a woman passing a man on a classical terrace. He stares wistfully at her, while above his head is a small statue of Eros and Psyche. Weguelin refrains from the archness of his other works in the depiction of this sensitive encounter, more restrained and emotional than much of Tadema. The woman carries a birdcage holding a dove, the bird of Aphrodite, suggesting several possibilities: that she is already married, that her heart has long been this man's, or that both are restrained by convention. In *Old Love Renewed* Weguelin avoids the excessive detail that obscured the motive of some of Tadema's canvases. With the exception of such a canvas, however, the trajectory of Weguelin's art reflects the late Victorian and Edwardian diminution that signaled the decline of classical-subject art. Baldry observes that the classical phase of Weguelin's art was "not a lasting one, and even while it continued was not marked by pedantic insistence upon the dry facts of archaeology. He was content for the most part to realise the classic atmosphere by a comparatively free adaptation of the records of the antiquarians and to deal in a more or less irresponsible way with the material which he collected from the history of ages long past" ("J. R. Weguelin" 193). Weguelin's work as an illustrator of Anacreon and Catullus, however, indicates the depth of his awareness of ancient literature.

The art of William Henry Margetson and Arthur Wardle reveals two different forms of the degeneration of the classical subject. William Henry Margetson (1861–1940) painted some mythological canvases before subsiding into classical genre. In 1890 he painted Cleopatra preparing to kill herself; the drawing of the figure is inadequate and the face is the model's, resembling no ancient sculpture. The heroic deed is reduced to genre. The *Pygmalion* of 1891, however, is Margetson's strongest achievement. Pygmalion is shown on his knees grasping the ankles of the statue. In this representation, the future Galatea appears troubled and intimidating, not the approachable woman of Burne-Jones's conception. The classical frieze in the background with its energetic horses suggests the passion of the sculptor. Margetson's art deteriorated after this achievement. *The Sea Hath Its Pearls* (1897), *The Wonders of the Shore* (1899), and *Whispers of Fancy* (1901) depict women by the coast, dressed in classical drapery but essentially vapid. Margetson's skill at drapery is decidedly less than Leighton's. Margetson's work is an indication not merely

of the decline but of the degeneracy of the classical-subject tradition. His involvement in the incidents is minimal. Viewers are given no suggestion of deeper implication; instead, women have been reduced to ciphers, their mythological potential exhausted. These canvases are devoid of the crucial signifying element of the strongest examples of classical-subject art.

In the works of Arthur Wardle (1864–1949) animals are used to suggest latent ferocity. Wardle painted a number of enchantresses in such canvases as *A Siren* (1893) and specialized in associating animals with dangerous women. The *Diana* of 1897 (Plate C-6) shows the goddess lying on the grass amid her hounds. This canvas is more effective than some of Wardle's depictions by its careful painting and pose of the goddess. The *Circe* of 1908 (Plate C-7) violates the legend by having the prone and draped woman surrounded by leopards rather than swine, with no suggestion of the function of the goddess in Homer. This freedom in the representation of Circe, noticeable in Wardle and in Wetherbee, marks the reduction of the importance of myth. In 1909 Wardle exhibited *A Bacchante* (Plate C-8), showing a Maenad with naked breasts holding grapes above her head, attended by a troop of leopards. If this canvas is compared with Leighton's *Syracusan Bride,* with its great solemnity and extraordinary color, the decline in classical-subject art may be recognized. Wardle's conception lacks dignity, since the face is too naturalistic. Wardle's *The Enchantress* of 1901 (Plate C-9) depicts a descendant of Circe recumbent on the earth, playing with two leopards, one of whom grasps her hair. Women are revealed in their tellurian, atavistic state; their bestiality is their essence.

The paintings of George Storey (1834–1919) range from early Pre-Raphaelite works to classical-subject canvases at the end of the nineteenth century and during the Edwardian period. Storey's mythological canvases retain the sense of careful detail and narrative implication that marked the work of Leighton, Poynter, and Waterhouse. An early mythological canvas is *Paris and Oenone* (1890), a restrained and sensitive depiction, with the exception of the Victorian dog. The suggestion of Paris' infidelity is conveyed in the manner in which he ignores the passive Oenone. The *Leda* (1906) is one of the rare depictions of this legend in British classical-subject painting. Artists refused to compete with Leonardo's, Michelangelo's, and Titian's representations of the episode. Leda watches cautiously as the swan sails in a stream. Her face suggests the bestial sensuality that will make her the mother of Helen of Troy and the fearsome Clytemnestra. Leda herself did not have the dangerous allure of her two daughters as a subject for art. *Phryne* (1908) compares un-

favorably with Leighton's depiction because of its awkward drawing and the self-conscious pose, absolutely at variance with the legend itself. The model has reigned over the myth, despite Storey's attempt to reproduce the Venus de Milo in the figure's lower half.

Storey could present a convincing *Circe* (1909) (C-10), a nude lying on a couch holding a cup to present to the unwary mariners. The exhibition of such a canvas during the height of the suffragette conflict cannot be accidental. The fact that the woman is an amalgam of classical and Edwardian elements increases its intimidating function. The pose is the front and reverse of Velásquez's "Rokeby Venus," which was slashed by a suffragette in 1914. The contrast between a work like the *Circe* and most of the remainder of Storey's oeuvre indicates the weakening of the classical-subject tradition. Storey had obviously lost faith in the mythology that sustained the works of the nineteenth-century classical tradition.

Storey's work was anticipated by that of Herbert Gustave Schmalz, who changed his last name to Carmichael after the war (1856–1935). In 1889 Schmalz, who lived near Leighton in London, was to marry Edith Pullan, a sister of Dorothy Dene, Leighton's preferred model. Schmalz exhibited genre works such as *Her First Offering* (1895), showing a young girl making an offering of flowers at the shrine of Eros, a sensitive image with carefully executed marble exteriors. However, it is the sensational *Faithful unto Death: "Christianae ad leones!"* (1888) (Plate C-11) that prefigures the Edwardian work of Storey. Exhibited at the Academy, it shows a number of totally naked women tied to pillars in the Coliseum during the feast of Bacchus, awaiting the arrival of the lions. Schmalz's title echoes that of Poynter's famous icon of male heroism in 1865 only to mock it. In the background, the interior of the amphitheater, much indebted to Tadema, is thronged with tiers of spectators. The canvas is prurient in the extreme, showing the debasement foreordained by the association of woman and beast in Leighton's *Syracusan Bride*. At the New Gallery in the same year, possibly inspired by Poynter's 1878 oil *Zenobia Captive*, Schmalz showed the imperious queen, Zenobia, viewing from the Temple of the Sun the destruction of her city by the Romans (Plate C-12). In both canvases, whether the woman is anonymous victim or regal empress, she is vanquished. *Zenobia's Last Look on Palmyra* depicts the captive queen surveying the conquest of her Syrian empire by the Roman emperor Aurelian in A.D. 275. At the queen's right is a relief of Apollo, taken from a metope of the sun-god Helios discovered by Schliemann at the excavations of Troy. The Apollonian masculine/solar power has vanquished the woman, whose left

foot is poised for her descent from the ramparts of her palace. Aurelian in fact exhibited her in his triumphal procession at Rome, by which time she had "pleaded her sex as an excuse for weakness" (Blakemore 48).

In at least one instance, Schmalz turned in the early twentieth century to one of the key origins of classical-subject art, Bulwer-Lytton's *The Last Days of Pompeii*, when he exhibited *Nydia, the Blind Girl of Pompeii* in 1908 (Plate C-13). Unlike the victims in *Faithful unto Death* or the doomed queen in *Zenobia's Last Look on Palmyra*, the study of Nydia is a recognition of the valor of Bulwer-Lytton's protagonist, who though blinded saw the light. However fleetingly, Schmalz in this canvas acknowledges the heroic potential of women. Schmalz's representations of the Pygmalion legend were contradictory. In *The Awakening of Galatea* (1907), Pygmalion grasps the feet of the awakened statue, bowing before her perfections. In *Pygmalion! Pygmalion!* (1915), however, he shows a naked female, bereft of her creator. Following a work such as *"Christianae ad leones!"* an artist like Storey was destined to sabotage the classical tradition. Schmalz promoted the degeneration of the classical into the prurient. In retrospect, Schmalz's 1883 canvas *The Temple of Eros*, at 42 by 84 inches challenging the mural-like works of Poynter and Leighton, proved prophetic of Schmalz's career. A group of men and women is shown presenting offerings at the temple of the god of love, and it is the themes of love and power, the erotization of power, that concerned Schmalz in many of his productions. The canvas is an autobiographic statement of Schmalz's intentions.

Two artists provide an additional insight into the decline of the classical-subject canvas, Henry Ryland (1856–1924) and John William Godward (1861–1922). Ryland and Godward specialized in painting single-figure studies of women in classical draperies against marble walls, usually exteriors. Ryland's genre figures in pensive moods, such as *The Dreamer* (1901), exhibit affinities with the art of Tadema and Moore. Ryland specialized in painting such works as *Grecian Girls*, two figures examining papyri on a terrace; *At the Fountain*, a title taken from Leighton but reduced to mundane activity; and *Springtime*, showing two women in a Tadema exedra, with a large lyre. *A Post of Observation* and *On the Balcony*, pictures of women looking out from terraces, are Ryland derivatives of *A Coign of Vantage* and numerous other Tadema studies. The legendary woman most attracting Ryland was Oenone, which he painted several times, once as a beautiful bust, another in 1917 as an abandoned woman. In 1898 the *Artist*, discussing Ryland, noted that "popularity in these days means wider recognition than it ever did before, owing

to the many cheap reproductive processes and the consequent large demand for these reproductions. . . . A thousand coins may be struck from the same die, but if the die itself is fine the mere repetition in no way lessens its value, though our familiarity may beget a certain contempt for the oft-repeated superscription" (F. M., "Henry Ryland" 2–3). The essay refers to "types of beauty" so popular at the time, and it is unfortunate that Ryland capitulated to this market in his work, the commercialization of Tadema.

Godward's work is the commercialization of Leighton. Godward favored the bust portrait of a single woman, executed with ingenious contrasts of colors and flesh tones. Godward's work is truly a classical "gallery of beauty," presenting one dark-haired, gorgeously robed figure after another. Godward's treatment of women is completely decorative. The drapery of Leighton, the slightly monumental cast of the figures, is used for decorative purposes. The monumentality of Godward's frozen beauties reflects a tormented personal life. According to Vern Swanson, Godward was independently wealthy. He pursued the career of artist against the family's approval. The family tradition represents him as insomniac, nervous, and introverted. Godward's mother was Low Church Evangelical, very severe and religious. This may account for the fact that Godward scarcely ever painted a nude, always resorting to diaphanous robes of various colors. Although very handsome, Godward appears to have had no sexual relationships. He was found dead on 18 December 1922, from "carbon monoxide (from coal gas) poisoning—killed himself while of unsound mind," his death certificate records ("Death Certificate of John William Godward"). Although emotionally distressed and disturbed, Godward painted his idealized classical beauties in states of marmoreal calm. This representation of women was unthreatening, their monumentality obviating any personal contact. *Ismenia* (1908) (Plate C-14), combines the marble of Tadema, the monumentality of Leighton, and the plate of cherries from Poynter in this depiction of a woman from an ancient "gallery of beauty." Godward presents marbles of such color contrasts in conjunction with one another that the archaeological conviction is dissipated; the lack of authenticity is apparent.

In his figure *Autumn* (1900), Godward shows a full-length woman grasping grapes. The *Art Journal* in 1901 observed: "Of works which visitors to the New Gallery cannot fail to notice are scrupulously academic works like those of Mr. J. W. Godward" (186). This dismissal is the result of repetition of motifs. *The New Perfume* illustrates Godward's strengths and weaknesses. The table with griffin tripods and the folding stool are studio props, positioned to contrast with the variegated marble floor and wall. The figure of the woman,

in a deep-red diaphanous robe, exhibits the influence of Leighton in its meticulous folds. The eroticism of the canvas is suggested by the woman's naked breast, where she will be applying the perfume. In its use of color the canvas has merit, but the specious recreation of a domestic interior is neither convincingly detailed nor archaeologically correct in the manner of Tadema. This welding of Tadema and Leighton in Godward is a potentially beautiful but also hazardous experiment. Women are lost in trances, as in *Repose* (1899), *Idle Thoughts* (1898), *Reverie* (1910), *Day Dreams* (1900), *Contemplation* (1899), *A Souvenir* (1920), *Summer Thoughts,* and *Sweet Dreams* (1901). Godward eroticizes the trance in a work like *Contemplation,* showing a woman gazing into a small hand mirror in what appears to be a bath. The diaphanous saffron dress emphasizes the dark nipples of the woman and her pubic hair. The simpler coloring of this work and its fewer props make it a more successful canvas than *The New Perfume.* While it is unfair to condemn Godward for the nature of his work, his art and that of Ryland are the most glaring examples of classical-subject painting degenerating into galleries of beauty. This movement represents a severe decline in the classical-subject tradition as women are reduced to meaningless icons. Both Godward and Ryland, artists of the emerging era of photography, replicated their images in imitation of the very device that would destroy the distinction of their particular form of depiction.

<center>II</center>

In the late Victorian and Edwardian period Henry Scott Tuke (1858–1929) derived a distinct form of art from his predecessors. Born at York, Tuke studied under Poynter at the Slade School; he first exhibited at the Academy in 1879. In 1880 he studied in Florence, where he became aware of the artists of the classical renaissance, later advancing to Paris for study from 1881 to 1883. He visited Leighton's studio and was a friend of John Collier. Tuke specialized in the naked male youth, the parallel to the preoccupation with *jeunes filles fatales* in Waterhouse and Thomas Cooper Gotch. These pictures represent naked youths, usually at the seacoast, with strongly homosexual overtones. Jeffrey Weeks notes that Tuke, the son of a physician, "was a boy-loving artist" (*Coming Out* 29), and it is known that observers recognized this homosexual element in his work. Graham Reynolds writes in *Victorian Painting* that the dealer Dominic Colnaghi was interested in supporting the first exhibition of the New English Art Club in 1886 but finally declined when he had seen

the pictures, "particularly one study of nude boys" evidently by Tuke (194). Tuke's nude males are ideograms of Apollonian phallocentrism, either solitary figures or groups, explicitly excluding the female. The Apollonian cast is made clear in *The Coming of Day* (1901) (Plate C-15). A naked youth with arms outstretched comes upon a group of seminaked men and women in a glade. The youth is crowned with vine leaves, and behind his head a solar nimbus indicates his Apollonian status. He is Ruskin's vital power, "a strong man to run his course," a "spiritual power." He embodies the same force as the male figure in Draper's *Day and the Dawn Star* of 1906. A canvas finished in 1904, *To the Morning Sun [A Sun Worshipper]* (Plate C-16), showing a boy garbed in a loincloth saluting the sun, indicates that Tuke's nudes are derived from the Apollonian worship in predecessors like Leighton. The boy is a young priest of Apollo.

In the early part of his career, Tuke worked in the classical-subject tradition with such canvases as *Perseus and Andromeda* (1890) and *Hermes at the Pool* (1900). In the *Perseus* (Plate C-17), Tuke shows a nude male hero with a small sword raised as he extends the Medusa head before him, presumably to petrify the creature in the water. Andromeda, chained to a rock and depicted from the rear, stands mutely awaiting her rescue. John Addington Symonds wrote Tuke about the *Perseus:* "The feeling for the nude in it seems to me as delicate as it is vigorous." Later in 1903, Symonds advised Tuke to paint his nudes as studies of "nature's beauty": "Unless you are inflamed with the mythus, the poetical motive, I do not think you will bring your mastery to bear upon the work in hand if it be mythological" (Sainsbury, *Henry Scott Tuke* 106–107). Tuke, however, retained a mythological cast in subsequent pictures, and a mythological subtext informed many of his paintings of boys in the sun. In the *Registers* of his paintings, Tuke recorded that a boy modeled for the figure of Andromeda in *Perseus and Andromeda.* The homoerotic intention of the canvas suggested by this detail is confirmed in a sonnet by Tuke pasted on the same page as this entry in the *Registers.* In the poem, Tuke praises the naked beauty of Perseus, victorious in the morning light. Tuke asserts that Perseus's final conquest will be the restoration of love to the world. This poem was to be included in an anthology of "Uranian" or homosexual poetry compiled by S. E. Cottam in the nineteen-thirties (Appendix I, Price, *Registers*). He began an *Endymion* which he never finished because he could not do the Selene, and a *Leander* was finished in 1890. On a journey to Rome, Tuke had admired above all other sculpture the naked Apoxyomenos, the athlete with a scraper, and his studies of young men retain this adu-

lation of the male nude. The *Hermes at the Pool* (Plate C-18) shows a male nude resting beside a cove, the cap, wings, and caduceus signifying the god's identity. The wand is held in a hand that conceals the man's genitals. This canvas reveals the homoerotic element of Tuke's work, however, as the wand seems an extension of the god's phallus.

Tuke specialized in young men, usually two or three, gathering in coves for swimming and sun worship. Such canvases as *A Bathing Group* (1915), *Beside Green Waters* (1897) and *The Sunbathers* (1927) show two male nudes in coves. In *Noonday Heat* (1903) (Plate C-19), one naked youth and one with his trousers still on gaze at one another in unmistakable homosexual attraction. This intention is confirmed in *Tuke Reminiscences,* where B. D. Price records the existence of a watercolor version in which the reclining boy was nude rather than clad in the trousers of the oil version (21). Canvases showing groups of nude boys—such as *Ruby, Gold, and Malachite* (1902) (Plate C-20), a boating scene; *Midsummer Morning* (1908), a group of naked boys fishing; *The Swimmer's Pool* (1895), showing a cove with nude youths and a boat; *August Blue* (1894), a group of youths diving in a harbor; and *The Diver* (1899) (Plate C-21), showing a male nude about to dive—mute the homosexual connotation but do not obscure it. The title of the first suggests that Tuke worked with sun on naked flesh for abstract purposes. His visit to Greece, Italy, and the Mediterranean in 1892 influenced him to combine classicism with *pleinairisme.* Many of Tuke's canvases represent impressionistic effects. However, the latent meaning is fairly evident, for example in *The Diver.* The viewer sees the diver from the rear while one naked youth in the boat gazes intently at the front of his naked body. The same device is used in *Under the Western Sun* (1918), showing two boys drying off after swimming, with one gazing at his naked friend, who stands with his back to the viewer. Frequently Tuke gave works involving youths ambiguous titles, as in *Playmates* (1909), showing two naked youths in a boat.

Tuke painted some female figures, as in *The Pearl* (1906) and *The Secret Cave* (1912), but the females have faces that correspond to one type Tuke used in the male canvases. In *The Pearl* the two women are examining a pearl discovered in the stream, while *The Secret Cave, Nude Bather,* and *The Shell* (1911) show crouching single female nudes. More unusual are Tuke's single-figure canvases of naked men. *July Sun* (1914), *Boy on a Beach* (1913), *On the Beach, Bather in a Cove* (1919), and *Summer Dreams* (1919) depict naked young men near the water. Some of these, such as *July Sun* and *Boy on a Beach,* show the figure gazing forlornly out to sea. A full frontal nude appears in

Tuke's variation of the Narcissus legend, *The Diving Place* of 1907 (Plate C-22). A naked youth gazes into the water, self-absorbed, with no Echo present, a naked worshiper of Apollo in the bright sunlight. According to Price, the canvas was originally exhibited without the genital detail. Subsequently a purchaser requested that the genitals be defined; later, it was altered again, prompting Tuke to call it "Love in a Mist" (*Tuke Reminiscences* 21). As with *Noonday Heat,* Tuke may have camouflaged the homosexual component, but it was unquestionably present. At least one of his models, Edward John Jackett (the model for the standing figure in *The Diver*), is recorded as having ceased to pose one day when a man observing him made homosexual advances (33–34). There is some speculation that Tuke's companion from 1920 to 1929, Colin Kennedy, was homosexual. *Summer Dreams* is the Endymion without Artemis, a naked youth sleeping in midday as opposed to the naked youth asleep at night. In *Faunus* (1914), a youth peers from between bushes. Tuke's art is an example of the practice of selecting one motif from the classical-subject tradition, such as the Apollonian element, and developing it. As O'Flaherty observes, the "phallic/seminal nature of the sun" is well established and "may be extrapolated from the solar nature of seed" (*Women, Androgynes* 205).

Tuke mythologizes his young men by the unseen presence of Apollo in every one of his nude studies. Beneath these depictions is the pathetic story of Apollo and Hyacinthus. These naked youths correspond to the numerous photographs of naked boys taken by Wilhelm von Gloeden and others in the nineteenth century. Pearsall notes that Tuke's "bodies [were] carefully arranged to avoid embarrassment" (*Tell Me* 145), but these strategies arouse voyeuristic curiosity in viewers, as Tuke often included a voyeur in the canvas. Quentin Bell notes that Tuke's youths were depicted on the Cornish coast "with always a mast, a spar, a passing seagull, some blessed bollard or a supremely fortunate garland of rigging to hide their impudence" (*Victorian Artists* 63). Tuke elevates the homosexual friendships of his youths into an alternative to the culture that was increasingly granting equal status to women. Like the homosexual pairs of classical mythology, these bands of youths form a phalanx against the prerogatives of females. Tuke presents his homosexual canvases to reinforce the prerogatives of the patriarchal system. By linking his naked youths to Apollonian sun worship, Tuke, like Wetherbee in *Adventurers,* associates them with a hypermasculine, phallocentric matrix. These Aryan Apollos, excluding women from their sacred groves, signify the privileging of the male in nineteenth-century culture.

During this same period, Frank O. Salisbury exhibited *The First Dive* in 1915, showing an older male in loincloth teaching a naked boy to dive. The work recalls the homoerotic if not homosexual dimension of Leighton's *Hit!*. As in Tuke, the swimmers are in a secluded cove. The work of Tuke and others at this period is an implicit argument to support the presentation of the naked contemporary male or female, particularly the male. In 1893 the *Studio* published an essay, "The Nude in Photography," which argued: "It is forbidden, as a rule, to depict contemporary humanity seen in the way that, as a matter of fact, it is rarely seen by contemporaries, and in this lies the chief argument of its opponents" (104). This essay was illustrated by photographs of naked boys by Wilhelm von Plushow, von Gloeden, and others. One photograph of a boy shows his complete genitals, but the other photographers evidently accepted the same challenge as Tuke: to display naked youths without showing the genitals. Tuke rarely shows the genitals amid all the nudity. The inial letter beginning the *Studio* essay used the capital *C* to cut through the genitals of two young boys standing on an Ionic column. The unmistakable Mediterranean origin of the boys associates them with classical nudity. Mediterranean youths were uncircumcised at a time when circumcision, after the 1890s, was becoming favored in England, particularly in the upper classes. These photographs, as attested by such collections as that of Linley Sambourne (with its subdivisions of "Youths Bathing," "Nude Youths"), were extremely popular. Tadema had a number of von Gloeden's nude Sicilian youths in his photographic archives now at the University of Birmingham. These boys were posed against classical columns, and they were often wreathed and playing the flute. In one such file at Sambourne House several reproductions of Leighton's *Hit!* are included in the packet of nude youths.

III

The Introduction illustrated the manner in which Acton, in his remarks about prostitutes, used mythology to foster male gynophobia: "Any susceptible boy is easily led to believe, whether he is altogether overcome by the syren or not, that she, and therefore all women, must have at least as strong passions as himself" (*Functions and Disorders* 163). This condemnation parallels the classical-subject emphasis on Sirens, mermaids, or Harpies. Classical-subject painting, elevating Nausicaa, Alcestis, or Penelope, argues for the passive, compliant, self-sacrificing wife rather than the individualistic, independent, and self-assertive spouse. Anxiety about male sexuality and misogy-

nistic mistrust are evident in the myths of classical-subject art and permeated society by a process of insidious cultural indoctrination.

In 1871 an essay appeared in the *Saturday Review* that confirmed the fears of Acton's readers. The writer of "Modern Man-Haters" transforms Acton's commentary into sociological analysis. "Among the many odd social phenomena of the present day may be reckoned the class of women who are professed despisers and contemners of men; pretty misanthropes, doubtful alike of the wisdom of the past and the distinctions of nature." The man-hater is "not content with taking the more patient and negative virtues which have always been allowed to women. . . . [She] boldly bestows on them the energetic and active virtues as well, and robs men of their inborn characteristics that she may deck her own sex in their spoils." The result of this "woman's crusade against masculine supremacy" is "home life as a state of declared warfare," a society full of "the shrieking sisterhood . . . the ranks of the unsexed" (528). This statement is indicative of the manner in which the culture defined male and female natures.

The writer proceeds to define three classes of man-haters: (1) "those who have been cruelly treated by men"; (2) "those restless and ambitious persons who are less than women, greedy of notoriety, indifferent to home life"; and (3) "those who are the born vestals of nature . . . unsexed by the atrophy of their instincts" (529). The classical-subject canvases represented each of these types, respectively, in the figures of Medea, Clytemnestra, and Artemis. A week later the visitor to the Academy could have seen Leighton's *Hercules Wrestling with Death,* Poynter's *The Suppliant to Venus,* and Leslie's *Nausicaa and Her Maids,* amid other pictures. The associations arising from each are intriguing. The Leighton suggests the rescue function of male heroism by its association with texts by Euripides and Morris. The Poynter, drawing from Morris' version of Atalanta, showed Melanion waiting in the Temple of Aphrodite for an answer from Atalanta's father, King Schaeneus. Melanion is clad in a leopard skin, wearing "the red robe of the goddess's votaries," as the *Athenaeum* noted (531).

The manner in which associations were formed is suggested by the fact that the *Saturday Review* essay on man-haters and the *Athenaeum* review appeared on the same day, 29 April. The third canvas, Leslie's *Nausicaa and Her Maids,* showed the women resting from playing ball prior to the discovery of the outcast Odysseus. In each instance, the classical-subject tradition confirms social prejudice. The Leighton distinguishes men as rescuers and women as self-sacrificial; Poynter suggests the perils of Aphrodite; Leslie advances the

function of women as nurturers. In the same year, 1871, it was revealed that there were 3.5 million single women over fifteen in Britain, evidence to some of the need of rescue. At the same time, Newnham College, Cambridge, was opened, suggesting the departure of women from male control. The Park/Boulton trial for transvestism the same year suggested the loss of male identity in andyrogynous activity, intimated in the Poynter by the costume of Melanion as noted by the *Athenaeum*. The *Saturday Review* noted the "gynecian war" then in progress and warned its readers against it. The *Athenaeum* presented the enduring verities, ambiguous in their assurances, offered by the classical-subject canvases at the Academy exhibition. This association of art with social conditions became the mechanism of critical response. In December of 1871, Robert Buchanan delivered his denunciation of Rossetti, full of expressions such as "covenant to extol fleshliness," "intellectual hermaphrodite," "epicene force," "hysteria of admiration," "shameless nakedness," and "namby-pamby," all denoting the feminization of men and implicitly evoking the heroism of Leighton's Hercules or Leslie's Odysseus, an association of ideas calculated to politicize classical-subject art.

Classical-subject painting, however, was not alone in presenting images opposed to female emancipation. Sculpture and literature, by the principle of Redundancy in Culture, also conditioned the public to accept the "classical" definition of women as passive or threatening, men as heroic. Leighton's *Athlete Struggling with a Python,* a celebration of male, Apollonian heroism, initiated the movement that became known as the New Sculpture. The chief mark of this school was a new naturalism in presenting the human body. In the works of the sculptors who succeeded Leighton, the images presented were types similar to the icons of classical-subject painting. If one examines the sculptures appearing at the Royal Academy and other galleries during the classical-subject period, the frequency of mythological depictions supporting female inferiority and male superiority is evident. In 1889, Hamo Thornycroft exhibited a *Medea* while Gleichen exhibited *The Gladiator's Farewell,* showing a man parting from his wife. Images of Circe (1893 Thornycroft; 1894 MacKennal, Drury; 1909 Franklin); Perseus and/or Andromeda (1851 Bell; 1894 Fehr; 1904 Stevenson; 1907 König; 1882 Gilbert; 1898 Pomeroy; 1908 Clapperton), Euryidice (1906 Clemens; 1907 Parker), Echo (1895 Ford); Venus (1905 Jenkins); Atalanta (1896 Natorp; 1909 Derwent Wood); Diana (1898 Natorp; 1908 MacKennal); Ariadne (1908 Parker); Electra (1908 Hatch); Hero (1896 Giles); Nausicaa (1911 Gotto); mermaids (1890 Marshall; 1898 Lantéri); nymphs (1905 Pegram; 1911 Pegram; 1910 Simson, Montford); Cephalus and

Procris (1910 Clemens); Lamia (1900 Frampton); Pandora (1890 Bates); Artemis (1881 Thorncroft); Daphne (1910 Parker); Phryne (1906 Goulden), Hero and Leander (1908 Bramwell); Wounded Amazon (1908 König); and Endymion and Selene (1891 Thornycroft) were among the explicit myths presented in sculpture.

Female nudes represented allegories or devotees of divinities, as in *An Offering to Hymen* by Gilbert (1884–1886), *Summer* by Thornycroft (1893), *Maiden Shame* by Baxter (1908), *Mysteriarch* by Frampton (1892), *Invocation To the Goddess of Love* by Fehr (1897), *Oceana* by MacKennal (1897), *Even* by Drury (1898), *Fortune* by Pegram (1910), *Greek Dancer* by Bayes (1905), *The Enchanted Chair* by Gilbert (1886), *The Dancer* by MacKennal (1904), *Sibylla Fatidica* by Pegram (1904, inspired by Leighton), *Feronia* by Pomeroy (1909), *Alpheus and Arethusa* by Pegram (1911), *A Dryad* by Pomeroy (1913), and *The Mask of Pan* by Jenkins (1912). These images paralleled the selective mythology of classical-subject painting.

Male types expressing male heroism were reinforced by sculpted images such as those of *Perseus and Andromeda* (Fehr 1893), *St. George and the Rescued Maiden* (Fehr 1898), *Rescued* (Allen 1899), *Icarus* (Gilbert 1884; Richardson 1907), *Orpheus* (Weins 1910), *Teucer* (Thornycroft 1881), *The Spearman* (Pomeroy 1900), *Beyond* (Baker 1914), *David* (Zietlin 1904), *St. George* (Gilbert 1896), *Destiny* (Jenkins 1909), *Prometheus Chained* (Parker 1909), *Athenian Youth* (Rhind 1906), *Narcissus* (Parker 1906), *Greek Runner* (Richmond 1879), and *The Wounded Warrior* (Baxter 1907). A marble such as *The Woman That Thou Gavest to Be with Me* (1910) by Charles Allen shows a man embracing a sleeping woman in the pose of Leighton's *Flaming June*. The ideal wife is Acton's woman: beautiful, asleep and thus nonsexual, nonthreatening. Hamo Thornycroft, in his lecture "The Study of Ancient Sculpture," derives inspiration from the work of the Parthenon, revering the compactness of its conceptions. The Greek model was aligned with a new sense of anatomy in most of the New Sculpture. The icons presented, however, paralleled the gynophobic iconography of the classical-subject painters, caused by and causing a similar cultural indoctrination. Artists who worked in both media (Watts, Leighton, Richmond) reinforced conservative attitudes about male and female definition. Ariadne was an abandoned victim frequently shown in a stupor, a compound of several stereotypes. Women in general were either intimidating or passive and victimized; men were heroic in the manner of Prometheus or Perseus.

The mythology presented in classical-subject painting was a part of the

discourse of its cultural circumstances. It was the strategy created for cultural indoctrination as well as a result of it. Misogyny and gynophobia were the expressions of the legal, educational, familial, political, and marital suppression of women and the agitation to remove that suppression. Sexual identity determined cultural definition for women. Acton observed: "Love of home, of children, and of domestic duties are the only passions [women] feel" (*Functions and Disorders* 164), thereby equating biological with sociological and cultural destiny. Like Acton's other comments about women's sexuality, this comes from his discussion of "false impotence."

Women were raised, as Cominos observes, in an atmosphere of "repressive innocence" ("Innocent Femina Sensualis" 157). The myths of Alcestis, Naucisaa, Penelope, and Andromeda promulgated this doctrine of subservience by generating degrading associations; John Burgon, a professor of divinity at Oxford, expressed the matter succinctly in 1884: "Woman's strength lies in her essential weakness" (Burstyn, *Victorian Education* 33). The canvases of the 1870s, 1880s, and 1890s, replete with female victims and male rescuers, conveyed this message in beauteous forms. The image of the "nice girl" was one of repression—of desire, of ambition, of passion, and of equality. Such a person was confined, rescued, restricted, and controlled. Danaë is locked in the tower to prevent the consequences of her sexuality from affecting the male establishment. Women were considered prone to temptation, unintellectual, nervous from menstruation, liable to infertility if educated.

This attitude prevented women from competing for positions and preserved male hierarchies, such as existed in the Royal Academy of Arts. In *Cassandra,* Nightingale wondered, "Why is she not a Murillo?" (30), but the art institutions themselves, beginning with training and continuing through the process of exhibition and review, did not allow women equal opportunity for progress. An artist like Henrietta Rae achieved her success to some extent by her marriage with Ernest Normand and the close relationship with Leighton it made possible. Discussion in such diverse fields as anthropology reinforced the association of women with immorality. In *Custom and Myth,* Andrew Lang juxtaposes various theories of matriarchal structures. In the discussion of polyandry, he notes: "The question now is, what are the circumstances that overpower morality and decency, and so produce polyandry?" (249). He speaks of "the patriarchal or monandrous family system" (261), citing Demeter as a deity of an older, earlier, and thus less developed cultural system. In Lang, an equation of matriarchy = polyandry = immorality, and the converse, patriarchy = monandry = morality, presented women as insatiable in their sexual

instincts, corroborating Acton's gynophobic statements affirming their atavistic status. The dual and confluent forces of medicine and anthropology sustained the myths by which classical-subject painting presented *la femme, la femme fatale, la jeune fille fatale,* and *la gynandre.*

Nightingale's question "Why is she not a Murillo?" isolates the reason for the phallocentric nature of classical-subject art. Women had little opportunity to create classical canvases that would have refuted the ideograms of their male counterparts. By their exclusion from drawing the nude, male or female, they were prevented from developing the vast mythological sources available to males. Male artists during much of the nineteenth century drew from the male nude, although various schools of art would permit the female nude model. Nochlin observes about the situation of women artists: "To be deprived of this ultimate stage [the living model] of training meant, in effect, to be deprived of the possibility of creating major art works" ("Why" 33). Even in 1858 one essay noted the problem: "The hand as well as the mind must be trained and exercised. . . . Besides, there is the knowledge of anatomy, which popular prejudice deprives woman of the means of acquiring" ("Women Artists" 164). This writer believed that the classical tradition itself enforced this prejudice: "Though the ancient Greeks embodied both sculpture and painting under a female form, few women handled either the pencil or the chisel" (165).

A Royal Commission had been appointed to investigate the insularity of the Academy in 1863, and a motion of censure against the Academy had been brought in the Commons in 1876, because the restriction of membership to a very limited number of places affected both men and women. This prerogative was a coveted privilege, if for no other reason than that Academicians were allowed to exhibit as many as eight works in the annual exhibition in May. The advent of the New Woman, the liberated inheritor of legal and educational reforms during the 1880s and 1890s, did not dislodge centuries of tradition and prejudice regarding women's art. Parker and Pollock observe that in most instances Victorian writing about female artists was insidious: "Victorian writings on 'Women Artists' simultaneously recorded the existence of women artists and laid the foundations for their obliteration. Because women artists were treated, as were all women, collectively as a homogeneous group by virtue of their shared gender, and separately from artists of a different gender, women were effectively placed in an absolutely different sphere from men. Thus art by women was subsumed into bourgeois notions of femininity and furthermore, art historically, relegated to a special category which was pre-

sented as distinct from mainstream cultural activity and public professionalism
—the preserve of masculinity. Thus at the very moment of a numerical in-
crease in the numbers of women artists working professionally, women artists
were represented as different, distinct and separate on account of their sex
alone" (*Old Mistresses* 44). In 1895 Helene Postlethwaite noted in the *Maga-
zine of Art:* "Not only her talents, it would seem, would entitle [Henrietta
Rae] to be first of her sex in modern times to become one of the Immortals,
but the indomitable perseverance which has served her so well in the past"
(17). When Rae died in 1928, she had not been made "Immortal" by admis-
sion to the Academy.

When mythology was applied in critical appraisals of women's art, it was
in an offensive manner. Writing of *Quatre Bras* by Elizabeth Thompson in
the *Academy Notes* of 1875, Ruskin admitted, "I have always said that no
woman could paint." He then observes of Thompson's painting: "It is ama-
zon's work this . . . Camilla-like the work is—chiefly in its refinement, a qual-
ity I had not in the least expected, for the cleverest women almost always
show their weakness in endeavours to be dashing" (*Works* 14.308–309). Rus-
kin implies that a woman who paints well is unnatural, since Amazons cut
off one breast to facilitate their participation in battle. The opening of the
Grosvenor Gallery in 1877 afforded little hope to women artists. The founder
of the gallery, Coutts Lindsay, stated: "There are several thoughtful men in
London whose ideas and method of embodying them are strange to us. . . . I
have built the Grosvenor Gallery that their pictures, and those of every other
man I think worthy, may be fairly and honestly seen and judged" (Bullen,
"Palace of Art" 353–354). Thus because of training, tradition, and policy,
even when they did exhibit the majority of women were forced into genre,
landscape, still life, or portraiture, all of which lacked the force, eternality,
and universality of mythological canvases.

In the hierarchy of artworks, mythological presentations maintained pre-
eminence as historical works, surpassing the value of the forms to which women
were consigned. The grand scale of many classical-subject canvases indicated
they were to be considered as "historical," not fantastical, thus of the highest
category in the hierarchy of types of painting. As a result of being restricted
to lesser types of painting, the art of women lacked both status and univer-
sality. The consequence was that their art appeared ephemeral and insignifi-
cant when compared with classical-subject art. Furthermore, genre, still life,
and landscape rarely attained the status of the powerful ideogram that con-
trolled associative reaction. Writing in the *Dome* in 1899, C. J. Holmes argued

that the female sex "has produced no great artist of the first rank. . . . The women who have been successful in painting have succeeded because they followed carefully the tradition of their time, and chose to paint portraits of flowers, where the model before them made any extended use of the imagination unnecessary" (5–6). Holmes implies that female artists have no imagination and must rely on models to execute a subject. He dismisses Rosa Bonheur as an imitator of Constant Troyon, who, allegedly, was himself a mediocre artist. He demeans Kate Greenaway's art as "a convention that calls for nothing more than taste and a very moderate amount of technical skill. . . . Her choice of subject, too, is one so entirely in harmony with the sympathies of her sex, that one is astonished that women should continue to cherish masculine ambitions" (7). He advises women artists: "In choice of subject they will do well not to forget the sympathies of their sex, and to avoid aiming at the heroic, the complicated, or the grandiose. If the painting of flowers and still-life is found unsatisfying or unprofitable, the portraiture of women, children, or animals will provide a wider field for their labour." Women should be restricted "to one, or at most two, first-class models" to emulate. Women, he notes, should avoid working in oil and try pastel, pen and ink, or wood engraving. "One might sum up the whole matter by saying, 'Be narrow!' Choose the one class of subject you like, and stick to it. Choose one great model of style, and stick to him. Choose one simple medium, use no other" (8–9). As Therese Schwartz comments, these passages illustrate the tendency of critics to comment solely on the sex of the artist when discussing work by women: "It is almost impossible to find direct, critical discussion of the work itself" ("History" 19). By specifically excluding women from "the heroic," Holmes would prevent them from participating in the classical-subject tradition at all; they would have no opportunity to counteract the ideograms of male classical-subject artists. Restricted in this manner, women had no opportunity, for example, to paint Ariadne aiding Theseus. Thus there was little defense against the messages of male superiority and female inferiority enunciated in male classical-subject art.

Classical-subject painting was at its highest point of development in the last three decades of the nineteenth century and the first two decades of the twentieth. This rise coincides with gynophobic and misogynistic attitudes in medical, anthropological, legal, and educational institutions of the culture, attitudes which became more intransigent as they became more assailed by demands for women's emancipation. The images of women in anthropology and medicine were those conveyed through classical-subject canvases in the

myths of the innocent, self-sacrificing female (Alcestis, Penelope, Nausicaa, Andromache); the threatening female (Medusa, Sphinx, Helen of Troy, Lamia, Siren, Harpy, Medea, Simaetha, Danaë, mermaid, Scylla, Circe); the fierce goddess (Artemis, Demeter, Persephone, Aphrodite); the foolish female (Psyche, Pandora); the helpless victim (Andromeda); the abandoned woman (Clytie, Echo, Phyllis, Ariadne); the bestial woman (Pasiphae, mother of the Minotaur; Leda); the whore (nymphs, hamadryads, Aphrodite), and the madwoman (Bacchante, Maenad). S. P. White, the author of "Modern Mannish Maidens," in 1890 declared: "A new social era, we are told, a veritable female millennium, is at hand, even at our doors." Analyzing the political climate, the author resorted to selective prototypes to criticize this change, such as Andromache, "undying type of sweetest womanhood" (253). The writer contended that "as there are men and men, so are there women and women; and notwithstanding these vagaries in a few, the great heart of British womanhood, we are satisfied, beats true enough." This British womanhood is defined as "something akin to divinity—born of [woman's] sweetness, her weakness, her lovingness—inherent in women." To the author, this constitutes the "true gynarchy" (262, 264). More indicative is the comment: "*Place aux dames* by all means, but then, dames in their place" (260). The repetition of images of dangerous women reveals that artists acknowledged female power, a power that had to be contained by legal, educational, marital, and familial constraints. Nina Auerbach argues that men feared the "disruptive powers" (*Woman and the Demon* 42) of women.

The superiority of the patriarchal was promulgated in classical-subject pictorial ideograms by the exaltation of classical heroes like Apollo, Prometheus, Hermes, Pygmalion, Perseus, Bellerophon, Theseus, and Heracles. The canvases depicting these "rescuers" are expressions of the "virility complex" noted by Mario Praz: "an anxious desire to appear masculine" (*Romantic Agony* 238). These icons defining male and female received extensive currency through reproduction and discussion. It was not necessary to visit the Academy, the Grosvenor, or the New Gallery to view these ideograms. After 1880, the use of photogravures produced countless reproductions of these icons, frequently in a Sunday supplement or Christmas number. At the same time, series like the *Royal Academy Pictures* published by Cassell or the *Academy Notes* published by Chatto and Windus collected illustrations of the annual exhibitions. Thus, the process of the formation of misogynistic attitudes was facilitated by high art; classical-subject paintings became the channel for the justification of such attitudes. In conjunction with other cultural forces—such as the

administrative prominence of many of these artists, the early intense classical education in schools, the role-modeling of childhood reading (for example, Kingsley's *Heroes*), the publication of painters' lectures, the culturally biased extensive reviewing of annual exhibitions, the male composition of hanging committees, the slanted commentary of guidebooks such as *Academy Notes,* and the reverential biographies prefacing exhibition handbooks—classical-subject iconography exerted a powerful indoctrinating influence.

This process of attitude formation was encouraged by the actual physical presentation of the pictures in various rooms at the Royal Academy, where the juxtaposition of certain pictures in one room emphasized a misogynistic leitmotif. In 1884, for example, Gallery III included the following canvases: Normand's *A Palace, yet a Prison* (women in a harem), H. M. Paget's *Circe,* Riviere's *Actaeon* (torn to pieces by Artemis' hounds), J. R. Weguelin's *Herodias and Her Daughter,* Edwin Long's *Thisbe,* and Poynter's *Diadumenè* (sketch for the sensational canvas of the following year). The sculpture exhibited reflected this same inclination. The best known depiction of a female was C. B. Birch's *Lady Godiva.* In contrast, at least four heroic male nudes appeared: J. W. Swinnerton's *The Victor,* Onslow Ford's *Linus,* G. A. Lawson's *"Ave Caesar! Morituri te Salutant",* and Gustav Natorp's *Hercules.* In 1892, Gallery II included Leighton's *At the Fountain,* Dicksee's *Startled,* and Sydney Muschamp's *Penelope's Web;* Gallery III conjoined Weguelin's *A Whispered Question* (the Sphinx), Riviere's *Dead Hector,* Leighton's *Garden of the Hesperides,* Poynter's *When the World Was Young,* and Tadema's *The Kiss.* In the same gallery, Marcus Stone's *Two's Company, Three's None* (a man choosing between two women, all in eighteenth-century dress) emphasized female passivity and reinforced the message of the classical-subject canvases. In 1894, the third gallery included Poynter's *Horae Serenae* and *Idle Fears,* Dicksee's *The Magic Crystal,* and Beatrice Gibbs' *Psyche Mourning Cupid;* in sculpture, men were represented by Adrian Jones' *Rape of the Sabines* and Charles Allen's *Perseus Returning Victorious to the Gods,* while women were depicted in Frampton's *My Thoughts are My Children* and Alfred Drury's *Circe.* A painting in contemporary dress could reinforce such representations as well. For example, in Gallery I in 1892, Waterhouse's *Circe Invidiosa* was accompanied by Louise Jopling's *Mrs. Tree as Ophelia* and G. D. Leslie's picture of aimless Victorian womanhood *The Rose Queen.* In Academy exhibitions, therefore, the very locations of the pictures formed by their conjunctions a misogynistic text reflecting the subjects of the individual canvases themselves.

A further element influencing the formation of these attitudes was the

scale of many of the exhibited canvases. Poynter's *Atalanta's Race, Perseus and Andromeda,* and *Nausicaa and Her Maidens* each measured 58 by 174 inches, height before width, intended as murals. Solomon's *Ajax and Cassandra* (132 × 60), *Niobe* (126 × 75), *Orpheus* (84 × 60), and *The Birth of Love* (100 × 50) could overpower the specific gallery by their size, physically dominating observers by their scale and therefore their messages. Leighton's canvases frequently were commanding by size alone, as with *The Daphnephoria* (89 × 204), *Captive Andromache* (77 × 160), *Hercules Wrestling with Death* (51½ × 104½), *The Syracusan Bride* (53 × 167), or *Perseus and Andromeda* (91½ × 50). In each instance, such Leighton canvases conveyed images of captive women and Apollonian male superiority. The massive size of Richmond's *The Release of Prometheus by Hercules* (141 × 72) disseminated male heroism and triumph on so grand a scale that it defied refutation. Scale could be used to emphasize the fearsome nature of women, as with Collier's *Clytemnestra* (94 × 58) or *Maenads* (69 × 105), overwhelming beholders with icons of female malevolence or madness. In such instances, the size of the canvas, when hung and framed, became a powerful political force to privilege the male over the female and to inculcate ideas of patriarchal dominance.

As the century progressed, the fear of women increased. "In the early 1890s the theory of seduction was revised. Although much survived of the original theory, the responsibility for seduction was now said to be the work of seductive and cooperative women" (Cominos, "Innocent Femina Sensualis" 165). If one considers that this shift occurred after the repeal of the Contagious Diseases Acts in 1886, the tenacity of male attitudes is evident. The paradigm of this social attitude is Aphrodite's seduction of Anchises as painted by William Blake Richmond. The goddess lies to the man, seduces him, and then renders him impotent. Mario Praz has commented: "The function of the flame which attracts and burns is exercised, in the first half of the century, by the Fatal Man (the Byronic hero), in the second half by the Fatal Woman." Praz's argument about literature, that "even in its most artificial forms [it] reflects to some extent aspects of contemporary life" (*Romantic Agony* 206), suggests the thesis of this analysis of classical-subject art. The trajectory from *la femme* to *la gynandre* reveals the confusion of sexual identity that emerged as a result of the changing political and legal situation of women.

Classical-subject myths constituted a symbolic language and a typological system, misogynistic and gynophobic, that reflected the political nature of the period. While appearing to be distant from the nineteenth century, a myth

in actuality became an inextricable part of it. The myth chosen, the particular episode, the repetition of the myth by the same artist or the recurrence of myths during several decades, the significant detail, and the omission of certain myths too disturbing to contemplate all played a role in an associative system having political, social, and sexual dimensions. It is erroneous to claim that classical myth distanced the disturbing material. Critics from Thomas Arnold to Walter Pater emphasized that the classical world was an integral part of the nineteenth-century consciousness. It is possible to argue that the influence of Victorian and Edwardian mythologizing persists. For example, writing about William Stead's *Maiden Tribute* in 1978, Deborah Gorham contended: "Beneath the surface of contemporary [i.e., twentieth-century] psychological theory, the myths that helped to shape nineteenth-century social policy still appear to exert a covert influence on current social policy concerning female adolescents" ("'Maiden Tribute . . .' Re-examined" 379).

The mythological system and its method constituted a great artistic and political semaphore. Classical-subject canvases were ideograms replete with explicit and implicit ideologies. Either from education or from books like Kingsley's *Heroes,* men and women of the nineteenth century were familiar with even an obscure legend like Cephalus and Procris, not to mention Perseus and Andromeda or Theseus and Ariadne. A social critic like Stead would never have used such a myth in a mass-circulation newspaper if it required explanation. In the nineteenth century, what needed explanation was the contemporary situation, not the mythological prototype. The language of mythology provided two powerful elements to the political dialogue concerning men's and women's identities—universality and eternality. A critic like Ruskin, respected for both political and aesthetic pronouncements, seized this opportunity as much as did the classical-subject artists. The myths of female identity and nature in these canvases delayed the cause of social reform by virtue of the universal characteristics attributed to women, such as passivity or madness. The "eternal feminine" was defined by icons from Ariadne to Medusa, often with the suggestion that women were evolutionary atavisms. The great classical-subject artists like Leighton, Burne-Jones, Alma-Tadema, Waterhouse, Draper, Dicksee, Poynter, and Richmond were famous men, as much "Victorian sages" as were Ruskin, Carlyle, or Matthew Arnold. Like these thinkers, they were engaged in the process of cultural indoctrination, an indoctrination reinforcing Social Darwinism. These artists conveyed their own conception of Victorian Hellenism, a Hellenism they advanced with Hebraic intransigence. This Hellenism had powerful antecedents in the writings of ancient

sages. In *The Politics,* Aristotle had declared: "The male is by nature superior, and the female inferior; and the one rules, and the other is ruled; this principle, of necessity, extends to all mankind" (8). The pictorial ideograms of the classical-subject artists, an associational amalgam of gynophobia, misogyny, and anxiety, conveyed a persistent ideology about women. For men in the nineteenth century, the message of classical-subject art vis-à-vis women is summarized in the defensive political and artistic equation: female difference = inferiority.

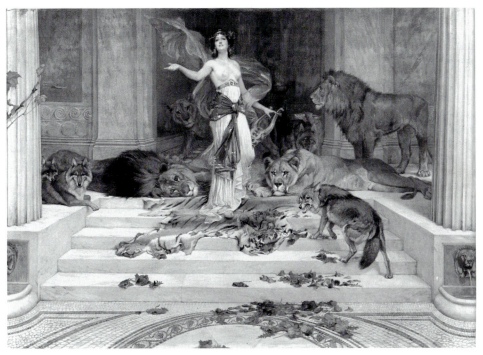

C-1. Wright Barker: *Circe*, 1912; 54 × 78; Bradford Art Galleries and Museums.

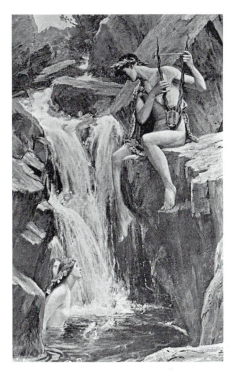

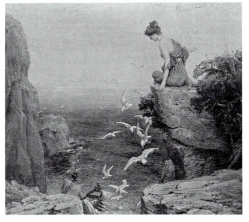

C-3. George Wetherbee: *Circe*, 1911; 38 × 44; photo: *RAP* 1911.

C-2. George Wetherbee: *Orpheus*, 1901; 50 × 30; photo: *RAP* 1901.

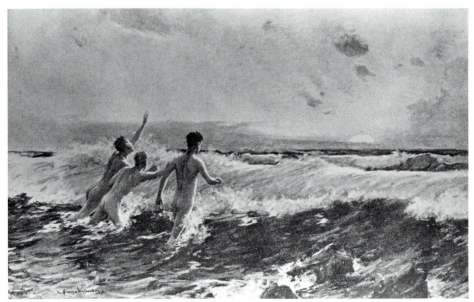

C-4. George Wetherbee: *Adventurers,* 1908; photo: *Pall Mall Pictures of 1908.*

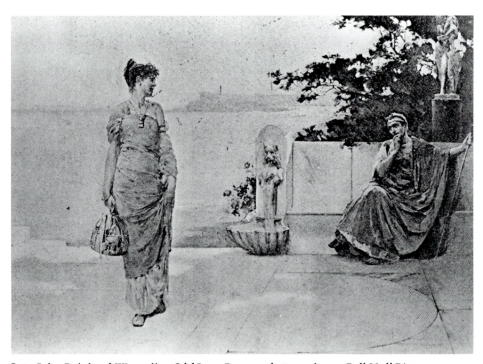

C-5. John Reinhard Weguelin: *Old Love Renewed,* 1891; photo: *Pall Mall Pictures of 1891.*

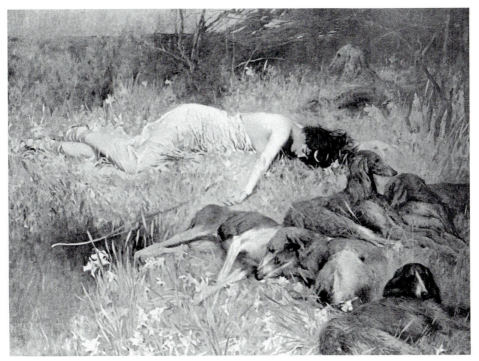

C-6. Arthur Wardle: *Diana,* 1897; 34 × 46; photo: *RAP* 1897.

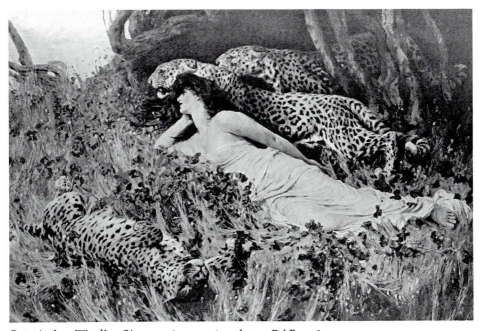

C-7. Arthur Wardle: *Circe,* 1908; 40 × 60; photo: *RAP* 1908.

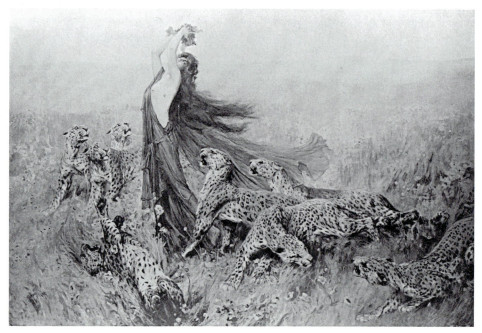

C-8. Arthur Wardle: *A Bacchante*, 1909; 40 × 60; photo: *RAP* 1909.

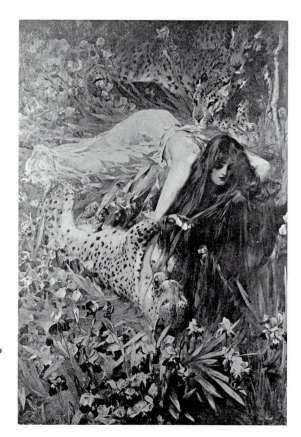

C-9. Arthur Wardle:
The Enchantress, 1901;
62 × 44; photo: *RAP*
1901.

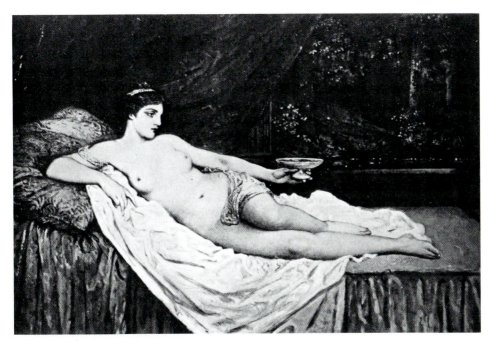

C-10. George Storey: *Circe*, 1909; 18 × 26; photo: *RAP* 1909.

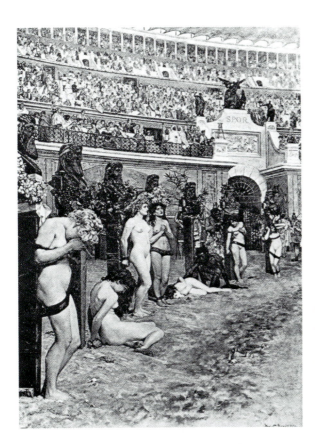

C-11. Herbert Gustave Schmalz: *Faithful unto Death: "Christianae ad leones!"*, 1888; 68 × 48; photo: *RAP* 1888.

361

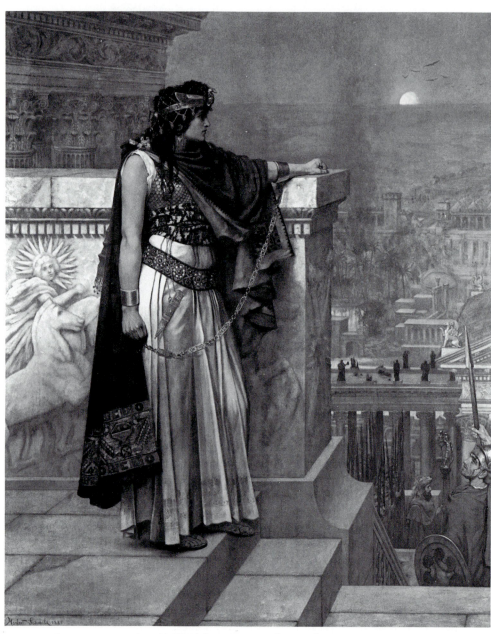

C-12. Herbert Gustave Schmalz: *Zenobia's Last Look on Palmyra*, 1888; 72½ × 60½; Art
Gallery of South Australia, Adelaide.

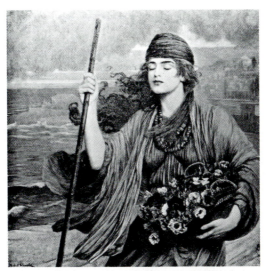

C-13. Herbert Gustave Schmalz: *Nydia, the Blind Girl of Pompeii,* 1908; 42 × 42; photo: *Pall Mall Pictures of 1908.*

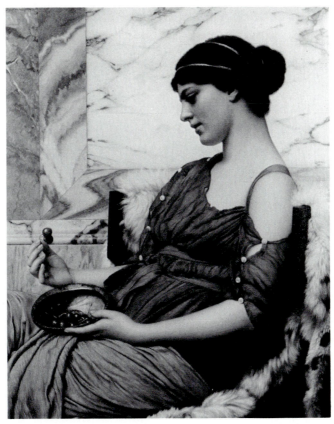

C-14. John William Godward: *Ismenia,* 1908; 31½ × 25½; photo: Sotheby's Belgravia.

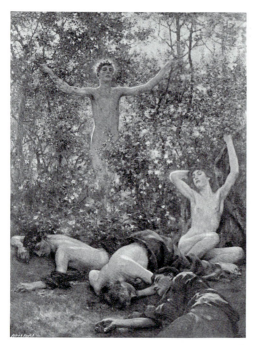

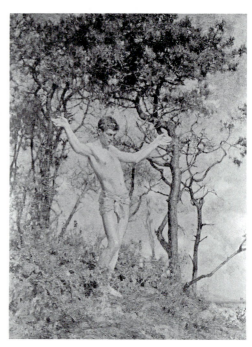

C-15. Henry Scott Tuke: *The Coming of Day,* 1901; 72 × 54; photo: *RAP* 1901.

C-16. Henry Scott Tuke: *To the Morning Sun [A Sun Worshipper],* 1904; 40 × 30; photo: *RAP* 1904.

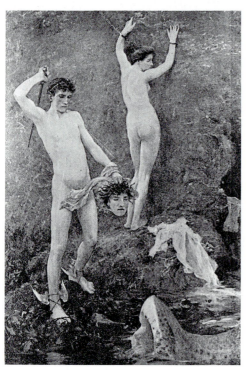

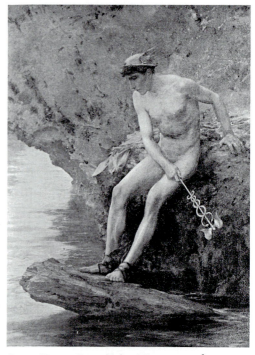

C-17. Henry Scott Tuke: *Perseus and Andromeda,* 1890; photo: *Pall Mall Pictures of 1890.*

C-18. Henry Scott Tuke: *Hermes at the Pool,* 1900; 60 × 45; photo: *RAP* 1900.

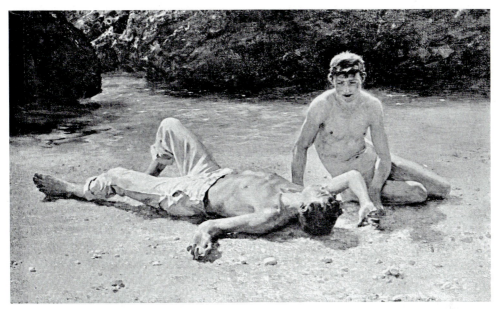

C-19. Henry Scott Tuke: *Noonday Heat,* 1903; 32 × 52; photo: *RAP* 1903.

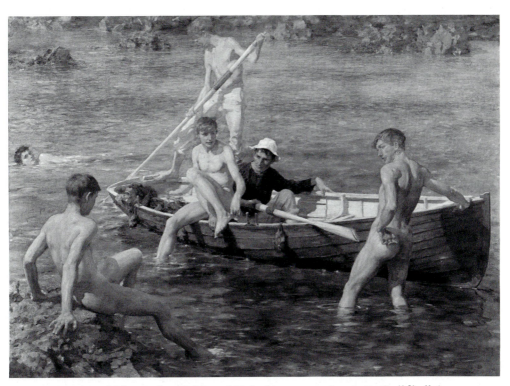

C-20. Henry Scott Tuke: *Ruby, Gold, and Malachite,* 1902; 46 × 62½; Guildhall Art Gallery, London.

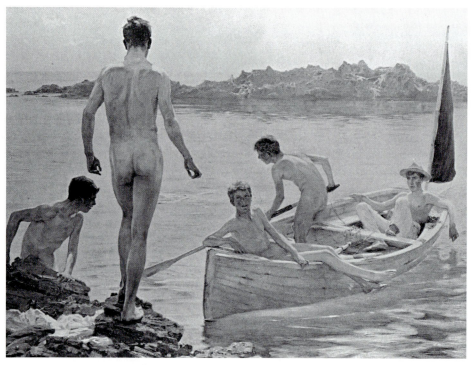

C-21. Henry Scott Tuke: *The Diver,* 1899; 50 × 70; photo: *RAP* 1899.

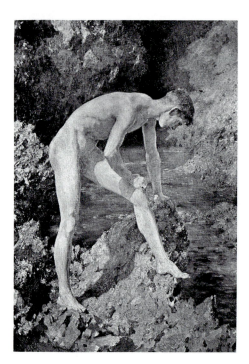

C-22. Henry Scott Tuke: *The Diving Place,* 1907; 56 × 32; photo: *RAP* 1907.

366

BIBLIOGRAPHY AND
REFERENCE LIST

INDEX

Bibliography and Reference List

THIS Bibliography is divided into three sections: Books and Monographs; Museum and Exhibition Catalogues; and Essays, Reviews, and Unpublished Materials. Throughout the text documentation is by author and short title.

BOOKS AND MONOGRAPHS

Acton, William. *The Functions and Disorders of the Reproductive Organs*. Philadelphia: Lindsay and Blakiston, 1875.

Adler, Alfred. *Study of Organ Inferiority and Its Psychical Compensation*. New York: Nervous and Mental Disease Publishing Company, 1917.

Agard, Walter. *Classical Myths in Sculpture*. Madison: University of Wisconsin Press, 1951.

Agresti, Olivia Rossetti. *Giovanni Costa: His Life, Work, and Times*. London: Gay and Bird, 1907.

Ainsworth, Maryan Wynn. *Dante Gabriel Rossetti and the Double Work of Art*. New Haven: Yale University Art Gallery, 1976.

Alston, Rowland. *The Mind and Work of G. F. Watts*. London: Methuen, 1929.

Altick, Richard D. *Paintings from Books: Art and Literature in Britain, 1760–1900*. Athens: Ohio State University Press, 1985.

Anderson, Warren D. *Matthew Arnold and the Classical Tradition*. Ann Arbor: University of Michigan Press, 1965.

Aristotle. *The Politics*. Trans. Benjamin Jowett. Oxford: Clarendon, 1885.

Armitage, Edward. *Lectures on Painting*. London: Trübner, 1883.

Arnold, Matthew. *Culture and Anarchy*. Cambridge: Cambridge University Press, 1960.

Arnold, Matthew. *Poetry and Criticism of Matthew Arnold*. Ed. A. Dwight Culler. Boston: Houghton Mifflin, 1961.

Arnold, Matthew, *Selected Prose*. New York: Penguin, 1970.

Auerbach, Nina. *Woman and the Demon*. Cambridge: Harvard University Press, 1982.

Bachofen, Johann Jakob. *Myth, Religion, and Mother Right*. Trans. Ralph Mannheim. Princeton: Princeton University Press, 1967.

Bade, Patrick. *Femme Fatale*. New York: Mayflower, 1979.

Bailey, Brian J. *William Etty's Nudes*. Bedford: Inglenook Press, 1974.

Baldry, A. Lys. *Albert Moore: His Life and Works.* London: George Bell, 1894.

Baldry, A. Lys. *Burne-Jones.* London: Jack, 1909.

Baldry, A. Lys. *Leighton.* London: Jack, 1908.

Baldry, A. Lys. *Modern Mural Decoration.* London: Newnes, 1902.

Baldwin, A. W. *The Macdonald Sisters.* London: Peter Davies, 1960.

Baldwin, Stanley. *The Torch of Freedom.* London: Hodder and Stoughton, 1937.

Barilli, Renato. *I Preraffaelliti.* Milan: Fratelli, 1967.

Barrington, Emilie [Mrs. Russell]. *G. F. Watts: Reminiscences.* London: George Allen, 1905.

Barrington, Emilie [Mrs. Russell]. *Leighton and John Kyrle.* Edinburgh: David Douglas, 1903.

Barrington, Emilie [Mrs. Russell]. *The Life, Letters and Work of Frederic Leighton.* 2 vols. New York: Macmillan, 1906.

Barthes, Roland. *Mythologies.* New York: Hill and Wang, 1972.

Bartram, Michael. *The Pre-Raphaelite Camera.* Boston: Little, Brown, 1985.

Basch, Françoise. *Relative Creatures: Victorian Women in Society and the Novel.* New York: Schocken, 1974.

Bauer, Carol, ed. *Free and Ennobled.* New York: Pergamon, 1979.

Bayliss, Wyke. *Five Great Painters of the Victorian Era.* London: S. Low, Marston, 1902.

Beattie, Susan. *The New Sculpture.* New Haven: Yale University Press, 1983.

Bell, Malcolm. *Drawings of Sir E. J. Poynter.* London: Newnes, 1906.

Bell, Malcolm. *Sir Edward Burne-Jones.* London: George Bell, 1902.

Bell, Malcolm. *Sir Edward Burne-Jones.* London: Newnes, 1907.

Bell, Malcolm. *Sir Edward Burne-Jones: A Record and Review.* London: George Bell, 1898.

Bell, Quentin. *A New and Noble School: The Pre-Raphaelites.* London: Macdonald, 1982.

Bell, Quentin. *Ruskin.* New York: Braziller, 1978.

Bell, Quentin. *Victorian Artists.* London: Academy, 1967.

Bendiner, Kenneth. *An Introduction to Victorian Painting.* New Haven: Yale University Press, 1985.

Benedetti, Maria Teresa, and Gianna Tiantoni, eds. *Burne-Jones dal preraffaellismo al simbolismo.* Milan: Mazzotta, 1986.

Bieber, Magarete. *Laocoön: The Influence of the Group since Its Recovery.* Detroit: Wayne State University Press, 1967.

Blackburn, Henry. *Academy Notes.* London: Chatto and Windus, 1875–1884.

Blackburn, Henry. *Grosvenor Notes.* London: Chatto and Windus, 1880–1889.

Blakemore, Trevor. *The Art of Herbert Schmalz.* London: George Allen, 1911.

Bloch, Ivan. *Sexual Life in England.* London: Corgi, 1965.

Blunt, Wilfrid. *"England's Michelangelo".* London: Hamish Hamilton, 1975.

Borzello, Frances. *The Artist's Model.* London: Junctin, 1982.

Bowra, C. M. *The Greek Experience.* New York: Mentor, 1957.

Branca, Patricia. *Silent Sisterhood: Middle-Class Women in the Victorian Home.* London: Croom Helm, 1975.

Broude, Norma, and Mary D. Garrard, eds. *Feminism and Art History*. New York: Harper and Row, 1982.

Bulwer-Lytton, Edward. *The Last Days of Pompeii*. New York: Heritage Press, 1957.

Burne-Jones, Edward. *The Beginning of the World*. London: Longmans, 1902.

Burne-Jones, Edward. *Letters to Katie*. London: Macmillan, 1925.

Burne-Jones, Edward. *The Little Holland House Album*. Ed. John Christian. London: Dalrymple, 1981.

B[urne]- J[ones], G[eorgiana]. *Memorials of Edward Burne-Jones*. 2 vols. London: Macmillan, 1904.

Burne-Jones. Paris: Lafitte, 1914.

Burne-Jones. Ed. May Johnson. New York: Rizzoli, 1979.

Burne-Jones: Pre-Raphaelite Drawings. New York: Dover, 1981.

Burne-Jones Talking. Ed. Mary Lago. Columbia: University of Missouri Press, 1981.

Burstyn, Joan N. *Victorian Education and the Ideal of Womanhood*. London: Croom Helm, 1980.

Calloway, Stephen. *Charles Ricketts*. London: Thames and Hudson, 1979.

Campbell, Joseph. *The Hero with a Thousand Faces*. New York: Bollingen, 1949.

Campbell, Joseph, ed. *Myths, Dreams, and Religion*. New York: Dutton, 1970.

Carlyle, Thomas. *On Heroes and Hero-Worship*. London: Dent, 1908.

Carpenter, Edward. *Love's Coming of Age*. New York: Boni and Liveright, 1911.

Carr, J. Comyns. *Coasting Bohemia*. London: Macmillan, 1914.

Carr, J. Comyns. *Papers on Art*. London: Macmillan, 1885.

Carr, J. Comyns. *Some Eminent Victorians*. London: Duckworth, 1908.

Casteras, Susan. *Images of Victorian Womanhood in English Art*. Rutherford, N.J.: Farleigh Dickinson University Press, 1987.

Catullus, Gaius Valerius. *The Poems of Catullus*. Trans. Peter Whigham. Baltimore: Penguin, 1966.

Cecil, David. *Visionary and Dreamer: Samuel Palmer and Edward Burne-Jones*. London: Academy, 1977.

Ceram, C. W. *Gods, Graves, and Scholars*. New York: Bantam, 1972.

Chesney, Kellow. *The Victorian Underworld*. New York: Schocken, 1972.

Christian, John. *The Pre-Raphaelites in Oxford*. Oxford: Ashmolean Museum, 1974.

Clapp, Jane. *Art Censorship*. Metuchen, N.J.: Scarecrow Press, 1972.

A Collection of Essays on Lord Leighton and His Works. London: Kensington Public Library, c. 1898.

Cooke, Nicholas Francis. *Satan in Society*. Cincinnati: C. F. Vent, 1876.

Corkran, Alice. *Frederic Leighton*. London: Methuen, 1904.

Craik, Dinah Mulock. *A Woman's Thoughts about Women*. Philadelphia: Peterson, 1858.

Crane, Walter. *An Artist's Reminiscences*. New York: Macmillan, 1907.

Curle, Brian, ed. *Lord Leighton's Letters*. London: Kensington and Chelsea Libraries and Arts Service, 1983.

Delamont, Sara, and Lorna Duffin. *The Nineteenth-Century Woman: Her Cultural and Physical World*. London: Croom Helm, 1978.

DeLaura, David. *Hebrew and Hellene in Victorian England.* Austin: University of Texas Press, 1969.

Delevoy, Robert L. *Symbolists and Symbolism.* New York: Rizzoli, 1978.

DeLisle, Fortunee. *Burne-Jones.* London: Methuen, 1904.

Dijkstra, Bram. *Idols of Perversity: Fantasies of Feminine Evil in Fin-de-Siècle Culture.* New York: Oxford University Press, 1986.

Dorment, Richard. *Alfred Gilbert.* New Haven: Yale University Press, 1985.

Dorson, Richard M. *The British Folklorists.* Chicago: University of Chicago Press, 1968.

Dorson, Richard M., ed. *Peasant Customs and Savage Myths.* 2 vols. Chicago: University of Chicago Press, 1968.

Doughty, Oswald, *A Victorian Romantic: Dante Gabriel Rossetti.* London: Muller, 1949.

Doughty, Oswald, and J. R. Wahl, eds. *Letters of Dante Gabriel Rossetti.* 4 vols. Oxford: Clarendon, 1965–1966.

Du Maurier, George. *Trilby.* Ed. Peter Alexander. London: Allen, 1982.

Edwardes, Allen, and R. E. L. Masters. *The Cradle of Erotica.* New York: Julian Press, 1962.

Eliade, Mircea. *Myth and Reality.* Trans. Willard Trask. New York: Harper, 1963.

Eliade, Mircea. *The Myth of the Eternal Return.* Princeton: Princeton University Press, 1971.

Ellmann, Mary. *Thinking about Women.* London: Virago, 1979.

Engen, Rodney K. *Walter Crane as a Book Illustrator.* London: Academy, 1975.

Farr, Dennis. *William Etty.* London: Routledge and Kegan Paul, 1958.

Faverty, Frederic E. *Matthew Arnold the Ethnologist.* Evanston: Northwestern University Press, 1951.

Feldman, Burton, and Robert D. Richardson. *The Rise of Modern Mythology, 1680–1860.* Bloomington: Indiana University Press, 1972.

Fish, Arthur. *Henrietta Rae.* London: Cassell, 1905.

Fitzgerald, Penelope. *Edward Burne-Jones: A Biography.* London: Michael Joseph, 1975.

Frazer, James. *The Golden Bough.* New York: Macmillan, 1922.

Fredeman, William E. *The Pre-Raphaelites: A Bibliocritical Study.* Cambridge: Harvard University Press, 1965.

Fredericksen, Burton B. *Alma-Tadema's "Spring."* Malibu: Getty Museum, 1978.

Freud, Sigmund. *Leonardo da Vinci.* New York: Random House, 1947.

Freud, Sigmund. *Sexuality and the Psychology of Love.* Ed. Philip Rieff. New York: Collier, 1963.

Freud, Sigmund. *Three Essays on the Theory of Sexuality.* Introduction by Steven Marcus. New York: Basic Books, 1962.

Fromm, Erich. *The Art of Loving.* New York: Harper and Row, 1974.

Fry, Roger. *Reflections on British Painting.* New York: Macmillan, 1934.

Fulford, Roger. *Votes for Women.* London: Faber and Faber, 1958.

Gaunt, William. *The Aesthetic Adventure.* London: Cape, 1945.

Gaunt, William. *The Pre-Raphaelite Dream.* New York: Schocken, 1966.

Gaunt, William. *The Restless Century.* Oxford: Phaidon, 1972.

Gaunt, William. *Victorian Olympus.* New York: Oxford University Press, 1952.

Gaunt, William, and F. Gordon Roe. *Etty and the Nude.* Leigh-on-Sea: F. Lewis, 1943.

Gilbert, Sandra, and Susan Gubar. *The Madwoman in the Attic.* New Haven: Yale University Press, 1979.

Gilchrist, Alexander. *Life of William Etty, R.A.,* 2 vols. London: David Bogue, 1855.

Gordon, Caroline, ed. *British Paintings of the Nineteenth Century.* London: Warne, 1981.

Gorham, Deborah. *The Victorian Girl and the Feminine Ideal.* London: Croom Helm, 1982.

Graves, Algernon, ed. *Dictionary of Artists in London, 1884–1901.* New York: Lenox Hill, 1970.

Graves, Algernon, ed. *The Royal Academy of Arts.* 8 vols. London: George Bell, 1906.

Graves, Robert. *The Greek Myths.* 2 vols. Baltimore: Penguin, 1955.

Greenhalgh, Michael. *The Classical Tradition in Art.* New York: Harper and Row, 1978.

Grieve, Alastair. *The Art of Dante Gabriel Rossetti. Found: The Pre-Raphaelite Modern-Life Subject.* Norwich: Real World Publications, 1976.

Grieve, Alastair. *The Art of Dante Gabriel Rossetti: The Pre-Raphaelite Period, 1848–1850.* Norwich: Real World Publications, 1973.

Grieve, Alastair. *The Art of Dante Gabriel Rossetti: The Watercolours and Drawings of 1850–1855.* Norwich: Real World Publications, 1978.

Haller, John S., and Robin M. Haller. *The Physician and Sexuality in Victorian America.* New York: Norton, 1974.

Hamerton, A. James. *Emigrant Gentlewomen: Genteel Poverty and Female Emigration, 1830–1914.* London: Croom Helm 1979.

Harding, James. *Artistes Pompiers.* London: Academy, 1979.

Harding, James. *The Pre-Raphaelites.* New York: Rizzoli, 1977.

Harrison, Jane E. *Ancient Art and Ritual.* London: Williams and Norgate, 1913.

Harrison, Jane E. *Myths of Greece and Rome.* London: Benn, 1927.

Harrison, Jane E. *Prolegomena to the Study of Greek Religion.* Cambridge: Cambridge University Press, 1903.

Harrison, Jane E. *Themis: A Study of the Social Origins of Greek Religion.* Cambridge: Cambridge University Press, 1912.

Harrison, Jane E., ed. *Manual of Ancient Sculpture,* by Pierre Paris. London: Grevel, 1890.

Harrison, Jane E., ed. and trans. *Manual of Mythology in Relation to Greek Art,* by Maxime Collingnon. London: Grevel, 1899.

Harrison, Martin. *Pre-Raphaelite Paintings and Graphics.* London: Academy, 1971.

Harrison, Martin, and Bill Waters. *Burne-Jones.* London: Barrie and Jenkins, 1973.

Hartland, Edwin Sidney. *The Legend of Perseus.* 3 vols. London: Nutt, 1894.

Hellerstein, Erna, ed. *Victorian Women.* Stanford: Stanford University Press, 1981.

Henderson, Marina. *Dante Gabriel Rossetti.* London: Academy, 1973.

Hesiod. *Theogony.* Trans. Norman O. Brown. New York: Bobbs-Merrill, 1953.

Hewitt, Margaret. *Wives and Mothers in Victorian Industry.* London: Rockcliff, 1958.

Highet, Gilbert. *The Classical Tradition.* New York: Oxford, 1957.

Hilton, Timothy. *The Pre-Raphaelites.* New York: Praeger, 1970.

Hobson, Anthony. *The Art and Life of J. W. Waterhouse.* New York: Rizzoli, 1980.

Homer. *The Iliad.* Trans. Richmond Lattimore. Chicago: University of Chicago Press, 1951.

The Homeric Hymns. Trans. A. N. Athanassakis. Baltimore: Johns Hopkins University Press, 1976.

Honour, Hugh. *Neo-Classicism.* New York: Penguin, 1968.

Horace [Q. Horatius Flaccus]. *Opera.* Oxford: Clarendon, 1963.

Hough, Graham. *The Last Romantics.* London: Duckworth, 1947.

Houghton, Walter E., and G. Robert Stange, eds. *Victorian Poetry and Poetics.* Boston: Houghton Mifflin, 1959.

Hueffer, Ford M. *Ford Madox Brown: A Record of His Life and Works.* London: Longmans, 1896.

Hueffer, Ford M. *The Pre-Raphaelites.* London: Duckworth, 1907.

Hunt, William Holman. *Pre-Raphaelitism and the Pre-Raphaelite Brotherhood.* 2 vols. New York: Macmillan, 1905.

Irwin, David. *English Neoclassical Art.* London: Faber and Faber, 1966.

James, Henry. *The Painter's Eye.* Ed. John L. Sweeney, Cambridge: Harvard University Press, 1956.

Jenkyns, Richard. *The Victorians and Ancient Greece.* Cambridge: Harvard University Press, 1980.

Johnston, William R. *The Nineteenth Century Paintings in the Walters Art Gallery.* Baltimore: Walters Art Gallery, 1982.

Jones, Ernest. *Hamlet and Oedipus.* New York: Norton, 1949.

Julian, Philippe. *Dreamers of Decadence.* New York: Praeger, 1971.

Kent, Sarah, and Jacqueline Morreau, eds. *Women's Images of Men.* New York: Writers and Readers, 1985.

Kerényi, Karl. *Apollo.* Dallas: Springer, 1983.

Kerényi, Karl. *Athene.* Dallas: Springer, 1978.

Kerényi, Karl. *Goddesses of Sun and Moon.* Dallas: Springer, 1979.

Kerényi, Karl. *The Gods of the Greeks.* London: Thames and Hudson, 1951.

Kerényi, Karl. *Hermes.* Dallas: Springer, 1976.

Kerényi, Karl. *The Heroes of the Greeks.* London: Thames and Hudson, 1959.

Kerényi, Karl, and C. G. Jung. *Essays on a Science of Mythology.* Princeton: Princeton University Press, 1969.

Kestner, Joseph. *Protest and Reform: The British Social Narrative by Women, 1827–1867.* Madison: University of Wisconsin Press; London: Methuen, 1985.

Kingsley, Charles. *The Heroes.* London: Blackie and Son, [1855].

Kingsley, Charles. *Hypatia.* London: Collins, 1853.

Klein, Melanie. *Envy and Gratitude and Other Works.* New York: Dell, 1975.

Knight, Richard Payne. *A Discourse on the Worship of Priapus.* In *Sexual Symbolism,* ed. Ashley Montagu. New York: Julian Press, 1957.

Konody, Paul G. *The Art of Walter Crane.* London: George Bell, 1902.

Lambert, Angela. *Unquiet Souls.* New York: Harper and Row, 1984.

Lambourne, Lionel. *An Introduction to "Victorian" Genre Painting.* London: Victoria and Albert Museum, 1982.

Landow, George P. *Victorian Types, Victorian Shadows.* Boston: Routledge and Kegan Paul, 1980.

Landow, George P. *William Holman Hunt and Typological Symbolism.* New Haven: Yale University Press, 1979.

Lang, Andrew. *Custom and Myth.* London: Longmans, Green, 1884.

Lang, Andrew. *Modern Mythology.* London: Longmans, Green, 1897.

Lang, Andrew. *Myth, Ritual, and Religion.* London: Longmans, Green, 1887.

Lansbury, Coral. *The Old Brown Dog: Women, Workers, and Vivisection in Edwardian England.* Madison: University of Wisconsin Press, 1985.

Larrabee, Stephen A. *English Bards and Grecian Marbles.* New York: Columbia University Press, 1943.

Leary, Emmeline. *The Holy Grail Tapestries.* Birmingham: Birmingham Museums and Art Gallery, 1985.

Lefkowitz, Mary R. *Women in Greek Myth.* Baltimore: Johns Hopkins University Press, 1986.

Leighton, Frederic. *Addresses Delivered to the Students of the Royal Academy.* London: Kegan Paul, Trench, 1896.

Lessing, Gotthold Ephraim. *Laocoön.* Trans. Ellen Frothingham. New York: Noonday, 1969.

Lewis, Jane. *Women in England, 1870–1950.* Bloomington: Indiana University Press, 1984.

Lewis, Roger C., and Mark Lasner, eds. *Paintings and Drawings of Elizabeth Siddal.* Wolfville, Nova Scotia: Wombat Press, 1978.

Lister, Raymond. *Victorian Narrative Paintings.* New York: Potter, 1966.

Löcher, Kurt. *Der Perseus-Zyklus von Edward Burne-Jones.* Stuttgart: Staatsgalerie Stuttgart, 1973.

Lombroso, Cesare, and William Ferrero. *The Female Offender.* New York: Appleton, 1899.

Lucie-Smith, Edward. *Eroticism in Western Art.* London: Thames and Hudson, 1972.

Lutyens, Mary. *Millais and the Ruskins.* London: Murray, 1967.

Lutyens, Mary. *The Order of Release.* London: Murray, 1947.

Lutyens, Mary. *The Ruskins and the Grays.* London: Murray, 1972.

Maas, Jeremy. *Gambart, Prince of the Victorian Art World.* London: Barrie and Jenkins, 1975.

Maas, Jeremy. *Victorian Painters.* London: Barrie and Jenkins, 1970.

MacKendrick, Paul. *The Greek Stones Speak.* New York: New American Library, 1962.

MacKendrick, Paul. *The Mute Stones Speak.* New York: New American Library, 1960.

Maclaren, Archibald. *The Fairy Family.* Illustrated by Edward Burne-Jones. Ed. John Christian. London: Dalrymple Press, 1985.

Malinowski, Bronislaw. *Myth in Primitive Psychology.* New York: Norton, 1924.

Manning, Elfrida. *Marble and Bronze: The Art and Life of Hamo Thornycroft.* London: Trefoil Books, 1982.

Marcus, Steven. *The Other Victorians: A Study of Sexuality and Pornography in Mid-Nineteenth-Century England.* New York: New American Library, 1964.

Mariller, H. C. *History of the Merton Abbey Tapestry Works.* London: Constable, 1927.

Marsh, Jan. *The Pre-Raphaelite Sisterhood.* New York: St. Martin's, 1985.

McHugh, Paul. *Prostitution and Victorian Social Reform.* London: Croom Helm, 1980.

Mill, John Stuart. *Mill's Ethical Writings.* Ed. J. B. Schneewind. New York: Collier, 1965.

Mill, John Stuart. *On Liberty.* New York: Norton, 1975.

Mill, John Stuart. *The Subjection of Women.* Chicago: University of Chicago Press, 1970.

Mill, John Stuart. *The Works of John Stuart Mill.* Ed. John Robson. Toronto: University of Toronto Press, 1963.

Millais, Geoffrey. *Sir John Everett Millais.* London: Academy, 1979.

Millais, John Guille. *The Life and Letters of Sir John Everett Millais.* 2 vols. London: Methuen, 1899.

Milner, John. *Symbolists and Decadents.* New York: Dutton, 1971.

Mitchell, Sally. *The Fallen Angel: Chastity, Class, and Women's Reading, 1835–1850.* Bowling Green: Bowling Green University Popular Press, 1981.

Modern Sculpture. 2 vols. London: Academy Architecture, 1912.

Monick, Eugene. *Phallos.* Toronto: Inner City Books, 1987.

Morris, William. *The Earthly Paradise. Collected Works,* Vol. 3. London: Longmans, Green, 1910.

Mullahy, Patrick, *Oedipus: Myth and Complex.* New York: Grove, 1948.

Müller, Max. *Comparative Mythology.* Ed. A Smythe Palmer. London: G. Routledge and Sons, 1909.

Müller, Max. *Essays on Mythology, Traditions, and Customs.* New York: Scribner's, 1869.

Murray, Henry A., ed. *Myth and Mythmaking.* Boston: Beacon Press, 1968.

Murray, Janet, ed. *Strong-Minded Women.* New York: Pantheon, 1982.

My Secret Life. New York: Grove, 1966.

Neff, Wanda. *Victorian Working Women.* New York: Columbia University Press, 1929.

Neumann, Erich. *Amor and Psyche.* New York: Harper and Row, 1956.

Nicoll, John. *Dante Gabriel Rossetti.* New York: Macmillan, 1975.

Nicoll, John. *The Pre-Raphaelites.* New York: Dutton, 1970.

Nightingale, Florence. *Cassandra.* Old Westbury, N.Y.: Feminist Press, 1979.

O'Flaherty, Wendy Doniger. *Women, Androgynes, and Other Mythical Beasts.* Chicago: University of Chicago Press, 1980.

Ogilvie, R. M. *Latin and Greek: A History of the Influence of the Classics on English Life from 1600 to 1918.* Hamden, Conn.: Archon, 1969.

O'Neill, William. *The Woman Movement.* London: Allen and Unwin, 1969.

Ormond, Leonée. *George du Maurier.* London: Routledge and Kegan Paul, 1969.

Ormond, Leonée, and Richard Ormond. *Lord Leighton.* New Haven: Yale University Press, 1975.

Ormond, Richard. *Leighton's Frescoes.* London: Victoria and Albert Museum, 1975.

Ovenden, Graham, and Peter Mendes. *Victorian Erotic Photography.* London: Academy, 1973.

Ovid [P. Ovidius Naso]. *The Heroides.* Trans. Grant Showerman. Cambridge: Harvard University Press, 1977.

Ovid [P. Ovidius Naso]. *The Metamorphoses.* Trans. Horace Gregory. New York: New American Library, 1958.

Pankhurst, Sylvia. *The Suffragette Movement.* London: Longman, 1931.

Panofsky, Dora, and Erwin Panofsky. *Pandora's Box.* New York: Harper and Row, 1962.

Parker, Rozsika, and Griselda Pollock. *Old Mistresses: Women, Art, and Ideology.* New York: Pantheon, 1981.

Parris, Leslie, ed. *Pre-Raphaelite Papers.* London: Tate Gallery, 1984.

Pater, Walter. *Greek Studies.* New York: Macmillan, 1895.

Pater, Walter. *Marius the Epicurean.* New York: Boni and Liveright, 1921.

Pater, Walter. *The Renaissance.* New York: Mentor, 1959.

Payne, Sandra K. *Atkinson Grimshaw: Knight's Errand.* Reading, Berkshire: T. A. Printers, 1987.

Pearsall, Ronald. *Tell Me, Pretty Maiden: The Victorian and Edwardian Nude.* London: Book Club Associates, 1981.

Pearsall, Ronald. *The Worm in the Bud: The World of Victorian Sexuality.* Harmondsworth: Penguin, 1971.

Phillips, O. S. *Solomon J. Solomon.* London: H. Joseph, 1933.

Pierrot, Jean. *The Decadent Imagination, 1880–1900.* Chicago: University of Chicago Press, 1981.

Plato. *Timaeus* [and *Critias*]. Trans. H. D. P. Lee. Baltimore: Penguin, 1971.

Pointon, Marcia. *William Dyce.* Oxford: Clarendon, 1979.

Poliakov, Léon. *The Aryan Myth.* Trans. Edmund Howard. New York: Basic Books, 1971.

Poynter, Edward J. *Ten Lectures on Art.* London: Chapman and Hall, 1880.

Praz, Mario. *The Romantic Agony.* New York: Meridian, 1956.

Pre-Raphaelite Illustrations. New York: Rizzoli, 1979.

Price, Brian D., ed. *Registers of Henry Scott Tuke.* Falmouth: Royal Cornwall Polytechnic Society, 1983.

Price, Brian D., ed. *Tuke Reminiscences.* Falmouth: Royal Cornwall Polytechnic Society, 1983.

Pugin, A. W. S. *Contrasts.* Leicester: Leicester University Press, 1973.

Pugin, A. W. S. *The True Principles of Pointed Architecture.* London: Academy, 1973.

Quennell, Peter. *John Ruskin: The Portrait of a Prophet.* London: Collins, 1949.

Quick, Richard. *Edwin Long.* Bournemouth: County Borough of Bournemouth, 1931.

Quilter, Harry. *The Academy, 1872–1882.* London: Kegan Paul, Trench, 1883.

Raglan, Lord [Fitzroy Somerset IV]. *The Hero.* New York: Meridian, 1979.

Rank, Otto. *The Double.* New York: New American Library, 1971.

Rank, Otto. *The Myth of the Birth of the Hero.* New York: Vintage Books, 1959.

Rank, Otto. *The Trauma of Birth.* New York: Harper and Row, 1973.

Read, Benedict. *Millais.* London: Medici Society, 1983.

Read, Benedict. *Victorian Sculpture.* New Haven: Yale University Press, 1982.

Report on the Papers of Frederic, Lord Leighton, in the Custody of the Royal Academy of Arts. Ed. Jean Agnew. London: Royal Commission on Historical Manuscripts, 1974.

Reynolds, Graham. *Painters of the Victorian Scene.* London: Batsford, 1953.

Reynolds, Graham. *Victorian Painting.* New York: Macmillan, 1966.

Reynolds, Joshua. *Discourses on Art.* Ed. Robert Wark. New Haven: Yale University Press, 1975.

Reynolds, Simon. *The Vision of Simeon Solomon.* Stroud: Catalpa Press, 1984.

Rhys, Ernest. *Frederic, Lord Leighton.* London: Bell, 1898.

Rhys, Ernest. *Frederic, Lord Leighton.* London: Bell, 1904.

Rhys, Ernest. *Sir Frederic Leighton.* Preface by F. G. Stephens. London: George Bell, 1895.

Robertson, W. Graham. *Time Was.* London: Hamish Hamilton, 1931.

Roheim, Géza. *The Panic of the Gods.* New York: Harper and Row, 1972.

Rose, Andrea. *Pre-Raphaelite Portraits.* Yeovil, Somerset: Oxford Illustrated, 1981.

Rose, Andrea. *The Pre-Raphaelites.* London: Phaidon, 1977.

Rosenberg, John. *The Darkening Glass: A Portrait of Ruskin's Genius.* New York: Columbia University Press, 1961.

Rosenblum, Robert. *Transformations in Late-Eighteenth-Century Art.* Princeton: Princeton University Press, 1967.

Rosenblum, Robert, and H. W. Janson. *Nineteenth-Century Art.* New York: Abrams, 1984.

Rossetti, William Michael. *Dante Gabriel Rossetti as Designer and Writer.* London: Cassell, 1889.

Rossetti, William Michael, ed. *The Germ.* New York: AMS, 1965.

Rossetti, William Michael, ed. *Ruskin: Rossetti: Pre-Raphaelitism.* London: Allen, 1899.

Rothenstein, William. *Men and Memories, 1872–1938.* Columbia, Mo.: University of Missouri Press, 1978.

Rowland, Benjamin. *The Classical Tradition in Western Art.* Cambridge: Harvard University Press, 1963.

Royal Academy Illustrated. London: Walter Judd, 1916–1925.

Royal Academy Illustrated. Ed. Henry Lassalle. London: Sampson Low, Marston, 1884, 1885.

Royal Academy Pictures. London: Cassell, 1888–1914.

Ruskin, John *The Genius of John Ruskin.* Ed. John Rosenberg, Boston: Houghton Mifflin, 1963.

Ruskin, John. *The Works of John Ruskin.* Ed. E. T. Cook and Alexander Wedderburn. 39 vols. London: Allen, 1902–1912.

Sainsbury, Maria T. *Henry Scott Tuke.* London: Secker, 1933.

St. Clair, William. *Lord Elgin and the Marbles.* New York: Oxford, 1983.

Sambrook, James, ed. *Pre-Raphaelitism: A Collection of Critical Essays.* Chicago: University of Chicago Press, 1974.

Sebeok, Thomas, ed. *Myth: A Symposium.* Bloomington: Indiana University Press, 1958.

Sharp, William. *Fair Women in Painting and Poetry.* London: Seeley, 1894.

Showalter, Elaine. *The Female Malady.* New York: Pantheon, 1985.

Showalter, Elaine. *A Literature of Their Own.* Princeton: Princeton University Press, 1977.

Simon, Bennett. *Mind and Madness in Ancient Greece.* Ithaca: Cornell University Press, 1978.

Spacks, Patricia. *The Female Imagination.* New York: Knopf, 1975.

Spalding, Frances. *Magnificent Dreams: Burne-Jones and the Late Victorians.* New York: Dutton, 1978.

Spencer, Herbert. *The Study of Sociology.* Ann Arbor: University of Michigan Press, 1961.

Spencer, Isobel. *Walter Crane.* New York: Macmillan, 1975.

Spencer, Robin. *The Aesthetic Movement.* New York: Dutton, 1972.

Spielmann, M. H. *Millais and His Works.* London: Blackwood, 1898.

Spitz, Ellen Handler. *Art and Psyche.* New Haven: Yale University Press, 1985.

Staley, Allen. *The Pre-Raphaelite Landscape.* Oxford: Clarendon, 1973.

Staley, Edgcumbe. *Lord Leighton of Stretton.* London: Scott, 1906.

Standing, Percy Cross. *Sir Lawrence Alma-Tadema.* London: Cassell, 1905.

Steiner, George. *Antigones.* New York: Oxford University Press, 1984.

Stephens, F. G. *Dante Gabriel Rossetti.* London: Seeley, 1894.

Stirling, A. M. W. *A Painter of Dreams.* London: John Lane, 1916.

Stirling, A. M. W. *The Richmond Papers.* London: William Heinemann, 1926.

Stocking, George W. *Victorian Anthropology.* New York: Free Press, 1987.

Strachey, Ray. *The Cause.* London: George Bell, 1928.

Strickland, Margot. *Angela Thirkell.* London: Duckworth, 1977.

Summerson, John. *The Classical Language of Architecture.* London: Thames and Hudson, 1963.

Surtees, Virginia. *The Paintings and Drawings of Dante Gabriel Rossetti: A Catalogue Raisonné.* 2 vols. Oxford: Clarendon, 1971.

Swanson, Vern G. *Sir Lawrence Alma-Tadema.* London: Ash and Grant, 1977.

Symonds, John Addington. *A Problem in Greek Ethics.* New York: Haskell, 1971.

Symonds, John Addington. *A Problem in Modern Ethics.* New York: Blom, 1971.

Symonds, John Addington. *Studies of the Greek Poets.* 2 vols. London: Smith, Elder, 1873.

Theocritus. *Idylls.* In *Greek Pastoral Poetry.* Trans. Anthony Holden. Baltimore: Penguin, 1974.

Theweleit, Klaus. *Male Fantasies, 1: Women, Floods, Bodies, History.* Trans. Stephen Conway. Minneapolis: University of Minnesota Press, 1987.

Thirkell, Angela. *Three Houses.* London: Oxford University Press, 1931.

Thomson, Patricia. *The Victorian Heroine.* London: Oxford University Press, 1956.

Tremain, Rose. *The Fight for Freedom for Women.* New York: Ballantine, 1973.

Tsigakou, Fani-Maria. *The Rediscovery of Greece.* New Rochelle, N.Y.: Caratzas, 1981.

Turner, Frank M. *The Greek Heritage in Victorian Britain.* New Haven: Yale University Press, 1981.

Vicinus, Martha, ed. *Suffer and Be Still: Women in the Victorian Age.* Bloomington: Indiana University Press, 1972.

Vicinus, Martha, ed. *A Widening Sphere.* Bloomington: Indiana University Press, 1977.

Von Gloeden, Wilhelm. *Taormina.* Introduction by Roland Barthes. Pasadena, Ca.: Twelvetrees Press, 1986.

Von Schleinitz, Otto. *Burne-Jones.* Leipzig: Von Velhagen and Klafing, 1901.

Von Schleinitz, Otto. *Walter Crane.* Leipzig: Von Velhagen and Klafing, 1902.

Walkowitz, Judith R. *Prostitution and Victorian Society.* London: Cambridge University Press, 1980.

Walters, Margaret. *The Male Nude.* New York: Penguin, 1978.

Warner, Marina. *Monuments and Maidens: The Allegory of the Female Form.* New York: Atheneum, 1985.

Waters, William. *Burne-Jones.* Aylesbury: Shire, 1973.

Waters, William. *Laus Veneris by Burne-Jones.* Newcastle: Laing Art Gallery, 1973.

Watts, Mary. *George Frederic Watts: The Annals of an Artist's Life.* 3 vols. London: Macmillan, 1912.

Webb, Peter, *The Erotic Arts.* London: Secker and Warburg, 1983.

Webb, Timothy. *English Romantic Hellenism, 1700–1824.* Manchester: Manchester University Press, 1982.

Weeks, Jeffrey. *Coming Out: Homosexual Politics in Britain from the Nineteenth Century to the Present.* London: Quartet, 1977.

Weeks, Jeffrey. *Sex, Politics, and Society: The Regulation of Sexuality since 1800.* London, 1981.

Weeks, John, ed. *The Dream Weavers.* Santa Barbara, Cal.: Woodbridge, 1980.

Weigle, Marta. *Spiders and Spinsters: Women and Mythology.* Albuquerque: University of New Mexico Press, 1982.

Welby, T. Earle. *The Victorian Romantics.* London: Cass, 1966.

Welland, D. S. R. *The Pre-Raphaelites in Literature and Art.* London: Harrop, 1953.

Westwater, Martha. *The Wilson Sisters.* Athens: Ohio University Press, 1984.

Whyte, Lancelot Law. *The Unconscious before Freud.* New York: Basic Books, 1960.

Wiesenfarth, Joseph. *George Eliot's Mythmaking.* Heidelberg: Carl Winter, 1977.

Williamson, George C. *Frederic, Lord Leighton.* London: George Bell, 1902.

Winckelmann, J. J. *History of Ancient Art.* Trans. G. Henry Lodge. 2 vols. Boston: Osgood, 1880.

Winckelmann, J. J. *Writings on Art.* Ed. David Irwin. London: Phaidon, 1972.

Wright, Thomas. *The Worship of the Generative Powers.* In *Sexual Symbolism,* ed. Ashley Montagu. New York: Julian Press, 1957.

Wood, Christopher. *The Dictionary of Victorian Painters.* Woodbridge, Suffolk: Antique Collector's Club, 1978.

Wood, Christopher. *Olympian Dreamers: Victorian Classical Painters, 1860–1914.* London: Constable, 1983.

Wood, Christopher. *The Pre-Raphaelites.* New York: Viking, 1981.

Wood, Christopher. *Victorian Panorama.* London: Faber and Faber, 1976.

Woodward, Jocelyn M. *Perseus: A Study in Greek Art and Legend.* Cambridge: Cambridge University Press, 1937.

Zimmern, Helen. *Lawrence Alma-Tadema.* London: George Bell, 1902.

Zolla, Elemire. *The Androgyne.* London: Thames and Hudson, 1981.

MUSEUM AND EXHIBITION CATALOGUES

The Age of Neo-Classicism. London: Arts Council, 1972.

The Age of Romanticism. London: Arts Council, 1959.

Albert Moore and His Contemporaries. Entries by Richard Green. Newcastle upon Tyne: Laing Art Gallery, 1972.

Ancient Marbles of . . . the Marquess of Lansdowne. London: Christie's, 5 March 1930.

Arthur Hughes. Cardiff: National Museum of Wales, 1971.

Atkinson Grimshaw. Entries by Jane Abdy. London: Alexander Gallery, 1976.

Atkinson Grimshaw. Entries by Alexander Robertson. Leeds City Art Gallery, 1979.

The Bancroft Collection. Wilmington: Delaware Art Museum, 1962.

The Bancroft Collection. Entries by Rowland Elzea. Wilmington: Delaware Art Museum, 1978.

The Blessed Damozel: Women and Children in Victorian Art. London: Christopher Wood Gallery, 1980.

British Artists in Rome, 1700–1800. London: Greater London Council, 1974.

British Eighteenth- and Nineteenth-Century Drawings. New York: Shepherd Gallery, 1984.

British Neo-Classical Art. Ickworth, 1969.

British Paintings and Drawings. London: Sotheby's, November 1981.

British Subject and Narrative Pictures. London: Arts Council, 1955.

Burne-Jones. Sheffield: Mappin Art Gallery, 1971.

Burnes-Jones. Entries by John Christian. London: Arts Council, 1975.

Burne-Jones: Studien, Zeichnungen, und Bilder. Munich: Museum Villa Stuck, 1975.

Burne-Jones and His Followers. Introduction by John Christian. Tokyo: Isetan Museum of Art, 1987.

Burne-Jones et l'influence des Préraphaelites. Paris: Galerie du Luxembourg, 1972.

Burne-Jones und der Einfluss der Prä-Raffaeliten. Munich: Michael Hasenclever Gallery, 1973.

Catalogue of Paintings, Drawings, and Mementos. Centenary Exhibition. London: Leighton House, 1930.

Catalogue of the Permanent Collection. Liverpool: Walker Art Gallery, n.d.

Catalogue of the Permanent Collection of Paintings. Leeds City Art Gallery, n.d.

Catalogue of the Valuable Library of . . . Lord Leighton of Stretton. London: Christie's, July 1896.

The City's Pictures. London: Barbican Art Gallery, 1984.

Charles Gleyre. New York: Grey Art Gallery, New York University, 1980.

Dante Gabriel Rossetti. Entries by Richard Green. Newcastle upon Tyne: Laing Art Gallery, 1971.

Dante Gabriel Rossetti. Entries by Virginia Surtees. London: Royal Academy, 1973.

Dante Gabriel Rossetti and His Circle. Lawrence, University of Kansas Museum of Art, 1958.

Decade 1890–1900. London: Arts Council, 1967.

The De Morgan Foundation at Old Battersea House. London: Wandsworth Borough Council, 1983.

Dionysus and His Circle. Cambridge, Mass.: Fogg Art Museum, 1979.

Drawings from the David Daniels Collection. Minneapolis Institute of Arts, 1968.

The Drawings of John Everett Millais. London: Arts Council, 1979.

Dreamers and Academics. London: Whitford and Hughes Gallery, 1981.

The Earthly Chimera and the Femme Fatale. Chicago: Smart Gallery, 1981.

Eastern Encounters. London: Fine Art Society, 1978.

Edmund J. and Suzanne McCormick Collection. New Haven: Yale Center for British Art, 1984.

Edward Burne-Jones. London: Fulham Library, 1967.

Edward Burne-Jones. London: Hartnoll and Eyre Gallery, 1971.

Edward Burne-Jones. London: Hartnoll and Eyre Gallery, 1972.

Edward Burne-Jones: Centenary Exhibition. London: Tate Gallery, 1933.

Edwardian Reflections. Bradford: Cartwright Hall, 1975.

Edward von Steinle. Kassel: Hessischen Landesmuseum, 1928.

English Nineteenth-Century Pre-Raphaelite and Academic Art. New York: Shepherd Gallery, 1983.

English Paintings, Drawings, and Watercolours, 1830–1930. New York: Shepherd Gallery, 1979.

The Etruscan School. Carlisle Museum of Art, 1978.

Exhibition of the Chantrey Collection. London: Royal Academy, 1949.

Exhibition of the Works of Sir Edward Burne-Jones. London: New Gallery, 1898–1899.

Exhibition of Victorian Pictures. Birmingham Museum, 1937.

Exhibition of Works by the Late Lord Leighton of Stretton. London: Royal Academy, 1897.

The Faringdon Collection. Buscot Park, Faringdon, 1982.

Fin de Siècle. London: Whitford and Hughes Gallery, 1980.

Firenze e l'Inghilterra. Florence: Palazzo Pitti, 1971.

The First Hundred Years of the Royal Academy. London: Royal Academy, 1951.

Ford Madox Brown. Entries by Mary Bennett. Liverpool: Walker Art Gallery, 1964.

Ford Madox Brown and the Pre-Raphaelites. Manchester City Art Gallery, 1911.

Frederick Sandys. Entries by Betty O'Looney. Brighton Museum and Art Gallery, 1974.

From Realism to Symbolism: Whistler and His World. New York: Wildenstein Gallery, 1971.

From Slave to Siren. Durham, N.C.: Duke University Museum of Art, 1971.

G. F. Watts. London: Whitechapel Art Gallery, 1974.

G. F. Watts: The Hall of Fame. London: National Portrait Gallery, 1975.

George Frederic Watts. Entries by David Loshak. London: Arts Council, 1954–1955.

George Howard and His Circle. Carlisle Art Gallery, 1968.

Great Victorian Pictures. London: Arts Council, 1978.

High Art and Homely Scenes. London: Maas Gallery, 1969.

High Victorian Art. London: Leighton House, 1969.

High Victorian Art. London: Leighton House, 1979.

Illustrated Catalogue of the Permanent Collection. Birmingham Museum and Art Gallery, 1923.

John Ruskin. London: Arts Council, 1954.

John Ruskin. London: Arts Council, 1983.

John William Waterhouse. Entries by Anthony Hobson. Sheffield: Mappin Art Gallery, 1978.

The Lady Lever Collection. Port Sunlight, 1971.

The Lady Lever Collection. Ed. Reginald Grundy and Sydney Davison. Port Sunlight: Lever Gallery, 1950.

Lawrence Alma-Tadema. London: Royal Academy, 1913.

Lawrence Alma-Tadema. London: Sotheby's, November 1973.

Lawrence Alma-Tadema. Sheffield: Mappin Art Gallery, 1976.

Lawrence Alma-Tadema: Victorians in Togas. Entries by Christopher Forbes. New York: Metropolitan Museum of Art, 1973.

Leeds City Art Galleries: Concise Catalogue. 1976.

Maclise. London: Arts Council, 1972.

The Male Nude. Hempstead, N.Y.: Emily Lowe Gallery, 1973.

Manchester City Art Gallery: Concise Catalogue. 1976.

The Moore Family Pictures. York City Art Gallery and London: Hartnoll Gallery, 1980.

Morris and Company at Cambridge. Cambridge: Fitzwilliam Museum, 1980.

Nineteenth-Century European Paintings and Drawings. London: Sotheby's, June 1984.

Nineteenth-Century European Paintings and Drawings. London: Sotheby's, June 1985.

Nineteenth-Century European Paintings, Drawings, and Sculpture. London: Sotheby's, November 1983.

National Art Gallery of New South Wales, Eighty Reproductions. n.d.

Olympian Dreamers. London: Christopher Wood Gallery, 1983.

Painting Women: Victorian Women Artists. Rochdale Art Gallery, 1987.

Paintings and Drawings by Victorian Artists in England. Ottawa: National Gallery of Canada, 1965.

Paintings from the Royal Academy. Washington, D.C.: International Exhibitions Foundation, 1984.

Pall Mall Pictures. London: *Pall Mall Gazette,* 1885–1902, 1908.

Le paysage anglais des Préraphaelites aux Symbolistes. Paris: Galerie du Luxembourg, 1974.

Peintres de l'âme. London: Whitford and Hughes Gallery, 1984.

Permanent Collection of Pictures. Bradford Art Gallery, 1924.

Pictures and Sculptures in the Russell-Cotes Museum. Bournemouth, n.d.

Pictures in the Walker Art Gallery, Liverpool. 1980.

Präraffaeliten. Entries by John Christian. Baden-Baden: Staatliche Kunsthalle, 1974.

PRB/Millais/PRA. Entries by Mary Bennett. Liverpool: Walker Art Gallery, 1967.

Pre-Raphaelite Art. State Art Galleries of Australia, 1962.

Pre-Raphaelite Art from the Birmingham Museum. Entries by Richard Lockett. Hong Kong Museum of Art, 1984.

The Pre-Raphaelite Era. Wilmington: Delaware Art Museum, 1976.

The Pre-Raphaelite Fringe. Cockermouth: Norham House Gallery, 1973.

Pre-Raphaelite Graphics. London: Hartnoll and Eyre Gallery, 1974.

The Pre-Raphaelite Influence. London: Maas Gallery, 1973.

Pre-Raphaelite Paintings. Manchester City Art Gallery, 1952.

Pre-Raphaelite Paintings. Manchester City Art Gallery, 1974.

Pre-Raphaelite Paintings. Entries by Julian Treuherz. Manchester City Art Gallery, 1980.

A Pre-Raphaelite Passion. Manchester City Art Gallery, 1977.

The Pre-Raphaelites. Cambridge, Mass.: Fogg Art Museum, 1946.

The Pre-Raphaelites. London: Whitechapel Art Gallery, 1948.

The Pre-Raphaelites. Indianapolis: Herron Museum of Art, 1964.

The Pre-Raphaelites. London: Tate Gallery, 1984.

The Pre-Raphaelites and Their Associates. Manchester: Whitworth Gallery, 1972.

The Pre-Raphaelites and Their Circle. National Gallery of Victoria, 1978.

The Pre-Raphaelites and Their Circle. Birmingham Museum, 1979.

The Pre-Raphaelites and Their Contemporaries. London: Maas Gallery, 1962.

The Pre-Raphaelites and Their Times. Introduction by John Christian. Tokyo: Isetan Museum of Art, 1985.

Pre-Raphaelites to Post-Impressionists. London: Maas Gallery, 1965.

Realism and Romance: Pre-Raphaelite and High Victorian Paintings. London: Christopher Wood Gallery, 1982.

The Rediscovery of Greece. London: Fine Art Society, 1979.

The Revolt of the Pre-Raphaelites. Miami: Lowe Art Museum, 1972.

Royal Academy of Arts Bicentenary Exhibition, 1768–1968. London: Royal Academy, 1979.

The Royal Academy Revisited. Entries by Christopher Forbes. New York: Metropolitan Museum of Art, 1975.

Ruskin and His Circle. London: Arts Council, 1964.

Sculpture from the David Daniels Collection. Minneapolis Institute of Arts, 1980.

Shakespeare's Heroines in the Nineteenth Century. Buxton, Derbyshire: Buxton Museum, 1980.

The Souls. London: Bury Street Gallery, 1982.

Southampton Art Gallery Collection. 1980.

Spring '85. London: Fine Art Society, 1985.

Strictly Academic: Life Drawing in the Nineteenth Century. Binghamton, N.Y.: University Art Gallery, 1974.

The Substance or the Shadow: Images of Victorian Womanhood. Entries by Susan Casteras. New Haven: Yale Center for British Art, 1982.

Sudley Museum: Illustrated Catalogue. Liverpool, 1971.

Symbolists, 1860–1925. London: Piccadilly Gallery, 1970.

The Taste for Antique Sculpture. Oxford: Ashmolean Museum, 1981.

The Taste of Yesterday. Liverpool: Walker Art Gallery, 1970.

Thomas Holloway: The Benevolent Millionaire. London: Thomas Agnew Gallery, 1981.

T. M. Rooke. London: Hartnoll and Eyre Gallery, 1972.

T. M. Rooke: Watercolours. London: Hartnoll and Eyre Gallery, 1972.

Trial and Innocence: Works from the Ferens Art Gallery. Entries by Helena Moore. Hull, 1984.

Victorian Art. Miami: Lowe Art Gallery, 1972.

Victorian Fanfare. London: Christopher Wood Gallery, 1983.

Victorian Figure Drawings. London: Hartnoll Gallery, 1980.

Victorian High Renaissance. Entries by Allen Staley, Richard Dorment, Gregory Hedberg, Leonée Ormond, and Richard Ormond. Manchester City Art Gallery, 1978.

Victorian Oil Paintings. Southport: Atkinson Art Gallery, 1978.

Victorian Olympians. Art Gallery of New South Wales, 1975.

Victorian Painters. Carlisle City Art Gallery, 1970.

Victorian Painting. London: Fine Art Society, 1977.

Victorian Painting, 1837–1887. London: Thomas Agnew Gallery, 1961.

Victorian Paintings. London: Arts Council, 1962.

Victorian Paintings and Drawings. London: Sotheby's, March 1981.

Victorian Paintings, Drawings, and Watercolours. London: Sotheby's, September 1975.

Victorian Parnassus: Images of Classical Mythology and Antiquity. Introduction by Christopher Wood. Cartwright Hall, Bradford, 1987.

The Victorian Rebellion. Peoria, Ill.: Lakeview Center for the Arts, 1971.

Victorian Romantics. Toronto: Macmillan and Perrin Gallery, 1979.

The Victorian Scene. London: Richard Green Gallery, 1979.

Victorian Taste: Paintings from the Royal Holloway College. Entries by Jeannie Chapel. London: Zwemmer, 1982.

The Victorian Venus: William Edward Frost. London: Maas Gallery, 1980.

Victorian Watercolours. Liverpool: Walker Art Gallery, 1974.

Viva Victoria: Major Victorian and Pre-Raphaelite Paintings. London: Roy Miles Gallery, 1980.

William Dyce. Aberdeen Art Gallery, 1964.

William Etty. York City Art Gallery, 1949.

William Etty. Entries by Dennis Farr. London: Arts Council, 1955.

William Etty. Lincoln: Usher Gallery, 1975.

William Etty/Atkinson Grimshaw. New York: Durlacher Brothers Gallery, 1961.

William Henry Hunt. Wolverhampton Art Gallery, 1981.

William Holman Hunt. Entries by Mary Bennett. Liverpool: Walker Art Gallery, 1969.

William Morris Collection: Catalogue. Walthamstow: Morris Gallery, 1969.

William Scott of Oldham. London: Fine Art Society, 1976.

"Ye Ladye Bountifulle": Women and Children in Victorian Art. London: Christopher Wood Gallery, 1984.

York Art Gallery Catalogue of Paintings. 1963.

ESSAYS, REVIEWS, AND UNPUBLISHED MATERIALS

Note: Reviews from the *Art Journal, Athenaeum, Magazine of Art,* and *Studio* are cited parenthetically to page number in the text.

"Academy Outrage." *Times,* 5 May 1914, p. 8.

"All Hands to the Pumps by Tuke." *Art Journal* (1907), 358–359.

Alma-Tadema, Laura. "Letters." Staatsbibliothek Preussische Kulturbesitz, West Berlin. [Unpublished]

Alma-Tadema, Laurence. "Letters." Staatsbibliothek Preussische Kulturbesitz, West Berlin. [Unpublished]

Alma-Tadema, Lawrence. "Alma Tadema on Art Training." *Journal of the Royal Institute of British Architects* 3 (1895), 623–624.

Alma-Tadema, Lawrence. "Alma Tadema on Sculpture." *Guild of Handicraft Transactions* 1 (1890), 47–51.

Alma-Tadema, Lawrence. "Art in Its Relation to Industry." *Magazine of Art* 16 (1893), 8–10.

Alma-Tadema, Lawrence. "Collection of Photographs." 168 boxes. Heslop Room, Main Library, University of Birmingham. [Unpublished]

Alma-Tadema, Lawrence. "L. Alma-Tadema's Reply." *Journal of the Royal Institute of British Architects* 13 (1906), 441.

Alma-Tadema, Lawrence. "Laurens Alma-Tadema." In *In the Days of My Youth*, ed. Thomas P. O'Conner, 201–208. London: Pearson, 1901.

Alma-Tadema, Lawrence. "Letters." Staatsbibliothek Preussische Kulturbesitz, West Berlin. [Unpublished]

Alma-Tadema, Lawrence. "Letters." Heslop Room, Main Library, University of Birmingham. [Unpublished]

Alma-Tadema, Lawrence. "Marbles: Their Ancient and Modern Application." *Journal of the Royal Institute of British Architects* 14 (January 1907), 169–180.

Alma-Tadema, Lawrence. "My Reminiscences." *Strand Magazine* 37 (1949), 286–295.

"Alma-Tadema at Home." *Review of Reviews* 11 (1895), 253.

Amaya, Mario. "The Roman World of Alma-Tadema." *Apollo* (1962), 771–778.

"An Appeal against Female Suffrage." *Nineteenth Century* 25 (June 1889), 781–788.

Anderson, Elizabeth Garrett. "Sex and Mind in Education: A Reply." *Fortnightly Review* 21 (1874), 582–594.

Armstrong, Walter. "Briton Riviere: His Life and Work." *Art Annual* (1891), 1–32.

"The Art of the Age: The Work of Walter Crane," *Pearson's Magazine* 21 (June 1906), 571–577.

Arthur, Marylin B. "Early Greece: The Origins of the Western Attitude Toward Women," *Arethusa* 6 (1973), 7–58.

Auerbach, Nina. "Magi and Maidens: The Romance of the Victorian Freud." In *Writing and Sexual Difference*, ed. Elizabeth Abel. Chicago: University of Chicago Press, 1980.

Baldry, A. Lys. "Albert Moore." *Studio* 3 (1894), 3–6.

Baldry, A. Lys. "The Drawings of Sir Edward Burne-Jones." *Magazine of Art* 19 (1896), 343–344.

Baldry, A. Lys. "J. R. Weguelin and His Work." *Studio* 33 (1904), 193–201.

Baldry, A. Lys. "J. W. Waterhouse and His Work." *Studio* 4 (1895), 103–115.

Baldry, A. Lys. "The Late J. W. Waterhouse." *Studio* 71 (1917), 3–14.

Baldry, A. Lys. "Lord Leighton's Sketches." *Magazine of Art* 21 (1897), 69–74.

Baldry, A. Lys. "Mr. Herbert J. Draper." *Magazine of Art* 23 (1899), 49–57.

Baldry, A. Lys. "Sir W. B. Richmond." *Magazine of Art* 25 (1901), 145–50, 197–203.

Baldry, A. Lys. "Some Recent Work by Mr. J. W. Waterhouse." *Studio* 53 (1911), 176–183.

Baldry, A. Lys. "The Treatment of Drapery in Painting." *Art Journal* (1909), 231–239.

Baldry, A. Lys. "The Work of Solomon J. Solomon." *Studio* 8 (1896), 2–10.

Baldry, A. Lys. "The Work of T. C. Gotch." *Studio* 13 (1898), 72–82.

Barrington, Emilie [Mrs. Russell]. "Lord Leighton: In Memoriam." In *A Collection of Essays on Lord Leighton and His Works*, 25–45. Kensington Public Library, c. 1898.

Barrington, Emilie [Mrs. Russell]. "Lord Leighton's Sketches." In *A Collection of Essays on Lord Leighton and His Works*, 75–93. Kensington Public Library, c. 1898.

Barton, E. A. "Lord Leighton's Death." London: Royal Academy Archives, 1896. [Unpublished]

Bell, Malcolm. "Some Features of the Art of Sir Edward Burne-Jones." *Studio* 16 (April 1899), 175–183.

Bennett, Mary. "A Check List of Pre-Raphaelite Pictures Exhibited at Liverpool, 1846–67, and Some of Their Northern Collectors," *Burlington Magazine* 105 (1963), 486–495.

Bennett, Mary. "Footnotes to the William Holman Hunt Exhibition." *Liverpool Bulletin* 13 (1968–70), 29–64.

Berger, Maurice. "Edward Burne-Jones' 'Perseus Cycle': The Vulnerable Medusa." *Art Magazine* 54 (April 1980), 149–153.

Blaikie, J. A. "J. W. Waterhouse." *Magazine of Art* 9 (1886), 1–6.

Boughton, George, and A. J. Hipkins. "Catalogue of Letters from Sir Lawrence Alma-Tadema to Sir George Henschel." University of Birmingham Library, 1973. [Unpublished]

A British Matron. "A Woman's Plea." *Times,* 20 May 1885, p. 10.

Brooke, Janet M. "The Cool Twilight of Luxurious Chambers: Alma-Tadema's *A Dealer in Statues.*" *Revue d'art canadien* 9 (1981), 21–34.

Brown, Norman O. "Daphne, or Metamorphosis." In *Myths, Dreams, and Religion,* ed. Joseph Campbell, 91–110. New York: Dutton, 1970.

Buchanan, Robert ["Thomas Maitland"]. "The Fleshly School of Poetry: Mr. D. G. Rossetti." *Contemporary Review* 18 (October 1871), 334–350.

Bullen, Barrie. "The Palace of Art: Sir Coutts Lindsay and the Grosvenor Gallery." *Apollo* 102 (November 1975), 352–357.

Burne-Jones, Edward. "The Cousins." *Oxford and Cambridge Magazine* 1 (January 1856), 18–27. Included in *The Dream Weavers,* ed. John Weeks (Santa Barbara: Woodbridge Press, 1980).

Burne-Jones, Edward. "Essay on *The Newcomes.*" *Oxford and Cambridge Magazine* 1 (January 1856), 50–51.

Burne-Jones, Edward. "Letters." Brotherton Collection, University of Leeds. [Unpublished]

Burne-Jones, Edward. "Letters." Harry Ransom Humanities Research Center, University of Texas at Austin. [Unpublished]

Burne-Jones, Edward. "Letters to Mrs. Gaskell." Department of Western Manuscripts, British Library, London. [Unpublished]

[Burne-Jones, Edward]. "Mr. Ruskin's New Volume." *Oxford and Cambridge Magazine* 1 (April 1856), 212–225.

Burne-Jones, Edward. "Sketchbooks." Fitzwilliam Museum, Cambridge; Birmingham Museum; Victoria and Albert Museum; Fogg Art Museum, Harvard University.

Burne-Jones, Edward. "A Story of the North." *Oxford and Cambridge Magazine* 1 (February 1856), 81–98. Included in *The Dream Weavers,* ed. John Weeks (Santa Barbara: Woodbridge Press, 1980).

Burne-Jones, Edward, and Thomas M. Rooke. "Conversations." Private Collection. [Unpublished]

Burne-Jones, Georgiana. "Materials for *Memorials.*" Fitzwilliam Museum, Cambridge.

Burne-Jones, Philip. "The Alma-Tadema Exhibition." *Times,* 7 January 1913, p. 9.

Burne-Jones, Philip. "Notes on Some Unfinished Works of Sir Edward Burne-Jones." *Magazine of Art* 33 (1900), 159–167.

Burstein, Janet. "Victorian Mythography and the Progress of the Intellect." *Victorian Studies* 18 (March 1975), 309–324.

Busst, A. J. L. "The Image of the Androgyne in the Nineteenth Century." In *Romantic Mythologies,* ed. Ian Fletcher, 1–95. London: Routledge and Kegan Paul, 1967.

Campbell, Joseph. "Mythological Themes in Creative Literature and Art." In *Myths, Dreams, and Religion,* ed. Joseph Campbell, 138–176. New York: Dutton, 1970.

Carr, J. Comyns. "Edward Burne-Jones." Introduction to *Exhibition of the Works of Sir Edward Burne-Jones.* London: New Gallery, 1898–1899.

Carr, Philip. "Alma-Tadema and His Friends." *Listener,* 9 December 1954, p. 1013.

Cartwright, Julia. "The Art of Burne-Jones." *Atalanta* 4 (October/November 1890), 18–26, 81–91.

Cartwright, Julia. "Edward Burne-Jones." *Art Journal* (January 1893), 1–9.

Cartwright, Julia. "Edward Burne-Jones." *Art Annual* (1894), 1–32.

Cartwright, Julia. "In Memoriam: Edward Burne-Jones." *Art Journal* (1898), 247–248.

Cassidy, John A. "Robert Buchanan and the Fleshly Controversy." *PMLA* 67 (March 1952), 65–93.

Casteras, Susan. "The Courtship Barrier in Victorian Art." *Browning Institute Studies* 13 (1985), 71–98.

Casteras, Susan. "Introduction." *The Substance or the Shadow.* New Haven: Yale Center for British Art, 1982.

Casteras, Susan. "Victorian Images of Emigration Themes." *Journal of Pre-Raphaelite Studies* 6 (1985), 1–24.

Casteras, Susan. "Virgin Vows: The Early Victorian Artists' Portrayal of Nuns and Novices." *Victorian Studies* 24 (Winter 1981), 157–184.

"Celtic and Classical Dreams." *Apollo* 102 (November 1975), 314–319.

Christian, John. "Burne-Jones's Illustrations to the Story of Buondelmonte." *Master Drawings* 11 (1973), 279–298.

Christian, John. "Burne-Jones's Second Italian Journey." *Apollo* 102 (November 1975), 334–337.

Christian, John. "Burne-Jones Studies." *Burlington Magazine* (January 1973), 93–109.

Christian, John. "Deux cartons de Vitraux par Edward Burne-Jones." *Revue du Louvre,* no. 6 (1972), 525–530.

Christian, John. "Early German Sources for Pre-Raphaelite Designs." *Art Quarterly* 36 (1973), 56–83.

Christian, John. "'A Serious Talk': Ruskin's Place in Burne-Jones's Artistic Development." In *Pre-Raphaelite Papers,* 184–205. London: Tate Gallery, 1984.

Christian, John, and Richard Dorment. "'Theseus and Ariadne': A Newly-Discovered Burne-Jones." *Burlington Magazine* (September 1975), 591–597.

"*Circe* by J. W. Waterhouse." *Magazine of Art* 15 (1892), 272.

Cixous, Hélène. "The Laugh of the Medusa." *Signs* 1 (Summer 1976), 875–893.

"*Clytemnestra* by John Collier." *Magazine of Art* 5 (1882), 389–390.

Cockerell, S. P. "Lord Leighton's Drawings." *Nineteenth Century* 40 (November 1896), 809–815.

Collier, John. "The Art of Alma-Tadema." *Nineteenth Century* 73 (March 1913), 597–607.

Cominos, Peter T. "Innocent Femina Sensualis in Unconscious Conflict." In *Suffer and Be Still,* ed. Martha Vicinus, 155–172. Bloomington: Indiana University Press, 1972.

Cominos, Peter T. "Late-Victorian Sexual Respectability and the Social System." *International Review of Social History* 8 (1962), 18–48, 216–250.

Constable, W. G. "*Hope* by Edward Burne-Jones." *Bulletin of the Museum of Fine Arts* 39 (February 1941), 12–14.

"*Consulting the Oracle* by J. W. Waterhouse." *Art Journal* (1909), 13–15.

"Contemporary Art—Poetic and Positive: Rossetti and Tadema—Linnell and Lawson." *Blackwood's* 133 (March 1883), 392–411.

Costa, Giovanni. "Notes on Lord Leighton." *Cornhill Magazine* 25 (March 1897), 373–384.

Cowper, Katie. "The Decline of Reserve among Women." *Nineteenth Century* 27 (January 1890), 65–71.

Crane, Anthony. "My Grandfather, Walter Crane." *Yale University Library Gazette* 31 (January 1957), 97–109.

Crane, Walter. "The Language of Line." *Magazine of Art* 11 (1888), 146–150, 325–328, 415–419.

Crane, Walter. "The Work of Walter Crane." *Art Journal Easter Annual* (1898), 1–31.

"The Cupid and Psyche Frieze by Sir Edward Burne-Jones at No. 1 Palace Green." *Studio* 15 (1898), 3–13.

Dafforne, James. "The Works of Edward J. Poynter." *Art Journal* (1877), 17–19.

Daniel, Glyn. "The Victorians and Prehistory." In *The Idea of Prehistory,* 50–68. Baltimore: Penguin, 1962.

Davidoff, Leonore. "Class and Gender in Victorian England." In *Sex and Class in Women's History,* ed. Judith L. Newton. Boston: Routledge and Kegan Paul, 1983.

"Death Certificate of John William Godward." Springville, Utah: Vern G. Swanson archive. [Unpublished]

DeVane, William C. "The Virgin and the Dragon." In *The Browning Critics.* Louisville: University of Kentucky Press, 1965.

Dibdin, E. Rimbault. "Frank Dicksee: His Life and Work." *Art Annual* (1905), 1–32.

Dicksee, Frank. "Broadcast on the Occasion of the Exhibition of Flemish and Belgian Art," 1927; Typescript, Royal Academy of Arts.

Dicksee, Frank. "Discourse Delivered to the Royal Academy on the Distribution of Prizes." 10 December 1925.

Dilke, M. M. "Female Suffrage: A Reply." *Nineteenth Century* 25 (July 1889), 97–103.

Dircks, Rudolf. "The Later Works of Sir L. Alma-Tadema." *Art Annual* (1910), 1–32.

Dorment, Richard. "Burne-Jones and the Decoration of St. Paul's American Church, Rome." Ph.D. diss., Columbia University, 1976.

Dorson, Richard M. "The Eclipse of Solar Mythology," In *Myth: A Symposium* ed. Thomas Sebeok. Bloomington: Indiana University Press, 1958.

Dowgun, Richard. "Some Victorian Perceptions of Greek Tragedy." *Browning Institute Studies* 10 (1982), 71–90.

Dowling, Linda. "Roman Decadence and Victorian Historiography." *Victorian Studies* 28 (1985), 579–607.

"Drawings by Federico Zuccaro and Sir Edward John Poynter." *Bulletin of the City Art Museum of St. Louis* (November–December 1970), 4–7.

Edwards, Lee. "The Labors of Psyche: Toward a Theory of Female Heroism." *Critical Inquiry* 6 (Autumn 1979), 33–49.

Eliot, George. "The Antigone and Its Moral." In *Essays of George Eliot,* ed. Thomas Pinney. New York: Columbia University Press, 1963.

Eliot, George. "The Art of the Ancients." *Leader* 6 (1855), 257–258.

Etty, William, "Autobiography." *Art Journal* 11 (1849), 13, 37–40.

F. M. "Henry Ryland, Art Worker." *Artist* (1898), 1–9.

Fawcett, Millicent Garrett. "Female Suffrage: A Reply." *Nineteenth Century* 25 (8 July 1889), 86–96.

Fee, Elizabeth. "The Sexual Politics of Victorian Social Anthropology." *Feminist Studies* 1 (1973), 23–39.

Fenn, W. W. "Briton Riviere." *Magazine of Art* (1879), 252–255.

Fenn, W. W. "Recollections of Sir Frederick [sic] Leighton." *Chamber's Journal* (1897), 790–793.

Fox, Greer Litton. "'Nice Girl': Social Control of Women through a Value Construct." *Signs* 2 (Summer 1977), 805–817.

"Frederick [sic] Leighton as a Modeller in Clay." *Studio* 1 (1893), 1–7.

"Frederick [sic] Leighton by George Frederick Watts." *Magazine of Art* (1888), 236.

Freud, Sigmund. "Medusa's Head." In *The Standard Edition,* Vol. 18. London: Hogarth Press, 1957.

Freud, Sigmund. "On Narcissism: An Introduction." In *Collected Papers,* Vol. 4. London: Hogarth Press, 1953.

Freud, Sigmund. "A Special Type of Choice of Object Made by Men." In *The Standard Edition,* Vol. 11. London: Hogarth Press, 1957.

Fry, Roger. "The Case of the Late Sir Lawrence Alma-Tadema." *Nation,* 18 January 1913, pp. 666–667.

Fulford, William. "Woman, Her Duties, Education, and Position." *Oxford and Cambridge Magazine* 1 (August 1856), 462–476.

"Funeral of Lord Leighton." *Daily Telegraph,* 4 February 1896, p. 5.

Gaines, Charles. "Those Victorian Ladies." *Architectural Digest* (January 1985), 122–127.

Garland, Madge. "Fair Face in Many Guises: Gaetano Meo." *Country Life,* 8 March 1984, pp. 604–605.

Genette, Gérard. "Complexe de Narcisse." In *Figures I.* Paris: Seuil, 1966.

Gitter, Elisabeth G. "The Power of Women's Hair in the Victorian Imagination." *PMLA* 99 (October 1984), 936–954.

Gorham, Deborah. "The 'Maiden Tribute of Modern Babylon' Re-examined: Child Prostitution and the Idea of Childhood in Late-Victorian England." *Victorian Studies* 21 (Spring 1978), 353–379.

Gosse, Edmund. "Hamo Thornycroft." *Magazine of Art* 4 (1881), 328–332.

Gosse, Edmund. "The New Sculpture." *Art Journal* (1894), 138–142, 199–203, 277–282, 306–311.

Gray, J. M. "Frederick Sandys." *Art Journal* (March 1884), 73–78.

Green, Richard. "Albert Moore: Recent Discoveries." In *The Moore Family Pictures,* 21–37. York City Art Gallery, 1980.

Greg, W. R. "Prostitution." *Westminster Review* 53 (July 1850), 238–268.

Greg, W. R. "Why Are Women Redundant?" (1862). In *Literary and Social Judgments.* Boston: Osgood, 1873.

Grieve, Alastair. "Style and Content in Pre-Raphaelite Drawings, 1848–1850." In *Pre-Raphaelite Papers,* 23–43. London: Tate Gallery, 1984.

"The Grosvenor Gallery." *Times,* 2 May 1887, p. 12.

Hamerton, Philip Gilbert. "Technical Notes on Lord Leighton." *Portfolio* 6 (1875), 31–32.

Harris, Lynda. "The Myth of Pandora and Women's Changing Images." In *Pandora's Box.* London: Trefoil, 1984.

Harrison, Brian. "Underneath the Victorians." *Victorian Studies* 10 (March 1967), 239–262.

Harrison, Jane E. "Death and the Underworld." *Magazine of Art* 6 (1883), 366–371, 464–468.

Harrison, Jane E. "Demeter." *Magazine of Art* 6 (1883), 145–153.

Harrison, Jane E. "Helen of Troy." *Magazine of Art* 6 (1883), 55–62.

Harrison, Jane E. "Hellas at Cambridge." *Magazine of Art* 7 (1885), 510–515.

Harrison, Jane E. "The Judgment of Paris." *Magazine of Art* 5 (1882), 502–510.

Harrison, Jane E. "The Myth of the Nightingale on Greek Vase-Paintings." *Magazine of Art* 14 (1891), 227–230.

Harrison, Jane E. "The Myth of Odysseus and the Sirens." *Magazine of Art* 10 (1887), 133–136.

Harrison, Jane E. "The Myth of Perseus and Andromeda." *Magazine of Art* 8 (1885), 498–504.

Harrison, Jane E. "Myths of the Dawn on Greek Vase-Painting." *Magazine of Art* 17 (1894), 59–63.

Harrison, Jane E. "Theseus and Ariadne." *Magazine of Art* 7 (1884), 317–323.

Harrison, Jane E. "The Youth of Achilles." *Magazine of Art* 8 (1885), 33–38.

Hellman, George S. "From a Burne-Jones Sketchbook." *Harper's* 141 (November 1920), 769–771.

"Henry Scott Tuke." *Magazine of Art* 26 (1902), 337–343.

Hersey, G. L. "Aryanism in Victorian England." *Yale Review* 66 (Autumn 1976), 104–113.

Higgins, Alfred. "Mr. W. B. Richmond's Work and His Life as an Artist." *Art Journal* (July 1890), 193–198, 236–239.

Hodges, Sydney, "Mr. Frank Dicksee." *Magazine of Art* 10 (1887), 217–222.

Holmes, C. J. "Women as Painters." *Dome* (1899), 2–9.

Hook, Philip. "The Classic Revival in English Painting." *Connoisseur* 192 (June 1976), 122–127.

Horsman, Reginald. "Origins of Racial Anglo-Saxonism in Great Britain before 1850." *Journal of the History of Ideas* 37 (July–September 1976), 387–410.

Hueffer, Ford Madox. "The Millais and Rossetti Exhibitions." *Fortnightly Review* 63 (February 1898), 189–196.

Hueffer, Ford Madox. "Sir Edward Burne-Jones." *Contemporary Review* 74 (August 1898), 181–195.

Hunt, Violet. "Stunners." *Artwork* 6 (Summer 1930), 77–87.

Hunt, William Holman. "Religion and Art." *Contemporary Review* 71 (January 1897), 41–52.

"Hylas and the Nymphs by J. W. Waterhouse." *Studio* 10 (1897), 243–247.

Ironside, Robin. "Burne-Jones and Gustave Moreau." *Horizon* 1 (June 1940), 406–424.

James, Henry. "The Private Life." In *New York Edition,* Vol. 17. New York: Scribner's 1907–17.

Janson, Dora Jane. "Introduction." *From Slave to Siren.* Durham, N.C.: Duke University Museum of Art, 1971.

Jenkins, Ian. "Frederic Lord Leighton and Greek Vases." *Burlington Magazine* (October 1983), 597–605.

Jones, Stephen. "Attic Attitudes: Leighton and Aesthetic Philosophy." *History Today* 37 (June 1987), 31–37.

Jope-Slade, Robert. "A Man of Liverpool and His Art: Robert Fowler." *Studio* 9 (1897), 84–98.

Joseph, Gerhard. "The *Antigone* as Cultural Touchstone." *PMLA* 96 (January 1981), 22–34.

Kains-Jackson, C. "H. S. Tuke." *Magazine of Art* 26 (1902), 337–343.

Kavanagh, Amanda. "Sir Frank Dicksee: A Post Pre-Raphaelite." *Country Life* (January 31, 1985), 240–242.

Kestner, Joseph A. "Edward Burne-Jones and Nineteenth-Century Fear of Women." *Biography* 7 (Spring 1984), 95–122.

Kestner, Joseph A. "The Perseus Legend and the 'Rescue' in Nineteenth-Century British Art." *Victorians Institute Journal* 15 (1987), 55–70.

Kincaid, James R. "What the Victorians Knew about Sex." Address, City University of New York, 1986.

Kingsbury, Martha. "The Femme Fatale and Her Sisters." In *Women as Sex Object: Studies in Erotic Art. Art News Annual* (1972), 182–205.

Kissane, James. "Victorian Mythology." *Victorian Studies* 6 (September 1962), 5–28.

Lago, Mary M. "Ernest S. Thomas and the Burne-Jones Centenary." *Apollo* 102 (November 1975), 358–361.

Lambourne, Lionel. "Paradox and Significance in Burne-Jones's Caricatures." *Apollo* (November 1975), 329–333.

Landow, George P. "There Began to Be a Great Talking about the Fine Arts." In *The Mind and Art of Victorian England,* ed. Josef L. Altholz, 124–145. Minneapolis: University of Minnesota Press, 1976.

Landow, George P. "Victorianized Romans: Images of Rome in Victorian Painting." *Browning Institute Studies* 12 (1984), 29–51.

Lang, Andrew. "Myths and Mythologists," *Nineteenth Century* 19 (January 1886), 50–65.

Lang, Mrs. Andrew. "Sir Frederick [sic] Leighton." *Art Annual* (1884), 1–32.

Lascelles, Helen. "Sir William B. Richmond and His Work." *Art Annual* (1902), 1–32.

"The Late Lord Leighton." *Times,* 28 January 1896, p. 7.

Laver, James. "Victorian Stage Design." *Apollo* (1962), 757–759.

Lawrence, Arthur H. "Mr. Hal Hurst and His Work." *Art Journal* (1898), 198–201.

Lecky, Elisabeth. "Some Ancient Representations of Eros and Psyche." *Magazine of Art* 13 (1890), 386–390.

Leighton, Frederic. "The Building Up of a Picture." *Magazine of Art* 22 (1898), 1–2.

Leighton, Frederic. "Letters." Kensington Public Library. [Unpublished]

Leighton, Frederic. "Notebooks." Royal Academy Archives, London. [Unpublished]

Leighton, Frederic. "Sir Frederic Leighton on the Relation of Architecture and the Sister Arts." *Studio* 3 (1894), 123–124.

Leprieur, Paul. "La Légende de Persée par M. Burne-Jones," *Gazette des beaux arts* 10 (December 1893), 462–477.

Linton, Eliza Lynn. "The Partisans of the Wild Women." *Nineteenth Century* 31 (March 1892), 455–464.

Linton, Eliza Lynn. "The Wild Women as Social Insurgents." *Nineteenth Century* 30 (October 1891), 596–605.

Lohf, Kenneth A. "The Burne-Jonesiness of Burne-Jones." *Gazette of the Grolier Club,* no. 17 (May 1972), 45–52.

"Lord Leighton's Pictures." *Art Journal* (1897), 58–60.

Loshak, David. "G. F. Watts and Ellen Terry." *Burlington Magazine* 105 (1963), 476–485.

Loss, Archie K. "The Pre-Raphaelite Woman, the Symbolist *Femme-Enfant,* and the Girl with Long Flowing Hair in the Earlier Works of Joyce." *Journal of Modern Literature* 3 (February 1973), 3–23.

Lusk, Lewis. "Sir E. J. Poynter as a Water-Colourist." *Art Journal* (1903), 187–192.

Lutyens, Mary. "Millais's Portrait of Ruskin." *Apollo* 85 (1967), 246–253.

Lynch, Michael. "'Here is Adhesiveness': From Friendship to Homosexuality." *Victorian Studies* 29 (1985), 67–96.

MacCurdy, John T. "Concerning Hamlet and Orestes." *Journal of Abnormal Psychology* 13 (1919), 250–260.

[Macdonald, Georgiana?]. "The Sacrifice." *Oxford and Cambridge Magazine* 1 (May 1856), 271–279.

Macmillan, John Duncan. "Holman Hunt's 'Hireling Shepherd': Some Reflections on a Victorian Pastoral." *Art Bulletin* 54 (June 1972), 187–197.

Mander, Rosalie. "Rossetti and the Oxford Murals, 1857." In *Pre-Raphaelite Papers,* 170–183. London: Tate Gallery, 1984.

Mander, Rosalie. "Rossetti's Models." *Apollo* 78 (July 1963), 18–22.

Margaux, Adrian. "The Art of Sir Edward J. Poynter." *Windsor Magazine* (1905), 67–82.

Marks, Arthur S. "Ford Madox Brown's 'Take Your Son, Sir!'" *Art Magazine* 54 (January 1980), 135–141.

Maudsley, Henry. "Sex and Mind in Education," *Fortnightly Review* 21 (1874), 446–483.

McAllister, Isabel G. "Some Water-Colour Paintings of Sir Edward Poynter." *Studio* 72 (1918), 89–99.

McCarthy, Justin. "The Pre-Raphaelites in England." *Galaxy* 21 (June 1876), 725–732.

McGann, Jerome. "The Beauty of the Medusa: A Study in Romantic Literary Iconology." *Studies in Romanticism* 11 (1972), 3–25.

Meynell, Wilfrid. "Alma-Tadema Seven Years Ago and Now." *Magazine of Art* 4 (1881), 94–96.

Meynell, Wilfrid. "Laurens Alma-Tadema." *Magazine of Art* 2 (1879), 193–197.

Meynell, Wilfrid. "The Many Moods of Sir Frederick [*sic*] Leighton." *Magazine of Art* 4 (1881), 51–53.

Meynell, Wilfrid. "Minor Memories of Lord Leighton." *English Illustrated Magazine* 14 (1896), 583–587.

Millais, John Everett. "Thoughts on Our Art of To-day." *Magazine of Art* 11 (1888), 289–292.

"Modern Man-Haters." *Saturday Review,* 29 April 1871, pp. 528–529.

Monkhouse, Cosmo. "Albert Moore." *Magazine of Art* 8 (1885), 191–196.

Monkhouse, Cosmo. "Frederic Leighton." In *British Contemporary Artists.* New York: Scribner's, 1899.

Monkhouse, Cosmo. "Sir Edward John Poynter." *Art Annual* (1897), 1–32.

Monkhouse, Cosmo. "The Watts Exhibition." *Magazine of Art* 5 (1882), 177–182.

Morris, William. "Ruskin and the *Quarterly.*" *Oxford and Cambridge Magazine* 1 (June 1856), 356–362.

"Mosaics by Sir Edward Burne-Jones at Rome." *Magazine of Art* 18 (1895), 256–260.

Müller, Max. "Solar Myths." *Nineteenth Century* 18 (December 1885), 919–922.

Myers, F. W. H. "Rossetti and the Religion of Beauty." In *Essays Modern.* London: Macmillan, 1902.

"National Gallery Outrage: The Rokeby Venus." *Times,* 11 March 1914, p. 9.

Nead, Lynda. "Woman as Temptress: The Siren and the Mermaid in Victorian Painting." *Leeds Arts Calendar,* no. 91 (1982), 5–20.

Nichols, Nina. "Transformations of Ariadne." *American Imago* 40 (1983), 237–256.

Nochlin, Linda. "Lost and *Found:* Once More the Fallen Woman." *Art Bulletin* 58 (March 1978), 140–153.

Nochlin, Linda. "Why Have There Been No Great Women Artists?" *Art News* 69 (January 1971), 23–39, 67–71.

"The Nude in Photography, with Some Studies in the Open Air," *Studio* 1 (1893), 104–109.

"Nude Studies." *Times,* 22, 23, 25 May 1885, pp. 6, 10, 10.

Oberhausen, Judith. "Rossetti's *Found.*" *Delaware Art Museum Occasional Papers* (December 1976), 1–54.

Ormond, Leonée, and Richard Ormond. "'Jonathan's Token to David.'" *Minneapolis Institute of Arts Bulletin* 61 (1974), 20–27.

Ormond, Leonée, and Richard Ormond. "Leighton in Paris." *Apollo* 97 (February 1973), 136–141.

Ormond, Leonée, and Richard Ormond. "Victorian Painting and Classical Myth." In *Victorian High Renaissance,* 33–42. Manchester City Art Gallery, 1978.

Ormond, Richard. "The Diploma Paintings from 1840 Onwards." *Apollo* 88 (1969), 56–63.

Parry, Linda L. A. "The Tapestries of Edward Burne-Jones." *Apollo* (November 1975), 324–328.

Pattison, Emilia F. S. "Edward J. Poynter." *Magazine of Art* (1888), 235–241.

Phillips, Claude. "Edward Burne-Jones." *Magazine of Art* 8 (1885), 286–294.

Pietrangeli, Carlo. "Archaeological Excavations in Italy, 1750–1850." In *The Age of Neo-Classicism,* xlvi–lii. London: Arts Council, 1972.

Pollock, W. H. "John Collier." *Art Journal* (1894), 65–69.

Pollock, W. H. "The Hon. John Collier." *Art Annual* (1914), 1–32.

Postlethwaite, Helene L. "Some Noted Women-Painters." *Magazine of Art* (1895), 17–22.

Powell, Kirsten. "Edward Burne-Jones and the Legend of the Briar Rose." *Journal of Pre-Raphaelite Studies* 6 (1986), 15–28.

Poynter, Edward J. "Letters." National Art Library, Victoria and Albert Museum, London. [Unpublished]

Poynter, Edward J. "Letters." Royal Academy of Arts, London. [Unpublished]

Poynter, Edward J. "Sir E. J. Poynter on Leighton and Millais." *Times* 11 December 1896 p. 10.

Praeger, Wilfred. "Sir Frederick [*sic*] Leighton." *Atalanta* 4 (March 1891), 372–383.

Praeger, Wilfred. "W. B. Richmond," *Atalanta* 4 (May 1891), 498–515.

Preyer, Robert O. "John Stuart Mill on the Utility of Classical Greece." *Browning Institute Studies* 10 (1982), 41–70.

Prinsep, Val. "A Student's Life in Paris in 1859." *Magazine of Art* (February 1904), 338–342.

Read, Benedict. "Was There Pre-Raphaelite Sculpture?" In *Pre-Raphaelite Papers,* 97–110. London: Tate Gallery, 1984.

Rein, David M. "Orestes and Electra in Greek Literature." *American Imago* 11 (1954), 33–50.

Richmond, William Blake. "Leighton, Millais, and William Morris: An Address to Students of the Royal Academy." In *A Collection of Essays on Lord Leighton and His Works,* 108–129. London: Kensington Public Library, c. 1898.

Richmond, William Blake. "Lord Leighton and His Art." *Nineteenth Century* (March 1896). Reprinted in *A Collection of Essays on Lord Leighton and His Works,* 60–74. London: Kensington Public Library, c. 1898.

Rinder, Frank. "The Art of Ernest Normand." *Art Journal* (1901), 137–141.

Rinder, Frank. "Henrietta Rae: Mrs. Ernest Normand." *Art Journal* (1901), 302–307.

Roberts, Helene E. "Art Reviewing in the Early-Nineteenth-Century Art Periodicals." *Victorian Periodicals Newsletter,* no. 19 (1973), 9–20.

Roberts, Helene E. "British Art Periodicals of the Eighteenth and Nineteenth Centuries." *Victorian Periodicals Newsletter,* no. 9 (1970), entire issue.

Roberts, Helene E. "The Dream World of Dante Gabriel Rossetti." *Victorian Studies* 17 (June 1974), 371–393.

Roberts, Helene E. "The Exquisite Slave: The Role of Clothes in the Making of the Victorian Woman." *Signs* 2 (Spring 1977), 554–569.

Roberts, Helene E. "Marriage, Redundancy or Sin: "The Painter's View of Women in the First Twenty-Five Years of Victoria's Reign." In *Suffer and Be Still,* ed. Martha Vicinus, 45–76. Bloomington: Indiana University Press, 1972.

Roberts, Keith. "Four Victorian Exhibitions." *Burlington Magazine* 110 (December 1968), 716–719.

Roberts, M. J. D. "Morals, Art, and the Law: The Passing of the Obscene Publications Act 1857." *Victorian Studies* 28 (1985), 609–629.

Roheim, Géza. "The Dragon and the Hero." *Imago* 2/3 (1939), 40–69, 61–94.

Romanes, George J. "Mental Differences between Men and Women." *Nineteenth Century* 21 (May 1887), 654–672.

Rosenfeld, Sybil. "Alma-Tadema's Designs for Henry Irving's *Coriolanus.*" *Deutsche Shakespeare-Gesellschaft West Jahrbuch* (1974), 84–95.

Rossetti, Dante Gabriel. "The Stealthy School of Criticism." *Athenaeum* (16 December 1871), 792–794.

"Rossetti and Tadema." *Blackwood's* 133 (March 1883), 401–405.

Ruskin, John. "Letter" (1877). *Pall Mall Gazette* 42 (9 July 1885), 4.

Russell, Bruce. "Wilhelm von Plushow and Wilhelm von Gloeden: Two Photo Essays." *Studies in Visual Communication* 9 (Spring 1983), 57–80.

Sawyer, Paul L. "Ruskin and St. George: The Dragon-Killing Myth in 'Fors Clavigera.'" *Victorian Studies* 23 (Autumn 1979), 5–28.

Schmalz, Herbert. "A Painter's Pilgrimage." *Art Journal* (1893), 97–102, 337–42.

Schutz-Wilson, H. "Frederick [*sic*] Leighton." *Magazine of Art* 1 (1878), 57–62.

Schwartz, Therese. "The History of Women's Art: Sins of Omission and Revision." *Helicon Nine,* no. 16 (1986), 9–19.

"The Sea Maiden: A Painting by Herbert J. Draper." *Studio* 3 (1894), 162–64.

Seaman, W. A. L. and S. C. Newton. "A Burne-Jones Discovery." *Burlington Magazine* 107 (1965), 632–633.

Sennett, Richard. "Narcissism and Modern Culture." *October* 4 (Fall 1977), 70–79.

Sharp, Herbert. "A Short Account of the Work of Edward John Poynter." *Studio* 7 (1896), 2–15.

Shaw, George Bernard. "J. M. Strudwick." *Art Journal* (1891), 97–101.

Shefer, Elaine. "The Nun and the Convent in Pre-Raphaelite Art." *Journal of Pre-Raphaelite Studies* 6 (1985), 70–82.

Showalter, Elaine, and English Showalter. "Victorian Women and Menstruation." In *Suffer and Be Still,* ed. Martha Vicinus, 38–44. Bloomington: Indiana University Press, 1972.

Sigsworth, E. M., and T. J. Wyke. "A Study of Prostitution and Venereal Disease." In *Suffer and Be Still,* ed. Martha Vicinus, 77–99. Bloomington: Indiana University Press, 1972.

Sizeranne, Robert de la. "In Memoriam: Edward Burne-Jones: A Tribute from France." *Magazine of Art* 22 (1898), 513–528.

Sketchley, R. D. "The Art of J. W. Waterhouse." *Art Journal* Christmas Number (1909), 1–32.

Smith, L. Toulmin. "What America Does for Her Girls." *Atalanta* 4 (September 1891) 755–764.

"Some Studies by Sir Edward Burne-Jones." *Studio* 14 (1898), 38–49.

Sparrow, Walter Shaw. "The Art of Mrs. William De Morgan." *Studio* 19 (May 1900), 221–232.

Spielmann, M. H. "Current Art." *Magazine of Art* (1885), 347.

Spielmann, M. H. "Edward J. Poynter." *Magazine of Art* 21 (1897), 111–120.

Spielmann, M. H. "The Late Lord Leighton." *Magazine of Art* 19 (1896), 197–216.

Spielmann, M. H. "The Royal Academy I." *Magazine of Art* 12 (1889), 224–227.

Spiers, R. Phene. "The Architecture of 'Coriolanus' at the Lyceum Theatre." *Architectural Review* 10 (July 1901), 3–21.

Staley, Allen. "The Condition of Music." *Art News Annual* 33 (1967), 81–88.

Staley, Allen. "Introduction." In *Victorian High Renaissance.* Manchester City Art Gallery, 1978.

Staley, Allen. "Post-Pre-Raphaelitism." In *Victorian High Renaissance,* 21–32. Manchester City Art Gallery, 1978.

Stanford, Derek. "The Pre-Raphaelite Cult of Women: From Damozel to Demon." *Contemporary Review* 216 (1970), 26–33.

Stanford, Derek. "Sex and Style in the Literature of the Nineties." *Contemporary Review* 216 (1970), 95–100.

Stead, W. T. *The Maiden Tribute of Modern Babylon. Pall Mall Gazette* 42 (6, 7, 8, 10 July 1885), 1–6, 1–6, 1–5, 1–6.

Stein, Richard L. "The Pre-Raphaelite Tennyson." *Victorian Studies* 24 (Spring 1981), 279–301.

Stephens, F. G. "Edward Burne-Jones." *Portfolio* 16 (November and December 1885), 220–225, 227–232.

Stephens, F. G. "Edward Burne-Jones as a Decorative Artist." *Portfolio* 20 (November 1889), 214–219.

Stokes, Margaret. "Hades in Art." *Art Journal* (1884), 217–220, 357–360.

"Studies by Lord Leighton." *Studio* 8 (1897), 106–117.

"Studies by Sir Edward Burne-Jones." *Studio* 7 (1896), 198–208.

Swinburne, Algernon Charles. "Notes on Some Pictures of 1868." In *Essays and Studies,* 358–380. London: Chatto and Windus, 1875.

Taylor, W. S. "King Cophetua and the Beggar Maid." *Apollo* 97 (February 1973), 148–155.

Temple, Ruth Z. "Truth in Labelling: Pre-Raphaelitism, Aestheticism, Decadence, Fin-de-siècle." *English Literature in Transition* 17 (1974), 201–222.

Thirkell, Lance. "Assassination of an Authoress." Sixty-Three Club, 1983.

Thomas, Keith. "The Double Standard." *Journal of the History of Ideas* 20 (1959), 195–216.

Thornycroft, Hamo. "The Study of Ancient Sculpture." *Architect* 27 (April 1882), 231–34, 251–253.

Tintner, Adeline. "The Sleeping Woman: A Victorian Fantasy." *Pre-Raphaelite Review* 2 (November 1978), 12–26.

Turner, Frank M. "Antiquity in Victorian Contexts." *Browning Institute Studies* 10 (1982), 1–14.

Vallance, Aymer. "The Decorative Art of Sir Edward Burne-Jones." Easter *Art Annual* (1900), 1–32.

Walcot, P. "Greek Attitudes Towards Women: The Mythological Evidence," *Greece & Rome* 31 (1984), 37–47.

Walker, Robert. "Private Picture Collections in Glasgow and the West of Scotland." *Magazine of Art* (1894), 361–367.

Ward, James. "Lord Leighton: Some Reminiscences." *Magazine of Art* 19 (1896), 373–379.

Waterhouse, John William. "Sketchbooks." Victoria and Albert Museum, London. [Unpublished]

Waters, William. "Painter and Patron: The Palace Green Murals." *Apollo* 102 (November 1975), 338–341.

Watts, G. F. "The Aims of Art." *Magazine of Art* 11 (1888), 253–254.

Watts, G. F. "More Thoughts on Our Art of To-day." *Magazine of Art* 12 (1889), 253–256.

White, Adam. "Hamo Thornycroft: The Sculptor at Work." Henry Moore Centre for the Study of Sculpture. Leeds City Art Gallery, 1983.

White, S. P. "Modern Mannish Maidens." *Blackwood's* 147 (February 1890), 252–264.

Wiesenfarth, Joseph. "The Greeks, The Germans, and George Eliot." *Browning Institute Studies* 10 (1982), 91–104.

Wilcox, John. "The Beginning of l'Art pour l'Art." *Journal of Aesthetics and Art Criticism* 11 (1953), 360–377.

Wilson, Michael I. "Burne-Jones and Piano Reform." *Apollo* 102 (November 1975), 342–347.

"Women Artists." *Westminster Review* 70 (1858), 163–185.

Wood, Esther. "A Consideration of the Art of Frederick Sandys." *Artist* 18 (November 1896), 1–64.

"The Works of Laurence [*sic*] Alma-Tadema." *Art Journal* (1883), 65–68.

Wright, William. "Lord Leighton at Damascus and After." *Bookman* (March 1896), 183–185.

Yendys, Carita Mary. "Golf as a Pastime for Girls." *Atalanta* 4 (September 1891), 792–794.

Zeitlin, Froma I. "Cultic Models of the Female: Rites of Dionysus and Demeter," *Arethusa* 15 (1982), 129–157.

Zeitlin, Froma I. "The Dynamics of Misogyny: Myth and Mythmaking in the *Oresteia*," *Arethusa* 11 (1978), 149–181.

Zick, Gisela. "Un Chant d'Amour: Zu einem Bildnis von Edward Burne-Jones im Clemens-Sels Museum, Neuss," *Neusser Jahrbuch für Kunst* (1973), 21–34.

Zimmern, Helen. "Lawrence Alma-Tadema: His Life and Work." *Art Journal* (1886), 1–32.

Zwerdling, Alex. "The Mythographers and the Romantic Revival of Greek Myth." *PMLA* 79 (1964), 447–456.

Index

NOTE: Gods and goddesses are indexed as their Greek designations except where titles refer to the Roman ones. Page numbers in bold italic type indicate plates.

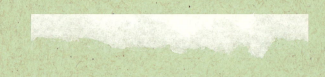